EXPLORING
the INVISIBLE

EXPLORING the INVISIBLE

ART, SCIENCE, and the SPIRITUAL

REVISED AND EXPANDED EDITION

Lynn Gamwell

Foreword by Neil deGrasse Tyson

PRINCETON UNIVERSITY PRESS

PRINCETON AND OXFORD

Major support for this edition was provided
by the School of Visual Arts in New York.

Published by Princeton University Press
41 William Street, Princeton, New Jersey 08540
6 Oxford Street, Woodstock, Oxfordshire OX20 1TR
press.princeton.edu

Library of Congress Control Number: 2019950789
ISBN 978-0-691-19105-8

British Library Cataloging-in-Publication Data is available

Editorial: Vickie Kearn, Susannah Shoemaker, and Lauren Bucca
Production Editorial: Karen Carter
Text Design: Jason Snyder
Jacket/Cover Design: Jason Snyder
Production: Steven Sears
Publicity: Matthew Taylor and Katie Lewis
Copyeditor: Amy K. Hughes

FRONT JACKET: Nurit Bar-Shai (Israeli, born 1974), *Objectivity [tentative]: Sound to Shape*, 2013.
Microbial culture on agar in a Petri dish. Courtesy of the artist.

SPINE: *Porpalia prunella*, in Ernst Haeckel, *Kunstformen der Natur* [Art forms in nature]
(Leipzig: Bibliographisches Institut, 1899–1904), plate 17, fig. 5.

BACK JACKET: *Quantum: An Ode to Particle Physics*, 2012. Choreography by Gilles Jobin,
performed in an installation by Julius von Bismarck, music by Carla Scaletti, at the
Large Hadron Collider, Geneva, Switzerland.

TITLE PAGE: Black hole at the center of the galaxy M87 (detail of plate 14-8).
Event Horizon Telescope Collaboration.

TABLE OF CONTENTS: Kenji Aoki (Japanese, born 1968), *A Male Indian Peafowl*,
2019. Photograph. ©Kenji Aoki, 2018. Courtesy of the artist.

This book has been composed in Neutra and Minion

Printed on acid-free paper. ∞

Printed in Korea

10 9 8 7 6 5 4 3 2 1

For Aaron Miller, neurologist, and Joshua Bederson, neurosurgeon, Mount Sinai Hospital in New York, and Herb Karpatkin, physical therapist, Hunter College, who made it possible for me to maintain my power of concentration and write this book.

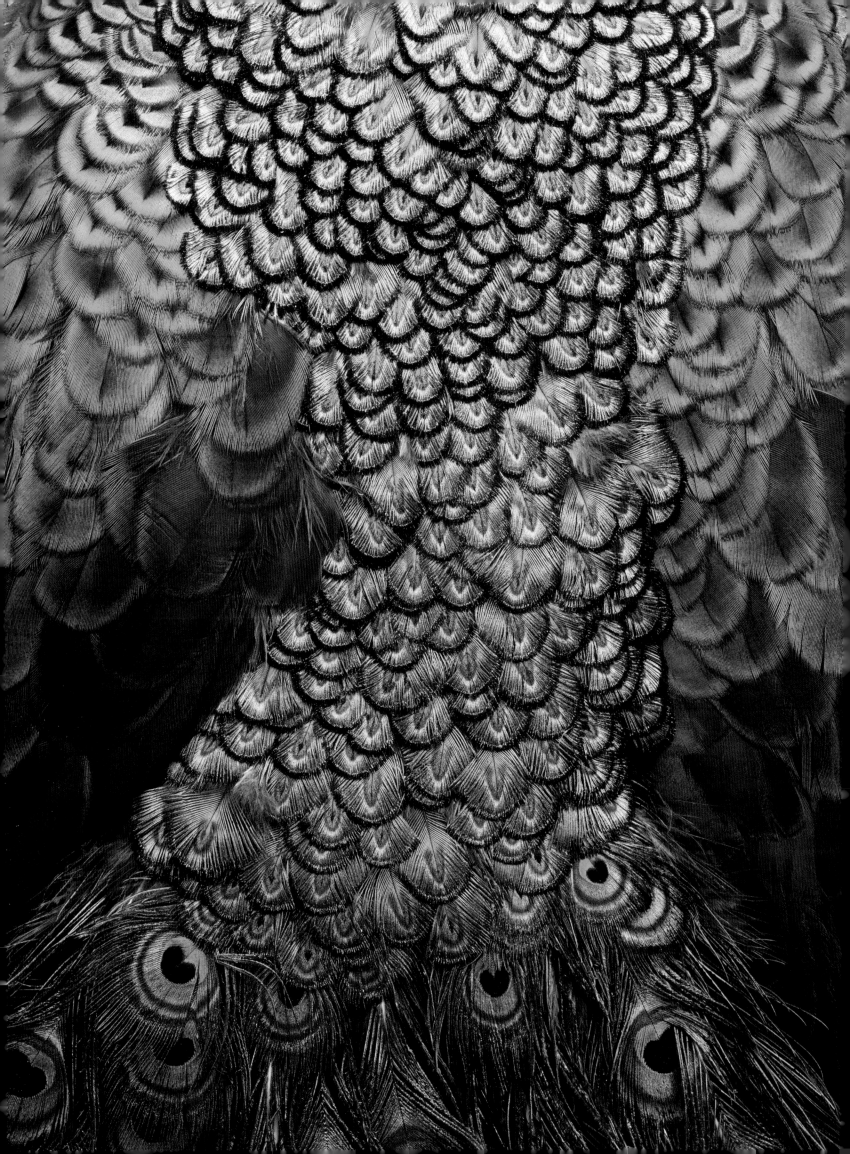

Contents

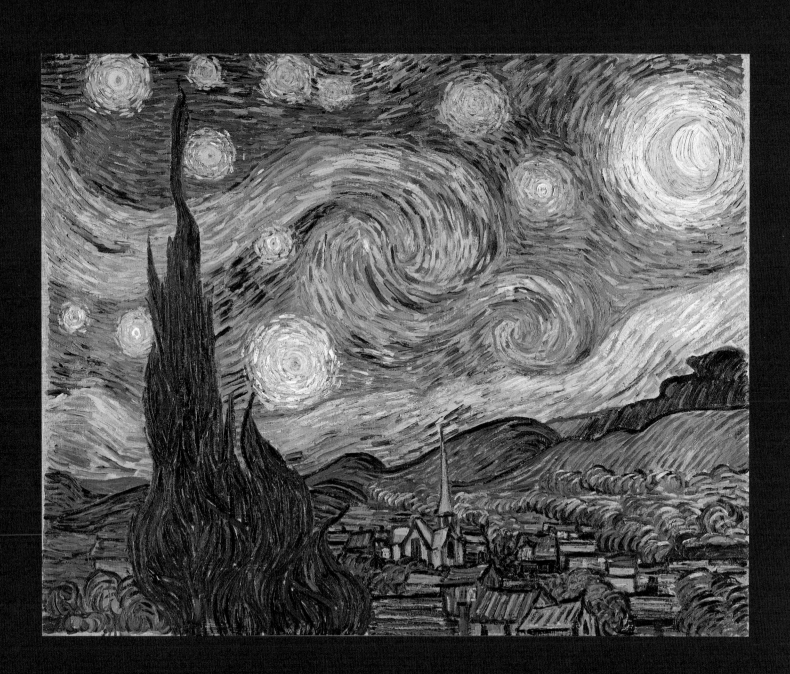

Foreword

Science as the Artist's Muse

Neil deGrasse Tyson

IN THE LATE 1880S, when Vincent van Gogh was in the South of France, classical physics was in its prime years, the Industrial Revolution was in high gear, and heavier-than-air flight was being actively researched. Vincent could have called one of his most famous paintings from that period "Tranquil Landscape" or "Village in the Valley" or "Evening Air." But no, he called it "The Starry Night."

In many ways science and art are profoundly similar. The best of each rise up from the depths of human creativity, nurtured by an individual's commitment and passion to the discipline. In common parlance, we are as equally likely to hear (or say ourselves) "She's got it down to a science" as "He's raised it to an art." In other ways, however, science and art are profoundly different. The most important scientific theories of all time, those that came from the minds of undeniably great scientists, would all have been discovered eventually by one or more other scientists. In some cases, important theories or discoveries have been rushed to publication out of fear they would be scooped by someone else. In art, however, Leonardo da Vinci didn't have to rush-paint his Mona Lisa out of fear that somebody else was going to create the identical portrait. And if Ludwig van Beethoven had never been born, nothing remotely approximating his famous Ninth Symphony would ever be written by anybody, anywhere, at any time.

If art indeed imitates life, then art is an expression of the beauty, the tragedy, and the complexity of the human condition. Central to imitating the human condition is the need to explore our sense of place and purpose in the world. If the discoveries of science were detached from this calling then one would never expect science to inspire creativity in the artist, or more specifically, one would never expect art to reach for scientific themes.

Other than the occasional portrayal of a comet or an evening moon, art before the Industrial Revolution rarely tapped science for its themes. Upon the arrival of that

0-2. Vincent van Gogh (Dutch, 1853–1890), *The Starry Night*, 1889. Oil on canvas, 29 × 36¼ in. (73.7 × 92.1 cm). Museum of Modern Art, New York, acquired through the Lillie P. Bliss Bequest.

seminal period of civilization, science began to touch people's daily lives. Today, we fully expect to be living differently (longer, better, healthier, stronger) next year than this one, simply due to the advancing frontier of science.

For most of the twentieth century the image of scientists held by the public was the wild-haired, lab-coat wearing, test-tube holding, unkempt-looking, antisocial variety. But what mattered more than these stereotypes was that scientists typically conducted their work in the confines of laboratories and rarely communicated their work to the public unless the results had direct implications for national health or defense. And even then, the results were only occasionally communicated by the scientists themselves.

True, the great physicists Galileo, Isaac Newton, Pierre-Simon Laplace, Michael Faraday, Arthur Eddington, James Jeans, and Albert Einstein all wrote popular accounts of their works. But they were exceptions. In modern times, it's expected (and even common) for scientists, along with traditional science writers, to communicate discoveries to the public through magazines, books, television, and public talks. During any week of your choosing, dozens of science programs appear on PBS and on cable TV channels, while multiple science news stories make headlines in the daily newspapers. The Internet further brims with endless science content, if you know where to find it.

And over the past two decades, I saw the Tony Award–winning play *Copenhagen* on Broadway, where the audience was transfixed by a retelling of important episodes in the history of particle physics and quantum mechanics as they related to the making of the first atomic bomb. At the same time, I noted that *The Elegant Universe*, a book on the search for a theory of everything, was still high on the best-seller list. And lately, there's been a science book on the list at least once a month. And science-inspired plays keep surfacing: one, titled *Proof*, which explores the relationship between mind and mathematical genius, and another, titled *QED*, exploring the life of the celebrated physicist Richard Feynman. Meanwhile, the Alfred P. Sloan Foundation funds a grant-stream that specifically targets playwrights who are inspired to tell the stories of untold episodes in the history of science.

We've also seen an unprecedented parade of first-run bio-pics that portray scientists, some known, some obscure—*A Beautiful Mind* (John Nash), *Agora* (Hypatia), *The Imitation Game* (Alan Turing), and *The Theory of Everything* (Stephen Hawking)—each attracting marquee actors and directors. On the fiction side, we have the two high-budget films *Interstellar* and *The Martian*, each chock full of accurate science, fully integrated with the art of storytelling.

We have evolved from a culture where science touched no one to one where science touches everyone. Caught in the transition were those pioneering artists who, one or two hundred years ago, sought cosmic themes at a time when the science was there, but accessible expositions of its discoveries were not. Today, if the artist's ways are any indication, the public has embraced science as never before—not as something cold

and distant but as something warm and nearby. From the mysteries of the Big Bang to the mapping of the human genome, to the stellar origin of the chemical elements to the search for life in the universe, people are beginning to feel that cosmic discoveries, made by members of our own species, belong to us all. People see, perhaps for the first time, that they are no longer bystanders in the scientific enterprise but vicarious participants.

In *Exploring the Invisible: Art, Science, and the Spiritual*, Lynn Gamwell traces and documents the resonant evolution of art and science through the centuries in as thorough an exposition as I have ever seen. We are entering an era of artistic inspiration derived from (and occasionally enabled by) the discoveries of modern science. Like the religious and mythological sources that so influenced art before and during the Renaissance, many artists are now moved by the need to capture the physical universe. The theories and discoveries of modern science may have limitless capacity to harness human emotion and unbridled wonder. If so, then artists can count among their many muses the cosmos itself.

0-3. Miwa Matreyek (American, born 1979), *This World Made Itself*, 2013. Multimedia solo performance, with music by Flying Lotus, Careful (Eric Lindley), and Mileece. Courtesy of the artist.

Onstage at Lincoln Center in New York, performance artist Miwa Matreyek reenacted the history of the universe, beginning with the Big Bang (shown here) and ending in modern times.

Preface

Man seeks to form, in whatever manner is suitable, a simplified and lucid image of the world, a world picture, and so to overcome the world of experience, by striving to replace it to some extent by that image. That is what painters do and poets and philosophers and natural scientists, all in their own way. And into this image and its information each individual places his or her center of gravity of the emotional life, in order to attain the peace and serenity which cannot be found within the confines of swirling personal experience.

Albert Einstein, "Principles of Research," 1918

I BEGAN RESEARCHING the origins of modern art in the context of science many years ago after reading Erwin Panofsky's classic essay "Die Perspektive als 'symbolische Form'" (Perspective as "symbolic form," 1924–25). Panofsky's insight that Renaissance artists developed linear perspective to express their concept of the world and only secondarily to imitate their visual experience made me wonder why modern artists had abandoned it. Where did abstract art come from? How did color and form come to be the vocabulary of the modern artist? Renaissance artists understood the world in terms of Neoplatonism and Christianity. Modern artists express what Einstein called their "world picture": the first secular, scientific worldview in human history.

In the Enlightenment, Carolus Linnaeus had organized plants and animals into a great "chain of being," but in the nineteenth century Charles Darwin's theory of evolution forever changed this picture of the world; what had been static and eternal was now constantly evolving. In 1687, Isaac Newton described the universe as a vast, immobile volume of space—the æther—in which stars and planets move slowly and precisely, like a great clock, held together by gravity. But in the early twentieth century Einstein replaced Newton's absolute space and time with a dynamic space-time universe.

These radical shifts have long been recognized for their impact on culture; in 2002 I described their infiltration into the visual arts in the first edition of this book. I wrote this revised edition to update developments in science and art and to include recent scholarship. In the intervening years there have been changes in international politics, which led me to write from a more global perspective.

0-4. Dorothy A. Yule (American, born 1950), *Memories of Science*, 2012. Letterpress printing on paper, embroidery, and brass charms, 2¾ × 2¾ × 1¾ in. (7 × 7 × 4.4 cm), edition of 50. Courtesy of the artist.

As a child, American artist Dorothy Yule was enchanted with science—capturing lightning bugs in a jar and looking at the moon through her telescope—memories she recalls in poems and pictures in this artist's book. In the center of the accordion-fold pop-up book is a crescent moon strung with brass stars between circular star maps drawn by the artist's twin sister, Susan Hunt Yule, accompanied by poetry in which the artist describes her maturation from childlike fantasy to sober science:

Against all scientific fact,
I liked to think Divinity
Might be at space's farthest reach
Where finite meets infinity.

Still on this point my mind was clear:
There was no moon-faced man on high,
Just light reflected from the sun
To my anthropomorphic eye.

The book is accompanied by a CD on which the text is set to music composed by the artist's brother Doug Yule and performed by his band, Big Red Dog: Doug Yule, Tom Collicott, Cary Lung, and Dan Yule.

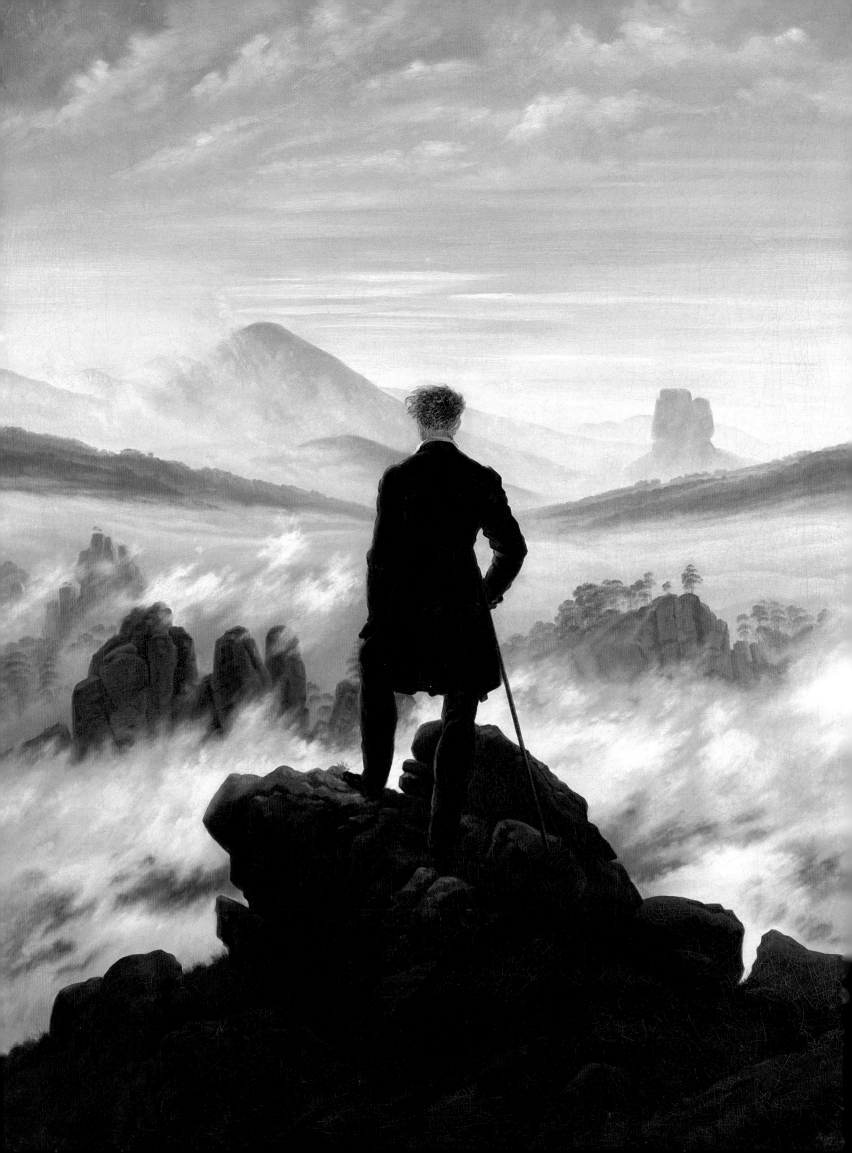

Art in Pursuit of the Absolute

German Romanticism

Landscape painting, though not simply an imitative art, has a more material origin and a more earthly limitation. It requires for its development a large number of various and direct impressions which, when received from external contemplation, must be fertilized by the powers of the mind, in order to be given back to the senses of others as a free work of art. The grander style of heroic landscape painting is the combined result of a profound appreciation of nature and this inward process of the mind.

Alexander von Humboldt, Cosmos: *Draft of a Physical Description of the Universe*, 1845–62

SOMETIME ABOUT 1818, the German artist Caspar David Friedrich finished a large oil on canvas whose apparent subject is seen only from the back. Titled *Wanderer above a Sea of Fog* (plate 1-1), it shows a man poised on a rocky outcropping. His posture tells us that his mood is pensive, perhaps troubled, as he gazes over mist-shrouded rocks toward a great, unreachable void. The subject is as much the feeling the painting evokes as it is the fog and jagged peaks.

Friedrich, who made the concept of the sublime a central concern of the Romantic movement, was among those artists who placed their trust in intuition and emotion, valuing the subjective experience over the rationalism that had powered the Enlighten-ment. This attitude did not, however, divide the artists from the scientists of their day but made them soulmates. In early nineteenth-century Germany, some of the loudest cries against Enlightenment reason came not from artists but from scientists.

The Enlightenment culminated at the close of the eighteenth century with Immanuel Kant's critiques of the foundations of human knowledge in his grand Teu-tonic system—German Idealism. Kant declared that the human mind has a spatial and temporal scaffolding that it uses to organize sensations—touch, taste, smell, sight, hearing, and sight—into one's experience of the natural world over time.

1-1. Caspar David Friedrich (German, 1774–1840), *Wanderer above a Sea of Fog*, ca. 1818. Oil on canvas, 38 × 30 in. (94.8 × 74.8 cm). Hamburger Kunsthalle.

Although Kant never doubted that colorful flowers and chirping birds exist in the "world-out-there" (the everyday world outside human consciousness), he concluded that, in a strict philosophical sense, one knows with certainty only the contents of one's own mind—seeing colors, hearing sounds—from which the mind constructs one's perception of the natural world. The second-generation Idealists—G. W. F. Hegel, Friedrich von Schlegel, Friedrich Schelling, and Arthur Schopenhauer, who were known as the *Naturphilosophen* (German for "nature philosophers")—rejected Kant's limits on knowledge and revived the ancient Greek philosophers Pythagoras and Plato's mystical, pantheist desire to become one with nature.

Romanticism occurred at a time of transition from speculative philosophy to experimental science. Philosophers who collected specimens and did laboratory experiments were called "natural philosophers," and as the balance shifted to a more experimental approach, a new breed of researchers came to be called "natural scientists." Since the Naturphilosophen saw the world through the lens of European Christianity, their philosophical views have ancient theological underpinnings. Modern science evolved from philosophy, and pivotal questions that have driven scientific research are philosophical—ultimately theological—in origin. For the Naturphilosophen and the natural scientists, everything depicted in a painting such as *Wanderer above a Sea of Fog*—the fog, the alpine rocks, the void, and the wanderer's deepest feelings—can be known immediately and directly and is therefore the subject of science.

The Union of Pantheism and Natural Philosophy

The pantheistic reverence for nature is based in the experience of wonder in the face of natural phenomena, and it entails an immediate feeling of unity of the self with the universe. In the West, the creed has a complex history that began in ancient cosmology and became associated with the Abrahamic religions: Judaism, Christianity, and Islam. In the East, pantheism appeared in mystical practices associated with Taoism, Hinduism, and Buddhism. When pantheism reappeared in the nineteenth century as a form of second-generation German Idealism, it was expressed by German Romantic artists such as Friedrich. Mystical pantheism has remained a strong current in German thought, forming the philosophical basis of abstract art in late nineteenth-century Jugendstil (German for "youthful style"), in Der Blaue Reiter (German for "the blue rider") art of the early twentieth century, and persisting to this day (plate 1-2). The common theme in all pantheist creeds is the assertion that nature is a unity and the unity is divine.

One of the oldest philosophical questions in Western culture was posed anew in the Romantic period and became central to modern science: How many kinds of things are there? The legendary philosopher Pythagoras identified only one, a primordial substance, called a *monad* (from the Greek word for "one"). A monad is *sentient,*

1-2. Gerhard Richter (German, born 1932), *Alpen (Stimmung)*, (Alps [Atmosphere]), 1969. Oil on canvas, 78¾ × 78¾ in. (200 × 200 cm). © Gerhard Richter 2018 (0010).

Gerhard Richter grew up after World War II in Dresden, which was then in the Soviet occupation zone of East Germany. When hiking in the Alps, Richter took a photograph (Atlas Sheet 127), from which he created this painting. Despite differences in era, Richter has described an affinity with his fellow Dresden artist: "A painting by Caspar David Friedrich is not a thing of the past. What is past is only the set of circumstances that allowed it to be painted: specific ideologies, for example. Beyond that . . . it concerns us—transcending ideology—as art that we consider worth . . . defending, perceiving, showing, making. It is therefore quite possible to paint like Caspar David Friedrich today" (Richter, letter to Jean-Christophe Ammann, Feb. 1973, in *Gerhard Richter: Writings, 1961–2007*, ed. Dietmar Elger and Hans Ulrich Obrist [New York: D.A.P., 2009], 72).

which means it has feeling or consciousness. Since mankind and the universe are both constructed from this substance, Pythagoras reasoned that man is a microcosm of the universe and animated by a common spirit, a World Soul, which is divine and eternal. Forces in nature exist in complementary, antagonistic pairs—male/female, dark/light, limited/unlimited—which are balanced in the living, dynamic cosmos. Followers of Pythagoras, such as Plato, taught that one can attain knowledge of the cosmos through philosophical reflection.[1]

The idea that the universe is ordered by one spiritual principle inspired a desire to unite with the World Soul, and there is a long association of monism with mysticism in the medieval and Renaissance eras. In the seventeenth-century, the deification of nature was articulated into a pantheist creed. Protestantism, with its declaration that the worshiper communicates with God directly, unmediated by saints or priests, produced the Lutheran mystic Jakob Böhme, who had a vision that nature is entirely a manifestation of a divine spirit—"the Abyss"—the ground of all things. Jewish mysticism, which encourages meditation on sacred writings (the Kabbalah), provided the intellectual setting for the Dutch philosopher Baruch Spinoza, who proclaimed that everything is a manifestation of one substance, called God/Nature.

But when Enlightenment natural philosophers asked how many things constitute their clockwork universe, they answered: "There are two—mind and matter." In Isaac Newton's mechanical worldview everything is made of matter, which is inert and does not move unless acted upon by a force such as gravity. Matter in motion follows strictly deterministic laws of cause and effect. In order to make room for free will and creative thought in this billiard-ball universe, the French philosopher René Descartes posited that the human soul (the mind) is not material but spiritual; it exists independent of the body. Thus a philosophical chasm opened, separating one's subjective mental experience from the material world, including one's own body and everyday objects. If spirit and matter are completely different substances, however, how can a person's (mental/spiritual) thought that they want to walk cause their (physical/material) legs to move? Descartes tried to close the gap by positing a place in the brain—the pineal gland—where the soul (the mind) and body meet (plate 1-3). Kant tried to solve the problem by arguing that a man's sensations (colors, sounds, smells) reflect properties of real flowers and birds, but the flora and fauna in itself (the physical objects in the world-out-there independent of the human mind) remains beyond the borders of perception.

Descartes's mind-matter distinction placed the (free, unpredictable) human soul safely outside the reaches of (deterministic, mechanistic) science, even though the distinction introduced an unsolvable puzzle (the "mind-body problem") into philosophy. But by around 1800, second-generation German Idealists were feeling ill at ease with several implications of the mind-matter distinction. First, since human beings have both a spiritual mind and a material body, they are alienated from nature, which is composed only of matter. Rather, everything in nature—humans, animals, trees, and

stars—is made of the same monads. Second, science is using the wrong model, because it treats nature as an inert machine that operates by deterministic laws of cause and effect. Rather, nature is an organic entity, made of interdependent parts that come together by self-assembly into a harmonious whole. Furthermore, human beings are one with this self-organizing, self-generating, dynamic, living system.

Thus, to rid philosophy of the mind-matter dualism, the Naturphilosophen revived the ancient Pythagorean-Platonic doctrine of cosmic unity and proclaimed that mind and matter are not distinct substances but one.[2] Already the seventeenth-century German philosopher Gottfried Leibniz had rejected the Cartesian dichotomy, arguing that all bodies are composed of monads, tiny organisms with souls (*Monadology*, 1714). Schelling similarly contended that mind and matter are an inseparable unity because they are made of monads. Schelling described a hierarchy of monads at the top of which was an impersonal, supreme intelligence, "Absolute Spirit," which for him was equivalent to the logical structure of all the sentient particles that make up the universe. Hegel's view of Absolute Spirit is also a secular reformulation of traditional Pythagorean notions—that one can attain higher mental levels through philosophical reflection or meditation. In Hegel's terms, a dialectical, mental process can move one beyond everyday perception of the natural world to self-consciousness, culminating in knowledge of Absolute Spirit.

In addition to reviving the Western Pythagorean-Platonic outlook, many Naturphilosophen noticed that traditional Eastern texts of Hinduism, Buddhism, and Taoism express a similar pantheist reverence for nature and a feeling of immediate unity with the universe. According to Hindu philosophers, the everyday physical world is unreal and ephemeral, and true reality is a primordial void—emptiness, nothingness—known as Brahma. Brahma is described in texts about meditation and spiritual practices, collectively called the Upanishads, which began appearing in the ancient language of India, Sanskrit, around 800 BC. These texts, which are part of a larger body of Indian literature that includes the sacred texts known as the Vedas, are the basis of India's hereditary caste system, according to which knowledge of Brahma (enlightenment, nirvana) is restricted to the upper classes. Buddha was born in Nepal in the late sixth century BC into a royal family, but he renounced privilege and became a reformer who declared that everyone—all classes—can reach enlightenment. Each person is born, dies, and is reincarnated in the physical world, but anyone can escape cyclical material existence and unite eternally with the primordial void—Brahma—through meditation and ascetic living.

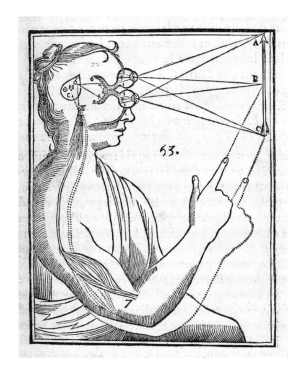

1-3. Diagram of the pineal gland, in René Descartes, *L'Homme* (Paris: Charles Angot, 1664), 79. Bibliothèque National de France.

Descartes declared that the pineal gland (a pine-cone-shaped organ, marked *H* in this diagram) is the place where mind meets matter. When this woman looks at an arrow (*A*, *B*, *C*), light strikes her retina (*5*, *3*, *1*), stimulating nerves that enter her brain (*6*, *4*, *2*). These nerves carry "animal spirits," which take the form of "a certain very fine wind, or rather a very lively and pure flame." When this nervous energy arrives at the pineal gland at point *b*, the woman sees an arrow. The pineal gland also plays a role in motion; if the woman has the thought (will, desire) to point at the arrow, nervous energy (animal spirits) leaves the gland at points *b* and *c*, connects with the nerves of the arm at *8*, and flows to *7*, where her elbow bends, her hand raises, and she points at the arrow. As Descartes wrote, "If we have an idea about moving a member [a part of the body], that idea—consisting of nothing but the way in which spirits flow from the [pineal] gland—is the cause of the movement itself." *L'Homme* (Man, 1664) in *Oeuvres de Descartes*, ed. Charles Adam and Paul Tannery (Paris: J. Vrin, 1965–73), 11:129 and 181; English translations are from *The Philosophical Writings of Descartes*, trans. J. Cottingham, R. Stoothoff, D. Murdoch, and A. Kenny (Cambridge: Cambridge University Press, 1991), 1:100, and René Descartes, *Treatise of Man*, trans. T. S. Hall (Cambridge, MA: Harvard University Press, 1972), 92.

1-4. Shen Zhou (Chinese, 1427–1509), *Poet on a Mountaintop*, 1496, from the *Landscape Album: Five Leaves by Shen Zhou, One Leaf by Wen Zhengming*. Album leaf mounted as a hand scroll, ink and color on paper, 15¼ × 23¾ in. (38.7 × 60.3 cm). The Nelson-Atkins Museum of Art, Kansas City, Missouri, William Rockhill Nelson Trust, 46-51/2.

Shen Zhou was a scholar-artist from the Jiangsu province on China's north-eastern coast. He wrote the inscription (translation by Jiajun Liu):

White clouds are like a scarf around the mountain's waist
Stone steps hang in space—a long, narrow path
Alone, leaning on my cane, I gaze intently at the scene
The murmuring brook has a pleasant chat with the music of my flute.

Taoism arose in China during a time of political instability, the Warring States period (ca. 475–221 BC), when people sought to escape palace intrigue and live in peace in the countryside. According to the legendary founder of Taoism, Laozi (fourth century BC), nature developed spontaneously from a formless void according to its own rules, the Tao (Chinese for "way"). To know the Tao is to be in harmony with the universe as an organic, unified, self-sufficient system. Meanwhile, Hindu leaders eventually pushed followers of Buddha out of India, so Buddhists migrated over the Himalayas into Tibet and followed the Silk Route east to China, Korea, and Japan, where, by the eleventh century AD, the concept of Brahma had merged with Tao, resulting in (Taoist) communication with nature as a key to (Buddhist) enlightenment (plate 1-4).

The prevalence of pantheism throughout history—East and West—can perhaps be explained by the perpetual philosophical observation that if one looks deep enough into oneself, one discovers not only the essence of oneself but also of the universe, because human beings and the universe are made of the same substance. In 1930, Albert Einstein called this intuition of the universe a "cosmic religious feeling":

The individual feels the nothingness of human desires and aims, and the sublimity and marvelous order that reveals itself both in nature and in the world of thought. He looks upon individual existence as a sort of prison and

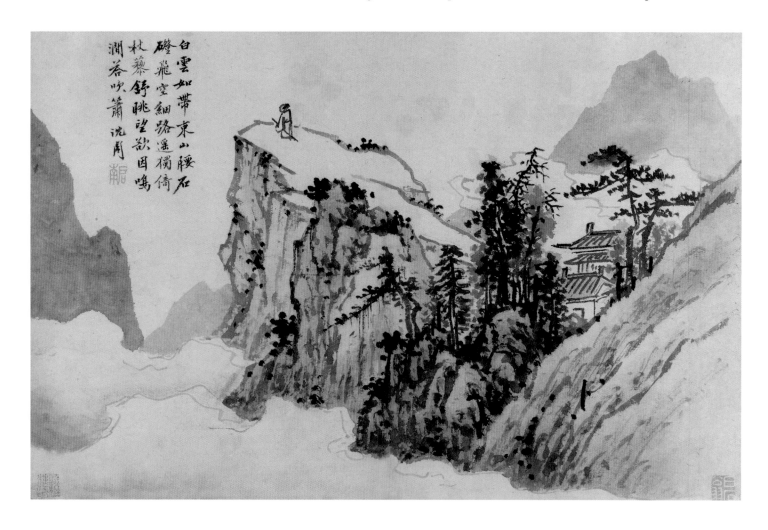

CHAPTER 1

wants to experience the universe as a single significant whole. The beginnings of cosmic religious feeling already appear at an early stage of development— for example, in many of the Psalms of David and in some of the Prophets. Buddhism, as we have learned especially from the wonderful writings of Schopenhauer, contains a much stronger element of this.[3]

The Naturphilosophen View of Asian Philosophy

German Romanticism occurred at a time when Western scholars were studying Eastern cultures, a practice that began during the Enlightenment, after Portuguese trading ships took Jesuit Catholic missionaries to China in the later sixteenth century. The Jesuits assumed there was a "natural theology"—knowledge of divinity based on observed facts and experience apart from revelation. According to the Jesuits, over the centuries humankind had corrupted this original, primeval religious feeling by means of superstition, ritual, and dogma; the Jesuit's goal was to reignite this original, international spiritual flame in the Chinese and convert them to Christianity.

Leibniz pointed out that the Jesuits' characterization of Chinese religion applied equally to Christianity. Leibniz praised Confucius (late sixth–early fifth century BC) because he was a practical philosopher with a secular orientation who focused on acting ethically in the present (as opposed to focusing on abstract concepts about an otherworldly realm), and the German philosopher suggested bringing Chinese missionaries to Europe to convert Portuguese, French, and German citizens to Confucianism.[4]

In the late eighteenth century, European interest in Asia shifted from China to India, as the Upanishads and other ancient Sanskrit texts became increasing available in translation by Orientalists such as Friedrich Majer, who declared that the sense of the unity and wholeness of nature had been lost in the Western rational, quantitative, mechanical way of viewing the universe. Majer was one of many German Romantics who felt that the fragmented philosophical and religious situation in Europe could be repaired only by returning to the origin of civilization, which Majer believed was in India, because in Hinduism ultimate reality (Brahma) is a (unified, undifferentiated) primordial void. As Majer wrote in 1818: "There is no doubt that the priests of Egypt and the sages of Greece have drawn directly from the original well of India."[5]

The philosopher Friedrich von Schlegel also condemned the effects of the Enlightenment on his contemporaries: "Man had indeed perfected the art of arbitrary partitioning or, what amounts to the same thing, of mechanism, and thus man himself has almost become a machine [*der Mensch selbst fast zur Maschine geworden*]"[6] What is the solution? Like Majer, Schlegel looked to the East, writing in 1800: "We must reach the summit of Romanticism [*das höchste Romantische*] in the East."[7] Not satisfied with reading secondary sources, in 1802 Schlegel moved to Paris (a center of philology), where he began a decade of intense study of Hinduism in Sanskrit documents, some of

After having preached his religion for forty years, when he [Buddha] felt death was approaching, he declared to his disciples that he had hidden the truth from them under the veil of metaphors, and that all reduced itself to nothingness, which was the first source of all things.

Gottfried Leibniz, *Theodicy*, 1710

You who worship the Creator
 of the immense universe,
Who call him Jehovah, God,
 Buddha, or Brahma,
Listen and hear the words of the
 Sovereign of all things. . . .
Love yourselves and your brothers!
Hold out the brotherly hand
 of everlasting friendship;
It was delusion, not truth,
 which withheld it for so long.

Hymn (K. 619), lyrics by Franz Heinz Ziegenhagen, music by Wolfgang Amadeus Mozart, 1781

which he translated into German. This was a time of cross-cultural study of the origins of languages: in 1786 the British linguist William Jones suggested that Sanskrit, Greek, and Latin developed from a common mother tongue, an ancient language that came to be called Indo-European, and in 1816 the German linguist Franz Bopp proved this hypothesis correct through a comparison of the three languages' grammars. In 1808, Schlegel published his own research on the grammatical connections between Sanskrit and European languages, together with his scholarly study of Hindu philosophy, in *Über die Sprache und Weisheit der Indier* (On the language and wisdom of the Indians).[8]

In their youth, Schelling and Hegel had been students and roommates together at the University of Tübingen, and for many years they were close friends. But Schelling drifted apart from Hegel because he was more open-minded about Eastern philosophy. Schelling's mature fascination with pantheism, a World Soul, and knowledge by intuition led him to praise the "sacred texts of the Indians" ("Lectures on the method of Academic Studies," 1802). He went on to give a series of lectures on mythology with extensive sections on Chinese and Indian traditions (*Philosophy of Mythology*, 1845–46).

Schlegel felt one could return to a pure, primeval past, but Hegel believed that history progresses irreversibly forward. According to Hegel, Buddhism and Taoism were part of the origins of ancient thought, but Eastern philosophy became petrified, and the development of philosophy occurred in the West, passing from Thales and Plato to Kant and himself.[9] Despite Hegel's condescending attitude, he took up a serious study of Indian philosophy, guided by his friend and colleague Franz Bopp, in Berlin. Hegel believed that the practice of yoga was the core of Indian philosophy because it encourages ascetic discipline, spiritual purification, and self-understanding: "Yoga is deep concentration without any object . . . a silencing of every inner feeling, desire, hope, or fear, a silencing of all affections and passions, the absence of all images, ideas, and particular thoughts."[10] He also praised Chinese philosophers for their concept of Tao, at the core of which is a negation: "To the Chinese what is highest in the origin of things is nothing, emptiness, the altogether undetermined, the abstract universal, and this is also called Tao" ("Oriental Philosophy," 1816).[11]

Lutheran Theology and Pantheism: Schleiermacher and Kosegarten

Friedrich Schlegel and his friend Friedrich Schleiermacher, the Lutheran theologian, shared a house in Berlin, where they were part of the burgeoning circle of Romantic young artists and writers. Schlegel and Schleiermacher worked together for several years on a German translation of Plato's dialogues, but Schlegel abandoned the project when he moved to Paris in 1802, and Schleiermacher finished it without him. Before Schlegel left Berlin, he and other young Romantics asked Schleiermacher to write a summary of his religious beliefs, in response to which he published *On Religion:*

Speeches to Its Cultured Despisers (1799), the "cultured despisers" being his educated, worldly friends such as Schlegel.

Schleiermacher begins *On Religion* by dismissing as worldly corruptions the churches' more off-putting features, such as narrow-minded dogmatism and a Christians-versus-heathens mentality. Belief in the Christian God is optional, according to Schleiermacher, because whether one believes in god as a person or a spirit, in one god or many gods or no god at all, depends on what culture one is from. There are, according to Schleiermacher, an endless variety of valid forms of religion, but belief in personal immortality—life after death—is positively *unreligious*, because such believers are narcissistically focused on themselves: "They are anxiously concerned about their individuality . . . they don't want to seize the sole opportunity death affords them to transcend humanity."[12] Rather, immortality is achieved when one intuits the universe and lives intensely in the present moment: "To be one with the infinite in the midst of the finite and to be eternal in a moment, that is the immortality of religion."[13]

What is the common thread running through world religions? What links the Hebrew prophet to the Taoist monk? According to Schleiermacher: "Religion's essence is neither thinking nor acting, but intuition and feeling. It wishes to intuit the universe, wishes devoutly to overhear the universe's own manifestations and actions, longs to be grasped and filled by the universe's immediate influences in childlike passivity."[14]

Schleiermacher's approach fit the new field of cross-cultural studies of world religions, which treated the Bible as a product of human history rather than divine revelation. For centuries, Christian scholars had estimated that God created Earth around 4000 BC. The German astronomer Johannes Kepler had put the date at 3992 BC, and Isaac Newton had figured 4000 BC; they arrived at similar dates because they used the same method—surveying the biblical dates of the male lineage from Abraham to Jesus.[15] But in Schleiermacher's day, scientists shifted from biblical to geological time. Using the method of measuring sedimentary layers in rock, geologists estimated that Earth is not thousands but millions of years old (see chapter 3; today geologists estimate that Earth is 4.5 billion years old).

The Lutheran theologian Ludwig Gotthard Kosegarten also put forth a pantheist reading of theology, but whereas Schleiermacher spoke to educated intellectuals, Kosegarten addressed the common people. After being ordained in 1792, Kosegarten served as pastor in Altenkirchen, a small village on the island of Rügen in the Baltic Sea. Each Sunday morning, for most of the year, fishermen from neighboring Vitt would walk to Altenkirchen to attend worship service, but when they were busy during the herring season (August and September) Kosegarten went to them. Lacking a chapel in Vitt, Kosegarten held services outdoors, giving "shore sermons" (*Uferpredigten*), in which he described how worshipers could feel a divine presence in nature, "according to the trumpet of the sea and the pipe organ of the storm."[16]

Philipp Otto Runge and Caspar David Friedrich

Both Philipp Otto Runge and Caspar David Friedrich were interested in theological questions; in 1801 Runge began an intensive study of the seventeenth-century Lutheran mystic Jakob Böhme, and he introduced Friedrich to Böhme's writings when they met the following year. The artists became friends with Kosegarten and often visited him at Rügen (plate 1-5).[17] In 1806, Kosegarten commissioned Runge to do a painting for his proposed new chapel in Vitt illustrating Jesus walking on the water (Matthew 14:25–31). As the story goes, one night Peter was in a boat with the other disciples, and in the darkness they saw a man walking toward them on the water. Who is it? they wondered. A ghost? Peter cried out, "Lord if it be you, bid me come to you on the water," which Jesus did. Peter got out of the boat and walked toward Jesus, but he became afraid and began to sink. Jesus reached out and caught him, saying, "O you of little faith, why did you doubt?" Runge began his painting of the dramatic story with great enthusiasm: "It will be possible to incorporate several imposing phenomena—the waves, the moonlight, the rocking of the boat—that echo with the natural surroundings on Rügen."[18] At this time, northern German territories were threatened by Napoleon's army, which occupied Rügen in 1807 and made it impossible for Runge to travel there and complete the painting.

1-5. Caspar David Friedrich (German, 1774–1840), *View of Arkona with Rising Moon*, ca. 1806. Pencil and sepia, 24 × 39½ in. (60.9 × 100 cm). Graphische Sammlung Albertina, Vienna.

Friedrich depicted the cape of Arkona on the island of Rügen, with the salt cliffs of Jasmund silhouetted in the background.

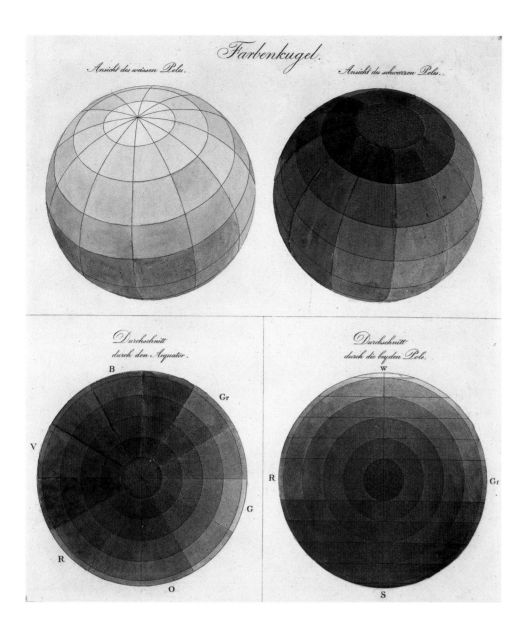

Farbenkugel.

Ansicht des weissen Poles. Ansicht des schwarzen Poles.

Durchschnitt durch den Aequator. Durchschnitt durch die beyden Pole.

1-6. Color sphere, from Philipp Otto Runge (German, 1777–1810), *Farbenkugel* (Color sphere) (Hamburg: Friedrich Perthes, 1810). Hamburger Kunsthalle.

Runge established a white pole (upper left) opposite a black pole (upper right), with hues located around the equator (lower left). Mixtures are shown in cross sections through the equator (lower left) and through the poles (lower right). Runge interpreted color in terms of Lutheran mysticism, associating the three primary colors with Jakob Böhme's divine trinity, in which God and nature form a unified whole; in Runge's words: "The divine trinity is the symbol of the highest light, just as the three primary colors represent sunlight. . . . When we understand the thousand refractions of the three primary colors, then we will be able to approach comprehension of the divine trinity that we feel in our souls" (Runge, letter to Pauline Bassenge, Apr. 1803, in *Philipp Otto Runge: Briefe und Schriften*, ed. P. Betthausen [Munich: C. H. Beckaq, 1982], 141).

Runge met the poet Johann Wolfgang von Goethe in Weimar in 1803, and they became close friends because of their shared interest in color theory (see plate 1-6 and sidebar on pages 12–13). While in Weimar, Runge conceived of a cycle of monumental paintings on the theme Times of Day—morning, noon, evening, and night—to be installed in a building in Dresden. Runge wanted to immerse the viewer in a visual, auditory, and verbal experience. On entering in the morning, for example, the viewer would see the painting of morning (plate 1-13) and hear appropriate music and poetry: "My four pictures . . . will be an abstract, fantastical-musical poem with choirs [*phantastisch-musikalische Dichtung mit Chören*], a composition for all three arts combined, for which architects should design a special building."[19] Runge even imagined that he himself would create a brand-new style of architecture for the building, which would be a continuation of northern Gothic (*die aber gewiß mehr eine Fortsetzung der Gotischen*), not classical Greek.[20] Unfortunately, Runge contracted tuberculosis and was unable to complete the project; he died in 1810 at age thirty-three.

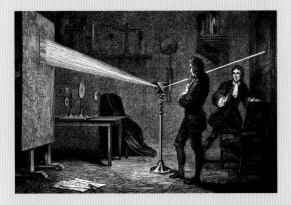

1-7. Isaac Newton, *Opticks: or, A Treatise of the Reflexions, Refractions, Inflexions and Colours of Light* (London: S. Smith and B. Walford, 1704), title page.

ABOVE
1-8. Newton, using a prism to break white light into a spectrum, with Cambridge roommate John Wickins. Engraving by Guillon, 1874.

RIGHT
1-9. Spectrum

NEWTON'S *OPTICKS* AND GOETHE'S *FARBENLEHRE* (THEORY OF COLORS)

During the Enlightenment, Isaac Newton proved that white light (sunlight) contains all the colors of the rainbow (*Opticks*, 1704; plate 1-7). To demonstrate this, Newton set up a darkened room so that a beam of sunlight entered through a tiny hole (an aperture) in an opaque window shade and passed through a prism onto a screen (plate 1-8). Different parts (now known to be wavelengths) of white light are deflected at different angles, so the parts fall on the screen in bands of color—a spectrum (plate 1-9). Several of Newton's contemporaries insisted that sunlight is only white light and that the color comes from the glass of the prism. Newton proved them wrong by separating a beam of sunlight into a spectrum and then gathering it with a lens and passing it through a second prism, which recomposed it into white light. He then passed that beam through a third prism, which again separated it into a spectrum (plates 1-10 and 1-11). White light, he showed, contains all the spectral colors, and all those colors combine to form white light.

Johann Wolfgang von Goethe was not only a poet but also a scientist; for example, he wrote a treatise on plants (*Metamorphosis of Plants*, 1790). But unfortunately, he let his prejudice against Enlightenment determinism lead to bad science, publishing a book on color, *Farbenlehre* (Theory of colors, 1810) that is a thinly disguised attack on Newton. After learning that Newton used a prism to produce a spectrum, Goethe replicated the experiment, but he failed to produce a spectrum because he made mistakes in how he set up his equipment. To produce a spectrum, one directs a narrow beam of light into the prism in a darkened room. Instead, Goethe opened the drapes and let the room be filled with sunlight, some of which shone on the prism. This doesn't produce a spectrum; rather it produces thousands of overlapping spectra that blend to form white sunlight. Failing to observe a spectrum, Goethe picked up

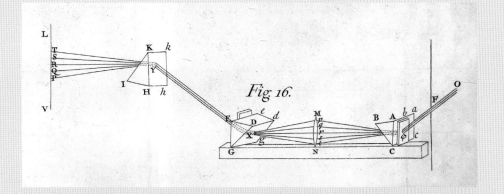

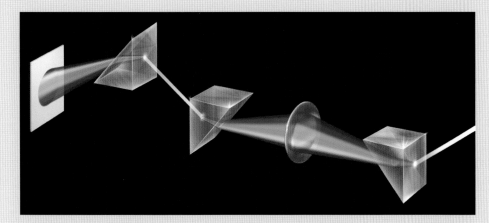

TOP LEFT

1-10. Isaac Newton, *Opticks* (1704), bk. 1, pt. 2, plate 4, fig. 16.

BOTTOM LEFT

1-11. Spectrum with three prisms

BELOW

1-12. Diagram of black-and-white patterns, in Johann Wolfgang von Goethe, *Farbenlehre* [Theory of colors] (Tübingen: J. C. Cotta, 1810), plate 2a.

the prism and looked through it, as one looks through a lens, at a black-and-white pattern (such as plate 1-12). He observed that the pattern had chromatic aberration (rainbow-like outlines around the black and the white shapes; see chapter 3). Such chromatic aberration was well known to lens grinders, but Goethe was evidently unaware of it, and so he cried, "Eureka! Newton was wrong!" Goethe concluded that the perception of color is caused by seeing a pattern of black-and-white spots, basing his pronouncement on Aristotle's ancient color theory, which had long ago been discarded. Goethe went on to attack Newton with such viciousness—calling Newton's *Opticks* a "ludicrous explanation"—that one suspects there was more than science going on. When Goethe published his color theory in 1810, the artist's role as a recorder of the natural world was being challenged, as physicists described color as a property not of birds and flowers but of light. Perhaps Goethe felt called upon to formulate a color theory that would stop the tide, as the German physiologist Hermann von Helmholtz suggested: "We must look upon his theory as a forlorn hope, a desperate attempt to rescue from the attacks of science the belief in the direct truth of our senses" (Helmholtz, "On Goethe's Scientific Researches" [1853], in *Popular Lectures on Scientific Subjects*, trans. E. Atkinson [New York: D. Appleton and Co., 1891], 39–59; the quote is on 54).

If Goethe were not the author of *Faust* (1808/1832), his color theory would have been tossed into the dustbin of science along with countless other laboratory mistakes and false hypotheses. But instead, gallons of ink have been spilled trying to make sense of it; a few examples: Michael J. Duck, "Newton and Goethe on Color: Physical and Physiological Considerations," *Annals of Science* 45 (1988), 507–9; Martin Kemp, *The Science of Art: Optical Themes in Western Art from Brunelleschi to Seurat* (New Haven, CT: Yale University Press, 1990), 297–99; and John Gage, "Goethe in the Twentieth Century," *Color and Meaning: Art, Science, and Symbolism* (Berkeley: University of California Press, 1999), 193–95.

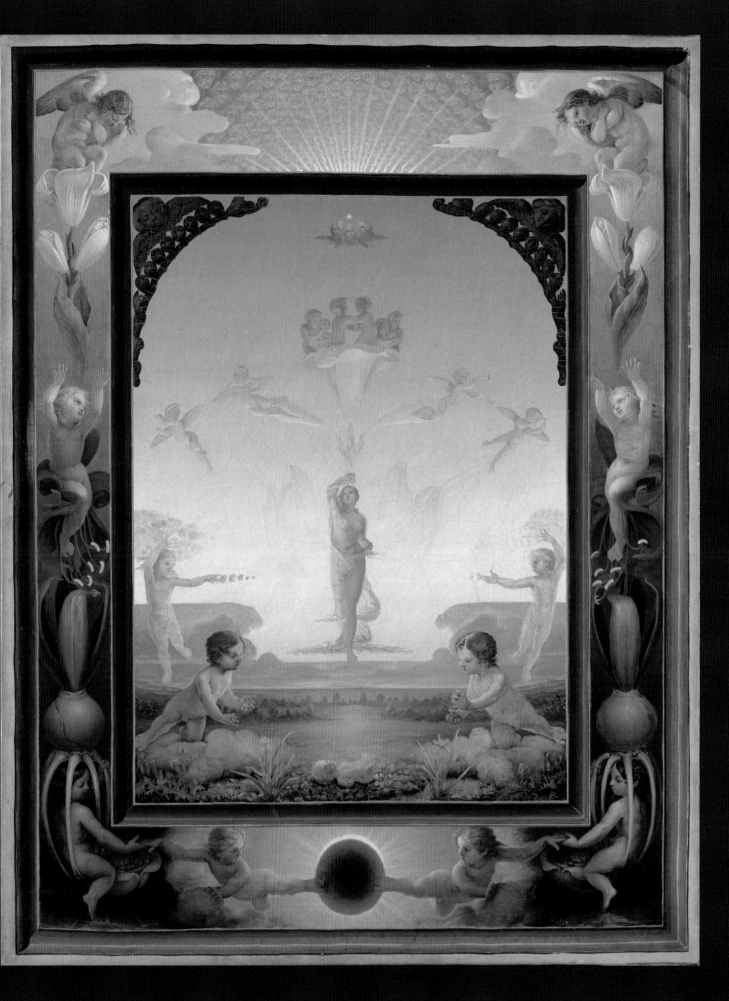

Between 1808 and 1810, Friedrich created a pair of paintings, *Monk by the Sea* (plate 1-14) and *Abbey in Oakwood* (plate 1-15). The solitary figure in *Monk by the Sea* is a religious man who meditates on nature; like Kosegarten's pulpit in Vitt, his cathedral is sea and sky. The monk is on an inner journey, symbolized by the physical pilgrimage that has brought him alone to the shores of the sea, where, like Schleiermacher, he desires to intuit the universe.[21]

In *Abbey in Oakwood*, it is dusk and a procession of monks carries a coffin toward a cross silhouetted in the portal of a Gothic-style church. Painting it when Germany was struggling against Napoleonic forces, Friedrich included Gothic architecture because of its association with German nationalism, but, sensing Germany's vulnerability, he showed the building in ruins. (When Friedrich made these paintings, Rügen was already occupied by French troops; Dresden would fall to Napoleon in August 1813.) The graveyard is untended, with tombstones tipping left and right; it is cold in the forest, and the oak trees have lost their leaves. Darkness approaches; the monks carry only two candles, and the moon is a faint sliver in the sky. In the foreground is an open grave.

Romanticism occurred in the wake of a revival of classical art spurred by Enlightenment historian Johann Winckelmann in writings such as *History of the Art of Antiquity* (1764). Students at Germany's leading art academy, the Akademie der Künste in Berlin, were instructed to go to Rome to study ancient monuments and paint the Italian countryside, to which Caspar David Friedrich responded: "Art critics are no longer satisfied with the German sun, moon, and stars, our rocks, trees and plants, our plains, lakes and rivers. To be big and beautiful, everything has to be Italian."[22] In contrast, Friedrich immersed himself in the German landscape. In 1821 the Russian writer Vasily Zhukovskii visited Dresden and met Friedrich. Zhukovskii invited Friedrich to join him on a trip to Switzerland and recorded Friedrich's reply: "I must stay alone and know that I am alone to contemplate and feel nature in full; I have to surrender myself to what encircles me, I have to merge with my clouds and rocks in order to be what I am. Solitude is indispensable for my dialogue with nature."[23]

Schopenhauer and Secularism

The Naturphilosophen held a progressive view of history in which civilizations continually improve, moving ever closer to a harmonious end, and although Schlegel, Hegel, and Schelling all appreciated Eastern thought in different ways and to different degrees, they all believed that Western philosophy and Christianity were superior. The German philosopher Arthur Schopenhauer disagreed. His views are a sign of things to come, as he declared that nature and human beings were the product of blind impulses (foretelling Charles Darwin and Sigmund Freud) and that Asian outlooks were a genuine

1-13. Philipp Otto Runge (German, 1777–1810), *The Small Morning*, 1809–10. Oil on canvas, 43 × 33⅞ in. (109 × 86 cm). Hamburger Kunsthalle.

Runge planned his four paintings of the times of day to be huge (each 24 × 18 feet/7.3 × 5.5 meters), but none was finished. This small study for *Morning* gives an idea of what the artist had in mind. In the center Runge painted the personification of morning as the Roman goddess Aurora (Latin for "dawn"). At the bottom of the outer frame, the sun—source of life/light—is eclipsed, but cherubs holding the moon ensure that life is not snuffed out by stretching to touch children below ground in darkness in the roots of amaryllis bulbs. Leaves and red flowers push upward, as do the white lilies, toward a sunburst between the clouds at the top. Within the frame, a baby awakens and looks up at Aurora, who holds aloft a lily pointing to the Morning Star (the planet Venus). Throughout the painting, cherubs and children herald a new day.

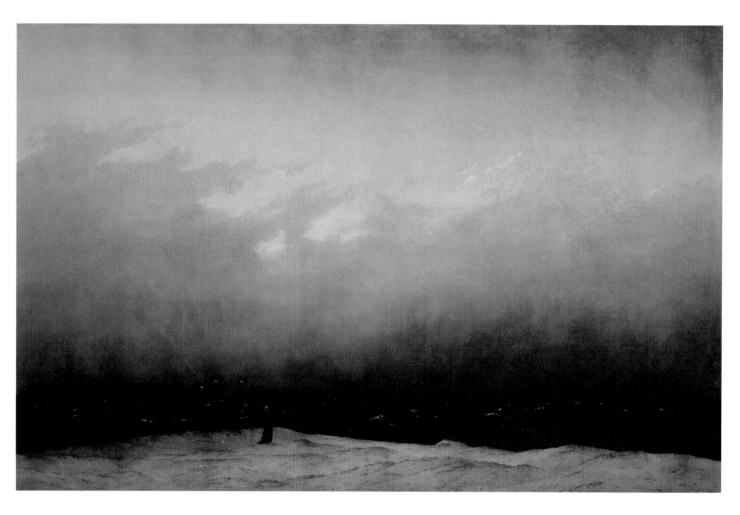

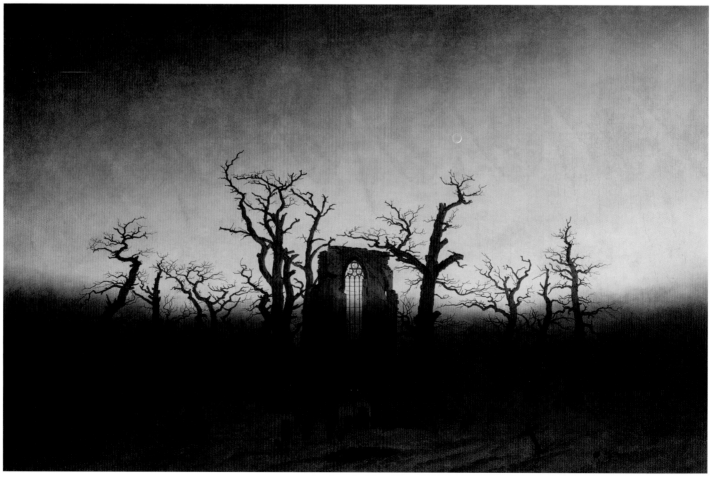

alternative to Christianity (a view widely held in the West after the precipitous decline of Christianity in Berlin, Paris, and London).

Schopenhauer grew up in Hamburg, but when he was seventeen years old, in 1805, his father died, and his mother, Johanna Schopenhauer, who was a prolific writer of novels, travelogues, and biographies, moved to Weimar. There she became friends with Goethe and hosted a lively intellectual salon. In 1810 she travelled to Dresden to write a piece on Caspar David Friedrich for a literary journal; she wrote of visiting the artist's studio, where she saw *Monk by the Sea* and *Abbey in Oakwood*:

> The first depicts the Baltic Sea with the sky arched high above. . . . White-fringed waves on the black-blue surface curl in countless rows; in the foreground is a barren shore where a recluse walks alone [*ein Einsiedler feierlich wandelt einsam*]. . . . The second painting shows the ruins of a church on a winter evening. . . . Nature is completely dead, the snow weighs heavily on the ground like a marble tombstone [*ein marmorner Grabstein*]; large black oaks stretch their bare branches to the sky like wailing ghosts [*klagende Gespenster*] around the remaining portal of the collapsed church. What a picture of death [*ein Bild des Todes*] this landscape is! . . . One shivers looking at it.[24]

The philosopher Hegel agreed with Johanna Schopenhauer that the artist's style was a deliberate display of harshness; Hegel must have seen paintings by Caspar David Friedrich on his trips from Berlin to Dresden in 1820 and 1821, after which he wrote: "Often if an artist has an extremely rigorous style, precision becomes an affectation, for example in the works of Friedrich of Dresden."[25]

During 1812–13, Arthur Schopenhauer attended lectures by Schleiermacher on the history of Western philosophy at the University of Berlin. After finishing his dissertation in 1813, at twenty-five years of age, Schopenhauer stayed at his mother's apartment, where he met Goethe, then fifty-five, and was introduced to Indian thought by the Orientalist Friedrich Majer, a frequent guest at Johanna Schopenhauer's salons. Majer was a close friend of Goethe, who had himself been introduced to Indian poetry by Friedrich Schlegel in 1808. Arthur Schopenhauer entered into an intense intellectual relationship with Goethe and began studying the Upanishads (in the 1801–2 Latin translation) as well as Chinese Buddhist texts.[26] He also studied Meister Eckhart, a medieval German monk and mystic who wrote: "The inward understanding is that which is based intellectually in the nature of our soul. . . . This understanding is timeless, without place—without here and now."[27] In the spring of 1814, Schopenhauer left Weimar and settled in Dresden, where he wrote *The World as Will and Representation* (1818). In the preface to the first edition, he wrote that to understand his book, the reader needed a knowledge of Kant and Plato, but that the biggest advantage was a familiarly with Indian philosophy:

OPPOSITE, TOP
1-14. Caspar David Friedrich (German, 1774–1840), *Monk by the Sea*, 1808–10. Oil on canvas, 44 × 68½ in. (110 × 171.5 cm). Nationalgalerie, Staatliche Museen zu Berlin.

When this painting was first exhibited at the Prussian Academy of Arts in Dresden, in 1810, the artist requested that it be displayed over its companion painting, *Abbey in Oakwood*, as it is on this page.

OPPOSITE, BOTTOM
1-15. Caspar David Friedrich (German, 1774–1840), *Abbey in Oakwood*, 1809–10. Oil on canvas, 43½ × 67⅜ in. (110.4 × 171 cm). Nationalgalerie, Staatliche Museen zu Berlin.

Friedrich described his religious outlook: "The glorious time of the temple and its servants is past and out of the shattered whole [*zertrümmerten Ganzen*] arises the desire for clarity and truth in a different era" (*Caspar David Friedrich in Briefen und Bekenntnissen*, ed. Sigrid Hinz [Munich: Rogner and Bernhard, 1974], 9).

Close your physical eye so that you can see your picture first with your spiritual eye. Then bring to light that which you have seen in the darkness so that it may react on others from the outside inward.

Caspar David Friedrich, notebook entry, ca. 1820

When we have intuited the universe and, looking back from that perspective on our self, see how, in comparison with the universe, our self disappears into infinite smallness, what can then be more appropriate for mortals than true unaffected humility?

Friedrich Schleiermacher, *On Religion: Speeches to Its Cultured Despisers*, 1799

If he has shared in the benefits of the Vedas, access to which, opened to us by the Upanishads, is in my view the greatest advantage which this still young century has to show over previous centuries. . . . If, I say, the reader has also already received and assimilated the divine inspiration of ancient Indian wisdom, then he is best prepared to hear what I have to say to him. . . . I predict that the influence of Sanskrit literature will penetrate European culture no less deeply than did the revival of Greek literature in the fifteenth century.[28]

Schopenhauer viewed plants, animals, and human beings as driven by instinctual drives, blind impulses—the subjective will (will to live, desire for pleasure). Nature isn't good or evil; it simply *is* as an objective "representation" that humans perceive (see, hear, touch). Value judgments ("this horse is good"; "that plant is bad") are imposed by the human will on meaning-free representations of natural, physical objects. Human knowledge is frustrated, because meaning-free mountains, trees, and stars don't respond to subjective human will (desire). Also, he asserted, there is continual suffering and strife in the world. Faced with frustration, suffering, and strife, Schopenhauer found tranquility in the Buddhist method of minimizing desire. Schopenhauer concluded that the most enlightened individuals are ascetics from all world religions—Jesus, Buddha, Meister Eckhart, Saint Francis of Assisi—because they have shifted focus from satisfying their subjective, personal will to finding composure and tranquility in a meaning-free world.[29]

Unlike other German Idealist philosophers, Schopenhauer was neither Christian nor a pantheist; for him, nature came into being by itself—by self-assembly—and is not imbued with divinity. For these reasons Schopenhauer is often called an *atheist*, although nowhere in his published work did he apply this term to himself. Although atheism (disbelief in the existence of God or gods) is implied in Schopenhauer's writing, it is best to avoid the term because of the association—then and now—of atheism with wickedness.[30] The word *secular* lacks a pejorative overtone and more accurately describes Schopenhauer's outlook, because he made statements about the human condition that have been adopted as moral guideposts in secular culture. For example, in an essay on free will and determinism, Schopenhauer encouraged tolerance—less criticism and more forgiveness—by arguing that people are a product of their history (their personal experience and their historical epoch). According to Schopenhauer, people can *do* whatever they want, but not *will* what they want, because *what* they want is determined by their history.[31] A brilliant young woman is free to love anyone; why does she fall in love with a man who hurts her? A healthy young man is free to adopt any political outlook; why does he become a suicide bomber? Schopenhauer (and Sigmund Freud) declared that the answer lies in their histories.

I do not at all believe in human freedom in the philosophical sense. Everyone acts not only under external compulsion but also in accordance with inner necessity. Schopenhauer's saying, "A man can do what he wants, but not will what he wants," has been a very real inspiration to me since my youth; it has been a continual consolation in the face of life's hardships, my own and others', and an unfailing wellspring of tolerance.

Albert Einstein,
"The World as I See It," 1930

CHAPTER 1

Beginning of Psychology: Science of the Mind

Experimental science separated from speculative philosophy in the early nineteenth century in the context of a debate between the two traditions of German Idealism: the attempted resolution of the Enlightenment mind-matter dualism (Descartes and Kant) and the beginning of modern monism (the Naturphilosophen Hegel and Schelling). Both were based in a scientific outlook that was strictly deterministic. Descartes and Kant's matter and Hegel and Schelling's monads are billiard balls that follow scientific laws of cause and effect. Both traditions produced a major worldview, one made of matter (the atomic version of Newton's clockwork universe) and one of monads (Einstein's mass-energy universe).

Kant and the Naturphilosophen differed in where they placed the human mind (soul, spirit, will, morals, creativity). Kant maintained that morality and creativity do not follow causal, scientific laws; they exist in a realm distinct from physics, in so-called metaphysics (ethics, aesthetics, and religion).[32] Schelling, on the other hand, declared that the mind is within the province of science. Both dualism and monism, and many related Idealist doctrines, were debated in Europe throughout the nineteenth century. As with any fluid ideas in a lively intellectual climate, the philosophical concepts often intermingled, and for the purpose of this book it is not important to keep them all straight. Suffice it to say that in the end, the Naturphilosophen won out. By 1900 there was no desire so intimate, no guilt so unspeakable that it was outside the domain of psychology, the new science of the mind.

Magnetism and Electricity

The vision of the unity of mind and matter is seen nowhere more clearly in Romantic-era science than in research on the mind in terms of magnetism and electricity. In the sixth century BC the Greek philosopher Thales expressed the thought that amber (fossilized tree resin) and lodestones (naturally magnetized iron ore) are somehow alive—have a soul—because they generate movement: amber when it is rubbed attracts lightweight objects such as feathers to it; lodestones attract and repel one another. As Aristotle said: "Thales came to the opinion that all things are full of gods."[33] In the district of Magnesia, which is near Miletus in Anatolia (modern Turkey), where Thales lived, there are deposits of a naturally magnetized mineral, an iron ore called *magnetite* (probably after Magnesia). During the Hundred Schools of Thought, which flourished during the Warring States era, Chinese scholars referred to lodestones, and during the Song dynasty, the Chinese developed the magnetic compass for sailors to use in navigation, a technology that spread quickly among the ships they encountered on trade routes.[34] By 1300 the compass guided ships in medieval Europe, and British sailors called magnetite a *lodestone* (from Middle English for "guiding stone").

At an early period, while philosophy lay as yet rude and uncultivated in the mists of error and ignorance, few were the powers and properties of things that were known and clearly perceived: there was a bristling forest of plants and herbs, things metallic were hidden, and the knowledge of stones was unheeded.

William Gilbert,
De Magnete, 1600

During the Enlightenment a British physician, William Gilbert, invented an instrument to detect the presence of an electric charge—an electroscope—the first of which was a pivoting magnetized needle called a *vesorium* (plate 1-16). The Romans had named the goddess of storm clouds Electra, from the Greek word for "amber," and 1,000 years later Gilbert coined the Latin word *electricus* ("electricity" in English) to name the attractive power of amber. Gilbert also experimented with heating a piece of iron to turn it into a magnet (plate 1-17) and published his findings in *De Magnete* (About the magnet, 1600), which is the founding text of electrical science.

In North America, research into electricity was advanced by a Philadelphia newspaper printer and editor, Benjamin Franklin, who discovered that there are two types of electric charges —positive and negative—while experimenting with a Leyden jar, a device used to store electricity. To increase the amount of electricity that could be stored, in 1800 the Italian physicist Alessandro Volta connected several Leyden jars, so that they could be charged and discharged simultaneously, thus producing a steady current. By the 1820s the flow of electric current through a wire was being studied in France by André-Marie Ampère. (The electrical units *volt* and *amp* are named for these European scientists). Franklin termed Volta's connected Leyden jars a *battery*, in reference to artillery, such as a battery of cannons, combined to inflict maximum injury (or battery).

Franklin also studied electricity in the atmosphere and did an experiment that proved that lightning is a form of electricity (plate 1-18). It was a short step for him to invent the lightning rod: attach a tall, pointed metal rod to the roof of a building or the mast of a ship, gild the tip to prevent rusting, and then run the rod down into the

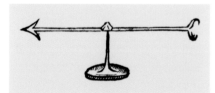

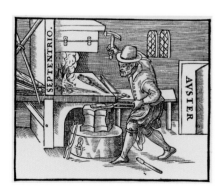

TOP

1-16. Vesorium, in William Gilbert, *De Magnete* (London: Petrus Short, 1600), 2:49.

A *vesorium* (Latin for "turn around") is a metal needle that pivots freely over a pin. When placed near a substance containing static electricity (such as a piece of rubbed amber), the needle points toward the substance.

BOTTOM

1-17. A blacksmith making a magnet, in William Gilbert, *De Magnete* (London: Petrus Short, 1600), 3:139.

Gilbert discovered how to make a magnet by trial and error. This blacksmith smelts (heats) iron in his fire, making it soft so he can pound it into the shape of an arrow oriented to the axis of *septentrio* and *auster* (Latin for "north" and "south"). When cooled and allowed to move freely, the arrow points north. As Gilbert stated: "verticity [turning toward a vertex or pole] exists in any iron that has been smelted" (3:139).

Today we have a physical explanation for how the blacksmith made a magnet, because we understand the electrical properties of atoms (see chapter 8). Briefly, iron is composed of atoms that are polarized—they carry more positive charge on one side of the atom and more negative charge on the other. In a solid bar of iron, the motionless atoms point in all different directions. But when heated, the atoms can move freely and line up with Earth's magnetic field, with all the positive-negative poles pointing in the same direction. As the iron cools, the atoms retain this orientation and the bar becomes a magnet, which can be used as a compass needle. Today scientists think that lodestones (rocks that contain magnetized iron) are formed when a lightning bolt strikes Earth, causing extreme heat, like this blacksmith's fire.

1-18. Benjamin West (American-born English, 1738–1820), *Benjamin Franklin Drawing Electricity from the Sky*, 1816. Oil on slate, 13⅜ × 10⅛ in. (34 × 25.6 cm). Philadelphia Museum of Art, gift of Mr. and Mrs. Wharton Sinkler.

Benjamin West portrays Franklin performing this experiment in 1752 by attaching a kite to the end of a string and tying an iron key to the other end. In the lower left is a battery of Leyden jars, in which will be stored the charge, directed to them through a wire (not shown) connecting them to the key. West shows the moment when a spark passes through the key and leaps to Franklin's knuckle. A few months later Franklin described his experiment in a letter to his friend Peter Collinson, a fellow at the Royal Society of British science: "When rain has wet the kite and twine, so that it can conduct the electric fire freely, you will find it streams out plentifully from the key at the approach of your knuckle. At this key the phial [Leyden jar] may be charged" (Franklin, letter of Oct. 19, 1752, to Peter Collinson, in *Experiments and Observations on Electricity, Made at Philadelphia in America*, pt. 2 [London: E. Cave, 1753], 107). In contrast to the portrayal in the painting, Franklin (aware of the danger of electrocution) stood on an insulated surface under an overhang to keep himself dry. The artist certainly knew the details of the experiment, as he and Franklin were close friends (Franklin was godfather of West's second son), but—tossing science to the wind—West transformed Franklin's kite experiment into a neoclassical allegory. Like the gods on Mount Olympus, Franklin floats aloft on storm clouds, surrounded by angelic assistants. On the left two cherubs operate the battery of Leyden jars, while on the right a wide-eyed young Electra, wearing her star-studded tiara, witnesses the spark. This painting is a small sketch for a large painting (unexecuted), which West planned as part of a series honoring Americans who had made major contributions to art and science.

ground or water. As Franklin wrote: "Would not these pointed rods probably draw the electrical fire silently out of a cloud before it came nigh enough to strike, and thereby secure us from that most sudden and terrible mischief!"[35] Soon lightning rods were installed on church steeples and sailing ships throughout the world. Franklin refused to accept any payment for his invention's proliferation, because he believed that knowledge should be shared: "As we enjoy great advantages from the inventions of others, we should be glad of an opportunity to serve others by an invention of ours, and this we should do freely and generously."[36]

In 1771 Franklin visited his close friend David Hume, the English philospher, in Edinburgh for three weeks of conversation. During the Enlightenment there had begun a shift from understanding the human mind in terms of philosophy (argument and reasoning) to science (observation and experiment), and David Hume embodied this shift. Hume aimed to give a completely naturalistic description of human experience based in sense perception; according to him, genuine knowledge must be traceable to observation—seeing, hearing, touching (*A Treatise of Human Nature*, 1738).

At this time the American colonies were part of the British Empire, and Franklin became a colonial hero by leading an effort in London for Great Britain to repeal heavy

taxes that were extremely unpopular in Boston and Philadelphia. After negotiating a shipment of guns and ammunition from France that was crucial for the revolutionaries in America, in 1775 Franklin returned home to Philadelphia, where he helped draft and signed the Declaration of Independence in 1776. After the Revolution, Franklin returned to Europe as the first United States ambassador to France.

Mesmerism and Hypnotism

In the 1700s researchers began studying the human body in terms of electricity and magnetism;[37] the English natural philosopher Stephen Gray's experiments revealed that the body conducts electricity (plate 1-19). A German physician, Franz Mesmer, has gone down in history as a researcher who made a great discovery but mistook what he had found.[38] Mesmer was treating a twenty-seven-year-old patient, Fräulein Österlin, who complained of severe physical pain and paralysis for which no organic cause could be found. Physicians of the era were beginning to use electricity and magnetism therapeutically; a Swiss physician had found that mild electrical stimulation relieved paralysis in the arm of a fifty-two-year-old woman,[39] and English physicians treated ailments with magnets. Mesmer placed magnets on Fräulein Österlin's legs and stomach and asked her to drink a solution containing iron. Within an hour she reported feeling a powerful force flowing through her body, and her symptoms disappeared. Mesmer believed he had found a magnetic force that flowed from doctor to patient—animal magnetism—but in fact, he had discovered the power of suggestion.

Mesmer studied medicine in Vienna and wrote his doctoral thesis on a (hypothetical) universal fluid that transmits forces from the motion of the planets to the human body. Fräulein Österlin's cure convinced Mesmer that this universal fluid was magnetism, and that his discovery would revolutionize not only medicine but also astronomy, chemistry, and biology, because animal magnetism, he purported, is a physical fluid that fills the universe, connecting the celestial bodies with all earthly creatures. According to Mesmer, disease results from an imbalance in positive and negative forces in the fluid, and health is restored when the opposing forces come into

1-19. The human body conducting electricity in an experiment by Stephen Gray, in Johann Gabriel Doppelmayr, *Neu entdeckte Phaenomena* [Newly discovered phenomena] (Nuremburg: Flieschmann, 1744), fig. 5.

In this experiment Stephen Gray suspended a boy by (insulating) silk cord, then touched a charged glass rod to the boy's body. Then the lad could (by static electricity) attract small, light objects (feathers, scraps of paper) with his torso and left hand. The electricity in his right hand was transferred to a rod, from which hung a ball, as reported in this mid-eighteenth-century textbook on experiments in electricity, which was compiled by the German mathematician Johann Doppelmayr.

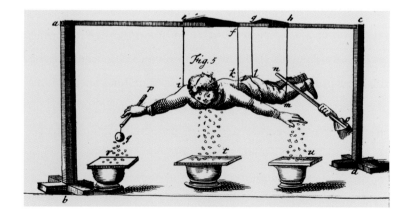

balance. Just as a Leyden jar collects static electricity, so the physician collects animal magnetism within his body and then channels the healing fluid to the patient in a process Mesmer named *mesmerism*.

After establishing a medical practice in Vienna, in 1778 Mesmer went to Paris, the medical capital of Europe, to announce his discovery. He soon had a large, lucrative practice mesmerizing members of high society (plate 1-20). He expected French scientists to eagerly adopt his theory, but instead they suspected fraud and convinced King Louis XVI to appoint a scientific commission, which included the chemist Antoine Lavoisier and Benjamin Franklin, who was in Paris as US ambassador. The commission concluded, in 1784, that there was no evidence for the existence of animal magnetism, and mesmerism was officially outlawed by the French Académie des Sciences. After the commission's findings were announced, Mesmer returned to Vienna, where he died, a bitter man, in 1815.

But interest in mysterious mental states had been aroused in France. Mesmer's followers continued his methods in secret, and one of them discovered a powerful new technique. The Marquis de Puységur, a well-educated aristocrat, was magnetizing an ill man and accidentally put him into a trance. Puységur was astonished to hear the entranced patient report information that he could not recall when awake. He also observed that in the trance the patient obeyed his commands, as if he were awake. Puységur recognized the similarity of the trance to somnambulism (sleepwalking) and named it "magnetic sleep." In 1843 the British scientist James Braid gave it its modern name, *hypnotism* (from Hypnos, the Greek god of sleep; plate 1-21).[40]

Since French physicians were forbidden to practice mesmerism, hypnotism was also disallowed, but many lay healers continued using hypnotism in the early nineteenth century. Because it developed outside the French scientific establishment, the field of hypnotic therapy was unregulated and hence defenseless against medical quacks and stage performers who hypnotized people for entertainment. French intellectuals became interested in mental states revealed under hypnosis, which was made all the more alluring by its shady reputation. As word of Mesmer's work spread across Europe, the German government also launched an inquiry into mesmerism, but it concluded that the doctrine was plausible, and professorships in mesmerism were established at the University of Berlin and the University of Bonn in 1816. Schelling and his colleagues in Naturphilosophie studied mesmerism enthusiastically, because its universal magnetic fluid (if it existed) could be the agent of the World Soul, pervading the universe and connecting all its parts into a whole. Because a person under hypnosis has exceptional lucidity and intuitive powers, Hegel and Schelling also believed that magnetic sleep offered an avenue whereby one could reach the highest level of understanding—knowledge of Absolute Spirit.

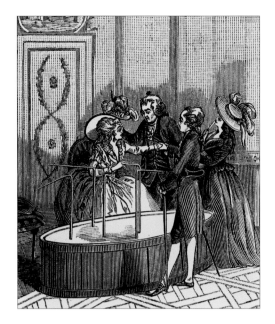

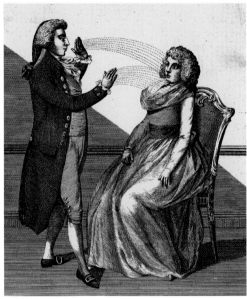

TOP

1-20. The tub of Mesmer, ca. 1800. Engraving. Wellcome Library, London.

Franz Mesmer constructed a large wooden tub with a polished lid from which protruded iron rods. Inside the tub, each rod was connected to a powerful magnet at its base, and then the tub was filled with water. In this illustration, the magnetic force ("animal magnetism") allegedly flowed from the rod to the woman's hand. Dr. Mesmer typically treated fashionable Parisian clients, like this woman and her friends, in a séance-like atmosphere.

BOTTOM

1-21. A man hypnotizing a woman, in Ebenezer Sibly, *A Key to Physic, and the Occult Sciences* (London, printed by the author, 1802), 260. Engraving by Daniel Dodd, platemark 8¾ × 7⅛ in. (22.3 × 18.1 cm). Wellcome Library, London.

Discovery of the Unconscious Mind

In the Western tradition, dreams and nightmares were seen as messages sent by a personal deity, such as Zeus on Mount Olympus (plate 1-22), or by God in heaven, after the merger of classicism with Christianity in the fourth century AD. In the East, Chinese philosophers thought that dreams come from the troubled mind of the dreamer. Zhuangzi (late fourth century BC) wrote that true men of old—sages—had no dreams while sleeping and no anxiety while awake.[41] Zhuangzi lived after Laozi, the founder of Taoism, and he may not have known about Taoist philosophy, but in the fourth century AD the scholar Guo Xiang (d. 312) assembled texts by Zhuangzi and believed they were written by a Taoist, because Zhuangzi described life as a journey, each traveller choosing what path to follow. Guo edited the texts into thirty-three chapters, which he called the *Zhuangzi* and presented as a Taoist manuscript. However, unlike Laozi, Zhuangzi did not describe *the* Tao (singular) but declared that there are many paths to choose from when one reaches a fork in the road. Which is the right path to follow? In an extreme form of relativism, Zhuangzi declared that "right" and "wrong" depend on each traveller's perspective; there is not one Tao that fits everyone. His paradigm is the antisocial hermit, who does not follow others down a well-travelled road, but—uncorrupted and pure—is a path-breaker who goes his own way.[42]

Zhuangzi was the pivotal philosopher of language in China's Hundred Schools of Thought. According to Zhuangzi, the words a traveller picks to describe his actions affect the path he follows in life; norms of language are intertwined with norms of behavior. Zhuangzi recorded his philosophy in conversations and parables, the reader of which does not attain *the* answer but ideally has gained a more comprehensive perspective on the topic. Zhuangzi told stories about everyday people—butchers and

1-22. Zeus sending a dream to Agamemnon, in *The* Iliad *of Homer* (Rome: 1793), plate 3. Engraving by Thomas Piroli after a drawing by John Flaxman, paper 10⅞ × 16½ in. (27.6 × 42 cm).

John Flaxman was a British sculptor who drew thirty-four illustrations of the *Iliad*, which were engraved by the Italian artist Tommaso Piroli. Flaxman drew with a clear, crisp outline that he learned in his neoclassical training at the Royal Academy of Arts in London. Homer's *Iliad* opens during the Trojan War, when the Greeks are led by Agamemnon. The soldier Achilles gets angry at Agamemnon because the commander disrespects him. Achilles begs his mother, Thetis, to ask Zeus to bring the Greeks to the point of annihilation by the Trojans, so Agamemnon will realize how much he needs Achilles. After hearing Thetis's request, Zeus agrees. In this illustration, Zeus is shown seated on his throne high above the clouds on Mount Olympus, amid the stars. Zeus sends Agamemnon the fatal message in the form of a dream; as Homer writes: "Fly hence deluding dream! and light as air, / To Agamemnon's ample tent repair" (from the 1715 translation of the *Iliad* by the poet Alexander Pope). Indeed, the dream fools Agamemnon into believing he can conquer Troy, and on waking, he foolishly prepares to attack.

musicians—who execute their specialty in a precise, focused, effortless manner; and he had conversations with the shunned—cripples and thieves—that illustrate differences in perspectives, yearnings, and needs. Entertaining and amusing, the *Zhuangzi* has always been a favorite of China's intellectual literati class, grown weary from reading Confucius's tedious moralizing.

Zhuangzi described dreams as the occasion for philosophical reflection. In a discussion of shifting perspectives and the goal of reaching a more comprehensive viewpoint, he made an analogy between dreaming and waking. While dreaming, one might be deluded and dream that one is dreaming, but on waking one gains a more accurate perspective—it was only a dream!

> Miss Li Zhi cries when she is betrothed to someone's son, and when she first goes off to the Jin state soaks her clothing with her tears; but then she arrives at the king's abode, sleeps with the king in his bed, eats fattened livestock and then starts to regret her tears. How do I know the dead do not regret their former clinging to life? We dream of eating and drinking and on awaking cry bitterly, we dream of weeping and wailing and awake in a good mood to go off hunting. When we dream, we don't know it as a dream, and in our dreams, judge something else as a dream. On awakening, we know it was a dream, and there could be another greater awakening in which we know a greater dream.[43]

In another parable about dreaming and waking, the relativist Zhuangzi described shifting perspectives on reality, concluding, "things change" (plates 1-23 and 1-24).

> Once before, Zhuangzi dreamt of being a butterfly, gaily butterflying and himself embodied in this sense of purpose! He knew nothing of Zhuangzi. Suddenly awakening, he then is rooted in Zhuangzi. He doesn't know if Zhuangzi dreamt being a butterfly or a butterfly is dreaming being Zhuangzi—though there must be a difference. This is called "things change."[44]

After the arrival of Buddhism in China during the Han dynasty (206 BC–AD 220), elements of Laozi's naturalism and Zhuangzi's relativism mixed with Buddhist meditative practices to form Chan Buddhism (Japanese Zen), with its focused attention on nature and living intensely in the present moment of everyday life.

A medical doctor in Dresden, Carl Gustav Carus, formulated the first systematic theory of the unconscious mind, which resonates with Eastern philosophy, with which he was familiar.[45] Carus trained in Western medicine and was appointed director of a maternity clinic. His view of the mind intermixes Eastern philosophy (the source of dreams) with Western biology: the human ovum has a soul (the essential attribute of life), and as the fetus grows it develops an "absolute unconscious" (*absolut Unbewußtes*)

T'ien Ken was wandering on the sunny side of Yin Mountain. When he reached the banks of Liao River, he happened to meet a nameless man. He questioned the man, saying, "Please may I ask how to rule the world?"

The nameless man said, "Get away from me you peasant! What kind of dreary question is that!" . . .

But T'ien Ken repeated his question. The nameless man said, "Let your mind wander in simplicity, blend your spirit with the vastness, follow along with things the way they are, and make no room for personal views, then the world will be governed."

Zhuangzi, fourth century BC

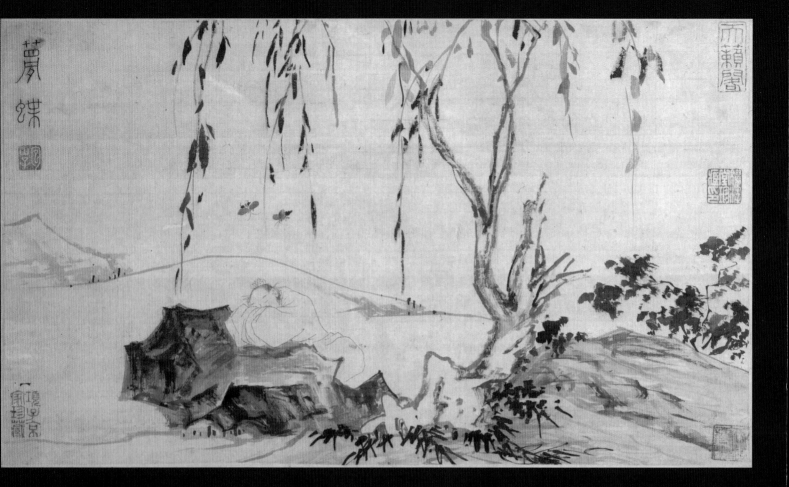

1-23. Lu Zhi (Chinese, 1496–1576), *Zhuangzi Dreaming of a Butterfly* (leaf 1 of 10 in an album by Lu Zhi), mid-1500s. Ink on silk, 11⅝ × 20¼ in. (29.4 × 51.4 cm). National Palace Museum, Beijing.

In the upper left is a short inscription (translation by Jiajun Liu):

Dreaming of being a butterfly.

1-24. Chiharu Shiota (Japanese, born 1972), *The Butterfly Dream*, 2018. Installation in the Museum of Kyoto, Japan. © Chiharu Shiota. Courtesy Blain|Southern, Berlin.

Inspired by Zhuangzi's dream, contemporary artist Chiharu Shiota created this installation. At the opening of the exhibition, Chiharu Shiota and artists from Kyoto staged a performance by lying down in the beds and drifting off to sleep, perchance to dream of a butterfly.

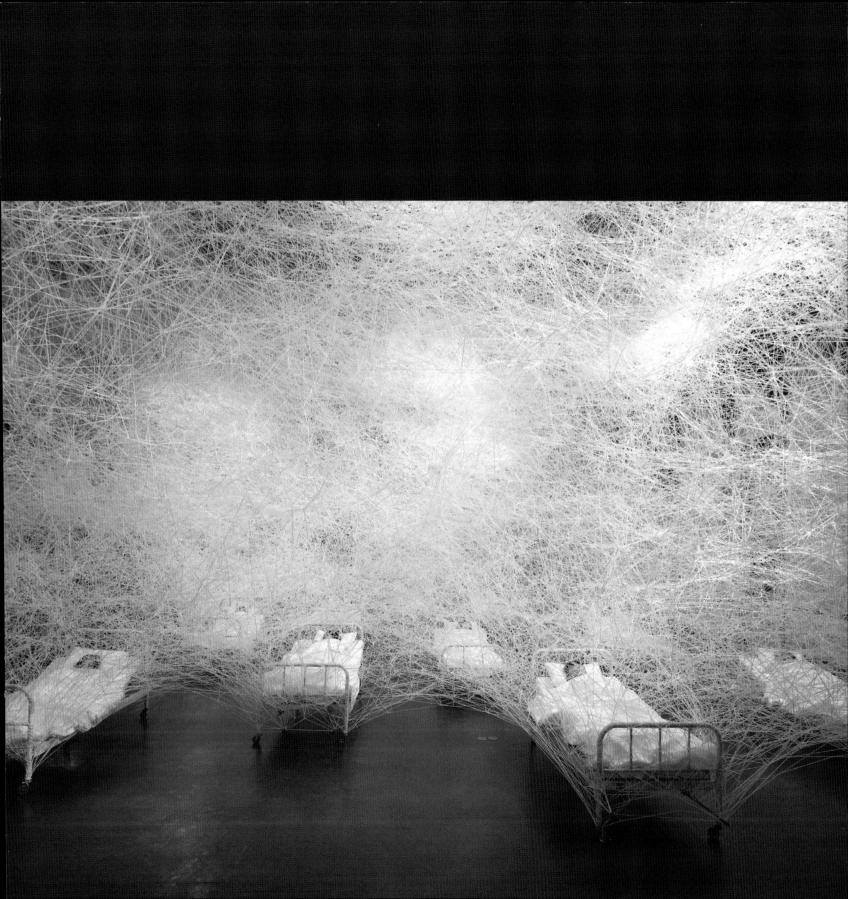

that controls bodily functions such as heartbeat, breathing, and metabolism. At birth the individual becomes conscious and begins developing a "relative unconscious" (*relativ Unbewußtes*), which is the repository of conscious thoughts—the memory. Each night the person returns to an unconscious state in sleep, Carus explains: "Sleep is a regular return into the unconscious. 'Sleeping on it' for even a short period has often clarified an obscure thought or revealed a missing connotation."[46] A dream is produced by the mind of the dreamer, by memory (the relative unconscious). "Some memories," he continues, "long since faded, often awaken clearly and poignantly within the soul after consciousness sinks for a short period into the unconscious [during sleep]."[47] Thus the unconscious mind is a dynamic biological system, actively transforming the thoughts and feelings that enter the brain during consciousness into memories, which return in sleep.[48]

Carus began his book *Psyche* (1846) with these prophetic words:

> The key to the knowledge of the nature of the soul's conscious life lies in the
> unconscious. This explains the difficulty, if not the impossibility, of getting
> a real comprehension of the soul's secret. If it were an absolute impossibility
> to find the unconscious in the conscious, then man should despair of ever
> getting knowledge of his soul—that is, a knowledge of himself. But if this
> impossibility is only apparent, then the first task of a science of the soul is to
> state how the spirit of man is able to descend into these depths.[49]

Self-taught as an artist, Carus painted with the eye of a naturalist, the mind of a psychologist, and the heart of a Romantic. He was a close friend of Goethe, who admired his art, writing: "How profoundly you comprehend the organic world, how keenly and accurately you depict it."[50] Carus illustrated the dream of Faust, which occurs in part 1 of Goethe's play; the devil, Mephistopheles, appears in his study, and Faust asks, "What is thy name?" The stranger replies that he comes from "the darkness [chaos, irrationality], which gave birth to light [order, reason]." After a discussion about the nature of reality, Faust falls asleep and dreams of a goblet of wine and a bare-breasted woman playing music on a lyre (plate 1-25). These are pleasures offered to him by Mephistopheles, shown in silhouette on the right, who says: "With fairest images of dreams enfold him / Plunge him in seas of sweet untruth!" When Faust awakens, the room is empty and he realizes that the devil and the pleasure—the "sweet untruth"—are only a dream, and he cries: "Am I really again so foully cheated?"[51] Carus portrays the dream as coming neither from the devil nor from the moonlit sky above but from Faust's own desires and restless mind.[52]

In *View through a Window with a Comet* (plate 1-26), Carus places the viewer in the realm of science, with a globe and telescope, looking at Gothic spires that suggest

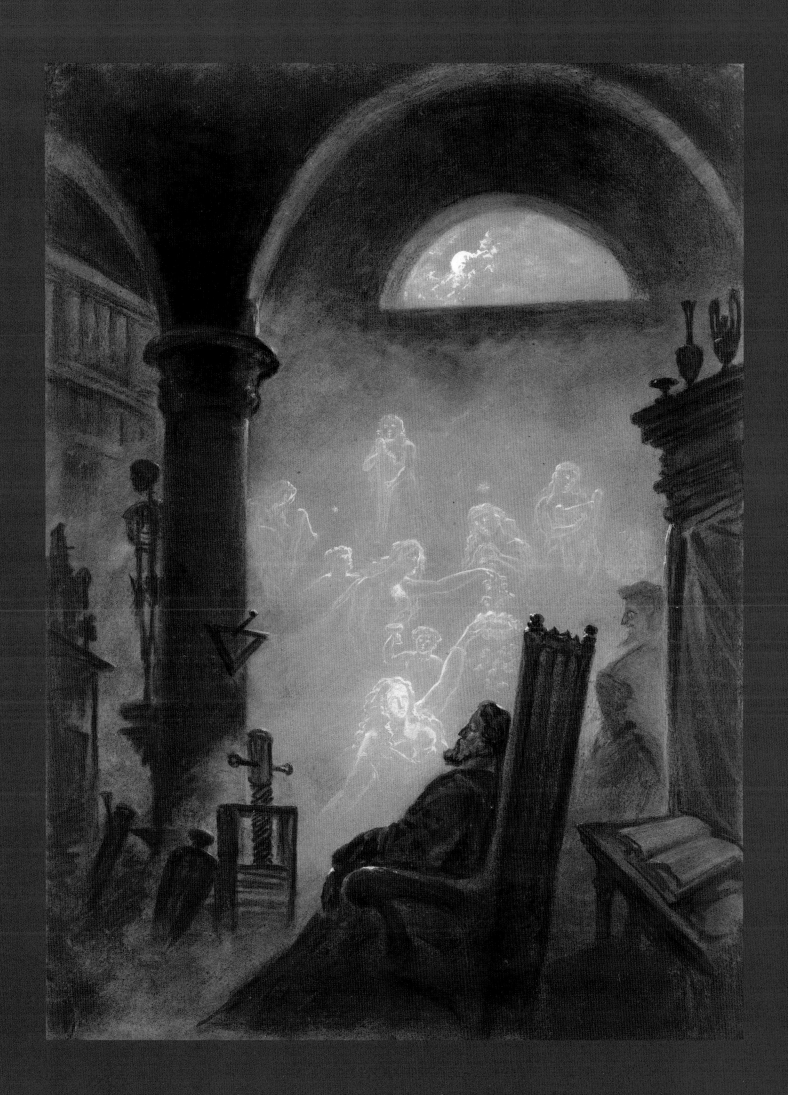

1-26. Carl Gustav Carus (German, 1789–1869), *View through a Window with a Comet*, ca. 1851. Charcoal on paper, 17¼ × 10¾ in. (43.8 × 27.3 cm). Kupferstich-Kabinett, Staatliche Kunstsammlungen, Dresden.

a spiritual realm. Linking science and the spiritual is a comet, at which the telescope points. Before Newton, each comet (from the Greek for "long-haired [stars]") was viewed superstitiously as an unpredictable omen of divine action. But it seemed to a friend of Newton, the British astronomer Edmond Halley, that gravity must control the motion of comets. Halley studied the dates when comets had appeared and their paths across the sky and noticed that a comet with the same path was recorded at regular intervals of approximately seventy-six years: 1456, 1531, 1607, and 1682. He hypothesized that these were all appearances of the same comet travelling, like a planet,

in an ellipse but in a very long ellipse (plate 1-27). Halley predicted that the comet would appear again, travelling in the same path, in 1758. When "Halley's comet" returned as predicted, it confirmed his theory and the explanatory power of universal gravitation. The English astronomer Thomas Wright then applied the law of universal gravitation to give an accurate description of the Milky Way as a rotating disk of stars held together by gravity. In 1750 Wright also speculated that the tiny wisps of mist or fog—*nebulas* (from the Latin for "clouds")—seen through a telescope are each a galaxy located outside our own (plate 1-28). When Halley's comet returned to Earth in 1835, Carus and the other German Romantics saw it over the skies of Dresden; it last appeared in the inner solar system in 1986 and will return in 2061.

German Romantic interest in the unconscious realm culminated in Eduard von Hartmann's classic compendium of all known types of unconscious mental activity, *Philosophie des Unbewußten* (Philosophy of the unconscious; 1869). The book's great popularity among Western intellectuals suggests how common discussions of the unconscious mind had become by the mid-nineteenth century.

TOP

1-27. Orbits of comets, in Thomas Wright, *An Original Theory; or, New Hypothesis of the Universe* (London: H. Chappelle, 1750), plate 2, between 10–11.

Wright illustrated Halley's theory with this diagram of the orbits of comets that had appeared in 1661, 1680, and 1682 (Halley's comet), each with an elliptical orbit extending way beyond the orbit of Saturn (the farthest planet known to him). Wright was so confident that Halley was correct that he published this book in 1750, eight years before the return of Halley's comet.

BOTTOM

1-28. The universe, in Thomas Wright, *An Original Theory; or, New Hypothesis of the Universe* (London: H. Chappelle, 1750), plate 31, between 82–83.

Wright speculated that the universe contains many systems of stars: "All the stars and planetary bodies within the finite view, are altogether but a very minute part of the whole rational creation. . . . That this in all probability may be the real case, is in some degree made evident by the many cloudy spots, just perceivable by us, as far without our starry regions, in which through visibly luminous spaces,

no one star or particular constituent body can possibly be distinguished; those in all likelihood may be external creation, bordering upon the known one, too remote for even our telescopes to reach" (83–84). In 1924 Edmund Hubble proved that Wright was correct about those "cloudy spots"; using the new 100-inch (254-centimeter) reflector telescope atop Mount Wilson in California, Hubble saw one of them (the Andromeda Galaxy). Today astronomers have discovered over 100 billion galaxies (see chapter 10).

2

The Industrial Revolution

This experience is by no means a trifling one. It may be attended with important consequences that no one can foresee. We should not suffer pride to prevent our progress in science. Beings of a rank and nature far superior to ours have not disdained to amuse themselves with making and launching balloons, otherwise we should never have enjoyed the light of those glorious objects that rule our day and night, nor have had the pleasure of riding round the sun ourselves upon the balloon we now inhabit.

Benjamin Franklin, after witnessing the first manned ascent in an untethered balloon, November 21, 1783

THE INDUSTRIAL REVOLUTION began in England and quickly spread to France and the Americas, where steam locomotives replaced horse-drawn carriages and mechanical looms wove textiles. Machines brought the promise of easing human toil, but they were powered by burning coal and oil, which polluted the air and water. Trade between Europe and Asia was expanding dramatically; in London, ladies drank Indian tea served in elegant "china"—porcelain cups from China. Trade routes from Europe to Asia sent ships south below Africa or South America, and navigators dreamt of sailing above North America—and began the search for the Northwest Passage.

Romanticism in Britain and America

In the 1770s the Scottish inventor James Watt perfected the design of a steam engine, and his fully developed version went into production in 1776. Watt, for whom a unit of power is named, introduced the term *horsepower* to provide a comparison of the output of steam engines to the power of workhorses, suggesting that machines could replace horses. Indeed, travelling on horseback became a thing of the past after two English engineers, the father-and-son team of George and Robert Stephenson, built the first steam-powered locomotives and laid railway tracks across the English countryside (plate 2-2). As England industrialized, many resisted the encroachment of machines, with their loud noise and dirty smoke (plate 2-3). J. M. W. Turner captured this moment in his portrayal of a majestic old sailing ship—white, ghostlike, obsolete—being pulled by a grimy tugboat to a berth to be destroyed (plate 2-4). The tug is powered by a steam engine; coal soot rises from its smokestack into the clear air, while in the background the sun sets on a bygone era.

2-1. The first manned, free ascent in a Montgolfier balloon, in Barthélemy Faujas de Saint-Fond, *Description des expériences de la machine aérostatique de MM. de Montgolfier* [Description of experiments of the aerostatic machine of Messrs. de Montgolfier] (Paris: Cuchet, 1784), 2 (frontispiece). Engraving by Nicolas Delaunay.

Benjamin Franklin watched the hot air balloon invented by the Montgolfier brothers fly over Paris from his balcony, while an artist drew this picture of the balloon floating high above Notre Dame Cathedral (center, on the horizon) and the dome of the Hôtel des Invalides (on the left). The balloon remained in the air for twenty-five minutes and landed 5.5 miles (9 kilometers) away, on the outskirts of Paris. A few hours later Franklin had visitors: "One of these courageous philosophers, the Marquis d'Arlandes, did me the honor to call upon me in the evening after the experiment, with Mr. Montgolfier the very ingenious inventor. I was happy to see him safe" (Franklin, letter to Joseph Banks, Nov. 21, 1783). The event was included in this publication, the first scientific description of balloon experiments, written by the French geologist Barthélemy Faujas de Saint-Fond.

33

2-2. Stephenson's Rocket, in Samuel Smiles, *The Life of George Stephenson and of His Son Robert Stephenson* (New York: Harper, 1868), 321.

In 1829 the Liverpool and Manchester Railway held a contest to choose the best steam engine. Robert Stephenson won with this engine, the Rocket, which was the template for steam locomotives for the next 150 years. Opened in September 1830, the Liverpool to Manchester railway was the first to use only steam power, with no horse-drawn carriages.

2-3. Halifax from Beacon Hill, 1869. Steel engraving by J. Stephenson after H. Warren. © The Board of Trustees of the Science Museum, London.

In the1840s–1860s one of the largest textile mills in the world, Dean Clough, a carpet factory that stretched a half mile (0.8 kilometer) long, was built in the city of Halifax in West Yorkshire, England. Two men stand on Beacon Hill and look over the industrial cityscape, while smoke pours into the air they breathe.

2-4. J. M. W. Turner (English, 1775–1851), *The Fighting Temeraire Tugged to Her Last Berth to Be Broken Up*, 1838. Oil on canvas, 36 × 48 in. (91 × 122 cm). National Gallery, London, Turner Bequest, 1856.

HMS *Temeraire* was a ninety-eight-gun warship that fought in the Battle of Trafalgar, which pitted the British Royal Navy against the combined fleets of France and Spain during the Napoleonic Wars. The Franco-Spanish fleet lost twenty-two of its thirty-three ships, while no British vessel was lost. Such a dramatic victory in this 1805 battle confirmed the naval supremacy of Britain, and ever after this ship was called "The Fighting *Temeraire*." The ship was decommissioned in 1838, the year Turner painted it being towed on the River Thames to be broken up for scrap wood and metal.

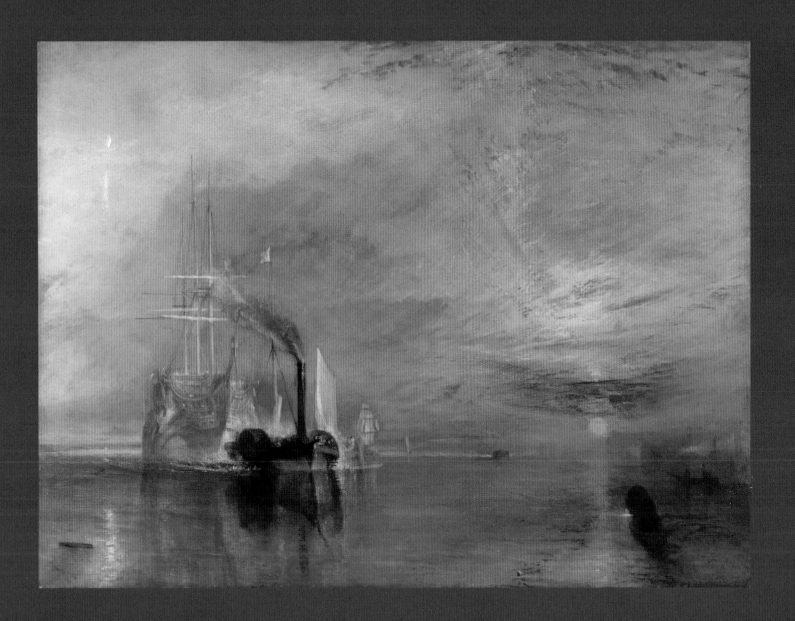

Science! true daughter of Old Time thou art!

Who alterest all things with thy peering eyes.

Why preyest thou thus upon the poet's heart,

Vulture, whose wings are dull realities?

Edgar Allan Poe, "Sonnet to Science," 1829

2-5. John Constable (English, 1776–1837), *Rainstorm over the Sea*, ca. 1824–28. Oil on paper laid on canvas, 9¼ × 14¼ in. (23.5 × 32.6 cm). Royal Academy of Arts, London.

OPPOSITE, TOP

2-6. John Constable (English, 1776–1837), *Cloud Study*, 1822. Oil on paper laid on canvas, 12 × 20 in. (30.5 × 50.8 cm). Yale Center for British Art, New Haven, Connecticut, Paul Mellon Collection.

Like a meteorologist, Constable recorded the weather on a label attached to the stretcher: "August 1, 1822. O'clock AM, very hot with large climbing clouds under the sun. Wind westerly."

In 1802, the naturalist Luke Howard formulated a theory of how clouds form in terms of temperature, altitude, and air currents.[1] He classified clouds into four types and published his findings in a book, *On the Modifications of Clouds* (plate 2-7). The English landscape painter John Constable was inspired by Howard's book, a summary of which he read in Thomas Forster's *Researches about Atmospheric Phenomena* (1812).[2] In the 1820s Constable made a series of cloud sketches in oil and declared: "I have done a great deal of skying, for I am determined to conquer all difficulties. . . . The sky is the source of light in nature, and governs everything."[3] Constable recorded the day, time, location, and weather conditions on the back of each sketch (plates 2-5 and 2-6).

On the shores of Walden Pond, near Concord, Massachusetts, an American variety of Romanticism was bred by the New England Transcendentalists, a group of writers led by Ralph Waldo Emerson and Henry David Thoreau, which flourished between the 1830s and the 1860s. Thoreau was a naturalist who lived for two years in a cabin in the woods. Emerson borrowed the term *transcendentalist* from Kant, according to whom space and time are transcendental (a priori) preconditions for experiencing the world. Emerson gave *transcendentalism* the vaguer meaning of anything that is intuitive: "What is popularly called transcendentalism among us, is Idealism . . . whatever

2-7. Forms of clouds, in Luke Howard, *On the Modifications of Clouds* (1830), 3rd ed. (London: John Churchill, 1865), plate 2. Mandeville Special Collections Library, University of California, San Diego, Hill Meteorology Collection.

Howard classified clouds as *nimbus*—dark gray clouds that precipitate rain, sleet, or snow; *stratus*—fog-like bands; *cumulus*—white, fluffy flat-bottomed clouds with rounded tops formed by ascending air masses; and *cirrus*—high-altitude clouds occurring in white wispy streaks. Howard introduced his classification of clouds in a paper read before the Akesian Society of London in December 1802 and published in *Philosophical Magazine* in 1803. He published the essay as a thirty-two-page pamphlet in 1830.

belongs to the class of intuitive thought."[4] Emerson was a clergyman ordained as a Unitarian, a Protestant sect that is pantheist in the sense that it asserts the unity (as opposed to the trinity) of the divine and the manifestation of God in nature.

In addition to Kant and the Naturphilosophen, Emerson and Thoreau read Chinese and Indian philosophy.[5] Like Friedrich Schleiermacher, Emerson and Thoreau viewed world religions as products of history and thus equally valid; as Thoreau declared: "I do not prefer one religion or philosophy to another—I have no sympathy with the bigotry and ignorance which make transient and partial and puerile distinctions between one man's faith or form of faith and another's. . . . To the philosopher, all sects, all nations, are alike. I like Brahma—Hare Buddha—the Great spirit, as well as God."[6] Emerson and Thoreau recognized similar pantheist themes in Eastern and Western religious texts, and—like prophets, monks, and philosophers throughout the ages—each lived his spiritual life in solitude in nature. Don't "grope among the dry bones of the past," as Emerson put it, but forge "an original relation with the universe."[7]

The leader of the Hudson River school of painting, Thomas Cole, was the artistic spokesman for American pantheism and the Romantic concept of the sublime.[8] The sublime had been defined a century earlier by Edmund Burke as the experience of the infinite in nature, such as the number of stars in the heavens, which, according to Burke, is enhanced by a fear of the unknown (*A Philosophical Enquiry into the Origin of Our Ideas of the Sublime and the Beautiful*, 1757). Disagreeing with Burke, Kant proclaimed that the experience of the sublime is thrilling, not terrifying. According to Kant, one experiences the sublime when confronted with something extremely vast, such as the heavens, or something overwhelmingly powerful, such as universal gravitation. Kant believed in the existence of the Christian God, but for him the proof of God's existence was not intellectual (he dismissed all theological proofs as inept reasoning) but an intuition that nature is a manifestation of cosmic order.

When Cole painted Niagara Falls in 1830, it was already a tourist attraction surrounded by hotels. But he imagined it as sublime—an untamed wilderness inhabited only by Native Americans (plate 2-8). The painting expresses his spiritual union with a divine natural splendor; as he wrote: "In gazing on it we feel that a great void had been filled in our minds—our conceptions expand—we become part of what we behold!"[9] American Romantic landscape painters shared their German and British colleagues' symbolic association of luminous skies with a divine presence; Cole heightens the drama of this thundering waterfall with a band of rain-filled nimbus clouds at the horizon, valley fog creeping in from the left, and the reassuring presence of wispy cirrus as the viewer looks toward the highest heavens.

I lay down the book and go to my well for water, and lo! there I meet the servant of the Brahmin, priest of Brahma and Vishnu and Indra, who still sits in his temple on the Ganges reading the Vedas. . . . The pure Walden water is mingled with the sacred water of the Ganges.

Henry David Thoreau, *Walden; or, Life in the Woods*, 1854

Standing on the bare ground—my head bathed by the blithe air, and uplifted into infinite space—all means of egotism vanishes. . . . I am nothing; I see all; here currents of the Universal Being circulate through me; I am part and parcel of God.

Ralph Waldo Emerson, "Nature," 1836

2-8. Thomas Cole (American, 1801–1848), *Distant View of Niagara Falls*, 1830. Oil on panel, 18⅞ × 23⅞ in. (47.9 × 60.6 cm). The Art Institute of Chicago, Friends of American Art Collection, 1946.396.

2-9. Clodion (pseudonym of Claude Michel; French, 1738–1814), *The Invention of the Balloon*, 1784. Terracotta, height 43½ in. (110.5 cm). Metropolitan Museum of Art, New York, Rogers Fund and Admiral Frederic R. Harris gift, 1944.

In January 1784 the director of the Académie Royale de Peinture et de Sculpture announced the competition to design a monument to the balloon, prompting Clodion to make this clay model in the hope that it would be cast in bronze and erected in the Tuileries Garden. It has a round base in dark terracotta, with leaping flames shown in paler clay. The bevy of cherubs hoisting sheaves of straw does what the balloon pilots, suspended below the balloon in the wicker basket, actually did, according to Benjamin Franklin's eyewitness account: "Each of them had a port through which they could pass sheaves of straw into the grate to keep up the flame, and thereby keep the balloon full" (Franklin, letter to Joseph Banks, Nov. 21, 1783). Clodion's balloon hovers high above flames tended by a few frantic cherubs, flanked by Aeolus, the Greek god of the winds (on the left, blowing with puffed cheeks), and Fame (on the right), sounding her trumpet in honor of the Montgolfier brothers. Enthusiasm for erecting a monument cooled after manned ascents became common across Europe, and three years after Clodion submitted this model to the competition, Louis XVI had more important things on his mind—it was 1789.

Hot-Air Balloons

In 1783, two Frenchmen, the brothers Joseph-Michel and Jacques-Étienne Montgolfier, lit a fire under a large cloth bag with a hole in the bottom. As the bag filled with hot air, it slowly ascended, beginning the balloon age.

The Montgolfier brothers were paper manufacturers in the small town of Annonay, France. Fascinated with flight, they made their balloon of cloth, lined with paper and covered with a fishnet for reinforcement. In Annonay on June 4, 1783, they held their first public demonstration of their balloon. Securely tied to a rope, the balloon ascended to somewhere between 5,200 and 6,000 feet (1,600–2,000 meters) and was aloft for ten minutes. Today the Montgolfier company continues to operate in Annonay under the name Canson, specializing in fine-art paper.

King Louis XVI was keen on science, and so he summoned the Montgolfier brothers to Versailles, where on September 19, 1783, they launched another balloon, this time with a barnyard crew in the wicker basket—a rooster, a duck, and a sheep named "Mont au ciel" (French for "climb to the sky"), delighting King Louis and Marie Antoinette. Two months later (on November 21), in Paris, two brave volunteers, Jean-François Pilâtre de Rozier and François Laurent d'Arlandes, climbed into the wicker basket and piloted the first manned ascent in a free (untethered) balloon, which was gaily decorated with sunbursts, eagles with spread wings, and lion masks, all painted in gold on a blue background. After the balloon had slowly lifted off from a platform in the park of the royal Château de la Muette in the Bois de Boulogne, the Montgolfier brothers untied the ropes, and the balloon ascended (plate 2-1, chapter frontispiece) to 3,000 feet (914 meters). Proud that two Frenchmen had invented lighter-than-air flight, Louis XVI commissioned a monument to the balloon for the Tuileries Gardens in Paris (plate 2-9). Inventors were soon placing barometers and thermometers in the gondolas of balloons, along with instruments to collect air at various altitudes, and the new science of meteorology was launched.

Botany in Latin America

In the eighteenth century the botanist Carolus Linnaeus of Sweden had described the chain of being in ever greater detail in *Systema naturae* (System of nature), first published in 1735, with ten more editions in his lifetime. By classifying thousands of plants and animals, Linnaeus established binomial nomenclature, in which the first term identifies the genus and the second the species, as in *Homo sapiens*. Linnaeus grouped plants into twenty-four classes by counting their reproductive organs: the stamen, which produces pollen, and the pistil, with its swollen base (the ovary) containing unfertilized seeds. Linnaeus made an analogy between plant and human sexuality, describing a stamen as a *maritus* (Latin for "husband") and a pistil as a *femina*

BOTANIC MUSE! who, in this latter age,

Led by your airy hand the Swedish sage,

Bade his keen eye your secret haunts explore

On dewy dell, high wood, and winding shore;

Say on each leaf how tiny graces dwell;

How laugh the Pleasures in a blossom bell;

How insect Loves arise on cobweb wings,

Aim their light shafts, and point their little stings.

Erasmus Darwin, "The Loves of the Plants," 1791

2-10. Carolus Linnaeus's classification of plants, 1736. Drawn by Georg Ehret, ink and watercolor, 13 × 8¼ in. (33 × 21 cm). © The Trustees of the Natural History Museum, London.

In this drawing of each of Linnaeus's twenty-four classes of plants—labelled "Linnaei Methodus Plantarum Sexualis" (Latin for "Linnaean sexual method of plants")—the German illustrator Georg Ehret drew flowers stripped of their petals to reveal their male stamens and female pistils. The last class (*Z*) comprises non-flowering groups such as ferns and fungi that reproduce by spores. In keeping with his analogy between plants and humans, Linnaeus named this twenty-fourth class *Cryptogamia* (Greek for "clandestine marriage").

("woman") in various forms of *conjugio* ("marriage") (plate 2-10).[10] His colorful writing inspired the British naturalist Erasmus Darwin (grandfather of Charles Darwin) to write botanical love poems, but the German botanist Johann Georg Siegesbeck found the analogy immoral—Linnaeus responded by naming a foul-smelling weed *Sigesbeckia orientalis*.

The most widely read early nineteenth-century scientist to extol the harmony of nature and the great chain of being was the German naturalist Alexander von Humboldt. From 1799 to 1804, while in his thirties, Humboldt led an expedition to South America, where he climbed the Chimborazo volcano in Ecuador to a dizzying 19,000 feet (5,800 meters), setting a world record for high-altitude climbing. The French botanist Aimé Bonpland was a member of the expedition, which collected over 60,000 plant and animal specimens.

At this time Latin American countries were colonies, mainly of Spain, which sent scouts whose primary task was to assess what minerals could be exploited, but these missions often also resulted in scientific research. In the late eighteenth century King Charles III of Spain had authorized a survey of Colombia to record its geography, potential for gold and silver mining, and the native flora and fauna. Led by the Spanish priest and botanist José Celestino Mutis, the expedition set sail in 1783 and settled in the Magdalena River valley in Colombia. Mutis established a workshop where he trained local artists, such as Salvador Rizo Blanco, to draw plants in a similar style so that all the drawings would form a unified publication (plate 2-11). Mutis taught the artists to draw each plant around a central axis of symmetry, and include buds, mature flowers, fruits, and seeds. He also encouraged the workshop, which numbered around thirty artists, to bring out the plant's natural beauty, with an occasional rococo flair. The expedition discovered over 6,000 new plant species, each described, catalogued, and drawn by the artists in exquisite detail. Mutis corresponded regularly with Linnaeus before the Swede's death in 1778, and when Humboldt and Bonpland arrived in Bogotá in July 1801, Mutis welcomed them warmly and shared his vast research. Humboldt and Bonpland were astounded at the breadth of Mutis's pictorial archive, and they stayed in Bogotá for two months studying it. Humboldt and Bonpland published their expedition findings in *Ideen zu einer Geographie der Pflanzen* (Essay on the geography of plants, 1807), which is the founding text of modern ecology (plate 2-13). The following year they published a study of the plants they had observed in Latin America, in *Plantes équinoxiales* (Plants near the equator, 1808), which they dedicated to Mutis, "as a simple sign of our admiration and gratitude."[11]

When Mutis died, in 1808, his nephew, the botanist Sinforoso Mutis, took over leadership of the expedition, and Rizo, now forty-six years old, left to devote himself to winning Colombian independence from Spain. In 1810 the citizens of Bogotá removed

Doct: LINNÆI
METHODUS *plantarum* SEXUALIS
in SYSTEMATE NATURÆ
descripta

G.D. EHRET.
FECIT & EDIDIT
Lugd: bat: 1736.

Lafoensia manguitensis

the Spanish governor and issued a declaration of independence. But in 1815 the Spanish general Pablo Morillo, a seasoned veteran of the Napoleonic Wars, arrived to crush the rebellion. He ushered in a reign of terror, torturing and killing the leaders of the independence movement, including Rizo, who was executed by firing squad on October 12, 1816. Mutis had wanted his team's research to remain in Colombia, but in 1816 Morillo ended the scientific expedition and ordered Mutis's archive sent to Spain, where it is today, in the Real Jardín Botánico in Madrid. After the Venezuelan soldier Simón Bolívar led another uprising against Spanish rule, Colombia won independence in 1819.

Before returning from Latin America to Europe, Humboldt made a short visit to the United States; he wrote to President Thomas Jefferson, who was interested in science, to let him know he was coming. Jefferson invited Humboldt to the White House, where they held intense discussions about fossils, especially certain brick-size teeth and massive bones that had been found in North America. Humboldt also travelled to Philadelphia and discussed medicinal plants with Benjamin Rush, a physician who wrote a treatise on mental illness (*Diseases of the Mind*, 1812) and was medical director of Pennsylvania Hospital, America's first hospital, established in 1751 by Benjamin Franklin.

Twenty-five years after his travels in the Americas, Humboldt, now in his sixties, travelled to Asia and traversed the entire Russian Empire, accompanied by the young German zoologist C. G. Ehrenberg (see plate 11-9 in chapter 11). Based on his observations in the Americas and Asia, Humboldt wrote his multivolume popular science compendium of nature, *Cosmos: Draft of a Physical Description of the Universe* (1845–62), which became the model for Carl Sagan's *Cosmos: A Personal Voyage* (1980) and Neil deGrasse Tyson's *Cosmos: A Spacetime Odyssey* (2014). In the introduction Humboldt stated that his goal was to describe nature as "a unity in diversity of phenomena; a harmony, blending together all created things, however dissimilar in form and attributes; one great whole (τò πᾶυ) animated by the breath of life."[12] It took Humboldt twenty-five years to write *Cosmos*; the first volume appeared when he was seventy-six, the fourth when he was eighty-nine, and the final volume after his death in 1859.

In the mid-nineteenth century, Westerners supported other major science publications, such as *General Atlas of the World* (plate 2-12). John James Audubon, who was both an artist and an ornithologist, found enough subscribers to produce *The Birds of America* (plates 2-14 and 2-15).

The painter Frederic Edwin Church, who was a student of Thomas Cole, combined an eye for aesthetics with careful observation of natural history. Humboldt, who had trained as a geologist, urged Romantic landscape painters to study the shapes of hills and valleys, to learn botany, and to sketch *en plein air* (French for "in the open air"), dismissing as "morbid sentimentality" the idea that scientific knowledge of nature diminishes aesthetic pleasure.[13] Inspired by Humboldt, Church took his

2-11. Salvador Rizo Blanco (Colombian, ca. 1762–1816), *Lafoensia mariquitensis*, ca. 1800. Watercolor on paper, 21⅜ × 14¾ in. (54.3 × 37.5 cm). Archivo del Real Jardín Botánico, Madrid.

When José Mutis arrived in Colombia, Salvador Rizo Blanco was twenty-one and eagerly joined the expedition. Mutis taught him to draw and paint, and Rizo became Mutis's right-hand man and the teacher of Colombian artists who joined the workshop. The artists didn't sign their work, but Rizo's hand has been identified in 159 drawings, including this one. At the top of the central stem are six buds, and to the left a flower is in full bloom, with a semicircular array of stamens (thin filaments supporting pollen sacs) in the center of which is a long thin style, the top of the pistil, which produces fruit and seeds. On the right is a post-bloom flower, and lower down on the stem Rizo has drawn two flowers with mature ovules (the base of the pistil, which contains a seed), with the spent stamens drooping down.

PHYSICAL GEOGRAPHY.

Edinburgh, Published by A.&C.Black.

ABOVE

2-12. "Physical Geography," in Sidney Hall, William Hughes et al., *General Atlas of the World* (Edinburgh: Adam and Charles Black, 1854), map 4. Hand-colored engraving. David Rumsey Historical Map Collection. © 2000 by Cartography Associates.

This diagram shows the comparative lengths of rivers and heights of mountains around the world. To accommodate the information, the twenty-nine rivers were straightened, and the 250 mountains were given a uniform profile and shown against a scale in the right-hand border, from 1,000 to 27,000 feet (305 to 8,230 meters) elevation. Volcanoes are indicated by rising smoke. To give their British readers a sense of scale, the geographers included the skyline of London (at the bottom edge, just left of center), silhouetted against the beige foothills of the British Isles, with the massive dome of Saint Paul's Cathedral the size of a grain of sand. The longest river is shown as the Missouri in North America (3,610 miles/5,649 kilometers); today most geologists agree that the longest is the Nile in Africa (4,132 miles/6,650 kilometers). The tallest mountains include Dhawalagiri in the Himalayas (26,862 feet/8,188 meters) and Samara in the Andes in South America (22,350 feet/6,812 meters). This information is based on expedition reports and government surveys

of the 1830s. The British carried out the survey of India because it was a British colony, but when they reached the foothills of the Himalayas, the rulers of Nepal would not let them pass because they were suspicious that the British might try to annex their land. Eventually geologists surveyed the Himalayas, and today the highest point is known to be 29,035 feet (8,850 meters), known in Asia as Sagarmatha (Nepali for "head in the sky") and Chomolungma (Tibetan for "mother of the world"). In the West it is known as Everest (after the British geologist George Everest).

OPPOSITE

2-13. Chimborazo map, in Alexander von Humboldt and Aimé Bonpland, *Ideen zu einer Geographie der Pflanzen* [Essay on the geography of plants] (Tübingen: F. G. Cotta and Paris: F. Schoell, 1807). Hand-colored, engraved map, about 24 × 36 in. (54 × 84 cm).

This diagram, which is a fold-out at the back of the book, shows a cross section of Ecuador's inactive volcano Mount Chimborazo, which has an elevation of 20,548 feet (6,263 meters). Humboldt and Bonpland printed the names of plants that live at different elevations, from the basin of the Amazon to the edge of the glacier, each with its unique temperature, humidity, and atmospheric-pressure conditions.

CHAPTER 2

easel to South America and retraced Humboldt's voyage.[14] In 1859 Church completed his grand vision of the harmony of nature, *Heart of the Andes*, in which he presents an encyclopedic overview of natural science, from glacial peaks to tropical lowlands, adorning each habitat with an array of flora and fauna appropriate to its climate (plates 2-16, 2-17, and 2-18). In April 1859 Church installed the painting in the Tenth Street Studio Building in Manhattan for a month of public viewing, after which he planned to ship it to Germany so that Humboldt could see it. As Church explained in a letter to a friend on May 9, 1859: "[My] principle motive in taking the picture to Berlin is to have the satisfaction of placing before Humboldt a transcript of the scenery which delighted his eyes sixty years ago—and which he had pronounced the finest in the world."[15] Unfortunately, just a few days before Church wrote this, Humboldt had died, so the painter was unable to fulfill his wish.

PLATE LXII

Passenger Pigeon.
COLUMBA MIGRATORIA, Linn
Male,1. Female,2.

2-14. John James Audubon (Haitian-born American, 1785–1851), Passenger pigeon, *The Birds of America* (London: published by the author, 1827–38), plate 62. Hand-colored etching and engraving by Robert Havell after a watercolor by Audubon, paper size 39 × 26 in. (99 × 66 cm). University of Pittsburgh.

Audubon was born in a French colony (today Haiti), where his father owned a plantation. He was raised in France and had French citizenship, but his father sent him to the United States during the Napoleonic Wars so he could avoid the draft. There he anglicized his name, became an American citizen, and supported himself in various business ventures. In 1810, at twenty-five years old, he began making the watercolor drawings of birds from which *The Birds of America* would eventually be engraved and printed.

To draw each bird, such as this male and female passenger pigeon, Audubon first killed the bird with a shotgun—rather than a rifle—because it fires very small spheres (shot) that do not destroy the feathers. Rather than stuff the lifeless shell in a stiff posture as most taxidermists did, Audubon used wire to prop the carcass into a natural position. He drew each bird life-size, working in layers of watercolor and adding colored chalk to achieve the softness of feathers. Based on his field observations, he surrounded each bird with vegetation from its habitat, and depicted it engaged in typical behavior, such as this female dropping a seed into the mouth of her partner.

Unable to find a publisher or financial backing in Philadelphia, in 1826 Audubon, now forty-one, set sail with his portfolio for London. There he found enough interest that he took the risk of self-publishing the prints, to which he sold subscriptions. Robert Havell prepared copperplates from Audubon's drawings, and once the sheets were printed, painters applied each color, in assembly-line fashion. Audubon produced a few prints, unbound and without text, every few months from 1827 to 1838. About 200 complete sets were printed; an accompanying text, written by Audubon and the Scottish ornithologist William MacGillivray, was published separately, as *Ornithological Biography*, in five volumes (1831–39).

2-15. Walton Ford (American, born 1960), *Falling Bough*, 2002. Watercolor, gouache, pencil, and ink on paper, 60½ × 119½ in. (153.7 × 303.5 cm). Courtesy of the artist and Paul Kasmin Gallery, New York.

The contemporary American artist Walton Ford paints in the style of Audubon. In this work Ford depicts a scene of early nineteenth-century America, when huge flocks of migratory passenger pigeons filled the skies. Breeding in the Great Lakes area, the passenger pigeon was once the most abundant bird in North America, numbering up to 5 billion at its peak population. In *Falling Bough*, Ford illustrated an observation made by Audubon: "The Pigeons, arriving by thousands, alighted everywhere, one above another, until solid masses were formed on the branches all round. Here and there the perches gave way under the weight with a crash" (John James Audubon, *The Birds of America* [New York: published by the author, 1840–44], 5:29). Already in Audubon's lifetime the population of the passenger pigeon had declined, due to deforestation and overhunting, as he noted: "Here, again, the tyrant of the creation, man, interferes, disturbing the harmony of this peaceful scene. As the young birds grow up, their enemies, armed with axes, reach the spot, to seize and destroy all they can" (Audubon, *The Birds of America*, 5:31). Despite conservation efforts that began in the 1890s, the passenger pigeon was soon extinct.

2-16. Frederic Edwin Church (American, 1826–1900), *Heart of the Andes*, 1859. Oil on canvas, 66⅛ in. × 119¼ in. (168 × 302.9 cm). Metropolitan Museum of Art, New York, bequest of Margaret E. Dows.

High in the background is the snow-capped summit of Mount Chimborazo. Church spent nine weeks in Ecuador in the spring of 1857 studying and sketching the local landscape. In the center of the canvas is a grass-covered plateau, with a village reflected in a still lake from which a river flows, cascading over the steps of a waterfall into the foreground. On the left, a path leads to a simple wooden shrine. The artist signed and dated the painting in the sunlit bark of the tree in the lower left.

2-17. Frederic Edwin Church, *Heart of the Andes*, detail of plate 2-16.

Trees cling to an eroded bank, their roots exposed amid a tangle of ferns and flowering vegetation.

2-18 April Gornik (American, born 1953), *Storm, Rain, Light*, 2013. Oil on linen, 68 × 72 in. (172.7 × 182.8 cm). Courtesy of the artist. Contemporary artist April Gornik paints dramatic skies in the American Romantic tradition of Frederic Church.

2-19. World map from Battista Agnese, *Portolan Atlas* (Venice, 1544). Watercolor, ink, and silver on vellum, 8¼ × 11⅜ in. (21 × 29 cm). Library of Congress, Washington, DC.

The cartographer Battista Agnese drew the route of Ferdinand Magellan's first circumnavigation of the globe in silver, which has oxidized, so the line is tarnished, appearing gray. The cherubs in blue and gold clouds represent the twelve winds, which evolved into the modern compass points. The winds are named here in Latin, following the philosopher Aristotle's system: *Aparctias* (N), *Caecias* (NE), *Apeliotes* (E), *Eurus* (SE), *Notos* (S), *Lips* (SW), *Zephyrus* (W), and *Argestes* (NW), and two half winds, *Thrascias* (NNW) and *Meses* (NNE) (Aristotle, *Meteorology*, ca. 340 BC).

When a young Charles Darwin set sail on HMS *Beagle* in 1831, he packed his copy of Humboldt's description of his South American voyage, *Personal Narrative* (1814–29). The next year, in the jungles of Brazil, Darwin wrote in his diary, "Humboldt's glorious descriptions are and will forever be unparalleled."[16] But by the time Darwin returned to London in 1836, he had come to the unsettling conclusion that nature is more a battlefield than a peaceable kingdom. Once Darwin's views became widely known in the 1860s, the era of grand Romantic landscape painting began to decline.

But the seeds of the modern search for the meaning of the human condition existed in other pantheist and German Idealist notions that remained very much alive. Kant's revolutionary claim that objective knowledge originates not in the world but in the mind would soon turn the search inward. The concepts of an Absolute Spirit and the unity of nature lingered and were reformulated in secular terms in late nineteenth-century science. In 1859 the seeds of these ideas were still hidden below ground, but they had been sown in fertile soil and were taking root.

2-20. "The Crews of HMS *Hecla* and *Griper* Cutting into Winter Harbour, September 26, 1819," in William Edward Parry, Robert Brown, Edward Sabine, et al., *Journal of a Voyage for the Discovery of a Northwest Passage from the Atlantic to the Pacific* (London: John Murray, 1821), plate 13, facing 97. Engraving by W. Westall after a sketch by F. W. Beechley.

The crews cut a canal so they could move their ships into a harbor for the winter. Some sailors saw through the ice while others pry up the rectangular slabs. In the center of the image, a sailor has attached a sail to an ice slab in order to move it past the ships and out of the canal. After the entrance to the canal froze over, to get the slabs out of the way the sailors pushed them under the ice sheet. The average thickness of the ice was 7 inches (18 centimeters) and the sailors cut a canal about 2.3 miles (3.75 kilometers) long (Parry, *Journal*, 96–98).

Search for the Northwest Passage

In 1519–22 the Portuguese explorer Ferdinand Magellan led the first expedition that circumnavigated Earth by sailing a southern route below Africa and South America, which became the principal maritime trade routes linking Europe to India and China (plate 2-19). For centuries European explorers sought a shorter route to Asia by sailing northwest from Europe, hoping to find a waterway through North America or a passage over the top of the continent. Sailing into unknown territory, they encountered dead ends and impassable ice fields. As water freezes it expands, and the ice crushed the wooden hulls of many boats. In 1609 the English navigator Henry Hudson, sailing on behalf of the Dutch East India Company, explored the coast near modern New York City and sailed up the river that now bears his name. Encouraged because the water was salty, he hoped to emerge in the Pacific Ocean, but after a few miles the water became fresh and the river dangerously shallow, so he turned back. He made another attempt in 1610–11, sailing farther north and entering a huge bay (also named for him), where his crew spent the winter on shore in Arctic conditions. After the spring thaw, Hudson announced to his crew that they were sailing west, but some of the sailors mutinied and set Hudson and a few others adrift (he was never seen again), and they headed home east across the Atlantic.

The search for a Northwest Passage continued in the early nineteenth century, when the Romantic imagination was fired by tales of Arctic exploration, such as William Parry's 1821 account of his British expedition in HMS *Hecla* and *Griper* (plate 2-20), which Caspar David Friedrich probably read in its German translation of 1822. The following year Friedrich painted *The Polar Sea* (plate 2-21), in which he depicted ice sheets in

varying colors and crystal forms. On the right is a vessel crushed by ice, and in the background precarious towers of ice fade into the void.[17]

By the 1820s, when he painted *The Polar Sea*, the artist was living as a virtual recluse. Friedrich's friend Carl Gustav Carus observed that the painter had "a very exalted notion of art, an essentially gloomy nature [*düsteres Naturell*] and—arising from both—a profound dissatisfaction with his own work. . . . In his dark shadowy room, he brooded almost incessantly on his own work."[18] Friedrich, who shared Carus's interest in plumbing "the secrets of the soul," advised other painters: "The artist should paint not only what he sees in the world but also what he sees within himself. However, if he sees nothing in himself, then he should stop painting what he sees in front of him."[19]

In June 1835 Friedrich had the first of several strokes, which left him partially paralyzed in his arms and legs. After it became difficult for him to hold a brush, he worked on paper, but he did manage to paint the dark and somber *Seashore by Moonlight* (plate 2-22), capturing the "eternal in a moment," as the Lutheran theologian Friedrich Schleiermacher put it. Despite depression and paralysis, Friedrich found within himself the strength to create this painting because he had, in the words of another great Lutheran theologian, Paul Tillich, "the courage to be."[20]

2-23. "Entering Lancaster Sound," in Elisha Kent Kane, *The US* Grinnell *Expedition in Search of Sir John Franklin* (New York: Harper, 1854), frontispiece. Engraving by John Sartain after a drawing by J. Hamilton, based on a sketch by Kane.

The *Grinnell* expedition of 1850 was the first American effort to find John Franklin and his crew. Searching along Franklin's proposed route to find a Northwest Passage, the Grinnell group encountered seven British ships, and together the eight captains co-ordinated a plan to search a huge area. The *Grinnell* expedition is shown here entering Lancaster Sound, which forms the eastern entrance to the Northwest Passage.

2-24. "Beechy Island: Franklin's First Winter Quarters," in Kane, *The US* Grinnell *Expedition*, between 162–63. Engraving by John Sartain after a drawing by J. Hamilton, based on a sketch by Kane.

In co-ordination with the British search missions, the crew of the *Grinnell* identified the remains of Franklin's winter camp on Beechy Island. They discovered three graves, which the author described: "Here, amid the sterile uniformity of snow and slate, were the head-boards of three graves, made after the old orthodox fashion of gravestones at home. . . . Sacred to the memory of W. Braine (32 years), John Hartnell (23 years), and John Torrington (20 years)" (Kane, *Grinnell*, 162).

Parry's Arctic expedition of 1819–20 was deemed a success because he made it halfway across the top of modern Canada, but the attempt to traverse the Northwest Passage by another British naval officer, John Franklin, ended in disaster. Franklin departed England in command of HMS *Erebus* and *Terror* in 1845. When he did not return by 1848, a search began, and over the next thirty years twenty expeditions were sent from England and the United States to find the Franklin expedition (plates 2-23 and 2-24). Although the search parties did not find the ships, their cumulative discovery of a trickle of remnants allowed the British navy to piece together what had happened: the HMS *Erebus* and *Terror* had been frozen in, and when spring and summer came but the ice didn't thaw, the crew of 129 men abandoned ship and hiked south, most dying from starvation. This long-held scenario is being revised, after the sunken ships were discovered in 2016; it now appears that in the spring of 1848, HMS

Terror was abandoned, and the remaining sailors made a desperate attempt to sail HMS *Erebus* south, where they met their fate.

In New York the public became fascinated with newspaper reports of the American-led missions to find Franklin, the *Grinnell* expeditions of 1850 and 1853. They were financed by Henry Grinnell, head of one of the wealthiest mercantile houses in Manhattan, who was passionate about polar exploration. Concerned about the fate of the HMS *Erebus* and *Terror*, he corresponded for decades with the captain's wife, Jane Franklin. Also very interested in geography, Grinnell was a founder in New York in 1851 of the American Geographical and Statistical Society, of which Frederic Church was a member. At a meeting of the society, Church met the physician Isaac Israel Hayes, who had sailed on the *Grinnell* expedition of 1853 as the ship's doctor. On the voyage, Hayes also made sketches, which he showed to Church, inspiring the artist to travel to the Arctic. In 1859 Church set sail on a month-long expedition, along with his friend Louis Legrand Noble, a writer who had published a biography of Thomas Cole. Church did sketches of icebergs, sometimes rowing a small boat in the freezing, deadly waters to see them up close. Back in New York, Church painted *The Icebergs* (1861; plate 2-25), and Noble published his account of their adventure, *After Icebergs with a Painter* (1861).

The Northwest Passage was first successfully traversed in 1903–6, by the Norwegian explorer Roald Amundsen. With melting of Arctic ice in recent decades due to global climate change, the Northwest Passage has become a viable trade route for cargo ships.

2-25. Frederic Edwin Church (American, 1826–1900), *The Icebergs*, 1861. Oil on canvas, 64½ × 112½ in. (163.83 × 285.751 cm). Dallas Museum of Art, gift of Norma and Lamar Hunt, 1979.28.

Ah, for just one time I would take
 the Northwest Passage
To find the hand of Franklin
 reaching for the Beaufort Sea;
Tracing one warm line through
 a land so wide and savage
And make a Northwest Passage
 to the sea.

Stan Rogers, "Northwest Passage," 1981

Positivism

In the wake of the American and French Revolutions, early nineteenth-century social reformers first expressed the concept of positivism: science gives the only valid ("positive") knowledge and science propels progress in history. In France positivism took the form of socialism, and in England it was expressed as utilitarianism; these positivist outlooks persisted not only in French and Anglo-American social order but also in the society of science.

The French social philosopher Henri de Saint-Simon made a fortune as a financier in Paris and then, in his fifties, took up the study of physics and began the perceptive analysis of European history that made him a founding father of French socialism. Saint-Simon sensed that he lived at a critical moment in history, when the privileges of monarchies were a thing of the past and Roman Catholic dogma had been rendered obsolete by science. In *Nouveau Christianisme* (New Christianity, 1825), Saint-Simon envisioned a new brotherhood of workers empowered by a scientific education.

Saint-Simon was associated during the last decade of his life with Auguste Comte, a mathematician and social philosopher who gave positivism an articulate formulation. Comte declared that human knowledge—by which he meant astronomy, physics, chemistry, and biology—progresses through three irreversible stages, beginning with theology, then metaphysics, and finally the scientific stage—positivism—in which explanations are found by the inductive method of generalizing from observed facts. Toward the end of his life, Comte despaired of forming a stable society by reason alone, and he attempted an eccentric mix of science and Roman Catholicism. Declaring himself high priest, he described a cult of reason, at the center of which was a new trinity composed of humankind, Earth, and celestial space; the cult celebrated holy days such as Newton's birthday and followed a calendar of saints with months named after Aristotle, Dante, and Shakespeare (*Catéchisme positiviste* [Positivist catechism], 1852).

For English-speaking audiences, the British philosopher John Stuart Mill developed a morality based on science in *A System of Logic* (1843), which was the most widely read nineteenth-century text on positivism. The centerpiece of his book is a defense of an extreme form of inductive reasoning in which all knowledge derives from experience. A radical libertarian, Mill argued that individuals are free to decide the truth of any proposition based on their own experience and to believe nothing solely on the basis of government authority or because it is the custom of the land. Mill agreed with his French counterparts Saint-Simon and Comte that the undermining of traditional moral beliefs posed a grave threat to the stability of society. His solution was to derive a moral code from experience and declare that a moral verdict can be rendered by observing the usefulness—utility—of an action in bringing about the greatest good for the greatest number of people. Mill's utilitarianism merged scientific knowledge, individual freedom, and human happiness.

The predominance of positivism in France and Britain led to the focus on observed fact in nineteenth-century French and British laboratories. American science was allied to British, and researchers in Philadelphia and Boston adopted the utilitarian outlook and reliance on what can be seen with one's eyes. As the general public in these countries adopted a scientific outlook, late nineteenth-century French, British, and American artists reflected the seeing-is-believing attitude by creating various styles that were based in observation. Even as their art became increasingly more abstracted from nature, painters in Paris, London, and New York included vestiges of depicted details in still lifes, landscapes, and portraits.

In contrast, nineteenth-century German science developed in a culture that was less affected by the socialist and utilitarian outlooks that arose in response to democratic reforms sweeping England, New England, and France. As laboratories opened in Dresden, Munich, and Berlin, German scientists were less concerned with collecting data from direct observation and more focused on theoretical questions about nature that they had inherited from German Idealism. Reflecting this distinctive feature of Germanic science, artists in Germany, Austria, and Russia were less grounded in what they saw in the natural world, and as laboratory evidence mounted that Mother Nature is not always what she appears to be, artists throughout Germanic culture stopped depicting the natural world and embraced radical abstraction.

Tanagra Darwini.

3

Adopting a Scientific Worldview

Man is descended from a hairy, tailed quadruped, probably arboreal in habits.

Charles Darwin, *The Descent of Man*, 1871

WHEN CHARLES DARWIN published his theory of evolution, two of his ideas became flashpoints for controversy. Darwin posited that plants and animals were created not by a divine designer but by natural selection and that man was not made in God's image but descended from an ape. The Bible says that each animal multiplies "after its kind" (Genesis 1:11, 21), which, taken literally, means that, like links in a rigid metal chain, every offspring is identical to its parent. How were the followers of Western religions—Judaism, Christianity, and Islam—for whom God's role as creator was unassailable, to reconcile the enormous implications of Darwin's ideas?

Fossils

Evidence that plants and animals change over time had been coming to light since the late eighteenth century as naturalists acquired fossils that did not match known existing species. In 1799 a Russian hunter, Ossip Schumachov, came across the frozen carcass of an elephant-like animal, so he removed the tusks and sold them. Hearing tales of the strange beast, Russian botanist Michael Friedrich Adams travelled to the Siberian site in 1806 and retrieved the skeleton, minus the tusks, which he was able to purchase from an ivory trader. Adams determined that the fossilized bones were from an animal similar to an elephant but covered with fur—a woolly mammoth—and he brought the remains to Saint Petersburg's Kunstkamera (German for "art chamber"), a museum founded by Peter the Great and opened in 1727. There the skeleton was mounted by the German naturalist Wilhelm Gottlieb Tilesius, a professor at Moscow University. The Kunstkamera already owned the skeleton of a modern Indian elephant, which Tilesius used as reference (plates 3-2 and 3-3). Ever since Tilesius completed assembling the fossil, the Siberian mammoth has remained on display in the Kunstkamera, which is today known as the Museum of Anthropology and Ethnography.

3-1. *Tanagra darwini*, in *The Zoology of the Voyage of HMS* Beagle, ed. Charles Darwin (London: Smith, Elder and Co., 1839–43), in vol. 3, John Gould, *Birds* (1841), plate 34, between 96–97. Lithograph by Elisabeth Gould (British, 1804–41), after a drawing by John Gould.

Ornithologist John Gould wrote this volume describing the birds collected on the voyage of HMS *Beagle*, many of which were previously unidentified species. He named this tanager, which is native to the Americas, for Charles Darwin. In the preface to Gould's book, Darwin expressed his appreciation for lithographs such as this: "The accompanying illustrations, which are fifty in number, were taken from sketches made by Mr. Gould himself, and executed on stone by Mrs. Gould, with that admirable success, which has attended all her works" (i–ii).

3-2. Hall of fossils in the Kunstkamera, Saint Petersburg, in Louis Figuier, *La Terre avant le déluge* [Earth before the deluge], 4th ed. (Paris: Hachette, 1864), fig. 309, on 345

This illustration shows an exhibition hall in the Kunstkamera in the nineteenth century: Wilhelm Gottlieb Tilesius's mounting of the bones of the extinct woolly mammoth that Michael Friedrich Adams had excavated (left), the skeleton of the modern Indian elephant that Tilesius used as a guide (center), and a stuffed modern African elephant (right). Tilesius's reconstruction of the mammoth is basically correct, except that he put the tusks in their opposite sockets, so they are shown (incorrectly) curving outward instead of inward, an error that was corrected in 1899.

OPPOSITE

3-3. Mammoth skeleton excavated by Michael Friedrich Adams, in Wilhelm Gottlieb Tilesius, *De Elephantis in genere et skeleto Mamonteo in specie* [On elephants in general and a particular mammoth skeleton] (St. Petersburg: printed by the author, 1814), plate 10, fig. 1, after 514.

Halfway around the world, the American portrait painter Charles Willson Peale led an archaeological dig that excavated the bones of another extinct ancestor of the elephant (plate 3-4). In the early nineteenth century, naturalists called any elephantine skeleton a mammoth, but paleontologists have since determined that mammoths lived in northern Europe, Russia, and the American West, and that Peale's Hudson River valley fossil was a different relative of the elephant—a mastodon.[1] After Peale's mastodon mount was completed in 1802, it was put on display in the Peale Museum on the second floor of Independence Hall in Philadelphia (plate 3-5). After Peale's death the museum moved and eventually closed, and Peale's collection was put up for sale. In 1854 a German naturalist, Johann Jakob Kaup, bought Peale's American mastodon for the Hessisches Landesmuseum in Darmstadt, Germany, where it has been displayed ever since. After the American Museum of Natural History was established in New York City, in 1869, it put another American mastodon fossil on display and hired the artist Charles R. Knight to depict the animal in its habitat (plates 3-6 and 3-7).

To fund his 1801–2 excavation, Peale got a loan from the American Philosophical Society, the president of which was Thomas Jefferson. By the 1780s Jefferson had become convinced that mammoths could still be alive, and after becoming third president of the United States, in 1801, he hired two soldiers, Meriwether Lewis and William Clark, to lead an expedition to find a route across the western half of the continent and to establish a presence there before Britain, France, or Spain claimed it. The Lewis and Clark Expedition also had scientific objectives: to collect specimens of minerals, plants, and animals, and to determine whether mammoths still roamed the prairies of the American West. In 1796 Jefferson had been sent fossil bones, including three large claws from an extinct relative of the ground sloth, *Megalonyx* (Greek for "large claw"), which had been discovered in Haynes Cave in West Virginia (see plate 3-18). The following year Jefferson presented a paper to the American Philosophical Society on the

fossil, which was later named for him—*Megalonyx jeffersonii*—and he declared that the beast might still exist in the American West: "In the present interior of our continent there is surely space and range enough for elephants and lions, if in that climate they could subsist; and for mammoths and the *Megalonyx* who may subsist there. Our entire ignorance of the immense country to the West and Northwest, does not authorize us to say what it does not contain."[2]

How did ancient elephants get from Africa and India to Siberia and North America? Ever since Magellan first circumnavigated the globe, map-makers had noticed that the continents fit together like pieces of a puzzle (plate 3-8). Were the continents once connected? If so, how did they separate?

In 1812 the leading expert on fossils, the French paleontologist Georges Cuvier, amazed the Paris scientific community by announcing that some strange bones found in Bavaria were the remains of a flying reptile, with wings made from a membrane of skin attached to a greatly elongated fourth finger, which he called a *Pterodactyl* (Latin for "wing-finger"; plates 3-9 and 3-10). In the 1820s an amateur British fossil hunter, Gideon Mantell, found a tooth that, except for its great size, matched one from a modern iguana (a lizard common today in Latin America). This herbivorous

3-4. Charles Willson Peale (American, 1741–1827). *The Exhumation of the Mastodon*, 1805–8. Oil on canvas, 50 × 62½ in. (127 × 158.8 cm). Maryland Historical Society, Baltimore.

Peale advertised in newspapers that he would pay for old bones. A farmer in upstate New York contacted Peale, who took the train from Philadelphia to see the bones and struck a deal with the farmer. Peale gave the farmer a sum of money, and in exchange the farmer allowed Peale to excavate the fossil during the 1801–2 planting season. To get rid of groundwater from the excavation pit, Peale erected a great wheel that was turned by men treading inside it. The wheel drove a belt that turned a pulley system, lifting water-filled buckets that spilled down a chute, sending the water into a nearby valley. In the foreground, workers shovel wet mud, while on the right others sift the dirt in search of tiny bones. In the center, workers search underwater and one holds up a bone. Peale stands on the right bank gesturing to the excavation with outstretched hand, and with his other hand he holds a large drawing of bones. The other end is rolled up in the hands of Peale's son Rembrandt Peale, who assisted on the dig. In a dramatic flourish, Peale painted storm clouds approaching; rain falls and lightning strikes in the distance on the far right.

reptile, given the name *Iguanodon* (Latin for "iguana tooth"), had slithered through the bucolic British countryside, measuring 30 feet (9 meters) long from nose to tail. When Mantell obtained the fossil remains of an entire *Iguanodon* in 1834, he invited the public to see the bones and then noted in his diary: "Among the visitors who have besieged my house today was Mr. John Martin. . . . I wish I could induce him to portray the country of the *Iguanodons*; no other pencil but his could attempt such a subject."[3]

3-5. Charles Willson Peale (American, 1741–1827), *The Artist in His Museum*, 1822. Oil on canvas, 103¾ in. × 79⅞ in. (263.5 × 202.9 cm). Pennsylvania Academy of the Fine Arts, Philadelphia, gift of Mrs. Sarah Harrison, the Joseph Harrison Jr. Collection.

In 1822, Peale, at age eighty-one, created this enormous painting of himself inviting the viewer to enter his museum. In the bottom left is a dead bird (a wild turkey) atop an open case with Peale's taxidermy tools. Compartments holding birds line the left wall, with the American bald eagle displayed first in the top row. Near Peale's feet, at the bottom right, are bones of a mastodon, while the mounted skeleton—the museum's main attraction—is partly visible behind the red curtain. On the table is Peale's artist's palette. The animal specimens in the background are organized according to Carolus Linnaeus's classification, and high on the walls are portraits of important Americans.

Martin was known in his day for his imaginative presentation of sublime themes on a grand scale, composed with great Romantic bravura; also an accomplished printmaker, Martin obliged Mantell by artistically bringing the *Iguanodon* to life (plate 3-12). In 1842 the British zoologist Richard Owen gave a new order of extinct reptiles the name *Dinosaurus* (Latin for "terrible [in the sense of awesome] lizards"; plate 3-11).

What had happened to the *Iguanodon*? The suggestion that one of God's creatures could go extinct bordered on heresy. To explain why some species no longer exist, Cuvier described a series of floods that had extinguished all life, after each of which God created new plants and animals (*Recherches sur les ossements fossiles de quadrupèdes* [Research on the fossil bones of quadrupeds], 1812). The biblical account of the deluge in which "every living thing on the face of the earth was destroyed" (Genesis 7:23), was, according to Cuvier, the last of the floods to occur. The French naturalist Jean-Baptiste Lamarck disagreed with Cuvier and proclaimed that plants and animals do indeed change form, undergoing "transmutation" during their life in response to their environment. For example, Lamarck hypothesized that the giraffe's neck was elongated as it stretched to reach high leaves. Such acquired characteristics, Lamarck suggested, erroneously, could be passed on to offspring.

Implacable November weather. As much mud in the streets, as if the waters had but newly retired from the face of the earth, and it would not be wonderful to meet a Megalosaurus, *forty feet long or so, waddling like an elephantine lizard up Holborn-Hill.*

Charles Dickens, *Bleak House,* **1852**

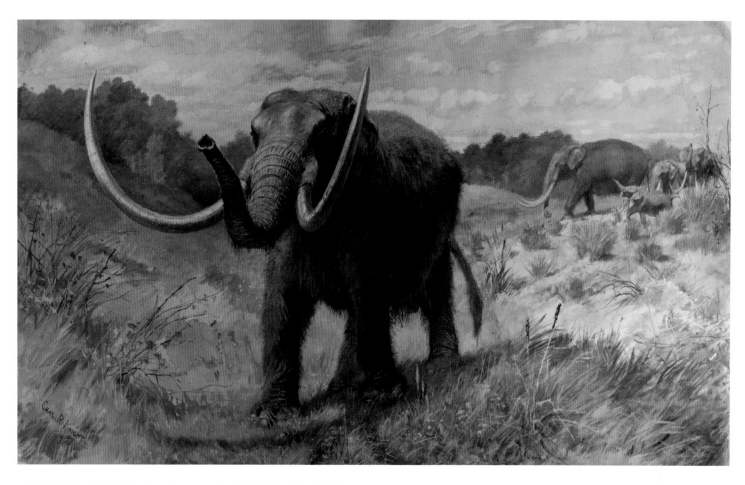

3-6. Charles R. Knight (American, 1874–1953), *Mastodon Herd*, 1897. Watercolor on paper, 17¼ × 28 in. (44 × 71 cm). American Museum of Natural History, New York.

3-7. American mastodon, late 19th century. Photograph. American Museum of Natural History, New York.

The American mastodon lived on the northeastern coast of the North American continent 11,000 years ago. This fossil was found in 1845 near Newburgh, New York, by a farmer digging for peat moss. The animal had died by sinking into a bog; the wet spongy soil was too soft to support its massive weight. Because it was submerged, other animals didn't eat the carcass, and every bone of this fossil is preserved. John Warren, a professor of anatomy at Harvard University, paid the farmer $5,000 for the fossil and shipped it to Boston, where it went on display in his museum of fossils. When Warren died, in 1856, he willed his fossils to his family, and several generations later, in 1906, they offered the entire collection to the American Museum of Natural History for $30,000. The director of the museum brought the collection to the attention of New York banker J. P. Morgan, who agreed to fund the purchase, and the Warren mastodon has been on display in the museum ever since.

3-8. The continents shown before and after they separated, in Antonio Snider-Pellegrini, *La Création et ses mystères dévoilés* [Creation and its mysteries unveiled] (Paris: A. Franck, 1859), figs. 9 and 10, between 314–15. Woodcuts by Bulard and Sotain.

After telling the biblical story of the creation of Adam and Eve, Snider-Pellegrini speculates that the continents were joined in the era between Adam and Noah, and that they separated during *le déluge*—the biblical flood (314). In 1912, the German polar researcher Alfred Wegener put forth a scientific theory—continental drift—to explain the map and the presence of similar fossils and rock formations on different continents, which had somehow "drifted" apart. In the 1950s American geologists Marie Tharp and Bruce Heezen explained how the continents move—plate tectonics (see plate 14-34 in chapter 14).

TOP LEFT

3-9. Pterodactyl fossil and reconstruction, in Edward Clodd, *The Story of Creation: A Plain Account of Evolution* (London: Longmans, Green, 1888), fig. 16.

TOP RIGHT

3-10. Max Klinger (German, 1857–1920), *Abduction*, plate 9 in the suite *A Glove*, 1881. Etching and aquatint on ivory chine collé, 10⅝ × 4¾ in. (26.9 × 12 cm). The Art Institute of Chicago, gift of Mr. and Mrs. Joseph R. Shapiro in honor of Teri Edelstein.

Exotic creatures from the past captured the imagination of the German symbolist Max Klinger, who cast a pterodactyl as the villain that stole a woman's glove in her nightmare.

BOTTOM LEFT

3-11. Statues of dinosaurs, in Samuel Phillips, *Guide to the Crystal Palace and Its Park and Gardens* (Sydenham, England: Crystal Palace Library, 1859), 167.

After the closing of the Great Exhibition of 1851 (the first world's fair), plans were made to relocate its signature structure, the Crystal Palace, to the town of Sydenham, and the board of directors included an outdoor amusement park populated with painted cement models of extinct plants and animals. The first dinosaur theme park opened here to great acclaim in 1854 and can still be visited today, a short train ride from London.

BOTTOM RIGHT

3-12. "The Country of the Iguanodon," mezzotint, by John Martin (English, 1789–1854), in Gideon Mantell, *The Wonders of Geology*, 7th ed. (London: Henry G. Bohn, 1838), vol. 1, frontispiece.

John Martin imagined a mortal battle between *Iguanodons* in the tropics during the Mesozoic—the age of reptiles. The fight is witnessed by a fluttering pterodactyl, and the ground is scattered with turtles and the coiled shells of ammonites (extinct cephalopods).

3-13. Geological map of the British Isles, in William Smith, *Delineation of the Strata of England and Wales, with Part of Scotland* (London: John Cary, 1815). Hand-colored, engraved map on a scale of 5 miles:1 in. (8 km:2.5 cm), composed of fifteen linen-backed segments, each 24¾ × 22 in. (62.9 × 55.9); the total map measures 10 ft. 4 in. × 5 ft. 6 in. (3.14 × 1.67 m). Stanford University Libraries, Samuel I. and Cecile M. Barchas Collection in the History of Science and Ideas, Stanford, California.

The son of a blacksmith, William Smith went to work at a young age, with little formal education, after his father died when William was eight. He became a surveyor and began assembling a large collection of fossils; by careful observation, he was able to determine the elevation of rock strata and associate each layer with particular fossils. Most English geologists were upper-class gentlemen, and they ignored Smith because he lacked education and family connections. But Smith persevered and published this enormous map at his own expense. Hoping for financial security, he borrowed money to invest in digging a quarry on land near his home, but the stone turned out to be of poor quality. He sold his fossil collection to the British Museum in an attempt to repay his debt. Unable to raise enough money, Smith lost his home and was sent to debtors' prison. After his release in 1819, Smith, by then fifty years old, worked as an itinerant surveyor. Meanwhile, geologists such as Charles Lyell had come to realize the importance of Smith's work, and in 1831 the world's oldest and most prestigious national geological society, the Geological Society of London, awarded Smith its highest honor and hailed him as the "Father of English Geology." By this time Smith had settled in Scarborough, where in 1829 he designed the Rotunda Museum to display fossils and minerals of the Jurassic era, collected from the surrounding North Yorkshire countryside.

Geology

Cuvier explained the layering of Earth's crust in terms of global floods, but the British geologist James Hutton theorized that the layers had been formed through very slow but observable processes, such as the accumulation of sediment on dry land and the ocean floor ("Theory of the Earth," 1788). It was a contemporary of Cuvier and Hutton, the English land surveyor William Smith, who made the crucial observation that each stratum of rock contains only a particular type of fossil. While supervising the digging of the Somerset Canal, which was used to transport coal in southwest England, Smith observed a cross section of rock stratum for many miles; as it got thicker and thinner, sometimes disappearing and then reappearing in the next hill, it always contained the same fossils. Smith hypothesized that fossils could be arranged chronologically by stratum and demonstrated that the lower (presumably earlier) layers of rock contain simpler organisms and higher (more recent) layers contain more complex fossils (*Strata Identified by Organized Fossils*, 1816–19). Smith also published the first detailed geological map of the rock layers in the British Isles (plates 3-13, 3-14, and 3-15).

Sketch of the Succession of STRATA and their relative Altitudes. Nº 34.

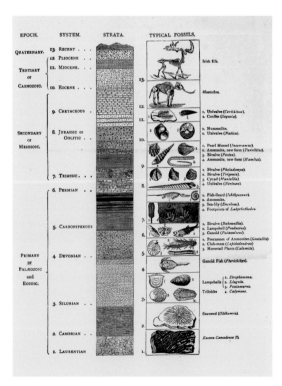

3-14. "Succession of Strata and Their Relative Altitudes," detail from the geological map of the British Isles, in William Smith, *Delineation of the Strata of England and Wales* (1815).

At middle right on his large map, Smith provided this color-coded key to elevation.

3-15. Stratified rocks and typical fossils, in Edward Clodd, *The Story of Creation: A Plain Account of Evolution* (London: Longmans, Green, 1888), fig. 4, facing 32. Wellcome Library, London.

This late nineteenth-century popularization illustrates William Smith's association of strata and fossils. The periods—such as Devonian and Jurassic—were named for the places where fossils from that strata were first excavated, in this case, respectively, the region of Devonshire in England and the Jura Mountains between France and Switzerland.

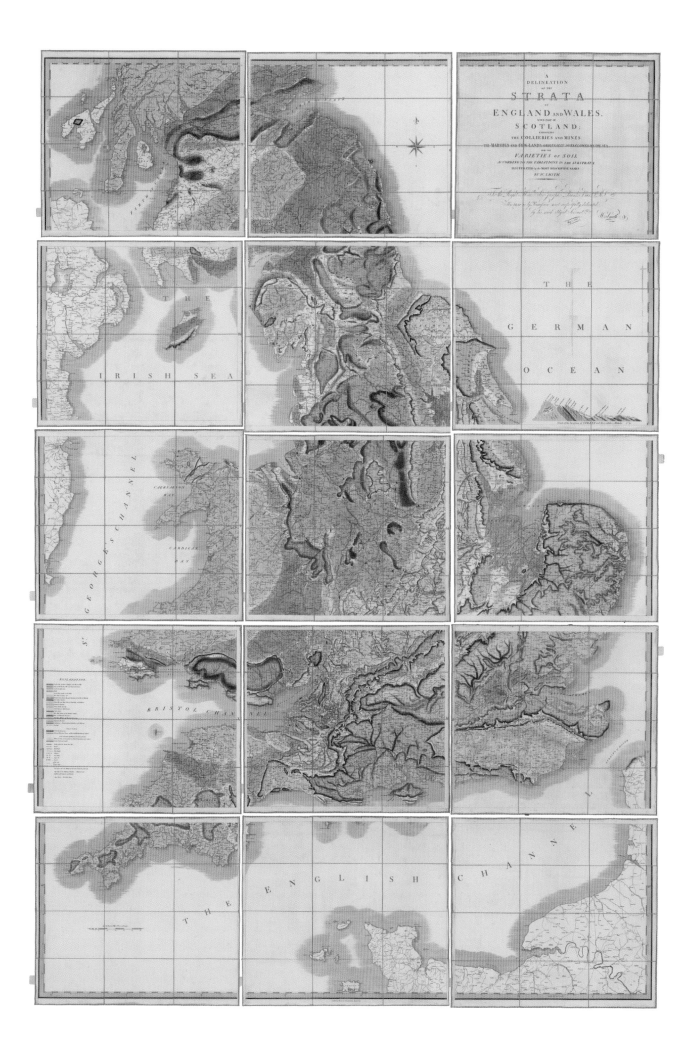

A
DELINEATION
OF THE
STRATA
OF
ENGLAND AND WALES,
WITH PART OF
SCOTLAND;
EXHIBITING
THE COLLIERIES AND MINES
THE MARSHES AND FEN LANDS ORIGINALLY OVERFLOWED BY THE SEA,
AND THE
VARIETIES OF SOIL
ACCORDING TO THE VARIATIONS IN THE SUBSTRATA
ILLUSTRATED by the MOST DESCRIPTIVE NAMES
BY W. SMITH.

THE GERMAN OCEAN

THE IRISH SEA

ST GEORGES CHANNEL

CAERNARVON BAY

CARDIGAN BAY

BRISTOL CHANNEL

EXPLANATION

THE ENGLISH CHANNEL

The British geologist Charles Lyell synthesized Hutton's work on the formation of Earth's crust with Smith's relation of the layers of strata to the fossil record in *Principles of Geology* (1830–33), a founding text for both geology and evolutionary biology. After publishing this landmark study in three hefty volumes, Lyell produced a smaller guidebook, *Elements of Geology* (1838), for geologists to use in their fieldwork (plates 3-16, 3-17, 3-18).

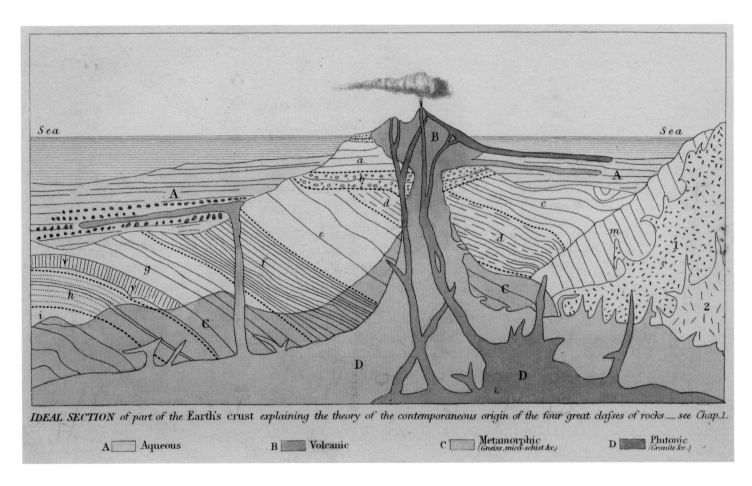

IDEAL SECTION of part of the Earth's crust explaining the theory of the contemporaneous origin of the four great classes of rocks.— see Chap. 1.

A ☐ Aqueous B ▪ Volcanic C ☐ Metamorphic *(Gneiss, mica-schist &c.)* D ▪ Plutonic *(Granite &c.)*

ABOVE

3-16. Cross section of Earth's crust, in Charles Lyell, *Elements of Geology* (London: John Murray, 1838), frontispiece. Wellcome Library, London.

In this diagram Lyell shows granite (uncolored) along with other rock types: Aqueous rocks (*A*) "have been accumulating in successive strata at the bottom of the sea," while "the volcanic cone (*B*) has been piled up during a long series of eruptions" from plutonic rocks (*D*), "which underlie the rest" (19–21). High heat from the volcanic plutonic intrusion (*D*) caused adjacent rock to transform to metamorphic rock (*C*). Rather than assume that the granite is earlier, and the aqueous and igneous rock later, Lyell stressed that all types of rock are continually being created.

OPPOSITE, TOP, AND FOLLOWING PAGES

3-17. Jonathon Wells (American, born 1960), *Pennsylvania—Shale Gas*, 2017 and detail. Digital composite, archival inkjet print, 28 × 75 in. (71.1 × 190.5 cm). © Jonathon Wells. Courtesy of the artist.

In this artistic and geologic image, Wells shows a 3 × 10 mile (4.8 × 16 kilometer) section of Earth's crust located in the Appalachian Basin in north-central Pennsylvania. The brownish-gray metamorphic rock (gneiss) layer at the bottom is more than 1 billion years

old. Between 520 and 360 million years ago, the Appalachian Basin filled with sediments transported from the erosion of mountains farther east. During the formation of the supercontinent Pangaea, pressure from the final mountain-building episode (the Alleghenian orogeny) caused an undulation in the layers above the light-colored salt layer in the middle. Wells, who is a geologist, created this image to help the public understand the extraction of natural gas from shale, commonly referred to as "fracking." A close inspection of the surface of the land in the photograph reveals five shale gas wells, which are drilled down to the Marcellus Shale formation.

OPPOSITE, BOTTOM

3-18. Devlin Cyr Wallace (American, born 1996), *Haynes Cave I*, 2017. Digital composite, archival inkjet print. Courtesy of the artist.

Haynes Cave was formed about 1 million years ago in the rugged Appalachian plateau, an area of karst—limestone marked with fissures, sinkholes, and caverns—in Monroe County, West Virginia. Wallace's photograph shows formations in the limestone caused by the movement of water. A native of Monroe County, Wallace is a descendant of the Larew family, which settled there in the early 1700s.

3-19. "Glacier at Zermatt," in Louis Agassiz, *Étude sur les glaciers* [Study of the glaciers] (Neuchatel, Switzerland: H. Nicolet, 1840), plate 4. Lithograph by J. Bettannier.

Agassiz proved that glaciers move, and he determined their speed by, for example, recording the position of a boulder frozen into the glacier in relation to a fixed point in the rock walls surrounding the glacier, and then returning in a future year and recording the distance the boulder had travelled (147).

3-20. Asher B. Durand (American, 1796–1886), *Rocky Cliff*, ca. 1860. Oil on canvas, 16½ × 24 in. (41.9 × 61 cm). Reynolda House, Museum of American Art, Winston-Salem, North Carolina.

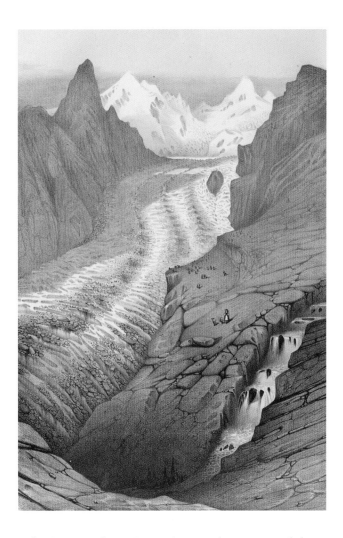

The imaginative artist . . . reads the historic record which time has written on all things for our instruction, through all the stages of its silent transition, since the period when this verdant earth was a lifeless, molten chaos, void and without form.

Asher B. Durand,
"Letter," *Crayon*, 1855

In the 1830s the Swiss zoologist Louis Agassiz demonstrated that, just as rivers cut through rock and carve valleys, as Hutton and Lyell had described, glaciers are rivers of ice that slowly sculpt the terrain (plate 3-19). Agassiz further proposed that Earth had gone through periods of extreme cold, which he named "ice ages," during which northern parts of Europe and the United States had been under sheets of ice that chiselled the Alps and gouged out the Great Lakes and the Hudson River as they receded.

The public's interest in geology was aroused by debates in the popular press about Earth's age; amateurs took nature walks and collected rock specimens, which they displayed in parlor curio cabinets.[4] The British art critic John Ruskin urged artists to forgo painting sublime vistas in broad brushstrokes and to record specific natural facts in accurate detail: "A rock must be either one rock or another; it cannot be a general rock."[5] Early landscape paintings by the second-generation Hudson River school painter Asher B. Durand were in the grand style of Thomas Cole's panoramic vistas, but Durand's mature work presents an intense close-up view. There is no "general rock" in *Rocky Cliff* (plate 3-20); Durand has documented layers of sedimentary rock, spotted with lichen. Mosses and grasses have taken root in cracks, and the growing tendrils are splitting open the rock on the right. Above, layers of shale are precariously perched, having been loosened by roots and erosion.

Evolution by Natural Selection

When Lyell proposed that Earth's rocky crust had formed and that organisms had changed over millennia, he was unable to answer the pivotal question of *how* the changes in plants and animals had occurred. If God didn't create all the animals on the fifth day, where did they come from? If species are not immutable—each reproducing "after its kind" (Genesis 1:11)—then how do they change? In 1831, twenty-two-year-old naturalist Charles Darwin set sail on a five-year, round-the-world voyage on HMS *Beagle*. While making careful records of flora and fauna, he began to answer the question and identify the mechanism for change that Lyell had sought: natural selection.

The *Beagle* docked in the Pacific Ocean about 650 miles (1,050 kilometers) west of Ecuador among a group of islands that was formed by lava from an underwater volcano; when the peaks of lava emerged above water and cooled, they formed new islands completely barren of life. Over time a few plants grew from seeds that were blown there from the mainland or a passing ship. Darwin collected specimens of turtles that crawled out of the sea and birds, which must also have arrived by wind or in the sails of a ship (650 miles being too far for most species to fly).

3-21. Four species of finches native to the Galápagos Islands, in Charles Darwin, *Journal of Researches into the Natural History and Geology of the Countries Visited during the Voyage of HMS* Beagle *round the World* (1840; repr. New York: D. Appleton, 1882), 379. Engraving.

These four birds are: (*1*) *Geospiza magnirostris*, (*2*) *Geospiza fortis*, (*3*) *Geospiza parvula*, and (*4*) *Certhidea olivasea*. Darwin wrote of them:

> *The most curious fact is the perfect gradation in the size of the beaks in the different species of* Geospiza, *from one as large as that of a hawfinch to that of a chaffinch, and (if Mr. Gould is right in including his sub-group,* Certhidea, *in the main group), even to that of a warbler. The largest beak in the species* Geospiza *is shown in fig. 1, and the smallest in fig. 3; but instead of there being only one intermediate species, with a beak of the size shown in fig. 2, there are no less than six species with insensibly graduated beaks (379–80).*

3-22. Charles Darwin, Tree of life, in Notebook B, July 1837, 36. Cambridge University Library, England.

On this page Darwin wrote:

> *I think*
> *Case must be that one generation then*
> *should be as many living as now.*
> *To do this & to have many species*
> *in the same genus (as is) requires*
> *extinction.*
> *Thus between A & B immense gap of*
> *relation. C & B the finest gradation,*
> *B & D rather greater distinction.*
> *Thus genera would be formed.—*
> *bearing relation*
> *to ancient types.* [This last line is written on the next page.]

When Darwin returned to London, he gave the birds to ornithologist John Gould to identify the species. Darwin thought the birds were a variety of species (finches, warblers), but Gould determined that they were all finches and were similar to a species found on the Ecuadorian mainland. But the finches from the Galápagos Islands had fourteen distinctly different beaks—either large, medium, or small; wide or narrow; long or short; straight or curved. Gould assumed that the islands had different plants, and he suspected that each island was home to a finch with a particular beak, but Darwin hadn't labelled his birds by island. Fortunately, the ship's captain, Robert FitzRoy, had been more fastidious and was able to provide Gould with the information he needed to establish that each island had birds with beaks that matched food of a certain size and shape. Birds with large beaks ate large seeds, while small wide beaks were good for eating cactus, narrow long beaks could retrieve burrowing insects, and so on (plate 3-21; see also plate 3-1, chapter frontispiece). Darwin postulated that all fourteen species of finches had descended from the same mainland species and that their beaks had differentiated in response to the food available on the different islands.

Darwin formulated his theory with the help of the British economist Thomas Malthus's *Essay on the Principle of Population* (1798). Progress, Malthus suggested, was always accompanied by an increase in human population, which would then decline as people outran the food supply, leading to famine and war. Darwin applied Malthus's

principle to his finches to explain their differentiated beaks as resulting from competition for food. In general, slight variations in each generation give some offspring the edge to survive longer and reproduce more. Natural selection forms new species over time as favorable traits accumulate, and separation is reinforced by an inability of species to interbreed. Darwin replaced the rigid chain of being with an organic tree of life (plate 3-22).[6]

The Scientific Method

Darwin's discovery of evolution by natural selection is a paradigm of the scientific method:

- Test ideas by experiment and observation.

- Build on ideas that pass the test, and reject those that fail.

- Follow the ideas wherever they lead.

- Question everything.

Darwin knew how counter-intuitive it is that intricate patterns—exquisitely shaped orchids, dazzling bird feathers—could come into being by chance, but he followed the evidence, and his data pointed to an unavoidable conclusion: species come into being by the blind process of chance mutations (see sidebar on pages 78–79).

Members of Darwin's generation read cross-cultural studies of world religions, which primed them to view the Bible as the product of history—of a particular time and place in the ancient world—rather than as the irrefutable word of the God of Abraham. Nevertheless, Darwin's declaration that species change over time left him feeling guilty, because his Christian parents had taught him the biblical creation story when he was a child—and furthermore he didn't want to upset his wife, who feared he would go to hell for committing the sin of heresy. As he put it: "It is like confessing to a murder."[7]

After formulating the theory of evolution by natural selection, Darwin searched in vain to find its physical mechanism. Meanwhile, in the 1860s, an Austrian monk, Gregor Mendel, discovered certain patterns of inheritance by crossbreeding plants in his monastery garden (plate 3-27). Thus developing his laws of inheritance, he published them in an obscure provincial journal in 1865 and sent copies to prominent biologists and scientific societies, including the Linnean Society of London, though there is no evidence that a copy came to Darwin's attention. Receiving no positive response, Mendel gave up crossbreeding and died in oblivion in 1884. In 1900 Mendel's laws of genetics were rediscovered and made widely available to biologists who were beginning the field of genetics in the early twentieth century.

Darwin delayed publication of his theory for two decades as he wrestled with the idea that natural selection took away God's role as designer of all the species, an unthinkable

The affinities of all the beings of the same class have sometimes been represented by a great tree. I believe the simile largely speaks the truth. . . . As buds give rise by growth to fresh buds, and there, if vigorous, branch out and overtop on all sides many a feebler branch, so by generation I believe it has been with the great Tree of Life, which fills with its dead and broken branches the crust of the earth, and covers the surface with its ever branching and beautiful ramifications.

Charles Darwin,
On the Origin of Species by Means of Natural Selection, 1859

In his book on the role of sex in natural selection, Charles Darwin described a distinctive pattern found in wing feathers of the male argus pheasant, which is native to the Malay Peninsula in Southeast Asia: "two, a and b, perfect ocelli. A, B, C, etc., dark stripes running obliquely down, each to an ocellus" (*The Descent of Man, and Selection in Relation to Sex* [London: John Murray, 1871], 2:143). The feathers are marked with colorful ocelli (ball-and-socket eyespots—i.e., spots surrounded by a ring; plates 3-23 and 3-26). The male uses these feathers to attract a female (plate 3-24): "These beautiful ornaments are hidden until the male shows himself off before the female. He then erects his tail, and expands his wing-feathers into a great, almost upright, circular fan or shield, which is carried in front of the body. The neck and head are held on one side, so that they are concealed by the fan." But from this position the male can't see the female, so he peeks at her by occasionally darting "his head between two long wing-feathers" (*The Descent of Man*, rev. ed. [London: D. Appleton, 1875], 398).

How did this ball-and-socket pattern come into being? Darwin wrote: "No one, I presume, will attribute the shading, which has excited the admiration of so many experienced artists, to chance—to the fortuitous concourse of atoms of coloring matter. That these ornaments should have been formed through the selection of many successive variations, not one of which was originally intended to produce the ball-and-socket effect, seems as incredible as that one of Raphael's Madonnas should have been formed by the selection of chance daubs of paint made by a long succession of young artists, not one of whom intended at first to draw the human figure" (1871, 2:141) (plate 3-25). But Darwin followed the evidence and discovered that the incredible is true: the pheasant's feathers result from chance association of atoms that determine color, which made the male more attractive to females and thus more likely to pass on the mutation to offspring. Therefore, after many generations, the ball-and-socket pattern came into being.

BELOW LEFT

3-23. Part of the secondary wing feather of argus pheasant, in Charles Darwin, *The Descent of Man, and Selection in Relation to Sex* (London: John Murray, 1871), vol. 2, fig. 56, on 143.

BELOW RIGHT

3-24. Side view of male argus pheasant while displaying before the female, in Charles Darwin, *The Descent of Man, and Selection in Relation to Sex* (1871), rev. ed. (London: D. Appleton, 1875), fig. 52, on 399. Engraving by T. W. Wood.

OPPOSITE, TOP

3-25. Raphael (Italian, 1483–1520), *Madonna della Seggiola* [Madonna of the chair], 1513–14. Oil on panel, diameter 28 in. (71 cm). Palazzo Pitti, Florence.

OPPOSITE, BOTTOM

3-26. Argus pheasant, in John Gould, *Birds of Asia* (London: published by the author, 1850–83), vol. 7, plate 52. Lithograph by William Matthew Hart (British, 1830–1908) after a drawing by John Gould.

In the upper left, a male prepares to display before a female.

3-27. Mendel's laws of inheritance.

By breeding garden peas (*Pisum sativum*), Gregor Mendel studied the inheritance patterns of seven traits, including height, seed shape, and flower color. He began by establishing pure-bred pea lines for each trait, such as red or white flowers, by breeding the plants until the offspring were identical to the parents for many generations. Then he cross-pollinated purebred plants with red flowers and those with white flowers and observed that in the second generation, the flowers of all plants were red, which he called *dominant* and white *recessive*. Mendel then bred the second-generation plants with each other, and the white flowers reappeared in the third generation, always in a 3:1 ratio. Mendel also observed that the seven traits are inherited independently. Gregor Mendel, "Versuche über Plflanzenhybriden" [Experiments in plant hybridization], *Verhandlungen des naturforschenden Vereines in Brünn* 4 (1865), 3–47.

The flowers of garden peas in this diagram were drawn and engraved by Frederick Polydore Nodder, for Thomas Maryn, *Thirty-Eight Plates to Illustrate Linnaeus's System of Vegetables* (London: J. White, 1799), plate 3. New York Botanical Garden.

Parental Generation

Second Generation

Third Generation

heresy. At almost fifty, he continued gathering an ever-growing mountain of data to make his case ironclad. But by 1858 a thirty-five-year-old British naturalist, Alfred Russel Wallace, had come up with natural selection independently. Before publishing so radical a theory, Wallace felt it was prudent to send his paper to a senior biologist for commentary to be sure he was not making a big mistake. Wallace sent his paper to the leading British biologist of the day, Charles Darwin. Startled by Wallace's discovery, Darwin was forced to join the younger biologist in the immediate publication of a joint paper announcing natural selection and to prepare his own manuscript for publication. The following year Darwin published his classic book, *On the Origin of Species by Means of Natural Selection; or, The Preservation of Favoured Races in the Struggle for Life.*

Apes and *Homo sapiens*

Darwin did not discuss humankind in *Origin of Species*, but the implications of his theory for *Homo sapiens* were obvious—humans are animals and part of the natural world. After his book was published, the satirical journal *Punch* gleefully depicted an ape in formal attire entering elite British society.[8] A few years later, in 1863, a young follower of Darwin, Thomas Huxley, published a book specifically stating that human beings descended from an ape, *Evidence as to Man's Place in Nature* (plate 3-28). Darwin himself published *The Descent of Man* in 1871.

LEFT

3-28. Skeletons (from left to right) of a gibbon, orangutan, chimpanzee, gorilla, and human, in Thomas H. Huxley, *Evidence as to Man's Place in Nature* (London: Williams and Northgate, 1863), frontispiece. Darwin Estate and Cambridge University Library, England.

BELOW

3-29. Henry Fuseli (Swiss, 1741–1825), *The Nightmare*, 1780–81, in *The Poetical Works of Erasmus Darwin* (London: J. Johnson, 1806), opposite 126. Engraved by Thomas Holloway after Fuseli. Wellcome Library, London.

Fuseli's depraved beast inspired Erasmus Darwin (Charles's grandfather) to write this poem:

> So in his nightmare through the
> evening fog
> Flits the squab fiend o'er fen, and lake
> and bog;
> Seeks some love-wildered Maid with
> sleep oppress'd,
> Alights, and grinning sits upon her
> breast.
> Such as of late amid the murky sky
> Was mark'd by Fuseli's poetic eye;
> Whose daring tints, with Shake-
> speare's happiest grace,
> Gave to the airy phantom form and
> place (Canto 3, 126).

The association of humankind's ancestry with the apes was particularly unacceptable because of old associations of apes with devils. During the Romantic era the animals' sullied reputation was reinforced when the Swiss clergyman Johann Caspar Lavater gave a low status to apes as part of his rules for evaluating an animal's character and personality on the basis of facial features—physiognomy—in his immensely popular *Essays on Physiognomy* (1775–78). Intended as a moral guide, Lavater's book assured readers that although some men (he chose manual workers as an example) have ape-like features, *Homo sapiens* are superior to apes. In a Zurich seminary run by Zwinglians (Protestants similar to Lutherans), Lavater met fellow cleric Johann Heinrich Füssli (later known as the artist Henry Fuseli), and the two became lifelong friends. Fuseli, who made the illustrations for the French edition (1781–86) of Lavater's *Essays on Physiognomy*, adopted the author's conviction that "differences in faces express differences in spirit [*Geist*] and heart."[9] When Fuseli portrayed an evil spirit who descended on a sleeping woman and gave her a nightmare, he employed a simian facial type (plate 3-29).

In the visual arts, the association of mankind with apes was also negative because *aping* has a pejorative association with imitation, as in the classical Latin aphorism *Ars simia naturae* (Art imitates [apes] nature). According to Plato, painting is mimesis: an imitation of an object perceived in nature, such as a flower, which itself is an imperfect copy of the Flower (its perfect Form). Thus two steps removed from the eternal perfect Forms, paintings "rank far below truth" (*Republic*, 596e–602c). As an ape mimics human action, so the painter imitates nature; by the Renaissance the simian beast had come to symbolize the arts, such as the ape holding a mirror (a source of illusions) crouching behind the idealized male nude in Michelangelo's *Dying Slave* (ca. 1513, Musée du Louvre, Paris).

Wilberforce-Huxley Debate

Darwin's reserved temperament didn't equip him for public battle, but he had an effective warrior in the young biologist Thomas Huxley. Tough and tireless, Huxley was born into a middle-class family that had fallen on hard times and lived in poverty in class-conscious England. From a young age Huxley was driven by a love of knowledge and, after having to leave school at age ten, was self-taught. At twenty he published his first scientific paper, and five years later he was elected a Fellow of the elite body of British science, the Royal Society. He had a combative personality and relished telling pompous, upper-class gentlemen that they descended from apes.

In 1860 the British Association for the Advancement of Science hosted a public debate, billed as "religion versus science," between Samuel Wilberforce, an articulate mathematician and bishop of the Church of England, and Huxley (plates 3-30 and 3-31). As those present at the debate recorded, Bishop Wilberforce, authoritatively attired in purple vestments, turned to Huxley and asked whether it was through his grandfather or his grandmother that he claimed descent from an ape. The crowd erupted with laughter, but Huxley won its heart for science with his reply: "If . . . the question is put to me, would I rather have a miserable ape for a grandfather, or a man highly endowed by nature and possessing great means and influence, and yet who employs those faculties and that influence for the mere purpose of introducing ridicule into a grave scientific discussion—I unhesitatingly affirm my preference for the ape."[10]

LEFT

3-30. *Samuel Wilberforce, Vanity Fair*, no. 38, July 24, 1869, 50. Chromolithograph by Carlo Pellegrini. © National Portrait Gallery, London.

RIGHT

3-31. *Thomas Huxley, Vanity Fair*, no. 117 (Jan. 28, 1871), 306. Chromolithograph by Carlo Pellegrini. © National Portrait Gallery, London.

Although in the Wilberforce-Huxley "religion versus science" debate, only the latter affirmed his "preference for the ape," the cartoonist showed whose side he was on by labelling both men "Ape."

CHAPTER 3

Huxley also provided the educated public with an alternative to the label *atheist* by coining the term *agnostic* (the opposite of *Gnostic*, a member of an ancient sect that claimed knowledge of immaterial things). An agnostic is a person who believes that immaterial things (the existence and nature of God) are unknowable by the scientific method.[11] Being an atheist was a sign of wickedness but being an agnostic, with its humble admission of the limitations of science, became a mark of learned sophistication.[12]

Darwin adjusted his theology to accommodate science rather than completely reject his religious upbringing. He concluded *Origin of Species* with a statement that life had been "breathed" into the first living thing, after which natural selection took over: "Thus, from the war of nature, from famine and death, the most exalted object which we are capable of conceiving, namely, the production of the higher animals, directly follows. There is grandeur in this view of life, with its several powers, having been originally breathed into a few forms or into one; and that, whilst this planet has gone cycling on according to the fixed law of gravity, from so simple a beginning endless forms most beautiful and most wonderful have been, and are being evolved."[13]

Throughout history, each new generation has asked: What is the best theology/philosophy of nature? In antiquity, the Chinese philosopher Zhuangzi gave his answer by telling a story, "The Mountain Tree." The contemporary British designer Thomas Heatherwick embodied his philosophy of nature in *Seed Cathedral* (plates 3-32–3-35). Nature is a sacred place—a cathedral—filled with sunlight and seeds. Visitors to the 2010 World Expo in Shanghai entered Heatherwick's cathedral not to worship seeds but to study them, and—in the spirit of secularism and science—to gain knowledge.

Entropy

In 1789 the French chemist Antoine Lavoisier had established that the total amount of mass in a closed system is constant; mass can be neither created nor destroyed. In 1847 the German scientist Hermann von Helmholtz established the complementary conservation law for energy, but a few years later the German physicist Rudolf Clausius pointed out that all energy is not equally useful and that in any conversion of energy, some will become irretrievable. Thus, he declared that the amount of useful energy in a closed system (such as the universe) is slowly decreasing, while there is an increase in its *entropy* (a term Clausius invented to refer to the unavailability of the lost heat energy). Therefore, Clausius declared, in the distant future everything in the universe will reach the same frigid temperature: "The entropy of the universe tends towards a maximum. The more the universe approaches this limiting condition in which the entropy is a maximum, the more do the occasions of further changes diminish; and supposing this condition to be at last completely attained, no further change could evermore take place, and the universe would be in a state of unchanging death."[14]

Zhuangzi was wandering in the fenced park at Diaoling when he glimpsed a weird magpie-like-thing flying in from the south. It had a wingspan of over seven-feet and passed so close to his forehead, he could feel it. Then it gathered its wings and settled in a chestnut grove. Zhuangzi thought "What bird is that? Massive wings of such power and eyes so large but it couldn't see me." He hiked up his robe and hurriedly tiptoed closer holding his crossbow at the ready. Then he spotted a cicada settling in the shaded shelter without a worry for itself, but a praying mantis opened its pincers about to grab it, also focused on its gain and ignoring its own bodily danger. The strange magpie burst out and harvested them both—similarly unaware of the natural dangers he faced.

Zhuangzi was suddenly seized with this thought, "We natural kinds are all interconnected! We two different species are mutually seeing things in our own ways." He dismantled his crossbow and fled, now himself pursued by the game warden shouting out his crimes.

Zhuangzi,
"The Mountain Tree,"
fourth century BC

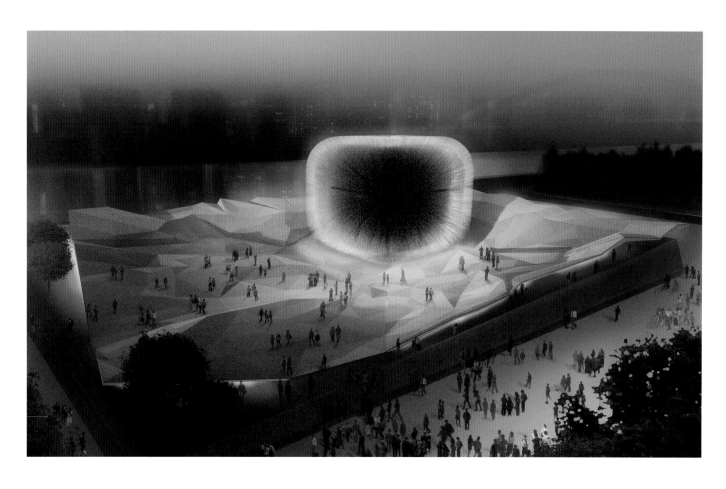

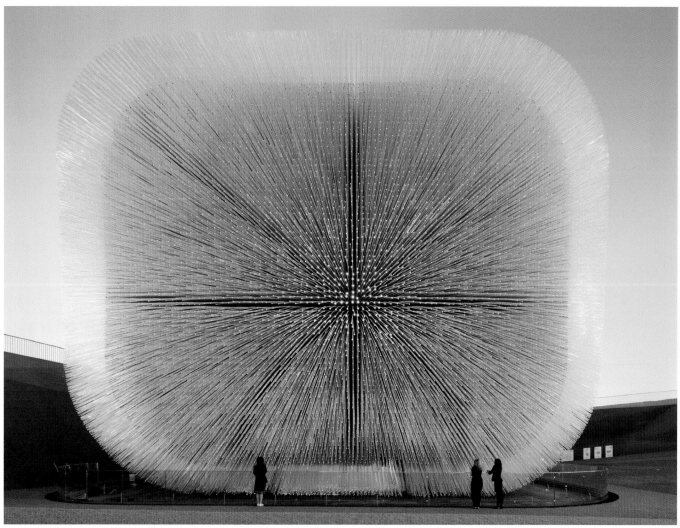

OPPOSITE, TOP

3-32. Thomas Heatherwick (English, born 1970), *Seed Cathedral*, UK pavilion for the World Expo 2010, Shanghai. Digital mock-up, Heatherwick Studio, London.

OPPOSITE, BOTTOM

3-33. Thomas Heatherwick, *Seed Cathedral*, exterior.

RIGHT

3-34. Thomas Heatherwick, *Seed Cathedral*, interior.

BELOW

3-35. Thomas Heatherwick, *Seed Cathedral*, detail of seeds.

Daylight enters through 60,000 acrylic rods that form the building's walls and ceiling. At the end of each rod, Heatherwick cut a hole, into which he put several seeds from plants that are endangered species.

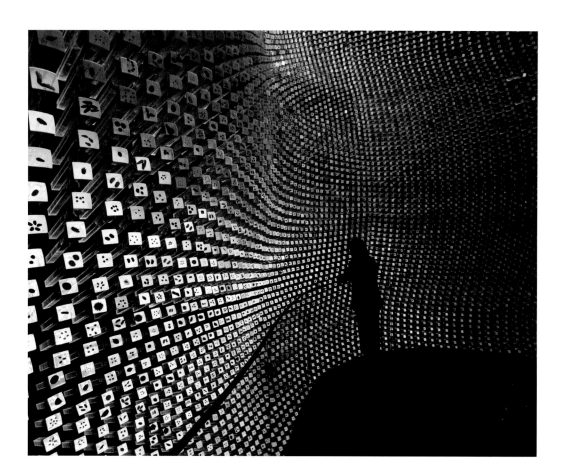

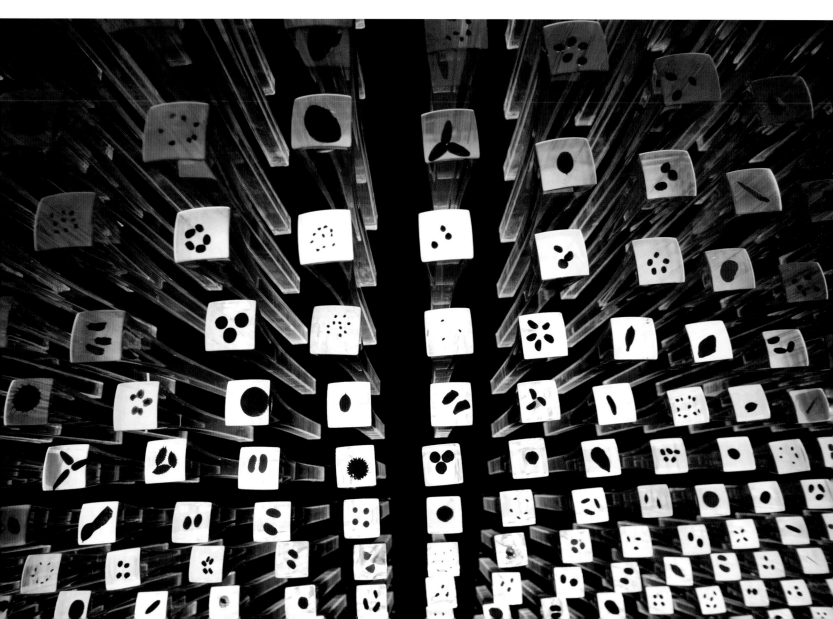

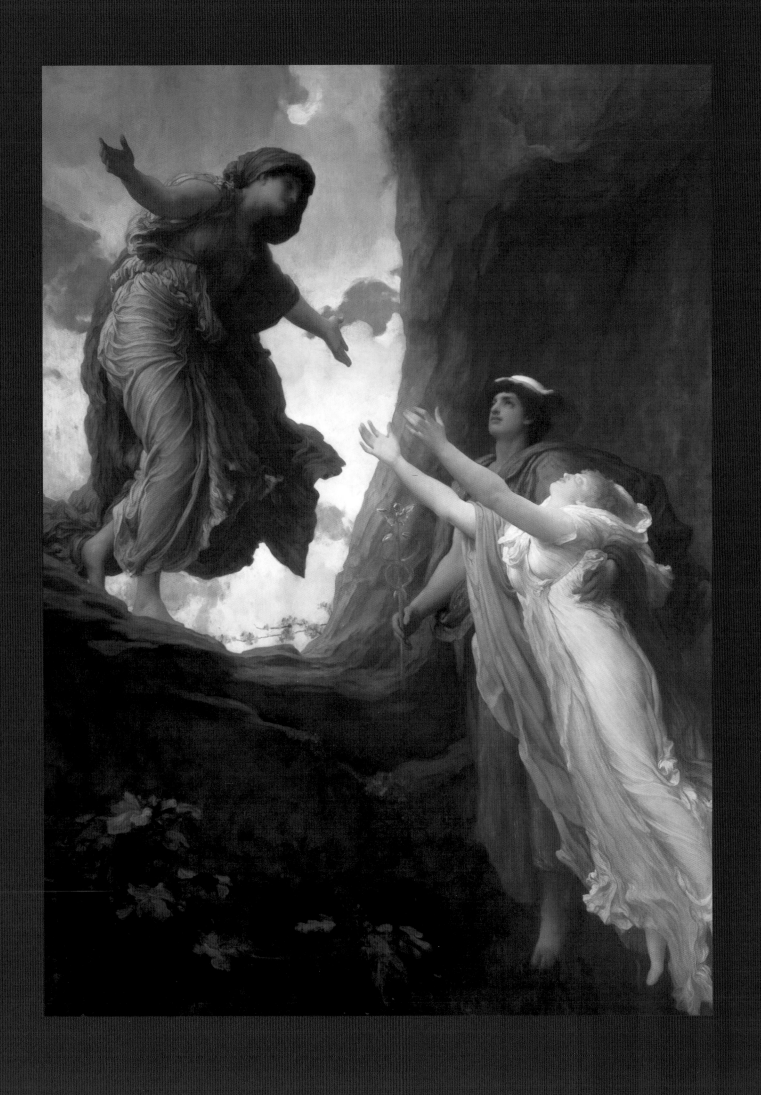

Darwin, who usually maintained his good cheer, despaired at the unavoidable conclusion: "[Just consider] the view now held by most physicists, namely that the sun with all the planets will in time grow too cold for life, unless indeed some great body dashes into the sun and thus gives it fresh life—there is a clash between 'life' and 'believing.' Believing as I do that man in the distant future will be a far more perfect creature than he now is, it is an intolerable thought that he and all other sentient beings are doomed to complete annihilation after such long-continued slow progress."[15]

The science journalist Camille Flammarion described entropy for the public in his 1881 book *Astronomie populaire* (Popular astronomy); in a dramatic flourish he suggested that there would come a day when "the last family on Earth has been touched by the finger of death, and soon their bones will be encased in a shroud of eternal ice."[16] In 1894 he went on to publish *La Fin du monde* (The end of the world, 1894), a fictionalized consideration of alternative ways that life on Earth might end; after being spared from threats by comets and asteroids, the planet succumbs to entropy. The unfortunate hero of H. G. Wells's *Time Machine* (1895; see plate 9-1 in chapter 9) travelled to the future and witnessed Earth's fate: "The darkness grew apace; a cold wind began to blow in freshening gusts from the east, and the showering white flakes in the air increased in number. From the edges of the sea came a ripple and a whisper. Beyond these lifeless sounds the world was silent."[17]

Late nineteenth-century personifications of nature were not embodiments of life, such as Flora, goddess of flowers, but more ambiguous deities, like Persephone (Proserpine), goddess of fertility and the bride of Hades.[18] The Pre-Raphaelite artist Dante Gabriel Rossetti painted many versions of her (such as *Proserpine*, 1874; Tate, London), and Frederic Leighton, the longtime president of the British Royal Academy, painted Persephone on her annual return from the underworld (plate 3-36). Escorted by Mercury, she rises toward the light, her arrival causing plants to sprout flowers. Greeted by her joyous mother, Demeter, goddess of agriculture, Persephone brings spring and summer, but after the fall harvest she is fated to return to a dark and lifeless land.

Today scientists predict that life on Earth will end not in ice but in fire. In 5 billion years the sun will use up its nuclear fuel and expand beyond Mars, engulfing the inner planets (see chapter 14).

Germ Theory of Infectious Disease

Just as the British controversy over evolution was heating up, in 1863 the French chemist Louis Pasteur announced that infectious diseases are caused by invisible organisms—the germ theory of disease. A few years earlier when he was researching the chemistry of fermentation, Pasteur discovered that if a microbe contaminated the juice of crushed grapes, then the juice turned sour rather than into wine. This led him to speculate that microorganisms infect plants and animals and cause disease. In the

3-36. Frederic Leighton (English, 1830–1896), *Return of Persephone*, ca. 1891. Oil on canvas, 80 × 60 in. (203 × 152 cm). Leeds Museums and Galleries, England.

ensuing years Pasteur, together with German colleagues led by the physician Robert Koch, discovered the disease-causing microbes that had cursed mankind for millennia: leprosy (1873), anthrax (1876), typhoid fever (1880), bacterial pneumonia (1881), tuberculosis (1882), diphtheria (1883), cholera (1884), and tetanus (1889). In the 1870s and '80s journalists reported the isolation of each new microbe by Pasteur and Koch as if they were war correspondents at a battlefront, and they described the threat each posed to public health (plate 3-37).

Darwin's theory met with resistance because it threatened core beliefs, but the germ theory of disease brought the explanatory power of science into every home. After its introduction, from Saint Petersburg to San Francisco, children drank cow's milk that had been pasteurized (heated to destroy bacteria), and parents disinfected

their child's every scratch with iodine. Doctors boiled the knife before surgery and washed their hands before delivering a baby; the number of deaths from infection during surgery and from puerperal fever (infection of the uterus after childbirth) dropped like a stone. Images in the popular press of microbes in a drop of drinking water reminded people to boil water (plate 3-38), and artists depicted subjects related to hygiene, such as Mary Cassatt's portrayal of a mother bathing her child (plate 3-39).

Darwin was mercilessly mocked in his homeland, where a British cartoonist portrayed him as ape-like (plate 3-40). In contrast, Pasteur was revered in Paris as a savior of lives who prevented needless suffering. After the anthrax bacteria, which threatens sheep, was isolated in 1876, a French cartoonist deified Pasteur by showing him carrying a lamb and making a pun on his name (*pasteur* is French for "shepherd"); the cartoon is titled "Le bon Pasteur" (The good shepherd), a reference to the biblical Savior (plate 3-41).

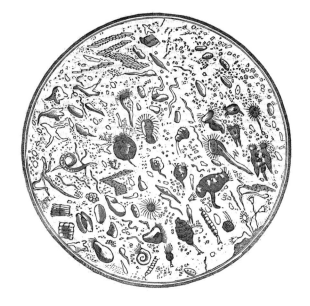

TOP

3-37. Cholera microbe, in *Le Grelot*, July 6, 1884, 1. Yale University Library, New Haven, Connecticut.

In the French port city of Toulon, sailors unload a cholera microbe, shown as a giant monster. A broker presents the city with its cholera bill; Toulon has a credit of 3,000 sick or dead but still owes the lives of thousands of its citizens. This cartoon was drawn in 1884, the year Robert Koch discovered the microbe for cholera, and it is a grim reminder that a shipment of goods can carry an invisible, deadly stowaway.

BOTTOM

3-38. Microorganisms in a drop of drinking water, *Semanario Pintoresco*, no. 113 (May 27, 1838), 578–79; the image is on 578.

The article that featured this illustration was a summary of C. G. Ehrenberg's publication on microscopy (see plate 11-9 in chapter 11), written for a popular audience in Madrid.

RIGHT

3-39. Mary Cassatt (American, 1844–1926), *The Bath*, 1890–91. Color drypoint, aquatint, and soft-ground etching, 12⅝ × 9¾ in. (32.1 × 24.7 cm). The Art Institute of Chicago, Mr. and Mrs. Martin A. Ryerson Collection.

An American who studied at the Pennsylvania Academy of Fine Arts in Philadelphia, Mary Cassatt continued her education in Europe and lived most of her adult life in France. In this print, the flat shapes and floral pattern on the mother's dress show Cassatt's indebtedness to Japanese woodcuts, which flooded Paris after Japan opened its doors to the West in the 1850s (see chapter 4).

BOTTOM LEFT

3-40. "Man Is but a Worm," cartoon by Lindley Sambourne, *Punch*, Dec. 6, 1881, 14.

In the lower left, life emerges as a worm from disordered matter—the tumbling rocks that spell CHAOS—then quickly passes through a reptile stage (lower right), evolving into a mammal in the ape family (the chimpanzee on top). From that point the ape begins to get a bigger brain, causing some scratching of the head, then stands erect. It's a short step to a caveman and, at the pinnacle of evolution, a British gentleman with gloves and a top hat. Darwin, sporting a toga, is a cross between a Greek sage and the pre-hominid ape below him.

BOTTOM RIGHT

3-41. "Le bon Pasteur" [The good shepherd], cartoon by Alfred Le Petit, in *Le Charivari* 51 (Apr. 27, 1882), 85. General Research Division, The New York Public Library. Astor, Lenox, and Tilden Foundations.

The Achromatic Lens

When seventeenth-century British naturalist Robert Hooke looked through a micro-scope at slices of cork, he saw a regular pattern of holes (Fig. 1B in plate 3-42), which he named *cells* because the holes are lined up like rooms—cells—in a monastery. Early instruments for magnification, which were invented by Dutch lens grinders, are called transmission microscopes because light passes (is transmitted) through the specimen. Let us suppose that a scientist wishes to view a single-celled organism in a drop of pond water or the brain of an animal, both of which are colorless. The specimen is prepared by staining to bring out its form. In the case of a large, opaque object (such as the brain), the scientist cuts a slice that is thin enough to be transparent. The drop of water or slice of tissue is then sandwiched between glass plates and the scientist looks through it to a light source, which is aimed from below using a mirror (plate 3-43). The microscope in plate 3-43 has a lens that creates chromatic distortion, a narrow, colored border at the edges of the magnified object (plates 3-44, 3-45, and 3-46). This is what Johann Wolfgang von Goethe saw when he looked through a prism at the black-and-white pattern (see sidebar on pages 12–13 in chapter 1). In 1826 the British scientist Joseph Jackson Lister invented the achromatic lens, which eliminates distortion (plates 3-47 and 3-49).

3-42. Magnified view of two slices of cork, in Robert Hooke, *Micrographia* (London: Royal Society, 1665), plate 11, facing 114. Rare Books Division, The New York Public Library. Astor, Lenox, and Tilden Foundations.

Cork is the protective layer of bark of the cork oak tree. As the tree grows, its outer layers of cells die, desiccate, and toughen to become cork (Fig. 1). Hooke was actually looking at empty plant cell walls. The branch below (Fig. 2) is unrelated.

3-43. Compound microscope, 1800–20, unsigned but undoubtedly made in England. Height 11 in. (28 cm). The Golub Collection, University of California, Berkeley.

A compound microscope has two lenses that work together to give greater magnification: the ocular (eyepiece) and the objective (closest to the object). This instrument is called a pocket microscope because of its small size and portability; it could be taken apart and carried in its mahogany case. The microscope is supported by a folding tripod stand and a rectangular pillar. The illuminating mirror is mounted to the lower part of the pillar by pushing its support pin into a hole. The pillar also supports the focus mechanism, on which the sample stage is mounted. Specimens were stained and sandwiched between thin pieces of glass, which were held together in slides with bone casings. On the right are three bone slides, each carrying five specimens. A living specimen, such as a tiny insect, could be viewed in a glass "live box" (not shown). The stage has a circular cut-out for holding a bone slide or a live box. Attached to the stage are a convex (bull's-eye) lens for concentrating light and a pair of forceps. A selection of four lenses sits at lower-left, next to brass forceps and a bone-handled pointer.

BELOW LEFT

3-44. Lens with chromatic distortion

When one looks through a lens with chromatic aberration, one sees the magnified image in many colors and sizes because the light-waves cross in different places (compare the achromatic lens in plate 3-47). In the lens with chromatic distortion, long wavelength light (red) comes into focus at a different position than short wavelength light (violet), so the entire image appears out of focus and outlined in a spectral border.

BELOW CENTER

3-45. Diatoms seen through the microscope in plate 3-43, which has a lens with chromatic distortion. The Golub Collection, University of California, Berkeley.

Diatoms are single-celled algae that have cell walls covered with the mineral silica in distinctive geometric patterns, which has made them a favorite subject for scientific imagery with a microscope.

BELOW RIGHT

3-46. Close-up view of the diatoms seen through the microscope in plate 3-43.

Using an achromatic microscope, the German physiologist Theodor Schwann and the botanist Matthias Schleiden could see a cell nucleus and other intracellular bodies (plate 3-48), and in 1838 they announced a fundamental fact of biology: all living tissue is composed of cells. During the first decade of the achromatic microscope's existence, the German biologist C. G. Ehrenberg, who had accompanied Alexander von Humboldt on his trek across Asia, made drawings that show the internal structure of microscopic, translucent sea creatures in minute detail (plate 11-9 in chapter 11). The subtle coloring and fine detail of these hand-colored engravings proclaim the fascinating world that now opened before scientists and artists. Pasteur discovered the germ theory of disease with an achromatic microscope, and images of microorganisms offered the nineteenth-century public transport to another scale and to a place—tinged with danger—that looks completely different from the everyday world. The achromatic lens was soon adopted by photographers (plate 3-49) to study the microscopic world.

Photography and Microscopy

Since antiquity, several people have independently discovered that they can produce an inverted image within a dark box—a *camera obscura* (Latin for "dark room")—by letting light enter through a hole (an aperture) in a wall; the smaller the aperture, the clearer the image. After the invention of the microscope, natural scientists experimented with projecting an enlarged image of specimens using a solar microscope, which was built into an exterior wall with a mirror hanging outside to reflect sunlight (plates 3-50 and 3-51).

In the early nineteenth century Thomas Wedgwood, son of the porcelain manufacturer Josiah Wedgwood, and fellow chemist Humphry Davy used a solar microscope

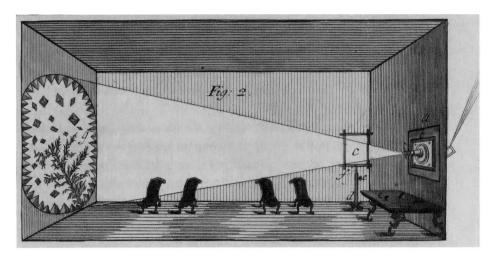

ABOVE LEFT

3-50. A solar microscope installed in the wall of a *camera obscura*, in Martin Ledermüller, *Amusement microscopique* [Microscopic amusement] (Nuremberg: Winterschmidt, 1768), vol. 3, plate 1, fig. 2, between 6–7.

By adjusting the mirror outside, the amateur microscope enthusiast Martin Ledermüller directed sunlight through a microscope, which projected an image of a tiny plant and crystals. Sometimes Ledermüller projected the image onto a piece of paper he had stretched across the square frame (*C*), which allowed him to trace the image. He suggests that readers invite their friends over for an afternoon of "microscopic amusement" and sit in the comfortable chairs as "spectators of fantasy [*spectateurs à vôtre fantasie*]" (9).

ABOVE RIGHT

3-51. Solar microscope in Amédée Guillemin, *The Forces of Nature*, trans. Mrs. Norman Lockyer, 3rd ed. (New York: Scribner, Welford, and Armstrong, 1877), fig. 232, on 304.

BELOW LEFT

3-52. Four diatoms, William Henry Fox Talbot (English, 1800–1877), 19th century. Microphotograph, 4½ × 4 in. (11.5 × 11.3 cm). National Science and Media Museum, London.

BELOW RIGHT

3-53. Botanical specimens, William Henry Fox Talbot (English, 1800–1877), 1839. Photogenic drawing negative, 8⅞ × 7¼ in. (22.4 × 18.4 cm). J. Paul Getty Museum, Los Angeles.

to project a tiny picture painted on a glass plate onto the wall of a camera obscura. They then recorded the projected picture with a small handheld camera obscura at the back of which they had placed paper treated with silver nitrate (a substance known to darken when exposed to light). In other words, they took a photograph of the painting they had projected (Wedgwood and Davy, "An Account of a Method of Copying Paintings upon Glass, and of Making Profiles, by the Agency of Light upon Silver Nitrate," 1802). However, Wedgwood and Davy were unable to fix the image, and in the presence of light the silver nitrate eventually turned the paper solid black.

In the 1830s the British mathematician and chemist William Henry Fox Talbot devised several ways to stabilize such an image with salt so that it didn't darken with further exposure to light. He replicated Wedgwood and Davy's experiment using a solar microscope, but instead of projecting a picture painted on glass, Talbot projected microorganisms. He then fixed the image, giving the world its first photomicrograph (plate 3-52). Talbot also created shadow images (photograms) by placing leaves and flowers on the photosensitive paper and exposing it to bright sunlight (plate 3-53). Talbot's chemical processes required long exposure time, so he set the work aside because he thought it was impractical.

Popularization of Science

By the early 1860s Darwin's theory of evolution and Pasteur's germ theory of disease were giving the educated public a new world picture. Pasteur was generally accepted but the popular reaction to Darwin varied from cool rejection (England and France) to warm embrace (Germany and Russia). These reactions resulted from the social structure of science, the outlook of leading scientists, and—crucially—the type of science journalism that developed in a country. The major science organizations of the day, Britain's Royal Society and the French Académie des Sciences, were formed during the eighteenth century as expressions of Enlightenment ideals; members were upper-class gentlemen for whom science was a speculative, philosophical pastime. Nineteenth-century researchers, on the other hand, were often middle class and performed the more mundane tasks of observing, recording, and synthesizing data in laboratory settings, where rapid communication and supportive camaraderie were essential. These laboratory researchers, who came to be called *scientists* after that term was coined in the mid-nineteenth century, were not welcome in the exclusive Royal Society or French Académie, so they founded their own organizations—national associations for the advancement of science. Most association meetings were open to the public and widely attended. To ensure vital government support for research, members encouraged public interest in science by regularly giving lectures and demonstrations for general audiences. Researchers in German regions (which weren't unified into a nation until 1871) especially felt the need to communicate with their colleagues and

formed the first such organization in 1822, the German Scientific Association. The British Association for the Advancement of Science was established in 1831, and its American counterpart in 1842. In defiance of older elite societies that conducted all activities in German, Moscow scientists formed the Society of Admirers of Natural Science in 1864 and attracted a broad base of new researchers as well as a popular audience by conducting all meetings and public programs in Russian. The failure of the French to establish a broad base of mid-level scientists (the French Association for the Advancement of Science was not founded until 1872) is widely seen as a reason French science was in decline in all areas by 1900. Members of the British Association, on the other hand, kept British science strong, but by the end of the nineteenth century, Germany was the unrivaled leader in science, mathematics, and technology.

New forms of science education and entertainment expanded in the nineteenth century, providing the crucial link between the scientist's laboratory, the public's living room, and the artist's studio.[19] The public read columns devoted to science in newspapers, and enterprising publishers found an expanding audience

for popular science periodicals. Lavishly illustrated books for a general audience conveyed to readers the beauty of the worlds seen through a microscope (plate 3-55). Between 1850 and 1914 the French public supported more than sixty science magazines, such as *La Science pour tous* (Science for all), a weekly that ran from 1856 to 1901; twenty-plus annuals, such as *L'Année électrique* (The year in electricity), which ran from 1885 to 1892; and over a dozen book series, including the Bibliothèque des merveilles (Library of wonders), which released 126 volumes between 1864 and 1895.[20] There were similar publications for children (plate 3-54) and special releases for visitors

Every person must have right or wrong thoughts, and there is no reason why a hedger or a ditcher, or a scavenger, should not have as correct opinions and knowledge as a prince or nobleman.

"Working Man's Friend and Family Instructor," *London Weekly*, 1850

3-56. Poster for the Exposition Universelle (world's fair) in Paris, 1900. Bibliothèque Forney, Paris.

This poster advertised things that a visitor could see at the 1900 world's fair. In *Le Monde Souterrain* (the underground world) are a dinosaur (*Barosaurus*, the first remains of which had been discovered by the American paleontologist Othniel Charles Marsh in South Dakota in 1889) and an extinct deer with massive antlers (*Megaloceros giganteus*, called the Irish elk because the first fossils were found in the bogs of Ireland in 1746). Egyptian archaeology captured the public imagination after the discovery in 1871 of a pair of painted limestone statues of the Old Kingdom prince Rahotep and his wife Nofret (seated behind the dinosaur on the right). In the lower right-hand corner there are gold objects from the

Mycenaean shaft graves on the Greek mainland, excavated in 1876 by the German archaeologist Heinrich Schliemann. The Buddha statue conveys a darker message: in 1900 three Buddhist countries in Southeast Asia were colonies of France—Laos, Cambodia, and Vietnam—and visitors would see the statue in the pavilions of Asian-French architecture in *Le Tour du Monde* (tour of the world). On the right, the *Exposition Miniére Souterraine* (exhibition of underground minerals) illustrates gold mining in the South African Republic (Transvaal), where rich gold deposits had been discovered in 1885. The exposition occurred during the Second Boer War (1899–1902), when Transvaal became a colony of Britain. Reflecting this political moment, a large Englishman dominates eight small Africans workers below.

3-57. An army of Martian fighting-machines destroys an English neighborhood, illustration by Henrique Alvim Corréa (Brazilian, 1876–1910), in a French translation of H. G. Wells, *War of the Worlds* (1898), trans. Henry-D. Davray, as *La guerre des mondes* (Brussels: Vandamme, 1906). The British Library, London.

Aliens from Mars plot to invade Earth to gain its resources. Unable to breathe Earth's atmosphere, the Martians stay inside protective cylinders and attack London using towering three-legged machines armed with heat-ray guns. In this illustration, one machine sets fire to a house, while smoke rises from three incinerated corpses in the courtyard. A man runs to join others who have climbed over a wall and crouch in darkness. All the weapons of the British army are ineffective against the invaders. In the end England is saved because the Martians could not escape an invisible microbe to which they had no immunity that silently slipped into their protective cylinders. The narrator observes that the invading Martians are "slain, after all man's devices had failed, by the humblest things that God, in his wisdom, has put upon this earth" (H. G. Wells, *The War of the Worlds* [London: William Heinemann, 1898], 282).

3-58. Exhibition halls of the Deutsches Museum, Munich, shown in a postcard designed by Joseph Engelhardt on the occasion of the opening of the halls in 1908. Deutsches Museum, Munich.

3-59. "Das mikroskopische Aquarium in Berlin" [The microscopic aquarium in Berlin], in *Illustrirte Zeitung* 68, no. 1754 (Feb. 10, 1877), 111 (illus.) and 113 (text). A drop of pond water becomes a "microscopic aquarium" when visitors see it through a microscope.

to international fairs (plate 3-56). Social reformers encouraged people of all classes, from manual workers to educated professionals, to study natural science as a healthy recreation that would develop their powers of reasoning.

After the invention of motion pictures in the 1890s, audiences flocked to see short silent films with invisible villains (*Afraid of Microbes*, 1908).[21] Science fiction was established as a literary genre by the French author Jules Verne and the British author H. G. Wells, who was a student of Thomas Huxley. Wells turned his knowledge of survival of the fittest into a battle between species on two planets—Earthlings versus Martians—in his 1898 novel *War of the Worlds* (plate 3-57).

The world's largest museum of science and technology, the Deutsches Museum in Munich, opened in 1908 (plate 3-58). In Berlin the public visited an aquarium dedicated to microscopic sea life (plate 3-59); the enlargements of amoebas and protozoa adorning its walls foretell a new artistic vocabulary of organic shapes—biomorphic abstraction—which has flat, curved forms mimicking the stained specimens sandwiched between glass plates and viewed with a microscope, as in the abstract art of Wassily Kandinsky (plate 3-60).[22] Today artists continue to be inspired by the invisible world of microscopy and visible biomorphic forms (plate 3-61).

Science journalists disdained technical jargon and appreciated the power of images to communicate an abstract concept to the public. Distinctive national styles of science journalism developed, reflecting attitudes in the laboratory. In England and France science magazines and books were written in an encyclopedic style, with assemblages of interesting facts; in London and Paris both the public and the scientists were taught to rely only on direct observation and discouraged from speculating about unobservable phenomena.

> *Abstract art, despite its emancipation, is subject here also to "natural laws," and is obliged to proceed in the same way that nature did previously, when it started in a modest way with protoplasm and cells, progressing very gradually to increasingly complex organisms.*
>
> **Wassily Kandinsky, *Point and Line to Plane*, 1926**

French Realist Art of Observation

*When you go out to paint, try to forget what you have before you, a tree, a house,
a field or whatever. Merely think, here is a little square of blue, here an oblong of pink,
here a streak of yellow, and paint it just as it looks to you, the exact color and shape,
until it gives your own naïve impression of the scene before you.*

Claude Monet, ca. 1890

REFLECTING THE ATTITUDES of French scientists, artists in Paris were committed to observation of nature. In the 1830s a Frenchman, Louis Daguerre, invented a tool—the camera—with which artists could capture every detail. But then *observation* was radically redefined by the German scientist Hermann von Helmholtz, who proclaimed that color and form are not properties of objects in the world but produced by nerves firing in the observer's eye and brain. Helmholtz's laboratory evidence that seeing color results from light striking the retina prompted a flurry of responses in the Paris art world and accelerated Impressionists' quest to capture their fleeting experience of light.

The Forbidden Topic: Evolution

In France the most important debate about the origin of species occurred at an 1830 meeting of the Académie des Sciences, where Georges Cuvier, the most respected scientist in Paris, denounced Jean-Baptiste Lamarck's theory of acquired characteristics so dramatically and in such bitter language that discussion of the evolution of species was discouraged for decades. Central to Cuvier's attack was his conviction that science should be based in observable data and repeatable experiments, not speculation. Observation was in, and theory was out; Lamarck's speculations violated the creed of observation.

When the French translation of Darwin's *Origin of Species* appeared in 1862, natural selection became one of several alternative explanations of evolution, or *le transformisme* (transformism), as it was called in France. The translator, Clémence Roger, positioned the book as opposed to religion, which made French Catholics suspicious of Darwin.[1] Louis Pasteur, who was largely silent on the disputes over transformism,

OPPOSITE
4-1. Claude Monet (French, 1840–1926), *Camille Monet in the Garden at the House in Argenteuil*, 1876. Oil on canvas, 32⅛ × 23⅝ in. (81.7 × 60 cm). Metropolitan Museum of Art, New York, the Walter and Leonore Annenberg Collection, partial gift of Walter and Leonore Annenberg.

FOLLOWING PAGES
4-2. Formation of Earth and the development of life, in Louis Figuier, *La Terre avant le déluge* (Earth before the deluge), 4th ed. (Paris: L. Hachette, 1865).

Top row, left to right: (*a*) Earth forming from a rotating cloud of gas, (*b*) condensation and rainfall on the early globe, (*c*) Silurian period, (*d*) Devonian period; *second row*: (*e*) marine life in the Carboniferous period, (*f*) Permian period, (*g*) Triassic period, with the dinosaurs *Ichthyosaurus* and *Plesiosaurus*, (*h*) Triassic period; *third row*: (*i*) Lower Jurassic period, (*j*) Middle Jurassic period, (*k*) Lower Cretaceous period, with dinosaurs *Iguanodon* and *Megalosaurus*, (*l*) Eocene epoch; *bottom row*: (*m*) Miocene epoch, (*n*) Pliocene epoch, (*o*) European landscape in the Quaternary period, (*p*) the appearance of humans; there is a woolly mammoth in the upper left.

A

B

E

F

I

J

M

N

C

D

G

H

K

L

O

P

continued Cuvier's focus on laboratory observation: "There are many great problems that arouse interest today: the unity or multiplicity of human races; the creation of man many thousands of years or centuries ago; the immutability of species or the slow and progressive transformism of one species to another; matter reputed to be eternal rather than created; the idea of God being useless, etc.: these are some of the learned questions that men dispute today. I do not discuss these grave topics. . . . I dare speak only on a subject that is accessible to direct observation."[2]

By the 1850s the popularization of science was established as a profession in France, where many of the writers had considerable science education. The best-known popularizer, Louis Figuier, had both a doctorate in chemistry and training in literature, which made him a skilled storyteller able to translate complex information into popular language. Figuier's *La Terre avant le déluge* (Earth before the flood, 1863) presented readers with an overview of nature, from the formation of Earth through the geological ages, each with its typical species, and ending with *Homo sapiens* (plate 4-2). As Darwinian as his book's illustrations appear, in his preface Figuier explicitly denied his support of Darwin's *Origin of Species* and stated that God directed the creation of new species and the demise of others. Figuier also, however, distanced himself from Cuvier's view that there was periodic destruction of all life on Earth in floods, assuring parents that his book was fit for children because this old view of apocalyptic ruin was no longer held by geologists: "Geology is, then, far from opposing itself to Christian religion, and the antagonisms that formerly existed have been replaced by happy agreement."[3]

Nationalist pride soared in 1868 when French paleontologists found a fossil of Cro-Magnon man (a modern human) in a cave on French soil. The skull of the hominid that the Germans found in their Neander River Valley in 1856 had a backward-sloping forehead, but the French caveman was a highbrow.

Photography

In the 1820s a French inventor, Nicéphore Niépce, covered a metal plate with a chemical (bitumen) that hardened in proportion to exposure to light entering through the aperture of a camera obscura. After exposing the plate for hours, he washed it, and only the hardened areas remained. After Niépce's death in 1833, his young partner, Louis Daguerre, continued the experiments using a silver-plated metal surface, polished until it was mirror-like. Daguerre discovered that by using certain chemicals (iodine vapor, silver oxide) he could record a very faint image in just a few minutes, and then enhance the image by exposing the plate to mercury fumes. Having solved the practical problem of exposure time, Daguerre announced the photographic process at a meeting of the Académie des Sciences in Paris on January 7, 1839, and he published his findings, referring to the method as *daguerreotype* (plate 4-3).[4]

Unknown to Niépce and Daguerre, the Englishman William Henry Fox Talbot had also experimented with photographic processes, but he had put the work aside because the long exposure time made it impractical (see chapter 3). After reading a report of Daguerre's invention in 1839, Talbot returned to photography. He placed photosensitive paper at the back of a camera obscura, where it captured a dim image through the lens and yielded a paper negative (plates 4-6 and 4-7). After experimenting with different chemicals, Talbot reduced exposure time to minutes, making his method competitive with daguerreotype. By the mid-1840s he could print positive images, and in 1844 he began publishing a series of pamphlets about photography, which he called

RIGHT

4-3. Title page of Louis Daguerre, *Historique et description des procédés du daguerréotype et du diorama* [History and description of daguerreotype and diorama processes] (Paris: Susse frères et Delloye, 1839). Bibliothèque Nationale de France.

BELOW

4-4. Photographer displaying daguerreotypes and cases, 1845. Hand-colored daguerreotype, and case. J. Paul Getty Museum, Los Angeles.

The metal surface of daguerreotype was easily scratched, and the silver tarnished when exposed to air, so the finished plate was often put behind glass and sealed in a protective case. This photographer presents himself in formal attire holding a selection of nine portraits. He holds two cases, and others lie on the table.

4-5. Cover of William Henry Fox Talbot, *The Pencil of Nature* (London: Longman, Brown, Green, and Longmans, 1844). J. Paul Getty Museum, Los Angeles.

Talbot published *The Pencil of Nature* in six installments between 1844 and 1846, illustrated with twenty-four photographs such as plate 4-6, selected to demonstrate a wide range of applications.

BOTTOM LEFT

4-6. "The Haystack," salted paper print from a paper negative in William Henry Fox Talbot (English, 1800–1877), *The Pencil of Nature* (London: Longman, Brown, Green, and Longmans, 1844), iss. 2, plate 10. Metropolitan Museum of Art, New York, gift of Jean Horblit, in memory of Harrison D. Horblit.

In text accompanying "The Haystack," Talbot wrote: "One advantage of the discovery of the Photographic Art will be, that it will enable us to introduce into our pictures a multitude of minute details which add to the truth and reality of the representation, but which no artist would take the trouble to copy faithfully from nature."

OPPOSITE

4-7. Hiroshi Sugimoto (Japanese, born 1948), *Photogenic Drawing*, 2009. Toned gelatin-silver print, 36⅞ × 29½ in. (93.7 × 74.9 cm), made from a paper negative taken by William Henry Fox Talbot of the China Bridge over the River Avon at Lacock Abbey, Apr. 3, 1840. Courtesy of the artist and Marian Goodman Gallery. © Hiroshi Sugimoto

Beginning in 2007, Hiroshi Sugimoto made a suite of photographs that he printed in positive from Talbot's original paper negatives of the early 1830s. As Sugimoto has described the project:

I decided to collect Fox Talbot's earliest negatives, from a time in photographic history very likely before positive images existed, and print the photographs that not even he saw. Most early Fox Talbot negatives languish in dark museum collection vaults, hidden from public view. Negatives predating any reliable method of fixing the image are always in danger of changing if exposed to the slightest light. I, however, had to take that risk to return to the very origins of photography and see those first positive images for myself. With fear and trepidation, I set about this task like an archaeological explorer excavating an ancient dynastic tomb.

("Photogenic Drawing," Hiroshi Sugimoto's website, accessed Nov. 20, 2018, http://www.sugimotohiroshi .com/photogenic-drawing.)

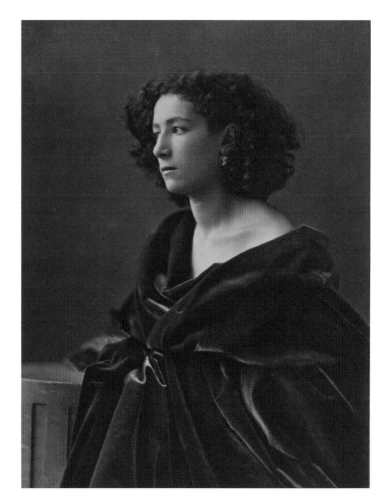

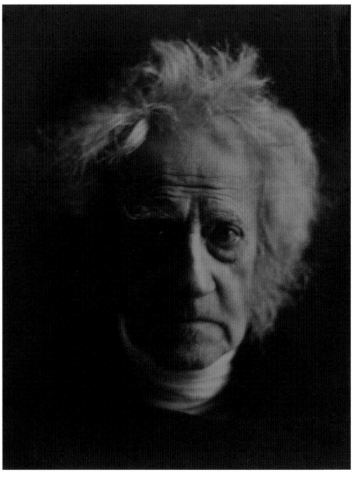

ABOVE

4-8. Honoré Daumier (French, 1808–1879), "Nadar élevant la Photographie à la hauteur de l'Art" [Nadar elevating photography to the height of art], 1862. Lithograph, 12½ × 9¾ in. (31.8 × 24.7 cm). Bibliothèque Nationale de France.

Nadar practiced aerial photography Paris in 1858, but the photographs he produced no longer exist.

TOP RIGHT

4-9. Nadar (pseudonym of Gaspard-Félix Tournachon, French, 1820–1910), *Sarah Bernhardt*, ca. 1864. Gelatin silver print, 8¼ × 6⅜ in. (21.1 × 16.2 cm). J. Paul Getty Museum, Los Angeles.

Sarah Bernhardt was about twenty when she posed for Nadar, at the beginning of her acting career. Nadar transferred the skills he honed as a caricaturist to create portraits that reveal the sitter's personality.

BOTTOM RIGHT

4-10. Julia Margaret Cameron (Indian-born British, 1815–1879), *John Herschel*, 1867. Albumen silver print from a glass negative, 14⅛ × 11 in. (35.9 × 27.9 cm). Metropolitan Museum of Art, New York, the Rubel Collection, partial and promised gift of William Rubel.

Cameron was born and raised in India, where her father worked for the British East India Company. After studying in France, she returned to India and married a lawyer in Calcutta, with whom she raised a large family. When Cameron was forty-eight and living in London, one of her daughters gave her a camera as a gift, which prompted her to take photographs. She used soft focus to achieve a melancholy mood in this portrait of her close friend John Herschel, an astronomer like his father, William Herschel, and also a chemist, who coined the term *photography*. In 1839 John Herschel developed a chemical method for fixing an image on light-sensitive paper, independently of William Henry Fox Talbot.

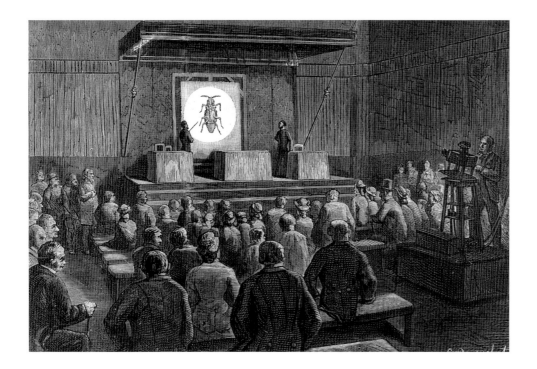

4-11. Public science lecture, in "L'Exposition des insectes" [Exhibition of insects], *L'Illustration* 76, no. 1958 (Sept. 4. 1880), 151 (text), 153 (illus.).

"photogenic drawing." Talbot illustrated the pamphlets with printed photographs that were pasted in by hand, stressing that the images were made "by the mere action of light upon sensitive paper . . . by Nature's hand" (plates 4-5 and 4-6).[5]

Soon there was a flourishing business in portrait photography, providing people with an exact likeness for a modest cost (plate 4-4). In 1858 balloonist and photographer Gaspard-Félix Tournachon (pseudonym Nadar) flew over Paris and took the first aerial photographs, inspiring Jules Verne's *Cinq semaines en ballon* (Five weeks in a balloon, 1863) and a cartoon by Honoré Daumier (plate 4-8). Nadar and the British photographer Julia Margaret Cameron developed insightful styles of portraiture (plates 4-9 and 4-10).

The spread of public education created an audience for lectures on science, often illustrated by a magic lantern, a projection microscope with a light source, such as an oil lamp (plate 4-11). After the invention of electric light bulbs for these projectors, theater audiences went on voyages to microscopic realms as entertainment (plate 4-12).

4-12. Poster for *Les Invisibles* [The invisible ones], 1883. Color lithograph, 21¾ × 14⅝ in. (55.3 × 37.2 cm). National Gallery of Canada, Ottawa.

Les Invisibles entertained audiences with a "voyage au monde des infiniment petits" (voyage to the world of the infinitely small). The audience saw cartoons of microbes resembling little dinosaurs "au microscope-géant electrique" (on a giant electric microscope); in other words, a projection microscope with an electric light source showed the still images on a screen.

Trade with Japan

By the 1850s, steam locomotives pulled trains across Europe, Russia, and the United States, as inventors of machines spurred the Industrial Revolution (plate 4-13). Cotton mills were powered by waterwheels turned by fast-flowing rivers and lubricated with whale oil, which was also used for heating and was burned in lamps (plate 4-14). Westerners had hunted whales to near extinction in the Atlantic Ocean, so they wanted to hunt whales off the coast of Japan. In 1851 Herman Melville described American sailors who hunt for a white whale—Moby Dick—in Japanese waters (plate 4-15).

ABOVE

4-13. Louis Poyet (French, 1846–1913), *La tête l'inventeur* [The head of an inventor], 1893. Lithograph.

BELOW

4-14. Power-loom factory in Lancashire, England, *Illustrated London News*, May 18, 1844, 314. Etching.

A waterwheel drove the horizontal shafts extending along the ceiling, which in turn drove the looms.

If that double-bolted land, Japan, is ever to become hospitable, it is the whale-ship alone to whom the credit will be due; for already she is on the threshold.

Ishmael speaking in Herman Melville,
***Moby-Dick; or, The Whale*, 1851**

ABOVE RIGHT

4-15. Herman Melville, *Moby Dick, or The White Whale* (1851; repr. Boston: Page, 1892), 510. Photolithograph of a watercolor by A. Burnham Shute. General Research Division, The New York Public Library. Astor, Lenox, and Tilden Foundations.

Narrated by the sailor Ishmael, an outcast like his biblical counterpart, who sails to the coast of Japan on the *Pequod*, a whaling vessel which is on the horizon in this illustration. Captain Ahab, whose Abrahamic namesake was a king of Israel who did more evil in the sight of God than "all that were before him" (1 Kings 16:30), sails the *Pequod* from Nantucket to the coast of Japan, where he and his crew are destroyed by the great white whale.

OPPOSITE, TOP

4-16. Foreign ship, ca. 1854–60. Japanese woodblock print. © Nagasaki Museum of History and Culture.

The foreign (American) ship has evil monsters on the bow and stern, belching smoke from its chimney and shooting fire from two of its many canons. A more cool-headed description is recorded in the inscription in the upper right (translation by Takumi Segi):

Ship length 445 ft. (135.61 m)
Width 119 ft. (36.36 m)
Wheel diameter 125 ft. (38.18 m)
3 Masts
Height above the water: 5 ft. (1.51 m)
10 Cannons
15 Large Cannons

OPPOSITE, BOTTOM

4-17. "Landing of Commodore Perry, Officers and Men of the Squadron, to Meet the Imperial Commissioners at Yoku-Hama, Japan, March 8, 1854." Color lithograph, 19th century. University of Virginia Library, Charlottesville

Matthew Perry (in the center) marches onshore with his black-clad comrades, flanked by rows of US Navy sailors holding rifles. Against a backdrop of nine huge American warships towering over a dozen small Japanese junks, Perry is greeted by Japanese carrying antiquated swords and spears.

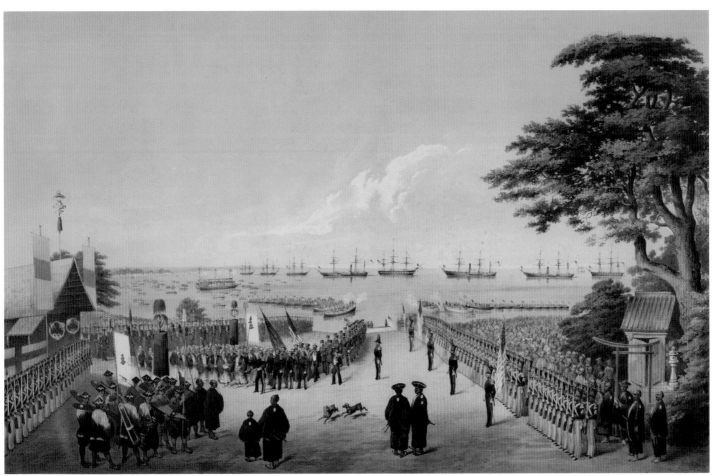

A Frenchman, an Englishman, and a German were each assigned to write a study of the camel.

The Frenchman went to the Jardin des Plantes, where he spent half an hour questioning the guard and tossing bread to the camel, whom he poked with the point of his umbrella. Returning home, he wrote an article for his paper full of sharp and witty observations.

The Englishman, taking his tea basket and comfortable camping equipment, pitched his tent in the Orient and, after two or three years, produced a thick volume of disorganized facts which reached no conclusions, but had real documentary value.

As for the German, filled with disdain for the Frenchman's frivolity and the Englishman's lack of general ideas, he shut himself up in his study, and there he wrote a several-volume work entitled: The Idea of the Camel derived from the Concept of the Self.

Le Pèlerin (Paris),
September 1, 1929

Japan, however, had been closed to the West for 250 years. Tokugawa Ieyasu, who became shogun in 1600, grew wary of the Portuguese because their trading ships brought along Jesuit priests, who were converting Japanese Buddhists to Catholicism. So in 1614 Ieyasu expelled the Portuguese and established trade exclusively with the Dutch, who were Protestant and not interested in religious conversion. Traders of the Dutch East India Company were restricted to the foreigners' port, Dejima, an artificial island in the bay of Nagasaki, and were forbidden to set foot on Japanese soil. During the next two centuries Japan, isolated from outside influences, refined its distinctive forms of calligraphy, ceramics, brush painting, and Zen Buddhism in an insular society ruled by Ieyasu's descendants, during the Tokugawa shogunate, which lasted until the mid-nineteenth century.

Then in 1853 four American warships sailed into the forbidden waters of the shogun's port of Edo (today Tokyo) (plate 4-16). Samurai surrounded the ships with junks—small sailboats—and demanded they leave. As American sailors ominously loaded their ships' cannons and aimed their rifles at the samurai, the US naval commander, Matthew Perry, came ashore and gave the shogun an ultimatum: begin trade talks or prepare for battle. After lengthy consideration of Japan's few options, given that the country hadn't updated its coastal defense for 250 years (the samurai were armed only with swords), the shogun decided to negotiate and open the country for trade (plate 4-17). Thus in 1854 the United States and Japan signed a mutually beneficial trade agreement. Within a decade the Tokugawa shogunate had ended, the samurai were officially disbanded, and the modern era of Japan had begun. Japan soon signed trade agreements with England and France, and Japanese goods flowed into European ports. Western artists became fascinated with these exotic objects and with the Eastern outlooks they expressed.

Realism

French science journalists shunned theory and filled their encyclopedic books with fascinating facts about biology, physics, astronomy, and technology. Hippolyte Taine, the leading spokesman for the fact-gathering bias of science popularizers, argued that artists, like any creatures, are the product of their environment and that art history and criticism should be based in the scientific method of observation. Taine stressed the importance of understanding art in terms of its epoch, geography, and culture (*Philosophy of Art*, 1865).

In 1864 Taine became professor of art history at the École des Beaux-Arts in Paris, and his views on aesthetics dominated French intellectual life in the second half of the nineteenth century. One writer who took up Taine's banner was Émile Zola, who in his fifties reflected on his career: "I have submitted to three influences, Musset, Flaubert, and Taine. I was around twenty-five years old when I read the last, and in reading him

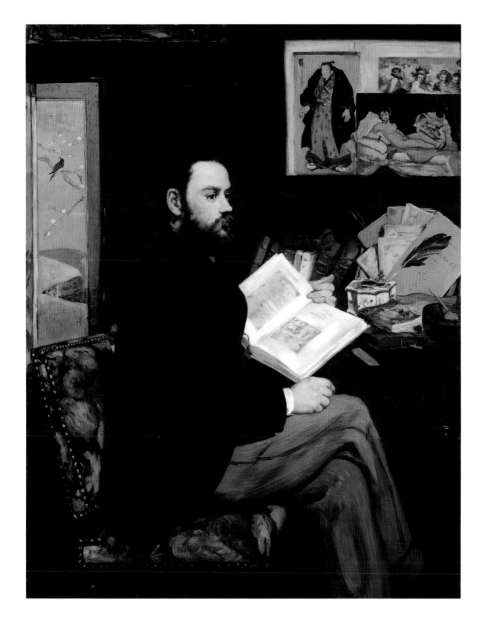

4-18. Édouard Manet (French, 1832–1883), *Portrait of* Émile Zola, 1868. Oil on canvas, 57½ × 44⅞ in. (146 × 114 cm). Musée d'Orsay, Paris.

Manet depicted his friend Zola reading an illustrated art book, and on his desk is a pamphlet Zola wrote in support of Manet (the pale blue cover behind the quill pen). In the background Manet included a small oil sketch for his painting *Olympia* (plate 4-19) and references to his admiration of the art of Spain (the engraving of a painting by Diego Velázquez) and Japan (the screen and a woodblock print).

I became a theoretician and a positivist" (plate 4-18).[6] In his novel *Thérèse Raquin* (1867), Zola's main characters, the adulterous Thérèse and Laurent, copulate because of their animal drives, and then they commit a murder. In response to complaints about his depravity, Zola wrote a preface to the second edition in which he described the tale as a realization of "a scientific goal": "I chose people who are driven by their flesh and blood, without free will, who are dragged along into each act by fate. Thérèse and Laurent are human animals [*brutes humaines*], and nothing more."[7]

In the essay "Le Roman expérimental" (The experimental novel; 1879), Zola compared his empirical approach to that of French physiologist Claude Bernard.[8] Praising Bernard's innovative work on the chemistry and electricity of the body, Zola stressed that, just as a doctor studies the body, a novelist dissects society. Zola proclaimed that this new scientific method of observation was expressed in the naturalism of the *plein-air* painters, especially Édouard Manet: "Science wanted a firm foundation and so returned to precise observation of facts. This effort has been going on not only in science; all disciplines, all human activities seek certainty in the natural world. Our

4-19. Édouard Manet (French, 1832–1883), *Olympia*, 1863. Oil on canvas, 51½ × 74⅞ in. (131 × 190 cm). Musée d'Orsay, Paris.

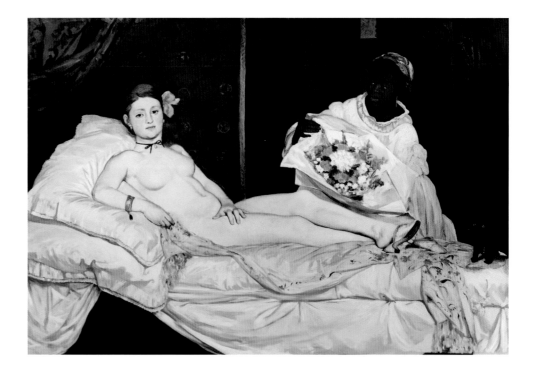

modern landscapists are far superior to history painters because they have studied our countryside, content to paint the first patch of forest they come upon. Édouard Manet applies this method to each of his works."[9] Zola declared that the task of the artist is to record society, not evaluate it as in Charles Dickens's moralizing commentary. When Manet painted a prostitute (plate 4-19), he recorded his observations without making a moral judgment about her.

Physiognomy and Phrenology

Zola was particularly interested in mid-nineteenth-century medical theories about how a person's mental state is manifest in facial expression and body posture. Realist artists, such as Edgar Degas, incorporated these same ideas into their art. Zola and Degas didn't use Darwin's theory of evolution, which was the talk of London in the 1860s and '70s, but instead looked to pre-Darwinian medical views of brain anatomy—physiognomy and phrenology.[10]

In the early nineteenth century Johann Caspar Lavater's theory of the face as an expression of the personality—physiognomy (plate 4-20)—merged with the German physician Franz Joseph Gall's theory that the shape of the head indicates mental traits—phrenology (plate 4-21)—to induce the widespread misconception that doctors could determine whether or not a patient had a mental illness by the shape of the skull. Artists adopted such cranial shorthand to get their expressive points across. When a follower of Gall, the Scottish physician and phrenologist George Combe, toured the United States in 1839–40, he made a studio visit to Rembrandt Peale and noted approvingly that the artist had done his phrenology homework before painting his portrait of the first president, *Washington before Yorktown* (1824–25; Corcoran Gallery of Art, Washington, DC):

"Washington's head as here delineated, is obviously large; and the anterior lobe of the brain is large in all directions; the organ of Benevolence is seen to rise, but there the moral organs disappear under his hair."[11]

Alessandro Volta knew that the body of an animal conducts electricity, and in 1810 Gall concluded that mental functions are localized in the brain and that it responds to electrical stimulation. After the development of the achromatic microscope in the 1820s enabled detailed examination of cellular structures, physiologists focused on long fibers that link brain cells—neurons—as possible carriers of electrical impulses. Thus the body began to be seen as an electrical machine, and by the 1860s neurology was emerging as a medical specialty.

In France, Degas mused in a notebook he used during the years 1868–72: "Make an academic *tête d'expression* [French studio parlance for "facial type"] a study of modern feelings. It's a Lavater, but a more relative Lavater, sometimes with accessory symbols."[12] In adding context and "accessory symbols" to Lavater's illustration of isolated heads, Degas reflected the view common in Parisian art circles that a simian-shaped head confirmed the bestiality of the lower classes. In Degas's drawings of Émile Abadie and Michel Knobloch, nineteen-year-old Parisians who confessed to brutal murders in 1879, the artist emphasized the criminals' telltale backward-sloping foreheads (plate 4-22). Their case raised fears about the decline of French youth that were frequently expressed in the decade following France's loss of the Franco-Prussian War in 1871; when Abadie and Knobloch's trial began in August 1880, the sensational story dominated the French press. What had caused these boys to go bad? Was it their poor

4-20. Faces demonstrating physiognomy, in Johann Caspar Lavater, *L'art de connaître les hommes par la physionomie* [The art of knowing men by their physiognomy] (Paris: Depélafol), 1820), vol. 4, plate 182 (detail), between 142–47. Wellcome Library, London.

In this diagram Lavater illustrated his view of four types of humankind (from left to right): *Caucasian* (native of the Caucasian Mountains, which are today in Russia, Georgia, Azerbaijan, and Armenia), *Tartar* (native of central Asia), *American* (native), and *Negro* (native of Africa).

TOP RIGHT

4-21. "Names of the Phrenological Organs," George Combe, *A System of Phrenology* (1819), 4th ed. (Edinburgh: Maclachlan, Stewart, and Anderson, 1836), vol. 1, frontispiece (detail).

This diagram shows a phrenological head in profile; in the center of the forehead are the regions of individuality and eventuality, surrounded by causality (*35*), time (*31*), and color (*26*). Phrenologists named these regions by guesswork, without experimental evidence. The Scottish lawyer George Combe was a spokesman for phrenology, and he made an analogy between exercising a muscle and exercising the mind; when the mind performs a task such as telling time, this expands the corresponding region of the brain (*31*), which, in turn, pushes out the skull. Thus, by measuring the skull, the phrenologist purported to determine a person's mental habits and abilities. Today neuroscience has established that the analogy between exercising a muscle and the mind is basically correct in the sense that mental activity causes the brain to grow new nerve cells and connections, although soft brain tissue moves within and does not alter the shape of the rock-hard skull.

BOTTOM RIGHT

4-22. Edgar Degas (French, 1834–1917), *Criminal Physiognomies of Émile Abadie and Michel Knobloch*, 1881. 18⅞ × 24¾ in. (47.8 × 63 cm). Private collection.

Degas attended the trial of Émile Abadie and Michel Knobloch and drew them seated in the courtroom dock, guarded by a gendarme, whose epaulette is visible on the left. The men were sentenced to life imprisonment on Devil's Island, which lay off the coast of French Guiana, a colony on the northeastern coast of South America that is still ruled by France.

4-23. Edgar Degas (French, 1834–1917), *Little Fourteen-Year-Old Dancer*, ca. 1880–81. Bronze, height 39 in. (99.1 cm). Musée d'Orsay, Paris.

neighborhoods? Did they have "bad blood"? Journalists, as well as Degas, sought a clue in their faces and skulls.

Degas displayed his drawings of Abadie and Knobloch in 1881, in the sixth Impressionist exhibition, together with the wax model for his statue *Little Fourteen-Year-Old Dancer* (plate 4-23). The connection was not lost on art critics, who noted the dancer's low forehead; according to one, such lowbrow characters were not welcome in the art world: "[Degas] presents us with the statuette of a dancer, who is a detestable and ugly female; the artist makes of her a horrible image of bestiality. . . . Put her in a museum of zoology, of anthropology or of physiology—but in a museum of art, never!"[13] Another praised Degas's keen observation of the girl: "Under her silk pleated skirt, notice . . . the solid placement of her feet . . . the torso like steel. Here is not a dancer with classical lines, but the rat of the opera with a modern expression, learning her trade, with all her stock of bad instincts and vicious inclinations. . . . An ordinary artist would make this dancer like a doll. Degas gives his work the aura of pungent taste and exact science."[14]

Chevreul's Law of Simultaneous Contrast of Colors

Michel-Eugène Chevreul was a French chemist who, as director of a factory where tapestries where woven, experimented with how to make fabrics appear more colorful. In the 1830s he began giving lectures on color to art audiences, and encouraged by his talks' popularity, he published a studio manual on color. Chevreul's friend the physicist André-Marie Ampère, an expert on electricity, suggested that Chevreul formulate his thesis in the form of a scientific law,[15] hence the book's title, *De la loi du contraste simultané des couleurs* (On the law of simultaneous contrast of colors, 1839). Chevreul did not discover the simultaneous contrast of colors, but he gave precise formulation and

4-24. Color studies, in Michel-Eugène Chevreul, *De la loi du contraste simultané des couleurs* [On the law of simultaneous contrast of colors], 1839; repr. Paris: Gauthier-Villars, 1889), plates 2 and 3, between 22–23. Bibliothèque Nationale de France.

In these examples, Chevreul demonstrated how to increase the apparent brightness of a hue by adding a halo of its complement. At the bottom of the page on the left, he shows a band of a warm red and cool blue at high intensity. Following Chevreul, a circle of red surrounded by a halo of green is offered as an example of an afterimage in plate 4-30.

visually compelling examples of a phenomenon known to artists throughout the ages: the apparent hue, value, and intensity of a patch of color changes with its environment, looking warmer against a cool background, lighter against a dark ground, and more intense in a low-intensity environment (plate 4-24). Chevreul's contribution was his restatement of age-old studio practices in the language of nineteenth-century science, thereby making them more accessible to modern artists. Chevreul never revised his book, which was reprinted in 1864 and 1889 and became the most widely read color manual of the nineteenth century. In 1963 the German-born American artist Josef Albers updated Chevreul's color theory and published the studio manual most used today, *Interaction of Color*.

Three-Receptor Theory of Color Vision

The scientific study of vision developed in the mid-nineteenth century in association with work on light and lenses, together with research on electricity and the nervous system. In 1803 the English physician Thomas Young did an experiment that proved light travels in waves (see plate 8-36 in chapter 8). Young wondered how the eye could perceive all colors in the spectrum, which is composed of a continuum of wavelengths. He reasoned that the eye must have only a few receptors, each capable of responding to only certain wavelengths. Young knew that artists arrange colors on their palettes with three primary hues—red, yellow, and blue—so he hypothesized that the human eye contains receptors for red, yellow, and blue light, which somehow combine to produce perception of all the colors of the rainbow.

In a remarkable example of the experimental method, Hermann von Helmholtz discovered the three receptors that Young predicted, but they were not for red, yellow, and blue light. Helmholtz first distinguished colored pigments (chemical compounds; plate 4-25) from colored light (wavelengths of energy; plate 4-26). The primaries for pigment are red, yellow, and blue, but the primaries for light can vary. Helmholtz then observed that the retina is lined with light-sensitive neurons that come in two shapes—rods and cones. All rod-shaped nerve cells contain the same photosensitive chemical, which responds to intensity (quantity) of light regardless of its color. Rods are responsible for night vision. Cone-shaped cells contain one of three different photosensitive chemicals, each of which responds to a different wavelength of light: red, green, or blue (plate 4-27). For example, when a blue cone—a cell containing the chemical that is sensitive to blue light—is stimulated, it triggers a chemical change that causes an electrical impulse to leave the cell and be relayed to the visual cortex at the back of the brain, causing the viewer to perceive blue (plates 4-28 and 4-29). A blue cone will also fire in response to red or green light but at slower rates.

In 1867 Helmholtz published *Handbuch der physiologischen Optik* (Handbook of physiological optics), which is the founding text of the physiology of perception. When

TOP
4-25. Pigment primaries
 For pigments the primaries are red, yellow, and blue, which combine to form the secondary hues, orange, green, and violet. Red, yellow, and blue pigments together form brown.

ABOVE
4-26. Light primaries
 For light the main primaries are red, green, and blue, which mix to form the secondary hues, yellow, cyan, and magenta. Red, green, and blue light together form white.

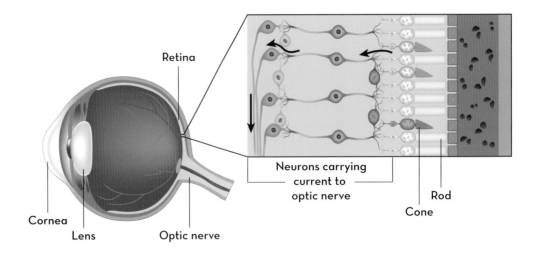

4-27. The Eye

Natural selection designed the eye like a camera obscura, except the eye has the form of a sphere rather than a cube. Light enters through the cornea, then travels through a lens, which is covered by a colored curtain, the iris, at the center of which is a round hole, the pupil. Tiny muscles control the shape of the lens, which shines the incoming light through the clear, watery fluid that fills the eyeball and focuses it on the retina, which is lined with light-sensitive nerve cells. Rod-shaped cells respond to quantity of light. Cones respond to three different wavelengths: red, green, or blue, depending on which of three photo-sensitive chemicals the cone contains. Cones are concentrated in the center of the retina (the fovea), giving clear focus and fine detail in the center of the visual field. Rods are concentrated on the perimeter, providing night vision and peripheral vision, which lack focus and detail. The human retina has 100 million rods and 6 million cones; when light strikes the retina, the electrical signals are relayed to the optic nerve, which carries them to the visual cortex, where the brain assembles the millions of impulses into a picture of the world.

BOTTOM RIGHT

4-28. Eye, optic nerve, and visual cortex

OPPOSITE

4-29. Jessica Lloyd-Jones (Welsh, born 1983), *Optic Nerve*, from the Anatomical Neon series, 2008–10. Blown glass and neon, 4¾ × 7⅞ × 4¾ in. (12 × 20 × 12 cm). Courtesy of the artist.

Inspired by the natural electrical activity of the nervous system, Jessica Lloyd-Jones made this sculpture of the human eye in blown glass and neon.

the French edition (*Optique physiologique*) was released that same year, it captivated the Paris art world because it explained so much about vision, such as the cause of afterimages (plate 4-30). When you stare at the red circle in plate 4-30, red light strikes the red-sensitive cones in your retina and a chemical (rhodopsin) in these nerve cells causes them to fire and you to see red. But if you continue to stare at the red circle for a total of thirty seconds, the rhodopsin in the cones is getting used up (notice that the red soon fades). In the absence of rhodopsin, another chemical now dominates these nerve cells and causes the nerves to fire aqua. So when you look away (remove the stimulus), the red cones continue to fire aqua, and you see an aqua afterimage until the chemical balance is restored. A similar process happens in your peripheral vision: the rods initially fire in response to the white background surrounding the red circle, and you see white, which quickly fades to the gray that you see in the afterimage.

Because the process of seeing color depletes chemicals in the cones, the eye is continually moving—rapidly and imperceptibly—to allow light to be always falling on fresh cones. (Notice it takes extreme concentration to stare fixedly at the red circle for a full thirty seconds.) The strong optical activity that Chevreul noted at the border of a red circle with a green halo (as in plate 4-30) occurs because the shifting eye sees opposite colors at the edges of the circle, red-green-red-green, in rapid succession. The cones send the brain signals for red and green, resulting in the perception of a flicker, or vibration, at the edge of the red circle.

Helmholtz's theory of vision, together with Darwin's theory of evolution, also explained the neurological basis for Chevreul's law of simultaneous contrast of colors.

4-30. Afterimage

Count to thirty while staring at the red circle in the green environment, and then stare at the black dot in the rectangle on the right. You will see an afterimage of a greenish (aqua) circle in a reddish environment.

The eyes of lower animals, such as moths, respond indiscriminately to quantity of light, whereas nerve cells in mammalian retinas have evolved to pick out distinctive features from complex patterns in the natural world. Neurons in the perimeter of the retina detect motion, a survival-linked adaptation to prompt one to flee a predator lurking in the shadows. The human eye also sees by contrast—light against dark, warm against cool—and because of this, the appearance of the color of an object can be distorted by its environment, seeming lighter on a dark ground (plate 4-33) and warmer on a cool ground.

The publication of Helmholtz's book inspired other scientists to study optical illusions (plates 4-31 and 4-32). Science writers were soon explaining Helmholtz's theory of vision to artists, beginning with Helmholtz, who did so in his own "On the Relation of Optics to Painting" (1871), in which he described the relevance of his discoveries for painters who depict nature.[16] The Viennese neurologist Ernst Wilhelm von Brücke wrote a book on the physiological basis of painting and poetry, *Bruchstücke aus der Theorie der bildenden Künste* (Fragments of a theory of the fine arts, 1877), which was translated into French the following year as *Principes scientifiques des beaux-arts* and included a French translation of Helmholtz's essay for painters as an appendix.[17] Taine wrote an exposition of research on the physiology and psychology of human knowledge (*On Intelligence*, 1870), which had gone through nine editions by 1900. With frequent references to Helmholtz, Taine described how knowledge, "from our most abstract ideas to our crudest sensations," is constructed in a strictly deterministic way from sense experiences—sights, sounds, touches, tastes, and smells—that are experienced at birth as meaningless patches of color, bits of sound, and so on. Through experience and "education of the senses," the child forms a picture of the world and invests the sensations with meaning.[18] Helmholtz's work helped artists understand the physiological basis for the contrast of colors and afterimages, but for practical advice on applying color theory to painting (which was not Helmholtz's topic), artists continued to consult Chevreul's manual.[19]

LEFT
4-31. Hermann grid illusion
When one looks at a white grid on a black background, one sees fuzzy gray spots at the intersections of the grid, but when one looks directly at an intersection, the gray spot disappears. The illusion was first reported by Ludimar Hermann, in "Eine Erscheinung simultanen Contrastes" [A phenomenon of simultaneous contrast], *Pflügers Archiv für die gesamte Physiologie* 3 (1870), 13–15.

RIGHT
4-32. Scintillating grid illusion
This variation on the Hermann grid is a gray grid on a black background, to which disk-shaped white dots have been added at the intersections. With each flick of the eye, black dots are perceived within the white dots. The Hermann grid illusion occurs when the eye is stationary, but the illusion of scintillation happens only when the eye moves. If the viewer stares at a fixed point, the scintillation subsides. The illusion is also dependent on the viewer's distance from the grid; the illusion disappears if one is too close or too far away. This illusion was first reported in the 1990s, by Michael Schrauf, Bernd Lingelbach, and Eugene R. Wist, in "The Scintillating Grid Illusion," *Vision Research* 37, no. 8 (May 1997), 1033–38.

BELOW
4-33. Simultaneous contrast of light and dark.
The same gray rectangle is shown against a uniform white background (below) and against a shaded background (above), where it appears light against dark and dark against a light. The illusion is produced by simultaneous contrast: when light falls on a neuron in the retina, the neuron not only fires but also inhibits the firing of neurons surrounding it. This ability of a neuron to disable its neighbors is called *lateral inhibition*—it acts sideways (laterally) across the retina. Evolution favored lateral inhibition because it improves vision by making forms stand out—lighter in a dark environment, and darker in a light environment.

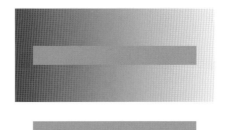

4-34. Three-color projection apparatus, ca. 1900. National Science and Media Museum, London.

This projector is based on the same principle as James Clerk Maxwell's projector. Using this projector, the English chemist William Abney took a portrait photograph by making three black-and-white transparencies on glass plates using green, red, and blue filters and then projected them through green, red, and blue lenses onto a screen, where they were superimposed, creating a color photograph.

Color Photography

Since the invention of photography in the 1830s, researchers had sought chemicals that would respond to different wavelengths of light and produce a color image. After learning of Helmholtz's three-receptor theory of color vision, the Scottish physicist James Clerk Maxwell reasoned that if the eye perceives all hues by combining information from three color receptors, then a color photograph can be produced by recording a scene using a red, a green, and a blue filter and then superimposing the three monochrome images. Maxwell collaborated with the photographer Thomas Sutton, and in 1861 they made the breakthrough to the mechanical production of a color image by projecting a red, green, and blue image of a colorful Scottish tartan ribbon, to the delight of Maxwell's audience at the Royal Institution (plate 4-34).

Visitors to the 1863 Salon des Refusés (the Paris art exhibition of works refused [*refusés*] by the jury of the official Salon) could see color photographic prints based on Maxwell's method by Claude Niépce de Saint-Victor (nephew of Nicéphore Niépce), which were shown only at half-hour intervals to preserve the color. Permanently fixing a color print was not solved until Hermann Vogel developed photosensitive dyes in 1873.

Landscape Painting in France

During the Romantic era in Germany, England, and the United States, the leading artists (Caspar David Friedrich, J. M. W. Turner, Frederic Church) were landscape painters, but in France landscape ranked very low. During the sixteenth and seventeenth centuries, French artists aspired to do history painting, illustrations of Greek and Roman history and mythology. French art students learned to draw idealized anatomy from plaster casts of ancient statues at the Académie Royale de Peinture et de Sculpture in Paris, and they submitted their art to a jury in the hope of being included in the annual Salon exhibition. Acceptance gave the young artist a chance; rejection meant one's brief career was over. French landscapists who hoped to succeed, like Claude Lorrain, moved to Italy and painted idealized, timeless views of the Roman countryside with references to the classical past (plate 4-35).

The first prize in painting at the Salon exhibition was the Prix de Rome for history painting, a postgraduate fellowship to study in Rome, where the classical statues and ruins could be viewed firsthand. In response to requests from landscape painters, in 1817 the Académie Royale began awarding a Prix de Rome for "historical landscape," natural scenes that included a historical vignette. In the 1850s several landscape artists, including Jean-François Millet, rebelled against the academy; rather than go to Rome and depict ancient stories, they settled in the village of Barbizon near the Fontainebleau Forest and painted modern life in France. The next generation of landscapists painted *en plein air* and, informed by the three-receptor theory of color vision, they created Impressionism.

4-35. Claude Lorrain (French, 1600–1682), *Landscape with Nymph and Satyr Dancing*, ca. 1641. Oil on canvas, 39 × 52⅜ in. (99.6 × 133 cm). Toledo Museum of Art, Toledo, Ohio, purchased with funds from the Libbey Endowment, gift of Edward Drummond Libbey, 1949.170.

Impressionism

In the 1870s, Claude Monet and Pierre-Auguste Renoir followed in the footsteps of Barbizon artists and painted what they saw around them—trees, hills, and sky. They also conceptualized painting in terms of Helmholtz's theory of vision, in which color and form are not in the world but created in the mind. Monet and Renoir turned their attention inward and recorded their subjective experience of light, resulting in a new art of observation.

According to Helmholtz, perceiving form is learned from experience, and geometry is not innate; indeed, he declared that there was nothing irrational about a space that violates the axioms of geometry developed in the fourth century BC by the Greek mathemetician Euclid (the first non-Euclidean geometry had been published in Moscow in 1826). Thus began the rapid erosion of Renaissance perspective in Western art, and Impressionism became a prime example of the insight of the German art historian Erwin Panofsky: perspective is not a depiction of the world but a "symbolic form" expressing one's concept of the world.[20] Quattrocento painters understood the picture plane as a window through which the viewer looks at an extension of real space into an illusory space. Linear perspective made artists conscious of the viewpoint (in front of the picture plane) as well as the illusion of a natural world "out there" (in back of the picture plane). After Helmholtz described vision as a product of the eye and the brain, the Impressionists, still pursuing the goal of accurate observation, created a new symbolic form—a physiological perspective—in which the picture plane was understood as an opaque surface on which to record their subjective response to light. When the next generation of Impressionists sought to structure the myriad colorful daubs and dashes of Monet's canvases, Paul Cézanne imposed an order derived not

4-36. Claude Monet (French, 1840–1926), *Coquelicots* [Poppy field], 1873. Oil on canvas, 19⅝ × 29⅝ in. (50 × 65 cm). Musée d'Orsay, Paris.

By "modernity" I mean the transitory, the fleeting, the contingent, the half of art whose other half is the eternal and the immutable.

Charles Baudelaire,
The Painter of Modern Life, 1860

from volumes in Euclidean geometry but from his subjective experience of space, from his lived perspective.

In the 1870s, Monet painted *Coquelicots* (Poppy field; plate 4-36) with small, varied brushstrokes in a palette of warm and cool colors, rendering the red poppies in the green field. In *Camille Monet in the Garden at the House in Argenteuil* (plate 4-1, chapter frontispiece), sunlight is suggested by thick strokes of pale hues on the woman's skirt. In Romantic landscape painting, light flooding from the skies was a spiritual metaphor for divinity coming from the heavens above, but after the adoption of the scientific worldview, Impressionist artists gave light (*éclairage* in French) secular associations to enlightenment (*éclaircissement*). Monet's sunlight is not eternal but flickering; it falls on a woman moving through a garden.

The immediacy of Monet's style was noted by contemporary art critics: "Claude Monet has succeeded in fixing fleeting impressions that his predecessors had neglected or considered impossible to render with the brush. The thousand nuances taken on by water of the sea and the rivers, the play of light in the clouds, the brilliantly colored flowers, and the dappled reflections of foliage in the rays of a burning sun have been

4-37. Pierre-Auguste Renoir (French, 1841–1919), *Dance at the Moulin de la Galette*, 1876. Oil on canvas, 52 × 69 in. (131 × 175 cm). Musée d'Orsay in Paris.

seized by him in all their truth."[21] French critics understood Impressionism in terms of the new theory of vision: "Proceeding from intuition to intuition, [the Impressionists] have little by little succeeded in breaking down sunlight into rays, its elements, and in reconstituting its unity by means of the general harmony of spectral colors that they spread out on their canvases. From the point of view of sensitivity of the eye, of subtle penetration of the art of color, it is a completely extraordinary result. The smartest physicist could never accomplish their analysis of light."[22]

Helmholtz's theory of vision was widely known in Paris from the late 1850s, in both the science community and the art world. Diego Martelli, a Florentine writer associated with the Italian avant-garde painters the Macchiaioli (from *macchia*, Italian for "patch" or "spot"), frequented Paris in the 1860s and '70s, when he befriended Degas and acquired Brücke's *Principes scientifiques* (1878). Brücke's Helmholtzian outlook is reflected in Martelli's explanation of the Impressionists to his countrymen: "Impressionism is not only a revolution in the field of thought, but also a physiological revolution of the human eye. It is a new theory that depends on a different mode of perceiving the sensation of light."[23]

ABOVE

4-38. Claude Monet (French, 1840–1926), *Grainstack (Sunset)*, 1891. Oil on canvas, 28⅞ × 36½ in. (73.3 × 92.6 cm). Museum of Fine Arts, Boston. Juliana Cheney Edwards Collection, 25.112.

OPPOSITE TOP

4-39. Claude Monet (French, 1840–1926), *The Rose Path, Giverny*, 1920–22. Oil on canvas, 35 × 39⅜ in. (89 × 100 cm). Musée Marmottan Monet, Paris.

Rose bushes grow along this path, and climbing roses twist around the trellises overhead. Monet finished this painting when he was eighty-two years old.

OPPOSITE BOTTOM

4-40. Étienne Clémentel (French, 1864–1936), *Monet in His Garden*, ca. 1920. Hand-tinted stereoscopic photograph 1¾ × 4⅛ in. (4.5 × 10.5 cm). Musée d'Orsay, Paris.

Claude Monet stands in front of a bridge in his garden at Giverny.

In *Dance at the Moulin de la Galette* (plate 4-37), Renoir captured his subjective experience of space. The dancers and the dappled sunlight are moving, figures look beyond the edges of the canvas and are cut off at the edge. The composition suggests the scattered, fragmentary, blurred glimpses one gets while moving among people in a park—glimpses that the mind, according to Helmholtz, learns through experience to synthesize into a coherent scene. Historians have disagreed about the extent to which photography influenced Impressionist compositions such as this one: were Monet and Renoir's new pictorial conventions, such as cropped "snapshot" compositions and blurred images, derived from photography or invented by the painters?[24] The dispute misses the source of both—Helmholtz's theory of vision—which gave Niépce and Maxwell the insights they needed to invent photography and led Monet and Renoir to a new art of observation.

Monet understood his eye as being like a camera. He opened the iris in front of the lens of his eye and recorded the light falling on his retina, like a camera that passively records the light falling on its photosensitive surface. Talbot had made this same analogy in his 1844 treatise on photography, in which a scene is drawn—not by an artist's

pencil but by sunlight, the "pencil of nature." Over the years Monet's work evolved, but he never changed his understanding of the eye, going so far as to tell a young artist that he "wished he had been born blind and had suddenly gained his sight [so that he could paint] without knowing what the objects were that he saw before him."[25]

From the 1880s, Monet worked in series and developed a more complex paint application in an effort to depict an atmosphere of light; in his words: "I am seeking 'instantaneity,' above all, the envelope, the same light spread over everything."[26] Like Talbot's photograph of a haystack (see plate 4-6), Monet passively recorded light in his painting *Grainstack (Sunset)* (plate 4-38). Monet suggests the "envelope" of daylight with a complex chromatic and textural web of paint, created by building up layers of warm and cool hues applied in a multitude of strokes. In 1890 Monet, now fifty years old, was prosperous enough to buy a house and land in Giverny, in Normandy, where he built a garden with water-lily ponds, a Japanese bridge, grape arbors, and a rose garden. He painted scenes in his garden in the Impressionist style until his death, in 1926, at eighty-six (plates 4-39 and 4-40).

In 1883 the young French poet Jules Laforgue wrote an influential essay, titled "Impressionisme," which he described in a letter to a friend, introducing Impressionism as "a new aesthetics that is consistent with the unconscious mind of von Hartmann, the evolution of Darwin, and the physiology of Helmholtz."[27] In the essay Laforgue wrote: "The Impressionist sees light as bathing everything . . . and the scene is decomposed into a thousand vibrant colors interacting with each other."[28] He stressed the ultimate impossibility of recording "the vision of the painter [with its] fusions of tone, opposing perceptions, imperceptible distractions, subordinant and dominant colors, variations in the force of the three cones one upon the other."[29]

Sketch-Finish Debate

In the French Académie Royale artists were taught to do oil sketches and then finish the painting by blending the colors together in precise detail. Setting up their easels in Paris and the countryside, Monet and Renoir applied unmixed colors—bright yellows, rich purples, brilliant reds—in loose brushstrokes. The French academic critic's biggest complaint about the work of Monet and Renoir was, *Ce n'est pas fini!* (It's not finished!). Mocking Monet's style, one critic quipped, "It's only an impression!" The artists adopted the name as a badge of honor, as in Monet's *Impression: A Sunrise* (1872; Musée Marmottan Monet, Paris).

The French sketch-finish controversy echoes an age-old debate in imperial China, where there were two main painting techniques: meticulous and literati. The meticulous style was practiced by artists such as Yin Hong, a Ming dynasty court painter who painted colorful landscapes with every petal and feather executed in fine detail (plate 4-41). Chinese gentlemen who were educated to be scholars—literati—such as

4-41. Yin Hong (Chinese, active ca. 1500), *Birds Gather under the Spring Willow*, ca. 1500. Hanging scroll, ink and color on silk, 94½ × 77 in. (240 × 195.5 cm). The Cleveland Museum of Art, purchase from the J. H. Wade Fund, 74.31.

the fourteenth-century artist Ni Zan, painted freehand in a loose style (plate 4-42). Living in the countryside, Ni Zan painted austere scenes with black ink on silk in rapid brushstrokes. Like the Barbizon artists and the Impressionists, who didn't submit their paintings to academy exhibitions, the literati scorned meticulous court painting and viewed their art as free expression. According to tradition, Ni Zan said: 'What I call painting is the joy of careless sketching with a brush. I do not seek formal likeness but paint simply for my own delight.' Recognizing an affinity of the literati with the Impressionists, the contemporary Chinese artist Zhang Hongtu painted a landscape that combines the styles of Ni Zan and Monet (plate 4-43).

• • •

By 1900 most educated Parisians professed some kind of transformism, but there was no Darwinian revolution in France because most biologists did not accept the theory of evolution by natural selection. French artists' exploration of the invisible was limited to what they saw through a microscope—the imitation of nature at a smaller scale. Instead, French artists excelled in exploring the visible; the Impressionists created a new symbolic form that embodies Helmholtz's theory of vision: the physiological picture plane—an opaque surface covered with colors and forms symbolizing subjective experience.

In Germany, Darwin was embraced, and the theory of evolution by natural selection merged with German Romantic pantheism, producing a powerful vision of spiritual evolution. Fin-de-siècle German scientists led the exploration of the full implications of the new scientific worldview, and the German mystical, pantheist reformulation of Darwin's core idea—nature is a web of dynamic forces without a predetermined purpose or meaning—provided the basis for abstract art. Jugendstil designers created decorative patterns to express the blind forces of nature, and soon artists in Munich and Moscow were painting completely non-objective canvases.

OPPOSITE LEFT

4-42. Ni Zan (Chinese, 1301–74), *Landscape*, 1372. Ink and wash on paper, 29⅜ × 14 in. (74.7 × 35.5 cm). National Palace Museum, Taipei.

Inscription (translation by Jiajun Liu):

1372, 5th, Lunar July. Written by Lingsheng [Ni Zan's courtesy name, which is a name given at adulthood in addition to the birth name].
Spring wind brings the apricot blossom to my room;
Although my room is narrow and small, here I live pleasantly.
A golden fish flits and dives in the water;
A colorful bird rests on bamboo near the stream.
Talking elegantly and writing beautifully,
Lifting his black gauze cap under which long white hair dangles in the wind,
Mr. Zhongren is a noble man who does not care about wealth and honor.
Those quacks who dishonestly claim to have knowledge are unworthy compared to him.

After this poem there is a paragraph, also written by Ni Zan.

Year of Jiayin (1374), Boxuan [Ni Zan's friend] *brought this painting back to me and asked if I could write a poem for his friend, Mr. Zhongren, who is a medical specialist, because he wanted to give this painting to Mr. Zhongren as a present. Xi Mountain is my hometown, and Rongxi Studio is the place where Mr. Zhongren lives at his leisure. One day I will come back to my hometown, go to Rongxi Studio with a bottle of rice wine and show this painting to Mr. Zhongren as a celebration of his birthday. I hope I can fulfill this wish. Written by Lingsheng* [Ni Zan's courtesy name].

OPPOSITE RIGHT

4-43. Zhang Hongtu (Chinese, born 1943), *Ni Zan—Monet*, 1999–2000. Oil on canvas, 56 × 28 in. (142.2 × 71 cm). Courtesy of the artist.

Inscription [the first column of glyphs on the left] (translation by the artist):

Hongtu remade Ni Zan in the winter of 1999

Zhang Hongtu

5

German Abstract Art of Contemplation

We are at the beginning of a totally new art, an art with forms that mean nothing and remind one of nothing and represent nothing. Yet these forms are able to move our souls so deeply, so strongly, as before only music could do.

August Endell, "The Beauty of Forms and Decorative Art," 1898

IN THE DAYS of Caspar David Friedrich, Germany was a conglomeration of industrially backward cities filled with crumbling Gothic architecture immortalized by the German Romantics. The 1848 revolutions that swept Europe demanding democracy and freedom of the press were suppressed in German lands, but the Frankfurt parliament determined to modernize and unify Germany. After defeating Austria in the Austro-Prussian War (1866) and France in the Franco-Prussian War (1870–71), the statesman Otto von Bismarck declared a German empire—the first *Reich* (German for "empire")—in 1871. By then Dresden, Berlin, Frankfurt, and Munich were the most industrialized cities in Europe.

As industrialists were rejuvenating German cities, scientists were modernizing laboratories and adopting the scientific method that had yielded such extraordinary results in Britain and France. Young researchers scorned the grandiose metaphysical speculations of the Naturphilosophen and declared themselves proponents of materialism and mechanism. Unlike British and French scientists, the Germans were not opposed to theoretical speculation, but they wanted each theory to be practical in the sense that it would be treated as a hypothesis, which makes predictions that can be confirmed (or refuted) by observation and experiment.

When German scientists sought philosophical guidance, they did not look to thinkers of the European Enlightenment such as René Descartes and John Locke but to their own Teutonic tradition—Spinoza and Kant. The leading German scientist of the second half of the nineteenth century, Hermann von Helmholtz, sought to ground Kant's Idealist vision of human knowledge in the physiology laboratory. Kant had presented verbal arguments for the power of the mind to organize sensory experience, and then—in a key shift from philosophy to science—Helmholtz demonstrated in repeatable, observable experiments, how the eye and the ear respond to light and sound, and

5-1. Wassily Kandinsky (Russian, 1866–1944), *Fugue*, 1914. Oil on canvas, 51⅞ × 51⅞ in. (129.5 × 129.5 cm). Fondation Beyeler, Riehen/Basel, Switzerland.

how the brain organizes these neurological impulses in the optical and auditory cortex into seeing objects in the world and hearing patterns of sound. In so doing, Helmholtz shaped the modern intellectual landscape in which neurologists describe the human mind as constructing a world picture from meaning-free signs—nerve impulses. This outlook provided the philosophical underpinnings for abstract, non-objective art.

Darwin in Germany

In an atmosphere of rapid change, the German translation of Darwin's *Origin of Species* appeared in 1860, and translations soon followed of Charles Lyell's *Principles of Geology* and Thomas Huxley's *Evidence as to Man's Place in Nature*. Throughout the 1860s and '70s, German scientists responded with dozens of books on Darwinian evolution. Faced with no real competition from other theories of evolution, German scientists adopted Darwin's natural selection as the master narrative of biology. While France was predominantly Catholic, and England was Anglican, German cities were home to diverse religious sects in the Abrahamic tradition (Lutheran, Evangelical, Catholic, and Jewish), and this proved to be a fluid climate in which people could work out compromises between their scientific and religious convictions. Since there was no unified German church to oppose Darwinism, the new biology caused only minor clerical grumblings.

Popular books on Darwin were written by practicing scientists, following a German tradition in which experts took it upon themselves to explain important discoveries to the public. In the nineteenth and early twentieth century, the key masterpieces of popular science were written in the German language: Humboldt's *Cosmos* (1845–62); Helmholtz's *Recent Progress of the Theory of Vision* (1868)—a nontechnical presentation of highlights from his groundbreaking *Handbook of Physiological Optics* (1867); and Einstein's *Relativity: The Special and General Theory, a Popular Exposition* (1917), a summary of his 1905 and 1915 publications. The authors of these works were teachers in the best sense; they gave lucid exposition, inspired curiosity, and were not dogmatic.

The German scientist who was Darwin's most ardent supporter and popularizer, Ernst Haeckel, was a twenty-six-year-old graduate of medical school when the German translation of *Origin of Species* appeared in 1860. From his first reading, Haeckel devoted himself to research in support of natural selection and to promoting the new biology in Germany (plate 5-2). Writing for a scientific audience, Haeckel published the first comprehensive presentation of Darwin's theory in German, *Generelle Morphologie der Organismen* (General morphology of organisms; 1866), and for the public he wrote *Natürliche Schöpfungsgeschichte* (Natural history of creation; 1868) and *Anthropogenie, oder, Entwicklungsgeschichte des Menschen* (Anthropogeny, or, the history of the development of humans; 1874).

5-2. "Pedigree of Man," in Ernst Haeckel, *Anthropogenie, oder, Entwicklungsgeschichte des Menschen* [Anthropogeny, or, the history of the development of humans] (Leipzig: Engelmann, 1874), trans. as *The Evolution of Man: A Popular Exposition*, no trans. (New York: Appleton, 1879), vol. 2, plate 15, between 188–89.

Since Haeckel was discussing the evolution of humankind, he included only animals in this tree of life, beginning at the bottom with single-celled organisms and then progressing to invertebrates, vertebrates, and finally mammals at the top.

Unlike most German scientists of his day, Haeckel read the works of the Natur-philosophen and he learned to draw and paint; he even considered becoming an artist rather than pursuing a career in science. As a science illustrator Haeckel has been faulted for taking artistic license with his scientific data,[1] but he has earned a place in art history with his illustrations of the new biology. In 1899–1904 Haeckel published the crowning achievement of his aesthetic pursuits, *Kunstformen der Natur* (Art forms in nature), a suite of over 100 lithographs made from his watercolors of organisms (see plates 6-1 and 6-3 in chapter 6, 14-38 in chapter 14, and 15-2 on page 490).

Darwin in Russia

In the 1820s Naturphilosophie was taught at universities in Saint Petersburg and Moscow, where most of the professors were German. After Russian army officers led an uprising in December 1825, the tsar suspected that the study of philosophy had encouraged political subversion, and he banned philosophy from Russian universities. But German Idealism continued to be discussed in small reading groups that met clan-destinely, and from the 1830s to the 1860s they focused on G. W. F. Hegel.

Russia's defeat by Turkey and Great Britain in the Crimean War (1853–56) led to a national reassessment of the country's position in the modern world. In the 1860s news of Darwin's theory began arriving from Germany, and when the Russian translation of *Origin of Species* appeared in 1864, scientists and intellectuals adopted the premise of evolution by natural selection.[2] Leaders of the Russian Orthodox Church, withdrawn from society and focused on a supernatural realm, were unable to stop the tide of secu-lar reform. As in Germany, popularizers appeared from the ranks of leading scientists, including the anatomist N. N. Strakhov and the plant physiologist K. A. Timiriazev, whose 1865 book on Darwin's theory provided a clear exposition of Darwin's thought for generations of Russians.[3] Russians were proud of the gigantic fossil of their Siberian mammoth with its twisted tusks (see plate 3-3 in chapter 3). As Russian intellectuals became familiar with Darwinian evolution, the study of Naturphilosophie and Ideal-ism declined, but as in Germany, these philosophies never disappeared.

Within a decade of the Russian translation of *Origin of Species*, the Polish-born Russian scientist Alexander O. Kovalevsky formulated a description of embryonic development that gave crucial support to Darwin's theory. Kovalevsky corresponded regularly with Darwin, who took serious note of his Russian colleague's work in *The Descent of Man* (1871).[4] Kovalevsky later recalled: "Darwin's theory was received in Russia with profound sympathy. While in Western Europe it met firmly established old traditions which it had first to overcome, in Russia its appearance coincided with the awakening of our society after the Crimean War and here it immediately received the status of full citizenship and ever since has enjoyed widespread popularity."[5]

Experimental Psychology

By the mid-nineteenth century, researchers concerned with the human mind were determined to join the ranks of experimental science rather than rely on philosophical speculation. They no longer described the unity of matter and spirit as pan*theism* (a universe permeated by divinity or a World Soul), but as pan*psychism* (a cosmos imbued with consciousness). They set about proving panpsychism in the laboratory by designing experiments to prove that a physical cause (such as seeing color and form) can have a psychological effect (feeling happy). In so doing they founded the new field of experimental psychology and also established the vocabulary for abstract art: color and form.

The key to understanding the origins of experimental psychology is in an illness suffered by its founder, Gustav Fechner.[6] Educated in Germany when Naturphilosophie was waning, Fechner nevertheless absorbed its outlook, completed a doctorate in medicine in 1822, and did work in physiology. In 1840, while doing experiments on the perception of afterimages, Fechner damaged his retinas (probably by looking at the sun) and found himself unable to read. As his vision deteriorated, he could not tolerate light, and so he wore a blindfold. He fell into a deep depression, lost his appetite, and became disoriented: "My inner self split up as it were in two parts, my self and my thoughts. Both fought with each other. . . . I was mentally occupied, not with thinking, but with banishing and bridling thoughts. I sometimes felt like a rider on a wild horse that has taken off with him, trying to tame it."[7] Fechner suffered in this state—blindfolded—for three years; then, in October 1843, his physical and psychological symptoms eased, which filled him with immense pleasure. He was gradually able to return to his previous life of writing and lecturing. Fechner felt his illness had given him insight into a fundamental law of the psychological world—the pleasure principle (*Lustprinzip*): "Man should, as much as he can, seek to bring the greatest pleasure, the greatest happiness whatsoever into the world."[8] He dedicated himself to proving that there is a link between the psychological and physical worlds, between pleasure (a mental feeling) and the brain (a physical object). According to Fechner, pleasure is the force that drives the mind; pleasure is to the mind as gravity is to matter. Ten years and thousands of experiments later (including classic investigations into the visual perception of color, brightness, and distance), Fechner published his results in *Elements of Psychophysics* (1860), the founding text of experimental psychology.

Fechner's psychophysical law relates the (physical) intensity of a stimulus to the (psychological) threshold of perception.[9] Fechner isolated the elements of vision into basic units of pleasure, just as the chemists of his day, such as Dmitri Mendeleev, isolated the elements of matter. From the complex, ever-changing mosaic of everyday perception, Fechner abstracted color, form, and line as the visual elements that cause pleasure, and he designed tests to measure the quantity of visual pleasure. For example, he placed

An investigator of such penetration as G. T. Fechner held a view on the subject of pleasure and unpleasure which coincides in all essentials with the one that has been forced upon us by psychoanalytic work.

Sigmund Freud, "Beyond the Pleasure Principle," 1920

on a table ten rectangles of varying dimensions but of the same area and color. He then asked subjects to rank the rectangles in order of aesthetic pleasure and tallied the results. Thus, he offered experimental proof that most people get pleasure from rectangles in the middle range, not too square and not too elongated.[10] Realizing that his work had implications for artists, Fechner extended his findings to aesthetics by defining the beauty of an object as those properties that cause pleasure and thus stimulate the mind, which is driven by pleasure (*Vorschule der Aesthetik* [Introduction to aesthetics], 1876).[11]

The Naturphilosophen declared that the human mind is expanding spiritually, and Fechner claimed to have identified the force—pleasure—that makes consciousness expand. After learning from Darwin's work that the human brain is evolving physically, Fechner merged his Romantic mystical pantheism with Darwin's evolutionary worldview into the concept of an evolving consciousness. According to Fechner, an aesthetic experience of beauty—such as the pleasure of looking at bright colors—causes viewers to expand/evolve their minds. In the last decades of the nineteenth century, Fechner's ideas were promoted by Haeckel and the physiologist Wilhelm Wundt, who opened the world's first institute for experimental psychology, in Leipzig, in 1879. Medical students went to Leipzig and returned home to establish laboratories for experimental psychology in Munich, Vienna, Saint Petersburg, and Moscow.

Helmholtz's Theory of Hearing

Helmholtz aimed to balance theoretical speculation and observation of data. He wrote: "Those only can experimentise profitably [are those] who have a clear-sighted knowledge of theory, and know how to propound and pursue the right questions; and, on the other hand, only those who can theorise with advantage [are those] who have great practice in experiments."[12] He criticized French scientists for being too narrowly focused on collecting facts, but he thought German scientists like Fechner and Haeckel erred in the opposite direction by not grounding their theories in laboratory data. Helmholtz's work on vision and hearing is an excellent example of an even balance of theory and observation.

In the 1860s Helmholtz described how the human eye transforms light-waves into nerve impulses (see chapter 4), and he also explained how the ear transforms sound-waves into nerve impulses. It had been known for centuries that the site of hearing is the cochlea (the spiral cavity in the inner ear; its name means "snail shell"), but no one knew how sound was perceived. Helmholtz showed that curled inside the cochlea is a ribbon-thin piece of tissue—the basilar membrane—that vibrates in response to sound-waves (plate 5-3). The membrane is lined with rows of nerve cells, which have hairlike fibers that sense the vibrations and transmit them to the auditory nerve, which in turn relays them to the cortex, where the brain assembles the impulses into the experience of hearing sound. Helmholtz theorized that there is one nerve cell for each

To flee into an ideal world is a false resource of transient success; it only facilitates the play of the adversary. When knowledge only reflects itself, it becomes insubstantial and empty, or resolves into illusions and phrases.

Hermann von Helmholtz, ca. 1870

5-3. Human ear, in Amédée Guillemin, *The Forces of Nature*, trans. Mrs. Norman Lockyer, 3rd ed. (New York: Scribner, Welford, and Armstrong, 1877), 210, fig. 145.

The outer ear canal (*B*) and inner ear are separated by a membrane (the ear drum, *C*), which vibrates (like a drum) when hit by vibrating air (sound-waves). The vibratory motion is amplified by small bones (*E*, *M*), which transfer the oscillations to the basilar membrane, coiled within the shell-shaped cochlea (*H*), causing the membrane to move in resonance with the sound-waves.

pitch that can be discriminated. Guided by this proposal, later scientists showed there are groups of some 24,000 nerve cells associated with each of the 1,500 pitches the ear can discriminate.

In antiquity the Pythagoreans discovered that there is a mathematical basis to music: the main musical consonances—an octave, a fifth, and a fourth—are expressible in ratios of the smallest whole numbers, 1:2, 2:3, and 3:4, respectively. For example, in a string instrument, when one string is twice the length of another, plucking the two strings together produces an octave, which gives the listener an agreeable feeling of finality—a consonance. A combination of tones that is not in a ratio of whole numbers—a dissonance—is experienced by the listener as unresolved. Thus, according to the Pythagorean philosopher Philolaus (*On Nature*, fifth century BC), there is an analogy between musical harmony and the harmony of the soul. Helmholtz demonstrated that when a neuron lining the basilar membrane fires, it causes a sympathetic vibration in neurons that correspond to the pitches in a 1:2, 2:3, and 3:4 ratio. In other words, Helmholtz discovered the physical mechanism for hearing musical consonances; hearing an octave, a fifth, and a fourth as a consonance, as well as the perception of overtones, are innate features of the human ear.

The Analogy of Music and Color

During the Enlightenment, Descartes organized the seven notes of a musical scale into a circle joined at the octave (*Compendium Musicae*, 1650). Newton believed the Pythagorean dictum that the cosmos has a musical structure, and so after he discovered the spectrum, he divided it into seven colors, "proportional to the seven musical tones."[13] Newton then arranged his seven colors on the seven notes in Descartes's musical circle, thereby creating a symbol for the analogy of music and color (plate 5-4).

In *Critique of Judgment* (1790), Kant described aesthetic judgment as knowledge that is incapable of being put into words: "An aesthetic idea cannot become a cognition because it is an intuition (of the imagination) for which an adequate concept cannot be found"; therefore, an aesthetic judgment is inexpressible in language.[14] Kant's successor at the University of Königsberg, Johann Friedrich Herbart, taught his students that for an aesthetic judgment to be pure, it must be based only on what is essential to the work of art (such as the pattern of notes in music) and not on any dispensable feature (such as the lyrics).[15] Inspired by Herbart, the Czech music critic Eduard Hanslick declared: "Music consists of successions and forms of sound, and these alone constitute the subject" (*The Beautiful in Music*, 1854).[16]

As the Romantics' suspicion grew that reason could not describe emotions and intuitions, the Naturphilosophen proclaimed that music could say the unsayable—that words are the language of reason, and music is the language of the heart. In *Aesthetics*

(1835), Hegel maintained that wordless instrumental music is the highest form of art because it does not represent anything in the external world but expresses the subjective life; melodies are "the immediate expression of the inner life," he wrote. "While being obedient to the necessity of harmonic laws, [they] at the same time lift the soul to the apprehension of a higher sphere."[17]

In the late nineteenth century, Jugendstil artists made an analogy between hearing wordless music and seeing patterns of color, citing the expressive power of music because of its privileged position in German Idealist philosophy. Helmholtz showed that hearing and vision are similar because they are both neurological responses to wave patterns, but he also pointed out dissimilarities that exist because of the differing physical structures of the ear and the eye. When a complex sound-wave, such as that produced by a three-note musical chord (plate 5-5), strikes the ear, the nerve cells lining the basilar membrane perform an analysis of the sound-wave and simultaneously send the brain separate nerve impulses for each of the three tones, causing the listener to hear a three-note chord. The nerve cells lining the retina are unable to perform such an analysis on complex colors. When the retina is struck by light from a mixed color such as brown, that brown wavelength stimulates some pattern of cones—some combination of red-blue-green—to fire; these signals are sent to the brain, and the viewer sees one mixed color, brown. In other words, the eye does analyze the wavelengths that compose a mixed color; as Helmholtz stated: "The eye is unable to decompose compound systems of luminous waves, that is, to distinguish compound colors from one another. It experiences them as a single, unanalyzable, simple sensation, that of a mixed color. It is indifferent to the eye whether this mixed color results from a union of fundamental colors or with non-simple ratios of periodic times. The eye has no sense of harmony in the same meaning as the ear. There is no music to the eye."[18] Despite this difference in the receptor mechanisms, as well as the fact that hearing music (unlike seeing color) occurs over time, many artists stress the similarities of hearing and vision, making an analogy between wordless music and abstract art.

A

B

5-6. Ebbinghaus illusion (*a*) and Müller-Lyer illusion (*b*), in Theodor Lipps, *Raumaesthetik, und geometrisch-optische Täuschungen* [Aesthetics of space, and geometric optical illusions] (Leipzig: Barth, 1897), 222 and 237.

The same size circle (in the center of each image, *a*) appears smaller or larger depending on the size of circles surrounding it, because the viewer estimates size by comparison. A line of the same length appears shorter or longer depending on the orientation of the V shapes (*b*). One explanation is that the viewer perceives the line as contracting or expanding; another is that the viewer reads the V shapes as advancing or receding corners because of visual cues learned from seeing rectangular objects. The illusions are named for the German psychologists who discovered them in the late nineteenth century, Hermann Ebbinghaus (1850–1909) and Franz Carl Müller-Lyer (1857–1916).

Abstract Art in Munich in the 1890s: Obrist and Endell

In 1894 Munich became a center for experimental psychology when Theodor Lipps founded the Psychological Institute at the University of Munich, which he modelled after Wilhelm Wundt's institute for experimental psychology in Leipzig. In 1897 Lipps published a study of spatial perception, including discussion of more than 100 optical illusions (plate 5-6).[19] Lipps (following Fechner) developed a theory of aesthetics based on the pleasure principle. Someone looking at a painting or listening to music finds joy in projecting his or her own emotions onto the aesthetic object—feeling empathy for it. Aesthetic experience is pleasurable, according to Lipps, because humans are basically narcissistic; in loving an artwork viewers (by empathetic projection) are loving themselves. In his laboratory experiments, Lipps studied abstract properties of objects; he found that most viewers associate yellow with joy and blue with sorrow, and respond to musical discord or harmony with feelings of struggle or triumph.[20] Lipps (following Helmholtz) also taught that vision and hearing are similar because the eye and ear record light and sound as nerve impulses. During his tenure at the University of Munich, from 1894 to 1914, Lipps gave public lectures on art and published a two-volume treatise, *Aesthetics* (1903–6).

A follower of Lipps, the art historian Wilhelm Worringer, extended the notion of empathy to explain changes in artistic styles. Artists represent the world realistically in eras (such as classical Greece) when they feel at home in—that is, have an empathy for—the everyday world; they abstract from nature during times (such as the Middle Ages) when they are alienated from observed reality (*Abstraktion und Einfühlung* [Abstraction and empathy], 1908).

In fin-de-siècle Germany, designers and architects, like their Art Nouveau colleagues in France, turned to nature in search of a new style. Art Nouveau designers remained based in nature, but Germans quickly moved into a totally non-representational style, Jugendstil (German for "youthful style").[21] Hermann Obrist studied biology and medicine at the University of Heidelberg, then pursued a career in art after seeing objects from the Arts and Crafts movement during a trip to London in 1897. Inspired by Haeckel's illustrations, he designed fountains with a vocabulary of organic forms, especially spirals.[22] Obrist also designed large embroideries, such as *Whiplash (Cyclamen)* (plate 5-7), which has flowers, leaves, and roots connected to a stem that thrashes with energy. The critic Georg Fuchs gave the piece the nickname "whiplash": "This racing movement seems to us like the abrupt, powerful convolution of the lash at the crack of a whip. Now it appears like the image of sudden, powerful elements: a lightning bolt."[23] Reflecting the experimental psychologist's association of abstract lines and colors with feelings, Fuchs described the appeal of Obrist's embroideries: "They fulfill our yearning for a more spiritual, purer, creative art. . . . These embroideries do not intend to 'mean' anything, to say anything . . . they are companions that involve themselves in our feelings."[24]

An apprentice to Obrist, August Endell, came to Munich in 1892 as a philosophy major at the University of Munich, and when Lipps opened the Psychological Institute there in 1894, Endell became his avid student. On the basis of his training in psychology, Endell won a commission to design the Elvira Photography Studio, for which he created a facade ornament and staircase covered with swirling shapes (plates 5-8 and 5-9). In an 1898 treatise on the psychology of perception in the Jugendstil magazine *Dekorative Kunst*, Endell described the power of forms to evoke feelings: "We must learn to look at a tree root, a stem, or a leaf and to see its form—in and of itself—and then to feel any changes in that form. If we can learn how to look at nature this way, a totally new, unfamiliar universe emerges. . . . This is the power of forms. They awaken our inner feelings directly and it is not necessary to posit any other psychological process between forms and feelings."[25] Thus, becoming empathetic (to use Lipps's term) entails a new way of seeing and feeling, as Endell wrote in an 1896 essay, "Um die Schönheit" (About beauty): "We all have to learn how to see in terms of pure colors and forms, and not to think about what they might depict. We also have to learn to feel the emotions that arise from seeing the colors and forms, to let these emotions reach our consciousness."[26] Endell declared that this approach led to an artistic vocabulary that was non-objective and that communicated emotion—like music. He designed the Elvira Studio to awaken feelings in the empathetic viewer, who would approach the swirling form on the facade and then enter

5-7. Hermann Obrist (Swiss, 1863–1927), *Whiplash (Cyclamen)*, ca. 1895. Silk on wool embroidery, 47 × 73 in. (119 × 183 cm). Münchner Stadtmuseum, Sammlung Mode, Textilien, Kostümbibliothek.

5-8. August Endell (German, 1871–1925), Elvira Photography Studio (facade), Munich, 1896–97. Photograph ca. 1900.

The Elvira Photography Studio was built in 1898 for the actress Anita Augspurg and the photographer Sophia Goudstikker, who were women's rights activists. Endell designed the swirling forms of the facade in red and gold stucco on a green background. Endell's decoration was removed in 1937 by the Nazis, and the building was severely damaged in the bombing of Munich in April 1944. Endell's designs survive only in black-and-white photographs.

5-9. August Endell (German, 1871–1925), Elvira Photography Studio (staircase), Munich, 1896–97. Photograph ca. 1900.

Endell designed the metal banister, which features a fixture for electric light bulbs as well as wall and ceiling decor in painted stucco.

5-10. Abstract ornament by Adolf Hölzel (German, 1853–1934), ca. 1900, in Arthur Roessler, *Neu-Dachau: Ludwig Dill, Adolf Hölzel, Arthur Langhammer* (Bielefeld and Leipzig: Velhagen and Klasing, 1905), 115–25.

the foyer and be moved emotionally by curving, undulating lines. Endell stated that the forms are completely abstract: "The depicted object has been eliminated. . . . Art comes forth for the first time absolute and unconditioned."[27]

In Vienna the critic Arthur Roessler advocated an abstract, decorative style based on the power of line: "Just as emotions can be expressed in certain bodily gestures, so too can artistic feelings as inner movement be made visible through line . . . [which is as] significant as symbolic veils, sensuously perceptible expressions of movement of the spirit."[28] Roessler pointed to the Munich artist Adolf Hölzel's decorative patterns as examples (plate 5-10). Hölzel painted genre scenes for public display, but he confided to Roessler in 1905 that for many years he had also drawn completely abstract patterns of lines that "express the inner process of feeling."[29] Roessler recognized the originality of this abstract approach to design, declaring: "The process is at first unconscious and intuitive, and then becomes a conscious expression of the soul and mind. . . . The forms, rhythms, colors and tones are in harmony with the soul."[30]

Naturphilosophie at the Fin-de-Siècle

Scientists sympathetic to Naturphilosophie were heirs to the Pythagorean tradition: nature is infused with consciousness; humankind and the universe are related as microcosm to macrocosm, joined by a common spirit. After Darwin published *Origin of Species*, Fechner and Haeckel updated the monism of the Naturphilosophen by declaring that natural selection provided the mechanism by which monads/atoms combine into ever-greater complexity, first becoming molecules, then cells, and so on to the brain and ultimately the universe. Fechner's experimental psychology showed artists the way to ascend the cosmic ladder to Absolute Spirit by raising the level of their consciousness, rung by rung, powered by the force of pleasure. When considering these doctrines today, it is crucial to keep in mind that for these scientists (Fechner, Haeckel, and their colleagues) the realm of psychology and Absolute Spirit were part of nature—they were *not* supernatural. These spiritual themes were part of fin-de-siècle European science.

Support for Fechner and Haeckel's view that the mind was evolving toward higher levels of consciousness was provided by a Canadian physician and asylum superintendent, Richard Bucke, who published *Cosmic Consciousness: A Study in the Evolution of the Human Mind* in 1901. Bucke declared that aesthetic intuition occurs at the highest level of the mind—cosmic consciousness—and that the most highly evolved brains belong to artists and poets. Having been Walt Whitman's physician and biographer, Bucke believed that the poet had attained cosmic consciousness in his epic *Leaves of Grass* (1855).[31] Bucke's view was especially influential because of his association with Whitman, whose celebration of sexuality had earned him a devoted following among the Russian avant-garde. Mikhail Larionov opened his manifesto "Rayonist Painting" (1913) with a quote from *Leaves of Grass*, which had been translated into Russian two years before.[32]

By 1900 experimental psychology in Germany and Russia had split into two branches, based on a division described by Fechner. *Outer psychophysics* studied the relation between physical stimulus (such as seeing food) and an objective, observable response (such as salivating or reaching for food). Russia became a center of research on outer psychophysics—behaviorism and conditioning (learned reflexes)—after the physiologist Ivan Pavlov performed experiments on the canine digestive system in the 1890s. *Inner psychophysics*, on the other hand, studied the relation between physical stimulus (seeing food) and a subjective response (such as feeling a desire to eat). German researchers pursued inner psychophysics, one example being Lipps's aesthetics of empathy.

The prime characteristic of cosmic consciousness is, as its name implies, a consciousness of the cosmos, that is, of the life and order of the universe. . . . Along with consciousness of the cosmos there occurs an intellectual enlightenment or illumination which alone would place the individual on a new plane of existence—would make him almost a member of a new species.

Richard Bucke,
Cosmic Consciousness: A Study in the Evolution of the Human Mind, 1901

Theosophy

As science developed in the West, so did resistance to its core values—objectivity and rationality. Theosophy was a movement whose founders, Helena Petrovna Blavatsky, a Russian, and Henry Steel Olcott, an American, expressed this resistance by practicing the occult sciences. Theosophists didn't research atoms in a laboratory but intuited them in a séance.[33] Blavatsky was self-educated in Russia, travelled in Europe, and came to the United States in 1873. There, at a séance in Vermont, she met Olcott, who had fought in the Civil War, attended Columbia University in New York, and worked as a lawyer. In 1875, in New York, Blavatsky and Olcott founded the Theosophical Society (*theosophy* is a contraction of *theology* and *philosophy*). As part of their rejection of Western science, Blavatsky and Olcott adopted themes from nineteenth-century German Orientalists such as Friedrich Majer (see chapter 1) and Friedrich Max Müller, translator of *Rig-Veda-Sanhita: The Sacred Hymns of the Brahmans* (1869), who described the Hindu/Buddhist method of attaining knowledge by intuition and the belief that ultimate reality—Brahma—is nothingness.

Blavatsky's Russian disciple Peter Ouspensky adopted Richard Bucke's cosmic consciousness and merged it with the occult notion that beyond the three-dimensional natural world is a fourth, which is neither spatial nor temporal but spiritual—the realm of cosmic consciousness (*The Fourth Dimension*, 1909).[34] Like Bucke, Ouspensky hailed poets and artists for developing their spiritual powers; he taught that one attains the highest state of consciousness by "intuitive logic—the logic of infinity, the logic of ecstasy," in which everything is both "A and not-A, or, Everything is all" (*Tertium Organum*, 1911).[35] The key difference between the scientific concept of an evolving consciousness (Fechner and Haeckel) and occult theosophy (Blavatsky and Ouspensky) is that for the occultists, the highest rung on the evolutionary ladder—cosmic consciousness—is supernatural.

Russian Suprematism: Kandinsky and Malevich

In an atmosphere in Russia that favored outer psychophysics, the Saint Petersburg neurologist Nikolai Kulbin, who specialized in the mechanisms of subliminal sensation,[36] was sympathetic to inner psychophysics and railed against the omission of the spiritual (subjective, psychological) dimension in experiments on Pavlov's dog. Kulbin became friends with avant-garde artists, including Kandinsky, and the neurologist learned to paint, creating Jugenstil landscapes (plate 5-11). Kandinsky was keenly aware of the opposed approaches to psychology within German and Russian science. The German physician Rudolf Virchow was a proponent of outer psychophysics: "I have opened up thousands of corpses, but I never managed to see a soul."[37] Kandinsky began his 1911 essay "Whither the 'New Painting'" by decrying the materialist approach of Virchow

and predicting that the future of art and science belonged to those who looked beyond the visible to explore the invisible, declaring that "a great interest in abstraction is being reborn."[38]

In Saint Petersburg in 1907 Kulbin organized a group of artists and poets under the name Triangle: Art and Psychology. He chose the name "Triangle" because he had concluded from his research that artists project not only their feelings but also geometric figures onto nature: "Painting is the spontaneous projection of conditional signs from the artist's brain onto the picture."[39] Kulbin also published essays in art magazines on the perception of color and music, lending his scientific backing to the analogy: "From my own researches I am convinced that it is possible to determine concords and discords in the spectrum, in the scales of colors, just as in musical scales."[40]

When Kandinsky went to Munich from his native Russia in 1896, he encountered Haeckel's panpsychism, Lipps's experimental psychology, and Endell's theory of a new spiritual (psychological) art based in abstract decoration. Kandinsky maintained close contact with Kulbin's Triangle group, and by 1910 he was moving toward abstraction while still retaining remnants of imagery, as in *Little Pleasures* (plate 5-12). Kandinsky wrote an essay for the catalogue to a 1910 exhibition in the Russian city of Odessa that included works by Mikhail Larionov, Vladimir Tatlin, Gabriele Münter, Alexey von Jawlensky, Kulbin, and himself. Entitled "Form and Content," it explores the theme of art as spiritual communication and presents ideas from contemporary studies of perception, including resonance (the sympathetic vibration of musical tones) and the ability of abstract colors and lines (form) to cause a mental response (content) in the mind. Kulbin read this text on Kandinsky's behalf at the All Russian Convention of Artists in Saint Petersburg in 1911:

- The work of art comprises two elements: the inner and the outer.

- The inner element, taken in isolation, is the emotion in the soul of the artist that causes a corresponding vibration (in material terms, like the note of one musical instrument that causes the corresponding note on another instrument to vibrate in sympathy) in the soul of another person, the receiver. . . .

- The vibration in the soul of the artist must therefore find a material form, a means of expression, which is capable of being picked up by the receiver. This material form is thus the second element, i.e., the external element of the work of art.

- The work of art is the inseparable, indispensable, unavoidable combination of the internal and external elements, i.e., of content and form.[41]

While living in Munich in 1911, Kandinsky attended a performance of Arnold Schoenberg's Second String Quartet, which is an atonal composition. The artist felt

5-11. Nikolai Kulbin (Russian, 1868–1917), *Sea View*, ca. 1905. Oil on canvas, 38¾ × 24¾ in. (97 × 62 cm). State Russian Museum, Saint Petersburg.

An artist who sees that the imitation of natural appearances, however artistic, is not for him, the kind of creative artist who wants to express his own inner world, sees with envy how naturally and easily such goals can be attained in music, the least material of the arts.

Wassily Kandinsky,
Concerning the Spiritual in Art, 1912

an immediate sympathy, because the composer rejected traditional rules for consonance and dissonance to achieve a new expressive form: "Schoenberg combines in his thinking the greatest freedom with the greatest belief in the ordered development of the spirit!"[42] Kandinsky later met Schoenberg, and they discussed their shared goal of breaking with tradition.[43] Once Kandinsky moved into complete abstraction, in 1914, he gave his paintings musical titles, such as *Fugue* (plate 5-1, chapter frontispiece).

Certain poets in Saint Petersburg and Moscow took Fechner and Haeckel's pan-

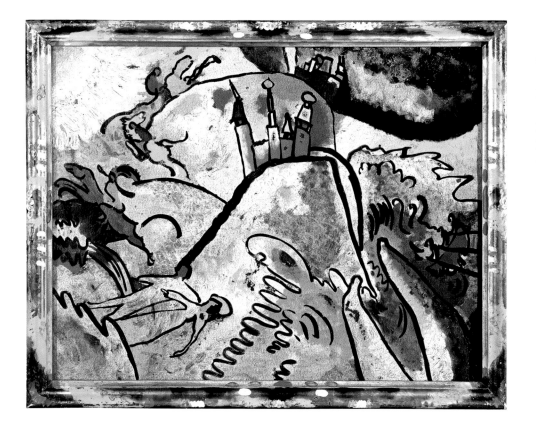

psychism at face value and imagined that they were literally evolving more complex brains in their lifetimes. Unschooled in biology, they evidently didn't understand that mammalian evolution proceeds at a more glacial pace. The poets Velimir Khlebnikov and Alexei Kruchenykh invented new languages to express their alleged expanded consciousness. Khlebnikov, who was educated in mathematics and linguistics, invented a universal language by isolating sounds common to Sanskrit and Slavic languages. For his part Kruchenykh invented the language *zaum* (Russian for "beyond reason"), which he based in part on recordings of indecipherable automatic speech (speaking in tongues) by Russian Orthodox monks, which he knew from a report published in Russian in 1908.[44] Kruchenykh intended zaum not to be irrational but to express a more evolved form of human reason.

Kazimir Malevich was drawn to theosophy: "We rejected reason because another kind of reason has grown in us, which in comparison with what we have rejected can be called 'beyond reason.'"[45] In 1913–15 Malevich gave his paintings titles that refer to the transrational realm of Blavatsky and Ouspensky, but by 1915 he had dropped the theosophical vocabulary and adopted more philosophical terms.[46]

To name his new style, Malevich coined the term *Suprematism*, suggesting its superiority to other avant-garde styles. In 1913, Kruchenykh, Mikhail Matiushin, Malevich, and Khlebnikov collaborated on the libretto, music, and stage sets for the Suprematist performance *Victory over the Sun*, in which they hoped to communicate their evolving consciousness. For the backdrop of the set Malevich drew a completely abstract pattern that precipitated his series of black squares, which included *Black*

For the depiction of the new and the future, completely new words and a new combination of them are necessary.

Alexei Kruchenykh,
New Ways of Words, 1913

5-13. Kazimir Malevich (Russian, 1878–1935), *Suprematist Elements: Squares*, 1923. Pencil on paper, 19¾ × 14¼ in. (50.2 × 35.8 cm). Museum of Modern Art, New York, acquisition of 1935 was confirmed in 1999 by agreement with the Estate of Kazimir Malevich and made possible with funds from Mrs. John Hay Whitney Bequest (by exchange).

Square (1915, State Tretyakov Gallery, Moscow) and *Suprematist Elements: Squares* (plate 5-13). In his treatise *From Cubism to Suprematism in Art* (1915), Malevich described his move into abstraction in terms of numbers with mystical associations: "I have transformed myself into a zero of form and have gone beyond *0* to *1*."[47]

After adopting a completely non-representational vocabulary in 1915, Malevich spoke the language of zaum; his vocabulary was lines and rectangles floating on a flat plane. In 1917 he described making his first completely non-objective painting: "I saw myself in space hidden among the points and colored strips, there, in the middle of them, I depart in the abyss."[48] In the early 1920s Malevich described his expanded consciousness as a spiritual feeling: "The ascent to the heights of non-objective art is arduous and painful. . . . No more 'likeness of reality,' no idealistic images—nothing but a desert! . . . But a blissful sense of liberating non-objectivity drew me forth into the 'desert,' where nothing is real except feeling."[49] Thus, in the first decades of the twentieth century Russian artists were hastening along the same path as the Romantics had trod—the road to the Absolute.

Russian Constructivism: Rodchenko and Tatlin

Contemporary with Suprematism, another style of non-representational art developed in Moscow, created by Aleksandr Rodchenko and Vladimir Tatlin, who based their approach in formalist mathematics, which they knew from literary sources such as the works of the Ukrainian writer and artist David Burliuk. The formalist approach arose in opposition to Euclid's classical geometry, which described Earth and the Platonic Forms. Led by German mathematician David Hilbert, the formalists treated geometry as an arrangement of meaning-free signs (*The Foundations of Geometry*, 1899). In a 1912 essay, Burliuk applied this formalist approach to the visual arts and described painting as meaning-free form and color—a flat surface covered with paint.[50] Inspired by this reductionist approach, Rodchenko painted geometric forms that were increasingly simple, until in 1921 he created the first monochrome painting—one color covering a surface (plate 5-14). The style—Russian Constructivism—was also developed by sculptor Vladimir Tatlin, who assembled geometric shapes cut from sheet metal and held together by wire (*Corner Counter-Relief*, 1914–15).[51]

Rodchenko and Tatlin understood meaning-free, abstract form not as an end in itself but as the means to design meaningful objects. After the Russian Revolution of 1917, Rodchenko applied geometric forms to the design of objects for the new Communist state, such as the model for the Workers' Club for the Soviet section of the 1925 Exposition Internationale des Arts Décoratifs et Industriels Modernes in Paris. Vladimir Lenin appointed Tatlin director of his Plan for Monumental Propaganda,

For the Third International, Tatlin designed three steel-and-glass office buildings within the spiral framework to house the decision-making bodies of the global administration in Moscow. Each building would move in harmony with Earth's daily rotation on its axis and annual revolution around the sun. At the bottom, moving imperceptibly to complete its annual revolution, would be the largest building, in the shape of a cylinder (housing conferences and congress meetings); in the middle, a conical office structure (for executive activities) would rotate monthly; and a cubic glass tower on top (housing an information center constantly broadcasting by telegraph, telephone, radio, and loudspeaker) would rotate daily. On top there was also to be an open-air screen, lit up at night, on which inspirational and news bulletins would be projected; during overcast weather—a frequent occurrence in Moscow—the text would be projected onto the clouds.

so the artist drew plans for the Monument to the Third International (a Communist organization; plate 5-15). Lenin intended the (unbuilt) monument to function as the center of world government after the (presumably imminent) Communist revolution swept the globe. Tatlin designed the external steel framework in the form of a spiral that points to Polaris, the North Star. As Earth rotates on its axis once every twenty-four hours, the constellations in the Northern Hemisphere appear to turn around Polaris—the celestial still point. Metaphorically, Moscow would be the terrestrial still point, with all the nations of the world revolving around it politically.

Color and Form in Motion: Animation

A limitation of the analogy of wordless music to non-objective art is that music occurs over time but a painting is static. Since the development of keyboard instruments in the seventeenth century, there have been attempts to overcome this limitation with color organs, instruments that display colors (by way of colored cards or colored lights), which are co-ordinated to the musical scale (plate 5-17). The Russian composer Alexander Scriabin invented a *clavier à lumières* (French for "keyboard with lights") for his symphony *Prometheus: The Poem of Fire* (1911; plate 5-18).

Disappointed with the dim flashes of colored light they attained with a color organ, the Italian Futurists Arnaldo Ginna and Bruno Corra applied color by hand to film, frame by frame. Happy with the brilliant colors they produced by projecting the film with an arc lamp in a darkened room, they produced five abstract films between 1910 and 1912, which Corra described in his manifesto "Abstract Cinema—Chromatic Music" (1912).[52] Of *L'arcobaleno* (Italian for "rainbow") Corra wrote: "The colors of the rainbow constitute the dominant theme. . . . The screen is initially grey, then in this grey background there gradually appears a very slight agitation of radiant tremors which seem to rise out of the grey depths, like bubbles from a spring, and when they reach the surface they explode and disappear."[53]

TOP

5-16. *Allegretto*, 1945. Film, directed by Oskar Fischinger. Iota Center, Los Angeles.

In this short film, Fischinger animated colorful abstract shapes that moved in tight synchronization to American composer Ralph Granger's pop tune "Radio Dynamics." Fischinger originally designed the film in 1936 for Paramount Studios, but he withdrew it because the company was not committed to color. Eventually, he produced this color version to his satisfaction. Fischinger also worked for Walt Disney Studios, where he animated abstract shapes for J. S. Bach's Toccata and Fugue in D Minor for the movie *Fantasia* (1940). He quit the project after Disney added arms and legs to his abstract shapes, transforming them into cute animals.

BOTTOM

5-17. "Chromatic scale in music and color," in A. W. Rimington, *Colour Music: The Art of Mobile Colour* (London: Hutchison, 1912), opposite 21.

5-18. Alexander Scriabin, *Prometheus: The Poem of Fire*, a symphony for piano, orchestra, and *clavier à lumières*, 1910. Performance Feb. 13, 2010, by the Yale Symphony Orchestra, New Haven, Connecticut. Scriabin assigned colors to the keys of his *clavier à lumières*, and he wrote a part for the instrument in the score of *Prometheus*. In 2010, the Yale Symphony Orchestra performed *Prometheus*, using modern technology to achieve the effect Scriabin described in his notes, including colored lighting of the entire hall. Toshiyuki Shimada conducted the piece, in collaboration with musicologist Anna Gawboy.

In 1926 the German film-maker Oskar Fischinger created an abstract animation to musical accompaniment that was projected on three screens to surround the viewer with both light and sound (*Raumlichtkunst*; Space-light-art). That same year Fischinger collaborated with the Hungarian composer Alexander László in the performance *Farblichtmusik* (Color-light-music), which combined Fischinger's visual music with László's color organ. During World War II, Fischinger immigrated to the United States, where he found employment as an animator in Hollywood, while continuing to create his own abstract films (plate 5-16).

· · ·

5-19. Stanton Macdonald-Wright (American, 1890–1973), *Conception Synchromy*, 1914. Oil on canvas, 36 × 30⅛ in. (91.4 × 76.5 cm). Hirshhorn Museum and Sculpture Garden, Smithsonian Institution, Washington, DC, gift of Joseph H. Hirshhorn, 1966.

BELOW

5-20. Paul Klee (Swiss, 1879–1940), *Drawing in Two Voices*, 1921–22. Paul-Klee-Stiftung, Kunstmuseum, Bern, Switzerland.

OPPOSITE

5-21. Toshio Iwai (Japanese, born 1962), *Piano—As Image Media*, 1995. Installation with altered piano. Courtesy of the artist.

Thus non-objective art emerged in Germany from ideas associated with German Idealism, experimental psychology, the theory of evolution, and the analogy of music to color, which became common wherever there was abstract art. Paul Klee, son of a music teacher in Bern, Switzerland, trained as a violinist and considered a concert career before pursuing the visual arts. For his students at the Bauhaus, Klee demonstrated the linear translation of a musical composition in *Drawing in Two Voices* (plate 5-20). In the United States in 1912, painters Stanton Macdonald-Wright and Morgan Russell collaborated on painting with color harmonies, which they named *Synchromism* (a contraction of *synesthesia* and *chroma*; plate 5-19). In the 1990s Japanese video artist Toshio Iwai created a music-color installation: the viewer enters a darkened room, in the center of which is a grand piano with a computer mouse sitting on a stand in front of the keyboard (plate 5-21). When the viewer moves the mouse, the piano keys move, emitting sound and colored light, which flashes on a scrim. As the room returns to darkness and silence, the viewer is left with an echo and an afterimage.

Biology and Art at the Fin-de-Siècle

All my originality consists in bringing fantastic beings to life by making them plausible, and, as much as possible, in putting the logic of the visible at the service of the invisible.

Odilon Redon, journal entry, 1909

THE NINETEENTH CENTURY saw major discoveries in the life sciences: evolution by natural selection, germ theory of disease, physiology of vision and hearing, and experimental psychology. The aesthetic impact of these discoveries crested at the fin-de-siècle in Art Nouveau, Georges Seurat, Vincent van Gogh, and Symbolism.

Art Nouveau

Louis Pasteur's germ theory of disease encouraged cleanliness to prevent the spread of infection, which led to a hygiene movement in the late nineteenth century. French architects and designers created a new design aesthetic, Art Nouveau (French for "new art"), with open, airy spaces that were easy to clean and ventilate. Gone were thick carpets and heavy drapes, which were home to invisible pathogens. In Brussels, Victor Horta designed Tassel House and all its furnishings based on natural motifs that he abstracted to simple lines and forms. One enters the townhouse into a foyer filled with energetic lines suggesting flagella, jellyfish, neurons, and vines (plates 6-1 and 6-2).

Enthusiasm for Art Nouveau peaked in 1900 at the Exposition Universelle (world's fair) in Paris, where viewers visited a pavilion with Art Nouveau furniture built for Siegfried Bing, gallery director of the Maison de l'Art Nouveau in Paris. Architect René Binet modelled the main entry portal to the fair on a radiolarian (a microscopic creature with a striking crystalline exoskeleton), which Binet knew from Ernst Haeckel's illustrations in a field report from the 1880s, reprinted in his *Kunstformen der Natur* (Art forms in nature; plates 6-3 and 6-5).[1] In Binet's book *Esquisses décoratives* (Decorative sketches; 1902), he described how he was inspired by viewing coral and marine microorganisms through a microscope (plate 6-4).

6-1. *Desmonema*, in Ernst Haeckel, *Kunstformen der Natur* [Art forms in nature] (Leipzig: Bibliographisches Institut, 1899–1904), plate 8. University of North Carolina at Chapel Hill.

Desmonema is a genus of jellyfish.

OPPOSITE
6-2. Victor Horta (Belgian, 1861–1947), Tassel House (entrance foyer), Brussels, 1893–95.

LEFT
6-3. *Calocyclas*, in Ernst Haeckel, *Kunstformen der Natur* [Art forms in nature] (Leipzig: Bibliographisches Institut, 1899–1904), plate 31. University of North Carolina at Chapel Hill.

In Brussels the architect Henry van de Velde considered the whole building as an organism and decorated his architecture with sinuous lines that seemed to grow out of the building as opposed to being applied to its surface. Van de Velde was invited by Bing to come to Paris and design Maison de l'Art Nouveau, which van de Velde transformed into a jungle of undulating lines covering the walls, lit by lamps designed by Louis Comfort Tiffany. When the Maison opened in Paris in 1895, it became the standard of Art Nouveau architecture. In Chicago, architect Louis Sullivan decorated his buildings with patterns based on vegetation (plate 6-7). A lifelong student of botany, Sullivan designed buildings to fit their site as plants evolve in response to their environment. Sullivan built some of the world's first skyscrapers (plate 6-6) and wrote the slogan of organic architecture: "form follows function."[2]

I discard the flower and leaf but keep the stalk.

Victor Horta, ca. 1895

6-4. Coral and colonies of *Bryozoa* (marine microorganisms), in René Binet, *Esquisses décoratives* [Decorative sketches] (Paris: Librairie centrale des Beaux-Arts, 1902), 7 and 9.

The architect René Binet drew these specimens after observing them through a microscope.

6-5. René Binet (French, 1866–1911), entrance portal to the Exposition Universelle (world's fair), Paris, 1900. Photograph. National Gallery of Art, Washington, DC.

6-6. Louis Sullivan (American, 1856–1924) and Dankmar Adler (German-born American, 1844–1900), Old Chicago Stock Exchange (1893–94), Chicago, 1894. Photograph. Cornell University Library, A. D. White Architectural Photographs.

Most of Chicago was destroyed by fire in 1871, and so the current city was begun during the era of early skyscraper construction. It was the building boom following the great fire that brought Louis Sullivan to Chicago.

6-7. "Fantasy, a Study of Curves in Three Dimensions," in Louis Sullivan, *A System of Architectural Ornament According with a Philosophy of Man's Powers* (New York: Press of the American Institute of Architects, 1924), plate 14. Art and Architecture Division, The New York Public Library. Astor, Lenox, and Tilden Foundations.

Life in the Deep Sea

After Darwin declared that the first plants and animals evolved in the sea, British biologists turned their attention to the ocean in search of the origin of life. Plants and algae are at the bottom of the food chain, and single-celled blue-green algae (today called *cyanobacteria*), as well as multicelled green plants, grow only in the presence of sunlight. Thus biologists assumed that there was life in the ocean only as far down as sunlight penetrates, which is about 200 feet (60 meters); it seemed impossible that anything could live at the bottom of the ocean, in total darkness, extreme cold, and intense pressure.

The Scottish zoologist C. Wyville Thomson became interested in sea creatures in connection with the first comprehensive charts of ocean currents, which were made in the 1850s by an American naval officer, Matthew Maury, who mapped the ocean floor as part of the American effort to lay a telegraph cable across the Atlantic (see plates 8-26 and 8-29 in chapter 8). During the project, the workers at sea occasionally pulled up a piece of cable, and they were surprised to find that, no matter how deep it had been, plants and animals were always clinging to it. Hearing these tales, Thomson sailed off the coast of England in 1868 and dredged up a familiar starfish from 2,500 feet (762 meters), but from lower depths, of around 4,000 feet (1,220 meters), he pulled up animals he had never seen before—"living fossils" (plate 6-9). Thomson concluded that there was no lower limit to life in the sea; all the remains from the alga-based food chain eventually sink to the ocean floor and provide nourishment all the way down. (Biologists later discovered a source of energy in the ocean floor—hydrothermal vents; see chapter 14.)

Fired with enthusiasm to explore ocean life, Thomson talked the British navy into giving him a ship and a crew for a three-and-a-half-year, round-the-world scientific expedition to study the chemistry, geology, and biology of the seven seas. In December 1872 Thomson set sail with a team of scientists on HMS *Challenger*. In their deepest dredge they brought up living specimens from an unprecedented depth of 18,373 feet (3.5 miles/5.6 kilometers). The ship was outfitted with natural history and chemistry laboratories, and the scientists catalogued and preserved in jars of alcohol all the specimens they discovered. From each port they shipped crates of specimens back to Edinburgh, where they were divided up and sent on to scientists such as Haeckel, who catalogued and drew specimens of one of his specialties, the Radiolaria, which inspired the architect René Binet. The report of the *Challenger* expedition documented thousands of marine species in fifty volumes containing 30,000 pages (plates 6-8 and 6-10).

As reports of the mission appeared in the science press, the public went to aquariums to learn about the mysterious creatures from the deep (plate 6-11). In *Vingt Mille Lieues sous les mers* (Twenty thousand leagues under the sea), Jules Verne took readers on an underwater voyage to meet Nemo (Latin for "nobody"), an early modern anti-hero who lives in a submarine because he has no homeland (plate 6-12).

Man, no one has sounded
the depths of your abyss;
Sea, no one knows your
intimate riches,
Both of you so jealously
guard your secrets!

Charles Baudelaire,
"Man and the Sea," 1857

6-8. Siphonophorae, in Ernst Haeckel's entry in *Report on the Scientific Results of the Voyage of HMS* Challenger *during the Years 1873–76*, vol. 28 (Edinburgh: Her Majesty's Stationery Office, 1880–95), 28, plate 24. Special Collections, Glenn G. Bartle Library, Binghamton University, State University of New York.

Siphonophorae live in total darkness at great depths. Since they do not need protection from light, their external membrane and internal organs lack pigment.

6-9. *Rossella velata*, a species of sponge dredged from 651 fathoms (3,906 ft./1,190 m), in C. Wyville Thomson, *The Depths of the Sea* (London: Macmillan, 1873), 419.

6-10. *Lophius naresi*, in *Report on the Scientific Results of the Voyage of HMS* Challenger *during the Years 1873–76*, *Zoology*, vol. 1, by Albert Günther (Edinburgh: Her Majesty's Stationery Office, 1880–95), plate 25. Woods Hole Oceanographic Institution, Massachusetts.

From March 4 to 10, 1875, HMS *Challenger* visited the Admiralty Islands, north of New Guinea in the South Pacific Ocean. Previously unknown to science, several *Lophius naresi* were found at a depth of 152 fathoms (912 feet/278 meters); they are a type of anglerfish measuring up to 8 inches (20.3 centimeters) long, with "head and body covered with long fringes" (56).

6-11. Aquarium at Le Havre, France, *Illustrated London News*, July 4, 1868, 21.

Located on the northeastern coast of France, this aquarium's exterior (*a*) was designed to suggest an exotic natural dwelling. The design of the aquarium's interior (*b*), with stalactites hanging from the ceiling, sand covering the floor, and tanks of swimming fish along the perimeter, gives visitors the impression that they are in an underwater cave. The illusion was heightened by pools filled with crustaceans, mollusks, reptiles, and seaweed.

A

B

Bizarre and beautiful sea life inspired Art Nouveau artist Émile Gallé. Son of a glass and porcelain manufacturer in Nancy, France, Gallé travelled to Weimar, Germany, in the 1860s to study philosophy, botany, and geology, returning home after the outbreak of the Franco-Prussian War in 1870. When his father retired in 1874, Gallé took over the family factory and continued his research in botany, becoming editor of the journal of the Lorraine Horticulture Society in 1880. Gallé used glass to suggest the sea, translucent at the top and opaque at the bottom. In *Deep Sea* (plate 6-13), he created a vase in red, blue, and black glass, with colorless, transparent fish and sponges that live in darkness at the bottom of the ocean. On the occasion of Louis Pasteur's seventieth birthday in 1892, Gallé made a vessel (Musée Pasteur, Paris) inscribed with the names of bacteria isolated by Pasteur and the line: "May this cooled crystal preserve the reflection of your flame."[3]

These secrets of the ocean are brought forth to us by brave deep-sea divers. They empty their marine harvest which passes from the laboratory to the studios of decorative art and to the museums of models. They draw and publish these undreamed-of materials for the artist: enamels and cameos from the sea.

Émile Gallé, *Decorative Art*, 1889

Scientific Aesthetics: Seurat

In the 1880s Georges Seurat and his associates—the Neo-Impressionists—determined to improve Impressionism. Claude Monet's recording of light led to the dissolution of form, which the Neo-Impressionists vowed to restore by incorporating scientific findings about light, vision, and experimental psychology.[4] The Impressionists had recorded nature's fleeting appearances with pigments, but the Neo-Impressionists would increase the luminosity of their canvases by following the dictates of American physicist Ogden N. Rood, who described how they could "paint with light." According to Rood, light is the key to capturing nature: "Nature and the painter actually employ, in the end, exactly the same means in acting on the eye of the beholder. The point, seemingly so trite, is touched upon, as an idea seems to prevail in the minds of many persons that Nature paints always with light, while the artist is limited to pigments:

in point of fact, both paint with light."[5] In 1881 Georges Seurat acquired the French translation of Rood's book (plate 6-14) and three years later began painting *A Sunday on La Grande Jatte—1884* (plate 6-15).

What does it mean to paint with light? Rood described optical mixture of color: "the custom of placing a quantity of small dots of two colors very near each other, and allowing them to be blended by the eye placed at the proper distance."[6] Viewing a painting is an example of optical mixture, as Rood described, and so is looking at a color reproduction of a painting in a book. In color printing, the original image is separated into patterns of dots on four

screens, one for each printer's ink (cyan [blue-green], magenta, yellow, and black),[7] which are printed on white paper. Similarly, optical mixture occurs when looking at a picture on a computer screen, which is composed of tiny points of light—pixels—in red, green, and blue. In all three cases—a painting, color printing, and a computer screen—optical mixture occurs only if the dots of color are the correct size for the viewing position, otherwise the image looks "pixelated."

On the occasion of the eighth Impressionist exhibition, in which Seurat unveiled *La Grande Jatte*, the critic Félix Fénéon declared that the Neo-Impressionists used optical mixture: "Georges Seurat, Paul Signac, Camille and Lucien Pissarro, Dubois-Pillet divide the tone in a conscious and scientific manner. If you consider a few square centimeters of uniform tone in Monsieur Seurat's *Grande Jatte*, you will find on each centimeter of its surface, in a whirling host of tiny spots, all the elements which make up the tone. . . . Those colors, isolated on the canvas, recombine on the retina: we have, therefore, not a mixture of material colors (pigments), but a mixture of differently colored rays of light."[8]

Both Seurat and Fénéon believed, as the critic stated, "the luminosity of optical mixture is always much greater than that of pigments mixed on a palette."[9] In fact, this is not true.

How luminous an image appears depends on the *source* of the light: *reflected colored light* (light reflected from a colored surface) does not appear as bright as *prismatic colored light* (colored light, such as produced by a prism). For example, Seurat's *La Grande Jatte* and a reproduction of the painting in a book are examples of *reflected color*. Neither looks as bright as a digital image of *La Grande Jatte* on a computer screen, which is composed of *prismatic* color—pixels of colored light. The perception of color is subjective, but one can objectively measure the amount of light coming from a surface with a light meter. Let us suppose that we go to the Art Institute in Chicago and measure the light reflected from

6-14. Ogden N. Rood, *Théorie scientifique des couleurs* [Scientific theory of colors], no trans. (Paris: Germer Baillière, 1881), frontispiece and title page.

Following the color and optical studies of Hermann von Helmholtz, Rood distinguished colored pigment from colored light. In the staircase diagram in the upper left of this frontispiece, Rood illustrates mixtures of the primary hues of pigments (red, yellow, and blue). In the triangle in the lower left, he puts at the vertices the primary hues of light (red, green and blue), which mix to white (center).

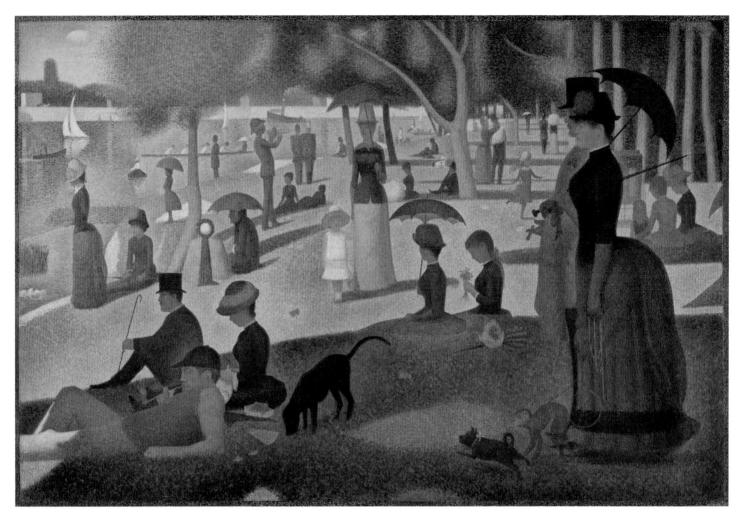

the surface of the actual painting *La Grande Jatte* hanging on the wall. We're measuring *reflected color* and we get a similar result if we measure light reflected from the reproduction of the painting on this page. But if we go to the Art Institute website and look at *La Grande Jatte* on a computer screen, our light meter will record higher luminosity because the screen *generates* light—pixels of *prismatic color*.

A B

Seurat and Fénéon both read about Rood's optical experiments using Maxwell disks, from which they drew the false conclusion that optical mixture yields more luminous color, something Rood never said (see sidebar on page 168). Their error entered art history textbooks and has been taught to students as gospel truth for over a century.[10]

Despite Seurat's fascination with color theory, his painterly instincts took over when he put brush to canvas, and his technique is not at all formulaic. He applied a base layer of paint in a dense thicket of overlapping brushstrokes that follow the contour of the volumes, curving over the form of a body, lying horizontal across the surface of water. In some areas he added an array of dots to encourage optical mixture, as in the dress of the little girl running (in the center of the painting; plate 6-16). He designed the overall composition in terms of Michel-Eugène Chevreul's law of simultaneous contrast of colors—using contrasts of light and dark values, as in the silhouetted man with a cane (lower left), and warm and cool hues, such as the red parasol against a green tree (center). In a drawing for the seated woman with a parasol (center), Seurat captured the subtle play of light (plate 6-17).

Optical mixture works best if the individual dots or brushstrokes are unsaturated hues of a uniform value, such as the flesh tones of the people in *La Grande Jatte*. In *Grammar of Composition* (1867), Charles Blanc described how Eugène Delacroix painted the luminous flesh of a nude figure: "How was this miracle wrought? By the boldness with which Delacroix had slashed the naked back of this figure with a definite green, which partly neutralized by its complement rose, forms with the rose in which it is absorbed a mixed and fresh tone apparent only at a distance, in a word a *resultant* color that is called optical mixture."[11] The experience that Blanc described is typical of viewing flesh painted by a fine colorist such as Delacroix; from a distance the flesh appears as a vibrant unity, but when the viewer steps up close to the canvas, a multicolored surface comes into focus. Blanc's remarks indicate how aware he was that the size of the brushstroke determines whether the artist achieves optical mixture or simultaneous contrast, noting that radiance (*éclat*, a term from Chevreul) could be achieved if green were "sown with orange spots,"[12] as Seurat has done on the green grass in the foreground. Critics have faulted Seurat for such areas, mistakenly assuming that his goal was the optical mixture of every last dot.[13] After completing *La Grand Jatte* in 1886, Seurat demonstrated his adherence to Chevreul's law—that the perception of color is affected by its environment—by returning in 1888 and adding a

LEFT

6-18. Charles Henry (French, 1859–1926), "Rapporteur esthétique" [Aesthetic protractor], folded and inserted into a sleeve in the back cover of Henry's book *Rapporteur esthétique* (Paris: Séguin, 1888). Printed on linen, width of base 13½ in. (34.3 cm).

Charles Henry designed this tool for artists and designers to use to determine which angles are "rhythmic" (*rhythmique*). As on a regular protractor, degrees are marked, in boldface, from 0 to 180, from left to right and right to left, crossing at 90 degrees at the top. Henry added two "ladders" of numerals running along the inner and outer edges, written on alternating sides of the rungs for readability. Beginning at the bottom of the inner ladder on the left, the numbers begin, 2, 2.005, 2.01, 2.017, 2.02, . . . reaching the numeral 4 at the top, then descending to 720 at the end of the inner circle on the right. The same series begins at the bottom of the outer ladder on the right and ends on the left. The series refers to a chart in which Henry has encoded composite numbers and prime numbers: "Thus it will be the number 2^n or prime numbers of the form $2^n + 2^0$ or $2^n + 1$, or the product of these numbers, that will mark the rhythmic sections of the circumference [*Ce seront donc les nombres 2^n ou les nombres premiers de la forme $2^n + 2^0$ ou $2^n + 1$ ou les produits de ces nombres qui marqueront les sections rythmiques de la circonférence*]" (10). He went on to give examples of rhythmic angles (plate 6-19a) as opposed to non-rhythmic (plate 6-19b), proclamations based on his personal taste. There is no experimental data supporting his claims.

RIGHT

6-19. Rhythmic and non-rhythmic angles, in Charles Henry, *Rapporteur esthétique* [Aesthetic protractor], 10, figs. 4 and 5.

COLOR VISION EXPERIMENTS WITH MAXWELL DISKS

In the 1850s, James Clerk Maxwell invented an apparatus to use to investigate color vision. His device was a top (similar to a child's toy); this hand-cranked version (plate 6-20) is a type also used to study vision by William Henry Fox Talbot and Isaac Newton (compare the device shown on the table in plate 1-8 in chapter 1). Two interlocking pieces of paper—known as Maxwell disks (plate 6-21c), colored *jaune* (yellow) and *bleu* (blue)—are mounted on the device and then spun at a rate too fast for the eye to discern the two hues, thus producing an optical mixture. In the example in plate 6-21a, a disk is spun that is one-third *rouge* (red) and two-thirds *vert bleu* (greenish blue); light reflects from the spinning disk, falls on the observer's retina, and the viewer sees *gris* (gray) (plate 6-21b). Adjusting the relative proportions of red and greenish blue produces a warmer or cooler gray (James Clerk Maxwell, "Experiments on Color, as Perceived by the Eye," *Transactions of the Royal Society of Edinburgh* 21, pt. 2 [1855], 274–99).

Both Félix Fénéon and Camille Pissarro attest to Georges Seurat's interest in Maxwell disk experiments. Fénéon mentions optical mixtures demonstrated using Maxwell disks in connection with Seurat's *La Grande Jatte* ("Les Impressionnistes" [1886], *Les écrivains devant l'impressionnisme*, ed. Denys Riout [Paris: Macula, 1989], 402–3). Pissarro said Seurat's sources included "the theory of colors discovered by Chevreul, the experiments of Maxwell, and the measurements of O. N. Rood" (Pissarro, letter to Durand-Ruel, Nov. 6, 1886, *Les archives de l'impressionnisme*, ed. L. Venturi [Paris: Durand-Ruel, 1939], 2:24).

The misconception that optical mixture appears more luminous entered the art history literature in 1886 when Félix Fénéon proclaimed: "It is known that the luminosity of optical mixture is always much greater than that of pigments mixed on a palette, as established by Rood in the numerous equations for luminosity" (Fénéon, "Les Impressionnistes" [1886], *Les écrivains*, 402). Fénéon is referring to an experiment in which Rood compared colors mixed on a palette with those mixed optically. Rood painted the center of the disk with a mixture of fifty drops of two colors, *vermillon* (vermilion) and *bleu d'outremer* (ultramarine blue) (plate 6-22). Then, he painted the outer disk half vermilion and half ultramarine. When Rood spun the disk, he perceived the inner disk as gray and the outer disk as reddish purple. He then added a section of black to the outer disk and increased the black band until, when spun, the outer and inner colors appeared the same. He repeated the experiment for nine pairs of colors, in each case adding an area of black until the inner and outer disks appeared the same; he remarked on the large amount of black he added to some outer disks, indicating that optical mixture appears brighter. Rood summarized his results: "These experiments serve, then, to show that the results furnished by the palette cannot be

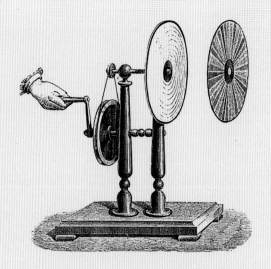

6-20. Apparatus for rotating James Clerk Maxwell's disks, in Amédée Guillemin, *Le Monde physique* [The physical world] (Paris: Hachette, 1882), 2:162.

relied on to guide us in the interpretation or study of the effects in nature depending on the mixture of colored light" (Rood, *Modern Chromatics with Applications to Art and Industry* [1879; repr., New York: Van Nostrand Reinhold, 1973], 149).

Fénéon seized on Rood's remark and declared that Rood had proven the superior luminosity of optical mixture. But Rood's experiment does not establish that all optical mixtures are more luminous; it simply shows, as Rood states, that the mixtures of light and pigment *differ*. In general, optical mixes of colors are more or less luminous than the corresponding pigments, depending on the mix. Rood's sample of nine pairs of colors is small, and more than half include violet. Had Rood chosen other hues, such as yellow and blue, he would have gotten a less luminous (dull gray) optical mixture and a brighter (emerald green) mix on the palette.

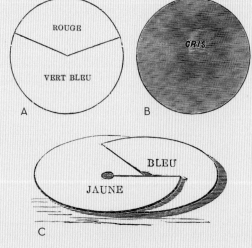

6-21. Maxwell disks *a*, *b*, and *c*, Ogden N. Rood, *Théorie scientifique des couleurs* [Scientific theory of colors], no trans. (Paris: Germer Baillière, 1881), fig. 37, on 90; figs. 47 and 48, on 109.

6-22. Disk for showing the difference between mixing colored light and colored pigment, Rood, *Théorie scientifique des couleurs*, fig. 61, on 123.

painted border so he could control the environment of colors located along the edges.

The Neo-Impressionists also wanted to maximize emotional impact by composing with lines and angles that cause the most pleasure, according to the experimental psychologist Gustav Fechner, author of Fechner's law, which was well known in Parisian art circles in the 1880s.[14] Seurat's source of information about experimental psychology was Charles Henry, a scientific dilettante who worked as a librarian at the Sorbonne, whose work Seurat knew from fellow Neo-Impressionist Paul Signac. In Henry's "Introduction à une esthétique scientifique" (Introduction to a scientific aesthetic, 1885), he restated Fechner's thesis: art's function is to expand and raise the viewer's consciousness through pleasure caused by seeing colors, lines, and forms.[15] Adopting Fechner's association of pleasure with warm hues and upturned lines, Henry invented an "aesthetic protractor," an arcane device used to measure how "rhythmic" a line is (plates 6-18 and 6-19). To make it a studio tool, Henry printed his aesthetic protractor on transparent linen (measuring about 13 inches/34 centimeters across), which he folded and slipped into a pocket in the back cover of his pamphlet *Rapporteur esthétique* (Aesthetic protractor; 1888). Similarly, Blanc suggested associations of upturned lines with happiness (as in a smiling face), horizontal lines with a non-committal expression, and downturned lines with sadness (as in a frown).[16] Seurat used such associations in the design of *Le Chahut* (plate 6-23). He drew the main lines of the composition, such as the dancers' legs and the conductor's baton as well as his mustache, at uplifting 45- to 60-degree angles. Seurat attributed the painting's happy mood to its warm colors and the upward tilt of its lines: "Cheerfulness of *value* is communicated by the dominant light value; of *hue*, by the dominant warm hue; of *line*, by lines above the horizontal."[17]

Along with his aesthetic protractor, Charles Henry published a tool for choosing colors—a color circle—designed by Signac, who used it to construct a portrait of Félix Fénéon (plate 6-24). Signac posed the critic in front of a spiral design from a Japanese print with pleasure-producing upturned forms in warm reds, oranges, and yellows, enlivened by complementary colors.[18] Fénéon celebrates the centerpiece

ABOVE

6-23. Georges Seurat (French, 1859–91), *Le Chahut*, 1889–90. Oil on canvas, 68⅝ × 56¼ in. (171.5 × 140.5 cm). Kröller-Müller Museum, Otterlo, Netherlands.

BELOW

6-24. Paul Signac (French, 1863–1935), *Opus 217. Against the Enamel of a Background Rhythmic with Beats and Angles, Tones and Tints, Portrait of Félix Fénéon in 1890*, 1890. Oil on canvas, 29 × 36½ in. (73.5 × 92.5 cm). Museum of Modern Art, New York, gift of Mr. and Mrs. David Rockefeller.

Signac's convoluted title echoes the obtuse jargon of his hero, Charles Henry (see plate 6-18).

of Henry's "scientific aesthetics"—his color circle—by gesturing with a cyclamen (a flower whose name derives from the Greek for "circle")

Henry, Fénéon, Seurat, and Signac all extracted data from German experimental psychology without the philosophical overview. Seurat's goal in *La Chahut* was to communicate gaiety, but unlike his German and Russian colleagues, he did not imagine happiness as a step on a road to the Absolute; in Paris, pleasure was an end in itself.

Seurat was caught up in the excitement of the science of optics and experimental psychology. He worked intensely for a decade, before his early death, at age thirty-one, from an infectious disease of uncertain origin. His vision of light is captured in his monochrome drawings (plate 6-17).[19] Ever since his brief career in the 1880s, Seurat has been an inspiration to artists who base their approach in science.

Van Gogh, *Japonisme*, and Scientific Buddhism

When Japan opened its ports after 250 years of self-imposed isolation, Japanese statesmen moved quickly to reorganize their government from a pre-industrial, feudal state ruled by the shogun to an empire ruled by a royal family. In 1867 the last shogun, Tokugawa Yoshinobu, resigned, and the Japanese crowned their first modern leader, Emperor Meiji (ruled 1867–1912).

French artists had been familiar with China for centuries, but Japan had been a closed door until the 1850s. When Japanese art reached Europe, it caused a sensation—*Japonisme* (French for "of Japan")—that peaked in Paris in the 1870s. Caught up in the passion for Japanese aesthetics, Vincent van Gogh collected Japanese woodblock prints and copied Utagawa Hiroshige's *Sudden Shower over Shin-Ohashi Bridge and Atake* (plates 6-25 and 6-26).[20] Van Gogh also responded to the Japanese reverence for nature traditionally associated with Zen Buddhism. According to the artist Paul Gauguin, van Gogh read an essay on Buddhism, "Le Bouddhisme en Occident" (Buddhism in the West), in the July 15, 1888, issue of the popular magazine *Revue des deux mondes*.[21] Two months later van Gogh wrote to Gauguin: "I have done a self-portrait in the color of ashes that results from mixing ochre with orange, on a pale ochre background, wearing a reddish-brown garment. Exaggerating my personality, I sought the character of a *bonze* [a Buddhist monk], a worshipper of the eternal Buddha."[22]

During the Meiji restoration of imperial power, leaders in Japan promoted Western learning and culture. Travel restrictions were lifted, and Japanese professionals were encouraged to study in the West. Yūjiro Motora was born in 1858 into a samurai caste, but he was interested in the wider world, so he learned English as a young person. After Meiji assumed power, Motora became interested in Western philosophy and psychology. In 1885 he travelled to the United States and studied psychophysics at Johns Hopkins University in the laboratory of experimental psychologist G. Stanley Hall, with whom he co-authored a paper ("Dermal Sensitiveness to Gradual Pressure

Changes," *American Journal of Psychology*, 1887). In 1888 Motora completed a doctorate in psychology at Johns Hopkins and returned to Japan, where he taught psychology at Tokyo's Imperial University and studied the meditation practices of Zen Buddhism from a Western perspective. In 1895 he spent a week meditating at Engaku-ji, a Zen Buddhist temple in Tokyo. In Zen Buddhism the meditator's goal is to achieve a state of mind free from anger and cravings, in harmony with the world, and feeling compassion for all. To reach this state of mind—Zen—the student's mind is sometimes stimulated by a paradox—a *koan* (Japanese for "material for thought"). Working with a Zen master, Motora meditated on a koan attributed to Hakuin Ekaku: "What is the sound of one hand clapping?" Hakuin, who is the central figure in Japanese Zen Buddhism, was an eighteenth-century monk who established meditation as the path to Zen (nirvana, enlightenment) and did ink drawings (plate 6-27). After many attempts and some direction from the Zen master, Motora was able to give an answer to Hakuin's koan that satisfied the master. Motora went on to compare the Western concept of selfhood—the ego—with personal identity in Eastern thought ("An Essay on Eastern Philosophy: Idea of Ego in Eastern Philosophy," 1905). Motora is an example of the merger of Eastern theology/philosophy with Western science of the mind/psychology that started with Friedrich Schlegel, Friedrich Schelling, and G. W. F. Hegel in the Romantic era and increased dramatically after Japan began communicating with the West. That merger continues today in the art of Zhang Hongtu (plates 6-28 and 6-29).

6-27. Hakuin Ekaku (Japanese, 1685–1768), *Two Blind Men Crossing a Log Bridge*, 18th century. Hanging scroll, ink on paper, 11 × 33 in. (28 × 83.8 cm). Manyo'an Collection, New Orleans.

The inscription reads (translation by Stephen Addiss):

> *Both inner life and the floating worlds*
> * around us*
> *Are like the blind man's round log*
> * bridge—*
> *A mind that can cross over is the best*
> * guide.*

A key event in this cross-cultural exchange of ideas was the first World's Parliament of Religions, a meeting of representatives of major world religions held in connection with the 1893 Chicago world's fair, at which key speakers advocated a merger of science and Eastern thought. The German-born American philosopher Paul Carus organized the event in response to the steep decline in Christianity in the West—the "Victorian crisis of faith"—which was precipitated by Darwin's 1859 publication of *Origin of Species*.

Anagarika Dharmapala, from Ceylon (today Sri Lanka), an island off the southern tip of India, stepped up to the podium and proudly presented his World's Parliament lecture, "The World's Debt to Buddha," in which he laid out the tenets of his worldview—scientific Buddhism—declaring that the teachings of Buddha are consistent with the scientific worldview of "the doctrine of evolution as the only true one, with corollary, the law of cause and effect." In Buddhism there is no need for a "Creator" because Buddhists understand the cosmos, Dharmapala explained, "as a continuous process unfolding itself in regular order in obedience to natural laws. We see in it all not a yawning chaos restrained by the constant interference from without of a wise and beneficent external power, but a vast aggregate of original elements perpetually working out their own fresh redistribution in accordance with their own inherent energies." Dharmapala went on to declare: "Buddhism is a scientific religion, inasmuch as it earnestly enjoins that nothing whatsoever be accepted on faith."[23]

His message was reinforced by another speaker, the Japanese Zen Buddhist Soyen Shaku, who gave a lecture titled "The Law of Cause and Effect, as Taught by the Buddha," in which he declared: "Just as a clock moves by itself without any intervention of any external force, so is the progress of the universe."[24]

Paul Carus, who was raised in a fundamentalist Christian home in Germany, gave a lecture in which he described his anguish when he learned a scientific fact that conflicted with the Bible. If one is a fundamentalist, believing man descended from an ape is a ticket to hell: "I have experienced in my heart, as a faithful believer, all the

6-28. Zhang Hongtu (Chinese, born 1943), *Van Gogh—Bodhidharma* [Daruma], 2015. Ink on paper, 35 × 27 in. (89 × 65.6 cm). Courtesy of the artist.

In this double portrait, Zhang merges van Gogh with Hakuin Ekaku's painting of the Bodhidharma (see plate 6-29), a Buddhist monk who lived during the fifth or sixth century and in Japan is known as Daruma. Van Gogh and Bodhidharma/Daruma were both on a spiritual mission: the artist's first career was as a Protestant layman ministering to the poor of Amsterdam; the monk brought Buddhism from India to China, from which it eventually spread to Japan. Zhang's painting also references Hakuin Ekaku, whose painting of blind men crossing a bridge encourages the viewer to overcome "inner life" (the depression that plagued van Gogh) by getting a mental image of the "floating worlds around us" (the log) and moving forward with confidence, feeling one's way.

6-29. Hakuin Ekaku (Japanese, 1685-1768), *Giant Daruma*, 18th century. Hanging scroll, ink on paper, 51½ × 21¾ in. (130.8 × 55.2 cm). Manyo'an Collection, New Orleans.

The inscription reads (translation by Stephen Addiss):

See your own nature and become Buddha.

curses of infidelity and felt the burning flames of damnation." Carus condemned the fundamentalist clergy for inflexibility and for causing educated Christians to suffer in fear: "You who preach such a religion, can you fathom the tortures of a faithful and God-loving soul, when confronted with ample scientific evidence of the untruth of his religious convictions? . . . Do you think the voice of science can be hushed? . . . Whenever there is a soul distorted by a conflict between faith and scientific insight, the latter will, in the long run, always be victorious." He went so far as to say that clergymen who are antagonistic to science are "irreligious."[25]

The lectures by Dharmapala and Soyen gave Carus a vision of scientific Buddhism, and for the next few years he studied Asian religions in depth. Carus edited two journals, *The Open Court*, a monthly magazine about science and religion, and *The Monist*, a quarterly academic journal of philosophy, and served as director of the Open Court Publishing Company, near Chicago. He recruited the young Japanese scholar D. T. Suzuki to do English translations of Zen Buddhist texts, which Carus then published and distributed to a large English-speaking audience. Suzuki also wrote texts popularizing Buddhism and merged the Eastern outlook with Western psychology by emphasizing the control of anger and cravings through breathing exercises and yoga and the attainment of peace and compassion through psychotherapy.

William James, who was professor of philosophy and psychology at Harvard University, attended the World's Parliament, where he entered into dialogue with the Buddhists and the Hindu monk Swami Vivekananda. James then wrote a book in which he declared that knowledge by mystical intuition is the common thread linking world religions (*The Varieties of Religious Experience: A Study in Human Nature*, 1902).

6-30. Odilon Redon (French, 1840–1916), *Les Origines* [Origins], 1883, frontispiece.

Symbolism: Redon and Munch

The aesthetic movement known as Symbolism, at its peak in Europe in the last decades of the nineteenth century, decried the materialistic preoccupations of the era. Wary of science and reason, Symbolists trusted their intuition.

Odilon Redon was a rare French artist who incorporated ideas about the origin of species into his work. In addition to Jean-Baptiste Lamarck's transformism by acquired characteristics and Darwin's evolution by natural selection, Redon learned of a third alternative, mutationism—the origin of species by mutation—which was expounded by botanists in Lyon and Bordeaux.[26] Scientists described monsters and freaks—mutants—and Redon brought them to life.

Redon's difficult childhood, including a nervous disorder (probably epilepsy), may account for his melancholic, introspective personality. In his twenties, the artist was befriended by the botanist Armand Clavaud,

A

B

C

D

E

F

G

H

6-31. Odilon Redon (French, 1840–1916), *Les Origines* [Origins], 1883. Lithographs, album with frontispiece and eight lithographs, each 12⅜ × 9 in. (30.9 × 22.6 cm). The Art Institute of Chicago, Charles Stickney Collection.

Darwin's theory of evolution raised the question of the origin of the first life from nonliving matter. Redon imagined this moment in the first plate (*a*), which he titled, "When life was awakening in the depths of obscure matter," showing microbes and a primitive vertebrate emerging from slime. In the second (*b*), Redon created a plant-animal mixture, and in the next five, *c*–*g*, he shows monsters from classical mythology as mutations—a head with a single eye (a cyclops), a woman who sings like a bird (a siren), a man with horns (a satyr), a human-horse hybrid (a faun), and a winged horse (Pegasus). The last image (*h*), shows an early man, a subject widely discussed in the 1880s after the discovery in the south of France of the fossilized remains of a Cro-Magnon, an early modern human.

6-32. Edvard Munch (Norwegian, 1863–1944), *The Scream*, 1893. Tempera and pastel on cardboard, 36⅜ × 29⅜ in. (91 × 73.5 cm). Nasjonalgalleriet, Oslo.

keeper of the Bordeaux Botanical Garden, who became Redon's lifelong intellectual mentor. Redon recalled: "Clavaud was extraordinarily gifted. He was both a savant and an artist (which is rare), always moved emotionally by the revelations of his microscope, ceaselessly visiting, caring for, and classifying his collection of plants. He was also passionately addicted to reading and literary research, which he did with brilliant erudition."[27] To combat the isolation of living in the provinces, Clavaud assembled a fine library and introduced the young Redon to Charles Baudelaire's *Les Fleurs du mal* (The flowers of evil), Gustave Flaubert's novels, and mystery stories by Edgar Allan Poe. Clavaud also introduced Redon to the microscope.[28]

Clavaud's botanical research concerned the border-land between plants and animals; as Redon described it: "He worked in the realm of the infinitely small. He searched—I don't know how else to say it—in the confines of an imperceptible world, the intermediary life between plant and animal, this flower or this creature, the mysterious element that is animal during some hours of the day and only under the action of sunlight."[29] This netherland between flora and fauna may have inspired Redon's many plant-animal combinations, such as *Cactus Man* (1881; Museum of Modern Art, New York). Redon settled in Paris in 1870, when Pasteur's battle against germs was dramatized in the popular press. In 1883 Redon created *Origins*, a suite of lithographs on the origin and evolution of life that opens with a title page covered with microbes, some with human faces (plate 6-30). Redon made an analogy between mutations and monsters from classical mythology (plate 6-31). In admiration for Pasteur, Redon sent the renowned chemist a copy of *Origins*, to which Pasteur responded: "Only Redon's pencil could give life to these monsters."[30]

The Norwegian artist Edvard Munch suffered from tuberculosis, of which the bacterial cause was isolated in 1882.[31] A hygiene campaign launched in Oslo to clean up working-class neighborhoods, where the disease thrived, was too late to save Munch's mother, who died when he was five, or his sister, Johanne Sophie, who died when he was fourteen. During Munch's years in Paris, 1889–92, his style crystallized under the influence of the French Symbolists, and after his return to Norway he painted *The Scream* (plate 6-32). Munch described his moment of inspiration for this work: "I was walking down a road one evening[;] on one side lay the city and the fjord—I was tired and ill—I stood gazing directly out over the fjord—and let my friends continue. The Sun was setting—and the air—turned the color of red—like blood—I felt as though a Scream—passed through nature—I thought I heard a scream—I painted this picture—I painted the air and the clouds like blood—The picture screams!"[32] For Romantic landscape artists such as Caspar David Friedrich, clouds symbolized a divine presence and were filled with heavenly light. For Munch, nature was filled with terror; he associated a colorful sunset not with paradise but with a hemorrhage. In the anonymous, androgynous figure on the bridge, Munch created an anguished Everyman who covers his ears to silence the scream of nature but can't repress the scream from within.

I was born dying. Sickness and insanity and death
were the black angels that hovered over my cradle
and have since followed me throughout my life.

Edvard Munch, 1933

7

Looking Inward

Art and the Human Mind

The nature of the sensation depends primarily on the peculiar characteristics of the (receptor) nervous mechanism; the characteristics of the perceived object being only a secondary consideration. . . . The quality of the sensation is thus in no way identical with the quality of the object that arouses it. Physically, it is merely an effect of the external quality on a particular nervous apparatus. The quality of the sensation is, so to speak, merely a symbol for our imagination.

Hermann von Helmholtz, *Handbook of Physiological Optics*, 1867

In a painter there are two things: the eye and the brain; each of them should help the other. The eye and the brain together provide the means of expression, and thus it is necessary to work toward their mutual development, in the eye by looking at nature and in the brain by the logical organization of sensations.

Paul Cézanne, *L'Occident*, 1904

AROUND 1900, SCIENTISTS and artists argued about the nature of the human mind. Is the brain a passive recorder of light, like a camera? The Impressionists answered *yes*; Claude Monet opened his eyes—as a mindless camera opens its aperture—and recorded light. But Paul Cézanne and the Cubists answered *no*; the mind is not passive but active in organizing what the artist sees. Most scientists agreed with Cézanne and the Cubists: in Berlin, Hermann von Helmholtz demonstrated that the brain constructs a coherent picture of the world by organizing nerve impulses below conscious awareness; in Vienna, Sigmund Freud declared that forbidden thoughts are repressed into the unconscious mind, where they are reordered and return to consciousness in disguise. Freud gave artists a new muse—their desires, dreams, and memories.

In the late nineteenth century, there was also a seismic shift in the treatment of mental illness, from caring for patients with severe psychotic disorders in mental hospitals to treating people with mild neurotic problems as outpatients. By 1900 Sigmund Freud was interpreting the dreams of his outpatients in a method he named *psychoanalysis*.

7-1. Juan Gris (Spanish, 1887–1927), *The Table*, 1914. Gouache, crayon, varnish, and printed papers, mounted on canvas, 23½ × 17½ in. (59.7 × 44.5 cm). Philadelphia Museum of Art, A. E. Gallatin Collection.

179

Helmholtz's Organic Model of the Mind

During the first wave of enthusiasm for the scientific worldview in the 1850s and '60s, physicians came to understand the human brain as an electrical machine with inputs from the sense organs that spark sensory and motor output. In this model, the eyes and ears act as passive recorders of light and sound. Sight and hearing have specific centers in the brain—switching stations between the inputs and the outputs. In 1861 this mechanical model seemed confirmed when the French neurologist Paul Broca found a speech center in the brain's left hemisphere (since named *Broca's convolution*), damage to which causes aphasia (disorders of language).

In the Impressionist era this mechanical model dominated French neurology, which was led by Jean-Martin Charcot at the Salpêtrière Hospital in Paris. Throughout the 1870s Charcot maintained that the eye is a passive recorder of light. Charcot was so well known in the Paris art world that the critic Joris-Karl Huysmans could drop his name in a review of an exhibition of Impressionism, referring to "Dr. Charcot's experience with alternations in the perception of color."[1]

When Helmholtz's *Physiological Optics* appeared in 1867, adherents to the deterministic electrical-machine model of the brain, such as Charcot, hailed the German scientist for explaining the mechanism of the eye. But Helmholtz disagreed with Charcot's model of the brain as a passive recorder and proclaimed that the brain is active in structuring vision. Helmholtz studied Immanuel Kant's spatial and temporal preconditions of experience (the mental frameworks into which the mind organizes its sensation of the world), and he was determined to anchor Kant's theory of knowledge in the human body. In doing this, Helmholtz subtly transformed the philosopher's system into a new, scientific view of cognition—the physiology of perception. Kant had described sensations as ideas reflecting properties of objects in the world, but Helmholtz shifted the emphasis to the retina and optical cortex and described vision as a lifelong learning process in which the mind constructs the world from visual signs.[2]

7-2. Development of the eye from the brain in the embryos of (from left to right) a human, chicken, turtle, and fish, in Camille Flammarion, *Le Monde avant la création de l'homme* [The world before the creation of man] (Paris: Flammarion, 1886), 24, fig. 10.

Helmholtz and his contemporaries also sought to assess the implications of Charles Darwin's theory of evolution for the human mind. In the 1870s the English neurologist John Hughlings Jackson suggested that the structure of the brain reflects the course of evolution, with the lower (earlier) brain stem controlling reflexes, the midsection controlling more complex motor functions, and the most recently evolved cerebral cortex being the seat of the intellect. He argued that, far from having simple in–out wiring, the brain is a multilayered structure that is active in organizing inputs (such as seeing red, hearing sound). In the 1870s and '80s the Russian evolutionary biologist Alexander O. Kovalevsky pointed out that as the embryo of any vertebrate grows, the eye develops from the brain. The eye appears first as a bulge in a layer of cells on the surface of the brain, and as it slowly separates to form the eye, it pulls with it the neural fibers that become the optic nerve. This view of the inseparability of eye and brain that was popularized in Paris in the 1880s (plate 7-2) captured the imagination of Paul Cézanne.[3] Like Helmholtz, Jackson, and Kovalevsky, the artist believed that vision arises from the brain acting on neurological sensations caused by light.

The Active Mind: Cézanne

In a 1904 conversation with Émile Bernard, Cézanne stated that the painter sees a landscape with his eyes, but that his brain logically organizes the sensations into a perception.[4] When Cézanne set up his easel to paint *Mont Sainte-Victoire* (plate 7-3), his goal was to structure his sensations of blue, green, and ochre in order to "deal with nature as cylinders, spheres, and cones."[5] Cézanne had inherited from the Impressionists the idea that the picture plane is an opaque surface on which to record his perception of color and form. In planar brushstrokes he painted cylinders, spheres, and cones, not frozen in a timeless Euclidean space but in a lived space—seen in glimpses, in changing light, from different angles, in and out of focus. Cézanne did for form what Monet had done for color; he rendered his subjective perception of space in the natural world. In *Mont Sainte-Victoire* he arranged the branches of the framing tree to follow the profile of the distant mountain, thus fusing the foreground and background space into an aesthetic whole. In a self-conscious emulation of the brain's construction of a picture of the world from retinal sensations, Cézanne achieved a "logical organization of sensations."

In his late paintings of Mont Sainte-Victoire, Cézanne tipped the scale away from observation and analysis of sensation toward a mental construction that is only tangentially related to vision; the 1902–4 *Mont Sainte-Victoire* shown in plate 7-4 is more abstract—built less from sensations and created more by imagination. In the conclusion to his essay "On the Relation of Optics to Painting," Helmholtz described art in words that apply to Cézanne:

7-3. Paul Cézanne (French, 1839–1906), *Mont Sainte-Victoire*, ca. 1887. Oil on canvas, 26 × 35⅜ in. (66 × 89.3 cm). The Courtauld Institute Gallery, Somerset House, London.

OPPOSITE

7-4. Paul Cézanne (French, 1839–1906), *Mont Sainte-Victoire*, 1902–4. Oil on canvas, 27½ × 35¼ in. (69.8 × 89.5 cm). Philadelphia Museum of Art, George W. Elkins Collection.

The specific elements of artistic technique to which investigation in physiological optics has led us are closely related to the highest goals of art. Indeed, we may perhaps entertain the thought that even the ultimate mystery of artistic beauty—that is, the wonderful pleasure we feel in its presence—is really based upon a sense of the smooth, harmonious, and vivid current of our ideas which, in spite of many changes, flows toward a common point and brings to light laws hitherto concealed, allowing us to gaze into the deepest recesses of our own nature.[6]

After Helmholtz died in 1894, his fertile mix of physiology, psychology, and philosophy was lost, as these fields narrowed their focus and began producing early twentieth-century specialists in clinical psychology, psychoanalysis, and symbolic logic. But before the cultural impact of specialization was felt, there was one last manifestation of the grand nineteenth-century quest to understand human cognition—Cubism.

Vision and Mimesis: Cubism

A posthumous exhibition of fifty-six works honored Cézanne at the Salon d'Automne in Paris in 1907. At the time, Georges Braque was painting colorful landscapes in a Fauvist style and Pablo Picasso was experimenting with Symbolism in pink and blue canvases. But the young artists were so inspired by seeing Cézanne's art that for the next five years they worked together to extend his vision. In 1908 Braque adopted Cézanne's method of recording the underlying form of a landscape, as seen in *Houses at L'Estaque* (plate 7-5). The artists quickly moved to composing freely with successive glimpses of forms and tilted planes, breaking the contours of objects and constructing with fluctuating marks in a shallow space. By 1910, in work such as the portrait of his dealer Daniel-Henry Kahnweiler (plate 7-6), Picasso barely retained the appearance of the sitter and was one small step from non-objective art.

In 1911 the Spanish artist Juan Gris joined Braque and Picasso, and together the three artists continued Cézanne's exploration. However, once they reached the brink of non-objective art in 1911 (plate 7-7), they asked anew a question that philosophers

7-5. Georges Braque (French, 1882–1963), *Houses at L'Estaque*, 1908. Oil on canvas, 29¼ × 26⅛ in. (73 × 59 cm). Kunstmuseum, Bern, Switzerland, Fondation Rupf.

have asked since Plato: How does a person know the world? And in their work between 1911 and 1914, they gave a fresh answer.

During 1907–11, when the artists were developing Cubism, many other avant-garde artists were moving toward total abstraction. August Endell in Munich and Wassily Kandinsky in Moscow removed the last vestiges of mimesis (imitation) in order to create an art of pure expression—like wordless music. But Braque, Picasso, and Gris were heirs to an art of observation. They were exploring the mind's symbolic construction of the world—the perception of objects—and thus in 1911 when they reached the brink of total abstraction, it was not like attaining Absolute Spirit, but like being blinded. In 1911 the Cubists had a brush with total abstraction (blindness), and it made them realize that (for them) the essence of art is mimesis—imitation/depiction of the natural world.

How does a person know the world? According to the Cubists, the mind constructs an image of the world from a multitude of signs and symbols. In *The Table* (plate 7-1, chapter frontispiece), Gris draws the viewer's attention to the distinction between illusion and reality that is at the heart of mimesis: the newspaper headline reads, LE VRAI ET LE FAUX (French for "the true and the false"). At the base of the blue oval, Gris pasted the cut-out page of a real book onto the canvas and then shaded the "true" page

to merge it with his depicted "false" book. Thus, Gris's *The Table* is a self-conscious absorption with mimesis—a picture about picturing/mimesis/depiction. The Cubists suggest that the essence—the magic—of pictures lies in this interplay of illusion and reality. In Braque's *Still Life with Clarinet* (plate 7-8), the newspaper headline declares L'ECHO; the drawn clarinet depicts—is an echo of—a real musical instrument. Picasso's *Card Player* (plate 7-9) is a catalogue of the artist's toolbox—collaged wallpaper, newspaper, playing cards, charcoal drawings, paper silhouettes, pencil sketches. But it's all an illusion, all puns created in oil paint.

In a move aimed at simplifying Kant's several kinds of judgments, Helmholtz had declared that there is only one cognitive process—a person's lifelong attempt to construct a meaningful world picture not only from sensations but also from emotions, fantasies, intuitions, deductions, unconscious inferences, and memories. In defining cognition as a symbolic construction of reality, Helmholtz launched the modern search for general theories of signs and symbols—cognitive science.

The writer Maurice Raynal and dealer Daniel-Henry Kahnweiler used the Kantian terms *analytic* and *synthetic* to describe the process of creating a Cubist painting; the artist first analyzes the still life or landscape into primary elements and then synthesizes the parts into a new whole.[7] In 1936, the American art historian Alfred H.

LEFT

7-6. Pablo Picasso (Spanish, 1881–1973), *Daniel-Henry Kahnweiler*, 1910. Oil on canvas, 39½ × 28½ in. (100.4 × 72.4 cm). The Art Institute of Chicago, gift of Mrs. Gilbert W. Chapman in memory of Charles B. Goodspeed.

RIGHT

7-7. Georges Braque (French, 1882–1963), *Le Portugais* (The Portuguese), 1911. Oil on canvas, 46 × 31⅞ in. (116.8 × 81 cm). Kunstmuseum, Basel, Switzerland.

7-8. Georges Braque (French, 1882–1963), *Still Life with Clarinet*, 1913. Pasted paper, charcoal, chalk, pencil, and oil on canvas, 37½ × 47⅜ in. (95.2 × 120.3 cm). Museum of Modern Art, New York, Nelson A. Rockefeller Bequest.

Barr gave the terms a different meaning by adopting them to name successive stages in the style: Analytic Cubism (which has come to be dated 1907–11) and Synthetic Cubism (now dated 1912–14)—and art historians ever since have used the terms in Barr's sense.[8]

From its earliest days in Paris, the Cubism of Picasso, Braque, and Gris was understood by those closest to it in terms of late nineteenth-century physiology of perception. Because Cubism was contemporary with another great revolution in science—Einstein's special theory of relativity (1905; see chapter 9)—many historians have speculated that Cubism was influenced by the new physics, or that the art and the science express a common world picture. This is incorrect for several reasons. One, Einstein's theory was unknown to the educated public in pre-war Paris because it had not been proven experimentally. Two, when the general theory of relativity was confirmed in 1919, it made headlines around the globe, but Braque and Picasso showed no interest in it, perhaps because the theory of relativity is irrelevant to the depiction of the earthly objects (landscapes, still lifes) that were the subject of Cubist art. Three, relativity is also irrelevant to the topic of cognition, which was at the core of Cubism.

7-9. Pablo Picasso (Spanish, 1881–1973), *Card Player*, 1913–14. Oil on canvas, 42½ × 35¼ in. (108 × 89.5 cm). Museum of Modern Art, New York, acquired through the Lillie P. Bliss Bequest.

Only Gris expressed an interest in the implications of the theory of relativity—he wrote in a 1922 letter to Raynal that he was studying Einstein's cosmology—but, weakened by prolonged illness, Gris did not pursue it (he died in 1927).[9]

Historians have mistakenly connected Cubism and Einstein's theory of relativity because there were three scientific revolutions in space and time—one in the physiology of perception, one in physics, and one in psychology—and writers have mixed them up. The first occurred when Helmholtz extended Darwin's evolutionary biology to the physiology of perception—from objective to subjective space—that led artists to abandon Renaissance perspective with its stationary viewpoint and to treat the picture plane as an opaque surface on which to record their subjective experience of color and form as they move through the world. Einstein brought about the second revolution in space and time—from earthly space (within the solar system) to space-time (beyond the solar system)—which led artists after 1919 to introduce the dimension of time by creating kinetic art and to create art with a *cosmic* perspective by building glass towers of light (skyscrapers) and by considering the relative position of the viewer to the artwork (see chapters 9 and 10). Freud contributed to the third revolution—from

conscious to unconscious space and time—with his study of neurosis, which led artists in the 1920s and '30s to create a *psychological* perspective by painting their dreams (see chapter 11).

All the evidence points to the origin of Cubism in the *first* revolution in space and time—the shift from objective to subjective space brought about by Helmholtz's physiology of perception.[10] During the development of Cubism (1907–14) writers associated the style with many scientific developments that were part of the complex matrix out of which Einstein forged his revolution, such as the French mathematician Henri Poincaré's speculations about the relativity of space and time that were precursors to Einstein's theory of relativity,[11] and non-Euclidean geometries. But Poincaré's speculations and the new geometries were nineteenth-century ideas awaiting a new synthesis, and there is no evidence that any Cubist artist was aware that an unknown German employee of a patent office in Bern, Switzerland, had accomplished this in 1905.

It is disheartening that although there is not one scrap of historical evidence establishing a connection between Cubism and Einstein, for 100 years historians have repeatedly claimed that there is.[12]

Asylum Medicine

In the early nineteenth century, physicians who treated mental disorders suspected there was an organic (physical) cause of mental illness and that symptoms were manifest in the patient's face and body. They used illustrated medical manuals to diagnose melancholia, mania, and dementia: the melancholic woman slumps with downcast eyes, the maniac shakes his fist in rage, and the demented man does not respond to commands (plate 7-10). With these types in mind, John Kearsley Mitchell, a physician at Pennsylvania Hospital in Philadelphia, commissioned an artist in the 1820s to draw

A

B

C

LEFT

7-11. Thomas Eakins (American, 1844–1916), *Retrospection*, 1880. Oil on panel, 14½ × 10⅛ in. (36.9 × 25.7 cm). Yale University Art Gallery, New Haven, Connecticut, bequest of Stephen Carlton Clark.

ABOVE

7-12. Melancholic patient, 1827–34. Drawing in a manuscript of John Kearsley Mitchell. Library of the College of Physicians of Philadelphia.

OPPOSITE

7-10. "Melancholia," "Mania," and "Dementia," in Allan McLane Hamilton, *Types of Insanity* (New York: William Wood, 1883), plates 3, 6, and 8. Lithographs after photographs of patients. Medical Heritage Library, University of Toronto.

Allan McLane Hamilton, a physician at several New York State hospitals for the insane, described these patients, whom he considered typical for their diagnoses:

(*a*) Melancholia: C. C____, aged thirty-seven. Duration of insanity seven months. Cause unknown. Auditory hallucinations. She hears voices commanding her not to eat, and it is often necessary to feed her with the tube. She has delusions of persecution. Her movements are sluggish, and she assumes fixed attitudes. There is rarely any play of facial expression and she takes no notice of those about her.

(*b*) Mania: J. B____, aged fifty-one, has been in the Ward Island Asylum eleven years. No history of cause. He is incoherent and excitable, but quite tractable. Disclaims his proper name, and has delusions that his bones are all broken and his head bashed. Is clownish in his behavior, and sings at the top of his voice. He is fond of decorating himself with rubbish and dirty finery.

(*c*) Dementia: R. P. I____, aged thirty-six. There is a strong family history of insanity, five of his uncles being insane. He is profoundly demented, and is dirty, stupid, and careless. His disease has lasted nineteen years, and followed melancholia.

his patients (plate 7-12). His son, the neurologist S. Weir Mitchell, lent the sketchbook to Philadelphia artist Thomas Eakins, who painted an anonymous woman with the telltale slouch and lowered eyes of a melancholic (plate 7-11).[13]

Early nineteenth-century asylum doctors in Britain, France, and the United States were so convinced that progress in medical science gave them the tools to cure mental illness that they convinced their governments to fund massive mental hospitals. For example, in the United States between 1830 and 1900, more tax dollars were spent on building state insane asylums than on building general hospitals, public schools, and libraries put together. The doctors were sure they could keep lunatics off the streets, cure them, and returned them to society as productive citizens. Encouraged by Louis Pasteur's discovery that microorganisms were the cause of tuberculosis, diphtheria, and cholera, asylum doctors looked through their microscopes in search of the bacteria responsible for melancholia, mania, and dementia. But after decades of detailed observations of patients' bodily fluids and brain tissue, asylum doctors found nothing. (The first physical marker for a mental illness [dementia]—the bacterium *Treponema pallidum*, which causes syphilis and destroys brain tissue—was discovered in 1905.) So by the 1880s, the asylums that had been built with high hopes of curing mental illness were overcrowded and underfunded. Thus the late-nineteenth-century saw the first wave of deinstitutionalization—the mass discharge of patients, many of whom had nowhere to go—which resulted in populations of homeless mentally ill that have become a feature of modern cities throughout the West.

Neurology

In the late eighteenth century, the English scientist Stephen Gray revealed that the human body conducts electricity (see plate 1-19, in chapter 1). A century later, in Madrid, Santiago Ramón y Cajal discovered that the cells that communicate electrical impulses form a network—the nervous system—and that unlike a telegraph system, in which the wires touch, the nervous system is not continuous throughout the body. Rather, nerve cells communicate with one another by sending a chemical signal across a gap—the synapse (plates 7-13 and 7-14).

Sigmund Freud studied neurology at the University of Vienna in the laboratory of a prominent member of the Helmholtz school of physiology, Ernst Wilhelm von Brücke (author of books on the physiological basis of aesthetics; see chapter 4). Freud began his career studying the nerves of lower animals (plate 7-15), but by the 1890s he was studying the nerves of the human ear, because he had become interested in disorders of language—aphasia, the loss of ability to speak or understand spoken or written words. Freud wanted to do for mental disorders what Helmholtz had done for normal vision and hearing: to ground psychiatric disorders in a neurological framework. In 1891 he drew a diagram of a person's use of a word, confident that he could

7-13. Santiago Ramón y Cajal (Spanish, 1852–1934), Purkinje cell, ca. 1899. Ink on paper. Instituto Cajal, Madrid. © Consejo Superior de Investigaciones Científicas, CSIC.

Santiago Ramón y Cajal, who was educated in both science and art, described this nerve cell: "From an aesthetic point of view, nervous tissue is incomparably beautiful. Is there in our parks any tree more elegant and lush [*más elegante y frondoso*] than the Purkinje cell of the cerebellum?" (*Recuerdos de mi vida* [Madrid: N. Moya, 1917], 2:156).

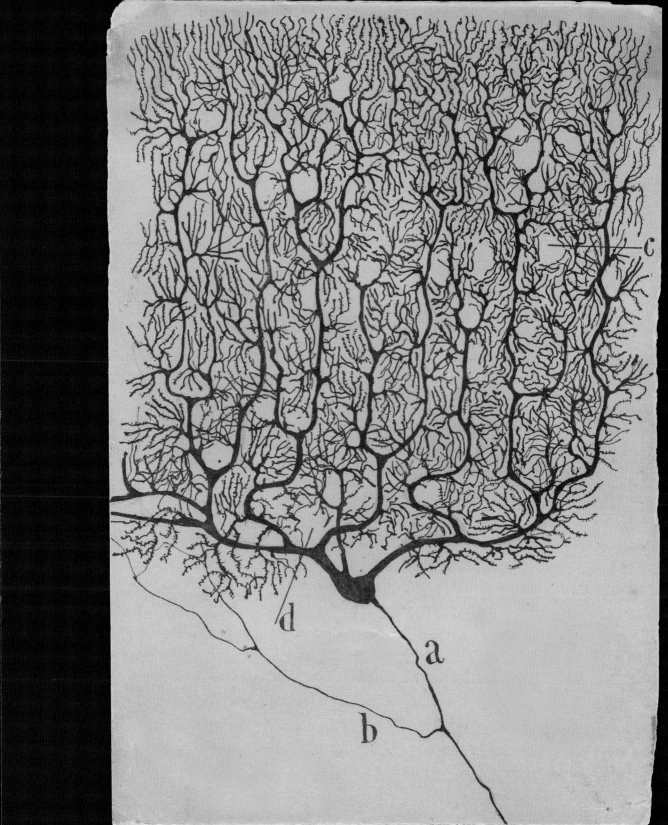

7-14. Pablo García-Lopez (Spanish, born 1977), *PET Soul Butterflies*, 2010, from the series Brain Garden. Silk and glitter on Plexiglas, 48 × 48 in. (122 × 122 cm). Courtesy of the artist.

Pablo García-Lopez has a doctorate in neurology from the Universidad Complutense in Madrid and an MFA in sculpture from the Maryland Institute College of Art in Baltimore. This scientist-artist refers to a positron emission tomography (PET), a non-invasive brain imaging method, in his illustration of a passage written by Santiago Ramón y Cajal: "The garden of neurology offers the investigator fascinating spectacles and incomparable artistic emotions. There my aesthetic instincts finally found full satisfaction. Like the entomologist hunting for colorful butterflies, my attention was drawn to the orchard of the gray matter, which contained cells with delicate and elegant forms, the mysterious butterflies of the soul [*las misteriosas mariposas del alma*], whose beating wings may one day clarify the secrets of mental life" (Santiago Ramón y Cajal, *Recuerdos de mi vida* [Madrid: N. Moya, 1917], 2:155–56).

map the neurological substrate in the cerebral speech centers (plate 7-16). In 1895 Freud described his vision for the merger of psychological (mental) and physical (neurological, chemical) causes of disorders such as aphasia in his "Project for a Scientific Psychology." However, by 1900 he abandoned the task, realizing that he lacked the tools to study the central nervous system in detail. (In 1900 neurologists were still arguing about whether or not nerve cells touch, a debate that wasn't settled in Ramón y Cajal's favor until the 1950s, after the development of the electron microscope.)

Psychological Causes of Mental Illness: Charcot and Freud

Although Jean-Martin Charcot held a mechanical model of the brain, he acknowledged that neurology had not progressed to the point where he could discover the physical causes of mental illness. Thus he adopted hypnosis, which had been absent from French medicine since mesmerism was outlawed (see chapter 1), but once it received Charcot's endorsement, hypnotism was adopted in Paris as a viable therapeutic tool. In 1884 the renowned neurologist married a rich widow, and they held weekly soirées in their lavish apartment that were attended by scientists, artists, and writers. Edmond de Goncourt repeatedly lampooned the pomposity of these evenings, but he

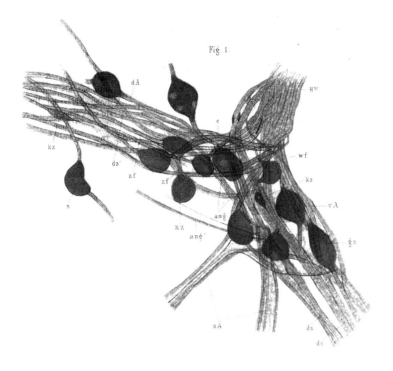

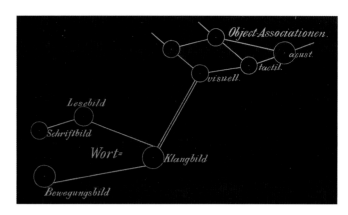

LEFT

7-15. Nerve cells drawn by Sigmund Freud to illustrate his essay "Über Spinalganglien und Rückenmark der *Petromyzon*" [On the spinal ganglia and spinal cord of the *Petromyzon*], *Sitzungsberichte der Mathematisch-Naturwissenschaftlichen Classe der Kaiserlichen Akademie der Wissenschaften* 78 (1878), vol. 1. New York Academy of Medicine.

Freud drew these neurons of the sea lamprey (*Petromyzon marinus*), a jawless fish similar to an eel.

ABOVE

7-16. Diagram of word presentation, in Sigmund Freud, *Zur Auffassung der Aphasien* [On aphasia] (Leipzig: Franz Deuticke, 1891), fig. 8. Collection of Bruce Sklarew, Chevy Chase, Maryland.

In the lower left is a word (*Wort*), which equals its image (*bild*) when read (*Lese*) or written (*Schrift*), its sound (*Klang*) when heard/spoken, and its meaning (*Bewegungs*). Freud diagrammed the word as a closed system (in the mind) linked to an object (in the world) by its sound image. In the upper right, the word's object association (*Object-Associationen*) includes what the object looks like (*visuell.*), its feel (*tactil.*), and its sound (*acust.*). The object is an open system, linked to the word by what it looks like (as the word is linked to the object by what it sounds like).

never missed one.[14] Charcot also gave dramatic public lectures, which earned him the nickname *Napoléon de la Névrose* (Napoleon of neurosis).

Charcot used hypnosis to treat patients diagnosed with hysteria, a nineteenth-century term for a disturbance of the nervous system characterized by a cluster of symptoms including convulsions and paralysis, thought to be caused by emotional distress. Since psychiatrists saw the condition more often in women, they speculated that it resulted from a disturbance of the uterus (*hysteria* is modern medical Latin for "malady in the womb"). Today the term is no longer used in medicine.

Although Charcot adopted hypnosis for diagnosing ailments with a psychological (unobservable) cause, for some cases he continued the old practice of making a diagnosis based on the patient's appearance. To record the appearance and behavior of patients with hysteria, in 1878 Charcot hired the photographer Albert Londe to establish a laboratory for time-lapse photography at Salpêtrière Hospital (plates 7-17 and 7-18).[15] Londe was a contemporary and close friend of the French physician and physiologist Étienne-Jules Marey, who also did scientific studies of figures in motion (plate 7-19). Charcot published Londe's pictures in his multivolume album *Iconographie photographique de la Salpêtrière* (Iconographic journal of the Salpêtrière, 1876–80), which brought the concept of hysteria to the attention of Symbolist artists.[16] In 1884 the art critic Joris-Karl Huysmans was familiar enough with the concept of hysteria to diagnose Salomé in Gustave Moreau's *The Apparition* (plate 7-20) as "the goddess of immortal hysteria, accursed beauty exalted above all other beauties by the catalepsy that hardens her flesh and steels her muscles."[17] Moreau illustrated

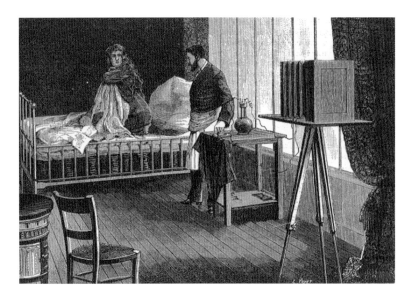

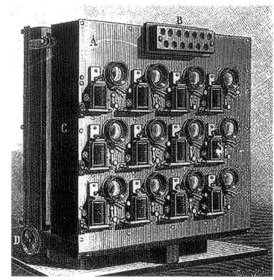

ABOVE LEFT

7-17. Photographing a hysteric patient, in "La Photographie en médecine" [Photography in medicine], *La Nature* (June–Nov. 1883), 215–18; the image is on 216. Science, Industry, and Business Library, The New York Public Library. Astor, Lenox, and Tilden Foundations.

This image shows Albert Londe's photographic equipment set up to record the movements of a patient diagnosed with hysteria in her bed at the Salpêtrière Hospital in Paris.

ABOVE RIGHT

7-18. Twelve-lens camera of 1891, in Albert Londe, "La Photochronographie" [Photochronography], *La Nature* (Nov. 1893), 370–75; the image is fig. 2 on 375.

Photochronography was an early form of photographing a moving object that developed into cinematography. Londe invented this camera with multiple lenses in order to record a moving patient, such as an epileptic during a seizure. The shutters were triggered by an electrified metronome, so that glass plates could be exposed in rapid succession. Shown here is his 1891 camera with twelve lenses.

BELOW

7-19. A man walking, in Étienne-Jules Marey, *La Machine animale* [The animal machine] (Paris: F. Alcan, 1886), 303. Photochronograph.

Marey made this image by taking multiple exposures of a man walking while wearing a black costume that had white lines and dots on it.

the biblical story of John the Baptist, whose decapitated head is the grisly apparition that has, according to Huysmans, brought on Salomé's catalepsy (a trance caused by a shock to the nerves that results in muscular rigidity; in other words, she's stopped in her tracks).

The critic's suggestion that a *femme fatale* embodies hysteria is in keeping with fin-de-siècle medical thinking. In a lithograph of Charcot teaching his medical students, the hysteric looks more seductive than sick—the *femme fatale* of Salpêtrière Hospital (plate 7-21).

In the 1880s Freud travelled to Paris and attended lectures given by Charcot, and he also went to the city of Nancy in northeastern France to meet Charcot's rival, the neurologist Hippolyte Bernheim, who argued that there are purely psychological disorders. Freud was also trained in evolutionary biology and learned of Darwin's description of the struggle for survival and reproduction. For many, the expression of emotions—grief, anxiety, and joy—remained a dividing line between human beings and other animals, but Darwin erased that line in *The Expression of the Emotions in Man and Animals*

OPPOSITE

7-20. Gustave Moreau (French, 1826–1898), *The Apparition*, 1876–77. Oil on canvas, 22 × 18⅜ in. (55.9 × 46.7 cm). Harvard Art Museums/ Fogg Museum, bequest of Grenville L. Winthrop.

Gustave Moreau painted Salomé dancing lewdly before the head of John the Baptist, blood dripping from its severed neck. On the left King Herod is enthroned in the shadows, and on the right stands the henchman with his bloody sword raised.

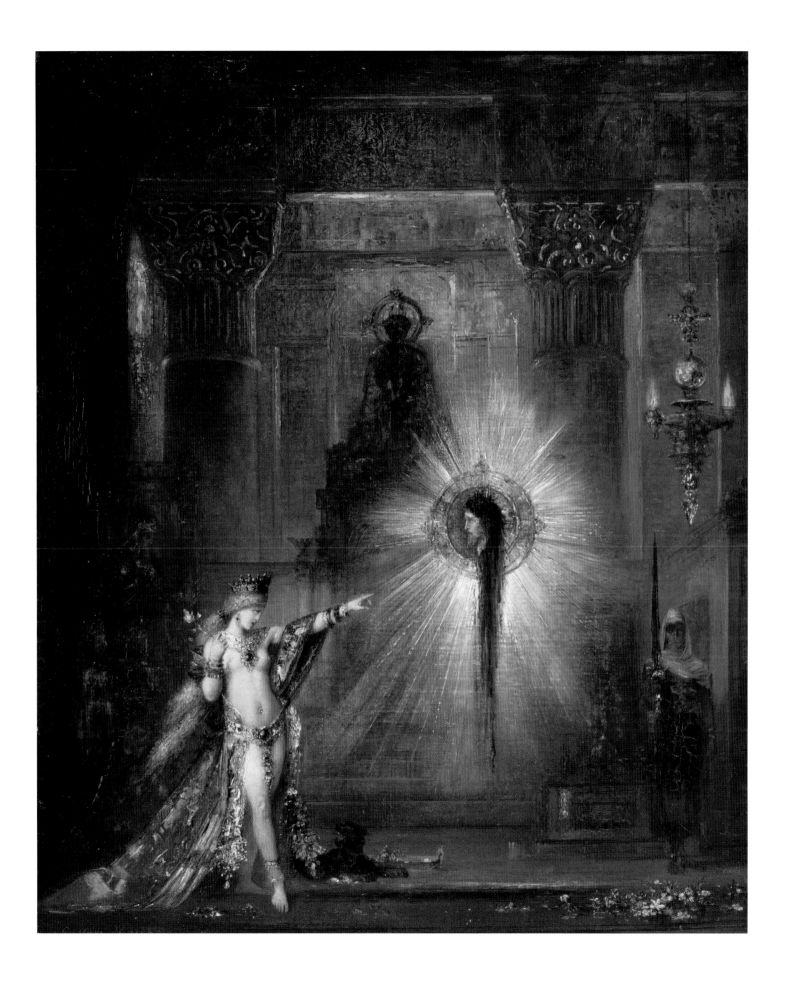

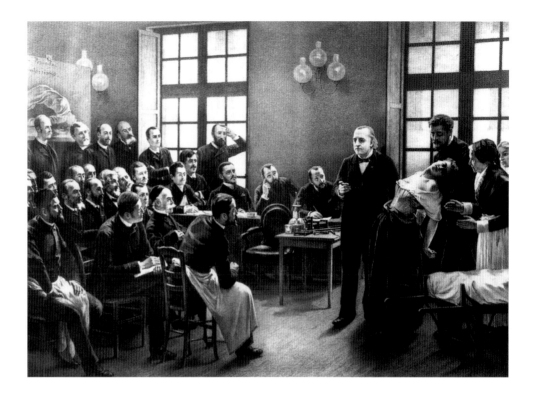

7-21. Jean-Martin Charcot giving a clinical lesson at the Salpêtrière Hospital in Paris (1887). Lithograph by André Brouillet. Freud Museum, London.

Charcot hypnotized hysteric patients and presented them to his students in a dramatic style, similar to a theater performance.

(1872). Darwin described a series of experiments in which scientists correlated emotions such as terror and pleasure with the movement of facial muscles and the emission of sounds in humans and apes (plates 7-22 and 7-23). Freud applied Darwinian biology to human behavior, describing human emotions as (disguised) animal drives—aggression (to survive) and passion (to reproduce).

The Viennese physician Josef Breuer began treating a patient, Anna O. (pseudonym of Bertha Pappenheim), whom he diagnosed with hysteria. Anna O. had a group of odd symptoms, including an ability to speak English but not her native language (German), and although she was overcome with thirst, she could not drink a glass of water. The patient was not conscious of the cause of her distress, but under hypnosis she could articulate the cause (her father's fatal illness), bring the memory to consciousness, and mourn the loss; her symptoms then disappeared. Breuer's younger colleague Sigmund Freud co-authored the case history of Anna O., "Studies on Hysteria" (1893–95).[18] Their method came to be known by the name Anna O. gave it, "the talking cure."[19]

Many physicians, such as S. Weir Mitchell, thought that women who exhibited symptoms of hysteria were troublemakers: "the pests of many households, who constitute the despair of physicians."[20] Mitchell recommended treatments that were punitive, such as pouring a pitcher of cold water over the patient (plate 7-24).[21] But Breuer and Freud believed Anna O. and suspected that she had experienced something (her father's death) that had caused her symptoms. Freud developed a method—psychoanalysis—to bring buried memories to consciousness, albeit in disguised form. Charcot diagnosed patients by looking at them, but Freud instead listened to them and wrote

their case histories. There are picture albums of Charcot's hysterics, but the case history of Anna O. is unillustrated. Breuer and Freud used hypnosis to aid Anna O. in retrieving memories, but Freud found that he could forgo hypnotism because his patients could recall their past by the free association of words and images. Soon patient and therapist did not even look at each other during therapy; the patient free-associated while relaxing on a couch, and the therapist sat out of sight taking notes (plate 7-25). Illustrated diagnostic manuals became a thing of the past as diagnosis was done by case history—a written record of the patient's thoughts, fantasies, and dreams. The French Symbolist Gustav Moreau painted a picture of a *femme fatale* (plate 7-20), but the German Symbolist Max Klinger symbolized a woman's unconscious fantasies—her dream (plate 7-26).

By 1900 psychiatry had split into two approaches to diagnosis and treatment: physical (chemical and neurological) treatment of severely disturbed—psychotic—patients, who were treated in a hospital setting, and psychological treatment (talk therapy) for those with a mild affliction—neurotics—as outpatients. These divergent physical and psychological paths did not rejoin until the 1950s, when scientists made key discoveries in neurology (REM sleep), biochemistry (psychotropic drugs), genetics (double-helix structure of DNA), and—crucially—invented a tool (the computer) to help them keep track of the 100 billion nerve cells that make up the human brain (see chapter 14).

Charcot's investigation of the unconscious mind was an unusually speculative tendency in French medicine. After Charcot's death in 1893, younger physicians, bitterly opposed to hypnotism, purged French psychiatry of research into (unobservable) unconscious phenomena. Anticipating this, Charcot had left his laboratory in the

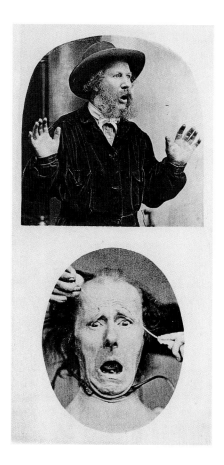

TOP

7-22. Terrified men, in Charles Darwin, *The Expression of the Emotion in Man and Animals* (1872; American ed., New York: D. Appleton and Co., 1873), plate 7, facing 300.

In the text accompanying the photograph of a terrified man (above), Darwin explained that the man's platysma muscle (extending from the collarbone to the lower cheeks) is contracted in terror, drawing the corners of the mouth and the lower part of the cheeks downward and backward. The French neurologist Guillaume-Benjamin Boulogne had produced the same terrified expression (below) by electrically stimulating the platysma muscle as well as the brow, in his classic *Mécanisme de la physionomie humaine* [Mechanism of human facial expression] (1862), from which Darwin reproduced this image.

BOTTOM

7-23. Placid and pleased ape, in Charles Darwin, *The Expression of the Emotion in Man and Animals* (American ed.), 136, figs. 16 and 17.

To show the similarities in the expression of emotion in humans and animals, Darwin argued that apes use the same platysma muscle and sounds to express terror as the men in plate 7-22. The same muscular and vocal similarities also hold for the expression of more pleasant emotions, such as those displayed by this ape, which is shown "in a placid condition" (above) and "pleased by being caressed" (below).

TOP

7-24. "Treatment of Hysteria," in Russell T. Trall, *Hydropathic Encyclopedia* (New York: Fowler and Wells, 1851), 2:209, fig. 186. The New York Academy of Medicine Library.

Russell T. Trall was an American physician who operated a water-cure center in New Jersey. He labelled this diagram "Treatment of Hysteria" and wrote: "Place the head over a basin, and pour water from a jug over the head and chest until the patient becomes chilly and revives. Never use anything but cold water for the hysterical fit, unless the party turns very cold, when you should discontinue it, and apply warmth to the feet" (209).

BOTTOM

7-25. Patient's couch in Sigmund Freud's consulting room, Berggasse 19, Vienna, Austria. Photograph by Edmund Engelmann, 1938.

OPPOSITE

7-26. Max Klinger (German, 1857–1920), *The Philosopher*, 1885–1900. Etching and aquatint, 19¾ × 13¼ in. (49.4 × 33.1 cm). Museum der Bildenden Künste, Leipzig.

"The philosopher" touches his brightly lit reflection in a mirror. Which is the *real* philosopher? Neither; both are in the woman's dream—the mirror of her soul.

hands of his trusted disciple, Pierre Janet, who was an expert in pathological forms of automatism (behavior, such as babbling, done without deliberation). So research into psychological causes of mental illness continued in Paris briefly, but by 1900, French mental hospitals offered only organic (chemical and neurological) treatment for psychosis. Meanwhile, in Vienna, Freud published *Die Traumdeutung* (English translation as *The Interpretation of Dreams* in 1913), and outpatient care of mild disorders with a psychological cause—neuroses—grew rapidly in the new field of psychoanalysis. After World War I, Freud's work was translated into French, and by the mid-1920s the Viennese doctor of the soul was the talk of Parisian cafés, setting the stage for Surrealism.

The Culmination of Newton's Clockwork Universe

The art that is now coming to prominence gives form to our scientific convictions. This art is our religion, our center of gravity, our truth. It is profound enough and strong enough to create the greatest form, the greatest transformation that the world has ever known.

Franz Marc, 1914–15

IN THE NINETEENTH CENTURY, astronomers and physicists closed in on an explanation of the workings of Newton's clockwork universe. Atoms are its indivisible building blocks—three atoms combine to form a water molecule, and billions form a star. Two forces hold the great clockwork together: gravity keeps the planets in their orbits, and electromagnetism binds atoms into molecules. At first physicists considered only light they could see, but then they discovered a whole spectrum of electromagnetic radiation: radio waves, infrared, visible light, ultraviolet, and x-rays. Then, between 1895 and 1905, physicists discovered that atoms aren't solid after all and that there are other unknown forces coming from within the atom itself.

Astronomy

In the fourth century BC, Aristotle placed a stationary Earth at the center of the cosmos and reasoned that since the sun, moon, and planets move in the heavens, which is the realm of perfection, they must move at a constant speed in a path described by the most perfect figure—a circle. So great was Aristotle's reputation that subsequent astronomers followed his dictum, even after the Polish astronomer Nicolaus Copernicus moved the sun to the center of the solar system in the early sixteenth century (plate 8-2). But the

8-1. Étienne Léopold Trouvelot (French, 1827–1895), direct electric spark, ca. 1888. Print on paper; 11½ × 9¼ in. (29.1 × 23.5 cm). © Musée des Arts et Métiers, Conservatoire National des Arts et Métiers, Paris.

To make this image of an electric spark, the French photographer Étienne Léopold Trouvelot first coated a metal plate with a photosensitive chemical, as a photographer would. Then, in a pitch-black darkroom, without using a camera, Trouvelot created a spark right against the photosensitive plate, which recorded the light. Trouvelot then etched the plate and printed this image. Trouvelot sent his results to Paris, and they were published in the prestigious journal of the Académie des Sciences. Trouvelot described this image (which is evidently a double exposure): "The images created by the opposing poles are completely different in character and form. The image created by the positive pole [seen in the center] is sinuous and branched; from its main branches stem thousands of long, serrated fibers, like seaweed. The image produced by the negative pole [seen in the outlying region] is very different; its principal branches are made up of straight lines that are often broken at right angles, which make them look like the lightning bolt the Greeks put in the hand of Zeus" ("La photographie appliquée à l'étude des décharges électriques" [Photography applied to the study of electric discharges], *Comptes rendus des séances de l'Académie des sciences* 107 [July 2, 1888], 684–85; the quote is on 685).

Born in France in the aftermath of the French Revolution, Trouvelot strongly supported democracy, so his life was in danger after the nephew of Napoleon Bonaparte re-established the monarchy in a coup d'état in 1851. At age twenty-four, Trouvelot fled to the United States and settled near Boston, where he made this photograph.

8-2. Solar system, in Nicolaus Copernicus, *De Revolutionibus oribium coelestium* [On the revolutions of the celestial orbs] (Nuremberg: Johannes Petreius, 1543), 21. Science, Industry and Business Library, The New York Public Library. Astor, Lenox, and Tilden Foundations.

Copernicus placed the sun (*Sol*) at the center, surrounded by concentric rotating orbs that carry Mercury, Venus, Terra (Earth, with its moon), Mars, Jupiter, and Saturn. The outermost orb was the *Stellarum fixarum sphaera immobilis* (immobile sphere of the fixed stars).

8-3. Movement of the planets, in Johannes Kepler, *Harmonices mundi* [Harmony of the world] (Linz, Austria: Ioannes Plancvs, 1619), 207. Science, Industry, and Business Library, The New York Public Library. Astor, Lenox, and Tilden Foundations.

Kepler scored a part for each of the planets known to him—Saturn, Jupiter, Mars, Earth (Terra), Venus, and Mercury—in general by calculating the low note corresponding to the planet's aphelion (the point in its orbit when it is farthest from the sun) and the high note determined by its perihelion (the point when it is nearest the sun). He also included the moon in his chorus: *Hic locum habet etiam* (This place is also here). Earth's orbit is almost circular, so Kepler declared that its perihelion and aphelion are only one note apart, *mi* and *fa* in the medieval scale. Kepler said Earth was associated with a sad sound, like a moan, because of the symbolic association of *mi* with *miseria* (misery) and *fa* with *fames* (famine).

German astronomer Johannes Kepler, who began his studies in the 1590s, could not make Aristotle's requirement fit with his observations of the planets in the sky. Kepler had studied Euclid, who defined a circle as all points equidistant from one point (*Elements*, 300 BC), and Apollonius of Perga, who defined an ellipse as all points equidistant from two points (*Conics*, ca. 200 BC). Based on his observations, Kepler declared that each planet moves in an ellipse with the sun at one point (one focus) and that the planet's velocity is always changing (speeding up as it approaches the sun and slowing down as it moves away), sweeping out equal areas in equal times (Kepler's first two laws of planetary motion, 1609). A decade later Kepler discovered that there is a constant ratio between the average radius of each planet's orbit and the time it takes to orbit the sun (radius cubed is proportionate to time squared: Kepler's third law of planetary motion, 1618). Kepler called this third law "harmonic," because "the motions of the heavens are nothing but a kind of perennial harmony in thought not sound" (*Harmonices Mundi* [Harmony of the world]; 1619).[1] In other words, the orbiting planets make a celestial pattern that is analogous to music—a (metaphorical) six-part harmony (plate 8-3).[2]

A contemporary of Kepler, the Italian scientist Galileo learned to grind glass lenses and, after experimenting with lenses of different strengths, in 1609 made a telescope so powerful that he could observe mountains on the moon and discover that Jupiter has four moons. To avoid the chromatic distortion that plagued glass lenses, in 1668 Isaac Newton invented a telescope that gathers (reflects) light using mirrors—the reflector telescope (plate 8-4).

These early astronomers evidently assumed that the six planets visible to the naked eye were the whole solar system, as none recorded using the telescope to search for other planets. Then one night in 1781, the German-born British astronomer William Herschel was looking through his 20-foot (6.1-meter) reflector telescope (plate 8-5), when he noticed an unusual point of light; it didn't have a fuzzy edge like a star but was a disk with a clear outline. Herschel was astonished to have stumbled upon a seventh planet (Uranus). Astronomers wondered: What else is out there?

　　　　　　　　　　　　　　　　　　　　　　　　　　　　CHAPTER 8

Photographing celestial bodies is difficult because the light from stars and planets is so dim; in 1839 Daguerre tried (unsuccessfully) to photograph the moon. Only in the 1870s did photographing the night sky become practical, with the development of gelatin silver negatives, made with a suspension of silver salt, which is very sensitive to light, in gelatin that is coated on a surface and then dried. Astrophotography was pioneered by the amateur astronomer Andrew Ainslie Common (plate 8-6).

Early science-fiction writers and film-makers fired the public imagination with fantasies of travel to the moon (plates 8-7 and 8-8). Earthlings began to have an inkling of their relative position (plates 8-11 and 8-12). The Lithuanian artist Mikalojus K. Čiurlionis studied musical composition and art in Warsaw, and in 1908 he was inspired by astronomy to paint *Sonata No. 6 (Sonata of the Stars) Allegro* (plate 8-9). Planets, stars, and light beams fill the composition, which surges up toward an angelic figure in the night sky.[3]

For decades after Herschel discovered Uranus, the planet was closely observed, and astronomers noticed that there was a deviation in its orbit. What was pulling on it? It was widely suspected that there was yet another planet, but what were an astronomer's chances of finding a body estimated (correctly) to be another billion miles (1.6 billion kilometers) beyond Uranus? If it were visible at all, it would be just a pinpoint of light among myriad stars, perhaps too small to resolve into a disk. The tale of the

8-4. Reflector telescope, in Isaac Newton, *Opticks; or, A Treatise of the Reflexions, Refractions, Inflexions and Colours of Light* (London: S. Smith and B. Walford, 1704), bk. 1, pt. 1, plate 5, fig. 29.

Light enters from the left and strikes a concave mirror that collects and focuses the beam on a second diagonal mirror, which is visible through the eyepiece at the bottom.

8-5. William Herschel's 20-foot (6.1-meter) reflector telescope, 1794. Copper engraving; printed from the original plate in 1976 by Studio Prints, London. © The Board of Trustees of the Science Museum, London.

Herschel completed this telescope in 1783. The tube was wood and the mirror was mainly copper, so it tarnished quickly and needed frequent polishing. Herschel went on to build an even larger, 40-foot (12.2-meter) reflector in 1785–89.

discovery of the eighth planet underscores the observational bias of British and French science as opposed to German love of theory.

The British mathematician John Couch Adams, in Cambridge, and the Frenchman Urbain Le Verrier, in Paris, independently calculated the position of the possible eighth planet so that an astronomer could point a telescope to an exact location in the night sky. But Britain's royal astronomer was so opposed to letting mathematics guide observation that he tossed Adams's co-ordinates into a drawer at the Royal Observatory at Greenwich. Meanwhile, Le Verrier calculated that on August 11, 1846, the eighth planet would be in opposition, that is, in a straight line with the sun and Earth, with Earth in the middle and therefore at its closest point to the planet, which would thus be at maximum visibility. Le Verrier was unable to persuade astronomers at the Paris Observatory to open the dome of their telescope on the night of August 11; he was getting frantic as the planet began to move away, so he mailed his calculations to a German colleague at the Berlin Observatory. Untroubled by a theoretical approach to science, after receiving Le Verrier's urgent letter on September 23, 1846, the German astronomer Johann Gottfried Galle pointed his telescope to Le Verrier's co-ordinates, and in minutes he had Neptune in his sights (plate 8-10).

OPPOSITE

8-6. Andrew Ainslie Common (English, 1841–1903), the moon, 1880. Photograph. © Science Museum, London.

Andrew Ainslie Common's father died when he was a child, and so he began working at an early age, but his passion was for astronomy. Common built a Newtonian reflector telescope with a 36-inch (91.4-centimeter) diameter mirror in his garden shed, and he taught himself

photography. This stunning image, one of the first high-resolution photographs of the moon, is a reminder that the word *amateur* derives from *amor* (Latin for "love"). The image shows craters that were formed when the moon was bombarded by asteroids; dark areas (known as *marias*, from Latin for "seas") formed when impact basins filled with lava.

LEFT

8-7. Train to the moon, in Jules Verne, *De la terre à la lune* [From Earth to the moon] (Paris: Pierre-Jules Hetzel, 1865), 113. Engraving by Stephane Pannemaker. Bibliothèque National de France.

RIGHT

8-8. *Le Voyage dans la lune* [Trip to the moon], 1903. Film, directed by Georges Méliès. Star Film, Paris.

Georges Méliès based his 1903 film on Jules Verne's 1865 novel *De la terre à la lune*.

LEFT

8-9. Mikalojus K. Čiurlionis (Lithuanian, 1875–1911), *Sonata No. 6 (Sonata of the Stars) Allegro*, 1908. Tempera on paper, 28⅞ × 24½ in. (72.2 × 61.4 cm). Čiurlionis National Museum of Art, Kaunas, Lithuania.

BELOW LEFT

8-10. The planets of the solar system, including Neptune, ca. 1860. Engraving.

BELOW RIGHT

8-11. Earth, as seen from the moon, in Amédée Guillemin, *Le Monde physique* [The physical world] (Paris: Hachette, 1882), 2:22.

OPPOSITE

8-12. Earthrise, 1968. NASA/NSSDC.

The nineteenth-century dream of seeing Earth from the moon came true in 1968, when the first manned mission, Apollo 8, flew around the moon ten times. One of the three astronauts on board, Bill Anders, took this photograph, which became an icon of space exploration. The following year Apollo 11 landed, and Neil Armstrong first set foot on the moon.

The Electromagnetic Spectrum

Early nineteenth-century scientists suspected that electricity and magnetism are somehow related to each other, because both have opposites that attract (positive and negative electrical charges, north and south magnetic poles), and both lose their force rapidly with distance. The British scientist Michael Faraday discovered that electricity and magnetism are not two forces but one, which he named *electromagnetism*.

Faraday was born into a working-class family in class-conscious England. His schooling ended when he was a teenager because he was apprenticed to work as a bookbinder, but he developed a passion for science and educated himself. The musician William Dance, a founder of the Royal Philharmonic Society, noticed how bright the young Faraday was and generously gave him hard-to-get tickets to attend popular lectures by Britain's pre-eminent scientist, Humphry Davy (the chemist who in 1802 did experiments with the light-sensitive chemical silver nitrate, which eventually led to photography; see chapter 4). In 1812, at age twenty, Faraday bound his lecture notes into a book, which he sent to Davy, who was impressed with the young man's understanding of chemistry. The following year Davy was injured in a laboratory accident; he remembered the young bookbinder and hired him as an assistant while he recovered. Thus Faraday left his blue-collar job and entered Davy's chemistry laboratory; he made himself indispensable, so Davy kept him on.

In 1820 the Danish physicist Hans Christian Ørsted suspended a compass needle near a wire through which no electricity flowed; the needle pointed north. But when he passed an *electric* current through the wire, the *magnetic* needle moved and pointed perpendicular to the wire (plate 8-13). How could one affect the other? Ørsted's experiment caused a flurry of activity, as Davy, the British chemist William Wollaston, and many others tried (and failed) to use electricity to produce motion (in other words, they tried to design an electric mover/motor).

But Faraday—the lowly lab assistant with no formal education—succeeded. He designed an experiment that not only got a magnet to move near a wire, as Ørsted had done, but—in a display of Faraday's creative imagination—he did Ørsted's experiment backward and got a wire to move near a magnet (plate 8-14). Faraday thus designed the first electric motor, which he described in a journal article of October 1821, launching the electronics industry.[4]

Davy, evidently jealous that his assistant had made this pivotal discovery, accused Faraday of plagiarizing Wollaston's work (a charge Wollaston denied, saying Faraday's work was completely his own).[5] Then, in a cruel gesture, Davy prevented Faraday from continuing experiments on electricity by assigning him research in a completely unrelated area (the chemical composition of optical glass). After Davy's death, in 1929, Faraday resumed his research on electromagnetism,

8-13. "Action of an electric current on a magnetized needle," in Amédée Guillemin, *The Forces of Nature*, trans. Mrs. Norman Lockyer (New York: Scribner, Welford, and Armstrong, 1872), fig. 408, on 605.

As in Hans Christian Ørsted's experiment, this diagram shows an electric current causing a magnet to move. The magnetic needle was suspended on a pivot so that it could move in a horizontal plane, as it does in a compass.

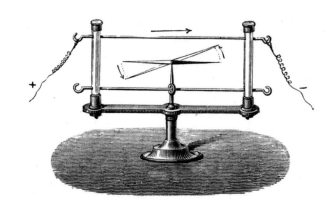

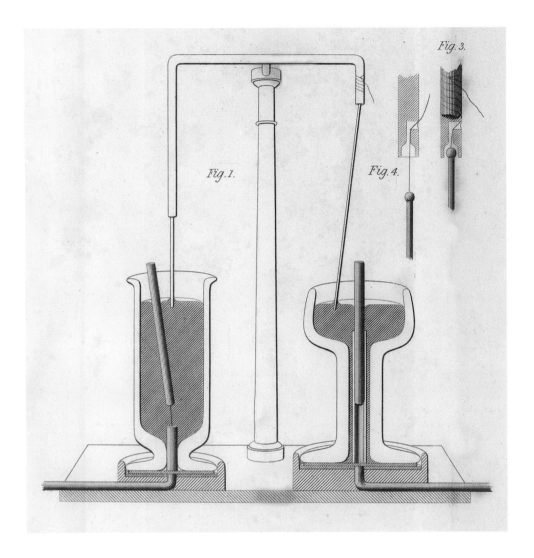

8-14. Electromagnetic rotation, in Michael Faraday, "Description of Electro-Magnetical Apparatus for the Exhibition of Rotary Motion," *Quarterly Journal of Science* 22 (Jan. 1822), 283; reprinted in Michael Faraday, *Experimental Researches in Electricity* (London: R. and J. E. Taylor, 1844), vol. 2, 148–51 (text); plate 4, figs. 1, 3, and 4 (images).

Using this apparatus, Faraday demonstrated that a cylindrical magnet moves around an electrified wire (left) and an electrified wire moves around a cylindrical magnet (right). Each vessel is filled with mercury and holds a long, cylindrical magnet. The magnet on the left is attached to the base by a wire, allowing it to rotate; the magnet on the right sits in a channel, keeping it motionless and vertical. Two wires hang from the arms of the T-shape bar and make contact with the mercury, which facilitates the "mercurial" current to flow through the wires after they are connected to a battery. On the left, the wire is rigid, but on the right, it is suspended by a ball-and-socket design (shown in figs. 3 and 4), which allows it to rotate (it is attached by a tiny wire so it doesn't fall out). When current is passed through the (stationary) wire on the left, the magnet rotates around the wire; when electricity flows through the wire on the right, it rotates around the (stationary) magnet. The direction of the rotation depends on the direction of the flowing current.

and in 1833, at age forty-two, he was given a laboratory (plate 8-16) and appointed professor of chemistry at the Royal Institution in London. At this time he began suffering from severe short-term memory loss, but he kept working, and in the 1850s he demonstrated the shape of an invisible magnetic field (plate 8-15). He also put forth the hypothesis that sunlight is a form of electromagnetic energy, and for years tried to convince the skeptical scientific community, but he lacked the mathematical skills to prove his conjecture.

8-15. Magnetic field around a bar magnet, in Michael Faraday, "Experimental Researches in Electricity," *Philosophical Transactions of the Royal Society* 142 (Jan. 1, 1852), 137–59; the image is plate 9, fig. 1, on 158. Royal Institution of Great Britain, Science Source.

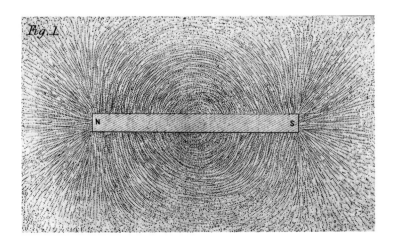

Michael Faraday made this diagram to show the structure of a magnetic field around a bar magnet. One cannot see the field, but one can see its effects. He first put a thin coat of melted wax on a piece of paper, which he laid on top of a bar magnet. He gently sprinkled iron filings (powdered iron), which are attracted to the magnet; the pattern shows that the strength of the magnetic force is concentrated at the poles. Faraday completed the diagram by warming the waxed paper to set the iron filings in place.

8-16. Harriet Jane Moore (British, 1802–1884), *Michael Faraday in the Chemical Laboratory of the Royal Institution Building on Albemarle Street*, 1852. Watercolor on paper, 16 × 18½ in. (40.6 × 47 cm). Collection of the Royal Institution of Great Britain, London.

Faraday is shown pouring liquid under a large black bellows that supplies air to the laboratory furnace below. The door to the furnace is open on the right; using the small hand bellows (shown lying on the floor), Faraday could raise the furnace temperature to a high degree. The prominent green spiral on the dark brown table on the far left is probably a curved glassware device—a retort—used for distillation. In the background the shelves are lined with reagent bottles, a type of laboratory glassware that is often tinted green or brown to protect light-sensitive chemicals. Below the shelves on the right hangs a mallet, and on the floor in the lower right is a hand-cranked device to produce static electricity.

Two years before painting this watercolor, Harriet Jane Moore attended six lectures by Faraday at the Royal Institution. She was from a family with social connections to scientists and artists, including the geologist Charles Lyell (see plate 3-16 in chapter 3) and the Swiss artist Henry Fuseli (see plate 3-29 in chapter 3). Her grandfather, the physician John Moore, met Fuseli in Rome in the 1770s, and after the artist settled in London in 1779, he came to know the whole Moore family. In 1806, when Harriet was four years old, Fuseli gave her the book *For Children: The Gates of Paradise* (1793), by William Blake, inscribed "To Harriet Jane Moore from her friend Henry Fuseli" (Frank James, "Moore's Watercolors of the Interior of the Royal Institution," in *Fields of Influence: Conjunctions of Artists and Scientists, 1815–60*, ed. James Hamilton [Birmingham: University of Birmingham Press, 2001], 127, n. 33).

The aging Faraday, whose memory continued to decline, was befriended by James Clerk Maxwell, a young upper-class gentleman who had been well educated in mathematics at Cambridge University. In the preface to his book *Electricity and Magnetism* (1873), Maxwell described how he approached the topic so as not to prejudice his mind with the thoughts of other mathematicians: "Before I began the study of electricity I resolved to read no mathematics on the subject till I had first read through Faraday's *Experimental Researches in Electricity*. I was aware that there was supposed to be a difference between Faraday's way of conceiving phenomena and that of the mathematicians, so that neither he nor they were satisfied with each other's language. I had also the conviction that this discrepancy did not arise from either party being wrong."[6] Maxwell gave an *abstract* mathematical description that accounted for Faraday's *concrete* experimental results, which he published as "On Faraday's Lines of Force" (1855). Maxwell gave a copy to Faraday, who responded: "I was at first almost frightened when I saw such mathematical force made to bear upon the subject, and then wondered to see that the subject stood it so well." Faraday said he planned more experiments, despite his declining health: "I am long in realizing my intentions, and a failing memory is against me."[7]

A few years later Maxwell gave a mathematical description of electromagnetism as a composite wave (plate 8-17). Maxwell noted that Rudolf Kohlrausch and Wilhelm Weber's 1856 calculation of the speed of electromagnetic undulations in a medium was almost identical to Hippolyte Fizeau's 1849 calculation of the speed of light. Maxwell therefore declared that Faraday's hypothesis about sunlight was correct—light *is* an electromagnetic wave—in his essay "On Physical Lines of Force" (1861–62). Scientists consider this essay by Maxwell as important as Newton's description of gravity in *Philosophiæ Naturalis Principia Mathematica* (1687) and Einstein's paper on the equivalence of energy and mass ($E = mc^2$) of 1905. Maxwell went on to publish a two-volume book, *A Treatise on Electricity and Magnetism* (1873), in which he described electromagnetic force fields, which travel at the speed of light to infinity (plate 8-18).

In the early nineteenth century, the astronomer William Herschel did an experiment to measure the temperatures of different colored lights by putting a beam of sunlight through a prism and then running a thermometer through the spectrum. He found that the thermometer rose as he moved it through the spectrum from blue to green to yellow to red. (Today physicists know that Herschel was actually measuring the *concentration* of the colored light,

8-17. Electromagnetic wave

Electromagnetism is a self-propagating composite of electric and magnetic fields that are polarized, meaning that the two undulations (the electric and magnetic waves) each move in only one plane. Furthermore, the electric and magnetic planes are perpendicular to each other. The fields pulse forward: the moving electric field produces a moving magnetic field, which in turn produces a moving electric field, and so on. This pulsing, self-propagating phenomenon happens at only one speed: 186,282 miles (299,792 kilometers) per second—the speed of light.

The velocity of transverse undulations in our hypothetic medium, calculated from the electromagnetic experiments of MM. Kohlrausch and Weber, agrees so exactly with the velocity of light calculated from the optical experiments of M. Fizeau, that we can scarcely avoid the inference that light consists in the transverse undulations of the same medium which is the cause of electric and magnetic phenomena.

James Clerk Maxwell,
"On Physical Lines of Force," 1861–62

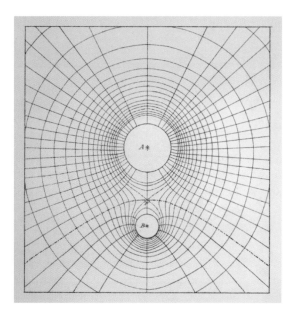

because when white light passes through a prism, each color [frequency] is refracted at a different angle. Blue wavelengths are shorter [have higher energy], but they are refracted more, so less is concentrated in the blue region of the spectrum. Red wavelengths are longer [have less energy], but they are refracted less, and so more energy is concentrated in the red region.) When Herschel put the thermometer in the darkness beyond red, and to his astonishment the temperature went up—he had discovered infrared radiation. It was a simple step to discover invisible ultraviolet radiation at the other end of the spectrum. In the 1880s Maxwell declared that infrared radiation, visible light, and ultraviolet radiation are all forms of the same thing—electromagnetism—that differ only in wavelength. He went on to predict the existence of a whole spectrum of invisible electromagnetic radiation of which visible light is but a small part (plate 8-19).

Within decades Maxwell was proven right, as radiation at other wavelengths was discovered. In 1888 the German physicist Heinrich Hertz was working with a slowly oscillating current that he suspected would produce electromagnetic rays with very long wavelengths, from a few feet to over a mile; soon he succeeded in measuring what we now know of as radio waves. In 1895 the German physicist Wilhelm Röntgen discovered that there are invisible rays at the other end of the electromagnetic spectrum—x-rays— that are so small they can penetrate fabric and soft tissue and form a picture of the dense bones inside a living body (plate 8-20). By 1900 gamma rays, which have even smaller wavelengths and hence could penetrate bone, had been discovered. Today scientists know that the wavelengths of radio waves can be taller than Mount Everest and gamma rays are as small as an atomic nucleus.

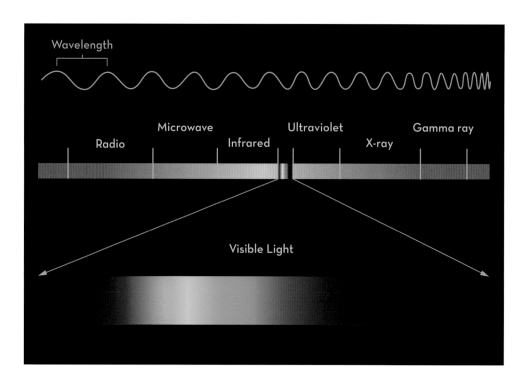

His doubts of the sanity of the entire business flashed and vanished again as he looked across to where Griffins sat at the breakfast-table—a headless, handless dressing-gown, wiping unseen lips on the miraculously held serviette.

"It's simple enough—and credible enough," said Griffin, putting the serviette aside and leaning the invisible head on the invisible hand.

"No doubt to you, but—" Kemp laughed. . . .

"You know I dropped medicine and took up physics? No!—well, I did. Light—fascinated me."

"Ah!"

"Optical density! The whole subject is a network of riddles—a network with solutions glimmering elusively through. And being but two and twenty and full of enthusiasm, I said, 'I will devote my life to this. This is worthwhile.' You know what fools we are at two and twenty?"

<div align="right">

H. G. Wells, *The Invisible Man*, 1897

</div>

8-20. X-ray of bones (left) and bones with arteries (right), in L. Gastine, "Nouvelles études au moyens des rayons x" [New studies using x-rays], *L'Illustration* 108, no. 2802 (Nov. 7, 1896), 363.

Probability Enters the Laboratory

In the mid-nineteenth century James Clerk Maxwell described the motion of molecules in a gaseous state, such as the water molecules in fog (*Kinetic Theory of Gas*, 1866). He showed how to determine the speed of a molecule, and defined the temperature of a gas as the average speed of the molecules. He gave the location of a molecule in a gas not as a certainty (as a whole number) but assigned it a degree of probability. For example, let us suppose that one needs to have a rough estimate (around 60 percent accuracy) of the location of every water molecule in fog; if the precise location of each molecule is known, Maxwell gave a way to estimate where each will be in one second, to a 60 percent degree of accuracy. If one needs a more precise estimate, then Maxwell's method can predict each molecule's location to 90 percent probability. Before Maxwell's time, the location of an object, such as the moon, was given as a certainty (100 percent probability). But as scientists studied more complex phenomena such as molecules in fog or people in a city, they began using probability theory (the term *statistics* derives from the German word for "of the state").

Maxwell was quick to see that his introduction of statistics into the kinetic theory of gas had implications for philosophical debates about determinism:

> Recent developments in molecular science seem likely to have a powerful
> effect on the world of thought. The doctrine that visible bodies apparently
> at rest are made up of parts, each of which is moving with the velocity of a
> cannon ball, and yet never departing to a visible extent from its mean place,
> is sufficiently startling to attract the attention of an unprofessional man. But

c'était
issu stellaire
le nombre
EXISTÂT-IL
autrement qu'hallucination éparse d'agonie
COMMENÇAT-IL ET CESSÂT-IL
sourdant que nié et clos quand apparu
enfin
par quelque profusion répandue en rareté
SE CHIFFRÂT-IL
évidence de la somme pour peu qu'une
ILLUMINÂT-IL
ce serait
pire
non
davantage ni moins
mais autant indifféremment

LE HASARD

(Choit
la plume

8-21. Stéphane Mallarmé, "Un coup de dés jamais n'abolira le hasard" [One throw of the dice never will abolish chance], *Cosmopolis* 6, no. 17 (May 1897), 417–27; this is page 425.

Mallarmé wrote this poem in *vers libre* (free verse) and had it printed in an irregular layout with a variety of typefaces. This page is from the only publication of the poem during Mallarmé's lifetime.

Mallarmé, intraduisible, même en français
[Mallarmé is untranslatable, even into French].

Jules Renard, *Journal*,
March 1, 1898

I think the most important effect of molecular science on our way of thinking will be that it forces on our attention the distinction between two kinds of knowledge, which may for convenience be called the dynamical and statistical.[8]

Maxwell is referring to the distinction between *dynamical determinism*, in which one knows the position of every molecule with precision, and *statistical determinism*, in which one knows the position to a degree of probability. Notice that probability theory is deterministic; if you flip one coin, whether it will come up heads or tails is completely unpredictable, but if you flip 100 coins, you can predict with certainty that the coins will come up 50 percent heads. Or, to quote the poet Stéphane Mallarmé, "one throw of the dice never will abolish chance" (plate 8-21), but many certainly will.

Cynicism Enters the Studio

After Maxwell used statistics to measure the motion of molecules, the French artist Alfred Jarry gleefully used chance methods to mock science, because he thought (incorrectly) that probability theory undermines Enlightenment determinism, evidently unaware that Maxwell's use of statistics *is* deterministic. Jarry wrote a play about a grotesque personification of stupidity, *Ubu roi* (Ubu the king), which premiered at the French Symbolist Théâtre de l'Oeuvre in 1896. Jarry playfully created other irrational nonsense, such as his 1898 satiric memoirs of "Dr. Faustroll, Pataphysician," who comes up with "the science of imaginary solutions."[9]

Jarry's antics were part of a resurgence of Romanticism in response to a perceived threat from the rise of science. Jarry was hailed for his cynicism, a philosophical outlook that arose in antiquity. In Greek philosophy the Cynics emerged in the mid-fourth century BC as a voice opposed to Plato and Aristotle's confidence in reason. These philosophers called themselves *Cynics* (Greek for "dogs") to mock mankind's elevated place in Aristotle's chain of being. They defied social taboos by being cynical—"playing the dog"—minimizing creature comforts (living in the street) and maximizing freedom of action (sniffing around wherever they pleased). The founder of Cynicism, the philosopher Diogenes, lived as a homeless beggar. One day he was sunning himself in the city of Corinth, when the powerful leader Alexander the Great walked over and said: "Ask whatever you desire," expecting the poor man to ask for gold. But Diogenes expressed his disdain for material possessions by telling Alexander what he most wanted from him: "Stand out of my light" (plate 8-23).[10]

In the early twentieth century Marcel Duchamp, who shared Jarry's love-hate relationship with science, devised his own standards of measurement (plate 8-22). Reflecting on the piece, *3 Stoppages Étalon* (3 standard breaks), the artist later mused: "Pure chance [*hasard pur*] interested me as a way of going against logical reality."[11] In notes written to accompany the viewing of his piece *The Large Glass* (1915–23; Philadelphia Museum of Art),[12] Duchamp wrote that he was in pursuit of "a reality that would be possible by slightly distending the laws of physics and chemistry."[13] Although Jarry and Duchamp created amusing satires, they did not make art about *science* per se, because if one "slightly" distends the laws of physics and chemistry, they're not the laws of physics and chemistry anymore.

ABOVE

8-22. Marcel Duchamp (French, 1887–1968), *3 Stoppages Étalon* [3 standard breaks], 1913–14. Three threads, each 1 m (39⅜ in.) long, glued to three painted canvas strips, each mounted on a glass panel; and three wooden slats. Museum of Modern Art, New York, Katherine S. Drier Bequest.

After dropping three meter-long threads, Duchamp cut three "meter sticks," each shaped to match the curve of one of the threads.

RIGHT

8-23. Honoré Daumier (French, 1808–1879), "Alexandre et Diogène," no. 20 in the series Histoire Ancienne [Ancient history], 1842. Lithograph, sheet 13 × 9⅞ in. (33 × 25 cm). Boston Public Library.

The cartoonist Honoré Daumier drew the well-attired Alexander the Great casting his shadow on the scantily clad philosopher Diogenes. Although it is daytime, Diogenes has a lamp at his side, because he searches day and night for an honest man.

Telecommunications

Once electromagnetism began to be understood, several inventors got the idea of sending messages by electrical impulses along a wire. Samuel F. B. Morse was an American portrait painter and founding president of New York's National Academy of Design, an art school based on the European academic method of copying old master paintings, as shown in Morse's *Gallery of the Louvre* (plate 8-24). Morse created this gigantic canvas—9 feet (2.74 meters) wide—in Paris in the early 1830s as a showpiece, meticulously painting forty miniatures of masterpieces from the Louvre. In the foreground Morse included his self-portrait as a teacher, leaning over the shoulder of a young artist and pointing to her canvas. In 1832 Morse, then forty-two years old, packed up his painting and set sail from France for home; during the voyage he heard about Faraday's experiments on electromagnetism and got the idea of an electric *telegraph* (from Greek for "to write at a distance"). In New York, Morse showed *Gallery of the Louvre* in a theatrical setting, hoping to win commissions. When no one hired him, he set aside his brushes and launched a commercial telegraph.[14]

8-24. Samuel F. B. Morse (American, 1791–1872), *Gallery of the Louvre*, 1831–33. Oil on canvas, 73¾ × 108 in. (187.3 × 274.3 cm). Terra Foundation for American Art, Daniel J. Terra Collection, 1992.51.

Like the French academy, the US National Academy of Design in New York had students set up their easels in an art museum and copy Renaissance and Baroque paintings. Morse was president of the National Academy of Design from 1826 to 1845, and again in 1861–62.

Morse invented a code so that text messages could be sent through wire as a sequence of short and long impulses—dots and dashes (Morse code). His friend Alfred Vail, an inventor and machinist, helped Morse build the telegraph equipment, and the two operated the first telegraph line, strung between Washington, DC, and Baltimore. On May 24, 1844, Morse officially opened the line by sending Vail the biblical phrase "What hath God wrought" (Numbers 23:23), after which he sent a second, more practical message: "Have you any news?" In the coming days Morse and Vail exchanged many news items, which were published in Washington and Baltimore newspapers, demonstrating the power of telegraphy in journalism.[15] By the 1840s Western cities were linked by telegraph lines strung high on poles (plate 8-25). In the later nineteenth century, lines were added to carry spoken messages after the invention in 1876 of the *telephone* (from Greek for "to sound at a distance") by the Scottish-born American Alexander Graham Bell. Sound moves as a vibration through a medium, such as air. When vibrating air (a sound-wave) enters the ear canal, it sets the eardrum vibrating, which is recorded by nerves in the inner ear (see plate 5-3, in chapter 5). Similarly, as illustrated in plate 8-27, when the man speaks into the telephone, his voice produces sound-waves that set a mechanical membrane vibrating; the vibrations cause electrical impulses carried by wire to a second membrane, which is set in motion, causing air to vibrate in the same pattern in the receiver—and the woman hears his voice. After perfecting the telephone, in 1885 Bell founded a company to manufacture telecommunication devices, American Telephone and Telegraph (AT&T).

8-25. Charles Burchfield (American, 1893–1967), *Song of the Telegraph*, 1917–52. Watercolor on paper, 34 × 53 in. (86.4 × 134.6 cm). Burchfield Penney Art Center, State University of New York at Buffalo, Collection of William and Rose-Marie Shanahan.

TOP

8-26. Vertical section of the Atlantic Ocean, in M. F. Maury, *The Physical Geography of the Sea* (New York: Harpers, 1855), plate 12.

This compressed view of the Atlantic Ocean at about 15 degrees North latitude shows (from left to right) the Yucatán (in southeastern Mexico), Cuba, Haiti, Puerto Rico, the Windward Islands, the Cape Verde Islands, and Senegambia (the region occupied by Senegal and Gambia on the western coast of Africa). Matthew Maury's *The Physical Geography of the Sea* is the founding text of oceanography.

ABOVE

8-27. Telephone, in Louis Figuier, *Les Nouvelles conquêtes des sciences* [New conquests of science] (Paris: Montgredien, 1883), 1:352.

Telegraph and telephone wires were strung across dry land, but 75 percent of Earth is covered with water, so engineers went to work putting wires underwater, and in 1851 a cable was laid across the English Channel. An underwater cable is a rope made from strands of metal wire, which is covered with insulation (such as rubber) to prevent electricity leaking into the water; the cable must be strong enough to not snap during a storm. American naval officer Matthew Maury mapped the floor of the Atlantic Ocean as part of the joint US-British effort to lay a telegraph cable across the Atlantic (plate 8-26). On July 29, 1858, the USS *Niagara* and HMS *Agamemnon* met up in the mid-Atlantic and spliced their cables together; then the *Niagara* headed west toward North America and the *Agamemnon* sailed east to England, both arriving within a week (plate 8-29). On August 16, 1858, Queen Victoria sent the first telegraph message to President James Buchanan in the United States, where citizens celebrated by dancing a polka (plate 8-28). The 1858 cable operated only three weeks before breaking, but engineers tried again and in 1866 succeeded in spanning the Atlantic with a permanent telegraph cable. To send a message

THE NIAGARA & AGAMEMNON COMMENCING TO LAY THE CABLE.

COMPOSED BY A.TALEXY.

FULL SIZE AND APPEARANCE OF CABLE.

MAP OF THE TELEGRAPH BETWEEN AMERICA & EUROPE.

BOSTON
Published by OLIVER DITSON & CO 277 Washington St.

LEFT

8-28. *Atlantic Telegraph Polka*, composed by A. Talexy (Boston: Oliver Ditson, ca. 1858). Lithograph by J. H. Bufford. Newberry Library, Chicago.

The composer dedicated the tune to Cyrus W. Field, the American businessman who organized the group of investors that funded the telegraph cable across the Atlantic. Field also paid for Frederic Church's expedition to South America, where the artist painted *Heart of the Andes* (see plate 2-16 in chapter 2).

ABOVE

8-29. "The starting point of the Atlantic Submarine Telegraph Fleet," detail of *Chart of the Submarine Atlantic Cable* (Philadelphia: W. J. Barker and R. K. Kuhns, 1858). Hand-colored engraving; chart measures 11¾ × 23⅝ in. (30 × 60 cm). Library of Congress, Washington, DC.

from London to New York via a mid-nineteenth-century sailing ship took ten days; the 1866 cable could transmit eight words per minute. Soon the globe was spanned by telegraph cables (plate 8-30). Today underwater cables are made of fibers of glass, through which messages are sent by light—fiber-optic cables (plate 8-31).

By the 1890s scientists knew that the current carrying Morse code through the metal wires was electromagnetic impulses. The Italian engineer Guglielmo Marconi developed a device that could transmit Morse code as radio waves through the atmosphere—"wireless" radio transmission. It would be another 100 years before engineers developed the parallel technology for telephones that send and receive calls by radio waves—handheld mobile cellular ("cell") phones.

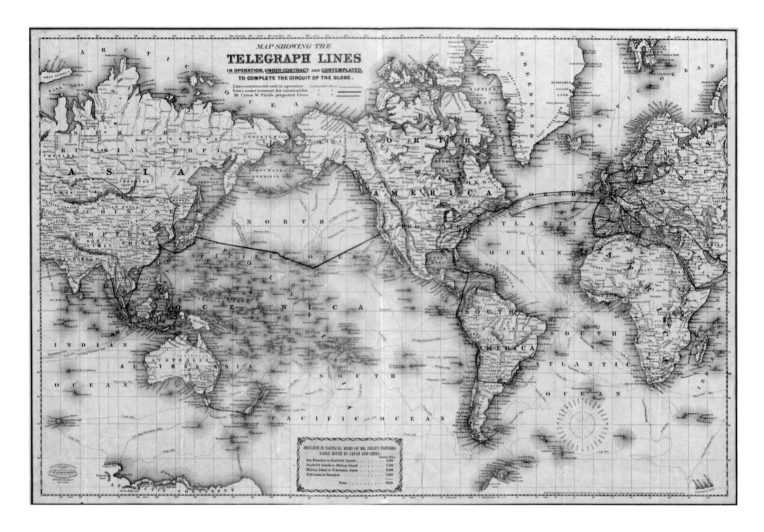

8-30. *Map Showing the Telegraph Lines in Operation, under Contract, and Contemplated, to Complete the Circuit of the Globe*, by J. H., G. W., and C. B. Colton and Nathaniel Prentiss Banks (New York: Colton, 1871). Library of Congress, Washington, DC.

OPPOSITE

8-31. Map of submarine fiber-optic cables that transport the Internet, 2011. Graphic by Nicolaus Rapp.

When the French engineer Gustave Eiffel built the Eiffel Tower for the 1889 Exposition Universelle in Paris, it was the tallest building in the world—984 feet (300 meters)—and the perfect place for a radio transmitter, which was installed by Eugène Ducretet, a French designer of scientific instruments. From atop the tower, Ducretet sent a message across Paris to the Panthéon, a distance of about 2.5 miles (4 kilometers) (plate 8-33). The building permit for the Eiffel Tower was for twenty years; by 1903 Eiffel was getting frantic because time was running out, so he convinced the French army captain Gustave Ferrié to test radio communication from the tower. Ferrié found that he could send wireless telegraphs to military installations throughout Paris, and by 1908 he was communicating with Berlin in the heart of Europe and Casablanca on the coast of North Africa. Convinced of the tower's military importance, the city renewed the permit for seventy years, and the Eiffel Tower became a symbol of the new age. Meanwhile, in 1901 and 1902, Marconi sent the first transatlantic radio transmissions from Cornwall, England, to Newfoundland and Nova Scotia, both provinces of Canada. Soon ship masts and steeples throughout the world bristled with radio antennas.

The invention of wireless telegraphy led scientists to study the electrical and magnetic properties of Earth and the atmosphere (plates 8-32 and 8-34). Hertz had shown that a focused beam of radio waves travels in a straight line; how could Marconi's radio waves travel the curved path over Earth's surface from England to Canada? In 1902

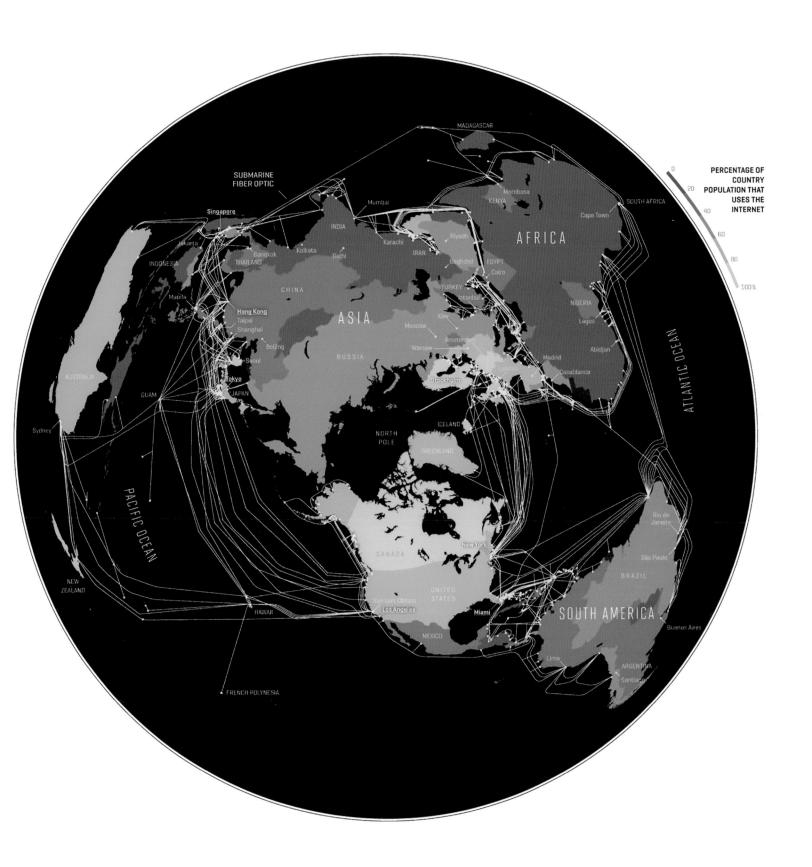

SUBMARINE
FIBER OPTIC

PERCENTAGE OF
COUNTRY
POPULATION THAT
USES THE
INTERNET

0
20
40
60
80
100%

MADAGASCAR

Mombasa
KENYA
SOUTH AFRICA
Cape Town

AFRICA

Mumbai
Singapore
INDIA
Karachi
Riyadh
IRAN
Baghdad
EGYPT
Cairo
NIGERIA
Lagos
Abidjan
Madrid
Casablanca

Jakarta
INDONESIA
Bangkok
THAILAND
Kolkata
Delhi
CHINA
ASIA
TURKEY
Istanbul
Manila
Hong Kong
Taipei
Shanghai
Moscow
Kiev
Amsterdam
Beijing
RUSSIA
Warsaw
London

Seoul
Stockholm

Tokyo
JAPAN
AUSTRALIA
GUAM
ICELAND

ATLANTIC OCEAN

Sydney
NORTH
POLE
GREENLAND

PACIFIC OCEAN

Rio de
Janeiro

CANADA
New York
São Paulo

NEW
ZEALAND
BRAZIL

San Luis Obispo
UNITED
STATES
Los Angeles
Miami
SOUTH AMERICA

HAWAII
Buenos Aires

MEXICO

Lima
ARGENTINA
Santiago

FRENCH POLYNESIA

TOP

8-32. Earth's magnetic field, in Hans Kraemer, *Weltall und Menschheit* [Cosmos and humanity] (Berlin: Bong, 1902–4), 1:401.

ABOVE LEFT

8-33. Eiffel Tower and exhibition halls in the Champ de Mars during the Exposition Universelle in Paris, 1889. Photograph.

The Eiffel Tower was built in a public green space known as the Champ de Mars.

ABOVE RIGHT

8-34. Tom Shannon (American, born 1947), *Compass Moon Atom Room*, 1991. Installation of 270 magnetic spheres, each diameter 4 in. (10 cm). Moderna Museet, Stockholm.

Installation artist Tom Shannon hung magnetic spheres, painted black and white, by nylon thread in a large room. Once suspended, the spheres align themselves to Earth's magnetic field so that all the white halves face north. Meanwhile, each sphere also generates its own local magnetic field, which links with the fields of the spheres surrounding it. If someone enters the installation and turns one sphere 180 degrees, this change in the local magnetic field causes the other spheres to slowly turn, first those close by and eventually the entire array, so that their white halves face south.

scientists discovered that the atmosphere contains layers of ions (atoms that carry an electric charge) and that radio waves are reflected from these layers, the ionosphere, as light is reflected from a mirror.

The directors of early silent films gave electromagnetism a starring role in mystery tales, such as the 1908 double feature released by Vitagraph Studios of America, *Galvanic Fluid* and *Liquid Electricity*.[16] In an era when swimsuits covered a woman's body from neck to knee, in 1909 the Société des Etablissements L. Gaumont, in Neuilly-sur-Seine, France, produced an adult film about a pair of glasses that gave the wearer x-ray vision, *Les Lunettes Féeriques* (Fairy glasses; directed by Émile Cohl).[17]

By wireless imagination I mean the absolute freedom of images or analogies, expressed by disconnected words and with no wire conductors of syntax and no punctuation.

Filippo Tommaso Marinetti, "The Wireless Imagination," *Lacerba*, 1913

Spectrography and Astrophysics

In 1801 the English physician Thomas Young shone light through two closely spaced slits onto a surface, and it formed an interference pattern (plate 8-36). This pattern is formed when waves cross ("interfere" with) each other, and thus Young concluded that light is a wave.

Isaac Newton had given a mathematical—not a physical—description of the spectrum, but Young's description of light as a wave gave a physical explanation. Light is refracted (changes direction) when it moves from one medium to another, such as from air to water. For example, a straw appears to bend as it enters a glass of water. The angle of refraction depends on the wavelength of the light. White light (sunlight) is composed of all wavelengths (colors). When white light moves from air to glass, different wavelengths of light are bent to different angles, so they leave a glass prism at different angles, resulting in a spectrum (plate 8-35).

LEFT

8-35. Prism

 A prism separates white light into different wavelengths (colors).

RIGHT

8-36. Double-slit experiment, in Thomas Young, *A Course of Lectures on Natural Philosophy and the Mechanical Arts* (London: J. Johnson, 1807), vol. 1, plate 10, fig. 267, facing 777.

 In the text accompanying this diagram, Young described the wave pattern formed by water: "Two equal series of waves, diverging from the centers *A* and *B*, and crossing each other in such a manner, that in the lines tending towards *C*, *D*, *E*, and *F*, they counteract each other's effects, and the water remains nearly smooth, while in the intermediate space it is agitated" (777). Scale down the apparatus and project light onto a screen through narrow slits at *A* and *B*, and one will see the same kind of interference pattern.

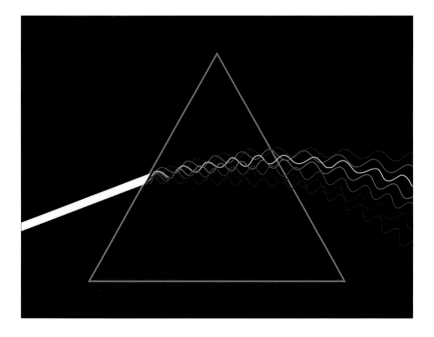

8-37. Joseph von Fraunhofer (center) demonstrating the spectrometer, in Williams Huggins, "The New Astronomy," in *Essays in Astronomy* (New York: Appleton, 1900), 441–72; the image is between 446–47. Photogravure of a painting (1897) by Richard Wimmer. Library of Congress, Washington, DC.

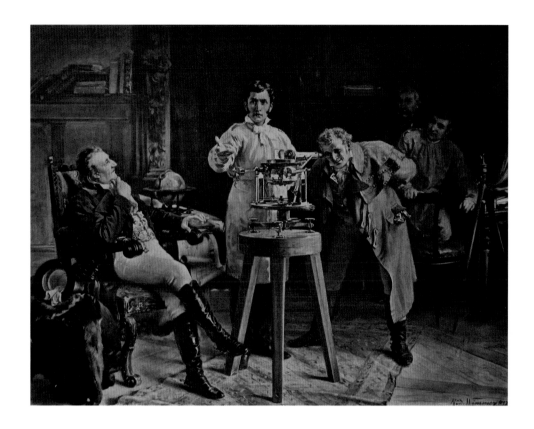

In 1814 the German physicist Joseph von Fraunhofer designed an instrument—a spectrometer (also called a "spectroscope"; it's similar to a small telescope)—through which he observed a narrow beam of light passing through a prism (plate 8-37). He discovered that a beam of sunlight produces a spectrum that is not continuous but missing certain wavelengths, which appear as dark lines (known as Fraunhofer lines; plate 8-38). After Fraunhofer invented spectrography, physicists found they could produce a more detailed spectrum if they used not one prism but a piece of glass etched with parallel lines that create tiny parallel prisms—a diffraction grating, which was invented by the American physicist Henry A. Rowland (plate 8-41).

In 1835 the French positivist Auguste Comte declared that the chemistry of the stars is unknowable: "We can conceive of the possibility of determining their forms, their distances, their sizes, and their movements; while there is no means by which we can ever study their chemical composition."[18] A few decades later the German physicist Gustav Kirchhoff proved Comte wrong, when he heated different elements to incandescence in his laboratory and observed the glowing substances with a spectroscope. If the element was absorbing energy (heating up) then he saw dark lines in its spectrum, but if the element was giving off energy (cooling down), then he observed the reverse—colored lines against a dark background (plate 8-39). Kirchhoff recorded that each element has a distinct pattern of Fraunhofer lines; in other words, each emits and absorbs light in only certain wavelengths. In 1859 he announced that every element has a spectral "fingerprint." Now an astronomer could determine the chemical composition of a star by looking at its starlight with a spectroscope. Kirchhoff didn't know *why* light had different patterns of Fraunhofer lines. To answer that question scientists

8-38. Dark lines in the spectrum of sunlight, Joseph von Fraunhofer, in *Bestimmung des Brechungs- und Farben-zerstreuungs-Vermögens verschiedener Glasarten, in Bezug auf die Vervoll-kommnung achromatischer Fernröhre* [Determination of the refractive index of different types of glass, in relation to the achromatic telescope] (Munich: Gedruckt mit Lentner'schen Schriften, 1817), plate 2, figs. 5 and 6, after 36. Deutsches Museum, Munich.

8-39. Spectrographs, in Sigmund T. Stein, *Das Licht* [The light] (Leipzig: Spamer, 1877), plate 6.

In the top row is an absorption spec-trograph of the sun (*Sonne* in German), below which is one for a star (Sirius). In the eighth row is an emission spec-trum of hydrogen (labelled *Wasserstoff*, literally "the stuff of water," the German name for hydrogen).

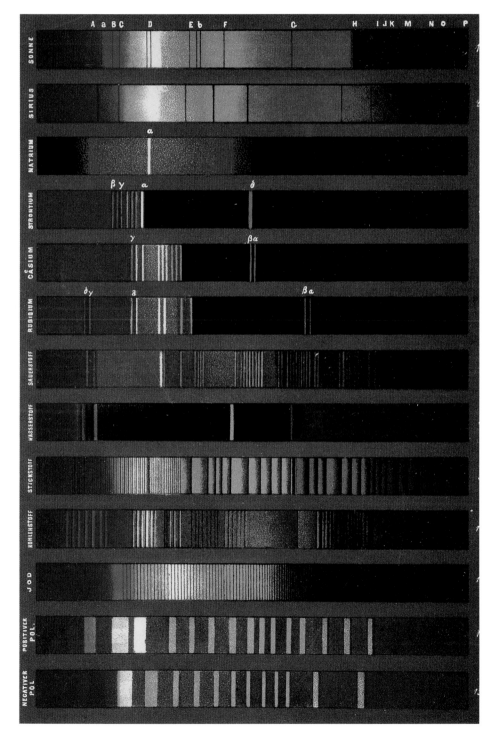

needed to enter the subatomic realm and explore the origin of electromagnetic energy inside the atom.

In the mythology of antiquity, the Greek messenger goddess Iris displayed her communication as a rainbow (plate 8-40). In the nineteenth century astronomers learned to read the messages in a rainbow—the dark lines in a spectrum—by putting starlight through a spectroscope and analyzing what elements a star is made of. Thus was born a new science that combines astronomy and physics—astrophysics.

Historians and astronomers have identified many celestial bodies in Vincent van Gogh's paintings of the night sky, such as the constellation Aries in *The Starry Night* (plate 0-2). The swirling forms in this painting look like spiral nebulas (plate 8-42).[19] Known today to be galaxies, spiral nebulas appear as wisps of a cloud (a "nebula") to the unaided eye; the spiral shape of the nebula in plate 8-43 was first seen in 1844. Images of spiral nebulas such as this were published in late nineteenth-century newspapers and science popularizations, which van Gogh certainly saw. In a letter to the painter Émile Bernard, van Gogh expressed confidence that questions previously addressed by religion would someday be answered by science, concluding, "Science—scientific reasoning, seems to me an instrument that will go very far in the future."[20]

ABOVE

8-42. Vincent van Gogh (Dutch, 1853–1890), *The Starry Night*, 1889; detail of plate 0-2 on page viii.

LEFT

8-43. Spiral nebula, in Camille Flammarion, *Astronomie populaire* [Popular astronomy] (Paris: C. Marpon and E. Flammarion, 1881), 814.

This nebula was drawn by the Anglo-Irish astronomer William Parsons in 1844 from observations he made using his telescope with a 72-inch (183-centimeter) diameter lens, which was the world's largest telescope (in terms of aperture size) until the early twentieth century. Today this spiral nebula is known as the Whirlpool Galaxy (Messier 51a).

OPPOSITE, TOP

8-44. Vincent van Gogh (Dutch, 1853–1890), *Starry Night over the Rhône*, 1888. Oil on canvas, 29 × 36 in. (73.7 × 91.4 cm). Musée d'Orsay, Paris.

OPPOSITE, BOTTOM.

8-45. "Multicolored Stars," in Camille Flammarion, *Les Merveilles célestes* [Wonders of the sky] (Paris: Hachette, 1869), opposite 156.

The color of a star (which is enhanced in this diagram) is caused by the visible light emitted (and absorbed) by the elements of which the star is composed.

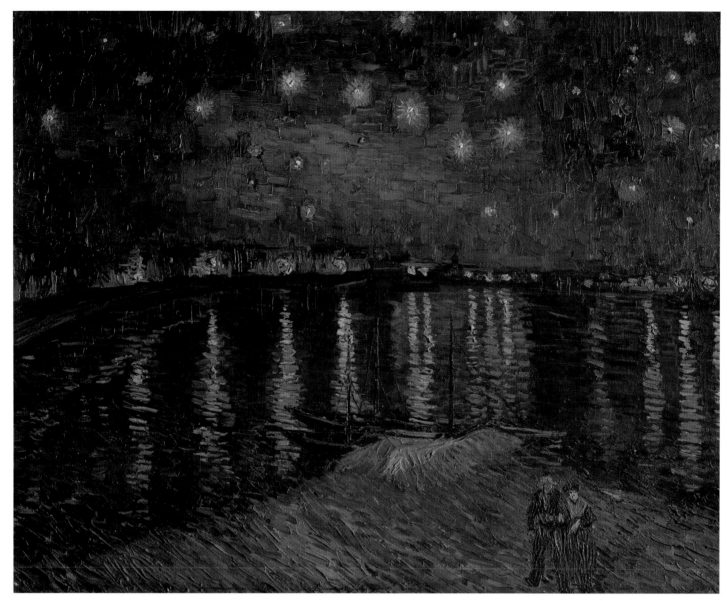

Kirchhoff suggested that the slight differences in the colors of stars result from their being composed of different elements. Van Gogh may have seen illustrations of the colors of stars in the French popular press (plate 8-45). A letter from the artist to his brother Theo van Gogh confirms that *Starry Night over the Rhône* (plate 8-44) was "painted at night under a gaslight [street light]"—in other words, from direct observation. The artist goes on to describe the painting: "The village is blue and violet, the gaslights are yellow, and their reflections range from reddish gold to greenish bronze. On the blue-green expanse of sky the Great Bear [which includes the Big Dipper] sparkles in green and rose; its unobtrusive paleness contrasts with the harsh gold of the gas."[21] Van Gogh then confided to his brother: "It makes me feel good to do things that are hard. Nevertheless, sometimes I have a terrible need of, I will say the word—of religion—then I go out at night and paint the stars."[22]

Kupka and Delaunay

Working at a time of great popular interest in x-rays and other invisible forms of electromagnetism, artists depicted the human figure not as solid but dissolved into a pattern of overlapping, transparent planes that revealed the body's interior. The Czech painter František Kupka created *Woman in the Triangles* with overlapping transparent planes that suggest an x-ray (plate 8-47). Artists could see pictures in the French popular science press of time-lapse x-ray studies (reproduced as film stills) of bodies in motion (plate 8-46).[23] Like an x-ray, Kupka's drawing reveals the invisible interior of a body in motion.

The French artist Robert Delaunay did a series of paintings on the theme of light. In *Windows*, he juxtaposed planes of red and green, orange and blue to enliven the surface with apparent movement—optical flickering—at the edges of the complementary colors (plate 8-48). In the same year he began his manifesto on the topic of light:

> Impressionism is the birth of light in painting.
> Light reaches us through our perception.
> Without visual perception, there is no light, no movement.
> Light in nature creates color-movement.
> Movement is provided by relationships of uneven measures,
> of color contrasts among themselves that make up reality.[24]

Oh Eiffel Tower!. . .
Your wireless telegraph shines forth with all
the magnificence of the aurora borealis.

Blaise Cendrars, "Tower," 1913,
a poem dedicated to Robert Delaunay

In this passage Delaunay demonstrates his familiarity with a century of research on light: Thomas Young's colors as different wavelengths ("uneven measures"), Michel-Eugène Chevreul's interaction of color ("color contrasts"), and Hermann von Helmholtz's physiology ("visual perception"). Delaunay also painted the Eiffel Tower, crowned with its radio transmitter, sending out invisible light (plate 8-49).

Futurism, Rayonism, and Vorticism

In Milan the Futurists advocated destroying Italy's classical past and creating new art expressing the present: "Victorious science of our time has disowned its past to better meet the material needs of our time; we want art, by disowning its past, to respond to the intellectual needs that drive us." The "Manifesto of Futurist Painters" (1910) was signed by Umberto Boccioni, Carlo Carrà, Luigi Russolo, Giacomo Balla, and Gino Severini.[25]

Balla chose subjects from technology; in *Street Light* (plate 8-50), a new electric lamp outshines the old-fashioned moon. Balla described the painting to Alfred H. Barr, the founding director of the Museum of Modern Art in New York, on the occasion of his acquisition of the work for MoMA in 1954:

8-49. Robert Delaunay (French, 1885–1941), *Champs de Mars: The Red Tower*, 1911–23. Oil on canvas, 63¼ × 50⅝ in. (160.7 × 128.6 cm). The Art Institute of Chicago, Joseph Winterbotham Collection.

Delaunay depicted a dynamic Eiffel Tower by painting fragments of it from different angles, as if he were moving.

8-50. Giacomo Balla (Italian, 1871–1958), *Street Light*, 1909. Oil on canvas, 68¾ × 45¼ in. (174.7 × 114.5 cm). Museum of Modern Art, New York, Hillman Periodicals Fund.

> This painting, besides being an original work of art, is also scientific because I tried to represent light by separating it into the colors that compose it. It is of great historical interest because of the technique and the subject. No one at that time [1909] thought that an ordinary electric lamp could be reason for pictorial inspiration. On the contrary, I was inspired by it, and in the study I wanted to represent light and above all to demonstrate that romantic "moonlight" had been supplanted by the light of the modern electric lamps, to wit, the end of Romanticism in art.[26]

Opposed to static subject matter, the Futurist painters visualized motion: "The attitude that we want to reproduce on our canvas will not be a *fixed instant* in the energetic motion of the universe. It will simply be the *dynamic sensation* itself."[27] In *Dynamism of a Dog on a Leash* (plate 8-51), Balla suggests motion of the dachshund's legs and leash with an overlapping, shifting pattern borrowed from time-lapse photographs of figures in motion by Albert Londe and Étienne-Jules Marey in the late nineteenth century (see plates 7-18 and 7-19 in chapter 7). In the first decade of the twentieth century, photographers

could produce much faster time-lapse images (plate 8-55). In his attempt to visualize motion, Balla soon edited out objects, presenting the "dynamic sensation itself" in the force lines of *Abstract Speed—Racing Car* (plate 8-52).

The experimental psychologist's interest in communicating emotion through abstract form, color, and line also informed Futurist thinking. Balla knew Cesare Lombroso, an experimental psychologist who directed an asylum in Turin, where the physician studied the artwork of his patients in search of clues to their mental condition.[28] Balla attended Lombroso's lectures and owned a copy of Lombroso's *L'uomo di genio* (Man of genius, 1888), a book in which Lombroso restated the age-old link between creativity and madness in modern psychiatric terms: according to Lombroso, all artists suffer from a psychotic illness. Early in his career, Balla painted a psychiatric patient in the Neo-Impressionist style (*La Pazza* [Madwoman], 1905; Galleria Nazionale d'Arte Moderna e Contemporanea, Rome).

Boccioni's *States of Mind: The Farewells* (plate 8-53) is a mix of physical and psychological dynamism. Borrowing a term from Maxwell's theory about magnetic force fields, Boccioni referred to "force lines [*lignes-forces*],"[29] and the artist adopted Maxwell's conception of electromagnetism travelling in a force field to infinity. Rather than show figures in successive positions, as Balla did in *Dynamism of a Dog*, Boccioni depicted energy extending from the figures into space simultaneously in all directions. As he wrote in his sculpture manifesto in 1912: "One must start from the central nucleus of the object that we want to create, in order to discover the new forms that link it invisibly but mathematically to the apparent [outer] infinity [of space] and the interior infinity."[30] In other words, the sculptor should discover new forms to convey that his subject is connected to space by invisible radiation, which Boccioni did in *Unique Forms of Continuity in Space* (plate 8-54) by dissolving the edges of a figure into floating planes to "cut throughout it and section it in a decorative pattern of curves and straight lines [*une arabesque de courbes et de lignes droites*]."[31] He wanted to achieve an illusion of infinite succession: "It seems

ABOVE

8-51. Giacomo Balla (Italian, 1871–1958), *Dynamism of a Dog on a Leash*, 1912. Oil on canvas, 35⅜ × 43¼ in. (90 × 110 cm). Albright-Knox Art Gallery, Buffalo, New York, bequest of A. Conger Goodyear and gift of George F. Goodyear.

BELOW

8-52. Giacomo Balla (Italian, 1871–1958), *Abstract Speed—Racing Car*, 1913. Oil on canvas, 19⅞ × 25⅞ in. (50.5 × 65.6 cm). Private collection.

8-53. Umberto Boccioni (Italian, 1882–1916), *States of Mind: The Farewells*, 1911. Charcoal and chalk on paper, 23 × 34 in. (58.4 × 86.3 cm). Museum of Modern Art, New York, gift of Vico Baer.

This drawing depicts people saying goodbye in a crowded train station. It was first shown in an exhibition of Futurist works, *Les exposants au public* (Exhibitors to the public), that opened in February 1912 at the Galerie Bernheim-Jeune, Paris. In a joint statement in the exhibition catalogue, the exhibitors (which in addition to Boccioni included Giacomo Balla) described how line can express emotion: "Confused and trepidating lines, either straight or curved, mingled with the outlined hurried gestures of people calling one another, will express a sensation of chaotic excitement" ("The Exhibitors to the Public" (1912), trans. Lawrence Rainey, in *Futurism: An Anthology* [New Haven, CT: Yale University Press, 2009], 105–9; the quote is on 108).

RIGHT

8-54. Umberto Boccioni (Italian, 1882–1916), *Unique Forms of Continuity in Space*, 1913. Bronze, 47¾ × 35 × 15¾ in. (121.3 × 88.9 × 40 cm). Metropolitan Museum of Art, New York, bequest of Lydia Winston Malbin.

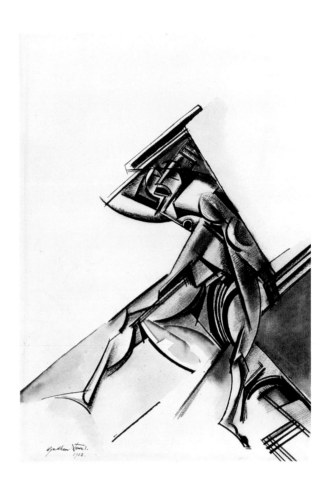

clear to me that this succession is not formed by repeating legs, arms, and faces, as many have foolishly believed, but by intuiting the *unique form that gives it continuity in space [forme unique qui donne la continuité dans l'espace].*"[32]

In 1909 Mikhail Larionov and Natalia Goncharova took up the Futurist cause in Moscow after reading a Russian translation of Filippo Tommaso Marinetti's "Manifesto of Futurism" (1909). Both artists had painted in the Russian Jugendstil and were familiar with the expressive use of abstract line and color. Together they developed Rayonism, depicting visible and invisible radiation, as in Larionov's *Glass* (plate 8-57), in which he painted rays reflecting and refracting from transparent, interpenetrating surfaces, as well as the patterns of light formed between sheets of glass.

In Britain the painter and poet Wyndham Lewis founded Vorticism in 1914 and edited its magazine, *Blast*. Like Futurism, Vorticism aimed to destroy (blast) its own (in this case Victorian) past and create art for the new machine age. The poet Ezra

LEFT
8-55. Falling drop of milk, in *La Nature* 37 (June–Nov. 1909), 199. Film stills.

ABOVE
8-56. Wyndham Lewis (English, 1882–1957), *The Vorticist*, 1912. Watercolor, ink, and chalk on paper, 16¼ × 11½ in. (41.4 × 29.4 cm). Southampton City Art Gallery, Hampshire, England.

OPPOSITE
8-57. Mikhail Larionov (Russian, 1881–1964), *Glass*, 1909. Oil on canvas, 41 × 38¼ in. (104.1 × 97.1 cm). Solomon R. Guggenheim Museum, New York.

*We do not sense the object with our eye, as it is depicted
conventionally in pictures and as a result of following this or
that device; in fact, we do not sense the object as such. We
perceive the sum of the rays proceeding from a source of light;
these are reflected from the object and enter our field of vision.*

Mikhail Larionov, "Rayonist Painting," 1913

Pound gave the movement its name, declaring: "The vortex is the point of maximum energy. It represents, in mechanics, the greatest efficiency. We use the words 'greatest efficiency' in the precise sense—as they would be used in a text book of Mechanics."[33] Pound described himself as a "wave detector," because to write poetry he had to detect the invisible, and he described art as "a sort of energy, something more or less like electricity or radioactivity."[34] Unlike the Italian Futurists, artists in England, where the Industrial Revolution began, were keenly aware of the dehumanizing effects of industrialism. *The Vorticist* (plate 8-56) is a self-portrait of Lewis crying out in the center of a vortex—a whirling mass of mechanical forms.

Entering the Subatomic Realm: The Electron

In the 1820s the Scottish botanist Robert Brown noticed that grains of pollen suspended in water continually move in an erratic jiggling pattern (*Brownian motion*). Such movement was studied throughout the nineteenth century, but it wasn't until 1905 that Albert Einstein worked out the mathematics of molecular size from the amount of particle jiggle, thereby proving that atoms and molecules are physical objects with dimensions. Then, in 1908, the French physicist Jean-Baptiste Perrin succeeded in making a photographic tracing of the microscopic path of particles in water (plate 8-58).

As Einstein and Perrin were confirming the physical existence of atoms, others were discovering that atoms are not solid but composed of smaller particles. Röntgen's discovery of x-rays in 1895, prompted many experiments on radiation at the atomic level. In 1896 the French physicist Henri Becquerel was studying phosphorescent salts (crystals that glow in the dark after exposure to light) and decided to see whether their glow is caused by the emission of x-rays. So without exposing the salts to visible light, he put each on a photographic plate and wrapped it in black paper. The results were negative for all but one; uranium salt gave off energy in total darkness and blackened the plate. Becquerel soon determined that uranium wasn't giving off x-rays but some other form of radiation, which came to be called *Becquerel rays*.

The Polish-born French chemist Marie Sklodowska Curie followed up on Becquerel's findings and tested several uranium compounds. She found that the mysterious Becquerel rays were two types of particles, which she called simply α and β: heavy, positively-charged alpha particles and light, negatively-charged beta particles. In 1898 Curie coined the word *radioactif* (French for "radioactive") to

8-58. The path of a single particle of gum resin suspended in water, photograph, in Jean-Baptiste Perrin, *Les Atomes* [The atoms] (Paris: F. Alcan, 1913), 166.

U (92)

α (2)

8-59. Radioactive decay
An atom is defined by the number of protons in its nucleus. When a uranium atom (92 protons and 146 neutrons) emits an alpha (α) particle (2 protons and 2 neutrons), the atom "decays" and becomes thorium (90 protons). If another alpha particle flies out of thorium, then it is radium (88 protons). If another flies out, it is radon (86 protons), until the decaying atom reaches lead (82 protons), which is stable.

name active (as opposed to passive) rays; atoms that spontaneously emit radiation in the form of charged particles are radioactive. By 1900 Curie and Becquerel realized that when a uranium atom gives off an alpha particle, the atom converts (*decays*) into a lighter element, and they charted the pattern of decay: from uranium to thorium to radium to radon and so on, until the decaying atom reaches lead, which is stable (not radioactive). Radioactive decay is the first example discovered by physicists of the transmutation of matter—one element changing into another (plate 8-59).

In 1901 Marie Curie's husband, the French chemist Pierre Curie, noticed that radioactive uranium and radium are warmer than room temperature. He was astonished to find that 1 gram of radium (a piece one-quarter the size of a sugar cube) gives off 140 calories per hour, and he calculated that it would continue emitting energy at that rate for 1,000 years. He speculated that radioactive atoms must contain a new kind of energy, far greater than any chemical fuel known to mankind. It would take physicists just a few decades to discover nuclear energy and unleash its power.

Meanwhile, across the English Channel, physicists at Cambridge University were studying electrical currents. In the eighteenth century, Benjamin Franklin had shown that a bolt of lightning is moving electricity; it moves too fast to be seen clearly, but in the 1880s photographers captured the discharge of electric sparks on a photographic plate, which scientists then studied to understand the pattern (plate 8-1, chapter frontispiece). In the 1890s the Serbian-born American Nikola Tesla photographed high-frequency bolts in his laboratory (plates 8-60 and 8-62). Cambridge physicist J. J. Thomson asked: What is electricity? What moves through the air in a lightning bolt? What moves through a copper wire and causes a light bulb to shine? Thomson did an experiment that showed that electricity moves as a stream of lightweight, negatively-charged particles (plate 8-61). The Irish physicist George Johnstone Stoney named Thomson's particle an *electron*, from the Greek word for "amber" (fossilized tree resin), which the ancients noticed attracts hair and feathers when rubbed, creating static (as opposed to moving) electricity. Then, in 1900, Becquerel determined that Marie Curie's negatively-charged beta particle and J. J. Thomson's negatively-charged electron are the same particle—a beta particle *is* an electron.

Today it seems that the transmutation of matter, the dream of the alchemists, is not a utopian fantasy. Our modern alchemists have discovered the philosopher's stone in radium.

M. Troller, "Radium and the Transmutation of Matter," *La Nature*, 1907

8-60. Nikola Tesla, with his equipment for producing high-frequency alternating currents in his laboratory in Colorado Springs, Colorado, ca. 1900. Double-exposure photograph by Dickenson V. Alley.

The Serbian-born American inventor Nikola Tesla was a dashing showman who dramatically presented electrical phenomena at the 1893 world's fair in Chicago. In this double-exposure photograph, he appears to be calmly reading a book, unfazed, while millions of volts are generated by his transmitter.

8-62. Hiroshi Sugimoto (Japanese, born 1948), *Lightning Fields 221*, 2009. Gelatin silver print, 23 × 18½ in. (58.75 × 47 cm), edition of 5. Courtesy of the artist and Marian Goodman Gallery, New York. © Hiroshi Sugimoto

8-61. J. J. Thomson's experiment using a Crookes tube, in Fredk. Soddy, *Radio-Activity: An Elementary Treatise, from the Standpoint of the Disintegration Theory* (London: Electrician, 1904), 50. Countway Library of Medicine, Boston.

In 1875 the British physicist William Crookes invented the vacuum tube, a tube of glass from which most of the air has been evacuated, creating an almost perfect vacuum. Thomson used a Crookes tube, so that electric discharges could be observed in a vacuum. On the left a copper wire carrying electricity enters the tube and stops at C, forming an electrode (the bare end of a wire). On the right, the inside of the tube is coated with a fluorescent chemical to form a "screen" that gives off light when struck by radiation. Thomson wanted to know: When current flows through the wire, what comes out of the electrode? He discovered that the (negatively-charged) electrical rays are attracted to (positively-charged) diaphragms A and B, which have fine horizontal slits to align the electrical rays into horizontal planes. The plates D and E can create a (local) magnetic field within the tube. If D and

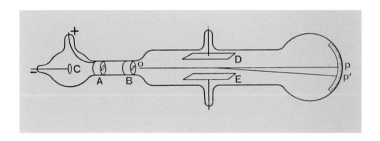

E are turned off, the rays strike the fluorescent screen at p'; their path deviates from a straight line, because it is affected by Earth's magnetic field. When Thomson turned on D and E, he could adjust the local magnetic field so that the rays go straight to p. With this data, he was able to conclude that an electrical current is a stream of particles that carry a charge (because they respond to local and global magnetic fields), and that the particles (electrons) are lightweight and have a very small mass (because the amount of deviation in their paths is small).

CHAPTER 8

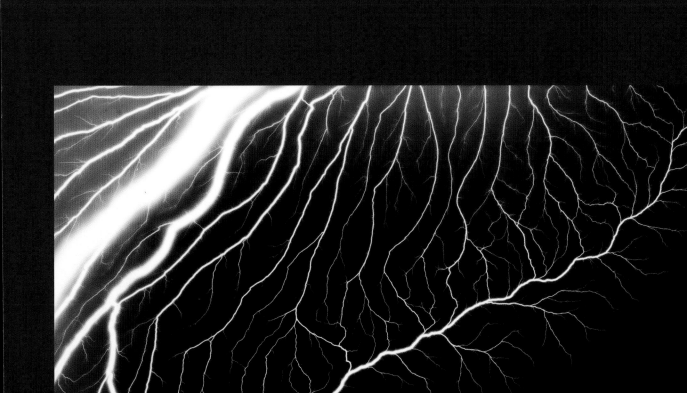

Proton and Neutron

Looking for ways to probe the atom, physicists invented a device—a particle accelerator—that fires alpha particles. The New Zealand–born British physicist Ernest Rutherford aimed the device at a very thin sheet of metal—gold leaf (plate 8-63). Most of the alpha particles went straight through, indicating that gold atoms are mainly empty space. But a few were deflected at various angles. What were the alpha particles hitting? From the number and angle of deflections, Rutherford deduced that atoms have a hard core—a nucleus—and from the size and spacing of deflections, he calculated the size of the nucleus. In 1911 he proposed the "solar system" model of the atom: most matter is densely concentrated in a positively-charged nucleus, around which revolve small, negatively-charged electrons—as planets revolve around the sun—resulting in an electrically-neutral atom. In 1914 Rutherford suggested that the hydrogen nucleus is a single particle, a *proton* (from Greek for "first"), which is the building block of the nuclei of bigger atoms; a 2-proton nucleus is helium, 3 protons make lithium, and so on up to uranium, which has a 92-proton nucleus surrounded by a swarm of 92 electrons (plate 8-64). In 1932 a third subatomic particle was discovered: the atomic nucleus also contains a particle that is the same size and weight as a proton but has no electric charge and hence is neutral—a *neutron*.

RIGHT

8-63. Ernest Rutherford's experiment to probe the atom.

In this experiment, designed to discover the structure of the atom, a highly radioactive element such as radium, which frequently gives off alpha particles, is suspended in a lead box. Most alpha particles bounce off the sides of the box, but some fly through an opening into a lead tube pointed at a piece of gold foil, which is hanging in a ring-shaped chamber. The inside surface of the chamber is coated with a fluorescent chemical that emits a spark when hit by a particle. Most particles pass through the gold foil, but a few alpha particles are deflected, which implies that the atomic nucleus is very small and positively charged. The physicist Ernest Rutherford used this data to develop his solar system model of the atom.

OPPOSITE

8-64. Ernest Rutherford and Niels Bohr's solar system model of the atom, in H. A. Kramers and Helge Holst, *The Atom and the Bohr Theory of Its Structure* (New York: Knopf, 1923), foldout following 210.

In parentheses following the name of each atom is the number of protons in its nucleus.

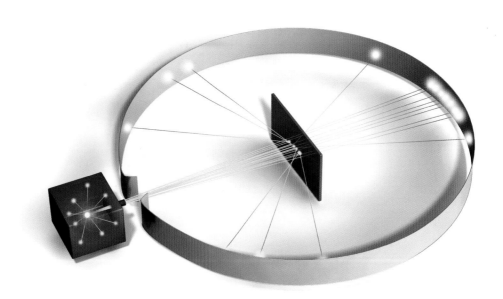

At the end of the century we thought that science had already penetrated the innermost depths of nature; but now we know that it had only worked on the surface of the physical universe.

N. A. Umov, "Evolution of the Atom," *Nauchnoe slovo*, 1905

RADIUM (88)

10⁻⁸cm

STRUCTURE OF THE RADIUM ATOM

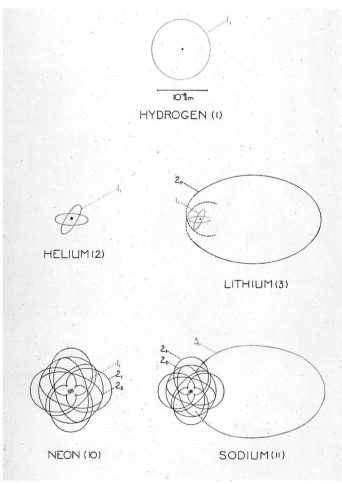

HYDROGEN (1)

HELIUM (2)

LITHIUM (3)

NEON (10)

SODIUM (11)

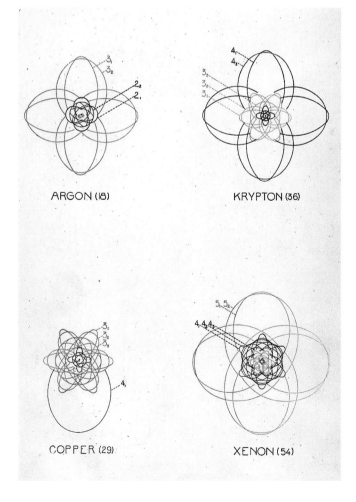

ARGON (18)

KRYPTON (36)

COPPER (29)

XENON (54)

The Periodic Table of Elements

Aristotle identified four terrestrial elements (earth, air, fire, and water), and the heavens were composed of a fifth—æther—the quintessence (*quinta essentia*, Latin for "fifth essence"; *Physics*, fourth century BC). But eighteenth-century experiments made it clear that there were many more gases besides air and æther, and thus the British chemist John Dalton revived an ancient rival to Aristotle's theory—atomism. In the fifth century BC, Democritus declared that nature is composed of tiny, dense, eternal particles—*atoms* (Greek for "indivisible"); plants and animals, stones and stars are all composed of atoms in different arrangements within a void. Dalton proposed that atoms differ in weight and combine in small groups to form molecules. By the 1850s it was clear that each atom could combine with only a fixed number of other atoms. Chemists found that an atom's ability to combine—its *valence* (from Latin for "power")—is related to its weight.

By the 1860s more than sixty elements had been discovered, each with a different weight, valence, and related properties, and chemists were looking for a way to organize them. The solution was found by the Russian chemist Dmitri Mendeleev, who arranged the elements in order by atomic weight and then, guided by their valence, noticed that there is a repeating "periodic" pattern to properties (such as the elements' ability to combine—some elements combine easily and others don't combine at all; to conduct electricity—some conduct electricity and others do not; and so on). He arranged the elements so those with similar properties are in a row (plate 8-65). In three cases Mendeleev didn't know of an element with the atomic weight and chemical characteristics predicted by his chart, so he left a space for the missing elements, confident that each would be discovered. The chemist lived to see his prediction come true: a French, a Swedish, and a German chemist discovered the three missing elements—respectively, gallium in 1875 (named for Gaul, the Latin name for France), scandium in 1879, and germanium in 1886.

In the late nineteenth century, chemists rearranged the elements so that those with similar properties are in vertical columns, and they added a column on the far right for the inert (*noble*) gases after the discovery of helium. After scientists entered the subatomic realms and discovered the electron (1897), proton (1911), and neutron (1932), they assigned each element an atomic number—its number of protons—written above the abbreviation of its name (see sidebar on the opposite page).

8-65. Dmitri Mendeleev published the first Periodic Table in 1869, in Russian in *Журнал Русского Химического Общества* 1, 60–77; and in German (pictured) in *Zeitschrift für Chemie* 12, 405–6; the image is on 405.

Nineteenth-century chemists grouped elements either by their atomic weight or their properties. Mendeleev's insight was that these features could be combined on a chart: up–down, the elements are in order of ascending atomic weight; left–right, the elements in rows have common properties.

THE PERIODIC TABLE OF ELEMENTS

An atom is identified by its number of positively-charged protons, which is written above its abbreviation on the Periodic Table of Elements (below). The number of protons is also often written in parentheses following its name, as in oxygen (8) in the diagram on the right. Each atom has a nucleus (made of protons and neutrons, which lack an electric charge) surrounded by negatively-charged electrons. To achieve electrical neutrality, the number of electrons equals the number of protons. The electrons are arranged in shells (named K, L, M, N, O, and so on) and the shells have sub-shells—orbitals—in this pattern:

SHELL NAME	SHELL MAX ELECTRONS	ORBITAL MAX ELECTRONS
K	2	2
L	8	2, 6
M	18	2, 6, 10
N	32	2, 6, 10, 14
O	50	2, 6, 10, 14, 18

An atom bonds with another to form a molecule by sharing an electron in its outer shell, which is called the atom's *valence shell* because its electron configuration determines its ability to interact. For example, oxygen (8 protons) has two open positions for an electron in its outer shell, so it readily bonds with other atoms; two hydrogen atoms fill the open positions and form a molecule of water—H_2O, which reads, "two hydrogen atoms and one oxygen atom." The outer shells of helium (2) and neon (10) are filled (there are no open positions) and so, like an aristocratic noble, they stay aloof and don't bond with others. They are among seven elements known as the noble gases. When someone pops a helium balloon, the atoms don't bond with air but slowly rise, eventually leaving Earth's atmosphere and going into outer space. The outer shell of iron (26) and copper (27) have many open positions, so electrons speed along these metals, which are good conductors of electricity.

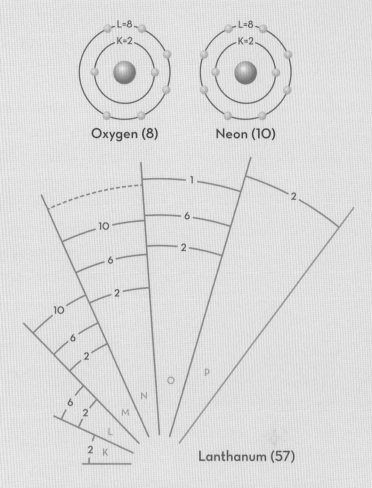

Oxygen (8) Neon (10)

Lanthanum (57)

When an atom gains a proton, it also gains an electron, which fills the shells in a particular order. Electrons in shells K and L are tightly held to the nucleus, so electrons fill K first and then L. But as the M, N, and O shells move away from the grip of the nucleus, their orbitals spread out and overlap. The atom lanthanum (57), has its 57 electrons configured as shown in the diagram. The next element is cerium (58), and its 58th electron begins to fill the outermost orbital of the N shell. This progression continues until that orbital is filled with 14 electrons, so the outer shell of elements 58–71 is the same, which means the atoms have identical properties. To simplify the Periodic Table, elements 58–71 (called the lanthanides since they are like lanthanum) are shown separately below; the same thing happens after actinium (89) with elements 90–103 (the actinides).

As nuclei get bigger, they become more unstable (radioactive), which means they lose protons, neutrons, and electrons. Uranium (92) is the largest atom found in nature. Bigger nuclei formed in particle accelerators are very unstable, most decaying in a few minutes to a day.

Periodic Table of Elements

1 H																	2 He
3 Li	4 Be											5 B	6 C	7 N	8 O	9 F	10 Ne
11 Na	12 Mg											13 Al	14 Si	15 P	16 S	17 Cl	18 Ar
19 K	20 Ca	21 Sc	22 Ti	23 V	24 Cr	25 Mn	26 Fe	27 Co	28 Ni	29 Cu	30 Zn	31 Ga	32 Ge	33 As	34 Se	35 Br	36 Kr
37 Rb	38 Sr	39 Y	40 Zr	41 Nb	42 Mo	43 Tc	44 Ru	45 Rh	46 Pd	47 Ag	48 Cd	49 In	50 Sn	51 Sb	52 Te	53 I	54 Xe
55 Cs	56 Ba	57 La	72 Hf	73 Ta	74 W	75 Re	76 Os	77 Ir	78 Pt	79 Au	80 Hg	81 Tl	82 Pb	83 Bi	84 Po	85 At	86 Rn
87 Fr	88 Ra	89 Ac	104 Rf	105 Db	106 Sg	107 Bh	108 Hs	109 Mt	110 Ds	111 Rg	112 Cn	113 Nh	114 Fl	115 Mc	116 Lv	117 Ts	118 Og

58 Ce	59 Pr	60 Nd	61 Pm	62 Sm	63 Eu	64 Gd	65 Tb	66 Dy	67 Ho	68 Er	69 Tm	70 Yb	71 Lu
90 Th	91 Pa	92 U	93 Np	94 Pu	95 Am	96 Cm	97 Bk	98 Cf	99 Es	100 Fm	101 Md	102 No	103 Lr

Science and Pseudo-Science

J. J. Thomson used the vacuum tube invented by British physicist William Crookes to discover electrons (see plate 8-61), but Crookes himself missed making the crucial discovery because he believed (incorrectly) that he had found a new state of matter—"radiant matter"—which allegedly constitutes the physical basis of the universe. In 1879, he proposed radiant matter at a lecture during which he demonstrated his vacuum tube: "In some of its properties, radiant matter is as material as this table, while in other properties it almost assumes the character of radiant energy. We have actually touched the border-land where matter and force seem to merge into one another, the shadowy realm between known and unknown, which for me has always had peculiar temptations. I venture to think that the greatest scientific problems of the future will find their solution in this border-land, and even beyond; here, it seems to me, lie ultimate realities, subtle, far-reaching, wonderful."[35]

Crookes was also attracted to the occult, and from 1896 to 1899 he was president of the British Society for Psychical Research. In an 1898 lecture to the British Association for the Advancement of Science, he posited that the wireless telegraph was analogous to mental telepathy.[36] However, despite his brush with pseudo-science, in the end Crookes adhered to the scientific method: repeatable experiments and independent confirmation of results.

Soon after Becquerel and Curie discovered radioactivity, in 1903 Crookes invented a device for actually *seeing* individual scintillations caused by subatomic particles. Called a spinthariscope, it was sold as a toy to a public curious about the subatomic world (plate 8-66). Subatomic particles are too small to see, but in a device called a cloud chamber they leave trails (of condensation), which were first photographed in 1911 and reproduced in the popular press for all the world to see (plate 8-67).

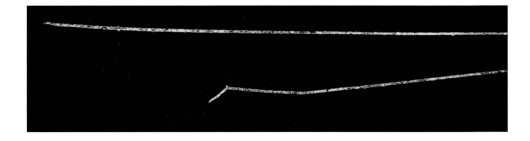

Der Blaue Reiter

Between 1911 and 1914, Wassily Kandinsky, Franz Marc, and Paul Klee joined with other artists to produce exhibitions and a publication, *Der Blaue Reiter Almanach* (The blue rider almanac). The latest discoveries in physics and astronomy—x-rays, spectrographs, and subatomic particles—were on view for these artists to see at Germany's premiere science museum, the Deutsches Museum in Munich (plate 8-68).

Kandinsky said that his move into a totally abstract style was prompted by the discovery that the atom is not solid: "The collapse of the atom was equated, in my soul, with the collapse of the whole world. Suddenly, the stoutest wall crumbled. Everything

8-68. Astronomy display (above), and Wilhelm Röntgen's x-ray equipment (below), in the 1907 guidebook to Munich's science museum, *Deutsches Museum* (Leipzig: Teubner, 1907), 50 and 69.

became uncertain, precarious, and insubstantial. I would not have been surprised if a stone dissolved into thin air before my eyes and became invisible."[37] Kandinsky symbolized nature as "dissolved"—mainly empty space—in the amorphous forms that merge with one another in *Composition no. 7* (plate 8-69).

Marc, a native of Munich, began his education in philosophy and theology before studying landscape painting in 1900. He became preoccupied with painting animals in the countryside because he felt they retain a spontaneous spirit lost to people who live in cities. Marc often spent hours observing horses and cows at pasture, as well as birds and deer in the wild, studying their particular ways of moving and of responding to light and noise. Marc sensed that Der Blaue Reiter artists would soon create art that embodied their scientific convictions (*wissenschaftlichen Überzeugung*),[38] a new artistic style that would reflect their knowledge of the deep structure of nature: "They will not be looking for this new form in the past, nor will they find it on the exterior of nature, on her facade in a conventional style. They will build the form from the inside out according to their new knowledge, which has transformed the old creation myth [*alte Weltfabel*] into a formula [*Weltformel*]."[39] In work such as *Blue Horse with Rainbow* (plate 8-70), Marc merged his depiction of the "exterior of nature"—animals in a landscape—with the new scientific discoveries about the essence of nature "from

8-69. Wassily Kandinsky (Russian, 1866–1944), *Composition no. 7*, 1913. Oil on canvas, 78¾ × 118 in. (200 × 300 cm). Tretyakov Gallery, Moscow.

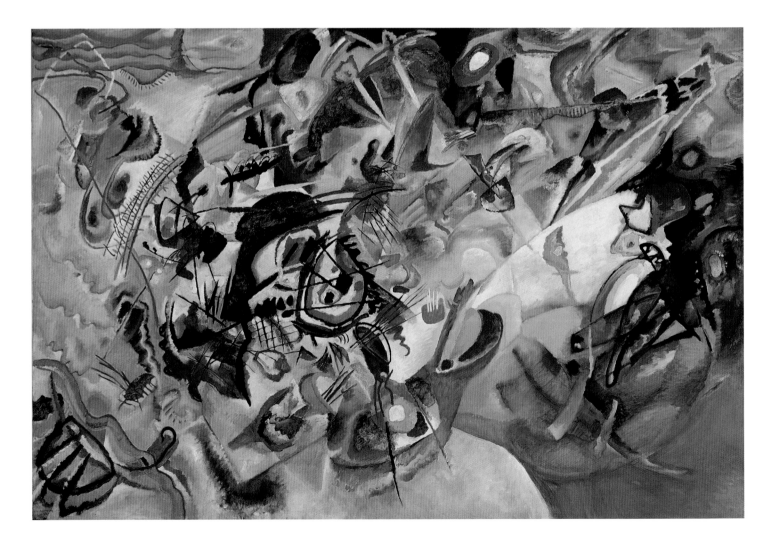

CHAPTER 8

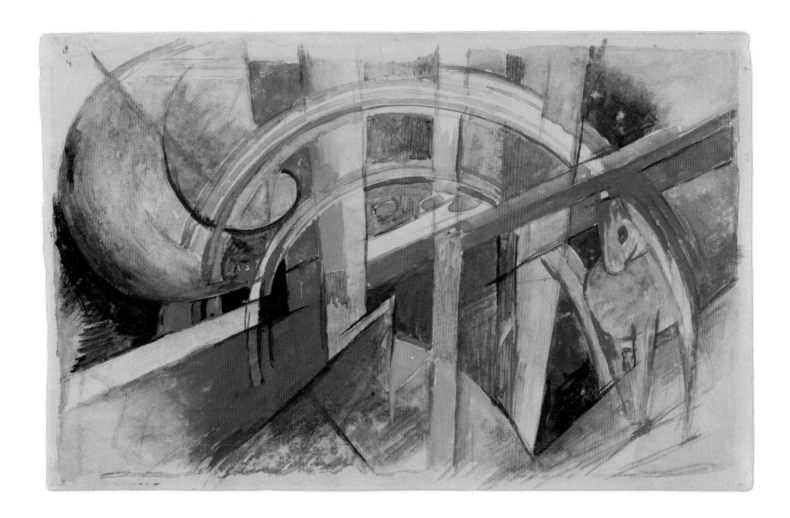

the inside out"—the atomic structure of matter. The forms of the horse and rainbow merge, and both appear solid, but the spectrum in the sky will vanish in a moment.

Paul Klee left his native Bern to study art at the Munich Academy from 1898 to 1901, after which he travelled throughout Europe, eventually returning to and settling in Munich in 1906. In 1910 he recorded in his diary that he wanted to "render light simply as unfolding energy" and "to accumulate vast quantities of energy lines."[40] In 1911 Klee met Marc and Kandinsky and began exhibiting with Der Blaue Reiter; in April 1912 he met the French painter Robert Delaunay, who participated regularly in Der Blaue Reiter activities, just as Delaunay was commencing his Windows series (see plate 8-48). Interested in Delaunay's views on color, Klee translated the Frenchman's manifesto on light into German and published it in a Berlin avant-garde journal (*Der Sturm*, February 1913).

Around 1910 the Danish astronomer Ejnar Hertzsprung and the American astronomer Henry Russell devised a way to determine the *absolute magnitude* of a star, which is its brightness as seen, in the imagination, by an observer at a uniform distance of 3 light-years (a *light-year* is the distance light travels in a year). Hertzsprung and Russell found that the spectrum (and hence the color) of a star correlates with its brightness in a regular way. When they arranged stars in a diagram from dim to bright, they observed that the colors of stars move through the spectrum from red (dim) to

8-70. Franz Marc (German, 1880–1916), *Blue Horse with Rainbow*, 1914. Watercolor, gouache, and pencil on paper, 6⅜ × 10⅛ in. (16.2 × 25.7 cm). Museum of Modern Art, New York, John S. Newberry Collection.

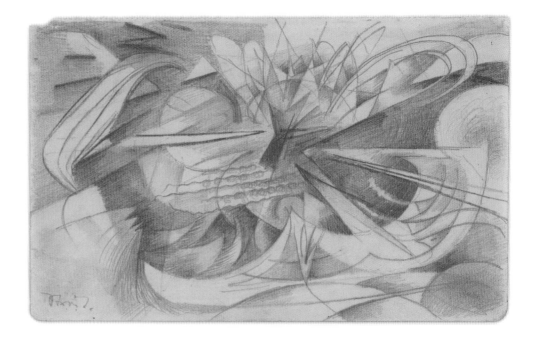

8-71. Franz Marc (German, 1880–1916), page from a wartime sketchbook, 1915. Pencil, 4 × 6¼ in. (9.8 × 16 cm). Staatliche Graphische Sammlung, Munich.

blue (bright), which suggested to them that the chemistry of a star changes over time (plate 8-73). The Hertzsprung-Russell diagram, which was published in 1914, pointed the way to understanding the chemical and physical evolution of stars.

In the same year as the Hertzsprung-Russell diagram's publication, Paul Klee created a metaphor for the evolution of stars in *Genesis of the Stars*, using dashes of ink and bursts of watercolor (plate 8-72). Across the bottom Klee wrote "1 Moses 1:14" (Moses is the name of the book of Genesis in the German Bible); the verse reads: "And God said, Let there be lights in the firmament of the heavens to divide the day from the night; and let them be for signs, and for seasons, and for days, and years." Klee never did a literal transcription of a concept from science or religion, but rather created symbols such as this for humankind's attempt to understand the structure and meaning of the natural world.

Der Blaue Reiter artistic collaboration ended because of the outbreak of World War I. Marc was mobilized and kept a sketchbook in his soldier's knapsack (plate 8-71), translating trench warfare into his abstract vocabulary: "I was surrounded by strange forms, and I drew what I saw; harsh evil forms in black, steel blue, and green, rattling against each other. My heart cried out in pain. Everything was fighting and suffering. It was a terrible sight."[41] Marc was killed in 1916 at the Battle of Verdun.

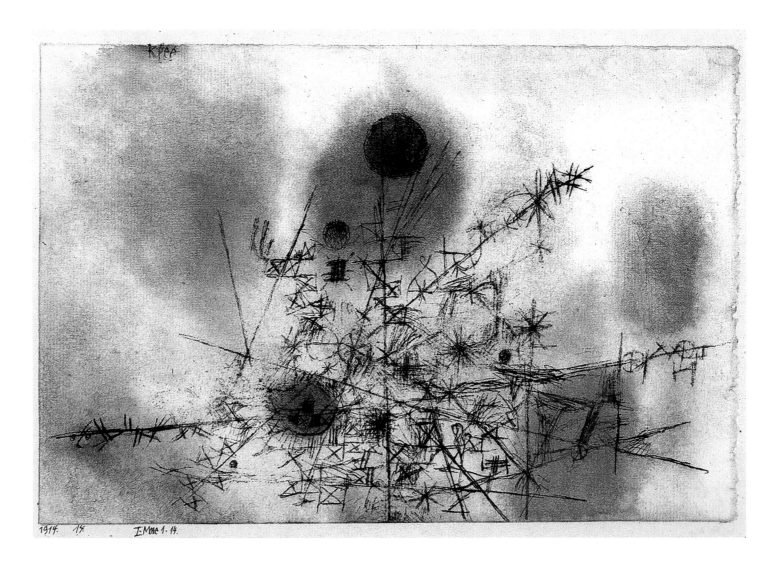

ABOVE

8-72. Paul Klee (Swiss, 1879–1940), *Genesis of the Stars*, 1914. Pen and watercolor on paper, mounted on cardboard, 6⅜ × 9½ in. (16.2 × 24.2 cm). Private collection, Munich.

RIGHT

8-73. Hertzsprung-Russell diagram linking the color of stars with their temperature, in Henry Norris Russell, "Relations between the Spectra and Other Characteristics of the Stars," *Nature* 93, no. 2323 (May 1914), 252–58; the diagram is on 252.

The astronomers Ejnar Hertzsprung and Henry Russell plotted stars by their luminosity (their absolute magnitude), shown on the vertical axis, from dimmest at the bottom to brightest at the top; they plotted the stars' surface temperature on the horizontal axis, moving from cool stars, which emit red light (on the right), through the spectrum to the hottest, which emit blue light (on the left). As stars go through their life cycle, they grow brighter (ascending the vertical axis) and emit red to blue light (moving from right to left on the horizontal axis). Astronomers call this pattern the "main sequence" because most stars follow it. However, stars over a certain mass reach a gravitational imbalance, which causes them to expand (moving off the main sequence and becoming red giants, shown in the upper right). This is the fate predicted for our sun in 5 billion years; it is currently in the main sequence, at absolute magnitude +5. Red giants eventually collapse into white dwarfs (shown below the main sequence on the left).

CLASSICS
Illustrated
Featuring Stories by the World's Greatest Authors

No. 133 15¢

THE TIME MACHINE
H. G. WELLS

9

Einstein's Space-Time Universe and Quantum Mechanics

Science is the attempt to make the chaotic diversity of our sense perception correspond to a logically uniform system of thought.

Albert Einstein, "Considerations Concerning the Fundaments of Theoretical Physics," 1940

EVER SINCE ISAAC NEWTON declared the law of universal gravitation in 1687, scientists have worked to gain an ever-more accurate picture of the natural world. In the nineteenth century Charles Darwin showed that plants and animals evolve by natural selection, and James Clerk Maxwell proved that light is a form of electromagnetic radiation. At the opening of the twentieth century Albert Einstein's theory of relativity (1905/1915) described a dynamic universe in which time and space are not absolute. When Einstein's theory was confirmed in 1919 by observation of starlight during a solar eclipse, scientists felt they were closing in on a detailed picture of the natural world.

Then, in the 1920s, some of Einstein's younger colleagues declared that this 200-year-old project is naïve, because all scientists can ever know is their subjective, conscious experience—their observations. Furthermore, the natural world is ultimately unknowable because it lies beyond the borders of perception. Einstein was incredulous that the younger generation was shifting attention away from the (objective) physical world and focusing on their (subjective) observations, marching straight off a cliff into a philosophical abyss. But that's exactly what they did.

Einstein and the younger physicists agreed about the *science* of electrons (the laboratory data), which would produce today's world of digital technology (computers, smartphones, and the like), but they disagreed about the *philosophy* (the meaning) of physics. For half a century the philosophical interpretation of physics remained mired in an unholy mix of German Idealism, the Danish philosophy of Søren Kierkegaard, and Austrian logical positivism. This *philosophical* hotchpotch—named "the Copenhagen interpretation" after the residence of its leader, the Danish physicist Niels Bohr—was written into physics textbooks as *science* and taught as gospel truth in physics classrooms throughout the West. Bohr dismissed Einstein as a senior scientist clinging

9-1. "The Time Traveler," cover of H. G. Wells, *The Time Machine* (1895), in its first adaptation to comic book format, Classics Illustrated, no. 133 (July 1956). First Classics, Chicago.

The hero of H. G. Wells's science-fiction novel *The Time Machine* has a machine that allows him to travel forward or backward in time. Einstein showed that there is one sense in which time distortion is really possible, because time slows down as an object approaches the speed of light. If astronauts are going half the speed of light, the clock on their rocket ship is ticking half as fast as clocks on Earth. When they return home after a five-year mission, a decade has passed on Earth. But, alas, spacecraft don't go anywhere near that speed: the fastest man-made object (NASA's Juno spacecraft) was recorded in 2016 going about 165,000 miles (365,000 kilometers) per hour; light travels about 186,000 miles (300,000 kilometers) per *second*.

253

to an outdated mode of being an objective observer. Younger physicists accepted Bohr's opinion and moved on.

The story of this bizarre break in the progress of science begins after Michelson and Morley's failed experiment led to Einstein's theory of relativity and quantum mechanics. The rupture split wide open at the fifth Solvay Congress of 1927, after which Einstein and Bohr argued about competing philosophical interpretations of quantum mechanics until the outbreak of World War II.

The Michelson and Morley Experiment

For hundreds of years scientists had known that the planets and stars are in continual motion. Newton, however, assumed that space itself is at rest. He conceived of space as a vast, motionless sphere filled with an invisible stationary æther—Aristotle's fifth element. Newton understood time as separate from space, counted out by points on an endless line. Any two events are either simultaneous or one comes after the other on the line. Newton's absolute space and time seemed so obvious that they were rarely discussed before the early twentieth century.

When the wave theory of light was adopted in the early nineteenth century it appeared to require the æther to transmit light vibrations through space; light needed something to "wave." Assuming that light travels through the æther at a constant speed, the American physicists Albert Michelson and Edward Morley set about to measure Earth's motion relative to the æther. They reasoned that a beam of light travelling in the direction of Earth's motion and reflected back by a mirror would have a shorter distance to travel than a beam sent out from the same point at a right angle and reflected back. To test this hypothesis, they invented a tool—an interferometer—to split a beam of light and send half of it straight ahead and half at a right angle. After the light is reflected back from the two mirrors, which are positioned at precisely the same distance from the beam splitter, the interferometer rejoins the beams so that any displacement in their light-waves can be observed (plate 9-2). But after many attempts, in 1887 Michelson and Morley concluded that the light always returned in phase. What does this mean?

In 1902 the French mathematician Henri Poincaré declared that the failure of the experiment was evidence for his view that the axioms of geometry are not generalizations from experience but mere conventions.[1] In other words, Euclidean geometry is not necessarily true but rather contains useful axioms, and for most purposes Euclidean geometry is convenient because it corresponds to sense experience when observing events on Earth and in the solar system. Poincaré suggested that the negative results of the Michelson-Morley experiment meant that science needed a new convention.

Newton designed his laws of physics based on observations on a human scale (from a molecule to the solar system) when co-ordinate systems—frames of reference—are

9-2. Interferometer

Mirror

Mirror

Light source

Beam splitter

Observer

moving at about the same velocity relative to each other (such as observing Mars from Earth). By the early twentieth century scientists were finding distortions in their data when observing objects moving at great speed relative to the observer's framework, such as celestial bodies outside the solar system. For example, a star appears to move (be displaced) in the direction of Earth's motion. Scientists were also observing events in the subatomic world, where particles approach the speed of light.

The Theory of Relativity

In 1905 Einstein supplied a new overall theory of time and space that accounted for Michelson and Morley's negative results, extended Poincaré's insight about the conventionality of frames of reference, and accounted for stellar displacement.

In the 1860s, James Clerk Maxwell had shown that the speed of light is always the same, regardless of the speed of its source. Einstein simply accepted Maxwell's pronouncement as a premise, from which he deduced that the speed of light is an upper speed limit—nothing can travel faster than light. Then Einstein did a thought experiment: Imagine riding on a beam of light through the heavens. What would the universe look like from that viewpoint? Einstein realized that as an object approaches the speed of light, mass and time are deformed: mass increases and time slows down (is *dilated*) (plate 9-3; see also plate 9-1, chapter frontispiece).

Einstein's laws of physics are an expansion of Newton's laws. On a human scale, within the solar system, one uses Newton's laws (for example, in 1969 American astronomers used Newton's law of gravity to land a man on the moon). But when one observes an event in subatomic or intergalactic space moving at great speed, Newton's laws no longer hold and Einstein's do. Einstein's theory is called *relativity* because speed is defined relative to an observer. The Michelson-Morley experiment had failed because there is no absolute time and space—no æther at rest—against which to define velocity.

A consequence of Einstein's theory is that mass can be converted into energy, and vice versa, as he summarized in the formula $E = mc^2$, in which E is energy, m is mass, and c is the speed of light. The speed of light squared (times itself) is such a vast number that if multiplied by even a small amount of mass, such as 1 ounce (28 grams) of uranium, it is equivalent to an immense amount of energy. In any process that gives off energy, such as burning oil, mass is lost; any gain of energy entails the gain of mass. On a human scale, the amounts are so minute that they had gone unnoticed, which is why Antoine Lavoisier and Hermann von Helmholtz considered mass and energy separately when they wrote their laws of conservation. But once researchers began studying radioactive elements, the relation between the loss of mass and the production of energy were no longer overlooked, because so much energy was produced

9-3. Deformations in mass and time

$$\text{Speed of light} = \begin{cases} 186,000/\text{mps} \\ 671 \text{ million/mph} \\ 1080 \text{ million/kph} \end{cases}$$

Mass (increases)

Time (dilates)

9-4. Space-time curvature. © ESA and C. Carreau.

This diagram shows a two-dimensional plane distorted by the presence of three massive bodies in outer space; the amount of distortion is proportional to the body's mass. Einstein defined gravity as the curvature of space-time.

9-5. Curved path of starlight during the 1919 solar eclipse, in J. Arthur Thomson, *The Outline of Science* (New York: Putnam, 1922), fig. 4, between 1030–31.

The diagram shows where a star would normally be seen in the sky from Earth ("actual position")—if one could see it in daylight—and where it appears to have shifted during a solar eclipse ("apparent position"), due to the curved path of light in the sun's gravitational field. During a total solar eclipse, many stars become visible.

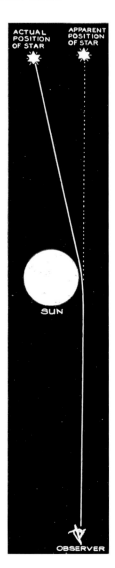

in proportion to the lost mass, as Pierre Curie had noticed (see chapter 8). Therefore, Einstein subsumed the old separate conservation laws for mass and energy under a new law of the conservation of mass-energy (theory of relativity, 1905).

In 1907, Russian-born German physicist Hermann Minkowski demonstrated that Einstein's theory of relativity meant that time must always be taken into account when giving location; space and time are not independent and should be joined into one concept, space-time. Minkowski also suggested describing events using a four-dimensional geometry—the traditional three dimensions of space plus time. Einstein welcomed the idea of incorporating time into measurements, because he was trying to generalize his 1905 theory (called "special" because it considers only objects moving at a constant speed) to apply to objects accelerating under the force of gravity. So he adopted Minkowski's notions of space-time and four-dimensional geometry.

When Einstein generalized his special theory of relativity to account for gravity, he stated that space-time is deformed by massive bodies such as the sun. When light moves through space it follows the path of deformation in the gravitational field (plate 9-4).

How could scientists test Einstein's theory experimentally? Einstein suggested that nature would do the experiment during a total eclipse of the sun. If astronomers observed a star lying just off the edge of the sun during a total eclipse, they could compare the star's position during the day at the moment of the eclipse with its position at night when the sun did not intervene. Any shift in position against the stellar background would be detectable and evidence of the deformation of space by the sun.

Einstein published the general theory of relativity in 1915, but the test of it had to await the end of World War I (1914–18). In 1919 the British Royal Astronomical Society organized an expedition to view a total solar eclipse from an island off West Africa. The stellar shift was observed exactly as Einstein had predicted, thus confirming that starlight curves as it passes through the sun's gravitational field (plate 9-5). These results were announced at a meeting of the Royal Astronomical Society

on November 6, 1919; the British mathematician Alfred North Whitehead was in the audience and described the event:

> The pilgrim fathers of the scientific imagination as it exists today are the great tragedians of ancient Athens: Aeschylus, Sophocles, Euripides. Their vision of fate, remorseless and indifferent, urging a tragic incident to its inevitable issue, is the vision possessed by science. Fate in Greek tragedy becomes the order of nature in modern thought. The absorbing interest in the particular heroic incidents, as an example and verification of the working of fate, reappears in our epoch as concentration of interest on the crucial experiments. It was my good fortune to be present at the meeting of the Royal Society in London when the Astronomer Royal for England announced that the photographic plates of the famous eclipse, as measured by his colleagues in Greenwich Observatory, had verified the prediction of Einstein that rays of light are bent as they pass in the neighborhood of the sun. The whole atmosphere of tense interest was exactly that of the Greek drama: we were the chorus commenting on the decree of destiny as disclosed in the development of a supreme incident. There was a dramatic quality in the very staging: the traditional ceremonial, and in the background the picture of Newton to remind us that the greatest of scientific generalizations was now, after more than two centuries, to receive its first modification. Nor was the personal interest wanting; a great adventure in thought had at length come safe to shore.[2]

It was in accordance with the high and proud tradition of English science that English scientific men should have given their time and labor, and that English institutions should have provided the material means, to test a theory that had been completed and published in the country of their enemies in the midst of war. Although investigation of the influence of the solar gravitational field on rays of light is a purely objective matter, I am nonetheless very glad to express my personal thanks to my English colleagues.

Albert Einstein, *Times* (London),
November 28, 1919

Einstein's Cosmic Religious Feeling

Einstein called his philosophy of science his "cosmic religious feeling."[3] He was born to German Jewish parents and raised in a secular home in Munich; his family did not attend synagogue, observe holy days, or abide by dietary restrictions. His education was broadly humanistic, and he was drawn to prophets and scholars who espoused a pantheistic outlook, such as Baruch Spinoza, with whom he shared an intuition that there is order in nature. Einstein had a feeling of awe before nature, and he held this sensation to be sacred in the sense of being of utmost importance. Like Spinoza, Einstein identified "God" with the laws of nature, which he believed were completely deterministic; he objected to any interpretation of the data of physics as inherently indeterministic: "Quantum mechanics is certainly imposing. But an inner voice tells me that it is not yet the real thing. The theory says a lot, but does not really bring us any closer to the secret of the 'Old One' [*des Alten*]. I, at any rate, am convinced that He is not playing at dice [*daß der nicht würfelt*]."[4]

Einstein made a distinction between the Judeo-Christian-Islamic concept of a personal, supernatural God, which he dismissed as pre-scientific, and the conviction

9-6. *The Night Journey*, 2007–18. Video game. Courtesy of Bill Viola Studio, Long Beach, California, and the University of Southern California Game Innovation Lab.

This video game is the result of a collaboration between Bill Viola Studio and the USC Game Innovation Lab. The game opens in an unfamiliar landscape where night is falling and there is no path to follow. The player's actions can slow the approach of darkness, or the player can go on a "night journey" in search of enlightenment. The visuals for the game are derived from the contemporary video artist Bill Viola's archive of footage. The texts are inspired by historical mystics, including Plotinus (third-century AD Neoplatonic philosopher), Rumi (thirteenth-century Islamic poet), Saint John of the Cross (sixteenth-century Spanish priest and poet), and Ryōkan (eighteenth-century Zen Buddhist poet).

that there is order in the natural world, which he felt was essential to the scientific outlook. Without intensely felt belief—a faith, if you will—that there is a structure in nature, science is simply gathering data: "Science without religion is lame; religion without science is blind."[5] Einstein objected to the association of science with atheism because he felt that a lack of—choose your word—mystical or metaphysical feeling was deadening to the imagination. He was equally opposed to the organized church's dogmatic resistance to science, because it led to intellectual poverty.

Einstein's contemporary Sigmund Freud, always on guard against psychoanalysis being viewed as a religion, published an essay in which he dismissed any religious feeling as neurotic ("Future of an Illusion," 1927). In Western religions (Judaism, Christianity, Islam), the belief that one is the special child of a personal God is, according to Freud, an infantile refusal to grow up and face reality unprotected by an omnipotent father figure. In Eastern religions (Hinduism, Buddhism, Taoism), Freud likewise insisted, one's desire to unite with nature—the Brahma (the primordial void) or the Tao (the way)—is a desire to return to a time when one *was* united with nature, in one's mother's womb and, after birth, in her arms.[6]

Einstein disagreed with Freud's diagnosis of Western and Eastern religions as pathological. According to Einstein, even pre-scientific religious feelings are the sign of a healthy (if uneducated) mind:

> We followers of Spinoza see our God in the wonderful order and lawfulness of all that exists, and in its soul, as it reveals itself in man and animals. It is a different question whether belief in a personal God should be contested. Freud endorsed this view in his latest publication. I myself would never engage in such a task. For such a belief seems to me preferable to the lack of any transcendental outlook of life, and I wonder whether one can ever successfully render to the majority of mankind a more sublime means in order to satisfy its metaphysical needs.[7]

Spinoza was Einstein's most direct spiritual ancestor because he was an uncompromising rationalist who proclaimed that the universe embodies an order that the human mind can discover. For Spinoza nature was sacred but not shrouded in secrets; God/Nature is completely deterministic (predictable) and knowable. In his major work *Ethics, Demonstrated in the Geometric Manner* (1677), Spinoza put forth his pantheist doctrine in the format of Euclid's *Elements*, as a proof from postulates and definitions.

Einstein's best-known statement on spiritual matters came in a long essay, "Religion and Science," written for the *New York Times Magazine* in 1930. Religious experience, he said, develops in three stages: in the first, the primitive human being has a "religion of fear"; in the second, the civilized person conceives of God as a father who rewards and punishes. Einstein described the third—"the cosmic religious feeling"—as:

Abandon this fleeting world, abandon yourself,
Then the moon and flowers will guide you along the Way.

Ryōkan, 18th century

the desire to experience the universe as a single significant whole. . . . The religious geniuses of all ages have been distinguished by this kind of religious feeling, which knows no dogma and no God conceived in man's image; so that there can be no church whose central teachings are based on it. Hence, it is precisely among the heretics of every age that we find men who were filled with this highest kind of religious feeling and were in many cases regarded by their contemporaries as atheists, sometimes also as saints. Looked at in this light, men like Democritus, Francis of Assisi, and Spinoza are closely akin to one another.[8]

Einstein also described a kind of creative thinking long associated with mysticism in religion, science, and art: experience of the *mysterious*—something that is inexplicable, and of the *ineffable*—a feeling that words cannot express (plate 9-6):

The most beautiful experience we can have is the mysterious. It is the fundamental emotion that stands at the cradle of true art and science. Whoever does not know it and can no longer wonder, no longer marvel, is as good as dead, and his eyes are dimmed. It was this experience of mystery—even if mixed with fear—that engendered religion. A knowledge of the existence of something we cannot penetrate, our perceptions of the profoundest reason and the most radiant beauty, which only in their most primitive forms are accessible to our minds—it is this knowledge and this emotion that constitute true religiosity; in this sense, and in this alone, I am a deeply religious man.[9]

Popularization of the Theory of Relativity

The 1919 confirmation of the theory of relativity was front-page news and made Einstein an international celebrity overnight. The presentation of the theory differed by country, leading to variations in artistic response. In Germany, the public knew about Einstein's theory well before the November 1919 announcement. In April 1919, Berlin's *Vossische Zeitung* reported on a public lecture by Einstein, "Basic Ideas of the Relativity Theory," in which he gave a clear, understandable exposition of his theory and announced the forthcoming eclipse.[10] On the day of the eclipse (May 29, 1919), a headline ("The Sun Brings It to Light") reminded the newspaper's readers of its significance, and thus Germans were prepared to applaud the confirmation of Einstein's prediction when the results were announced in November 1919. Already in 1917, Einstein had published the popularization *Relativity: The Special and General Theory; A Popular Exposition*, and he gave many interviews to the media and public lectures after his theory was confirmed.[11] Other German scientists also assumed the role of teacher; for example, Max Born, a professor of physics at the University of Berlin, in

1919–20 wrote lucid newspaper articles, lectured to large public audiences, and published the popular book *Relativity Theory* (1920). In general, German scientists and science journalists presented the theory of relativity as intelligible and of great interest to all educated Germans. They spoke in a restrained, tutorial tone, and did not hesitate to include some mathematics. German-speaking artists, such as the Russian sculptor Naum Gabo, responded by incorporating ideas about the new cosmology into their work (see plate 10-1 in chapter 10).

In France, Poincaré's work on the conventionality of the axioms of geometry had set the stage for the theory of relativity, as Einstein often acknowledged, and so relativity was welcomed in Paris in 1919 as confirmation of the views of the French mathematician, who had died in 1912. Science journalists gave clear explanations of the relativity of motion (plate 9-8) and when Einstein lectured in Paris in 1922 his work was described in the popular Parisian press.[12] French journalists always presented Einstein in the same breath with Poincaré and gave the public the impression that, yes, the theory of relativity is revolutionary, but it is a continuation of Poincaré. Surrealists who referred to space-time typically gave the topic a psychoanalytic spin (plate 9-7).

In 1934 the French philosopher Gaston Bachelard wrote a summary of the new cosmology that was widely read by the Surrealists.[13] Bachelard began his university education studying physics and gradually shifted his focus to the philosophy of science, so he wrote well-informed expositions of Einstein's theory of relativity. He criticized Auguste Comte's positivist assumption that science always moves forward by steady progress. Rather, according to Bachelard, occasionally there is a scientific revolution such as the general theory of relativity, which constitutes an epistemological break in the progress of science. Three decades after Bachelard's book, Thomas Kuhn made the

"To you it was fast."

9-9. Cartoon by Eric Lewis.
New Yorker, Nov. 13, 2000.

9-10. Photoelectric effect
 The energy of light increases with its frequency: the smaller the wavelength, the higher the energy. In this diagram, low-energy red light shining on a surface has no effect, but high-energy blue light causes the emission of electrons. Very high-energy ultraviolet causes the electrons to fly out with even greater energy.

same point for English-language audiences in *The Structure of Scientific Revolutions* (1962).[14]

Unlike their German and French colleagues, British and American scientists and science journalists described the theory of relativity as incomprehensible.[15] In the aftermath of World War I, writers for the *Times* of London, sensationalized the theory as a battle in which the English father of modern physics was under attack by a "Swiss Jew,"[16] declaring in a headline of November 7, 1919, "Newtonian Ideas Overthrown." An amused Einstein declared there is a *political* theory of relativity because national frameworks influence observation: in London journalists dismissed him as a "Swiss Jew," but in Berlin he was hailed as a "German scientist."[17] In the United States, Einstein's theory was dramatized as a battle between ivory-tower intellectuals and everyday people with common sense. Rather than help non-scientists understand Einstein's theory so that the man on the street could feel part of the revolution, American scientists hid behind a mask of inscrutability. In the days after the British royal astronomer confirmed Einstein's theory, the *New York Times* published comments by American astronomers; one said, "Enough has been said to show the importance of Einstein's theory, even if it cannot be put into words," and another stated that Einstein's discoveries, "while very important, did not, however, affect anything on earth . . . [and] do not personally concern ordinary human beings."[18] Thus British and American artists made little use of Einstein's cosmology in the decades following its confirmation, and their occasional references to it betray an appalling lack of science education, such as the misunderstanding that physical relativity implies cultural relativity—"everything is relative" (plate 9-9).

The *Science* of Quantum Mechanics

In the late nineteenth century, scientists observed that when light shines on an opaque, non-reflecting surface (a so-called *black body*) at room temperature, the body gives off electrons; this is known as the *photoelectric effect* (plate 9-10). In 1899 Max Planck accounted for this observed pattern by assuming that electromagnetic energy (light) comes in units of energy with a precise quantity (*quantum* in Latin). As the energy of the light increases, so does the frequency of its electromagnetic wave, with the two always remaining in the same *constant* proportion to each other (*Planck's constant*). A few years later Einstein realized that light can be treated as a particle (a *photon*) with a quantum of energy determined by the frequency of its wavelength—the photon theory of light (1905).

Because atomic events occur at such a small scale, scientists use quanta (wavelengths of light) as their unit of measurement. Research in the atomic realm is called *quantum mechanics* (or *quantum physics*), as opposed to *classical mechanics* (or *classical physics*), which uses larger units such as meters or light-years to measure events on a human or cosmic scale.

In 1911 Ernest Rutherford suggested that the atom is like a miniature solar system, with a positively-charged nucleus in the center and tiny negatively-charged electrons revolving around it. Two year later, Niels Bohr adopted Einstein's photon theory of light and applied it to an electron; just as a wave of light can be treated as a particle, so an electron (a particle) can be treated as a wave, with its quantum of energy determined by the frequency of its wavelength. Bohr went on to refine Rutherford's solar system model of the hydrogen atom by representing the energy absorbed or emitted by its single electron in terms of quanta ("On the Constitution of Atoms and Molecules," 1913; see sidebar on page 264).

During 1914–18 travel was restricted because Europe was engulfed in conflict. After World War I ended, the international scientific community resumed research on the atom, and by the early 1920s physicists were observing that the electron did not seem to be located in a specific point (like the point particle in Rutherford's solar system model) but rather to be spread out, as if it were mass undulating in a *wave* (as in Bohr's quantum mechanical model). The Austrian physicist Erwin Schrödinger envisioned this vibrating wave of matter (the electron) as a cloud of energy. In 1925, he wrote an equation (now named for him) that describes the changes in this wave of matter—a ψ (psi) wave—over time. Then the German physicist Max Born refined the Schrödinger equation by noting that his equation doesn't describe an electron's wave-like mass but rather gives a probability distribution for estimating the electron's position. In other words, Schrödinger's ψ function can be used to estimate the probability of an electron being in a given region at a given time (plate 9-11).

The Schrödinger equation, along with other mathematical formulas of quantum physics, make predictions about events in the subatomic world that can be observed indirectly. For 100 years these mathematical descriptions of subatomic events have been repeatedly confirmed by rigorous experiment. No scientist doubts the accuracy of quantum mechanics, and engineers have put electrons to work for humankind, producing the high-tech world in which we live today (plates 9-20 and 9-21).

2p m = 0

4f m = 3

2S m = 0

4d m = 1

5f m = 0

3S m = 0

9-11. Erwin Schrödinger's probability distributions for an electron, imagined as clouds, in H. E. White, "Pictorial Representations of the Electron Cloud for Hydrogen-like Atoms," *Physical Review* 37 (June 1, 1931), 1416.

In these models of the hydrogen atom, the shapes represent probability distributions for different locations of the electron.

STRUCTURE OF THE ATOM

The hydrogen atom has one positively-charged proton in its nucleus surrounded by one negatively-charged electron that moves in the K shell, which has several energy levels. Let us suppose that the electron is in the lowest energy level, closest to the nucleus, when suddenly a high-energy beam of blue light comes flying in and is absorbed by the atom, causing the electron to jump (make a "quantum leap") to the highest energy level, far from the nucleus. If a low-energy red photon is absorbed, the electron moves a little farther from the nucleus but not as far. When hydrogen cools down (loses energy), the electron moves closer to the nucleus, emitting a blue or red photon (depending on its starting position).

Where does light come from? Atoms are the source of light. Electromagnetic energy is emitted by electrons as they move closer to the nucleus, leaping from orbital to orbital. When light is emitted from an atom, it doesn't start out slow and speed up but only ever travels at one speed—the speed of light.

The absorption and emission of photons explains the dark lines in a spectrum first observed by Joseph von Fraunhofer in 1814 (see chapter 8). A hydrogen atom absorbs energy in very specific wavelengths (red, blue, and three in the violet range) and its spectrum has dark lines in those wavelengths when it is absorbing energy. Conversely, hydrogen emits red, blue, and violet light when it is giving off energy.

Once physicists entered the quantum realm, they could explain why each element on the Periodic Table has a distinct "spectral fingerprint," as first recorded in 1859 by

Gustav Kirchhoff (see chapter 8). Every element has a different number of protons, so each has a different configuration of electrons and hence distinct absorption and emission spectra (plate 9-12).

HYDROGEN ATOMS ABSORBING AND EMITTING ENERGY

EMISSION AND ABSORPTION SPECTRA OF HYDROGEN

9-12. Emission spectra of the elements. Courtesy of Field Tested Systems LLC. © Field Tested Systems LLC.

RESTORATION OF HUBERT AND JAN VAN EYCK'S GHENT ALTARPIECE

Understanding the structure of the atom makes it possible for scientists to develop methods to preserve artwork such as the Ghent Altarpiece, which has a complex history. Around 1420, a merchant, Joos Vijd, commissioned Hubert van Eyck to paint the altarpiece, *The Adoration of the Mystic Lamb,* for his chapel in Saint Bavo's Cathedral in Ghent, Belgium. The subject is the sacrifice of a lamb, symbolizing the crucifixion of Jesus, the "lamb of God." The lamb stands on a red altar in the lower central panel, worshipped by earthly throngs below and a heavenly host above (plate 9-13). After beginning the project, Hubert fell ill and, sensing death was near, wrote the epitaph for his grave: "Formerly known and highly honored in painting, this all was shortly turned to nothing." Hubert died in 1426, probably when he was in his thirties, and his younger brother Jan completed the oil painting on oak panels, which was installed in the Vijd chapel on May 6, 1432.

During its 600-year history, the altarpiece has been overpainted, re-varnished, and the individual panels pawned, sold, and stolen. In 1934 one panel (lower left) was taken from the Vijd chapel at night by an unknown thief, and in 1942 the other panels were seized by the Nazi army on orders from Adolf Hitler. After World War II, the Allies returned the panels to Saint Bavo's Cathedral, where in 1951 the altarpiece was reassembled and cleaned, including removal of some overpaint and old varnish.

In 2012 the Church Council of Saint Bavo's Cathedral authorized restorers from the Belgian Royal Institute for Cultural Heritage to assess the condition of the painting

ABOVE

9-13. *The Adoration of the Mystic Lamb* (known as the Ghent Altarpiece), (open). Oil on panel, 11 feet 5 in. × 15 feet 1 in. (3.5 × 4.6 m). Saint Bavo's Cathedral, Ghent.

In the lower central panel, four groups of worshippers surround the altar: (top left) Catholic bishops and cardinals; (top right) female martyrs carrying palms; (bottom left) kneeling Old Testament prophets and standing philosophers and scholars from all over the world; and (bottom right) the twelve apostles in white robes and the Popes wearing red. In the panels on the far left, Just Judges and Knights of Christ arrive on horseback, and on the far right pilgrims and hermits arrive on foot. (The panel of the Just Judges is a copy of the stolen panel.) Above Adam and Eve, two choirs, and Mary and John the Baptist are shown on either side of a deity, who is either God the Father or Jesus.

and do minor restoration (a light cleaning of the surface). The restorers began their work equipped with new technology. Macro-x-ray fluorescence (MA-XRF), which is used in art conservation laboratories around the world, consists of (harmlessly) bombarding the painting with high-energy x-rays, which dislodge an electron from the K-shell (see diagram). After the inner electron flies out of the atom, an outer electron (from the M-shell, for example) does a quantum leap to the K-shell and replaces the missing electron. When the outer electron transitions to the K-shell, it emits an electromagnetic wave (a photon), giving off light and exhibiting "fluorescence." Since each element on the Periodic Table has a unique array of electrons, the emitted radiation can be used to identify each atom and its position in the painting. The method, which is nondestructive and can be used over wide areas (whole panels), allows scientists to construct images of the painting one element at a time.

A limitation of MA-XRF is that it can only be used to identify atoms that have electrons beyond the L-shell (in other words, atoms with more than 10 electrons). Since MA-XRF cannot be used to identify atoms such as hydrogen at the low end of the Periodic Table, it is supplemented by another nondestructive technique, x-ray diffraction (XRD), with which scientists can identify minerals (crystals) in pigments, such as lapis lazuli (ultramarine blue pigment) and

9-14. Cross section in ultraviolet light of a microscopic paint sample from a typical oil painting (not the Ghent Altarpiece) that shows the original paint layers (1-3) superimposed with original varnish (4), then overpaint (5). The Conservation Center of The Institute of Fine Arts, New York University.

9-15. This macrophotograph shows a dark region of a typical oil painting that has been over-painted with white. Looking through a binocular microscope, the restorer softens each tiny flake of overpaint with a solvent and then removes it with a cotton swab or a scalpel, being careful to not disturb the original layer. The Conservation Center of The Institute of Fine Arts, New York University.

MACRO-X-RAY FLUORESCENCE (MA-XRF)

X-RAY DIFFRACTION (XRD)

cinnabar (brilliant red). The atoms in a crystal are arranged in a lattice with regular, uniform spacing. XRD consists of aiming two x-ray beams with identical wavelength and phase at the crystal (see diagram). The beams bounce off two different atoms; the distance between the atoms (called their "d-spacing") determines the angle of diffraction and whether the x-ray beams leave the crystal in or out of phase. Since every crystal has a unique set of d-spacings, the minerals in a paint sample can be precisely identified, allowing scientists to construct images of the painting one mineral (crystal) at a time. XRD was invented in 1913 to study the surface of crystalline solids; during the assessment of the condition of the Ghent Altarpiece, the method was improved by using a particle accelerator to produce extremely high-energy x-rays capable of determining the crystalline structure of pigments in all paint layers.

Restorers use MA-XRF and XRD images to separate, for example, copper-based red pigment in an upper layer from lapis-based blue pigment in a lower layer, and lead-based white pigment in the lowest layer. After doing such noninvasive chemical analysis, there can still be uncertainty about the exact structure of the paint layers, so a tiny fragment (smaller than a grain of sand) is taken from the painting. The fragment, which ideally contains material from all layers of the painting, is examined under high magnification (plate 9-14).

Using these and other methods, restorers from the Belgian Royal Institute determined that the Ghent Altarpiece has three levels:

- the original painting with the original varnish on top

- a first overpainting consisting of a thin colored, translucent layer with several layers of varnish on top

- a second, largely opaque overpainting, covered with varnish, some of which had been removed in the 1951 cleaning

Furthermore, their analysis revealed that 70% of the original painting in the outer panels was covered with overpaint, which had been applied in the sixteenth and seventeenth centuries. On the basis of this assessment, St. Bavo's Cathedral revised its mandate to the restorers: remove all overpainting, stabilize the original surface, and apply fresh varnish (plate 9-15). In 2016 the restorers finished the outer panels (plates 9-16 and 9-17).

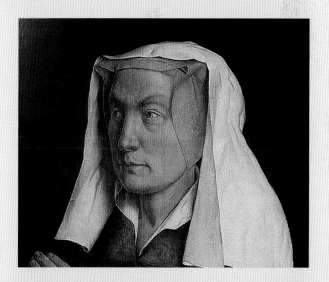

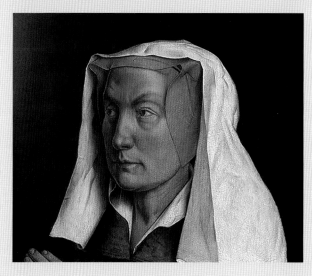

ABOVE

9-16. Ghent Altarpiece (closed) before restoration (left) and after (right). Saint Bavo's Cathedral, Ghent.

In the upper register is an Annunciation and below, portraits of the donor, Joos Vijd, and his wife, Elisabeth Borluut, flank statues of John the Baptist and John the Evangelist. The 2016 restorers discovered that the frame of the outer panels was originally painted faux stone; four lines of verse (see page 268) are written across the bottom of the frame, one line under each panel.

RIGHT

9-17. Elisabeth Borluut (detail), shown before restoration (above) and after (below).

dull, lifeless faces typical of Baroque portraits, Blondeel and Scorel overpainted the face of the sacrificial lamb and made him impassive, void of emotion (plate 9-18 [top]). With the overpainting removed, today we see Hubert and Jan van Eyck's lamb—vulnerable in the face of his imminent death, blood gushing from a wound in his chest into a chalice on the altar (plates 9-18 [bottom] and 9-19).

In 1824, Gustav Waagen, a curator at the Royal Prussian collection in Berlin (where the doors of the altarpiece were then located), discovered four lines of verse written (in Latin) in black and red letters across the bottom of the frame of the outer panels (visible in plate 9-16 [right]). The 2016 restorers determined that the inscription is original, hence put there by Jan van Eyck:

> Pictor hubertus eeyck maior quo nemo repertus
> Incepit pondus que johannes arte secundus
> Frater perfecit judoci vyd prece fretus
> Versu sexta mai vos collocat acta tueri

In keeping with Jan van Eyck's love of puns and puzzles, when the red letters in the last line are read as roman numerals, they add up to 1432, the date the altarpiece was completed.

The inscription translates:

> The painter Hubert van Eyck, who was greater than anyone,
> Began this work. His brother Jan, who is second best in art,
> Completed it at the request of Joos Vijd.
> With this verse on the sixth of May [1432], the donor entrusts the work to your care.

When the restorers turned their attention to the inner panels, they discovered that overpaint had altered the entire mood of the altarpiece. In the mid-sixteenth century, Emperor Charles V hired his favorite artist, Titian, to paint several portraits of himself, and he also enlisted Lancelot Blondeel and Jan van Scorel, famous painters in their day, to update church paintings to his taste throughout his realm (the Netherlands, Belgium, and Spain). In keeping with the

TOP LEFT

9-18. Lamb (detail) shown before restoration (above) and after partial restoration (below). In 1951, restorers began to remove overpaint, revealing the lamb's original ears, but they stopped in the middle of their work because they lacked the necessary technology. So, from 1951 to 2018 the lamb had four ears. They also stopped short of removing overpaint from areas in the green background where the original light green oil paint had lifted. In 2018 this overpaint was removed, revealing van Eyck's dark green underpainting. In keeping with the restorer's creed to only do treatment which is reversible, these dark patches will be filled in with light green opaque watercolor when the restoration is complete.

LEFT

9-19. Lamb, after partial restoration; this photograph was taken in 2018.

Einstein's *Philosophy* of Quantum Mechanics: The de Broglie–Bohm Interpretation

In contrast to the universal acceptance of the *science* of quantum mechanics, there has been endless debate about the *philosophy* of quantum mechanics. What does quantum mechanics mean? What does it tell us about reality? Elsewhere I've written a detailed account of the rival interpretations of quantum mechanics based on two landmark studies: Max Jammer's book on the philosophy of quantum physics and Paul Forman's essays on science in the Weimar Republic.[19] Below I'll summarize the philosophical interpretations, mentioning but a few among the cast of characters in these rival narratives.

Einstein was heir to the Enlightenment outlook, epitomized by Spinoza, that nature has a unified structure that humankind can discover using reason and observation. Trained in classical physics and a founder of quantum mechanics, Einstein sided with the French physicist Louis de Broglie, who in 1927 formulated an interpretation of quantum mechanics that preserves deterministic laws of cause and effect. In 1952 the American physicist David Bohm (unaware of de Broglie's work) put forth a similar interpretation, in which quantum physics describes an objective reality (the natural world) independent of an observer. The approach is named for both men—the de Broglie–Bohm interpretation.

It is important to keep in mind that "deterministic laws of cause and effect" include probability theory (statistics); the position of one electron (like the toss of one coin) involves an element of chance, but on average electrons obey laws of probability that *inevitably—deterministically*—produce a pattern (after many coin tosses, the results will be 50–50 heads and tails). After Schrödinger formulated the ψ function, all physicists (including Einstein, de Broglie, and Bohm) used probability theory to estimate the position of an electron.

De Broglie based his approach on Einstein's 1905 paper on the photoelectric effect. Einstein had shown that when light interacts with matter, it does so as if it were a particle with mass (a photon), and thus light can be considered both a wave and a particle (a wave-particle). De Broglie suggested that an electron *also* has dual wave-particle properties; in other words, the movement of an electron can be treated as if it were a wave. He then took Schrödinger's equation for a ψ wave (for describing the position and momentum of an electron) and gave the ψ wave a particle interpretation in terms of its trajectory. The electron is guided along its path by this pilot wave (the ψ wave). Thus an electron has a well-defined position and momentum, and it has an objective reality that does not depend on an observer.

9-20. Charles Ross (American, born 1937), *Quarks, Gluons, Particles of Light*, 1990–91. Dry pigment exploded onto paper using dynamite Primacord, 54½ × 38 in. (138.4 × 96.5 cm). © Charles Ross.

Charles Ross's drawing was inspired by a diagram representing the behavior of subatomic particles by American physicist Richard Feynman. Ross first drew the Feynman diagram, and then exploded dry pigment onto the paper using detonating Primacord.

Bohr's *Philosophy* of Quantum Mechanics: The Copenhagen Interpretation

In the 1920s, Niels Bohr and his young disciple Werner Heisenberg worked in the exciting field of quantum mechanics; laboratory science was their primary focus. They had a secondary interest in the philosophical implications of their work. Both were thoroughly educated in physics and upheld rigorous standards of precision in their laboratory work. Neither had advanced training in philosophy, and they dropped their intellectual standards when they waxed philosophical. Their philosophical writing is a patchwork of elements from their cultural milieu: German Idealism, the *Lebensphilosophen* (life philosophers, such as Søren Kierkegaard), psychological theories of consciousness (William James), and logical positivism (Ernst Mach and Wolfgang Pauli).

German intellectuals read the works of the Lebensphilosophen (including Friedrich Nietzsche in addition to Kierkegaard) during a resurgence of Romanticism in German society triggered by the country's defeat in World War I. Since the founding of modern Germany—the First Reich in 1871 to World War I (1914–18)—Germany had been the undisputed leader of science. Citizens were proud of the contributions of German science and technology to the war effort, and they felt confident of victory. But in 1918 the tide of the war turned, the emperor of the First Reich, Wilhelm II, abdicated, and Germany collapsed in defeat.

In the post-1918 Weimar Republic (the Second Reich), citizens felt betrayed by science and grew suspicious of its soulless mechanism and fatalistic determinism. When physicists from Austria, Belgium, Scandinavia, Russia, and Eastern Europe met their German colleagues at conferences in Berlin, Brussels, Copenhagen, and Warsaw, their common language was German, and the grim mood of Weimar Germany filled the air.

Intellectuals read the work of Kierkegaard, who wrote a parody of rational thought that was designed to instill doubt and lead the reader away from knowledge rather than toward it (*Either/Or*, 1843).[20] While an undergraduate at the University of Copenhagen, Bohr adopted the Danish philosopher's critique of science, according to which it is impossible to be an objective observer of nature because one is part of nature.[21] In his youth, Bohr also read the American psychologist William James, from whom he learned that an act of consciousness—the subjective experience linking a person to an observed fact—is impossible to study by introspection.[22] For example, suppose that while observing an electron, Bohr reflected on his experience of observing the electron—then he wouldn't be observing the electron anymore.

Positivism was a creation of the nineteenth-century political philosopher Auguste Comte, who declared that society should be built on scientific principles that give certain (positive) knowledge. Continuing Comte's pursuit of certainty, the early twentieth-century Austrian physicist Ernst Mach analyzed the logical structure of assertions

g

Q

Q

$PP \rightarrow \gamma X$ Quarks, Gluons, and Particles of Light

Chal Ross 1990/91

about perceptions, which he called "sense-data" (a term he borrowed from British logician Bertrand Russell); thus Mach's method is called *logical* positivism. After 1918, Mach's approach was developed by a group of philosophers, led by the German logician Rudolf Carnap, who gathered in Vienna to analyze the logical structure and interrelation of linguistic expressions of science. In other words, the group didn't practice science but had philosophical discussions about the *language* of science. The group was officially named the Verein Ernst Mach (Ernst Mach Association) but is known by its nickname—the Vienna Circle.

In the 1920s the Vienna Circle discussed the philosophy of language against a backdrop of Immanuel Kant, according to whom one knows the natural world as a mental construction made from perceptions (patches of color, sounds, smells). According to German Idealism one knows only these perceptions, appearances, *ideas* (the contents of one's mind). As Kant wrote: "The order and regularity of the appearances, which we entitle *nature*, we ourselves introduce."[23] Echoing Kant and the Vienna Circle, Bohr produced a new *scientific* version of German Idealism by updating the terms *appearances* and *sense-data* to the language of quantum mechanics. According to Bohr, the basic building blocks of the natural world are *observations*, which turn out to match observations using Schrödinger's ψ waves (the probabilistic descriptions of the quantum state of a physical system). In other words, the building blocks of scientific knowledge are ideas—*observations*—in the mind of the scientist.

According to Bohr, at the level of protons and electrons there is an irreparable break in the chain of cause and effect, and thus it is theoretically impossible to give a complete description of events in the natural world. Furthermore, a boundary separates scientists from what they observe, and this dividing line between subject and object cannot be investigated by the scientific method—it is forever shrouded in mystery. Therefore, all scientists can hope to know is their subjective conscious experience—their observations. Is there a natural world-out-there (protons and electrons, plants and animals, planets and stars)? If so, it is unknowable, because all physicists can know is their own sense perceptions. As Heisenberg wrote in 1927: "It may be suggested that behind the statistical universe of perception there lies a hidden 'real' world ruled by causality. Such speculations seem to us—and this we stress with emphasis—useless and meaningless. For physics has to confine itself to the formal description of the relations among perceptions."[24]

In 1927 Heisenberg wrote an essay about measurement in the subatomic realm in which he described his uncertainty principle. To measure any object, the observer has to interact with it in some way. An example from the macro-world is measuring the temperature of water by dipping a thermometer into it. The outcome is affected by the method and the scale: if the water is hot and the thermometer is room temperature, then the act of measuring will cool the water—how much depends on whether it's a teaspoon or bathtub full of water. An example from the micro-world is measuring the

Sometimes a concept is baffling not because it's profound but because it is wrong.

E. O. Wilson, *Consilience: The Unity of Knowledge*, 1998

9-21. Eric J. Heller (American, born 1946), *One Bounce*, 2003. Digital print. Courtesy of the artist.

Physicist and artist Eric J. Heller created this image by launching an electron wave from the top, where it began as a tidy pattern. The wave then descended in a gravitational field, wavelengths growing shorter as it sped up, then bounced off the irregular surface at the bottom and went back to the top, now looking jagged and dishevelled. This still image of the quantum wave captures the moment when it reached the top. Heller used the computer programming language Fortran (name derived from "formula translation") to translate a formula describing the quantum wave into a file that was readable in Photoshop, where he added the color. Brightness indicates the amplitude (amount of vibration) of the wave.

9-22. "Heisenberg's γ-ray [gamma-ray] microscope," in George Gamow, *Mr. Tompkins* (Cambridge: Cambridge University Press, 1967), 76. Drawing by George Gamow.

This illustration was drawn by physicist George Gamow, who wrote short stories about Mr. Tompkins, a bank clerk who falls in love with the daughter of a physicist, from whom he learns about the subatomic world.

position of an electron by hitting it with a gamma ray (short wavelength, high-energy radiation), a method Heisenberg proposed in a thought experiment using what he called a "gamma-ray microscope" to detect the electron (plate 9-22).[25] When the gamma ray interacts with the electron, the gamma ray disturbs it by changing the electron's momentum. Therefore, the observer determines where the electron *was*, but the transfer of momentum changes the path of the electron, so the observer has little idea of where it *is*. Measuring the position of an electron *affects* its velocity, and thus one can know its momentum only approximately; similarly, measuring the momentum of an electron *affects* its position, and therefore one can know its position only approximately. Thus, according to Heisenberg, a degree of uncertainty is inherent in the process of measuring an electron. So far Heisenberg had described a truism of modern physics; James Clerk Maxwell used probability theory (statistics) to approximate the location of water molecules in steam in his kinetic theory of gas of 1866, and Einstein used statistics to estimate the location of particles suspended in liquid in his study of Brownian motion. Maxwell and Einstein believed that each molecule and particle *has* a precise location, even though it was unknown to them (since they had approximated it). Heisenberg, on the other hand, claimed that the location of an electron is not only unknown but *unknowable* because the electron *lacks* a precise location until it is observed and measured, which causes the electron (the probabilistic ψ wave) to exist in ("collapse" to) a particular time and place.

The important thing to notice about the dates in this tale is that the gist of the Copenhagen approach *predated* the laboratory experiments that it interpreted. Bohr, Heisenberg, and others in their circle were swept up by a tide of Romanticism—a revolt against rationalism and a celebration of intuition that began after the Great War ended in 1918. Then, beginning around 1925, Bohr and Heisenberg gave their laboratory data a *philosophical* interpretation that was consistent with their Romantic worldview, culminating in 1927 on the stage of the Fifth Solvay Congress in Brussels, a major gathering of physicists from around the world (the congress was named for its founder, Belgian industrialist Ernest Solvay).

The Fifth Solvay Congress of 1927

De Broglie walked to the podium in Brussels and gave his interpretation of events in the quantum realm, which preserves deterministic laws of cause and effect, independent of an observer. The Austrian-born Swiss physicist Wolfgang Pauli, a member of Bohr's circle, followed and gave a sharply critical response to de Broglie, which silenced him.[26]

When it was his turn, Heisenberg delivered a paper in which he declared that physics is not governed by deterministic laws of cause and effect: "Quantum mechanics

establishes the final failure of causality."[27] Bohr concurred and described quantum mechanics to the audience of the Solvay Congress: "Its essence may be expressed in the so-called quantum postulate, which attributes to any atomic process an essential discontinuity, or rather individuality, completely foreign to the classical theories." Thus, according to Bohr, there is no deterministic cause and effect: "This [quantum] postulate implies a renunciation as regards the causal space-time co-ordination of atomic processes . . . an inherent 'irrationality.'"[28]

Einstein was in the audience shaking his head at the celebration of irrationality (Bohr) and uncertainty (Heisenberg). At this 1927 meeting in Brussels, Einstein and Bohr began a long-running debate about the philosophical *meaning* of quantum mechanics, which has gone down in the history of science as a metaphorical battle between Enlightenment reason versus Romantic intuition.[29] In the end, their disagreement was about: What is real? What does quantum mechanics tell us about the nature of reality?

Two years after the Fifth Solvay Congress, Bohr waded waist-deep into the philosophical swamp when he declared that quantum mechanics ensures free will: "[Many have noted] the contrast between the feeling of free will, which governs the psychic life, and the apparently uninterrupted causal chain of the accompanying physiological processes, [but] we have learned, by the discovery of the quantum of action, that a detailed causal tracing of atomic processes is impossible . . . [because there is] a fundamental uncontrollable interference in their path. . . . We can hardly escape the conviction that in the facts that are revealed to us in the quantum theory . . . we have acquired the means of elucidating general philosophical problems."[30] Elsewhere Bohr had defined the "quantum of action" as the discovery that subatomic particles in a closed system can behave in a way that is not completely determined by prior conditions. He went on to speculate about the implications of this *fact of science* for "general philosophical problems" such as "the feeling of free will" that human beings experience.

It is ironic that Bohr, for whom observation was the touchstone of science, should claim that a scientific discovery about atoms is relevant to philosophical questions about human free will (purposeful actions and decisions). Bohr was making what philosophers call a *category mistake*. Other examples of category mistakes are: "this grilled cheese sandwich has free will" and "logic is in the refrigerator."[31]

After 1927, the Copenhagen interpretation held a virtual monopoly. It was written into physics textbooks as *the* truth, and professors taught generations of students that it is theoretically impossible to give a deterministic account of quantum phenomena and that reality consists of human consciousness (awareness, observation). As Schrödinger complained in 1935: "We are told that no distinction is to be made between the state of a natural object and what I know about it. . . . Actually—so they say—there is intrinsically only awareness, observation, measurement."[32] The Irish physicist John Stewart Bell learned from his teacher, Max Born, that any alternative to the orthodox

Nothing exists until it is measured.

Niels Bohr, ca. 1930

The moon is there even when I'm not looking at it.

Albert Einstein, ca. 1930

I find the idea quite intolerable that an electron exposed to radiation should choose of its own free will, not only its moment to jump off, but also its direction.

Albert Einstein, letter to Max Born, April 29, 1924

Copenhagen interpretation is impossible, but then, as he recalled: "In 1952, I saw the impossible done. It was in papers by David Bohm . . . the essential idea was one that had been advanced already by de Broglie in 1927 in his 'pilot wave' picture. . . . Why is the pilot wave picture ignored in textbooks? Should it not be taught, not as the only way, but as an antidote to the prevailing complacency? To show us that vagueness, subjectivity, and indeterminism, are not forced on us by experimental facts, but by deliberate theoretical choice?"[33]

After this summary of two *philosophical interpretations* of quantum mechanics, it bears repeating that all the pioneers—Planck, Einstein, Schrödinger, de Broglie, Bohr, Heisenberg, Pauli, and Born—agreed about the *science* (the laboratory data) of quantum mechanics.

Popularization of Quantum Mechanics: Physical Paradoxes

In his popular writing, Einstein endorsed de Broglie and declared that physics is not about what is in your head—(subjective) ideas, perceptions, observations—but describes the (objective) physical world: "Without the belief that it is possible to grasp reality with our theoretical constructions, without the belief in the inner harmony of our world, there could be no science."[34]

In France, the physicist-philosopher Bachelard's popularization of the theory of relativity also included an exposition of quantum mechanics in *Le nouvel esprit scientifique* (The new scientific spirit, 1934). From his perch at the center of French physics and philosophy, Bachelard was well aware of the importance of de Broglie's work, which he summarized in this book. He also described the *science* of Bohr and Heisenberg, without endorsing their *philosophy*—the Copenhagen interpretation. In 2008 the British art historian Gavin Parkinson published a study of Surrealism and science in which he wrote that Bohr and Heisenberg's proclamations about the end of causality and the beginning of irrationality are "the heart of what Surrealist fellow-traveler Gaston Bachelard would soon call the 'new scientific spirit.'"[35] In fact, Bachelard said the opposite: "causality is still an important feature of the rational coherence of contemporary science [*la causalité qui est encore un trait important de la cohérence rationnelle de la science contemporaine*]."[36] Like Parkinson, many French popularizers accepted the Copenhagen interpretation at face value, but Bachelard was too philosophically sophisticated to parrot Bohr and Heisenberg.

In 1935, Einstein and Schrödinger created two images that are most associated in the public imagination with quantum mechanics: photon entanglement and Schrödinger's cat. Both argue that *if* Bohr's claim, that nothing exists until it is observed, is correct, then information can travel faster than light (in photon entanglement) and an animal (Schrödinger's cat) can be both dead and alive. Einstein and Schrödinger's

point was that since Bohr's premise leads to these paradoxes, *it is impossible* for him to be right (see sidebar on pages 278–279).[37]

Bohr's response to Einstein and Schrödinger's paradoxes was to insist that the Copenhagen interpretation is *the* interpretation, the only one possible: "Quantum mechanics is as complete as it can be. There is no more information to be had than quantum mechanics can give us."[38] Others in Bohr's circle adopted his promotional style in their popular writing and in the spirit of salesmanship made extravagant claims for their "product."[39] In a 1928 article in a German daily newspaper, Max Born asserted that the Copenhagen interpretation was capable of restoring the reader's faith in a higher power: "If the state of a closed system is known precisely at one instant, then natural laws determine the state at every later point in time. The laws of earlier physics always made this claim. Such an interpretation of nature is deterministic and mechanistic. There is no place for freedom of any kind or for the will of a higher power [*einer höheren Macht*]. . . . But recent physics has discovered new laws, supported by much empirical data, that do not conform to this deterministic schema."[40] The following year Bohr assured the pious that quantum mechanics makes it impossible to give a biological explanation of the origin of life from inorganic matter: "The distinction between the living and the dead escapes comprehension."[41]

These bizarre claims in popularizations of the Copenhagen interpretation contributed to the condition known as postmodernism, in which there is no objective truth.[42] The word *modern* refers to the revival of the ancient scientific conviction that nature embodies patterns that humankind can know by using reason, which spurred the Enlightenment and the adoption of the scientific worldview. Germany became the world leader of science, mathematics, and technology, but confidence that reason can discover objective truth was undermined when Germany lost World War I and completely shattered after the nation's defeat in World War II. *Postmodern* refers to the decades after 1945 when many in the West lost confidence in reason and the ability to determine what is true.

· · ·

The Copenhagen interpretation was based in German philosophy, which became a casualty of World War II. After 1945, German Idealism ceased being passionately discussed in coffeehouses and became an intellectual fossil studied in academia. The Germanic Copenhagen interpretation also began passing into history,[43] bringing an end to this strange episode in the history of science. Alternative interpretations were put forth by physicists from France, Britain, and the United States, including the de Broglie–Bohm interpretation (1950s), many-worlds (1950s), and string theory (1980s) (see chapter 14). Today international teams of scientists have resumed the task of giving an ever-more accurate description of the natural world.

The ideal subject of totalitarian rule is not the convinced Nazi or the convinced Communist, but people for whom the distinction between fact and fiction (i.e., the reality of experience) and the distinction between true and false (i.e., the standards of thought) no longer exist.

Hannah Arendt, *The Origins of Totalitarianism*, 1951

Truth isn't truth.

Rudy Giuliani, speaking as lawyer for President Donald Trump, interview with Chuck Todd on NBC's *Meet the Press*, August 19, 2018

PHOTON ENTANGLEMENT AND SCHRÖDINGER'S CAT

Physicists discovered that under certain conditions when a subatomic particle (such as a photon) disintegrates it emits twin daughter particles that have paired properties; if one particle spins up, then the other spins down. The two particles are "entangled." According to Albert Einstein, the twin daughter particles have their paired properties from birth (their creation in a lab). According to Niels Bohr, each daughter particle has only the *potentiality* of direction of spin; the up and down directions coexist as possibilities—they are in *superposition*—until the (human or mechanical) observation of the particle causes the possibilities to "collapse," after which the particle spins either up or down.

In an attempt to show that Bohr was wrong about the role of observation, Einstein proposed a thought experiment. Suppose that the particles of an entangled pair fly off in opposite directions and get very far apart. Then imagine that an observer measures the spin of one particle and its spin measures up; the distant twin then must *instantaneously* measure down, which violates the theory of relativity that nothing can travel faster than the speed of light (Einstein, Boris Podolsky, and Nathan Rosen, "Can Quantum

Mechanical Description of Reality be Considered Complete?" *Physical Review* 47 [1935], 777–80) (plate 9-24). Erwin Schrödinger named Einstein's physical paradox photon "entanglement" (*Verschränkung*), and he came up with his own version of a quantum-measurement paradox. Suppose that a cat, a flask of poison, and a source of radioactivity such as a speck of radium, are placed in a sealed box, along with a monitor (such as a Geiger counter). If the monitor detects radioactivity (such as the random release of an alpha particle), it breaks the flask, releasing the poison, which kills the cat. According to Bohr, until there is human or mechanical observation of the state of things inside the box, both possible states exist in superposition—the cat is alive and the cat is dead (Erwin Schrödinger, "Die gegenwärtige Situation in der Quantenmechanik," *Naturwissenschaften* 23 [Nov. 1935], 807–12, 823–28, and 844–49; trans. John D. Trimmer, as "The Present Situation in Quantum Mechanics: A Translation of Schrödinger's 'Cat Paradox' Paper," in *Quantum Theory and Measurement*, ed. John Wheeler and Woyciech Hubert Zurek [Princeton, NJ: Princeton University Press, 1983], 152–67) (plate 9-23).

OPPOSITE

9-23. Jiang Shan (Chinese, born 1979), *Schrödinger's Cat*, 2012. Ink and pencil, digitally colored giclée print, 22½ × 31½ in. (57 × 80 cm), edition of 60. Courtesy of the artist.

Half-hollow cats walk on a yellow path that comes from the mouth of Erwin Schrödinger, whose dramatic face with huge eyes and pointed teeth was inspired by a Balinese mask. According to the artist, Schrödinger's fantastic head symbolizes myths—such as Schrödinger's cat—that humans create to understand their world.

ABOVE

9-24. Anna Fine Foer (American, born 1957), *Entangled Particles*, 2016. Collage, 24 × 24 in. (61 × 61 cm). Courtesy of the artist.

A Non-Euclidean, Expanding Universe

Space and time are reborn to us today. Space and time are the only forms on which life is built and hence art must be constructed.

Naum Gabo and Antoine Pevsner, "Realist Manifesto," 1920

IN THE EARLY twentieth century the dualisms that had defined the clockwork universe—electricity and magnetism, matter and energy, space and time—were dissolving, and artists asked: What does the new cosmology mean for us? Painters and sculptors who composed with squares and cubes of Euclidean geometry learned that Albert Einstein used a four-dimensional, non-Euclidean geometry to describe the new space-time universe. Suddenly Isaac Newton's model of the universe as a vast three-dimensional Euclidean volume seemed obsolete.

Geometric Art in German-speaking Lands

Euclid designed a mathematical system—a proof from premises—that rested on a foundation of five axioms (*Elements*, 300 BC). Some thought that Euclid should have proved (rather than assumed) the fifth axiom, which is called the "parallel postulate," because one formulation of the axiom states that parallel lines never meet. In the nineteenth century, the Russian mathematician Nikolai Lobachevsky tried to prove Euclid's fifth axiom using a proof by contradiction. In such a proof, one assumes the opposite of what one wants to prove and then derives a contradiction. Since only a false premise leads to a contradiction, it follows that the opposite of the false premise (what one wants to prove) is true. So Lobachevsky assumed the opposite of Euclid's fifth axiom, but instead of deriving a contradiction, to his astonishment he found himself proving theorem after theorem, in a new geometry in which Euclid's first four axioms are true but the fifth is false. Lobachevsky had developed the first non-Euclidean geometry, which describes a space with negative curvature. He published it as *Imaginary Geometry* (1826), because he thought he had discovered a place that exists only in the imagination. The most influential early nineteenth-century mathematician, the German Carl Friedrich Gauss, also explored non-Euclidean space, and in 1854 Gauss's student

10-1. Naum Gabo (Russian, 1890–1977), *Kinetic Construction: Standing Wave*, 1919–20 (1985 replica). Metal, wood, and electrical mechanism, height 24¼ in. (61.6 cm). Tate, London.

A motor in the base causes the metal bar to oscillate, producing a pattern of waves known in physics as a *standing wave*. Gabo created *Kinetic Construction* to symbolize space-time and mass-energy. The sculptural volume (*space*) is created by the motion of the bar (over *time*). Also, the sculptural form (*mass*) is equal to the oscillation (*energy*), When the motor is switched off, there's no sculpture, only hardware.

281

Bernhard Riemann wrote a non-Euclidean geometry, which describes a space with positive curvature.

While Euclid wrote laws governing the artifical language of mathematics, his contemporary Aristotle wrote laws governing the spoken language of verbal argument—syllogisms. One syllogism has the form: If all A are B, and all B are C, then all A are C (If all Greeks are human, and all humans are mortal, then all Greeks are mortal). Aristotle's logic survived unchanged into the early nineteenth century, when the British mathematician George Boole devised modern *symbolic* logic that uses algebraic notation and has two values—1 and 0, for *true* and *false* ("The Mathematical Analysis of Logic," 1847). When engineers designed electrical equipment to process information, they adopted a Boolean algebra with two values, for *on* and *off*. This search for a universally valid logical language culminated in the British mathematicians Bertrand Russell and Alfred North Whitehead's *Principia Mathematica* (Mathematical principles) of 1910–13. As its title suggests, Russell and Whitehead gave the mathematical laws for logical reasoning, as Newton had given the mathematical laws for physics and astronomy in *Philosophiæ Naturalis Principia Mathematica* (Mathematical principles of natural philosophy) of 1687.

In 1907–14, Cubists Georges Braque, Pablo Picasso, and Juan Gris organized their fleeting sensations into geometric planes and volumes. During World War I (1914–18), artists of Purism, De Stijl, Suprematism, and Constructivism vowed to move beyond the faceted planes of Cubism and arrive at a purer geometry; their art would be based in the reasoning power of the mind alone. Amédée Ozenfant, Piet Mondrian, El Lissitzky, and Naum Gabo cited the authority of past masters of geometry, especially Euclid, and they composed with a vocabulary of straight lines, circles, and cubes.

Then the world learned in 1919 that the universe is not Euclidean after all but best described by an arcane geometry in which parallel lines meet. Einstein found that the space described by Riemann's non-Euclidean geometry—with continuous positive curvature—best describes the real universe, because space is warped by massive stars and galaxies. On Earth we still use Euclidean geometry because terrestrial space is in one gravitational field (Earth's), where the shortest distance between two points *is* a straight line, as defined by Euclid. But when we measure the path of starlight in outer space, the shortest distance between two points is a curved line, in Riemann's non-Euclidean geometry.

Within the complex intellectual matrix of Germanic culture in the 1920s, the confirmation of Einstein's theory of relativity hit like a shock wave, because a fundamental tenet of Immanuel Kant's theory of knowledge is that Euclidean geometry is part of the framework of human reason. In other words, according to Kant, Euclid's five axioms are innate—hardwired in the human brain. After Einstein declared that the cosmos is non-Euclidean, all areas of thought that use geometry reassessed their procedures, including painting, sculpture, architecture, and the psychology of spatial perception.

Berlin and the Bauhaus

After Germany's defeat in World War I, architects in Berlin created a powerful metaphor for humankind's spiritual renewal in the new space-time universe: towers of light—glass skyscrapers—that link Earthlings to the universe. These tall building had been made possible by the invention of steel, but nineteenth-century skyscrapers had been sheathed in brick and stone. In 1919 the architect Bruno Taut made an analogy between the medieval cathedral and modern skyscrapers: the cathedral is supported by stone arches and the skyscraper by steel beams; since neither needs the walls for support, both can have large glass windows. Taut proclaimed that the deep spirituality of the bygone era could be revived if the tall steel structures were veiled in glass. In the center of every city he would build a glass tower—a *Stadtkrone* (German for "city crown")—where weary citizens could refresh their souls and contemplate the universe.[1]

During the economic slump of the post-war years, there was no money in Germany to build such utopian fantasies, but after the 1919 confirmation of Einstein's theory, Taut's imagination was fired to produce one more vision of architecture linking the microcosm and macrocosm, the artist's book *Alpine Architektur* (Alpine architecture; 1919). Taut tells the story of a destroyed Gothic cathedral whose shattered fragments "become atoms and are dispersed through the universe" until they coalesce under the force of gravity into a "cathedral star" (plate 10-2). After colliding with a meteor, debris from the cathedral star falls to Earth, where the atoms are recycled to build modern architecture (plate 10-3).

Ludwig Mies van der Rohe was also in Berlin dreaming about what could be built with the new materials. In his model for a glass skyscraper of 1922, he imagined buildings in which the floors are cantilevered out from a steel spine and the outer walls are tilted panes of glass, giving the skyscraper a crystalline appearance (plate 10-4). When the Bauhaus school of design opened in Weimar in 1919, its director, Walter Gropius, vowed to incorporate the latest scientific and technological advances into modern design in order to renew humankind's spirit through secular architecture. Gropius underlined the spiritual mission of architecture by choosing a woodcut of a Gothic cathedral by Lyonel Feininger to adorn the title page of the founding manifesto of the Bauhaus. When the school came under right-wing political attack, Gropius sought the support of Germany's cultural leaders, and Albert Einstein responded by joining the Bauhaus board of directors in 1924.[2] After the school relocated to Dessau the following year, Gropius designed its new building with large windows to provide daylight for the workshops and to make the students' spirits soar.

In 1932, for the Museum of Modern Art in New York, Henry-Russell Hitchcock and Philip Johnson curated an exhibition of modern architecture that included photographs of buildings by Mies and Gropius. By the early 1930s there were buildings in a style that emphasized steel, glass, and concrete in cities around the world, so the

DOMSTERN

„DIE KUGELN! DIE KREISE! DIE RÄDER!"

curators named it the International Style. After immigrating to the United States, Mies built the Lake Shore Drive Apartments in Chicago (1949–51) and the soaring Seagram Building in New York (with Philip Johnson, 1954–58; plate 10-5).

The Hungarian designer László Moholy-Nagy, who joined the faculty of the Bauhaus in 1923, also focused on humankind's interaction with space, time, and light. Approaching the new physics with cautious enthusiasm, Moholy-Nagy created gravity-defying layouts by letting sans serif typefaces run vertically up the page (plate 10-6). He taught at the Bauhaus in Weimar and Dessau until 1928, when he went to London. After relocating to the United States in 1937 to become founding director of the New Bauhaus in Chicago, Moholy-Nagy reflected on the impact of Einstein's revolution on the conceptual framework of designers: "Einstein's terminology of 'space-time' and 'relativity' has been absorbed into our daily language. . . . they designate a new dynamic and kinetic existence freed from the static, fixed framework of the past."[3]

Color theory at the Bauhaus followed French chemist Michel-Eugène Chevreul's law of simultaneous contrast (see chapter 4), taught by the German painter Josef Albers. The study of form at the Bauhaus was dominated by Gestalt psychology. The term *Gestalt* (German for "form") had been introduced into psychology in the 1890s by the Austrian philosopher Christian von Ehrenfels, a contemporary of the experimental psychologists Theodor Lipps and Wilhelm Wundt. Like Lipps and Wundt, Ehrenfels studied optical illusions, because they supported his view that the perception of

10-7. Josef Albers (German, 1888–1976), *Homage to the Square*, 1961. Oil on board, 30 × 30 in. (76.2 × 76.2 cm). Mead Art Museum, Amherst College, Massachusetts, gift of Richard S. Zeisler.

When looking at the top of the squares, most people perceive the bright red square on top, but when looking at the bottom, most see it as a red hole.

space is inherently structural; one does not see the world as a mosaic of patches but as a form—*Gestalt*. The confirmation of Einstein's non-Euclidean cosmos in 1919 gave support to Gestalt psychology because it implied that spatial perception is learned from experience. Gestalt was centered in Berlin, where researchers analyzed the perception of optical illusions (plate 10-8). After the Nazis closed the Bauhaus in 1933, Albers relocated to the United States, where he developed his Gestalt studies. Albers's mature style combines Chevreul's color theory with lessons in spatial perception from Gestalt psychology, as seen in his Homage to the Square series (plate 10-7).

Dutch De Stijl

In 1917 the Dutch painter Theo van Doesburg organized a group, De Stijl (Dutch for "the style"), to create a universal language of pure color and form. The group included the painter Piet Mondrian, the architect J. J. P. Oud, and the sculptor Georges Vantongerloo. Van Doesburg and Mondrian covered white canvases with rectangles of color, while Oud and Vantongerloo composed with cubes and spheres (Oud, Café de Unie, Rotterdam, 1925; Vantongerloo, *Construction in a Sphere*, 1917).[4] In its 1918 manifesto, the De Stijl group proclaimed: "There is an old and new consciousness of the age. The old one is directed towards the individual. The new one is directed towards the universal. . . . In the new plastic art, by removing the restriction of natural forms, they [referring to themselves in the third person] have eliminated what stands in the way of the expression of pure art."[5]

Van Doesburg was editor of the journal *De Stijl*, in which he published Mondrian's multipart text "Neoplasticism in Painting." Mondrian had been raised in a Christian (Calvinist) home, and he showed an interest in spiritual topics from an early age. In 1909, Mondrian joined the Dutch chapter of the Theosophical Society and read lectures by Rudolf Steiner, a follower of Helena Blavatsky. Mondrian summarized the theosophical outlook in his painting of three women attaining higher levels of consciousness through meditation (*Evolution*, 1911; Haags Gemeentemuseum, The Hague). Over the next two decades, Mondrian methodically developed a style based on a classical Platonic, Euclidean worldview, in which nature embodies geometric form. To symbolize the basic forms in nature, Mondrian used abstract elements of painting: straight lines, primary colors, and geometric shapes. As the artist put it in 1917: "The new plastic cannot be cloaked by what is characteristic of the particular, natural form and color, but must be expressed by the abstraction of form and color—by means of the straight line and determinate primary colors."[6] After World War I, Mondrian moved ineluctably toward his signature style of horizontal and vertical black lines forming squares and rectangles filled in with primary hues. In *Composition with Red, Yellow, and Blue* (plate 10-9) the artist presented a view of reality that was "directed towards the universal."[7]

After the confirmation of Einstein's theory of relativity, van Doesburg vowed to create an art in keeping with the non-Euclidean cosmos.[8] In a style he called Elementarism, van Doesburg added a fourth dimension of time by painting diagonal lines to suggest motion (plate 10-10). In protest of this shift away from Euclidean space, Mondrian withdrew from De Stijl in 1924.

In the early 1920s van Doesburg also began exploring ways to incorporate the new cosmology into architecture. His basic idea was that, after Einstein's revolution in cosmology, educated men and women thought differently about their relation to the universe. When Earthlings measure a star, they have to take into account Earth's

10-8. Necker cube
Gestalt psychologists studied the apparent spontaneous reversal of this cube's orientation in search of a mental mechanism to explain it. The optical illusion was first noted in 1839 by Swiss crystallographer Louis Albert Necker.

OPPOSITE, TOP

10-9. Piet Mondrian (Dutch, 1872–1944), *Composition with Red, Yellow, and Blue*, 1920–26. Oil on canvas, 36⅜ × 29 in. (92.4 × 73.7 cm). Tate, London.

OPPOSITE, BOTTOM

10-10. Theo van Doesburg (Dutch, 1883–1931), *Contra-Composition of Dissonances XVI*, 1925. Oil on canvas, 40 × 72 in. (100 × 180 cm). Gemeentemuseum, The Hague.

LEFT

10-11. Theo van Doesburg (Dutch, 1883–1931), *Contra-Construction*, 1925. Ink and gouache, 22¼ × 22 in. (56.3 × 56 cm). Stedelijk Museum, Amsterdam.

motion relative to the faraway celestial body. Van Doesburg wanted to make people feel at home in their universe by building homes to echo the heavens—a microcosm of the macrocosm. In his 1925 drawing for a house, *Contra-Construction* (plate 10-11), van Doesburg designed the structure by estimating the movements of the inhabitant through the rooms, considering motion (time) integral to the floor plan (space). Van Doesburg's space opens in all directions to its surrounding environment: "It throws the functional space (as well as canopy planes, balcony volumes, etc.) out from the center of the cube, so that height, width, and depth plus time become a completely new plastic expression in open spaces. In this way architecture (in so far as this is constructionally possible—a task for the engineers!) acquires a more or less floating aspect which, so to speak, runs counter to the natural force of gravity."[9]

While the expressive possibilities of Neoplasticism are limited to two dimensions (the plane), Elementarism realizes the possibility of plasticism in four dimensions, in the field of space-time.

Theo van Doesburg, "Elementarism (Fragments of a Manifesto)," *De Stijl*, 1926–27

Gabo and El Lissitzky

Russian Constructivism was developed by Aleksandr Rodchenko and Vladimir Tatlin before the October Revolution of 1917 (see chapter 5), after which they were enthusiastic about Communism. They were also fascinated by cosmology. The Russian sculptor Naum Gabo went to Germany in 1910 to study science at the University of Munich, where he attended lectures by the discoverer of x-rays, Wilhelm Röntgen, and the art historian Heinrich Wölfflin.[10] In 1912 Gabo shifted his studies to philosophy, in a department that was still dominated by Lipps's aesthetics of empathy. Gabo continued his scientific education at a technical university in Munich, studying mathematics and engineering, and thus he had a deep knowledge of science as well as German philosophy. When the war broke out he took refuge in Norway, but after the October Revolution he returned to Russia, where there was great interest in x-ray technology after the Russian physicist Abram Ioffe, an assistant to Röntgen in Munich, established the State X-Ray and Radiological Institute in Saint Petersburg in 1918.

In 1920 Gabo and his brother, the artist Antoine Pevsner, wrote a manifesto acknowledging the significance of Einstein's theory of relativity for "the growth of human knowledge with its powerful penetration into the mysterious laws of the world."[11] They expressed their fascination with light: "Look at a ray of sun[light] . . . the stillest of the still forces, it speeds more than 300 kilometers in a second . . . behold our starry firmament . . . who hears it . . . and yet what are our depots to those depots of the universe? What are our earthly trains to those hurrying trains of the galaxies? [the ellipses are in the original text]."[12] Gabo scoffed at the Italian Futurists' attempt to create the illusion of motion using time-lapse photography: "From the simple graphic registration of a row of momentarily arrested movements, one cannot recreate movement itself."[13] In 1919–20 he created his first moving—kinetic—sculpture, *Kinetic Construction: Standing Wave* (plate 10-1, chapter frontispiece).

The Russian artist El Lissitzky was educated in engineering and keenly aware of the significance of Einstein's revolution. In 1920–21 he proclaimed: "The absolute of all measures and standards has been destroyed. When Einstein constructed his theory of special and general relativity, he proved that the speed with which we measure a particular distance influences the size of the unit of measure."[14] Using simple lines and geometric shapes, Lissitzky created a series, which he named *Proun* (acronym for a Russian phrase that translates "project for the affirmation of the new"), as an expression of Einstein's universe. Lissitzky's *Proun: Eight Positions* literally incorporates the dimension of time (plate 10-12).

Proud that the first non-Euclidean geometry had been created by a Russian, Lissitzky titled his artistic manifesto "K.[unst] und *Pangeometrie*" (A.[rt] and *Pangeometry*; 1925), in reference to Lobachevsky's 1829 book *Pangeometry*. In the spirit of Lobachevsky's creation of an imaginary universe, Lissitzky conceived of the space in

each *Proun* as unrelated to terrestrial landscapes. In his manifesto, the artist paid tribute to his intellectual ancestors: "Lobachevsky and Gauss were the first to prove that Euclidean space is only one instance in the unending succession of spaces. Our minds are incapable of visualizing this, but that is precisely the characteristic of mathematics—that it is independent of our powers of visualization."[15]

In 1921 Lissitzky went to Berlin, where he met the Swedish animator Viking Eggeling and the German film-maker Hans Richter, who felt they could symbolize Einstein's universe because film creates objects with light (plate 10-13). According to the Russian film-maker Sergei Eisenstein, it was film's ability to show events in the three-dimensional world over time that made it the medium most suited to the modern era: "Possessing such an excellent instrument of perception as the cinema—even on its primitive level—for the sensation of movement, we should soon learn a concrete orientation in this four-dimensional space-time continuum" ("The Filmic Fourth Dimension," 1929).

10-13. *Diagonal-Symphonie* [Diagonal symphony], 1923. Film, directed by Viking Eggeling. Produced by the artist in Berlin.

In Viking Eggeling's *Diagonal-Symphonie*, white shapes and lines move slowly against a black background. The film premiered at an avant-garde film festival in Berlin in 1925, together with an abstract film by Hans Richter.

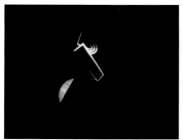

The Expanding Universe

In the late eighteenth century, an astronomer had noticed that the brightness of stars in the constellation Cepheus fluctuates; such stars became known as Cepheid variable stars ("variable" because they vary in brightness). In 1912 the American astronomer Henrietta Leavitt determined that Cepheid variable stars get brighter and dimmer in a regular way that tells how luminous they are; the longer the period of the star's brightness, the greater its luminosity. The great usefulness of Cepheid stars is that they give astronomers a way to measure distance; if astronomers know how luminous a star is, they can use its apparent luminosity as seen from a telescope on Earth to calculate its distance. If a Cepheid star has a long period and appears faint, then it is very far away.

By the mid-1920s astronomers had used Cepheid variable stars to determine that the Milky Way Galaxy is a disk with a diameter of 100,000 light-years (plate 10-14). This struck astronomers as very big, and they wondered: Is the Milky Way the entire universe? Or are there are other galaxies (plate 10-15)? To answer the question, astronomers focused on nebulas—tiny cloudlike luminous objects that are visible to the naked eye. On a clear, moonless night one sees in the constellation Andromeda a very distinct elongated oval nebula. Kant speculated that the Andromeda nebula is an "island universe," and William Parsons discovered its spiral structure in 1844 (see plate 8-43 in chapter 8). But Parsons saw no stars in the nebula. Why did it glow? Using the new 100-inch (254-centimeter) reflector telescope atop Mount Wilson, near Pasadena, California, in 1924, Edwin Hubble focused on the Andromeda nebula, and he saw a disk-shaped galaxy composed of stars; he had discovered a second galaxy (plate 10-17).

The Andromeda Galaxy contains Cepheid stars, so Hubble could calculate that it is 2.5 million light-years away. Hubble then pointed the telescope at other nebulas and

10-14. Milky Way, in J. S. Plaskett, *The Dimensions and Structure of the Galaxy* (Oxford: Clarendon Press, 1935), plate 2, facing 30.

This 1935 diagram of the Milky Way, which is essentially the one used today, shows the galaxy edge-on, as a vast rotating disk. The diagram is in parsecs, an astronomical unit of length based on the distance from Earth at which stellar parallax equals one second of arc (1 par[allax]sec[ond] equals 3.26 light-years). The absolute brightness of Cepheid stars is measured from a standard distance of 10 parsecs (32.6 light-years). The disk of the Milky Way has massive clusters of stars pulled to its center by gravity. The diameter is 100,000 light-years, and the sun is about three-fourths of the way out, shown here on the left, about 10,000 parsecs (30,000 light-years) from the galaxy's center.

CHAPTER 10

discovered other galaxies. By the late 1920s it was clear that the universe contains hundreds of galaxies. Today astronomers have counted more than 100 billion (plate 10-18).

In addition to learning to measure the distance from Earth to Cepheid variable stars, astronomers in the 1920s discovered that they could also measure the direction a star is moving and its speed using the star's spectrum. Light-waves shift in the same way that sound-waves do. If a whistle is blowing at a constant pitch on a moving train, a passenger on the train hears a constant pitch, but an observer standing in the station hears the whistle get higher as the train approaches and lower as the train speeds away. Similarly, the Fraunhofer lines (see chapter 8) in starlight shift to the blue end of the spectrum if the star is approaching Earth and to the red end if the star is receding; the speed of the star is calculated from the amount of blue shift or red shift (plate 10-16). As new galaxies were discovered, Hubble measured their distance using Cepheid variable stars, and he determined their direction and speed using their spectra. He found that Andromeda is moving toward the Milky Way, but most galaxies are moving away.

10-15. Theories of the universe, in Charles Nordmann, "L'Univers est-il infini?" [Is the universe infinite?], *L'Illustration* 158 (Nov. 19, 1921), 458–61; the image is on 460.

This 1921 illustration in the French popular press invited readers to consider two possible universes. *Left:* Is the *Voie Lactée* (French for "Milky Way") the entire universe, surrounded by *Nébuleuses spirales* (spiral nebulas) and an *Amas d'étoiles* (cluster of stars)? *Right:* Or are there *Autres Voies Lactées* (other Milky Ways)?

10-16. Spectra of hydrogen

The topmost of these three spectra of hydrogen was recorded in a laboratory, where the vessel of hydrogen and the scientist are at rest relative to each other. The other two were recorded by astronomers looking through telescopes at a galaxy of stars (which are made primarily of hydrogen), and putting the light through a prism. The light from one galaxy (middle spectrum) is red-shifted, which means it is moving away, and the light from the other (bottom) is blue-shifted, because it is moving toward Earth. Astronomers calculate the speed of galaxies relative to Earth by the amount of their red shift or blue shift.

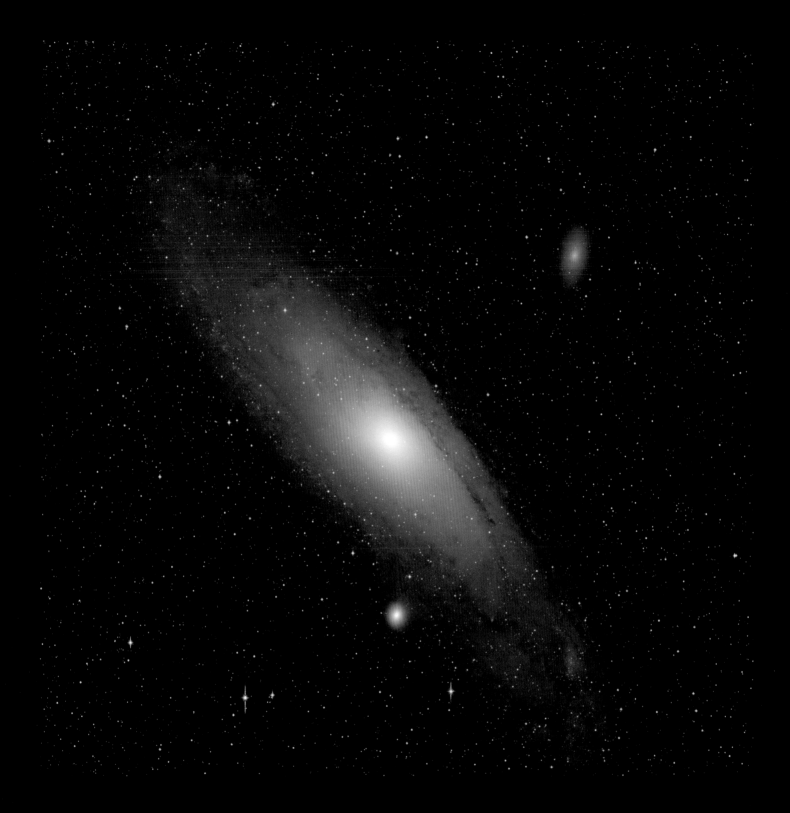

10-17. Andromeda. This image was made by combining three wavelengths of visible light from observations made on Feb. 7, 2019, at the Zwicky Transient Facility (ZTF), Palomar Observatory, in California. Courtesy of ZTF/D. Goldstein and R. Hurt (Caltech).

Edwin Hubble first observed Andromeda while looking through the reflector telescope on Mount Wilson in Pasadena, California. That instrument is no longer used because of smog in the Los Angeles basin. However, the skies are still clear 90 miles (145 kilometers) southeast of Los Angeles in the Palomar Mountain range, where this image was recently made in visible light from a ground-based reflector, giving a good idea of what Hubble saw in 1924.

This photograph of Andromeda was taken using a new camera named for Swiss astronomer Fritz Zwicky, which became operational in 2018 after being mounted on the Samuel Oschin 48-inch (122-centimeter) mirror Schmidt telescope at Palomar Observatory. A Schmidt reflector telescope is used only for astronomical photography, which is done by placing a photosensitive device inside the telescope at the focal point. Palomar's 48-inch Schmidt was completed in 1948; for many years it was the largest Schmidt telescope in the world. It is continually upgraded and will remain in use in southern California as long as the air is clear.

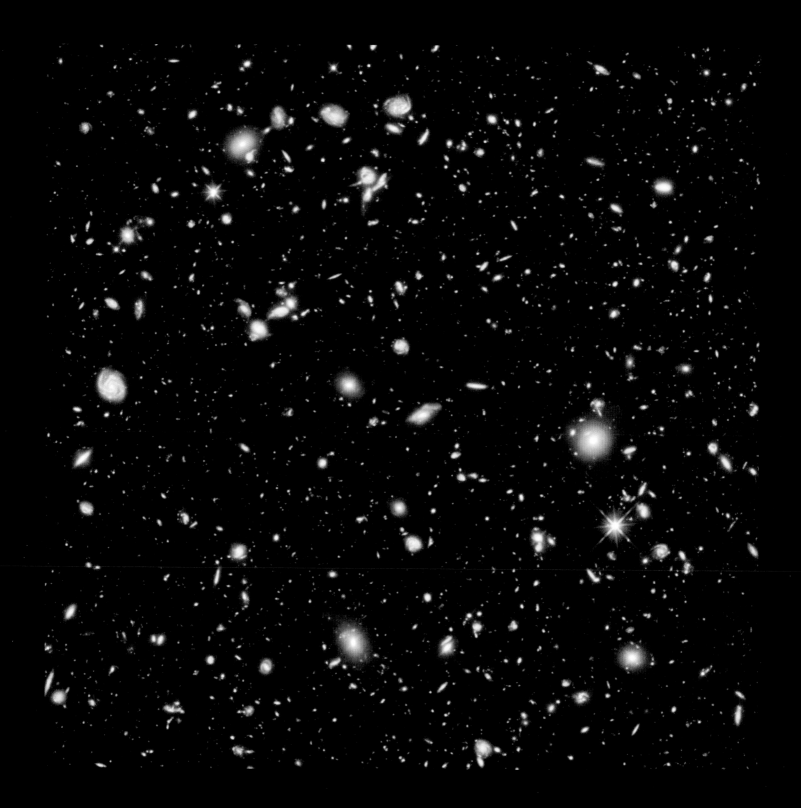

10-18. Hubble Ultra Deep Field, 2014. NASA, ESA, H. Teplitz and M. Rafelski (IPAC/Caltech), A. Koekemoer (STScI), R. Windhorst (Arizona State University), and Z. Levay (STScI).

Light in the full range of the visible spectrum, from near infrared to ultraviolet, was recorded by the Hubble Space Telescope during 841 orbits around Earth between September 2003 and January 2004 and then combined to form this image, which shows 10,000 galaxies in a tiny patch of sky (about the size occupied by a star viewed from Earth with the naked eye). The smallest, reddest galaxies were formed when the universe was just 800 million years old, about 13 billion years ago. The larger, brighter, well-defined spirals and elliptical galaxies are the most recent, formed about 1 billion years ago.

10-19. "The Velocity-Distance Relations for Extra-Galactic Nebulae," in Edwin Hubble, *The Realm of the Nebulae* (New Haven, CT: Yale University Press, 1936), 69.

On the right are images of five nebulas (known today to be galaxies) that Hubble picked to demonstrate his law because they contain Cepheid variable stars, and thus he could measure the distance of each nebula from Earth. He then did a spectral analysis of the light coming from the five nebulas; the absorption lines (recorded for calcium) are shown on the left. Each spectrum looks similar because Hubble published this illustration of the patterns of absorption lines in black and white; but in color, as he saw them, the lines in the top spectrum (for NGC 221) moved from the blue end of the spectrum on the left to red on the right; in the next (NGC 4473) the color of the pattern of lines is shifted slightly to the red end of the spectrum (indicated by the small arrow pointing right). Just as a train whistle sounds as if it is descending the scale as it speeds away, the shifting of light from a nebula toward the red end of the spectrum indicates that it is receding. NGC 221, located 900,000 light-years away, is receding at 125 miles (200 kilometers) per second; NGC 4473, located much farther from Earth, at 7 million light-years away, recedes much more rapidly, at 1,400 miles (2,250 kilometers) per second. The pattern continues with Hubble's other three nebulas, whose increasing red shifts he indicated with longer arrows.

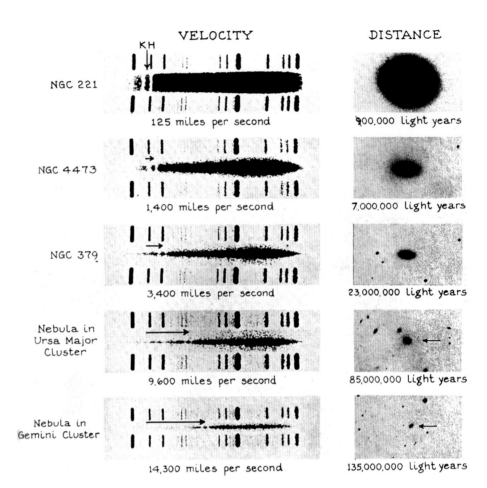

In 1929 Hubble announced that all the accumulated measurements show a pattern: as galaxies get farther away, their velocity increases proportionally (Hubble's law). In other words, if one galaxy is twice the distance, then it is receding at twice the speed. Science journalists announced to a startled world that the universe is expanding rapidly; Hubble recorded a galaxy located 135 million light-years from Earth moving away from the Milky Way at 14,300 miles (23,000 kilometers) per second (plate 10-19).

The Big Bang

After Hubble determined that the universe is expanding, it was natural to run the clock backward and ask: How did the expansion begin? Russian-born American physicist George Gamow synthesized the thinking of several physicists on the topic and in 1948 announced that the universe began in an explosion—the Big Bang. Gamow predicted that evidence for the primal conflagration still lingers in the universe today. He reasoned that the initial explosion would have produced a surge of energy that had a wavelength relative to the size and temperature of the universe in any given epoch, as the universe expanded and cooled. According to Gamow's calculations, today there should be microwaves throughout the universe. This telltale radiation was recorded from Earth in the mid-1960s and from the satellite COBE (COsmic Background Explorer), which operated between 1989 and 1993. Two other spacecraft have since recorded

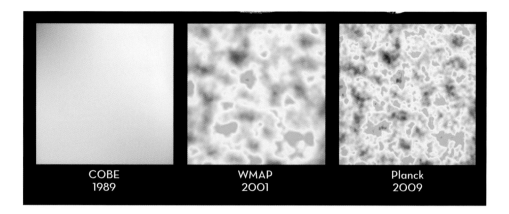

COBE
1989

WMAP
2001

Planck
2009

TOP

10-20. Cosmic microwave background, based on data from spacecraft launched in 1989, 2001, and 2009. NASA, JPL-Caltech, ESA.

These three panels demonstrate the evolution in the precision of recordings of the cosmic background radiation, which is light from 380,000 years after the universe exploded into existence 13.8 billion years ago. Each square shows a patch of the sky created by one of the three space telescopes designed to detect cosmic background radiation: COBE (COsmic Background Explorer), WMAP (Wilkinson Microwave Anisotropy Probe), and Planck. The blue and orange regions represent tiny fluctuations in temperature that correspond to slightly different densities of matter (clouds composed of 75 percent hydrogen and 25 percent helium), which over time evolved into stars and galaxies.

BOTTOM

10-21. Cosmic microwave background, based on data from the Planck mission, launched in 2009. ESA and the Planck Collaboration.

This map shows the cosmic background radiation in the greatest detail to date.

these microwaves in greater detail: WMAP (Wilkinson Microwave Anisotropy Probe, named in memory of American cosmologist David Wilkinson) and Planck (named for German physicist Max Planck). The data collected provided dramatic confirmation of the Big Bang theory of the origin of the universe (plates 10-20 and 10-21). With these recordings, cosmology went from being a speculative philosophy to a science with precise data. The Big Bang entered the public imagination and inspired artists (plates 10-22, 10-23, and 10-24).

The Origin of Atoms

When Dmitri Mendeleev organized atoms on the Periodic Table of Elements (see chapter 8), he didn't know where they came from. In the 1930s a German physicist, Hans Bethe, hypothesized that if protons collide when travelling extremely fast, they will fuse. Bethe's theory, together with Gamow's theory about the Big Bang, eventually led scientists to today's understanding of the origin of atoms.

Hydrogen was made in the aftermath of the Big Bang, and the nuclei of two hydrogen atoms (with 1 proton each) fused to make helium (with 2 protons). The nuclei of lightweight elements such as carbon (6 protons) and oxygen (8 protons) were fused in the thermonuclear cores of stars. A star forms in layers over millions of years, as gravity pulls the heavier nuclei to the center (plate 10-25). If the star has enough mass,

10-22. Josiah McElheny (American, born 1966), *Last Scattering Surface*, 2006, in collaboration with cosmologist David Weinberg. Hand-blown glass, chrome-plated aluminum, and electric lighting, diameter 10 ft. (3 m), shown hung 6 in. (15.2 cm) above the floor. Courtesy of the artist and Andrea Rosen Gallery, New York. © Josiah McElheny.

This spherical sculpture symbolizes the creation of the universe in the Big Bang. From a point of infinite density, primordial plasma formed and began expanding; at first, light could not move freely in the dense plasma but was scattered, which McElheny suggests with the central sphere, the surface of which is the "last scattering surface" of the work's title. After 380,000 years the primordial plasma expanded and thinned enough to allow light to shine forth and travel in a straight path. In the sculpture this is symbolized by the chrome rods that emerge from darkness in the inner sphere and go to the perimeter. When we look out in space we look back in time, and we can see as far as the last scattering surface, the pattern of light recorded by COBE, WMAP, and Planck.

OPPOSITE, TOP

10-23. Charles Brown (American, born 1954), *Implicit Model*, 1999. Installation of clay, slate, steel, salt, glass, copper leaf and gold leaf on nori. Courtesy of the artist.

On the right-hand wall, small lumps of clay in the form of bread rolls are displayed on tiny shelves, and on the left wall, funnels made from rice and clay sit in a row. Between them are small sheets of nori (seaweed), each printed in copper and gold leaf with an astronomy diagram (see detail images). On the free-standing tables rest rows of madeleine cakes cast in salt, and on the floor sit mounds of salt. Together the installation is a metaphor for scientific and artistic creation that characterizes the human mind, a topic central to the author Marcel Proust, for whom a character's memory was triggered by the taste of a madeleine. As in the creative process, each object is represented in a substance foreign to itself: bread is clay, madeleines are salt, and galaxies are copper and gold. As in a system of representation, each object is made with a mold or pattern—an implicit model, implied by the existence of the objects, although it is not seen in the finished piece.

OPPOSITE, BOTTOM

10-24. Charles Brown, *Implicit Model*, details of plate 10-23. Copper and gold leaf on nori, each ca. 10 × 8 in. (25.4 × 20.3 cm).

These copper- and gold-leaf images are based on the Hertzsprung-Russell diagram (left; see plate 8-73 in chapter 8) and a model of the expanding universe (right).

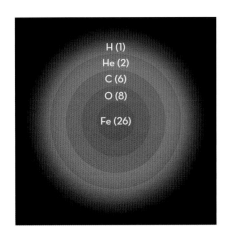

10-25. Cross section of a star

Inside a star, elements fuse in very high—thermonuclear—temperatures and form layers. Lightweight elements, with few protons, such as hydrogen (H) and helium (He), move to the surface, and heavier elements, such as carbon (C), oxygen (O), and iron (Fe), are pulled inward by the force of gravity.

10-26. Earth's atmosphere and electro-magnetic radiation from outer space

Earth is constantly bombarded by radiation from outer space. The whole range of the electromagnetic spectrum—from radio waves to gamma rays—comes from the blackness of outer space (above), but only radio waves and visible light easily penetrate Earth's atmosphere (shown in gray below).

10-27. Paul Klee (Swiss, 1879–1940), *Horizon, Zenith, and Atmosphere*, 1925. Watercolor on paper, 15 × 10⅝ in. (37.9 × 26.9 cm). Solomon R. Guggenheim Museum, New York.

the fusion process continues until it forms atoms as large as iron (26 protons), which is abbreviated *Fe*, for *ferrous* (from the Latin for "iron"). At this point the star becomes unstable and undergoes a catastrophic collapse followed by an explosion—called a *supernova*—a temporary, enormous increase in the star's brightness. A supernova produces stupendous energy capable of fusing the nuclei of all the heavy elements, from cobalt (27 protons) to uranium (92 protons), in a fraction of a second.

Transatmospheric Telescopes

In the 1920s and '30s, there was extensive study of Earth's atmosphere, which inspired Paul Klee to create *Horizon, Zenith, and Atmosphere* (plate 10-27). At this time, most households had a radio, but it was plagued by a crackling interference pattern—static. Bell Telephone Company in New Jersey assigned one of its engineers, Karl Jansky, the job of finding where the errant radio waves causing the static were coming from—telephone lines? aircraft flying overhead? In 1932, Jansky announced to his astonished colleagues that the radio waves were coming from a source 143 light-years from Earth in the constellation Sagittarius. By the early 1940s engineers had crafted radio telescopes to detect radio waves coming from outer space.

The more astronomers learned about Earth's atmosphere and the ways it obstructs their view of the sky, the more frustrated they were. Earth's atmosphere allows visible light and radio waves to pass through, but it absorbs and deflects other wavelengths (plate 10-26). In the 1950s, the United States and Soviet Russia developed rocket technology to threaten each other with annihilation during the nuclear arms race. Fortunately, the rockets were not used to carry warheads during the Cold War but rather to launch satellites into space, beginning in 1957 with the Soviet spacecraft Sputnik. Soon rockets were carrying telescopes above the atmosphere; in 1968 the United States launched the first space telescope, the Orbiting Astronomical Observatory.

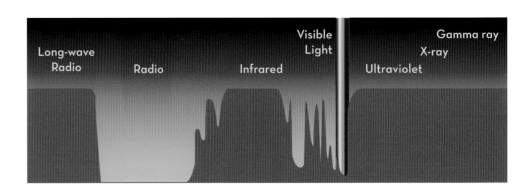

BELOW LEFT

10-28. Crab Nebula (Messier 1), map of radio waves emitted from the nebula, made ca. 1960 with the radio telescope at the University of Cambridge, England.

The Crab Nebula is visible with the naked eye as a tiny cloud surrounded by filaments, which give it the shape of a crab (see plate 10-30). It is also known as Messier 1 (M1), because it was the first of 110 astronomical objects catalogued by the French astronomer Charles Messier in 1771 in his *Catalogue des Nébuleuses et des Amas d'Étoiles* (Catalogue of nebulas and star clusters).

BELOW RIGHT

10-29. Neutron star

OPPOSITE

10-30. Crab Nebula (Messier 1). NASA, ESA, G. Dubner (IAFE, CONICET-University of Buenos Aires) et al.; A. Loll et al.; T. Temim et al.; F. Seward et al.; VLA/NRAO/AUI/NSF; Chandra/CXC; Spitzer/JPL-Caltech; XMM-Newton/ESA; and Hubble/STScI.

This image was made by combining data from five telescopes recording in five wavelengths. The Crab Nebula is a cloud consisting of filaments of gas (optical light/green) and dust particles (infrared/olive green). At its core is a rapidly rotating neutron star ejecting a swirling mass of energetic electrons (ultraviolet/blue and x-rays/magenta), which energize the whole cloud, causing it to emit radio waves (red). The background stars appear blue because they give off strong ultraviolet radiation.

Neutron Stars

When a star becomes a supernova, its fate depends on its mass, which is measured in a unit, called a *solar mass*, that equals the mass of the sun. If the star has between 10 and 29 solar masses, the supernova fuses protons into the nuclei of all the heavy elements (with 27 to 92 protons). It also fuses other protons into an atomic nucleus the size of a city, typically about 12 miles (20 kilometers) in diameter, which stays together because the protons lose their charge when they fuse and become neutrons. What is left is a rotating sphere composed of solid (fused) neutrons—a neutron star—which is extremely dense; one teaspoonful weighs 1,000 times more than the Great Pyramid of Giza. Einstein showed that light can be considered a particle (a photon), and so it is controlled by gravity. Great mass means strong gravity, so light can leave the neutron star only at its magnetic poles. As a neutron star rotates, it sends out beams of light like beacons from a lighthouse. From Earth a neutron star appears to blink or pulse, and thus it is called a *pulsar* (plate 10-29).

Using a ground-based radio telescope, in the 1960s astronomers recorded radio waves coming from the Crab Nebula (plate 10-28), a supernova that formed in AD 1054, at which time it was observed by Chinese astronomers (Europe was in the Dark Ages). There is a neutron star in the center of the Crab Nebula that has been rotating thirty times a second ever since. Today, five transatmospheric telescopes have recorded the light from the Crab Nebula—with the blinking, pulsing frenzy at its core—across the range of the electromagnetic spectrum (plate 10-30).

Radio

Infrared

Optical

Ultraviolet

X-ray

Discovery of Pluto

In 1930 the heavens were again brought to public attention by the discovery of a new planet. Because the discovery of Neptune, in 1846, had left a tiny fraction of Saturn's and Uranus's perturbations unaccounted for, astronomers, with ever-bigger telescopes, had continued the search for more planets. The long, tedious search had not been described in the popular press, and in 1930 the public was surprised to learn that there was a ninth planet, which was named Pluto, after the ruler of the netherworld. (In 2006, after astronomers discovered several other objects of similar size beyond Neptune, the International Astronomical Union reclassified Pluto as a dwarf planet.) In 1931, the year after Pluto's discovery, the American artist Alexander Calder created his first kinetic sculpture composed of forms suspended from the ceiling—a mobile (plate 10-31). Calder suspended the forms and let them be arranged by chance (i.e., by whatever air currents happened to be in the room). Calder described the cosmic associations of his mobiles: "The idea of detached bodies floating in space, of different sizes and densities, perhaps of different colors and temperatures, and surrounded and interlarded with wisps of gaseous condition, and some at rest, while others move in peculiar manners, seems to me the ideal source of form."[16]

The Austrian artist Herbert Bayer studied at the Bauhaus in 1921–23 and taught there in 1925–28, after which he worked as a designer in Berlin. After immigrating to the United States in 1938, he incorporated celestial imagery in his work. As the artist recalled: "Around 1940, the paintings explode with diagrammatic arrows, flying receptors and activities in space. They reflect a vision of cosmic intervals and exchange inspired by the sciences probing into the universe" (plate 10-32).[17]

10-31. Alexander Calder (American, 1898–1976), *Mobile*, 1941. Painted aluminum, steel, steel rod, and wire. Height 60 in. (152.4 cm). Metropolitan Museum of Art, New York, Rogers Fund, 1942.

10-32. Herbert Bayer (Austrian, 1900–1985), *Interstellar Exchange*, 1941–42. Oil on canvas, 66 × 37 in. (167.6 × 94 cm). Denver Art Museum, Herbert Bayer Collection.

Black arrows and white lines suggest moving waves carrying the messages of "interstellar exchange" through red and gray nebulas to distant stars, with the dots above forming the dome of the heavens. Bayer included a reference to the ultimate source of the electromagnetic radiation, the ball-and-stick models of atoms, and indications of currents in the atmosphere (flames, smoke, and a weather station tower topped by twin balls).

Biomorphic Abstraction

Art Nouveau and Jugendstil artists had used curving biomorphic forms from the microscopic realm. In the early twentieth century the Czech painter František Kupka began a series with cosmic themes, including *Cosmic Spring* (plate 10-33), in which biomorphic forms and crystals merge in bands over a celestial globe. In 1912–13 the artist described his cosmic vision: "Reproductive cells connect to other cells, and these connect to others. Thus every organism launches into its environment as it expands and grows, and the ways in which it adapts to its particular milieu is manifest in its appearance. The same is true of clouds, which are accumulations of vapor that are shaped by movements in the atmosphere. . . . Stalactites suspended in salt caves . . . icicles from waterfalls . . . both result from the same process of condensation that creates patterns of frost on a windowpane" [the ellipses are in the original text].[18]

Films made through a microscope brought the public fascinating glimpses of cells in motion (plate 10-34). During World War I, artists expanded their vocabulary of biomorphic shapes using automatic methods. Jean (Hans) Arp began his career in Munich collaborating with Der Blaue Reiter artists, but when World War I broke out he fled Germany for Switzerland, where, after the poet Tristan Tzara launched Dada in Zurich, Arp began using automatic techniques such as tearing paper and pouring ink to generate biomorphic shapes (plate 10-35). Unlike the Dadaists, Arp was drawn to automatism not because of its link with irrationality but because of its associations with automatic processes such as breathing that don't require conscious control. Arp was familiar with automatism from his friend the German psychoanalyst Richard Huelsenbeck, who wrote: "The automatic forces of nature are the forces that support the self, as we feel these and their regulatory influence in our bodies and in our daily lives."[19]

Arp had a lifelong interest in mystical philosophy, and in 1915 he wrote an essay in which he expressed the central theme of his work—a search for truth in the Platonic mystical tradition of seeing (finding insight) in the darkness: "Art should lead to the spiritual, and the real. This reality is neither objective reality, nor the subjective reality of thought, but a mystical reality that is related to vision in the following Neoplatonic sense: 'When in daylight one cannot truly see; one can see truth only in darkness, in the abyss.'"[20] For a reading he gave onstage at Zurich's Cabaret Voltaire on May 12, 1917, Arp chose a text by the seventeenth-century Lutheran mystic Jakob Böhme (a favorite of German Romantics), in which Böhme described his journey toward union with the World Soul as moving from blindness to sight: "I am as blind a man as ever was, and am able to do nothing. But in the spirit of God, my rejuvenated spirit seeth all."[21]

After World War I, Arp settled in Paris, where he used biomorphic abstraction to express Einstein's new cosmology, which was widely publicized to the art world in periodicals such as *L'Esprit nouveau*. For example, his Constellations series (plate 10-36) is composed of biological forms (the microcosm) floating in empty space (the macrocosm)

OPPOSITE, TOP

10-33. František Kupka (Czech, 1871–1957), *Cosmic Spring*, 1911–20. Oil on canvas, 46 × 50 in. (115 × 125 cm). National Gallery, Prague.

OPPOSITE, BOTTOM

10-34. Film of a drop of blood infected with spirochetes, in "Cinématographie de l'invisible" [Cinematography of the invisible], *La Nature* 37 (June–Nov. 1909), 365.

This drop of blood, magnified 10,000 times, reveals infection with spiral-shaped bacteria (spirochetes), which are visible in the film as wavy white lines.

created by automatic processes (the "laws of chance"); as Arp wrote: "The forms that I created between 1927 and 1948 and that I called cosmic forms were vast forms meant to encompass a multitude of forms such as: the egg, the planetary orbit, the path of the planets, the bud, the human head, the breasts, the sea shell, the waves, the bell. I arranged these forms into patterns like constellations 'according to the laws of chance.'"[22]

At the Bauhaus, Kandinsky did drawings after microscopic images (plate 10-38) and painted cellular shapes (plate 10-37). In 1933 Kandinsky left Germany and travelled to Paris, where he joined Arp, his old friend from Der Blaue Reiter days. In sympathy with Arp's approach to nature, Kandinsky declared, "The 'hidden soul' in all things, seen either by the unaided eye or through microscopes or binoculars, is what I call the 'internal eye.'"[23]

Constantin Brancusi studied mathematics, physics, and sculpture in his native Romania before coming to Paris. He had the education to understand the significance

of the confirmation of Einstein's new cosmology in 1919, and the following year, in *Beginning of the World* (plate 10-39), he created a biomorphic symbol of creation, an ovoid form suggesting both an egg and a celestial body. The Spanish artist Joan Miró also adopted a vocabulary of cellular shapes in 1920s Paris, after experimenting with Fauvism and Cubism in his native Barcelona. In *The Birth of the World* (plate 10-41), using automatic techniques, he dripped and stained the background, on which he painted symbols of origins—an egg, a cell with flagella, a seed, a star.

In the 1930s, the microscopic realm was dramatically brought to public attention by the discovery of antibiotics (chemicals that kill bacteria). When Louis Pasteur announced the germ theory of disease in the 1860s, he could tell people how *not* to get

10-37. Wassily Kandinsky (Russian, 1866–1944), *Several Circles*, 1926. Oil on canvas, 27⅝ × 27⅝ in. (70.1 × 70.1 cm). Solomon R. Guggenheim Museum, New York.

10-38. Wassily Kandinsky (Russian, 1866–1944), Drawings of microscopic animal tissue (left) and single-celled flagella (right), in his *Punkt und Linie zur Fläche* [Point and line to plane] (Munich: Langen, 1926).

Kandinsky copied these images from a popular encyclopedia, *Die Kultur der Gegenwart* [Culture of the present] (Leipzig: Teubner, 1905–26).

10-39. Constantin Brancusi (Romanian, 1876–1957), *Beginning of the World*, ca. 1920. Marble, metal, and stone, height 29⅝ in. (75.2 cm). Dallas Museum of Art, Foundation for the Arts Collection, gift of Mr. and Mrs. James H. Clark.

10-40. Joan Miró (Spanish, 1893–1983), *Morning Star*, from the Constellations series, 1940. Tempera, gouache, egg, oil, and pastel on paper, 15 × 18⅛ in. (38 × 46 cm). Fundació Joan Miró, Barcelona.

10-41. Joan Miró (Spanish, 1893–1983), *The Birth of the World*, 1925. Oil on canvas, 98¾ × 78¾ in. (250.8 × 200 cm). Museum of Modern Art, New York, acquired with a gift by the artist and funds from Mr. and Mrs. Joseph Slifka and Armand G. Erpf.

FOLLOWING SPREAD, LEFT
10-42. Karl Blossfeldt (German, 1865–1932), *Passiflora* [Passionflower], ca. 1930. Gelatin silver print, 11⅝ × 9¼ in. (29.6 × 23.7 cm). Museum of Modern Art, New York, Thomas Walther Collection.

FOLLOWING SPREAD, RIGHT
10-43. Karl Blossfeldt (German, 1865–1932), *Nigella Damascena Spinnenkopf*, ca. 1932, printed 1976. Gelatin silver print, 9⅞ × 7⅝ in. (25.2 × 19.3 cm). Metropolitan Museum of Art, New York, Warner Communications Purchase Fund, 1978.

The name of the flower has the following meaning: *Nigella* is a diminutive of the Latin *niger* for "black," a reference to the plant's little black seeds; *Damascena* refers to Damascus in Syria, where the plant grows; *Spinnenkopf* (German for "spider head"), refers to the plant's thorny protection.

sick (wash hands, breathe fresh air), but he had nothing to offer them once they were infected; the body's immune system either fought off or succumbed to the invader. In 1935 sulfa drugs, the first antibiotics, were developed, and in 1939 the antibiotic penicillin was discovered. Amid this heightened attention to microorganisms, Miró created the Constellations series in the 1940s (plate 10-40); against an empty background space, the artist painted cells and stars that float in the void, then connected them with lines to form pictures (constellations).

Meanwhile, the German artist Karl Blossfeldt photographed plants using a camera he altered to achieve unprecedented detail in the stems, petals, and leaves (plates 10-42 and 10-43). In 1928, Berlin gallerist Karl Nierendorf curated an exhibition and produced a book with 120 of Blossfeldt's botanical photographs, *Urformen der Kunst* (Original forms of art), which established Blossfeldt's reputation.

11

Surrealist Science

Psychoanalysis and Physics

*The unconscious is the true psychic reality; in its innermost nature it is as much unknown
to us as the reality of the external world, and it is as incompletely presented by the data of
consciousness as is the external world by the communications of our sense organs.*

Sigmund Freud, *The Interpretation of Dreams*, 1900

SURREALISM WAS INSPIRED by Sigmund Freud's theory of the unconscious mind—
psychoanalysis—and it occurred during Einstein's revolution in cosmology. Thus some
Surrealists made an analogy between the space-time universe and the strange world
of their dreams.

Sigmund Freud and the Psychological Perspective

Surrealism was an international intellectual movement centered in Paris in the 1920s.
United in a desire to plumb the depths of the unconscious mind, poets and artists were
first inspired by the work of the French neurologist Jean-Martin Charcot (see chap-
ter 7). His student Pierre Janet did research on automatic behavior, such as babbling,
which he deemed pathological because it is done without deliberation (*L'Automatisme
psychologique* [Psychological automatism], 1889). Freud travelled from Vienna to Paris
to attend lectures by Charcot, but he departed from the French neurologist in both his
concept of the unconscious mind and his therapeutic methods. Darwin was not wel-
come in Paris, and evolutionary biology had little effect on French psychology, but it
was adopted in Austria, where Freud realized that the animal drives for reproduction
and survival, elucidated by Darwin, were the biological basis for what drives the human
psyche—passion and aggression, love and hate, life force and death drive. According
to Freud, the psyche is a battleground where the unbridled expression of passion and
aggression is held in check by the mature ego, which reflects social norms and represses

11-1. Wanda Wulz (Italian, 1903–1984),
Cat and I, 1932. Silver print, 5⅞ × 4 in.
(15 × 10 cm). Museo Nazionale Alinari
della Fotografia, Florence.

315

forbidden thoughts into the unconscious.[1] But irrepressible desires reappear in disguised form—a symptom without a physical cause, a revealing mistake (a "Freudian slip"), or the character in a dream. The psychic material has been rearranged (disguised) below conscious awareness, making it nonsensical to the person. Freud's method for going from the observed data (the symptom, the mistake, the remembered dream) to the psychic cause (the repressed animal drive) is the free association of words and images. Together patient and therapist follow the chain of associations until they reach the repressed thought. The goal of psychoanalysis is to bring the buried thought to consciousness, examine it in the light of day, and thereby dispel its dark powers.

Popularization of Psychoanalysis

In the German tradition of making science accessible, Freud wrote popularizations of psychoanalysis, beginning with *Über den Traum* (On dreams, 1901). In 1909, G. Stanley Hall, who had left Johns Hopkins to become president of Clark University in Massachusetts, invited Freud to come to the United States and lecture on psychoanalysis. Freud accepted, and psychologists travelled from three continents to be in the audience. Artists became aware of psychoanalysis as the practice spread in their countries and as Freud's writings were translated into their languages.

Since the early nineteenth century, French politicians, intellectuals, and artists had subscribed to Auguste Comte's view that science propels society forward toward an ever-brighter future, but positivism was undermined by World War I, during which science and technology were used to make poison gas and machine guns mounted on aircraft. After the outbreak of the war, Freud described the shocking cruelty of ordinary citizens as the shallow repression of animal aggression beneath a veneer of civility ("Thoughts for the Time of War and Death," 1915). In this atmosphere of diminished confidence in the power of reason, the Surrealists commenced their exploration of the mind.

A key difference between Charcot and Freud is that Charcot treated psychosis, severe disorders that were stigmatized as forms of insanity, while Freud developed psychoanalysis to treat neurosis, mild ailments of otherwise healthy people. In Paris, artists learned about psychoanalysis from about twenty reviews and articles on the subject published in French before 1914;[2] the leader of Surrealism, the French poet André Breton, studied psychiatry before dropping out of medical school, and as an aid worker during World War I, he cared for psychiatric patients. Breton's close collaborator Max Ernst, who was from Cologne, read Freud in German before settling in Paris in 1922. By the early 1920s psychoanalysis was well known in Paris; Freud's founding text of psychoanalysis, *Die Traumdeutung* (1900; English translation as *The Interpretation of Dreams* in 1913) was translated into French in the late 1920s, and by 1930 it was fashionable in Paris to undergo psychoanalysis.

Surrealism in Paris

In 1919 Breton joined the French writer Philippe Soupault in an experiment with automatic writing in which they emulated the patients of Janet, who treated people with pathological forms of automatism. Soupault stated, "The term *automatic writing* was suggested to us by Pierre Janet."[3] Like Janet's babbling psychotics, the poets let words flow from their unconscious in stream-of-consciousness poetry, which they published as "Les Champs magnétiques" (Magnetic fields, 1919; Breton and Soupault borrowed their title from Michael Faraday and James Clerk Maxwell's concept of electromagnetic fields). Artists in Breton's circle, such as Max Ernst, developed other automatic techniques to suspend conscious control. For example, to begin works of art such as *Histoire naturelle* (Natural history, 1926), Ernst took rubbings from uneven surfaces in a technique he called *frottage* (French for "rubbing"; *frottage* is a term used in French psychiatry for the abnormal desire to rub one's clothed body against the body of a stranger). Breton defined Surrealism as "pure psychic automatism by which one proposes to express, verbally, by writing, or by any other means, the real functioning of thought. It is the dictation of thought, in the absence of any control exercised by reason, apart from any aesthetic or moral preoccupation."[4]

Given his clinical background (limited though it was), Breton considered himself an expert on psychiatry and borrowed concepts from it throughout his career. He and the French writer Louis Aragon published a commemoration of Charcot's work on hysteria, "The Fiftieth Anniversary of Hysteria: 1878–1928," in *La Révolution surréaliste* (1928), and defined their artistic goal as beauty that is "convulsive" (as in a hysteric's seizure). The editors of *La Révolution surréaliste* designed their periodical to look like the popular science magazine *La Nature* and not like an art magazine.[5] That same year Breton published a novel in the form of a psychiatric case history of a deranged woman in a mental hospital who wants to kill a doctor (*Nadja*, 1928). Publicly denounced by Pierre Janet for inciting patient violence, Breton responded with a defense of Surrealist expression without "any aesthetic or moral preoccupation."[6]

In 1936 the editor of the Surrealist magazine *Inquisitions* invited Gaston Bachelard to write an essay for the first (and only) issue. In his 1934 book on the new scientific spirit, Bachelard had written an impassioned defense of creative thought in which he declared that the mind can get bogged down by uncritical repetition of past ideas. What is needed is a fresh, unbiased look. How did Einstein come up with the theory of relativity? He forgot everything he learned from textbooks and imagined what it would be like to ride through the heavens on a beam of light. In his essay Bachelard gave an example from mathematics: Nikolai Lobachevsky denied one of Euclid's axioms and found himself in a completely new space (*Imaginary Geometry*, 1826). Since Earthlings live in a Euclidean space with zero curvature (in which the angles of a triangle add up to 180 degrees), they have difficulty visualizing Lobachevsky's non-Euclidean space with

11-2. Man Ray (American, 1890–1976), *Surface with a Constant Negative Curvature, Derived from the Pseudosphere*, 1932–34. Photograph, 9⅝ × 7¼ in. (24 × 18 cm).

Man Ray showed his photograph of a non-Euclidean model at a 1936 Surrealist exhibition in Paris.

negative curvature (where the angles of a triangle add up to less than 180 degrees). So as a teaching tool, the German mathematician Felix Klein produced a series of plaster models, a set of which was acquired by the Institut Henri Poincaré in Paris and photographed by Man Ray (plate 11-2). In his essay, Bachelard also cited the Romanian poet Tristan Tzara, who wrote a prose poem about a society in which there is no distinction between waking and dreaming ("Grains et issues: rêve experimental" [Seeds and bran: experimental dream], 1935). Tzara's creative thinking is called *Surrealism* in the art world; Bachelard proposed the term *Surrationalism* to name imaginative thought in the science world ("Le Surrationalisme" [Surrationalism], *Inquisition* 1 [1936]).

Surrealist poets and artists welcomed the support of Bachelard, who was a professor of philosophy at the University of Dijon in 1936. Bachelard's essay on Surrationalism was translated into English and published in a book edited by the director of New York's leading Surrealist gallery, Julien Levy (*Surrealism*, 1936). That same year Bachelard cast his shadow over a special issue of the Parisian art periodical *Cahiers d'art* that was illustrated with twelve of Man Ray's photographs of geometric models of non-Euclidean spaces (plate 11-2). In an essay titled "Mathematics and Abstract Art," the magazine's founder, Christian Zervos, a historian of ancient Greek art, was critical of art and science that were too rational and "lacking the feelings of the heart" by using "calculation, reasoning, and formal rules." Like Bachelard, he called on artists and scientists to mix reason with passion/intuition in the tradition of the Pythagoreans, "to mathematize the soul [*mathématiser l'âme*]."[7] Zervos was encouraged that: "in the science of our day, which holds some points in common with Greek science before the Platonic era, a greater poetry is revealed. Excessive precision is suppressed. The abstract formulae of contemporary science are enriched by anxiety and by the human senses, for the passion underlying our life is incorporated as much into abstract thought as into the aesthetic realm."[8] Zervos didn't say to what "science" he was referring, but assuming he is taking his cue from Bachelard, he meant creative thinkers like Lobachevsky and Einstein, as well as physicists like Maxwell, who used probabilistic (as opposed to exact) measurement in the laboratory, and psychoanalysts like Freud, who argued that free association is as precise a clinical method as the data allows. Breton also followed Bachelard's lead in an essay in which he argued that a piece of Surrealist art eliminates the border between consciousness and the unconscious, because the artwork (a physical object in the external world) expresses a mental concept in the inner world ("Crisis of the Object," *Cahiers d'art*, 1936).

Symbolist artists had depicted the facade (see chapter 7), but Surrealists created a new psychological perspective, which visualized the inner world of the mind. In a self-portrait, the Italian photographer Wanda Wulz appears as a woman on the outside, but within she's a cat (plate 11-1, chapter frontispiece). Freud taught that space and time are distorted in dreams because the unconscious mind reorganizes psychic material. Events are transposed in space: an adult dreams she is in her childhood crib.

The flow of time is uneven: a terrified dreamer runs but moves at a snail's pace. The painter René Magritte made an analogy between the distortion of time in dreams and in Einstein's theory of relativity, borrowing from science journalists the metaphor of a moving vehicle to explain the relativity of time (plates 11-3 and 11-4). In a painting by Salvador Dalí, memories merge and form an "endless enigma": mountains in the distance become a reclining man, which becomes a greyhound, which morphs into a mandolin, face, and hoofed beast (plates 11-5 and 11-6). What does it all mean? In psychoanalysis—talk therapy—the patient interprets a dream by pairing images with words in free association, symbolized by Magritte in *Key of Dreams* (plate 11-7). A person dreams of a horse and associates it with "the door." To get to the latent (hidden) meaning, the dreamer follows a chain of verbal associations, such as: door>open>escape-on-horseback>freedom. A key question is how did the dreamer *feel* during the dream—anxious? exhilarated? The dreamer asks whether the verbal associations match the *feeling* of the dream. After interpreting the meaning of the dream of a horse, the dreamer might ask: "What am I escaping from?"

Max Ernst found collage an effective way to present a psychological perspective, because the technique—juxtaposing fragments of printed pictures and text—echoes the unconscious mind's creation of a dream from various memories. Borrowing science images of microscopic sea life, Ernst made an analogy between the invisible and the unconscious (plates 11-8 and 11-9).[9] Microscopic imagery gave Ernst a way to transport the viewer from the common-sense world into an unfamiliar place filled with alien creatures—as in a dream.

Surrealists also felt that warped space-time was an apt metaphor for their wildest dreams. In Magritte's *Universe Unmasked* (plate 11-10), a terrestrial building disintegrates beneath a sky from which cubes emerge to reveal (unmask) the geometric structure of the universe.

Max Ernst made an analogy between the dreamer making new symbolic associations—what Freud called *dreamwork* (*Traumarbeit* in German)—and the artist creating new visual signs; as the psychoanalyst examines how a dream is constructed, so the artist reflects on the art-making process. In Ernst's *Day and Night* (plate 11-11), eight bright paintings depict a darkened landscape. The colorful paintings (*Day*)

11-3. René Magritte (Belgian, 1898–1967), *La Durée poignardée* [Duration stabbed]; usual English title, *Time Transfixed*, 1938. Oil on canvas, 57⅞ × 38⅞ in. (147 × 98.7 cm). The Art Institute of Chicago, Joseph Winterbotham Collection.

Magritte compares ordinary time (the stationary clock on the mantel) with relative space-time (represented by the moving train below). With the title, Magritte suggested that time—or duration (*la durée*)—has been annihilated. *Poignardée* has the connotation of being made motionless by awe, but it literally means "impaled" or "stabbed." Space has also been shattered; the mirror in this strange new world reflects only one candlestick.

11-4. Relativity of time, in Charles Nordmann, "Une Révolution dans notre connaissance du monde" [A revolution in our understanding of the world], *L'Illustration* 157, no. 4082 (May 28, 1921), 504–7; the image is on 504.

Shells are shot from either end of a moving tank when it is at the exact midpoint between two targets. To observers in the tank, a shell strikes the left target first; light travels a shorter distance from the left target than from the right because the observers are moving left. But to the timekeepers standing below the targets, the shells strike simultaneously.

11-5. Salvador Dalí (Spanish, 1904–1989), *The Endless Enigma*, 1938. Oil on canvas, 45 × 57⅝ in. (114.5 × 146.5 cm). Museo Nacional Centro de Arte Reina Sofía, Madrid.

11-6. Catalogue, shown with overlays closed (left) and open (right), of an exhibition of Dalí's *The Endless Enigma*, in 1939, at the Julien Levy Gallery, New York. Printed on paper, 12⅝ × 10 in. (32 × 25.4 cm), with glassine overlays, 6¼ × 8 in. (15.9 × 20.3 cm).

In this exhibition catalogue (plate 11-6), Dalí separated the components of the painting (plate 11-5) into six images and showed how he constructed the "endless enigma" by red-printing the images onto six transparent sheets of glassine, which he stapled over a half-tone reproduction of the painting. On the left, the six transparent sheets are laying down, showing how the red-printed images connect with each other. On the right, the six sheets are pulled back to reveal the completed painting. Dalí labelled the six images (clockwise from the upper left): "beach of Cape Creus with seated woman mending sail, seen from the back, and boat"; "reclining philosopher"; "face of the great one-eyed moron"; "mythological beast"; "mandolin, fruit-dish with pears, two figs on table"; "greyhound."

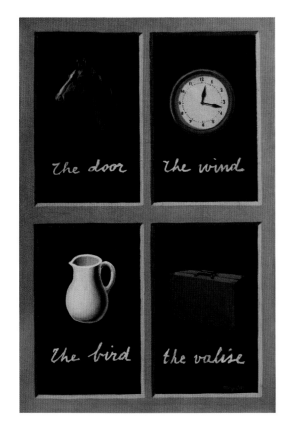

plantation boophile d'outremer hyperboré·enne / max ernst

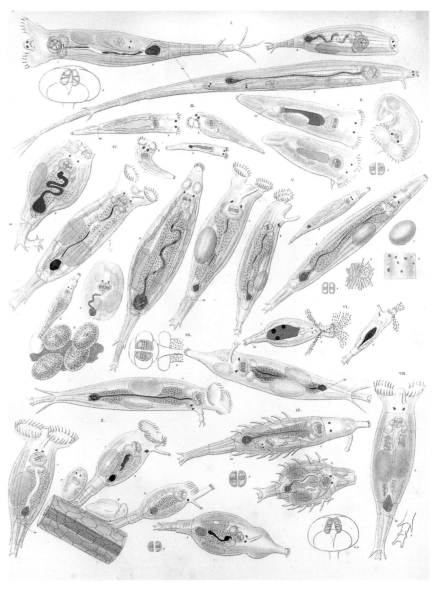

ABOVE

11-7. René Magritte (Belgian, 1898–1967), *Key of Dreams*, 1935. Oil on canvas, 16¼ × 10¾ in. (41.3 × 27.3 cm). Collection of Jasper Johns, New York.

TOP RIGHT

11-8. Max Ernst (German, 1891–1976), *Plantation boophile d'outremer hyperboréenne* [Planting the love of cattle in a hyperborean region overseas], ca. 1921. Watercolor and ink on printed reproductions, 3¾ × 4⅞ in. (9.5 × 12.5 cm). Private collection, Berlin.

To make this collage, Ernst cut out science illustrations, which he rearranged and painted with watercolor. For example, on the left Ernst used *Philodina*, a species of the phylum Rotifera ("wheel animal"), freshwater microorganisms that were described by C. G. Ehrenberg in 1838 (plate 11-9). In the spirit of a farce, Ernst made up absurdly complex technical terms for the title of his collage.

BOTTOM RIGHT

11-9. *Philodina*, in C. G. Ehrenberg, *Die Infusions-thierchen als vollkommene Organismen* [*Infusoria* as complete organisms] (Leipzig: L. Voss, 1838), plate 61.

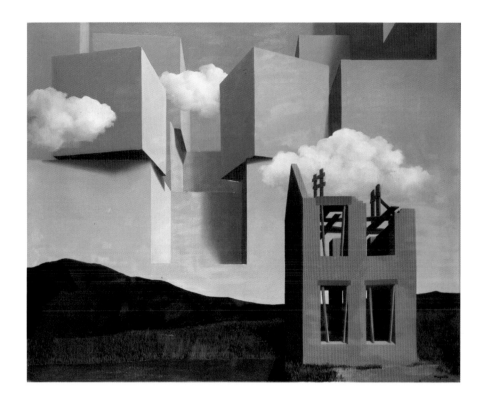

LEFT

11-10. René Magritte (Belgian, 1898–1967), *The Universe Unmasked*, 1932. Oil on canvas, 29 × 36⅞ in. (75 × 91 cm). Collection Crik, Brussels.

BELOW

11-11. Max Ernst (German, 1891–1976), *Day and Night*, 1941–42. Oil on canvas, 44¼ × 57½ in. (112.4 × 146 cm). Menil Collection, Houston.

11-12. Mary Wigman (born Marie Wiegmann, German, 1986–1973), starring in *Totentanz II* [Dance of death 2] at the Mary Wigman Dance School, Berlin, 1926. Photograph.

Death approaches in the right foreground, and the character played by Mary Wigman (wearing striped gown) swoons, surrounded by other masked dancers.

appear more real than the barren landscape (*Night*), but both day and night are illusions, because *Day and Night* is a painting. Such puzzles and paradoxes were explored as Surrealist artists self-consciously examined their craft.

The psychological perspective was adopted by Hungarian dancer and choreographer Rudolf Laban, who described his goal: "Dazzled by the vision of the inner life, I tried to shape tangible characters from the forces at work within man. The conflict between the unconscious mind of the individual and that of the masses became the content of my new dance-plays."[10] Classical ballet was a showcase for virtuosity and acrobatics; the ballerina wore a corset and appeared weightless in pointe shoes, her hair in a tidy bun. Laban's dancers expressed their feelings onstage while barefoot and wearing loose clothes, with their hair unbound. He choreographed dances that had a narrative, like a play, filled with characters who were tragic (the soldier whose dead comrades visit him in a nightmare) or funny (the tottering old woman, her wig askew, who reminiscences about her lost youth). Together with his student and collaborator the German dancer Mary Wigman, Laban spent World War I in Zurich, where he was associated with the Cabaret Voltaire and the Galerie Dada. Laban and Wigman understood performance as an inner dialogue that might lead to unchoreographed gestures. Wigman spent 1918 in solitary retreat in the Alps preparing for her solo career, which began in 1919 with a tour of Switzerland and Germany. Wigman expressed the unconscious forces of her inner life, such as fear of death, in *Totentanz* (Dance of death; plate 11-12).

Surrealist film-makers proclaimed that film is the best medium to represent a dream because it can distort time (by being run backward or in slow motion) and space (with double exposures or one image dissolving into another). Like a dream, film is viewed in darkness in a semi-hypnotic state, and it occurs over time; as the film critic

Jean Goudal wrote in 1925: "A true hallucination is required, which tends to reinforce the other conditions of the cinema, just as, in a dream, the moving images succeed each other without depth, on a single plane artificially delimited by a rectangle, like a geometric hole into a metaphysical kingdom."[11] A film may have sound and a narrative storyline, but watching a film (like having a dream) is primarily a visual experience. Freud wrote that vision is the most directly linked with feeling: "Seeing is an activity that is ultimately derived from touching. Visual impressions remain the most frequent pathway along which libidinal excitation is aroused; indeed, natural selection counts upon the accessibility of this pathway . . . when it encourages the development of beauty in the sexual object" (*Three Essays on the Theory of Sexuality*, 1905).[12]

In *Un Chien Andalou* (1928), Dalí and Luis Buñuel used montage (the cinematic version of collage) to present a dreamlike series of unrelated events. Location is displaced, as a cloud moving across the full moon metamorphoses into a scalpel slitting a woman's eyeball (plate 11-13). According to Buñuel, the film does not depict a particular dream but rather mixes "the aesthetics of surrealism with Freudian discoveries."[13]

In 1937 André Breton invited Freud to join him in the publication of dream texts describing the manifest dream (the remembered dream). Freud replied that he wasn't interested in the manifest dream but rather its meaning (its hidden, latent content), by following the dreamer's chains of associations. As Freud explained, "The telling of the dream, what I call the 'manifest' dream, is of no interest to me. I have been dealing with a way to find the latent meaning of the dream, which could be obtained from the manifest dream by analytic interpretation. A collection of dreams without the connected associations, without knowledge of the circumstances under which it has been dreamt, does not have any meaning to me, and I can barely imagine what it would mean to others."[14]

This Breton-Freud exchange points to a basic difference between the artistic and scientific use of dreams. Freud, as a therapist, aimed to demystify the dream by giving a rational explanation of its origin in the patient's history. Breton, as a poet, wanted to retain the mystery of the dream. Thus, Surrealism spawned art that depicts the manifest dream and is therefore uninterpretable. Looking at a Surrealist's symbol-packed artwork is like listening to a stranger's symbol-packed dream; the meaning of the art, and the dream, is inaccessible. What is the meaning of symbols in Dalí's painting (plate 11-5) or Ernst's collage (plate 11-8)? Only these artists have the answer, but Surrealists didn't record their associations for posterity, because their goal wasn't clarity but obfuscation.

After Hitler's annexation of Austria into Nazi Germany in 1938, Freud (eighty-two years old and terminally ill), fled to London, where he died the following year.

11-13. Poster for *Un Chien Andalou* [An Andalusian dog] (1928). Film directed by Luis Buñuel (Spanish, 1900–1983) and Salvador Dalí (Spanish, 1904–1989), 1968. Printed on paper, 47¼ × 31½ in. (120 × 80 cm).

Buñuel and Dalí made the film in 1928, but it didn't have a major cinematic release until 1968, when this poster was done. The stills show scenes from the film's unrelated events.

Surrealism in Japan

In the early twentieth century, Japan rapidly adopted Western science and technology, and Emperor Taishō (reigned 1912–26) encouraged liberal policies, including individual rights and democratic reforms. The Japanese government hired Western faculty to teach in its universities and encouraged Japanese students to study abroad. When Freud gave a lecture series, "The Origin and Development of Psychoanalysis," at Clark University in Massachusetts in 1909, the audience included two Japanese psychologists, Sakyo Kanda and Hikozo Kakise, who had come to the United States to earn doctorates at Clark with G. Stanley Hall. Another Japanese psychologist, Matataro Matsumoto, began studying in Tokyo with Yūjiro Motora (see chapter 6), who had been a student of Hall at Johns Hopkins in the 1880s. Matataro then travelled to Leipzig to study with Wilhelm Wundt before completing a doctorate in psychology at Yale University. After returning to Japan, Matataro founded the Japanese Psychological Association in 1927 and served as its president until his death in 1943.

These early Japanese scientists were experimental psychologists grounded in the nineteenth-century tradition of Gustav Fechner, but slowly their focus shifted to Freudian psychoanalysis under the guiding hand of Heisaku Kosawa. A devout Buddhist, Kosawa completed an MD degree in psychiatry at Tohoku University in Sendai in 1926, and then studied at the Psychoanalytic Institute in Vienna, where he visited Freud for conversation. In 1932 Kosawa presented Freud with his thoughts about how psychoanalysis would apply to a Buddhist culture, contrasting the Oedipus complex, which Freud named for a character in a Greek myth, with the Ajase complex, which Kosawa named for a character in a Buddhist legend that began to be told in India in the fifth century BC (plate 11-14). After Buddhism came to Japan via China, the legend was written down in the thirteenth century AD in *The Sutra of the Contemplation of Infinite Life*. Queen Idaike (also written Vaidehi), fearing that she was losing power as her beauty faded, wanted to protect her status as queen and ensure the love of her husband by bearing a child. She consulted a soothsayer who told her that an old hermit would die in three years and be reincarnated in her womb. Impatient, Idaike went to the forest and killed the hermit, whose dying words were, "I will be reincarnated as the son of the king, but one day your son will kill his father." Pregnant at the instant of the hermit's death, the queen now resented her unborn child because of the hermit's curse. She decided to give birth in a tower and drop the infant to his death, but he survived with only one broken bone, hence his nickname, Ajase, "broken finger." The child grew up idolizing his mother, but when he discovered the circumstances of his birth, he tried to kill her. Overcome with guilt, Ajase became ill, and nothing would cure him. Queen Idaike consulted Buddha, who instructed her to stop focusing on herself and care for her son, who regained his health. In most versions of the legend, Ajase then forcibly takes over the kingdom of his father, whom he either imprisons or kills.

11-14. Taima Mandala, 1750. Ink, color, and gold on silk, hanging scroll, image 41¾ × 37¾ in. (106.2 × 96 cm). Metropolitan Museum of Art, New York, Charles Stewart Smith Collection.

The painting depicts Buddha in the center of an enormous red and green palace, bordered on three sides by parables from the Buddhist legend of Queen Idaike (Vaidehi) telling how, with Buddha's help, she became a mother devoted to her son, Ajase.

The Oedipus complex is on the theme of patricide; Oedipus feels guilty for (unknowingly) killing his father and marrying his mother. The Ajase complex is on the theme of matricide; Ajase feels guilty for trying to kill his mother (Kosawa, "Two Kinds of Guilt Feelings," 1931).[15] After returning to Japan in 1934, Kosawa opened a private practice in Tokyo, and in 1955 he founded the Japan Psychoanalytic Society.

In addition to Western science, the Japanese government also wanted students to study Western art, especially oil painting and linear perspective. But the pace of reform was slowed by a Harvard-educated American, Ernest F. Fenellosa, who came to the Imperial University in Tokyo in the late nineteenth century to teach economics. After unexpectedly falling in love with the traditional Japanese arts, Fenellosa and his economics student Okakura Kakuzo (also known as Okakura Tenshin) drafted a law to protect temples, shrines, and their art treasures. In 1887, Fenellosa and Okakura founded the government-sponsored Tokyo Fine Arts School, where they resisted the presumed superiority of Western art and hired Japanese faculty to teach calligraphy and traditional landscape painting with black ink on silk. But within a decade, government reformers forced them out and replaced them with Westernizers who taught *Yōga* (Western-style, realistic oil painting).

In the first decades of the twentieth century, Dada and Surrealism were adopted in Tokyo and Kyoto by a diverse underground of artists united in their opposition to *Yōga*.[16] Since the young artists were not trained in the government-approved Western style, their employment prospects were bleak. Thus, unlike young Japanese scientists, the artists couldn't afford to travel to the West. The exception was Fukuzawa Ichiro, who came from a wealthy banking family, which supported him in Paris from 1924 to 1931. Fukuzawa was drawn to Surrealism, especially the work of Max Ernst. He created paintings, such as *Poisson d'Avril* (April fish), by reassembling images cut from popular science publications, much as did Ernst (plates 11-15 and 11-16). After returning to Japan at age thirty-three, Fukuzawa became a source of information about Surrealism, publishing articles and reviews, his writing culminating in a 1937 book on Surrealism.

In the 1920s Ohtsuki Kenji, a student of literature who was self-taught in psychoanalysis, organized the Japanese translation of Freud's collected works. A champion of lay analysis, Ohtsuki founded, in 1933, the first Japanese journal of psychoanalysis, which had English editorials that kept the West informed about psychoanalysis in Japan. Artists could also read Japanese translations of French Surrealist literature, as well as Japanese Surrealist poems, in the literary journal *Shōbi.Majutsu.Gakusetsu* (Rose.Magic.Theory), which began publication in 1927 and was edited by the poet Kitasono Katue. In 1929 André Breton's *Manifesto of Surrealism* was translated into Japanese, by Kitagawa Fuyuhiko.

The first reproductions of Surrealist art appeared in Japan in 1928 in an article by Toyama Usaburo in the art magazine *Chūō Bijutsu* (Central art). These were followed in 1930 by a special issue on Surrealism in *Atorie* (Atelier). Japanese artists first saw original

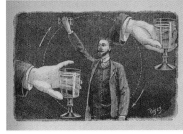

A

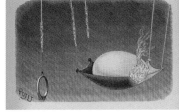

B

C

D

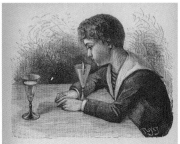

E

F

LEFT

11-15. Tom Tit (pseudonym of Arthur Good), *La Science Amusante* [Entertaining science] (Paris: Larousse, 1890), vol. 1. General Research Division, The New York Public Library. Astor, Lenox, and Tilden Foundations.

Tom Tit shows readers how to entertain their friends with science. *Left to right, top to bottom* (all illustrations are by Louis Poyet, except d):

(a) *Centrifugal force.* Hold a glass of water in the hand such that the arm can move in a great circle. Not a drop will be spilled (1:93).

(b) *Hanging without a cord.* Soak cords in very salty water and let them dry out. Hang a little hammock by four cords, and place in it a very lightweight eggshell. Light the cords on fire; the eggshell will remain suspended, because only the salty outside of the cord burns (1:119).

(c) *Make a paper fish swim across water.* Make a paper fish with a slot (*b*) ending in a hole (*a*), as pictured, and place it in a tub of water. Gently put a drop of oil in the hole (*a*). As the oil tries to reach the surface, it will flow along the channel (*a* to *b*) and emerge at *b*, pushing the paper fish forward in the opposite direction (1:79).

(d) *The difficult ignition.* Two people kneel on the floor facing each other, each holding a candle, one of which is lit. By pressing their wrists together they can easily keep their balance while lifting opposite knees; as they do so, one candle lights the other. Illustration by A. E. Tully (1:173).

(e) *Lift a glass with an open hand.* Fill a glass almost to the top with water and lay the palm over the top, letting the fingers dangle down the side. Then quickly flatten the palm while pushing down, which creates suction, allowing the hand to lift the glass (1:103).

(f) *The breakaway coin.* In a conical glass place two different-size coins horizontally, the small coin below and the large above. Then blow hard on the edge of the large coin, which will rotate and flip out the small coin (1:89).

RIGHT

11-16. Fukuzawa Ichiro (Japanese, 1898–1992), *Poisson d'Avril* [April fish], 1930. Oil on canvas, 31⅝ × 45⅞ in. (80.3 × 116.5 cm). National Museum of Modern Art, Tokyo.

In France, *Poisson d'Avril* is a day to make a fool of other people by putting a fish on their back, much as tricks are played on others on April Fool's Day in Anglo-American culture. This "fool's day" is not celebrated in Asia. Fukuzawa got his images from *La Science Amusante* (plate 11-15), a series first published in *L'Illustration* and later released in three volumes between 1890 and 1893.

POISSON D' AVRIL

11-17. Ei-kyu (pseudonym of Sugita Hideo, Japanese, 1911–1960), *Work D*, 1937. Collage, 10½ × 9¾ in. (26.7 × 23.5 cm). National Museum of Modern Art, Tokyo.

11-18. Ei-kyu (pseudonym of Sugita Hideo, Japanese, 1911–1960), *Photo-drawing no. 5*, from the album *Nemuri no riyū* (The reason for sleep), 1936. Photogram, 12 × 9⅞ in. (30.5 × 25.1 cm). National Museum of Modern Art, Tokyo.

Surrealist artwork in 1931, when the German exhibition *Film und Foto* (Film and photo), which had opened in 1929 at the Deutscher Werkbund in Stuttgart, travelled to Tokyo and Osaka. The exhibition included 1,180 photographs by artists including Eugène Atget, Hannah Höch, László Moholy-Nagy, Paul Outerbridge, Man Ray, and Aleksandr Rodchenko. Japanese photographers responded with an extraordinary series of works. In 1936 Ei-kyu created photograms, which he published as *Nemuri no riyū* (The reason for sleep; plate 11-18), and he also made collages, such as *Work D*, in which an eye peers at the viewer above a mask and bit of film (plate 11-17). In an untitled work from the late 1930s by Kansuke Yamamoto, a body levitates above the sand (plate 11-19).

After the self-imposed isolation of the Tokugawa shogunate, during which samurai warriors fought with swords that were virtually unchanged for 250 years, Japan quickly modernized its military on a Western model and began aggressive military conflicts to expand its sphere of influence and colonize its neighbors. Japan won the First Sino-Japanese War (1894–95) when China, the age-old regional power, suffered a humiliating defeat and lost control of Korea and Manchuria. Japan emerged as the new dominant force in the region, completely defeating the Russian army in the Russo-Japanese War (1904–5). By 1910 Japan controlled Taiwan, and after setting up a puppet state (Manchukuo) in Manchuria in 1931, Japan invaded other parts of northwestern China, precipitating the Second Sino-Japanese War (1937–45). By this time World War II was underway in Europe, and in 1940 Japan signed an agreement (the Tripartite Pact) with Adolf Hitler's Germany and Benito Mussolini's Italy and became a member of the Axis powers.

Meanwhile, after the death of Emperor Taishō, in 1926, liberal reforms ceased and Emperor Hirohito (assuming the throne in 1929) ushered in an era of ultra-nationalist emperor worship. After imperial Japan invaded Communist China in 1937, Japanese citizens were scrutinized for treasonous Communist leanings, and the totalitarian *Tokkō* (thought police) were suspicious of any anti-authoritarian utterances. In 1938 Kansuke Yamamoto started a Surrealist poetry journal, *Yoru no Funsui* (The night's fountain), which caught the attention of the Tokkō; Yamamoto was interrogated in 1939 and forced to discontinue publication. He responded by creating *Buddhist Temple's Birdcage*, in 1940 (plate 11-20). Traditionally, a Buddhist temple is a place of peace and contemplation, but this temple has a cage (to control, to contain) and it doesn't hold a singing bird but a telephone (an instrument of communication) that has been silenced (its wires are cut).

Other than photography, the first original Surrealist works to be shown in Japan were paintings in a 1937 exhibition, *Surrealist Art from Overseas*, shown in Tokyo and Kyoto, which was organized by Japan's leading Surrealist poet, Takiguchi Shuzo. The exhibition inspired Ai-Mitsu, who painted *Landscape with an Eye* (plate 11-21) in 1938. The artist gave the landscape an unsettling mood in the Surrealist style by inserting an eye into the rocks. In 1944 Ai-Mitsu was drafted and sent to the Manchurian

11-21. Ai-Mitsu (Japanese, 1907–1946), *Landscape with an Eye*, 1938. Oil on canvas, 40⅛ × 76⅛ in. (102 × 193.5 cm). National Museum of Modern Art, Tokyo.

front during the Second Sino-Japanese War; he died of a war-related illness in a hospital in Shanghai in 1946, at age thirty-eight.

In 1936 Takiguchi, who was a friend of the painter Fukuzawa Ichiro, published the collection *Nanatsu no shu* (Seven poems), with each dedicated to a Surrealist artist; the poem to Max Ernst begins: "A night traveller / devours / night's cryptic handcuffs / like a piece of meat." In 1936 there was a curfew, so it was illegal to be a "night traveller" devouring "handcuffs." In 1941, Takiguchi and Fukuzawa were arrested by the Tokkō and detained for six months. Fukuzawa was allowed to see a judge after he denounced Surrealism. Takiguchi recalled the ordeal: "I was investigated about once a week. The center of the investigation lay on the single point of whether or not the Surrealist movement had any connection with international Communism (of course, without basis). Among my handwritten texts a correspondence with Breton was found, and I was intensely pursued on this."[17]

In 1941 the lay psychoanalyst Ohtsuki Kenji was also put under police surveillance, as his wife recalled: "My husband openly defied the oppression of the military authorities. Do you know that they raised a slogan 'Luxury is a hostile act'? Then my husband soon delivered a lecture with the title of 'Is luxury really a hostile act?' making him a more hateful figure to them. . . . We were always being followed by an agent of the Special Higher Police."[18]

Cross-Cultural Borrowing

Works by the psychoanalyst Kosawa and the photographer Yamamoto are good examples of the importation of ideas from one culture to another, a practice often dismissed as mere copying or as lacking originality. Such charges miss the mark with Kosawa and Yamamoto because they rethought the concepts in terms of their own experience and merged them with Buddhism, Kosawa with his Ajase complex and Yamamoto with his *Buddhist Temple's Birdcage*. Kosawa and Yamamoto didn't lack originality when they borrowed Western ideas any more than van Gogh merely copied Japanese prints. All three made something entirely new.

Surrealism in Latin America

The North American colonies' declaration of independence from England in 1776 propelled Central and South American countries to declare their independence from Spain and Portugal throughout the nineteenth century. As each country worked to establish a stable post-colonial government, politicians looked to science and technology as a way to overcome social turmoil, ensure progress, and create a sound economy. Latin American leaders imported the French positivism of Auguste Comte, who advocated faith in modern science (see chapter 2). Fundamental to transforming each country into a successful industrialized nation was the replacement of colonial-era Catholic schools with a secular system of public education. By the late nineteenth century, positivism was established throughout Latin America, and it remained in place until World War I undermined faith in the civilizing power of science. In the 1920s positivism was replaced by other outlooks, especially Marxism and psychoanalysis.

In the early twentieth century Argentina became a major center for physics after Germany sent scientists to Buenos Aires to establish a research center at the Universidad Nacional de La Plata in 1913–14. The German government wanted to establish a political presence in Latin America, and German physicists were welcomed in Argentina because they were the undisputed leaders in their field.

In 1906, Leopoldo Lugones, a leading Argentine poet and novelist, published a collection of short stories, *Las fuerzas extrañas* (Strange forces), in which the laws of physics played a leading role. After the confirmation of Einstein's theory of relativity in 1919, Lugones gave a lecture in Buenos Aires in 1920 on the cultural implications of physics. By the early 1920s other Argentine writers were showing an interest in the new understanding of time and space, such as Jorge Luis Borges, in his 1923 poem "Líneas que pude haber escrito y perdido hacia 1922" (Lines that I could have written and lost around 1922).

Several groups came together to issue an invitation to Einstein to visit Argentina, which he did in 1925. Lugones co-ordinated the diverse sponsors—Argentine

China and India were transformed. Now the West, too, must change. We inhabit the woods. We are in the shallow streams. We are in the breeze that wafts over the rose. We are in the evening light that lingers on the temple wall. We are everywhere, always.

The Spirit of Japan, speaking in Akutagawa Ryunosuke's short story "Smiles of the Gods," 1927

Silent battles of the sunset in farthest suburbs, always old defeats of a war in the sky ruined sunrises that reach us from the deserted bottom of space as from the bottom of time

Jorge Luis Borges, "Lines that I could have written and lost around 1922," 1923

11-22. Horacio Coppola (Argentine, 1906–2012), *Egg and Twine*, 1932. Gelatin silver print, 8⅜ × 10⅛ in. (21.3 × 25.7 cm). Museum of Modern Art, New York, Thomas Walther Collection. © The Estate of Horacio Coppola.

Coppola studied photography with Walter Peterhans, who taught Bauhaus students to use a grazing light, a light source placed close to surfaces to emphasize their different textures: a looping twine and an eggshell on a worn wooden floor.

physicists from La Plata, German scientists living in Buenos Aires who were friends of Einstein, and the Argentine Jewish community—and organized the visit. Before Einstein's arrival, the general public was well informed about the new cosmology: the *Revista de Filosofía* published a translation of Lynton Bolton's award-winning account in *Scientific American* (February 5, 1921), and the French science writer Charles Nordmann, who was a frequent contributor to Buenos Aires newspapers, wrote a detailed exposition for *La Prensa* (September 28, 1924). Einstein's lecture series was extensively covered by newspapers and magazines, and thus by the late 1920s the educated public was familiar with space-time.[19]

The young Argentine photographer Horacio Coppola travelled to Germany in 1932 to study the latest trends at the Bauhaus (plate 11-22). In Berlin he met Grete Stern, a German graphic designer and photographer. When the Nazis came to power in 1933, the couple fled to London, where they married. Eventually arriving in Buenos Aires in 1935, they mounted an exhibition that introduced avant-garde photography to Argentina.

Freud's work was available in Spanish translation, published in Madrid in 1923, and psychoanalysis gained a strong following in Argentina.[20] But an open-minded atmosphere ended in 1930, when the military seized control of the government, beginning the *década infame* (infamous decade) of widespread unemployment and police surveillance of ordinary citizens. In response to the coup d'état, the writer Ezequiel Martínez Estrada published *Radiografía de la pampa* (Radiograph [or x-ray] of the pampa, 1933), a pessimistic account of the long history of repression of free speech and

11-23. Juan Batlle Planas (Spanish-born Argentine, 1911–1966), *Radiografía Paranoica* [Paranoid radiograph], 1936. Tempera and graphite on paper, 13⅝ × 10⅜ in. (34.6 × 26.5 cm). Museo de Arte Latinoamericano de Buenos Aires, Costantini Collection.

The large skeleton looks like an x-ray of a living person, standing on a checkered floor with arm raised, surrounded by machines, as in a clinic. The skeleton's mouth is open as if to speak, and meandering lines above suggest thoughts emerging from the skull. But speech and thought are silenced by spikes that pierce the skull, forming an *X*, as in x-ray (*rayos X*) and x-ed out (*tachado*). The fate of the person is suggested by the small lifeless skeleton suspended in the upper right.

political corruption in Argentina. (The word *pampa*, Quechua for "plain," refers to the vast Argentine lowlands and is a symbolic name for the country as a whole.) Perhaps inspired by Martínez Estrada's use of *radiografía*, or x-ray, as a metaphor for penetrating analysis, the artist Juan Batlle Planas did a series, Radiografía Paranoica (Paranoid radiograph), in which an x-ray exposes the inner lives of the people of Argentina living under a military dictatorship (plate 11-23).[21]

In the 1930s the Swiss-born Argentine psychiatrist Enrique Pichon-Rivière popularized Freud among artists by writing psychoanalytic studies of French writers, such as the playwright Antonin Artaud. Restrictions in Argentina ended around 1940, after a decade of rule by a military dictatorship, and in 1942 Pichon-Rivière joined five other psychiatrists to form the Argentine Psychoanalytic Association. But soon the viability to practice psychoanalysis began to slip away as Argentina entered decades of political

11-24. Grete Stern (German-born Argentine, 1904–1999), *Articulos Eléctricos para el Hogar* [Electric appliances for the home], 1949. Gelatin silver print, 10½ × 9 in. (26.6 × 22.9 cm). Museum of Modern Art, New York, Latin American and Caribbean Fund through gift of Marie-Josée and Henry R. Kravis in honor of Adriana Cisneros de Griffin.

Stern's photomontage shows two appliances for the home—a lamp and a woman—merged by condensation (to use Freud's term) in a woman's dream. A man's hand reaches down and turns on the lamp/woman, which is electric— exciting and stimulating.

instability with the election in 1946 of President Juan Perón, who had fascist tendencies and was critical of European cultural dominance. In the coming years, Argentine scientists, psychoanalysts, and artists, all of whom felt a strong connection to Europe, came under increasing threat.

After settling in Buenos Aires, Grete Stern underwent psychoanalysis and became friends with Pichon-Rivière, who showed her work in his home and became interested in Surrealism. Pichon-Rivière began making collages in the Surrealist style, and in 1951 he travelled to Paris, where he met André Breton and the Romanian poet Tristan Tzara.[22] In 1948 the popular women's magazine *Idilio* (Spanish for "idyll") launched the weekly column "Psychoanalysis Will Help You," which invited readers to send in the text of a remembered dream for analysis to reveal its latent content. Stern illustrated the chosen dream with a photomontage, and over the next three years she created 140 photomontages for the magazine, translating dream symbols into striking images (plate 11-24).[23]

In Brazil the liberation from Portugal was gradual and orderly, and the positivist approach of Comte was especially strong. When Brazil became a republic in 1889, its flag carried the motto "Ordem e Progresso" (Order and Progress), a phrase borrowed from Comte's *Système de politique positive* (System of positive politics, 1851), and Brazil's educational system followed Comte's secular curriculum. Faith in the power of reason and science continued to be fostered in the mid-twentieth century by the

11-25. Frida Kahlo (Mexican, 1907–1954), *El Sueño* [The dream], 1940. Oil on canvas, 29⅛ × 38¾ in. (74 × 98.4 cm). Private collection.

French philosopher of science Gilles-Gaston Granger. After completing a doctorate at the École Normale Supérieure in Paris as a student of Gaston Bachelard, Granger taught from 1947 to 1953 at the University of São Paulo, and he was a major force in promoting science in Brazil. Granger returned to France, where he had a long academic career, but he maintained contact with his Brazilian colleagues, and many of his books were translated into Portuguese, such as *Lógica e filosofía das ciências* (Logic and philosophy of science, 1955).

Brazilians began studying psychoanalysis after the translation of Freud into Portuguese appeared after World War I. In 1927 the young psychiatrist Durval Marcondes founded the Brazilian Psychoanalytic Society. To become a psychoanalyst, the candidate must undergo psychoanalysis by an experienced training analyst; there were none in Brazil, so in the early 1930s Marcondes inquired through international channels whether there was a European analyst willing to relocate in Brazil. The Berlin psychoanalyst Adelheid Koch, who was Jewish, was desperately looking for a way to get her family out of Nazi Germany, and so she seized the opportunity. Thus in 1936

11-26. Wifredo Lam (Cuban, 1902–1982), *The Jungle*, 1943. Gouache on paper mounted on canvas, 94¼ × 90½ in. (239.4 × 229.9 cm). Museum of Modern Art, New York, Inter-American Fund.

she arrived in São Paulo, not speaking a word of Portuguese, along with her husband, the attorney Ernst Koch, and their two young daughters. Since psychoanalytic work is verbal, Adelheid Koch quickly learned Portuguese, assumed her duties as training analyst, and under her leadership the Brazilian psychoanalytic community thrived.

Pierre Janet introduced Mexico City to European psychology when he gave a course of lectures at the Universidad Nacional in 1925. The poet Octavio Paz assumed a psychological perspective beginning in the 1930s, and he later wrote an incisive analysis of the Mexican psyche as dark nihilism hiding behind a colorful mask of civilizing customs, *El laberinto de la soledad* (The labyrinth of solitude, 1950).

In the 1930s intellectuals fleeing Germany included the German-Jewish psychoanalyst Erich Fromm, who went first to Geneva, then to New York, before eventually settling in Mexico City in 1949 to teach sociology at the Universidad Nacional, with which he maintained contact for the rest of his life. Surrealist artists and poets also found a haven in Mexico, where they met Frida Kahlo and Diego Rivera. Kahlo had a deformed leg from childhood polio and was in a bus accident as a teenager that left her severely disabled. In an era before analgesic drugs (painkillers), she endured thirty-two operations (many on her spine) and the amputation of her right leg before her death by presumed suicide at age forty-seven. Unschooled in art, she began painting while recovering from her near-fatal accident. Most of her work relates to her struggle to live, as in *El Sueño* (The dream; plate 11-25), which shows Kahlo having a nightmare about being a skeleton in a body-cast holding a funereal bouquet.

The Cuban artist Wifredo Lam arrived in Mexico by a circuitous route. After studying academic painting for five years at the Escuela de Bellas Artes in Havana, in 1923, at age twenty-one, he left for Madrid, where he studied with the realist painter Fernando Álvarez de Sotomayor, curator of the Prado and teacher of Salvador Dalí. When the Spanish Civil War broke out in 1936, Lam fought with the defenders of democracy, but when fascist forces gained the upper hand, in 1938 he fled to Paris, where he became associated with Surrealism. In 1941 Nazi sympathizers in the Vichy French government banned Breton's writings, and so Breton and Lam boarded a ship packed with immigrants headed for the Americas. Seven months later Lam (now thirty-eight) set foot in Cuba again after his long absence. Struck by the plight of the downtrodden African Cuban people in his homeland, he symbolized their spirit of survival in work such as *The Jungle*, of 1943, which shows masked figures in a rainforest (plate 11-26). Lam and Breton went on to Mexico and then spent four months in Haiti before returning to Paris together after the war.

The Peruvian-born Surrealist poet and artist César Moro was another immigrant who found a haven in Mexico. Born in Lima, at age twenty-two Moro moved to Paris and entered Breton's circle. After returning to Peru in 1933, he co-organized an exhibition of Surrealist works (thirty-eight by himself and nine by other Latin Americans), which opened at the Academy Alcedo in Lima in 1935. In the foreword to the catalogue,

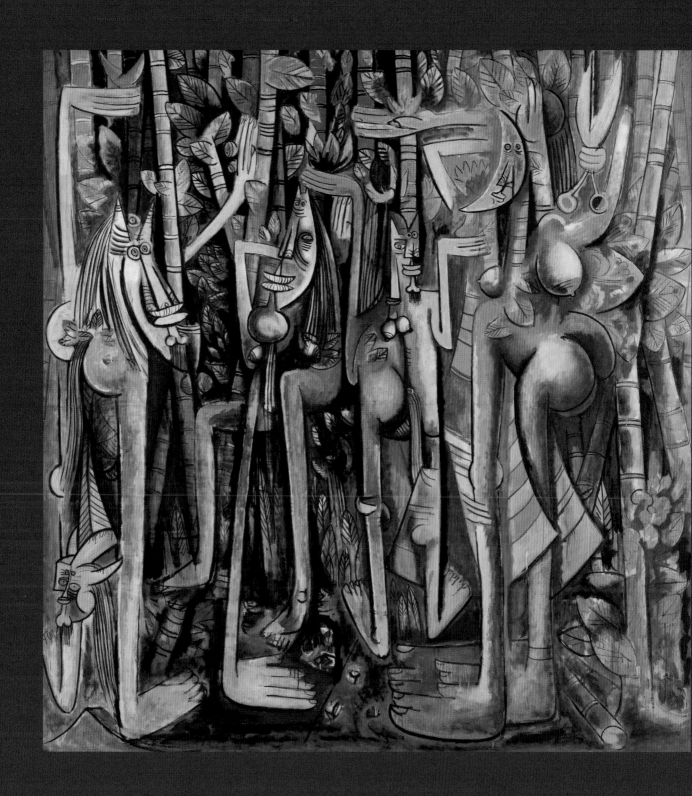

Moro wrote: "In Peru, where everything is closed in, where everything takes on the horrifying color of a church at twilight . . . people want to discredit American painting to the point that not one of these brave, fearless painters can face the canvas anymore without being overcome with the urge to throw the painting to the Devil."[24] Moro peppered the catalogue with a dozen inflammatory quotations, including: "When atheism wants martyrs, my blood is ready," Marquis de Sade; and "The spirit of the family has made man into a carnivore, feeding on the flesh of others," Francis Picabia. Three years later Moro printed a pamphlet in support of democracy, which was a crime in Peru during the Spanish Civil War, so he fled to avoid being arrested. Thus in 1938 Moro arrived in Mexico City, where he connected with fellow refugee Wolfgang Paalen and painted a portrait in the Surrealist style (plate 11-27). Breton, Paalen, and Moro organized the Exposición Internacional del Surrealismo (International Exhibition of Surrealism) in Mexico City in 1940.

Paalen was from a wealthy Jewish family in Vienna; in 1933 at age twenty-eight he moved to Paris, participated in Surrealist exhibitions, and married the French poet Alice Rahon. The couple was visiting Mexico when World War II broke out, so they remained and became permanent residents. At first Paalen experimented with automatic techniques (plate 11-29), but in the early 1940s he broke with the Surrealists to realize his vision of an art based in Einstein's cosmology. *The Messenger* (plate 11-30) is a figure made of wavy lines suggesting light-waves, as if it were a secular version of a traditional celestial messenger streaming through the cosmos. From 1942 to 1944 Paalen published the magazine *Dyn* (from the Greek word for "possible") in Mexico City and distributed it in New York, Paris, and London, which brought his art and science program to an international audience.[25]

In the early 1930s, the Spanish painter Remedios Varo lived in Paris, where she married the French poet Benjamin Péret. Together they fled to Mexico, where she developed her Surrealist style based in the history of science. In *Phenomenon of Weightlessness* (plate

LEFT

11-31. Remedios Varo (Spanish, 1908–1963), *Phenomenon of Weightlessness*, 1963. Oil on canvas, 29½ × 19⅝ in. (75 × 50 cm). Private collection, Mexico.

RIGHT

11-32. Remedios Varo (Spanish, 1908–1963), *Woman Leaving the Psychoanalyst*, 1960. Oil on canvas, 27¾ × 16 in. (70.5 × 40.5 cm). Museo de Arte Moderno, Mexico City.

After baring her soul to the psychoanalyst, a woman walks through a courtyard under a stormy sky. She is dishevelled after the fifty-minute ordeal: her mask has slipped from her face, and her basket is open. But she strides forward, confident in the knowledge that she's vengefully exacted an emotional toll from her shrink, whose shrunken head she dangles by his beard over a pool of dark water.

11-31), a man (sporting an Einsteinian halo of hair) steps from an old-fashioned concept of space (the armillary spheres on the shelves) into space-time, which has a new model of Earth and moon. After years in Surrealist circles, Varo displayed her keen understanding of psychoanalysis in *Woman Leaving the Psychoanalyst* (plate 11-32). In 1958 Varo participated in the First Salon of Women's Art at the Galerías Excelsior in Mexico City.

Chilean Surrealist Roberto Matta lived in Paris in the 1930s and was an avid reader of science popularizations.[26] He came to New York during the war, and in 1941 travelled to Mexico with American painter Robert Motherwell, who translated French texts to English for publication in Paalen's *Dyn*. Well read in psychology and astronomy, Matta described his Surrealist painting *The Vertigo of Eros* (plate 11-33) as an "inscape," an image of his inner, erotic world where circular lines suggest spinning—the vertigo of Eros. He also stated that he wanted his Surrealistic work to suggest forms floating in a non-Euclidean cosmic space.[27]

As a young artist in Mexico City, Rufino Tamayo studied at the Escuela

CHAPTER 11

Nacional de Bellas Artes and collected pre-Columbian art. Beginning in 1936, then age thirty-seven, he divided his time between Mexico City and New York. After World War II, he was commissioned by a philanthropist in Dallas, Texas, to create a mural, and the artist chose the theme of man's place in the universe. Irrespective of nationality or politics, mankind is of Earth but reaches for the stars (plate 11-28).

After his exile during World War II, Breton returned home to Paris in 1946, but in his absence a new outlook had taken hold, led by Jean-Paul Sartre. According to the French philosopher, one defines oneself by one's actions—one's *existence*—hence the name of Sartre's outlook is *existentialism* (plate 11-34). When Breton fled from the war to Mexico, Sartre stayed in France and fought the German occupation in a secretive and dangerous resistance movement. Sartre mocked the Surrealist concept of action by quoting Breton, who wrote, in the *Second Manifesto of Surrealism* (1929), that the supreme Surrealist act consists of running down the street with a gun and shooting randomly into the crowd.[28] Sartre advocated literature that was committed to political action and positive social change, dismissing Breton's writing as self-indulgent and negative.[29]

11-33. Roberto Matta (Chilean, 1911–2002), *The Vertigo of Eros*, 1944. Oil on canvas, 77 in. × 99 in. (195.6 × 251.5 cm). Museum of Modern Art, New York.

11-34. Anselm Kiefer (German, born 1945), *Essenz/Ek-sistenz* [Essence/Existence], 1975. Watercolor and gouache on paper, 11¾ × 15⅝ in. (29.8 × 39.7 cm). Metropolitan Museum of Art, New York, Barnett Newman Foundation.

In this work the German artist Anselm Kiefer symbolized the existentialist dictum: existence precedes essence. The mountain range is solid and has a clear silhouette; Kiefer labeled it *Ek-sistenz* (existence, using a term from Jean-Paul Sartre's German counterpart Martin Heidegger). What is the essence of a mountain or a human being? That is determined by the mountain's physical rocks and the human's actions. Physical, practical actions determine *Essenz* (essence), which is amorphous, so Kiefer wrote it on the fog. According to Sartre, a man (like André Breton) who says he is really (in essence) brave, although he acted (in existence) cowardly (fleeing Europe at the outbreak of war), is deceiving himself; he is in bad faith (*mauvaise foi*). Breton's cowardly actions prove he's essentially a coward.

Existentialism dominated French intellectual life during the Cold War, but the Surrealists continued to publish periodicals, such as *Néon* (1948–49), *Médium* (1952–55), *L'Art magique* (1953–57), and *Surréalisme même* (1956–59), and hold exhibitions, such as *Eros* (1959–60, Galerie Daniel Cordier, Paris). When Breton died in 1966, he left no heir to lead the Surrealist movement, which slowly dissipated.

Jacques Lacan and Psychosis

In the 1930s the young French psychiatrist Jacques Lacan was a rare example of a scientist whose thinking was directly influenced by an artist. Freud developed psychoanalysis to treat mild neurosis, but Lacan extended psychoanalysis to treat severe psychosis. Lacan focused on paranoia because it has both a mild neurotic form (being suspicious) and an extreme psychotic version (being delusional). Hearing tales about an artist who used a "paranoid-critical method," Lacan visited Dalí's studio, where the artist described how he combined unrelated images to form a new symbolic whole, such as the crouching youth and pile of rocks that echo each other's form in *Metamorphosis of Narcissus* (plate 11-35). Dalí called his method "paranoid" because he aspired to see the world as a delusional patient would—objects are not what they seem; a boy is a pile of rocks.[30] Lacan incorporated Dalí's symbolic reordering of reality in his psychiatric doctoral thesis of 1932.[31]

11-35. Salvador Dalí (Spanish, 1904–1989), *Metamorphosis of Narcissus*, 1937. Oil on canvas, 20 × 31 in. (50.8 × 77.5 cm). Tate, London.

Carl Jung and the Collective Unconscious

Carl Jung's theory of a collective unconscious was contemporary with Surrealism, but its influence was felt less in Europe than in the United States. Jung, the son of a Swiss Protestant clergyman, was an early follower of Freud, but the alliance ended in 1912 because Jung disagreed with Freud's views on sexuality. Freud believed that children have pleasure in the body—*libido* (Latin for "desire")—from birth, in the sense that a healthy baby wants to thrive: to eat, be warm, and feel good (*Three Essays on the Theory of Sexuality*, 1905). Jung held that children do not feel pleasure in the body until puberty (Jung, *Psychology of the Unconscious: A Study of the Transformations and Symbolisms of the Libido*, 1912).

During World War I, Jung secluded himself in his residence near Zurich, where he performed a self-analysis. He wrote down his dreams and fantasies, eventually transcribing his thoughts and images into a red leather-bound journal, known as *The Red Book*. By 1919 Jung was confident that he had discovered within himself a series of primordial images, which he called *archetypes*; these included his anima (the feminine aspects of his inner self). Through studying the myths of other cultures, Jung generalized this finding in *The Psychological Types* (1921), in which he declared that all human beings are born with a collective unconscious, the repository of archetypes. Jung also proposed a psychological variant of Ernst Haeckel's late nineteenth-century biological view that "ontogeny recapitulates phylogeny"; as each individual matures, he or she repeats the historical development of culture (first a "savage" toddler, then an "intuitive" adolescent, and finally a "reasonable" adult). The problem with modern man, according to Jung, is that he has an overly developed reason. In several popular books, Jung declared that to achieve mental health, modern individuals must rejuvenate feeling/intuition (the "soul" in the title of Jung's *Modern Man in Search of a Soul*, 1933) by bringing to consciousness archetypes that are buried (forgotten) in the savage or intuitive parts of the brain. The role of the artist is to express these archetypes; according to Jung: "The creative process, so far as we are able to follow it at all, consists in the unconscious activation of an archetypal image, and in elaborating and shaping this image into the final work."[32]

In addition to disagreeing about the onset of sexuality, Freud and Jung also disagreed about the nature of the unconscious mind. Freud held that the unconscious is individual in the sense that each person builds his or her unique unconscious mind over time (through the person's experience); dreams are an expression of the individual's memories. Jung argued that the unconscious is collective in the sense that all *Homo sapiens* are born with the same innate archetypes; dreams are an expression of archetypes. After the rise of neuroscience in the 1980s, researchers tried to settle the question experimentally. There is extensive evidence that Freudian concepts of memory and dreams are grounded in neurological mechanisms, but there is no

experimental evidence for Jungian archetypes.[33] Freud and Jung also disagreed about religion (by which they meant the Judeo-Christian-Islamic tradition). Jung viewed religion as a healthy expression of humankind's spiritual aspirations, whereas Freud thought it infantile for adults to believe they are the special child of an omnipotent father and delusional to believe in angels, devils, or a life after death.

Jung's outlook never took root in Surrealist circles—it was too prudish and too religious—but it suited mid-war America, where Jung's promise of spiritual rebirth through myth had a strong appeal. Jung spoke fluent English and was a regular lecturer in New York; in 1936 the city's Jung Institute was founded to train analysts and publish Jungian doctrine.

In the early 1940s, during the formative years of Abstract Expressionism, American artists painted Jungian archetypes, such as Mark Rothko's *Omen of the Eagle* (1942; National Gallery of Art, Washington, DC). In a 1943 interview, Rothko declared: "If our titles recall known myths of antiquity we have used them again because they are the eternal symbols upon which we must fall back to express basic psychological truths. . . . And modern psychology finds them persisting still in our dreams, our vernacular, and our art."[34]

11-36. Jackson Pollock (American, 1912–1956), *Male and Female*, ca. 1942. Oil on canvas, 73¼ × 48⅞ in. (186 × 124.3 cm). Philadelphia Museum of Art, gift of Mr. and Mrs. H. Gates Lloyd, 1974.

Since his adolescence in Wyoming, Jackson Pollock had been addicted to alcohol, and after moving to New York he was treated for alcoholism at several mental health facilities; his first hospitalization was for four months in 1938 (at age twenty-six). In 1939–41, he underwent a Jungian analysis in New York with Joseph L. Henderson, who encouraged the artist to draw his dreams, because they are, according to Jung, an expression of archetypes.[35] In *Male and Female* (plate 11-36), Pollock depicted Jungian archetypes as if carved on a Native American totem pole (recalling his youth in Wyoming); each figure has a Jungian animus and anima (male and female aspects of the personality), symbolized by their combined male and female anatomies.

Rothko's and Pollock's depictions of Jungian archetypes ceased in 1945 when American pilots dropped the atomic bomb on Japan. Analyzing dreams suddenly seemed irrelevant.

The Atomic Sublime

My clothes were tattered and covered with blood. I had cuts and scratches all over me, but all of my extremities were there. I looked around me. Even though it was morning, the sky was dark, as dark as twilight. Then I saw streams of human beings shuffling away from the center of the city. Parts of their bodies were missing. Their eyes had been liquefied.

Setsuko Thurlow, eyewitness account of Hiroshima on August 6, 1945

Wouldn't it be odd if these were the only two atomic bombs ever dropped?

General Carl Spaatz, commander of the United States Air Force in the Pacific, August 1945

The atomic bomb has changed everything except the hearts of men.

Albert Einstein, *New York Times Magazine*, June 23, 1946

PHYSICISTS DISCOVERED nuclear energy as their countries were heading into a global conflict, and thus the first application of the new technology was to design a weapon. Research on the atomic bomb was top secret, so on August 6, 1945, the world was completely unprepared for the news that American soldiers had destroyed a Japanese city and killed 70,000 people in a fraction of a second. Suddenly the threat of a global inferno loomed. Never before had temperatures as hot as the sun—thermonuclear heat—been created on Earth.

Italian Physics and Aeropittura

In 1901 Pierre Curie had hypothesized that there was a new energy source in the atom, and in the following decades Ernest Rutherford and others probed the atom by firing alpha particles (2-proton "bullets") at the nuclei of different elements. Since antiquity alchemists had tried to transmute the basest matter—dung—into the most precious: gold. In 1934 the French husband-and-wife team of physicists Frédéric Joliot and Irène Curie (daughter of Pierre and Marie Curie) accomplished the first transmutation of one element into another; they managed to get a 2-proton alpha particle to lodge in the nucleus of an aluminum atom (which has 13 protons), transmuting it to phosphorous (15 protons). Physicists kept firing protons at nuclei, never imagining that a propelled

12-1. Hijikata Tatsumi (Japanese, 1928–1986), performing in *Revolt of the Flesh*, Tokyo, 1968. Hijikata Tatsumi Memorial Archives, Tokyo.

particle could break the nucleus in half—but they discovered that it can. The research that led to splitting the atom and setting up a controlled chain reaction of nuclear fission (the essence of an atomic bomb) began in Italy in the 1930s under the direction of Italian physicist Enrico Fermi.

In the mid-1920s one of Italy's senior physicists, Orso Corbino, who was also politically active as a senator, dreamed of making Rome a research center for the new field of subatomic physics. Although he was wary of the right-wing ideology of the government that came to power in 1922 under Benito Mussolini, Corbino convinced key politicians that science was essential to the modernization of Italy. He secured the funds to equip the laboratories of the University of Rome and to hire Italy's brightest young physicists; in 1926 Fermi accepted Corbino's job offer. Corbino also enlisted Fermi to recruit university students and instill enthusiasm for science in the general public. To these ends, in 1928 Fermi published the first textbook on quantum physics in Italian (rather than German).[1] He also gave public lectures at the Italian Association for the Advancement of Science, where his audience included second-generation Futurist artists who had relocated from Milan to Rome after World War I. Still led by Giacomo Balla and Filippo Tommaso Marinetti, the group included such younger artists as Fedele Azari, Gerardo Dottori, and Enrico Prampolini. Second-generation Futurist painting expressed the unity of the microcosm and macrocosm, in keeping with Einstein's cosmology but with several distinctly Italian features: ancient Roman pantheism and an aerial viewpoint.[2]

The theme of cosmic unity was discernible in Parisian art of the period, but the artists who created it—Jean (Hans) Arp, Joan Miró, Alexander Calder, and Wassily Kandinsky—lacked a common philosophical outlook because they had diverse backgrounds (German-French, Spanish, American, and Russian). By comparison, every Italian schoolchild is taught Cicero's *Dream of Scipio* (51 BC) and its Roman Catholic restatement by Dante Alighieri in *The Divine Comedy* (ca. 1308–20). Based on Plato's cosmology, Cicero described an individual's soul as coming from a perfect place beyond the moon, to which the soul returns after death. In his introduction to *The Banquet* (ca. 1304–7), Dante acknowledged that Cicero's pantheist vision of humankind's unity with the heavens underlies his three-tiered inferno, purgatory, and paradise in *The Divine Comedy*.

Before World War I, first-generation Futurists had painted from a stationary viewpoint; for example, Balla's *Abstract Speed* (see plate 8-52 in chapter 8) is a moving auto as seen by a motionless viewer. Some second-generation Futurists had been pilots during the war, and they incorporated an aerial viewpoint in their art, calling their style Aeropittura (Italian for "aerial painting"); it captures the experience of flying at low altitudes (around 3,000 feet/914 meters) in a single-engine propeller plane, which is capable of making tight turns and dramatic nosedives from as high as 12,000 feet (3,658 meters). These panoramas include the illusion (when in a spin) that the

The globes of the stars far surpassed the earth in size, and now the earth itself seemed to me so small that I was ashamed of our empire, which reaches hardly more than a point on its surface.

Cicero, *Dream of Scipio,* 51 BC

CHAPTER 12

12-2. Alessandro Bruschetti (Italian, 1910–1980), *Spin*, 1932. Oil on canvas, 23½ × 19⅝ in. (60 × 50 cm). Fonte d'Abisso Arte, Milan.

BOTTOM

12-3. Filippo Masoero (Italian, 1894–1969), *Descending over Saint Peter's*, 1930–33. Photograph, 9⅛ × 12¼ in. (23.2 × 31 cm). Touring Club Italiano Archive, Milan.

ground is curving, as in Alessandro Bruschetti's *Spin* (plate 12-2) and Filippo Masoero's *Descending over Saint Peter's* (plate 12-3). An X-shaped visual field results from doing a quick, 360-degree aerial somersault (or loop), as in Tullio Crali's *Looping* (plate 12-6). The artists declared: "The changing perspectives of flight constitute an absolutely new reality. . . . Soon a new extraterrestrial spirituality will be achieved" (*Manifesto dell'aeropittura* [Manifesto of aerial painting], 1929).[3] Scipio dreamed that he viewed Earth from the heavens above, and like him, the Aeropittura artists are not in the sky but *of* the sky; they look down to their physical home, such as the hills in Dottori's *Reds and Greens* (plate 12-4), and up to their spiritual home, such as the nebulas in Dottori's *Dynamic Forces* (plate 12-5).

Splitting the Atom and Building the Bomb

Ever since Rutherford had discovered that the atomic nucleus is composed of positively-charged protons, physicists had wondered: how can the nucleus stay together if positive charges repel each other? The search for an answer led to the discovery of a force much stronger than electromagnetism: the strong nuclear force, which is carried by neutrons and holds the nucleus together. (There is a second, weak nuclear force that causes the nucleus to decay.) The nucleus of a hydrogen atom has only 1 proton, so it is stable. But helium has 2 protons pushing apart, so it needs 2 neutrons carrying the strong nuclear force to counteract the outward push of the protons and hold the helium nucleus together. And so on up the Periodic Table; as the nucleus of each element is increased by 1 proton, it gains 1 (or more) neutrons to hold the nucleus together. As nuclei get bigger, they become less stable (more likely to lose particles; i.e., more radioactive).

TOP LEFT

12-4. Gerardo Dottori (Italian, 1884–1977), *Reds and Greens*, 1925. Oil on canvas, 14 × 32 in. (35 × 80 cm). Lattuada Studio, Milan.

Using the traditional Italian fresco medium, Dottori also painted *Apotheosis of Flight* (1929) for Rome's Ostia Airport, from which Dottori flew his plane.

TOP RIGHT

12-5. Gerardo Dottori, (Italian, 1884–1977), *Dynamic Forces*, 1926–28. Colored pencil on board, 10 × 13⅜ in. (25 × 34 cm). Lattuada Studio, Milan.

ABOVE

12-6. Tullio Crali (Italian, 1910–2000), *Looping*, 1938. Location unknown.

When the neutron was discovered in 1932, it gave physicists an excellent tool with which to probe the atomic nucleus. Unlike protons, a neutron has no electric charge, so it is not repelled by the positively-charged nucleus and more easily penetrates it. A proton and neutron have the same mass and differ only in electric charge; a neutron can become a proton (and vice versa) by gaining (or losing) an electric charge.[4] When Fermi shot a neutron into the nucleus of an atom of carbon (which has 6 protons), a negative charge was given off (an electron flew out) and the neutron became a proton. In this way Fermi produced a 7-proton nucleus—an atom of nitrogen. Fermi also discovered a way to control the speed of the neutron, which gave him more control over the transmutation process.

Fermi's success with transmutation made him wonder whether he could create a new atom unknown in nature by adding a proton to the last element on the Periodic Table, uranium, which has 92 protons. So in 1934 Fermi aimed his neutron bullets at uranium. Chemical analysis indicated that a new element with 93 protons was among the bombardment debris, but Fermi could not explain all the characteristics of the other resulting atoms. In June 1934, in a burst of enthusiasm, Corbino (without Fermi's approval) publicly announced that new "element 93" had been created in Rome. The Italian press declared a victory for Italian science, and newspapers around the world reported the discovery. But, as Fermi knew, the announcement was premature because he had not proven conclusively that he had created the new element. It took him several years to realize that he had actually done something much more revolutionary, something that even the medieval alchemists had never dreamed of—he had split the atom.

While Fermi was doing this research, he was distracted by political pressure from Mussolini's government, which was increasingly allied with Hitler. In 1938 Fermi became distressed when the Fascists passed racial laws, because his wife, Laura Capon, was Jewish. The anti-Semitic laws meant she lost her civil rights and her travel was restricted. That same year the Royal Swedish Academy of Sciences announced that Fermi had won the Nobel Prize for Physics, and Mussolini was very proud. Seeing an opportunity to flee, Fermi requested of Mussolini that his wife and their two small children be allowed to travel with him to Stockholm to receive the prize on behalf of the Italian government. The request was granted, and so Fermi and his family got on a train in Rome and never returned; from Sweden they sailed to the United States.

Two of Fermi's colleagues in Berlin, the German chemist Otto Hahn and the Austrian physicist Lise Meitner, were replicating Fermi's experiments with uranium. Meitner was Jewish, but the German anti-Semitic laws didn't apply to her because she was Austrian. But on March 12, 1938, Hitler annexed Austria into Germany, and overnight Meitner no longer had a valid passport and lost her civil rights. When the Nazis refused to let her leave Germany, the Dutch physicist Dirk Coster travelled to Berlin and persuaded Meitner to don a disguise and leave with him. At the Dutch border,

Really, I live in evil times!
A guileless word is foolish.
A smooth brow
Hints at indifference.
He who can still laugh
Has not yet received
The terrible news.

What times are these when
It is almost a crime to talk of trees
For that means silence about so
many evil deeds!
Bertolt Brecht, "To Posterity," 1939

What times are these
when a conversation
is almost a crime
because it includes
so much made explicit?
Paul Celan, "A Leaf, Treeless,
for Bertolt Brecht," ca. 1968

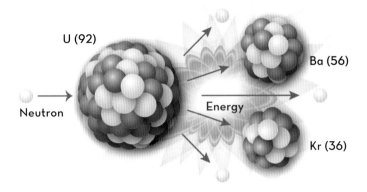

U (92)

Neutron

Energy

Ba (56)

Kr (36)

12-7. Nuclear fission

When a neutron strikes uranium (92 protons), the nucleus splits into barium (56 protons) and krypton (36 protons) and releases several neutrons. During nuclear fission there is a loss of mass, which is converted to energy.

Coster convinced the German immigration officers that she had permission to accompany him to the Netherlands. The guards let her pass, so Meitner arrived safely in Amsterdam, thanks to Coster, although she had lost everything but her life—her job, pension, manuscripts, books, even her native language.

Meitner eventually settled in Sweden, where she was able to communicate with Hahn by letter and continue their partnership; Hahn performed the experiments, and Meitner interpreted the laboratory data. Hahn was still trying to create an element with 93 protons, but he kept finding smaller atoms (barium, 56 protons; krypton, 36 protons). He sent the data to Meitner, who realized that a neutron had split the uranium nucleus into the two smaller atoms. She came to this realization with her nephew, the physicist Otto Robert Frisch, and together they published their findings in the February 1939 issue of the British journal *Nature*, effectively letting the nuclear genie out of the bottle.[5]

When the uranium nucleus is split, the weight of the two smaller nuclei is less than the original (plate 12-7). The lost mass is converted into energy; the conversion formula is $E = mc^2$. Equally important, when the uranium nucleus splits, it releases neutrons, which in turn split other nuclei, beginning a chain reaction. Splitting one nucleus releases 200 million electron volts (MeV) of energy and 2 neutrons; which split two more nuclei, releasing 400 MeV and 4 neutrons; which split four more nuclei, releasing 800 MeV and 8 neutrons, and so on. In a billionth of a second an astonishing amount of energy is produced; fissioning 1 ounce (28 grams) of uranium (the weight of ten sugar cubes) is equal to detonating 600 tons of TNT (the weight of 300 automobiles).

When World War II broke out in 1939, the Nazi government put Werner Heisenberg in charge of the German effort to build an atomic bomb. By this time Einstein was a refugee in the United States, where he was affiliated with the Institute for Advanced Study in Princeton, New Jersey. As a lifelong pacifist, he wanted nothing to do with building a weapon. But in August 1939 it came to his attention that fissioning experiments were being conducted in Berlin, and Einstein felt obligated to alert President Franklin D. Roosevelt and recommend that the United States accelerate research on nuclear fission. In 1941 Roosevelt approved an American effort to design an atomic weapon (code name, the Manhattan Project).

In 1942, at the University of Chicago, the first nuclear reactor maintained a self-sustaining chain reaction (it "went critical"). Three years later at the Los Alamos National Laboratory in New Mexico, under the direction of the American physicist J. Robert Oppenheimer, the first atomic bomb was detonated. The Los Alamos team

included Enrico Fermi, Lise Meitner's nephew Otto Robert Frisch, and Niels Bohr, who came to the US as a Jew fleeing Nazi-occupied Denmark.

Hitler's Germany had made a pact with Mussolini's Italy, and in 1940 Japan joined them as the third member of the Axis powers. In the long history of Japan, the country had never been defeated by a foreign power. It is a mark of Japan's confidence in its invincibility that, while already at war with China (the Second Sino-Japanese War), this small island nation attacked two other huge realms, the United States and the British Empire. On the night of December 7, 1941, Japan bombed United States military bases in Hawaii (Pearl Harbor), Wake Island, Guam, and the Philippines, as well as the British possessions of Malaya, Singapore, and Hong Kong. The next morning, the United States and the United Kingdom declared war on Japan.

The Manhattan Project completed production of the atomic bomb in the summer of 1945. Mussolini had already been executed (on April 28, 1945, by the Italian resistance movement), and Hitler had committed suicide (on April 30), followed by the German surrender to Allied forces (on May 7, 1945). But fighting continued in the Pacific. On July 16, 1945, the Manhattan Project physicists watched the detonation of the first atomic bomb in a desert in New Mexico. Three weeks later, August 6, 1945, the United States dropped the atomic bomb on Hiroshima and then on Nagasaki. Japan surrendered on August 15, 1945, and World War II ended.

We knew the world would not be the same. Few people laughed, few people cried, most people were silent. I remembered the line from the Hindu scripture, the Bhagavad-Gita. Vishnu is trying to persuade the Prince that he should do his duty and to impress him takes on his multi-armed form and says, "Now I am become Death, the destroyer of worlds." I suppose we all thought that, one way or another.

Robert Oppenheimer,
recollection of July 16, 1945,
in an interview with NBC, 1965

Surrealism after World War II

After the war, Niels Bohr returned from the United States to Copenhagen. Werner Heisenberg was rounded up by British forces and detained for questioning in England.[6] He was eventually allowed to return to Germany, where he became director of the Kaiser-Wilhelm Institut für Physik (today the Max Planck Institut für Physik) in Munich.

After 1945 most Surrealists, led by André Breton, expressed shock at the bombing of Hiroshima and cooled their enthusiasm for physics.[7] But Salvador Dalí, who lacked a moral anchor, drifted toward whatever got the most publicity, and nothing got the world's attention more than the atomic bomb. He was also attracted to demagogues, including Hitler.[8] Dalí found the perfect combination in Heisenberg, the architect of Hitler's (unrealized) atomic bomb: "In the surrealist period I wanted to create the iconography of the interior world—the world of the marvelous, of my father Freud. I succeeded in doing it. Today the exterior world—that of physics—has transcended the one of psychology. My father today is Dr. Heisenberg."[9] Dalí declared that his art would now express the atomic age by a mix of Roman Catholic occultism (magical doctrine known only to the initiated) and quantum physics. As Dalí put it, in his *Manifeste mystique* (Mystical manifesto; 1951): "The paroxysmal crisis in Dalían mysticism mainly relies on the progress of the particular sciences of our times, especially on the

12-8. Salvador Dalí (Spanish, 1904–1989), *The Disintegration of the Persistence of Memory*, 1952–54. Oil on canvas, 10 × 13 in. (25.4 × 33 cm). Salvador Dalí Museum, Saint Petersburg, Florida.

metaphysical spirituality of the substantiality of quantum physics."[10] As an expression of his new manifesto, Dalí painted a revision of his 1931 *Persistence of Memory* (see plate 9-7 in chapter 9); in *The Disintegration of the Persistence of Memory* (1952–54), the ground is reduced to fragments (plate 12-8).

American Art after World War II: Abstract Expressionism

In the 1920s atomic physics had been presented to the American public as incomprehensible, but after 1945, scientists, journalists, and government spokespeople made great efforts to explain the atomic bomb to the ordinary citizen. President Harry Truman, who had authorized the bombing of Japan, gave a speech to the nation in which he described how nuclear energy powers the sun.[11] *Life* magazine, which had 5 million subscribers, presented a lucid, illustrated exposition of how energy is released when a uranium atom is split, which, the editors wrote, "provided another proof of the Einstein theory that matter is simply energy in another form."[12] The *Life* editors also described the bombing of Hiroshima: "In the heart of the city were oil stores, electric works, and many bridges . . . centuries-old temples and a public garden famous for its flowering trees. . . . The atomic bomb had blown three-fifths of Hiroshima off the face of the earth."[13] In the same issue, *Life* published a commentary on the implications of the bomb for future wars. In "The Atomic Bomb and Future War," Hanson W. Baldwin, who was a military analyst for the *New York Times*, wrote that the future held the possibility of "devastating 'push-button'

battles."[14] Three months later *Life* published a description of a possible future World War III—ominously titled "The 36-Hour War"—based on a report written by General Henry A. Arnold, commander in chief of the US Air Force (plates 12-9 and 12-10).

A flood of radio and newspaper reports compared the modern discovery of nuclear energy to prehistoric humans' discovery of fire, and there was a sense of foreboding about what the discovery meant for the future. After Japan's surrender, the broadcast journalist Edward R. Murrow commented on CBS News: "Seldom if ever has a war ended leaving the victors with such a sense of uncertainty and fear, with such a realization that the future is obscure and that survival is not assured."[15] The American artists Barnett Newman, Mark Rothko, and Jackson Pollock heard about the atomic bomb along with everyone else on August 6, 1945. Driven by themes associated with atomic energy, within a few years each artist moved into total abstraction—Abstract Expressionism—and achieved his mature style: Newman with his "zip" paintings (beginning in 1948), Rothko his floating rectangles of color (in 1947), and Pollock his poured paintings (in 1947).[16]

Newman was suited by education (earning a BA in philosophy from the City University of New York in 1926) and by contemplative temperament to assume the role of spiritual leader. He had a lifelong attachment to the philosophy of Baruch Spinoza, and he sought a union of the self with nature in language that recalls Spinoza's God/Nature.[17] The year after the atomic bomb, in *Pagan Void* (plate 12-11),

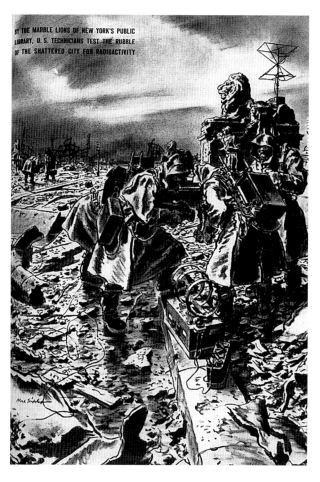

BY THE MARBLE LIONS OF NEW YORK'S PUBLIC LIBRARY, U. S. TECHNICIANS TEST THE RUBBLE OF THE SHATTERED CITY FOR RADIOACTIVITY

TOP RIGHT

12-9. "The Atom Bombs Descend on U.S.," in "The 36-Hour War," by an anonymous staff writer, with lengthy quotations from General Henry A. Arnold, commander in chief of the US Air Force, *Life*, Nov. 19, 1945, 27–35; the illus., by A. Leydenfrost, is on 28–29.

The text accompanying this illustration reads: "In the panorama above, looking eastward from 3,000 miles above the Pacific, *Life*'s artist has shown the U.S. as it might appear a very few years from now, with a great shower of enemy rockets falling on 13 key U.S. centers. Within a few seconds, atomic bombs have exploded over New York, Chicago, San Francisco, Los Angeles, Philadelphia, Boulder Dam, New Orleans, Denver, Washington, Salt Lake City, Seattle, Kansas City, and Knoxville" (28–29). Despite the destruction of these cities, which would kill an estimated 10 million Americans, the article ends on an upbeat note—"The U.S. wins the atomic war" (34)—because the United States retaliates and destroys Moscow, Odessa, and Saint Petersburg.

BOTTOM RIGHT

12-10. "By the marble lions of New York's Public Library, U.S. technicians test the rubble of the shattered city for radioactivity," in "The 36-Hour War," *Life*, Nov. 19, 1945, 27–35; the illus., by N. Sickles, is on 35.

The accompanying text reads: "San Francisco's Market Street, Chicago's Michigan Boulevard and New York's Fifth Avenue are merely lanes through the debris" (34).

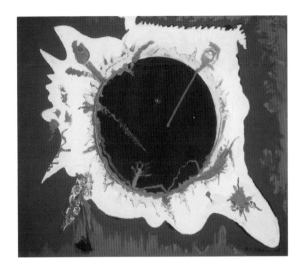

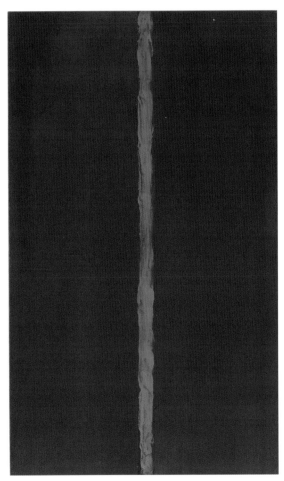

Newman painted a black hole in the midst of a shape that suggests both a microscopic amoeba and a massive cloud; this is not an abyss reached after a spiritual journey but nonexistence—a void—produced by secular ("pagan") science. Newman wrote that modern people don't have terror before unknown forces of nature because science understands nuclear energy: "Terror can only exist if the forces of tragedy are unknown. We now know the terror to expect. Hiroshima showed it to us. We are no longer, then, in the face of mystery."[18]

Newman revived the Romantic term *sublime* and described himself as aiming for a transcendental union with the "world-mystery"—as distinct from Surrealists who focused inward and aimed at expressing individual feelings: "The present painter is not concerned with his own feelings or the mystery of his own personality but with the penetration into the world-mystery. His imagination is therefore attempting to dig into metaphysical secrets. To that extent his art is concerned with the sublime. It is a religious art which through symbols will catch the basic truth of life, which is its sense of tragedy."[19] The Romantic sublime was symbolized by Caspar David Friedrich as light streaming down from the heavens, but Newman's was a new sublime—an atomic sublime—because science had changed artists' understanding of nature. In "The Sublime Is Now" (1948), Newman wrote: "We are asserting man's natural desire for the exalted, for a concern with our relationship to the absolute emotions. We do not need the obsolete props of an outmoded and antiquated legend. . . . We are making it out of ourselves, out of our own feeling. The image we produce is the self-evident one of revelation, real and concrete."[20] In the tradition of pantheism, Jewish mysticism, and Spinoza's God/Nature, Newman had his revelation of cosmic unity in January 1948, when he made a line that was not *on* the surface but *part of* (one with) the surface in a continuous field, his first "zip" painting (plate 12-12).

TOP

12-11. Barnett Newman (American, 1905–1970), *Pagan Void*, 1946. Oil on canvas, 33 × 38 in. (83.8 × 96.5 cm). National Gallery of Art, Washington, DC, gift of Annalee Newman, in honor of the 50th anniversary of the National Gallery of Art,1988.57.1.

ABOVE

12-12. Barnett Newman (American, 1905–1970), *Onement I*, 1948. Oil and masking tape on canvas, 27¼ × 16¼ in. (69.2 × 41.3 cm). Museum of Modern Art, New York, gift of Annalee Newman.

Newman described this work: "A field that brings to life other fields, just as the other fields bring to life this so-called line. That painting called *Onement I*: what it made me realize is that I was confronted for the first time with the thing that I did, whereas up until that moment I was able to remove myself from the act of painting, or from the painting itself" (interview with British art critic David Sylvester for the BBC [1965], in *Barnett Newman: Selected Writings*, ed. John P. O'Neill [New York: Knopf, 1990], 256).

OPPOSITE

12-13. Mark Rothko (American, 1903–1970), *Number 20*, 1957. Oil on canvas, 91¾ × 76 in. (233 × 193 cm). National Gallery of Australia, Canberra.

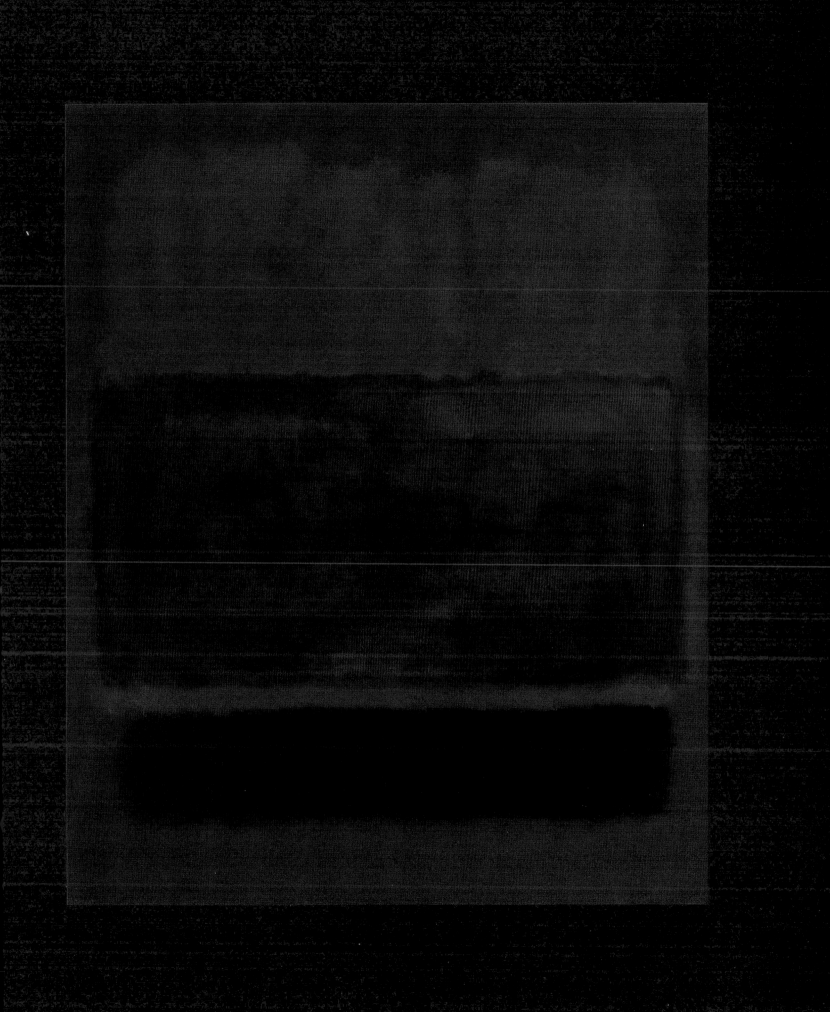

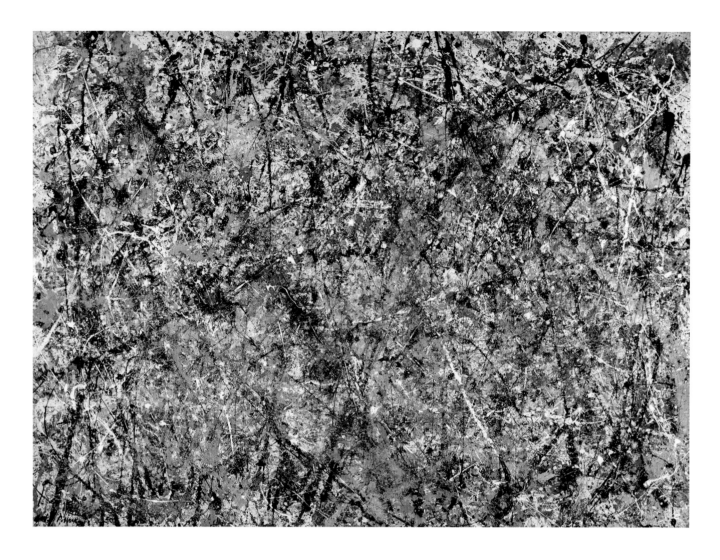

12-14. Jackson Pollock (American, 1912–1956), *Number 1 (Lavender Mist)*, 1950. Oil on canvas, 87 × 118 in. (221 × 299.7 cm). National Gallery of Art, Washington, DC, Ailsa Mellon Bruce Fund.

Like Newman, Rothko had the education and introspective disposition to assume the role of spiritual leader. He had immigrated to the United States from Russia when he was thirteen years old, speaking only Russian and Yiddish, but within a few years he had so excelled in high school that he won a scholarship to Yale University, where he studied literature, history, and mathematics. Like many American intellectuals during World War II, Rothko was drawn to Carl Jung's hypothesis of a collective unconscious, with its promise of cross-cultural bonds uniting people around the world (see chapter 11). In 1943, as war raged in Europe and the Pacific, Rothko and the painter Adolph Gottlieb gave an interview: "All primitive expression reveals the constant awareness of powerful forces, the immediate presence of terror and fear, a recognition and acceptance of the brutality of the natural world as well as the eternal insecurity of life. That these feelings are being experienced by many people throughout the world today is an unfortunate fact, and to us an art that glosses over or evades these feelings, is superficial or meaningless."[21] By the late 1940s Rothko was composing with rectangles of luminous color floating on a uniform field (plate 12-13); the subject of this work, he said in an interview, was "basic human emotions—tragedy, ecstasy, doom."[22] Rothko acknowledged his Romantic lineage,[23] and his fields of color recall Friedrich's vast voids with their spiritual overtones, as in *Monk by the Sea* (see plate 1-14 in chapter 1).

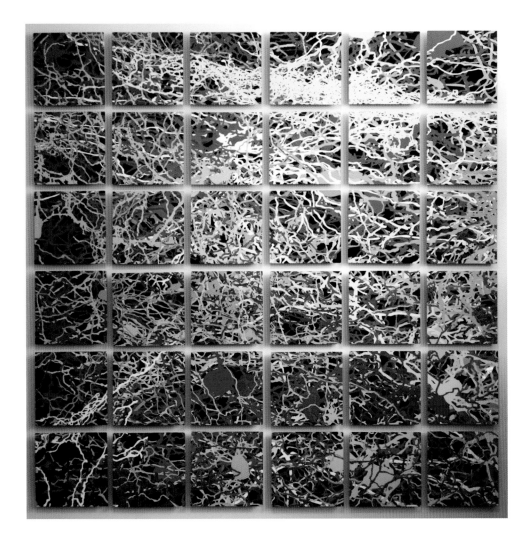

12-15. Julia Buntaine Hoel (American, born 1988), *For Pollock*, 2017. Color print on aluminum, 65 × 65 in. (165 × 165 cm), edition of 5. Courtesy of the artist.

Contemporary artist Julia Buntaine Hoel has dedicated one of her dynamic images of neural networks to Pollock in recognition of the frenzied energy in his work. The neuron data in her piece is from the video game *Eyewire*, designed by the American neuroscientist Sebastian Seung, in which players are challenged to "wire the eye" (map the neurons of the retina).

Pollock intuited the dangerous heart of the atom, and his poured paintings are embodiments of matter as energy. Asked by an interviewer in 1951 to comment on the "controversy" caused by his "method of painting," Pollock replied: "It seems to me that the modern painter cannot express this age, the airplane, the atom bomb, the radio, in the old forms of the Renaissance or of any other past culture. Each age finds its own technique."[24] The artist's web of gestural lines symbolizes the energy associated with nuclear forces (plate 12-14). Pollock's poured paintings also communicate human nervous energy. Pollock saw his technique, which was grounded in the Surrealist expression of the unconscious, as expressing emotion, as he stated in 1951: "I want to express my feelings rather than illustrate them. Technique is just a means of arriving at a statement."[25] Sensitive to the suffering caused by the atomic bomb, Pollock was also acquainted with his own demons, as a self-destructive, chronic alcoholic, and his poured paintings resonate both with nuclear energy and human nervous energy (plate 12-15). By the mid-1950s the artist was in severe physical and mental decline; in 1956, driving under the influence of alcohol, he crashed and killed himself and a woman, and seriously injured one other passenger.

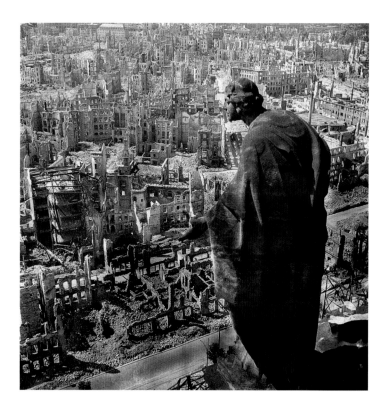

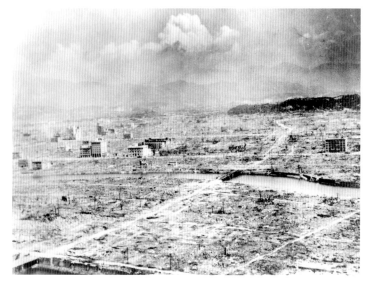

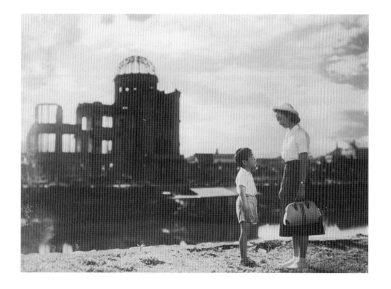

Japanese Art after World War II

World War II was the first war fought extensively with airplanes. Allied pilots flew their planes in formation over cities such as Dresden, Germany, and dropped hundreds of bombs filled with the chemical compound trinitrotoluene (TNT), which causes explosions, and incendiary bombs that start fires. Cities were carpet-bombed—covered with explosions and fires as a carpet covers a floor—which transformed them into infernos that burned for days, leaving corpses strewn amid the charred ruins (plate 12-16). By contrast, an atomic bomb causes a single flash of thermonuclear heat (as hot as the sun), which vaporizes organic matter (plants, animals, wooden architecture, etc.) in a fraction of a second. In other words, as the thermonuclear heat breaks atomic bonds, organic matter is no longer solid but becomes a vapor (a gas). In Hiroshima at ground zero (an area with a 5-mile/8-kilometer diameter), there were no burning buildings or corpses but only vapor—a cloud of atoms and molecules that slowly blew away (plate 12-17). Outside the 5-mile diameter, on the outskirts of the city, survivors suffered extensive burns and radiation poisoning (plate 12-18).

TOP LEFT
12-16. Dresden, Germany, Feb. 15, 1945. Photograph.
 View from the tower of the Rathaus (town hall) in Dresden, after Allied forces carpet-bombed the city on February 13–15, 1945.

CENTER LEFT
12-17. Hiroshima, Japan, Aug. 6, 1945. Photograph.
 View of Hiroshima after it was destroyed by an atomic bomb on August 6, 1945.

BOTTOM LEFT
12-18. *Genbaku no ko* [Children of Hiroshima], 1952. Film, directed by Kaneto Shindô. © 1952 Kindai Eiga Kyokai Company, Tokyo.
 The film tells the story of Takako Ishikawa, a kindergarten teacher from Hiroshima who was out of town on August 6, 1945, when her parents and sister were killed. Now a teacher on an island off the coast of Japan, Takako returns to Hiroshima to visit the graves of her family. She also visits her former students and learns of the suffering endured by each child, such as Taro, with whom she is shown standing in front of the ruins of the Hiroshima Prefectural Promotion Hall, which today serves as a memorial to the people killed by the atomic bomb.

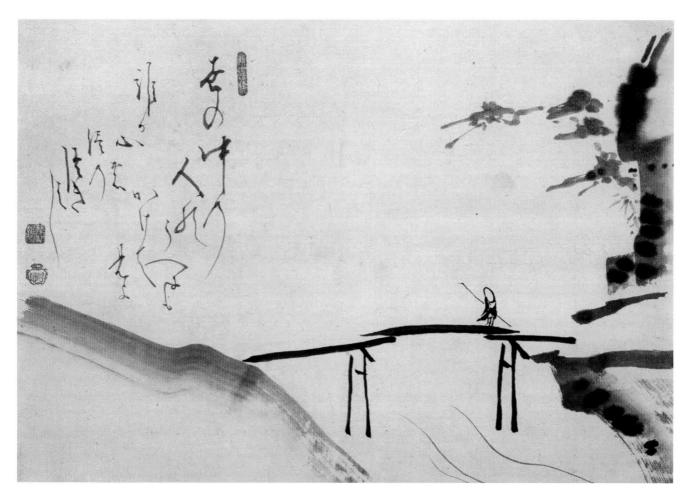

For the first time in its history, Japan was occupied by a foreign power. Unlike the surrender and occupation of Germany, which the Allies divided into West Germany (American, British, and French zones) and East Germany (Russian zone), the occupation of Japan was essentially done by the United States under the direction of General Douglas MacArthur, the commander of Allied powers. MacArthur's goal was to dismantle the Japanese military, revive the economy, and replace the totalitarian controls and emperor-worship with American-style democracy that guarantees freedom of expression and civil rights. After centuries of glorifying the samurai warrior and practicing the martial arts, Japan adopted a post-war constitution that vows to "forever renounce war as a sovereign right of the nation." For guidance on the future of their country, many Japanese looked to the tradition of Zen Buddhism, especially its central figure, the eighteenth-century monk Hakuin Ekaku, who offered advice on who should govern (plate 12-19).

Although the Japanese people were devastated by the human suffering caused by the war, many welcomed the changes brought about by their country's surrender, because after decades of totalitarian oppression, censorship, and isolation from Europe, there was an open society with free speech that was part of the American-imposed democracy. In the 1950s artists in Tokyo and Osaka were eager for knowledge of recent trends in Western art, and there was a great increase in the number of art magazines published in Japan. International art exhibitions began to travel to Tokyo, and large exhibitions of contemporary Japanese art were organized.

12-19. Hakuin Ekaku (Japanese, 1685–1768), *The Bridge at Mama*, 18th century. Ink on paper, 15½ × 22⅛ in. (39.4 × 56.2 cm). Private collection, Tokyo.

The Mama River flows into Tokyo Bay. The inscription reads (translation by Stephen Addiss):

Who has the jointed bridge of
Mama in his heart?
Him would I have throw a bridge
over the world of men.

Aspiring sincerely to an international peace based on justice and order, the Japanese people forever renounce war as a sovereign right of the nation and the threat or use of force as means of settling international disputes.

The Constitution of Japan, 1946, Article 9

12-20. Yoshihara Jiro (Japanese, 1905–1972), *Red Circle on Black*, 1965. Acrylic on canvas, 71½ × 89⅜ in. (181.5 × 227 cm). Hyōgo Prefectural Museum of Art, Kobe. © Yoshihara Shinichiro.

Gutai

In 1954 in Osaka, the painter Yoshihara Jiro founded Gutai (Japanese for "concreteness") after finding himself suddenly—and unexpectedly—in a post-war Japan that promoted freedom of expression. Artists associated with Gutai aspired to not overwork their materials but to let the expressive quality of the material as a physical object—its concreteness—be manifest. Yoshihara adopted the gestural brushstroke of the post-war international avant-garde (such as Jackson Pollock of Abstract Expressionism in the United States and Georges Mathieu of Tachism in France), as he described in the Gutai manifesto of 1956: "We highly regard the works of Pollock and Mathieu. Their work reveals the scream of the material itself, cries of the paint and enamel."[26] Yoshihara gave the automatic gesture a Japanese identity by painting the circle as a symbol of satori (enlightenment) in Zen Buddhism (plate 12-20).

In 1955 Yoshihara established the journal *Gutai*, and in a park near Osaka the group's artists staged their first outdoor exhibition of transitory objects in *Experimental Exhibition of Modern Art to Challenge the Mid-Summer Sun*. In the spirit of open-ended possibilities, artists explored unusual materials. Tanaka Atsuko, for example, used electricity in an exhibition in Tokyo's Ohara Kaikan Hall. She connected twenty electric bells with wire strung through several galleries. When a visitor activated one bell by touching or stepping on it, that bell sounded and set off a chain reaction (*Bell Piece*, 1955). Walking through the exhibition, visitors would hear chimes at unpredictable intervals. For her appearance in Gutai performance events, Tanaka made the spectacular *Electric Dress* from hundreds of light bulbs painted with bright colors (plate 12-21). After working together for over a decade, the Gutai group disbanded in 1972, after Yoshihara's death.

In the early years of the occupation, the United States fostered the demilitarization of Japan, but this changed with the escalation of the Cold War between the United States and the Soviet Union and a perceived Communist threat from China. In 1949 Mao Zedong founded the People's Republic of China. In 1950 the Korean War began with a joint Communist offensive by the Soviet Union and China in North Korea, while the United States took up the defense of South Korea. The leaders of the American occupation encouraged an anti-Communist agenda in Japan, leading to the passage in 1952 of the Subversive Activities Prevention Law, which revived dark memories of government suppression of dissent, prompting a public outcry from artists and intellectuals. Also, General MacArthur, in violation of Article 9 of the 1947 Japanese constitution, authorized the formation of a national police reserve, the mission of which was to guard the nation's internal security. In 1951 the occupation began to come to an end when the United States and Japan signed a security treaty (known in Japan as Anpo). The following year Japanese sovereignty was restored, but Anpo gave the United States

In Gutai Art, the human spirit and the material shake hands with each other, but keep their distance. The material never compromises itself with spirit; the spirit never dominates the material.

Yoshihara Jiro, *Gutai Art Manifesto*, 1956

12-21. Tanaka Atsuko (Japanese, 1932–2005), *Electric Dress*, 1956/1986 replica. Painted light bulbs, electric cords, and timer, 65 × 31½ × 31½ in. (165 × 80 × 80 cm). City Museum of Art, Takamatsu, Japan. © Kanayama Akira and Tanaka Atsuko Association.

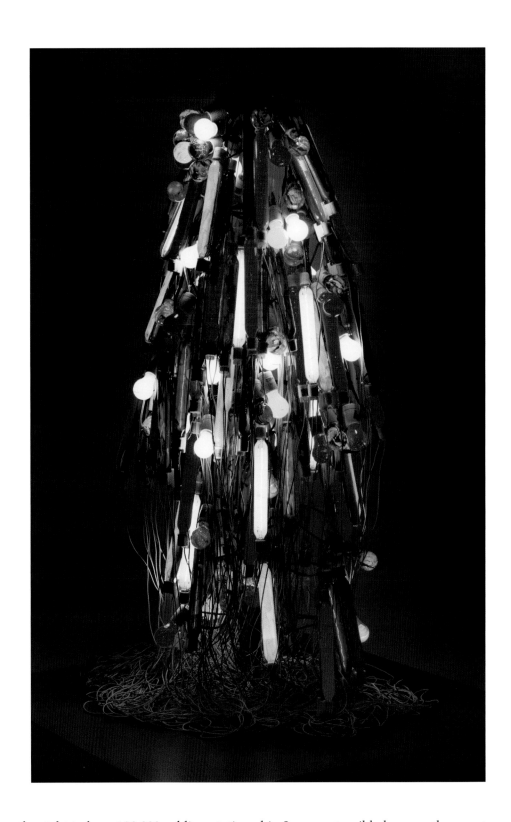

the right to keep 100,000 soldiers stationed in Japan, ostensibly because the country was defenseless without its military, but the provision was widely seen as an American strategy to keep a military presence in East Asia.

After decades of isolation, at the end of World War II Japanese artists were eager for contact with Western avant-garde art movements. But by the early 1950s, when Japan was once again an independent nation in charge of its own destiny, many felt that Japan had become too Americanized. Japanese artists wanted to form their own artistic identity by combining their Eastern traditions with Western modernism.

Bokujin-kai

In 1952 four Kyoto calligraphers, led by Morita Shiryū, founded Bokujin-kai (Japanese for "human ink society"), with the goal of combining Eastern calligraphy with Western gestural abstract painting. In traditional Japanese philosophy, writing with characters (pictographs) is an act that unifies the body (as the hand moves the brush) and spirit (as the calligrapher thinks about the meaning of the glyph). The Kyoto calligraphers were all disciples of Ueda Sokyu, who separated calligraphy from meaning by painting made-up pictographs that are meaning-free, non-objective forms.

Drawn to the Zen Buddhist tradition of artist-monks such as Hakuin Ekaku (plate 12-19), Morita painted large screens in black and gold in bold gestures (plate 12-22). Morita was editor of the group's journal, *Bokubi* (Ink art), and to stress his desire to forge an East-West merger, on the cover of the first issue, of June 1951, he reproduced a painting by the Abstract Expressionist Franz Kline. In his editorial Morita stated his vision for calligraphy: "To research the aesthetic and philosophic expression of calligraphy; To see calligraphy in the context of the whole life of a human being."[27]

Ankoku Butoh

Modern dance was imported to Japan from the West in the early twentieth century, at a time when Japanese choreographers wanted to shed their centuries-old past in Noh (classical drama) and Kabuki (dance-drama). After training as a dancer at the Imperial Theater in Tokyo, Ishii Baku toured from 1922 to 1925 in the United States and Europe, where he became captivated with German Expressionist choreographer Rudolf Laban and dancer Mary Wigman (see chapter 11). Another Japanese pioneer of modern dance, Eguchi Takaya, studied with Wigman in Dresden from 1931 to 1933.

Ohno Kazuo was in his twenties when he saw a performance by the German dancer Harald Kreutzberg, a disciple of Laban and Wigman, which led him to begin training in the 1930s with Ishii and Eguchi. Ohno's career was interrupted when he was drafted into the army during the Second Sino-Japanese War and sent to the front in China, where he served for nine years. After World War II he returned to dance and developed characters with searing insight, including a man dressed as a flamboyant woman with a huge bonnet and spike heels, who is both physically imposing and psychologically fragile. In 1949, at the age of forty-three, Ohno presented his first recital in Tokyo; in the audience was another student of Eguchi, twenty-year-old Hijikata Tatsumi.

Ohno and Hijikata worked together from 1959 to 1966 on the creation of a style that expressed the bleak post-war outlook, Ankoku Butoh (Japanese for "dance of darkness"; plate 12-1, chapter frontispiece and plate 12-23). The US-Japanese security treaty (Anpo) was scheduled for renewal in 1960, and as the date approached there was a push from Japanese artists and intellectuals to not renew, out of a desire to escape American

FOLLOWING SPREAD
12-22. Morita Shiryū (Japanese, 1912–1998), *Ryu* [Dragon], 1965. Four-panel screen, aluminum-flake pigment in polyvinyl acetate medium and yellow alkyd varnish on paper, 63⅝ × 122 in (161.5 × 310 cm). The Art Institute of Chicago, gift of Charles C. Haffner III.

The calligraphers of the Han and Jin dynasties in China, and Hakuin and Ryōkan in Japan, achieved world relevance in their work because they could go beyond characters and literary content and express human integrity in their creation of form. . . . If one can create forms that spring from the naked human heart, everyone will understand them, without regard to time or place.

Morita Shiryū, 1951

political and cultural influence. When Prime Minister Kishi Nobusuke announced in the spring of 1960 that the treaty would be renewed, mass protests followed.

Hijikata's performances were absurd, erotic, and brutal. In *Kinjiki* (Forbidden colors; 1959), the curtain opened on a stage that was completely dark. A faint light slowly began to glow, revealing young Ohno Yoshito (the son of Ohno Kazuo) standing toward the front of the stage. There was a sound of movement in the darkness and Hijikata suddenly leapt forward and thrust into Ohno's hands a live white chicken, which the boy suffocated between his thighs. The dance ended with Hijikata chasing Ohno in darkness and silence except for sexually explicit sounds—heavy breathing, whispers of "Je t'aime" (French for "I love you"). By using the French language, Hijikata was referencing the Théâtre de la cruauté (Theater of Cruelty) of playwrights Antonin Artaud and Jean Genet, who assaulted audiences with their own bleak expressions of rage. In Hijikata's *Revolt of the Flesh* (1968), which was his last performance, he was carried onstage under a parasol, wearing a bridal kimono, which he took off to reveal that he was naked except for a golden G-string and phallus. Alternately grinning and screaming at the audience, Hijikata then danced wearing an elegant satin evening gown together with black rubber gloves, twirled in a cancan skirt, and gestured frantically

RIGHT

12-23. Ohno Kazuo (Japanese, 1906–2010; left) and Hijikata Tatsumi (Japanese, 1928–1986; right), rehearsing in Tokyo, 1977. Dance Archive Network, Tokyo.

OPPOSITE

12-24. Ushio Amagatsu (Japanese, born 1949), in *Umusana: Memories before History*, by Sankai Juku, Tokyo, 2012. Choreographed and designed by Ushio Amagatsu, music by Takashi Kako, YAS-KAZ, and Yoichiro Yoshikawa.

while dressed in a short kimono and knee-high sports socks (plate 12-1). The performance ended with Hijikata being slowly lowered onto the audience entwined in ropes, as if he were a sacrificial animal.

The co-founders of butoh continued working together until Hijikata's death, in 1986, at age fifty-seven. Ohno's last international performance was in 1999, when he was ninety-four, at the Japan Society in New York, where he danced *Requiem for the Twentieth Century*. Ohno and Hijikata had close personal ties to the choreographer and dancer Ushio Amagatsu, who in 1975 founded Sankai Juku (Japanese for "mountain sea academy"), a dance company that performs a refined, visually exquisite form of butoh (plate 12-24). Sankai Juku has toured extensively, bringing the dance of darkness to a world stage.

Pseudo-Science of Quantum Mysticism

Bohr and Heisenberg rejected core values of science—objectivity and rationality—and, like the Romantics, they celebrated subjectivity, irrationality, and uncertainty. In this sense their Copenhagen interpretation is similar to doctrine of the Theosophical Society, which was also based in Romanticism. Annie Besant (author of *Occult Chemistry*, 1919), who was a theosophist (see chapter 5), and physicist Werner Heisenberg, who proclaimed the uncertainty principle in 1927 (see chapter 9), both trusted their subjective intuitions. Therefore, it is not surprising that Bohr and Heisenberg's popularizations of the Copenhagen interpretation were heralded by the Theosophical Society's heirs in the New Age movement as scientific proof of their occult worldview.[28]

From its earliest days, the Theosophical Society linked its outlook to India; in 1880 the society's founders, Helena Blavatsky and Henry Steel Olcott, moved the organization from New York to Madras (today Chennai), India. What became known as "quantum mysticism" began in 1947, when Bohr encouraged an analogy between Eastern religion and quantum mechanics, designing his coat of arms with the Taoist yin-yang to symbolize the dual wave-particle nature of electrons.[29] Heisenberg also contributed to quantum mysticism when he claimed that the location of an electron is not just unknown but *unknowable*, because the electron *lacks* a location until it is observed and measured. This is one small step from saying that observation (human consciousness) *causes* the location of the electron. Heisenberg never actually said that, but his vaguely worded popular writing led New Agers to conclude that Heisenberg gave support to their occult doctrine that human consciousness causes the physical world.[30]

When Heisenberg published (in English) *Physics and Philosophy: The Revolution in Modern Science*, in 1959, his reference to revolution resonated with members of the New Age movement and the 1960s counterculture, who repeatedly referred to Heisenberg's proclamations about the role of observation in quantum mechanics.[31] These popularizations by Bohr and Heisenberg inspired a deluge of books linking quantum

physics to Eastern thought, such as Fritjof Capra's *The Tao of Physics* (1975), which reproduces Bohr's coat of arms and repeatedly cites the authority of Heisenberg.[32] Capra declared: "In modern physics, the universe is thus experienced as a dynamic, inseparable whole which always includes the observer in an essential way. In this experience, the traditional concepts of time and space, of isolated objects, and of cause and effect, lose their meaning. Such an experience, however, is very similar to that of the Eastern mystics."[33] Alas, Capra ignores fundamental differences between what physicists and mystics actually do.

Authentic Wisdom from the East

It's tempting to dismiss quantum mysticism for its lack of conceptual clarity and for its proponents' annoying habit of plucking religious practices from their historical contexts, but its persistence points to deeper truths in the dialogue between East and West. Ancient Western creation myths feature a person (Zeus, Yahweh, Allah) who created heaven and Earth. In the East nature emerged from nothingness (Brahma) and made itself by following the way (Tao) of nature. As Western science developed, it confirmed these ancient Eastern intuitions; the universe *did* emerge from nothing (in the Big Bang), and nature *does* make itself (by natural selection). In Taoism, Hinduism, and Buddhism, the goal of human beings is to become one with nature (through meditation and ascetic living), and, at death, to unite with the primordial void. These fundamental principles of Eastern thought are authentic wisdom from the East.

When the Theosophical Society relocated to India, the country was a colony of England, which denigrated the local culture as backward. At first Indians were thrilled that Westerners found value in their religions; Buddhist monks invited Blavatsky and Olcott to Ceylon (today Sri Lanka), where in 1880 they became the first Westerners to make a formal conversion to Buddhism.[34] On Blavatsky's death in 1891, the English political activist Annie Besant became leader of the society. She learned Sanskrit and studied Hindu texts; during World War I she campaigned for democracy in India and the end of British rule, which led to her election as president of the Indian National Congress, the anti-colonialist political organization, in 1917. But the leader of the independence movement, Mahatma (Sanskrit for "venerable") Gandhi, took over the congress and forced Besant out because she had a European vision of Indian culture. As a native of India, Gandhi was rooted in Hinduism and in tune with the needs of ordinary people. After India gained independence in 1947, some Indian intellectuals argued that to become a modern nation on a global stage India had to establish research laboratories controlled by Indian scientists, but Hindu scholars argued that the nation should study the Vedas in search of ancient truths that had been lost.[35] In the end the scientists won, and on May 18, 1974, Indian physicists detonated an atomic bomb, which, in a nod to tradition, they named "Smiling Buddha."

Hinduism is a relentless pursuit after truth, and if today it has become moribund, inactive, unresponsive to growth, it is because we are fatigued. As soon as the fatigue is over, Hinduism will burst forth upon the world with a brilliance perhaps never known before.

Mahatma Gandhi,
"What Is Hinduism?"
Young India, **April 24, 1924**

Early twentieth-century Indian artists were taught to speak English and to paint in styles of Western realism and Impressionism at the British-run Government College of Art and Craft in Kolkata (Calcutta), which Jamini Roy attended. As a mature artist in the 1930s, Roy rejected the Western approach and sought inspiration in traditional Indian folk art practiced by artisans in rural villages in Bengal, the region of South Asia that was the center of British India and Gandhi's freedom movement (today the area is divided between the Indian state of West Bengal and the country of Bangladesh). There Roy found inspiration in the folk art *patua*—painted scrolls on fabric in bright colors and bold outlines. Roy mixed *patua* with international abstract art, thereby achieving a modern Indian aesthetic.[36]

In Roy's painting of a Bengali mother and child (plate 12-25), the indigo-blue color of the woman's sari is a reference to Indian nationalism. In 1914 poor farmers whose families were starving revolted because they were not allowed to grow food but forced to plant the cash crop indigo (genus *Indigofera*), so that British landlords could extract valuable indigo dye and sell it for a profit. Gandhi travelled to the countryside and, after witnessing this needless famine, led a non-violent

12-25. Jamini Roy (Indian, 1887–1972), *Mother and Child*, ca. 1940. Tempera on board, 17 × 11¼ in. (43 × 28.5 cm). The Kumar Collection.

protest march—a *satyagraha* (Sanskrit for "standing up for truth")—on April 19, 1917, which marks the beginning of the Indian independence movement. Roy made this painting on the eve of Indian independence, which was achieved in 1947. The woman boldly looks straight ahead; she and her child are thriving. Indigo blue is no longer for privileged foreigners—it's her color. In the lower right, the artist signed his name, not in English but in Bengali.

The Cold War and the Arms Race: From Fission to Fusion

In 1956 the American physicist Clair Patterson first accurately calculated the age of Earth—4.5 billion years. Scientists already knew that the solar system was formed by a rotating cloud of hydrogen and that the sun and the planets are the same age, but questions remained. How could the sun emit light for 4.5 billion years? What is it made of?

In the early 1930s the German physicist Hans Bethe gave the first plausible explanation for what makes the sun shine by describing a sequence of nuclear reactions. The sun is made of a rotating cloud of hydrogen atoms (each with 1 proton). Bethe

hypothesized that two hydrogen atoms fuse to create helium (2 protons) and when they fuse there is a loss of mass, which is converted to energy in the form of electromagnetism—radio waves, microwaves, infrared radiation, visible light, ultraviolet radiation, x-rays, and gamma rays—causing the sun to shine. When Bethe made this hypothesis he was a professor of physics at the University of Tübingen, but he couldn't test his hypothesis in his laboratory because he thought (correctly) that hydrogen would fuse only at very high (thermonuclear) temperatures that do not exist on Earth. In 1933 Bethe was fired from his job by the Nazis because of his Jewish ancestry, so he relocated to the United States, where he went to work at Los Alamos National Laboratory on the atomic bomb. The fissioning of uranium creates temperatures as hot as those on the sun, and after the war Bethe and his colleagues did experiments to use thermonuclear heat to fuse hydrogen. They succeeded and proved Bethe's hypothesis correct: the energy of the sun is produced by nuclear fusion: $E = mc^2$. (Today scientists have confirmed that every second the sun converts 4 million tons of mass into energy.) By the early 1950s the United States and the Soviet Union were in a nuclear arms race, and Bethe (now a US citizen) joined the American effort to develop a new weapon using hydrogen fusion. On November 1, 1952, the American military detonated the first hydrogen fusion bomb (H-bomb) on an atoll (a coral reef island) in the Pacific Ocean, releasing 500 times the energy of the atomic bomb dropped on Hiroshima.

Since hydrogen fusion releases neutrons, physicists realized that they could build a bomb in layers, alternating the capacities for uranium fission and hydrogen fusion. When the core of uranium is fissioned, it strikes a thermonuclear "match" to fuse the hydrogen, which in turn releases neutrons that fission an outer blanket of uranium. A second H-bomb (with three layers: fission-fusion-fission) was detonated at Bikini atoll in the Marshall Islands in the Pacific Ocean on March 1, 1954. Why stop at three layers? Scientists around the world observed ominously that there is no theoretical limit to the number of layers with which such a bomb could be built. This 1954 H-bomb also released radioactive atoms (which are cancer-causing) into Earth's atmosphere, a side effect that scientists had not predicted. The whole globe received fallout of an isotope—a variation of an element that is radioactive and not found in nature—strontium-90, which has a half-life of 28.9 years.[37] This radioactive by-product of the second H-bomb is chemically similar to calcium, and thus the body mistakes strontium-90 for calcium and absorbs it into bone. Strontium-90 from the 1954 H-bomb will remain in the atmosphere and in the bones of vertebrates—all fish, reptiles, birds, and mammals on Earth—for another 150 years (plate 12-26).

Alarmed by these outcomes, Bethe joined Albert Einstein on the Emergency Committee of Atomic Scientists and urged the US government to end the nuclear arms race. In 1954 European scientists established the European Organization for Nuclear Research—best known by its French name, Conseil Européen pour la Recherche Nucléaire, abbreviated as CERN—to encourage the peaceful use of nuclear energy.

The animal, standing over 400 feet tall, which has ravaged Oto Island and now threatens Tokyo, is an extinct creature from the Jurassic age. Let us call it "Godzilla," according to the legend of Oto Island. What has brought this animal back to life? My analysis of its footprints shows the presence of strontium-90, which is produced only by the H-bomb. Thus I conclude that the radioactivity in our environment from the repeated H-bomb tests has caused the resurrection of Godzilla.

Professor Yamani, a physicist speaking at a press conference, in *Godzilla*, 1954

TOP

12-26. *Godzilla*, 1954. Film, directed by Ishiro Honda. Toho Company, Tokyo.

In this film, underwater testing of hydrogen bombs has brought back to life an ancient sea monster, Godzilla. To protect their island, the Japanese Self-Defense Forces construct a tall electrified fence along the coastline. Godzilla emerges from the water in Tokyo Bay, breaks through the 50,000-volt fence with its fiery breath, and destroys the city.

ABOVE

12-27. Major Kong riding the H-bomb, in *Dr. Strangelove; or: How I Learned to Stop Worrying and Love the Bomb*, 1964. Film, directed by Stanley Kubrick. Columbia Pictures, Los Angeles.

After an unhinged US Air Force general orders a nuclear attack on the Soviet Union, B-52 bombers take off carrying hydrogen bombs. The president of the United States, Merkin Muffley (played by Peter Sellers) tries to re-call the bombers, but he is unable to reach one plane. The commander of that aircraft, Major "King" Kong (played by Slim Pickens, a rodeo performer), releases the H-bomb over a Soviet site, riding it like a stallion and triggering a nuclear apocalypse.

Hello? Uh, hello? Hello, Dmitri? Listen, I can't hear too well, do you suppose you could turn the music down just a little? A-ha, that's much better. . . . Now then, Dmitri, you know how we've always talked about the possibility of something going wrong with the bomb. The BOMB, Dmitri. The hydrogen bomb. Well now, what happened is, uh, one of our base commanders, he had a sort of— Well, he went a little funny in the head. You know. Just a little funny. And uh, he went and did a silly thing.

Well, I'll tell you what he did. He ordered his planes . . . to attack your country.

Well, let me finish, Dmitri. Let me finish, Dmitri. Well, listen, how do you think I feel about it? Can you imagine how I feel about it, Dmitri? Why do you think I'm calling you? Just to say hello?

United States president Merkin Muffley speaking on a "hotline" to Soviet premier Dmitri Kissov, *Dr. Strangelove*, 1964

Located near Geneva on the Swiss-French border, today CERN operates the most powerful particle accelerator in the world. After Einstein's death, in 1955, Bethe continued the crusade and helped persuade the administrations of John F. Kennedy and Richard Nixon to sign, respectively, the Partial Nuclear Test Ban Treaty (1963) and the Anti-Ballistic Missile Treaty (1972; plate 12-27). In 1985 the number of active nuclear warheads (atomic bombs and hydrogen bombs) in the world peaked at 68,000; in 2018 the United Nations estimated that number had dropped to 10,000, but most of the 58,000 bombs were decommissioned and stored, not destroyed. Countries that have joined the "nuclear club," besides the United States (which detonated its first nuclear weapon in 1945) and Russia (1949), include the United Kingdom (1952), France (1960), Israel (1960), China (1964), India (1974), Pakistan (1998), and North Korea (2006).

Art about the Nuclear Arms Race

In the doomsday atmosphere of the nuclear arms race between the United States and the Soviet Union, Barnett Newman did a series of his "zip" paintings in black and white on the theme of the Passion of Christ (plate 12-28). The artist's goal was to express the moment in Christ's suffering described in Matthew 27:46, in the New Testament: "And about the ninth hour Jesus cried out with a loud voice, saying *Eli, Eli, lema sabachthani?*" This quote—Aramaic for "My God, my God, why hast thou forsaken me?"—is from Psalm 22:1, written by the shepherd David, who became the king of Israel. In other words, when Jesus reached his darkest hour, he was linked by this quotation to the leader of the Jewish people. Newman wrote: "The cry of *lema*—for what purpose?—this is the Passion and this is what I have tried to evoke in the paintings."[38] Thus in the aftermath of World War II, Newman, a Jew, chose this Jewish/Christian subject to communicate a question universally asked at times of excruciating anguish: For what purpose?

12-28. Barnett Newman (American, 1905–1970), *The Stations of the Cross: Lema Sabachthani*, 1958–1966 (six of the fourteen paintings are shown). Magna and oil on canvas, each 78 × 60 in. (198 × 152 cm). National Gallery of Art, Washington, DC, collection of Robert and Jane Meyerhoff.

12-29. Tetsuo, in *Akira*, 1988. Film, animation directed by Katsuhiro Otomo. TMS Entertainment, Tokyo.

Mark Rothko was commissioned to create a series of paintings for an ecumenical chapel in Houston, which opened in 1971. He filled the walls with large triptychs and panel paintings in shades of purple and black. A central skylight in the octagonal building illuminates the still, silent space. With these funereal colors and shadowy forms, Rothko expressed the human condition in the nuclear age.

The Japanese animator Katsuhiro Otomo expressed the apocalyptic mood of the nuclear arms race in his film *Akira* (1988), based on his six-volume manga (1982–90), which takes place in 2019 in futuristic Neo-Tokyo after World War III. The film begins in an earlier time, with a massive explosion caused by a child, Akira (symbolizing the atomic bomb), who has incomprehensible powers; the blast destroys Tokyo and triggers World War III. Neo-Tokyo is run by oppressive bureaucrats who build a massive military complex to protect the city from supernatural powers. But the greatest threat to the city comes from within its walls, where the streets are controlled by a lawless subculture of violent protesters and marauding biker gangs. One gang member, Tetsuo (symbolizing the next unknown calamity), crashes his bike in a fight with a rival gang (plate 12-29). In the aftermath, Tetsuo develops telekinesis—the ability to affect physical objects at a distance by mental effort—which he uses to destroy the military complex in this bleak, high-tech allegory about an uncontrollable force (nuclear energy). A somber mood is also created by Japanese artist Chiharu Shiota, who burned a grand piano and wooden chairs, then covered the ruin with a web, silencing the music (plate 12-30).

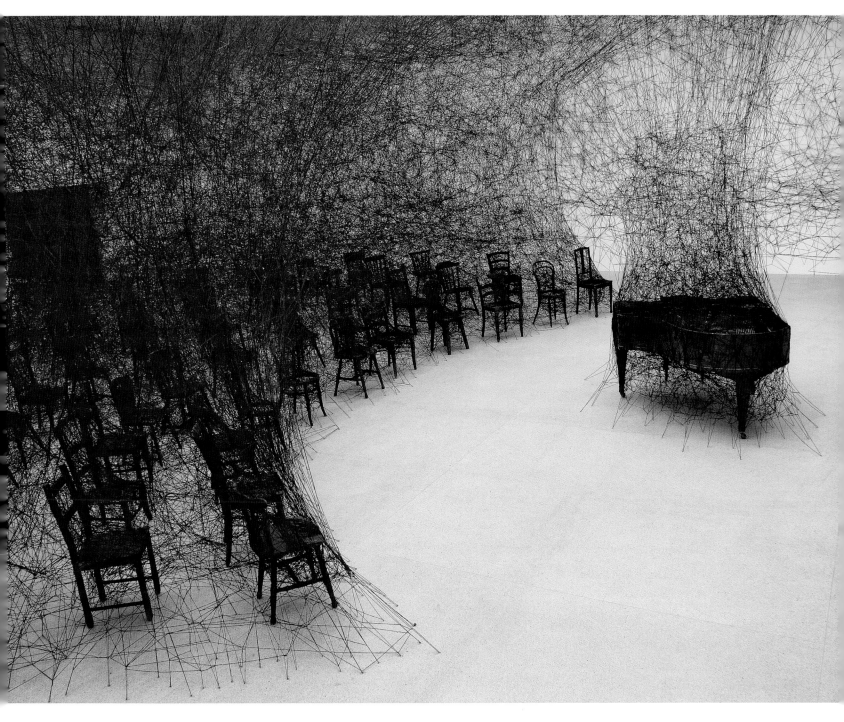

12-30. Chiharu Shiota (Japanese, born 1972), *In Silence*, 2008. Installation of black wool, burnt grand piano, and burnt chairs, in the Pasquart Kunsthaus Centre d'Art, Biel, Switzerland. © Chiharu Shiota. Courtesy Blain|Southern, Berlin.

13

The Computer and Post–1945 Geometric Art

We hope that machines will eventually compete with men in all purely intellectual fields.

Alan Turing, "Computing Machinery and Intelligence," 1950

IN 1936 A BRITISH graduate student at Princeton University, Alan Turing, did a thought experiment. He imagined there was a set of instructions that operated—like a machine—in a completely deterministic way (without human thought), along with an input-output device and a memory. He didn't intend to actually build a machine, but in September 1939 England declared war on Germany, and the British government recruited Turing to help decipher the military code created by the German encryption device Enigma. Turing designed a decoding procedure and built a computing machine—the first computer—which helped the Allies defeat Germany and win World War II. After the war, the computer industry began in England and the United States, quickly spread around the world, and soon artists were adopting the computer as a tool.

After 1945, German and Austrian artists no longer expressed confidence in the power of reason because their philosophical foundation was in ruins. As a living body of thought that was passionately believed and vigorously argued, German Idealism was damaged in the dismantling of European intellectual life during World War I and completely destroyed in World War II (see chapter 9). However, in Western countries that suffered losses but were not utterly destroyed, artists continued to express confidence in reason by creating geometric abstract art—including Concrete Art in Switzerland, Optical Art in France, Arte Programmata in Italy, Constructivism in Latin America, and Minimal Art in the United States. In Japan, artists created Mono-ha, a geometric style that embodies meditation on nature and on nothingness.

13-1. Elias Sime (Ethiopian, born 1968), *Tightrope 3*, 2009–14; detail of plate 13-5. Reclaimed electronic components and fiberglass on panel, 5 ft. 9 in. × 16 ft. (1.75 × 4.87 m). © Elias Sime. Courtesy of the artist and James Cohan, New York.

Ineffability and Incompleteness:
Ludwig Wittgenstein and Kurt Gödel

For two millennia Western mathematicians viewed Euclid's *Elements* as the foundation of geometry and arithmetic, so in 1826 it was unsettling when Nikolai Lobachevsky published the first non-Euclidean geometry, describing a surface with negative curvature. Another milestone in non-Euclidean geometry upended the Euclidean assumption that a plane is a flat surface where parallel lines never meet, when the German mathematician Bernhard Riemann described a spherical surface on which parallel lines cross, in "Über die Hypothesen, welche der Geometrie zugrunde liegen" (On the hypotheses underlying geometry; 1854/1867). Euclid did arithmetic only with finite numbers, so in his arithmetic, $x + 1$ is bigger than x (which is an example of Euclid's common notion: the whole is greater than the part). But the German mathematician Georg Cantor described a non-Euclidean arithmetic that uses an infinite number he called \aleph (aleph, the first letter in the Hebrew alphabet), which is the set of the counting numbers—1, 2, 3, and so on—in *Grundlagen einer allgemeinen Mannigfaltigkeitslehre* (Foundations of a general theory of manifolds, 1883). In Cantor's non-Euclidean arithmetic, $\aleph + 1$ is the same (infinite) size as \aleph.

After Euclid's *Elements* was dislodged from its position as the cornerstone of geometry and arithmetic, mathematicians defined new foundations for mathematics. The German mathematician David Hilbert determined that many of Euclid's assumptions—indeed, his most profound—had been left unstated. For example, Euclid assumed that geometry is a description of Earth and of Plato's Forms, and that axioms are necessary truths. Thus, Hilbert began his rebuilding of geometry by cutting the ties binding geometry to the world, and then he wrote axioms that are "formal" in the sense that they describe only the abstract structure of a system. For Hilbert, geometry is an arrangement of abstract, meaning-free signs within an internally consistent, self-contained structure. According to Hilbert, axioms are not necessary truths but hypotheses, which can be true or false. The mathematician assumes axioms and then sees what internally consistent, self-contained abstract structure follows from them (*The Foundations of Geometry*, 1899).

A decade before Hilbert published the axioms for geometry, in 1889 the Italian mathematician Giuseppe Peano had written the formal axioms for arithmetic. On the eve of World War I, Alfred North Whitehead and Bertrand Russell published the formal axioms for logic in a completely abstract symbolism—without any words (*Principia Mathematica*, 1910–13). Since axioms had been written for these major areas of mathematics, Hilbert suspected that there was one set of axioms from which derive the three sets of axioms for arithmetic, geometry, and logic. In other words, Hilbert suspected that there could be a deeper level to the foundation, and in 1920 he challenged mathematicians to find one set of axioms for all areas of mathematics written in the formal language of *Principia Mathematica*.

Hilbert's challenge (known as Hilbert's Program) was enormously influential because he was a professor at Germany's University of Göttingen, which was the world center of mathematics from the early nineteenth century to 1933. Many mathematicians worked to find the axioms, but within a decade Hilbert's hunch had been proven wrong by two Austrians: there is no set of axioms that can express every true statement in natural (spoken) language or in artificial (symbolic/mathematical) language. The first limitation of the axiomatic method was shown by the philosopher Ludwig Wittgenstein, who said that the universe (the set of all facts) cannot be described in spoken language, because in order to conceive of the whole universe, one must "step out" of the set and cease being one of the facts. Wittgenstein called what lies beyond the boundary of spoken language *das Mystische* (German for "the mystical"), ending his treatise: "Whereof one cannot speak, thereof one must be silent" (*Tractatus Logico-Philosophicus*, 1921).[1]

A decade after Wittgenstein proved this limit on spoken language, the logician Kurt Gödel proved a parallel result for an artificial language—the symbols for logic in *Principia Mathematica*. Gödel picked this artificial language because Whitehead and Russell had proved that arithmetic (a fundamental part of mathematics) is reducible to the logical symbolism of *Principia Mathematica*. Hilbert's challenge was not only to design a system with one set of axioms for all parts of mathematics but also to prove that the system is complete (every true statement formulated in mathematics can be proven within the system) and consistent (the set of axioms can never lead to a paradox). Furthermore, the system must have absolute consistency (the proof of consistency must be written in the language of the system itself—in other words, in the artificial language of *Principia Mathematica*). Gödel proved that Hilbert's challenge cannot be met.

There is an ancient biblical paradox attributed to the Apostle Paul, who wrote, referring to Epimenides, who was from the island of Crete: "One of themselves, even a prophet of their own, said, The Cretans are always liars" (Titus 1:12). If the Cretan is telling the truth, then he's lying; if the Cretan is lying, then he's telling the truth. Gödel structured his proof on a version of this paradox (see sidebar on this page). Gödel's proof means that there is an inherent limitation on what can be demonstrated within a formal system, and suggests that the products of human reason can never be fully formalized.

Since antiquity, people have known that self-reference can lead to a paradox. Gödel wrote his proof in the language of *Principia Mathematica*, which Whitehead

GÖDEL'S PROOF OF THE INCOMPLETENESS OF MATHEMATICS

Gödel showed how to construct a sentence Q (in the language of *Principia Mathematica*) that is logically equivalent to "Q is not provable" (in the *Principia Mathematica* system). Just as the Cretan said (referring to himself), "Cretans are liars," so Q asserts (of itself), "Q is not provable." The sentence Q is either true or false (it is either provable or not provable).

Alternative #1: Q is provable. Given that Q is equivalent to "Q is not provable," the first alternative leads to a paradox. Since the first alternative means that there is an (unacceptable) inconsistency in the *Principia Mathematica* system, we have to assume that Q is not provable.

Alternative #2: Q is not provable. Recall that Q is logically equivalent to the statement that it (Q) is not provable, so the statement "Q is not provable" is true. Therefore, Gödel has produced a true statement (in the language of *Principia Mathematica*) that cannot be proven (in the *Principia Mathematica* system), which means that the system is incomplete.

Furthermore, Gödel extended his proof and showed that not just *Principia Mathematica* but any set of axioms that can generate the positive whole numbers—1, 2, 3, etc. (the basis of mathematics)—*must* be incomplete ("On Formally Undecidable Propositions of *Principia Mathematica* and Related Systems," 1931).

and Russell designed to *prevent* self-reference (to avoid the danger of paradox). Gödel wanted to *create* a paradox, so he invented a parallel language (a numerical code) that mirrors that of *Principia Mathematica* and allows for self-reference. For the general public, Gödel's proof is much more important for this parallel language he invented to achieve his result than for the result itself: Gödel designed a numerical code that can translate any statement *in* mathematics or *about* mathematics into numbers. Once Gödel had translated statements into the number code, he then defined the relation between premises and conclusion as an arithmetical relation, and *computed* his result *mechanically*, just as a calculator does arithmetic (without human thought). Gödel's use of finite numbers and the operations of ordinary arithmetic—addition, subtraction, and so on—to achieve his stunning proof led mathematicians to investigate computation further. What else can be done with simple arithmetic?

Impossibility: Alan Turing

Meanwhile, in 1928, Hilbert had announced another challenge, the *Entscheidungsproblem* (German for "decision problem"): design a mechanical procedure that can be applied to any mathematical statement to determine whether it is true or false. Hilbert and many other mathematicians worked to find a solution, but twenty-four-year-old Alan Turing showed, in 1936, that there is no mechanical decision procedure. He did a thought experiment: imagine a machine with an input–output device, step-by-step rules, and memory (a "Turing machine"). Then imagine mapping machines to numbers the way Gödel had mapped mathematical statements to numbers. Turing's key insight was that self-reference is possible when a Turing machine operates on symbols, because the machine *is* symbols (its software and memory); in other words, a Turing machine can describe itself. Then suppose there is an "original" Turing machine, which, when applied to the number describing any other Turing machine, will tell whether or not that Turing machine (the "other" one) will *halt* (reach a decision) when fed any given number (any positive integer, some of which encode a mathematical statement). If there were such an "original" machine, it would provide a mechanical decision procedure for mathematical statements and solve Hilbert's *Entscheidungsproblem*. But Turing showed that if such an "original" machine (the solution to the decision problem) were to exist, he could use it to construct another Turing machine with self-contradictory properties. But a self-contradictory mechanical procedure is not logically possible, so the original machine *cannot* exist—there is no mechanical decision procedure—and the *halting* (decision) problem is undecidable (Turing, "On Computable Numbers, with an Application to the *Entscheidungsproblem*," 1936).

From Mechanical Proofs to Computing Machines

In the spring of 1938, Turing completed a doctorate in mathematics at Princeton University and returned home to England, which was preparing for the possibilty of war with Germany. The British government recruited Turing to join a top-secret team of mathematicians and logicians who were trying to break the military code encrypted by Germany's Enigma machine. Resembling a typewriter, an Enigma machine put the message into code by electrically scrambling the letters of the alphabet; by the end of the war, Polish, British, and American codebreakers had built several machines that were able to unscramble the messages and read virtually all German traffic. After the war, Turing pioneered artificial intelligence and introduced the "Turing test" for whether or not a machine can think (Turing, "Computing Machinery and Intelligence," 1950). But in 1952 Turing's career came to an end when he was convicted of homosexuality by a British court and forced to choose between grim punishments; two years later he committed suicide at age forty-one. In a cruel irony, Turing was destroyed by the country he had saved. Homosexuality was decriminalized in England in 1967.[2]

Meanwhile, John von Neumann added a significant feature to the Turing machine: the ability to store its operating instructions (software), so the machine would not have to be reprogrammed every time it was turned on. Stored operating instructions that could be updated without resetting wires or switches, together with a programming language, were the essential steps leading to effective general-purpose computers. Apart from Turing and Neumann, none of the early innovators foresaw the application of their ideas to the construction of an all-purpose digital computer.[3] Since the digital computer was developed, computer scientists have continually invented algorithms for storing and retrieving data, and programmers have devised software, while engineers have made computers smaller and more reliable, using vacuum tubes (1940s), transistors (1960s), integrated circuits, and microprocessors (1970s). Today a computer consists of input and output devices, hardware (which is permanent), an operating system (which is not changed except for updates), and software (programs that are regularly changed and can be switched on or off).

13-2. Herbert W. Franke (Austrian, born 1927), *Elektronische Grafik* [Electronic graphic], from the series Pendeloszillogramme [Pendular oscillogram], 1955. Oscillograph, 15¼ × 11¼ in. (38.7 × 28.5 cm). Kunsthalle Bremen. © Herbert W. Franke.

Computer Art

In the 1950s and '60s, the first people to experiment with the computer as an artistic tool were typically associated with companies or universities that could house and maintain the room-size machines that operated with vacuum tubes and transistors. For example, the Austrian engineer Herbert W. Franke, after completing a doctorate in physics at the University of Vienna in 1950, worked for the electronics company Siemens in Erlangen, Germany. There he began using an oscilloscope and camera to record oscillations of an electrical current (plate 13-2). In 1959 Franke showed his oscillographs in *Experimentelle Ästhetik* (Experimental aesthetics) at the Museum für Angewandte Kunst (Museum of Applied Arts) in Vienna. In Japan, Hiroshi Kawano studied Western philosophy (the German physicist Max Bense's information aesthetics), learned to program a computer, and in 1964 began generating images using a computer at the University of Tokyo. Using the computer printout as a guide, Kawano hand-painted the image in ink on paper (plate 13-3).

After the development of microprocessors in the 1970s, the size and cost of computers dropped dramatically, and personal computers became available for office, laboratory, and the art world. The Austrian artist Thomas Feuerstein has made computer technology the subject of his art. In a computer operating system, a *daemon* is a program that runs in the background and is not under the direct control of the computer's user. Computer scientists at the Massachusetts Institute of Technology in the 1960s named such a program after "Maxwell's demon," a character in one of James Clerk Maxwell's thought experiments who does an automated task.[4] Like demons in Greek mythology, neither a computer daemon nor Maxwell's demon has a bias toward good or evil. Feuerstein translated digital information into movement and sound in a computer installation he named *Daimon* (a variation of the word *daemon/demon*; plate 13-4). When Feuerstein's *Daimon* detects a daemon coming over the Internet into its server, the computers and cables begin to slowly vibrate, emitting low-frequency sounds, as if they're coming to life.

LEFT
13-3. Hiroshi Kawano (Japanese, 1925–2012), *Design 6 Data A*, n.d. Ink on computer paper, 67 × 11⅞ in. (170 × 30 cm). Zentrum für Kunst und Medientechnologie, Karlsruhe, Germany.

OPPOSITE, TOP
13-4. Thomas Feuerstein (Austrian, born 1968), *Daimon*, 2007. Computer and audio installation in the Tiroler Landesmuseum Ferdinandeum, Innsbruck, Austria. Software by Peter Chiochetti. Courtesy of the artist.

OPPOSITE, BOTTOM
13-5. Elias Sime (Ethiopian, born 1968), *Tightrope 3*, 2009–14. Reclaimed electronic components and fiberglass on panel, 5 ft. 9 in. × 16 ft. (1.75 × 4.87 m). © Elias Sime. Courtesy of the artist and James Cohan, New York.

Today all types of digital equipment—computers, cell phones, compact disks—are continually improved and rapidly become obsolete, creating a mountain of electronic waste that poses risks to the environment and human health. To evaluate the threat, the United Nations established the Global E-Waste Monitor, which predicts that by 2021 the amount of global electronic trash (e-waste) will total 52.2 million tons per year.[5] The artist Elias Sime is based in Addis Ababa, Ethiopia, where he buys e-waste that has been shipped in bulk from the West. He makes order from this chaotic debris by precisely fitting pieces together by hand with extreme care to create abstract art, as in *Tightrope 3* (plates 13-1, chapter frontispiece; and 13-5). From circuit boards, wires, and batteries, Sime creates patterns that look like an urban map, a reference to the delicate balance—as on a tightrope—a city like Addis Ababa must maintain to survive and thrive.

Video Art

The Korean artist Nam June Paik graduated from the University of Tokyo with a thesis on the Austrian composer Arnold Schoenberg, and then studied at the University of Munich with the Greek musicologist and pianist Thrasybulos Georgiades. While in Germany, Paik met the American composer John Cage and began participating in activities of the experimental art group Fluxus. Inspired by Cage's use of noise in his music, Paik created an art exhibition of altered television sets—scattered on their sides, upside down—and used magnets to distort their sounds and images. Paik made the TVs interactive, responding to the movements of visitors to the installation, at the Galerie Parnass in Wuppertal, Germany (*Exposition of Music: Electronic Television*, 1963). For decades after this exhibition, Paik created electronic moving images as fine art, as in *Mirage Stage*, of 1986 (plate 13-7). The title, a theatrical term that refers to a large stage, evokes what the viewer sees when standing before the multiple screens of *Mirage Stage*. Each monitor shows rapid-fire images from Paik's works in a silent, sound-free environment.

Austrian artist Peter Weibel's 1977 installation *Video Lumina* (Latin for "I see light") is a philosophical musing on the essence of video art. In a room are seven monitors placed at different heights and angles, all showing the same eye, which occasionally blinks simultaneously on all seven screens (plate 13-6). *Video Lumina* is the counterpart to a *camera obscura* (Latin for "dark room"). In a camera, light goes *into* a dark box and is recorded on film; in video, light emanates *from* a dark box and is recorded on the viewer's retina. Therefore, unlike photography, video breaks down the subject-object distinction, because the viewer experiences the (subjective) gaze of an eye looking out from a monitor, at the same time the viewer is looking at the (objective) electronic source of the light. As Weibel explained: " If you look closely at the eye on the screen, you can see the camera in the pupil. In the image one also sees the imaging organ. The (feigned) immediacy and subjectivity of the gaze is reflected in its technical and objective conditions. The image chain breaks through subjectivity."[6]

13-6. Peter Weibel (Austrian, born 1944), *Video Lumina*, 1977. Installation of seven TV monitors.

13-7. Nam June Paik (Korean, 1932–2006), *Mirage Stage*, 1986. Three-channel video (Betacam SP and DVD; color, silent, continuous projection), 33 TV monitors, and 40 wooden TV carcasses, width 20 ft. (6.1 m). Museo Nacional Centro de Arte Reina Sofía, Madrid. © Nam June Paik Estate.

Concrete Art in Switzerland

Despite the fact that the basis of the mathematical approach to art is in reason, its dynamic content is able to launch us on astral flights which soar into unknown and still uncharted regions of the imagination.

Max Bill, *Mathematical Approach to Contemporary Art*, 1949

Beginning in Zurich in the 1930s a group of artists painted colorful forms arranged in symmetrical patterns in a style they called Concrete Art. The leader of the group, Max Bill, studied graphic design at the Bauhaus in 1927–28. Then in 1938, Bill did a portfolio of prints, *Fifteen Variations on a Theme*, that resonates with a theme from Albert Einstein's cosmology: space can be transformed from one viewpoint to another by the use of rules that preserve the original design (plate 13-8). Switzerland remained neutral during World War II, even as the country was surrounded on her three borders by Hitler's Germany, Mussolini's Italy, and Nazi-occupied France. During this time, Bill interpreted his art as symbolizing order in the midst of chaos, and after the war he became founding director of the Hochschule für Gestaltung, in Ulm, Germany, where he designed functional objects to promote peaceful living in post-war Europe. Bill's international reputation grew, and in 1950 he was given a retrospective exhibition by the Museu de Arte Moderna in São Paulo, Brazil.

The first-generation Swiss Concrete artists were joined in the 1950s by Karl Gerstner, an artist in his twenties who shared their interest in geometric abstraction and Einstein's cosmology. In 1956 Gerstner devised a modular system—a movable palette with 196 hues in 28 groups—for experimenting with progressions that link form with color (plate 13-9).

RIGHT

13-8. Max Bill (Swiss, 1908–1994), *Variation 1*, from the portfolio *Fifteen Variations on a Theme*, 1935–38, published as a suite (Paris: Éditions des Chroniques du Jour, 1938), reprinted in *Max Bill, Maler, Bildhauer, Architekt*, ed. Thomas Buchsteiner and Otto Letze (Ostfildern-Ruit: Hatje Cantz, 2005), 228–32. 16 lithographs, each 12 × 12⅝ in. (30 × 32 cm). Used with permission.

OPPOSITE

13-9. Karl Gerstner (Swiss, 1930–2017), *Polychrome of Pure Colors*, 1956–58. Printer's ink on cubes of Plexiglas, each 1¼ × 1¼ in. (3 × 3 cm), fixed in a metal frame, 18⅞ × 18⅞ in. (48 × 48 cm). Courtesy of the artist.

Shown here are four of myriad possible arrangements of Gerstner's palette of 196 movable colored cubes.

Optical Art in France

As a young artist, François Morellet learned about the art of Max Bill while visiting São Paulo and was inspired by Swiss Concrete Art to launch a career in geometric abstraction. Like Bill, Morellet made art by passively performing a task following precise rules that generate a regular pattern (plate 13-10).

The Hungarian painter Victor Vasarely left Budapest in 1930 and settled in France, where he developed a geometric style to express "the internal geometry of nature" ("Yellow Manifesto," 1955). Vasarely created paintings that are active optically in the sense that the viewer looks at a flat surface but perceives a warp or motion (plate 13-11). In 1955 he curated an exhibit that included works by himself, the Venezuelan artist Jesús Rafael Soto (plate 13-18), Israeli sculptor Yaacov Agam, and Swiss sculptor Jean Tinguely. The exhibition, *Le Mouvement* (Movement, 1955, Galerie Denise René, Paris), launched Optical Art.

In 1961 in Paris the Groupe de Recherche d'Art Visuel (Group for Research on Visual Art) was founded by an international set of artists: Morellet, Vasarely's son Jean-Pierre Vasarely (known as Yvaral), the French painter Joël Stein, the Argentine artists Julio Le Parc and Horacio García Rossi, and the Spanish sculptor Francisco Sobrino. As the name implies, the group took a scientific approach, studying Gestalt psychology and the perception of motion, together with optical effects of form and color.

Arte Povera and Arte Programmata in Italy

In the 1960s Italian artists challenged the commercialization of art by making objects from humble, impermanent materials such as rags and twigs, prompting critic Germano Celant to name the style Arte Povera (Italian for "poor art"). In 1969 one protagonist, Giuseppe Penone, carved the first of his series Alberi (Trees), which was on the geometry of growth. A tree grows by adding layers of tissue to its trunk, which in cross section appear in rings, and its age can be determined by counting the rings. In this sculptural series, Penone removed bark and outer growth rings from a mature tree until he reached a metaphorical sapling—hidden life—at the core of the old tree (plate 13-12).

In Milan, artists pursued technology in the tradition of Italian Futurism. Designer Bruno Munari and writer Giorgio Soavi curated an exhibition of abstract art that incorporated computer ideas and equipment, *Arte Programmata* (Programmed art, 1962), which was displayed at the Olivetti showroom in Milan's dramatic nineteenth-century Galleria shopping mall. At this time Gianfranco Chiavacci took a computer-programming course and became fascinated with binary relations, which have intrigued philosophers since Pythagoras: light/dark, hot/cold, up/down. Self-taught as an artist, Chiavacci never used a computer to make art but rather employed binary logic to generate patterns that he painted by hand (plate 13-13).

ABOVE

13-12. Giuseppe Penone (Italian, born 1947), *Albero Porta* [Tree door], 1993, from the series Alberi [Trees]. Sequoia wood, 100¾ × 47¼ in. (256 × 120 cm). Private collection. Courtesy of the artist and Gagosian Gallery, New York.

RIGHT

13-13. Gianfranco Chiavacci (Italian, 1936–2011), *GF0296*, 1969. Oil on wood, 18 × 31½ in. (45.7 × 80 cm). Courtesy Sous Les Etoiles Gallery, New York, and the estate of Gianfranco Chiavacci, Pistoia, Italy.

Geometric Abstraction in Iran: Monir Farmanfarmaian

World War II and subsequent wars in the Middle East caused massive population shifts. The Iranian artist Monir Farmanfarmaian was forced to relocate several times, and her art fuses traditions from her native Tehran and her adopted home in New York. After studying art in the 1940s at the University of Tehran, she planned to study in Paris, but after the Nazi occupation of France, she instead went to New York and entered Abstract Expressionist circles. At this time, Iran was ruled by a shah (monarch), Mohammad Reza, who was put in power in 1941 with support from the United States and Britain. After returning to Iran in 1957, Farmanfarmaian began creating mosaics from mirrors by mixing modernist abstract design with patterns from traditional Persian textiles and tiles. In February 1979 she was visiting New York, when the shah was deposed during the Islamic Revolution. As Farmanfarmaian was a member of the elite ruling class, her home was confiscated and her artwork destroyed, and so she was exiled in New York. In 1992 she was able to return to Tehran, where she continues to make reliefs that mix Middle Eastern traditions with Western geometric abstraction (plate 13-14).

13-14. Monir Farmanfarmaian (Iranian, born 1922), *Third Family—Decagon*, 2011. Mirror, reverse-glass painting, and PVC, 46 × 48 × 11¼ in. (116.8 × 122 × 28.5 cm). Haines Gallery, San Francisco.

Constructivism in Latin America

The Brazilian government associated geometric art with orderly social progress, and so in 1948 it funded museums of modern art in São Paulo and Rio de Janeiro, and launched an international art fair, the São Paulo Biennial in 1951. When Max Bill won the grand prize at the first biennial, geometric abstraction was adopted by young Brazilian artists, some of whom travelled to the Hochschule für Gestaltung in Ulm to study with Bill.[7]

Waldemar Cordeiro was raised in Italy by his Italian mother and Brazilian father, and he moved to São Paulo in 1945, at age twenty. In 1952, he formed the Grupo Ruptura (Portuguese for "ruptured group"), which adopted the Russian Constructivist style of geometric abstraction (see chapter 5).[8] Cordeiro advocated creating art in complete objectivity, which attracted him to computer technology. In 1972 he created *Gente Ampli 2* (plate 13-15) by abstracting a photograph of a crowd of people and printing the computer output on paper.

13-15. Waldemar Cordeiro (Italian-born Brazilian, 1925–1973), *Gente Ampli 2* [Ample people 2], 1972. Computer output on paper, 52⅞ × 28½ in. (134.5 × 72.5 cm). Museum of Modern Art, New York, Latin American and Caribbean Fund.

The Italian artist Lucio Fontana, born and raised in Argentina, set up a studio in Milan in the 1930s. To escape World War II, he spent 1940 to 1948 in Buenos Aires, where he opened an art academy, Escuela de Arte Altamira. He proclaimed a new art of space and time, echoing themes related to Einstein's theory of relativity: "Color, the element of space, sound, the element of time and the movement that takes place in time and space, are the fundamental forms of the new art, which contains the four dimensions of existence. Time and space" ("Manifiesto blanco" [White manifesto], 1946).[9] In this and other writings, Fontana formulated his theories about an environmental art—Spazialismo (Italian for "spatialism")—in which his medium was light. In *Spatial Environment in Black Light* (1949), Fontana created art with energy (light) by completely blackening the interior of the Galleria del Naviglio in Milan and hanging amorphous forms covered with fluorescent paint, which he lit with ultraviolet light. Viewers entered the total darkness, and after a few minutes their eyes were adapted for night vision, and the phantom forms appeared. In 1949 Fontana produced a work of art by stretching a canvas and then puncturing it with holes to create passageways between the terrestrial world (the artist's canvas) and the universe (metaphorically the void beyond the canvas). Reflecting on his Buchi (Holes) series, the artist has stated: "I made a hole in the canvas to suggest the expanse of cosmic space that Einstein had discovered. Light and infinity pass through these holes; there is no need to paint."[10] In keeping with post-war gestural abstraction (such as American Abstract Expressionism, French Tachism, and Japanese Gutai), Fontana also slashed the canvas in his Tagli (Cuts) series (plate 13-16).

13-16. Lucio Fontana (Argentine-born Italian, 1899–1968), *Waiting*, 1960, from the series Tagli (Cuts). Museo d'Arte Contemporanea, Milan.

Argentine artists in the Asociación Arte Concreto-Invención (Spanish for "concrete-invention art association"), such as Tomás Maldonado, created paintings with a strong physical (concrete) presence (plate 13-17). The artist has described his desire to remove from painting any lingering spatial illusion: "We began by breaking with the traditional format of the painting."[11] In other words, the Concreto-Invención artists invented the shaped canvas. In 1954 Max Bill invited Maldonado to teach at the Hochschule für Gestaltung in Ulm, and Maldonado directed the school from 1964 to 1966.[12]

Artistic expression ended in Argentina in 1966, when a coup installed a military dictatorship that decimated cultural life during the decades-long state-sponsored killing of civilians in the Guerra Sucia (Spanish for "dirty war"). The political turmoil subsided with the return of civilian rule in 1983.

Venezuelan artists travelled to Paris in the 1950s and formed the émigré group Los Disidentes (Spanish for "the dissidents"), which included Jesús Rafael Soto, whose artworks are kinetic in the sense that they move or their appearance changes when the viewer moves. For example, Soto superimposed similar geometric patterns slightly out of alignment so that the moving viewer observes the wavy lines known as moiré patterns (plate 13-18). During the 1952–58 rule of the Venezuelan dictator Marcos Pérez

OPPOSITE

13-17. Tomás Maldonado (Argentine, 1922–2018), *Desarrollo de 14 Temas* [Development of 14 themes], 1951–52. Oil on canvas, 78⅞ × 82¾ in. (200.3 × 210.2 cm). Colección Patricia Phelps de Cisneros.

LEFT

13-18. Jesús Rafael Soto (Venezuelan, 1923–2005), untitled, 1956. Paint on Plexiglas, wood, and metal screws, 21¾ × 21⅞ × 13 in. (55.2 × 55.6 × 33 cm). Museum of Fine Arts, Houston, Caroline Weiss Law Endowment Fund.

Jiménez, the visionary architect Carlos Raúl Villanueva designed a new campus for the Universidad Central de Venezuela in Caracas. In 1952 Villanueva invited Soto to create public art for the campus. Other government commissions followed, and Venezuela became a vibrant center for contemporary art in the Constructivist style.[13]

Minimal Art in the United States

In the first decades of the twentieth century, Russian Constructivist artists Aleksandr Rodchenko and Vladimir Tatlin defined the essence of painting as a flat monochrome surface, and the essence of sculpture as a simple geometric form (see chapter 5). From the 1920s onward, color and form became the vocabulary of visual art. In the 1960s Minimal artists again defined the essence of painting and sculpture and came up with exactly the same definitions. Elsewhere I've written a detailed account of this bizarre rerun;[14] a brief summary follows.

By the early 1960s the Cold War was over, European refugees had returned home, and the pathos of the Abstract Expressionists had passed into history. The American artists of the next generation were energized by being citizens of the new political and economic superpower. Donald Judd, Dan Flavin, and other so-called Minimal artists redefined the essence of art (which everyone already knew) because they were swept up in a wave of enthusiasm since New York had become an international art center after the post-1945 decline of Europe. New York after World War II was a different historical context than Moscow during the Russian Revolution, and therefore American artists (and critics) made a claim that the Russians never did. Rodchenko and Tatlin

defined the essence of art (color on canvas, form in steel) as the *means* to an end. After living through the political upheaval of the Russian Revolution and its aftermath, these artists applied colors and forms to practical designs for the new Communist state. Minimal artists, on the other hand, defined the essence of art (color and form) as an *end in itself;* according to Judd and Flavin, color and form should neither be applied to some meaning-filled practical task nor interpreted in terms of symbolism nor given a transcendental reference (plates 13-19 and 13-20).

Minimal art also occurred after the atomic bomb and the destruction of Russian and Germanic culture by Stalin's brutality and Hitler's fascism, when Western culture entered an era of cynicism and dread during the Cold War and the volatile 1960s. The American focus on "just the facts" was part of the unmasking of metaphysical certitudes that occurred throughout Western culture after 1945, and it also reflected a more general anti-metaphysical atmosphere that pervades modern secular thought. The goal of certain (not all) artists associated with Minimal Art was to make painting and sculpture devoid of meaning (in the many senses of that word). Rodchenko, Tatlin, and other Constructivist artists *never* did this.[15] Early twentieth-century abstract artists in Russia, Poland, Germany, Austria, and Switzerland—even when they made art in factory-style anonymity—developed a meaning-free vocabulary as a *tool,* a visual *language,* with which to communicate important content, as art always has.

RIGHT

13-19. Donald Judd (American, 1928–1994), untitled, 1968. Wood, metal, and Plexiglas. Private collection.

FAR RIGHT

13-20. Dan Flavin (American, 1933–1996), *Monument for V. Tatlin,* 1968. Fluorescent fixtures. Private collection.

Maximal Art in Germany

Born after World War II, Wolfgang Laib lives a contemplative life close to nature in rural Germany. He was educated in science, but in 1975 he left medical school and created his first "milkstone," a square slab of white marble over which he pours fresh milk each day, giving it symbolic associations to anointment and consecration (plate 13-22). Laib has stated: "The milkstones are a direct answer to what I left, to what I found milk and stone to be about. Milk is not what I was taught in hygiene. You can learn everything about this liquid but have no idea what it is."[16]

Laib roams the countryside gathering pollen to use to make a luminous square on the floor (plate 13-21). At the close of each exhibition he carefully gathers up the pollen and puts it in glass storage jars: "Milk or pollen are extremely beautiful, like the sun or the sky. And why be afraid of beauty? Recently so many artists, especially German artists, seem to think that art has to be as ugly and brutal as possible. They say 'Beauty is bourgeois'—what a strange idea. It is my great fortune to participate in beautiful things."[17]

Mono-ha in Japan

Artists associated with Mono-ha (Japanese for "school of things") were born during World War II, grew up during the American occupation, and were in their twenties in the 1960s during the civil unrest prompted by the first renewal of the US-Japanese security treaty (Anpo) in 1960 and the student riots that swept Japan and the West in 1968. By the late '60s, as the second renewal of Anpo approached, Japanese citizens protested that allowing US troops to be stationed in Japan made their country a staging ground for American support of South Vietnam in its war against the North, which was in turn supported by the Soviet Union, China, and their Communist allies. Like the Korean War (1950–53), the Vietnam War (1955–75) was a proxy war—a Cold War battle instigated by the United States and the Soviet Union but fought on Asian soil. When the Japanese government renewed Anpo in 1970, there were huge protests against American control of Japanese territory. Many Japanese also objected to the continued American presence on the Japanese island of Okinawa, which includes thirty-two military bases that take up about one-fourth of the island. In a sign of the mounting tensions, on the night of December 20, 1970, violence erupted spontaneously between 5,000 residents of Okinawa and 700 American soldiers; by dawn many were injured, and much of one US air base had been destroyed by handmade Molotov cocktails (bottles filled with a flammable liquid) thrown by residents.

By 1970 Japan had made tremendous advances in technology and industry. It had one of the world's largest economies, second only to that of the United States, and a massive export market in cars made by Toyota, Honda, Nissan, Mazda, and Subaru; televisions by Sony; cameras by Canon and Nikon; guitars by Yamaha; and aircraft by Mitsubishi. But for many, these economic gains had come at a loss of traditional Japanese values of spirituality and connection to nature.

Mono-ha artists, such as Sekine Nobuo, express the essence of Japanese identity in the modern world by merging abstract art, which is an artistic expression of the Western scientific worldview, with Buddhist and Taoist philosophy. The particular abstract art on which Sekine bases his work is Russian Constructivism, in which the painting or sculpture is a meaning-free, physical object. Sekine learned this approach from his teacher at Tama Art University in Tokyo, Saito Yoshishige, who in turn learned it from a leading theorist of Russian Constructivism, the artist and writer David Burliuk (see chapter 5). Burliuk defined painting as a meaning-free physical object: "Painting is a colored space. . . . The component elements into which the essential nature of painting can be broken down are: I. line, II. surface, III. color, IV. objecthood (*faktura*)."[18] By "objecthood" Burliuk meant the painting as a physical object.

Burliuk visited Japan in 1920–22, bringing with him hundreds of examples of Russian Constructivism, and he curated the *First Exhibition of Russian Paintings in Japan*, which showed 473 works by twenty-eight artists, including Tatlin.[19] The exhibition

I would call back at least for literature this world of shadows we are losing. In the mansion called literature I would have the eaves deep and the walls dark, I would push back into the shadows the things that come forward too clearly, I would strip away the useless decoration. I do not ask that this be done everywhere, but perhaps we may be allowed at least one mansion where we can turn off the electric lights and see what it is like without them.

Tanizaki Jun'ichiro,
In Praise of Shadows, 1933

opened at the Hoshi Pharmacy Company in Tokyo, then travelled to Osaka and Kyoto, where it was shown in department stores (in the 1920s Japan did not have Western-style art galleries). The Russian artist Varvara Bubnova was also in Japan. After 1917 she had been active in the Institut Khudozhestvennoy Kultury (Institute of Artistic Culture) in Moscow along with Rodchenko and Varvara Stepanova. In 1922 Bubnova moved permanently to Japan, where she published several articles about Rodchenko and Constructivism. The Russian art theorist Aleksei Gan wrote a key book on the style, *Konstuktivizm* (Constructivism; 1923), which was translated into Japanese in 1927.

Saito Yoshishige was a teenager when he first saw Russian Constructivist art and watched Burliuk paint: "In about 1920, when I was in middle school, I saw an exhibition of David Burliuk's work. . . . I think it was my first introduction to abstract art. . . . I also watched him paint. At the time I believed that one had to paint from an object. But he had no model; he used the brush as if he were inscribing a manuscript. I watched him, totally stupefied."[20] Saito developed as an artist under the influence of Russian Constructivism, and in the 1930s he made wooden reliefs painted in monochrome in a series entitled Toro-Wood (plate 13-23). After World War II, he began making large-scale sculptural installations using planks of painted wood. Like the work of Rodchenko, Saito's Toro-Wood series and his post-war installations are meaning-free objects. The art is not about anything but simply exists in the natural world, as a tree or a stone exists. From 1964 to 1973 Saito taught at Tama Art University, where Sekine was his student. A devoted follower of Laozi and a reader of Western philosophy, Saito encouraged his students to think deeply about the philosophical foundations of their art.

13-23. Saito Yoshishige (Japanese, 1904–2001), *Toro-Wood*, 1939/reconstructed in 1973. Acrylic on plywood, 39⅜ × 47¼ in. (100 × 120 cm). National Museum of Art, Osaka.

Like the Russian Constructivists, Saito emphasized the physical surface of the this relief by cutting holes in it. In Japanese, *toro* is the name of the specific part of a tuna that is used to make sushi. When Saito painted one of his early wooden reliefs red, it looked like a rectangular piece of reddish fish (toro) lying on wood, so he gave it the name *Toro-Wood*. Saito made the series in the late 1930s, but it was destroyed in the war, so he replicated it in 1973. The artist described the series: "I made my Constructivist works in my late twenties when I started making art again and was influenced by German and Russian Constructivism. Later I decided to go beyond the 'ism' of Constructivism, and I started experimenting. I finally arrived at the series of *Toro-Wood*. It was before the war and I took many roundabout ways" ("Ki no ato: Saito Yoshishige to kataru," *Saito Yoshishige-ten* [Tokyo: Tokyo Metropolitan Art Museum, 1984], 8–17; trans. Reiko Tomii, as "Trajectory of Wood: Talking with Saito Yoshishige," in "Readings in Japanese Art after 1945," *Japanese Art after 1945: Scream Against the Sky*, ed. Alexandra Monroe [New York: Abrams, 1994], 379).

In 1968 in a park in Kobe, Sekine dug a huge cylindrical hole and then packed the removed soil into a cylinder of the same dimensions (plate 13-24). The artist titled the work *Phase—Mother Earth*, borrowing the term *phase* from physics, where it refers to the transformation of one form (phase) to another. The following year Sekine made a sculpture in which water is moved from one place to another, *Phase of Nothingness—Water* (plate 13-25). In the Constructivist spirit, Sekine created this sculpture as a meaning-free object: "In the midst of the world just as it is, all I can do is make things just as they are and show this vividly."[21]

The spokesman for Mono-ha, Korean-born Lee Ufan, came to Japan in 1956 to study philosophy at Nihon University in Tokyo. Educated in German Idealism and Edmund Husserl's phenomenology, Lee also read ancient texts by the founders of Taoism, Laozi and Zhuangzi. By combining philosophical concepts from Europe and Asia, Lee was following in the footsteps of Japan's foremost twentieth-century philosopher, Nishida Kitaro, who in 1926 described his vision for a modern Japanese philosophy:

> It goes without saying that there is much to admire . . . in the impressive
> achievements of Western culture, which thought form as being and the
> giving of form as good. However, does there not lie hidden at the base of
> our Eastern culture, preserved and passed down by our ancestors for several
> thousand years, something which sees the form of the formless and hears the
> voice of the voiceless? Our hearts and minds endlessly seek this something;
> and it is my wish to provide this quest with a philosophical foundation.[22]

In Western philosophy there are fundamental dualisms, such as the distinction between the *subject* (observer/perceiver) and the *object* (of observation/perception). During the Enlightenment, René Descartes introduced the related dualism between mind and matter, which culminated in the German Idealism of Immanuel Kant, according to whom one knows only mind. The everyday *material* world of raindrops, birds, and flowers "remains unknown to us" (Kant, *Critique of Pure Reason*, 1781).[23] If philosophers accept these dualisms, then they cannot explain how a person sees the natural world (rain, birds, flowers), because subject and object, mind and matter are different substances, which, by definition, cannot interact. To solve the problem the second-generation German Idealists, led by G. W. F. Hegel, revived the ancient Greek Pythagorean/Platonic tradition in which there are no dualisms because everything is made of one substance—monads (see chapter 1).

Nishida proposed a different solution to the problem: there are no dualisms in the Zen Buddhist concept of nothingness—Brahma. In the Buddhist and Taoist traditions, one knows nature by emptying one's mind of peripheral thoughts and focusing on nothingness. Just as Hegel revived Plato, Nishida revived Zhuangzi (a contemporary of Plato), who wrote in the fourth century BC: "Embody to the fullest what has no end

ABOVE

13-24. Sekine Nobuo (Japanese, born 1942), *Phase—Mother Earth*, 1968. Earth and cement, height × diameter of cylinder and hole 86⅝ × 106¼ in. (220 × 270 cm), installation in the *First Kobe Suma Rikyū Park Contemporary Sculpture Exhibition.* Courtesy of the artist, and Blum and Poe, Los Angeles.

LEFT

13-25. Sekine Nobuo (Japanese, born 1942), *Phase of Nothingness—Water*, 1969/2012. Steel, lacquer, water; in two parts: cylinder height × diameter 47¼ × 47¼ in. (120 × 120 cm); rectangle 11⅞ × 86⅝ × 63 in. (30.2 × 220 × 160 cm). Courtesy of the artist and Gladstone Gallery, New York.

and wander where there is no trail. Hold on to all that you have received from heaven but do not think you have gotten anything. Be empty, that is all. The perfect man uses his mind like a mirror—going after nothing, welcoming nothing, responding but not storing."[24]

Lee established himself as the spokesman for Mono-ha by publishing a series of essays on Sekine's art. In "World and Structure" (1969), Lee, echoing Nishida, described the dualisms that are presuppositions of the modern Western artist, who makes a painting or sculpture by imposing form on nature. Instead of imposing form, Sekine lets the world reveal itself. As Lee wrote of Sekine's *Phase—Mother Earth*: "Sekine's act, then, does not mean to turn the world into an object of cognition as with the case of *objet* [using Descartes's French term] but to liberate it amidst non-objective phenomena, into the realm of perception; that is, to let the world be in its own being."[25] In Russian Constructivism, Rodchenko did not see form as an end in itself but as a means to communicate meaning. Like Rodchenko, Sekine *gave* his forms meaning—a distinctly Asian meaning—by relating the forms to nature and to the concept of nothingness. *Phase—Mother Earth* is made of soil (nature) and a void (nothingness); *Phase of Nothingness—Water* is made of water (nature) and an empty vessel (nothingness).

ABOVE AND OPPOSITE

13-26. Endo Toshikatsu (Japanese, born 1950), *Void-Blackening*, 2015. Wooden sphere, diameter 45⅝ (116 cm). SCAI The Bathhouse, Tokyo.

The finished sculpture is exhibited in an art gallery with photographs of its making displayed on the wall.

Mono-ha has had a profound influence on the next generation of Japanese artists, such as Endo Toshikatsu. To create *Void-Blackening* (plate 13-26), Endo rubbed a wooden sphere with tar and set it aflame, demonstrating the transformative power of the forces of nature. As the artist has said: "It is within the cosmological relation—where human life becomes linked with fire, earth, water, air, sun and other physical elements of the universe—that the material imagination can become manifest and bring meaning."[26]

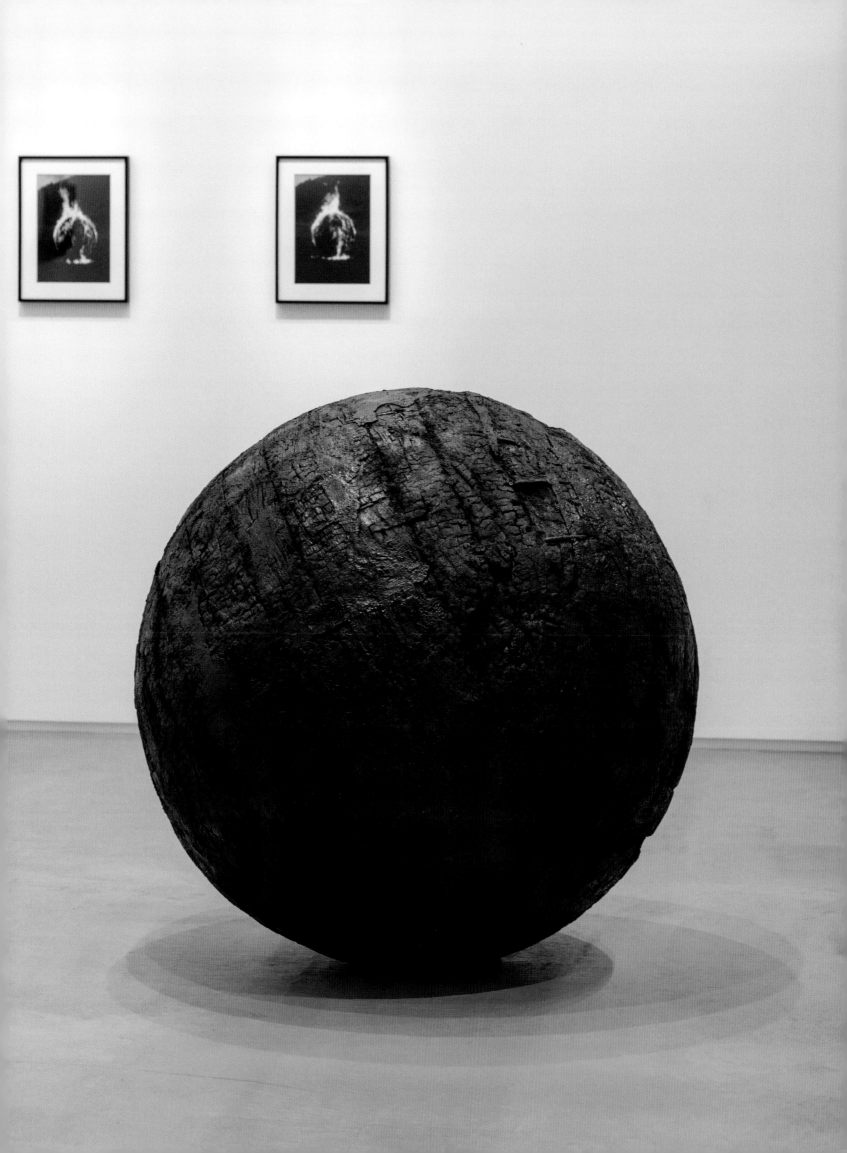

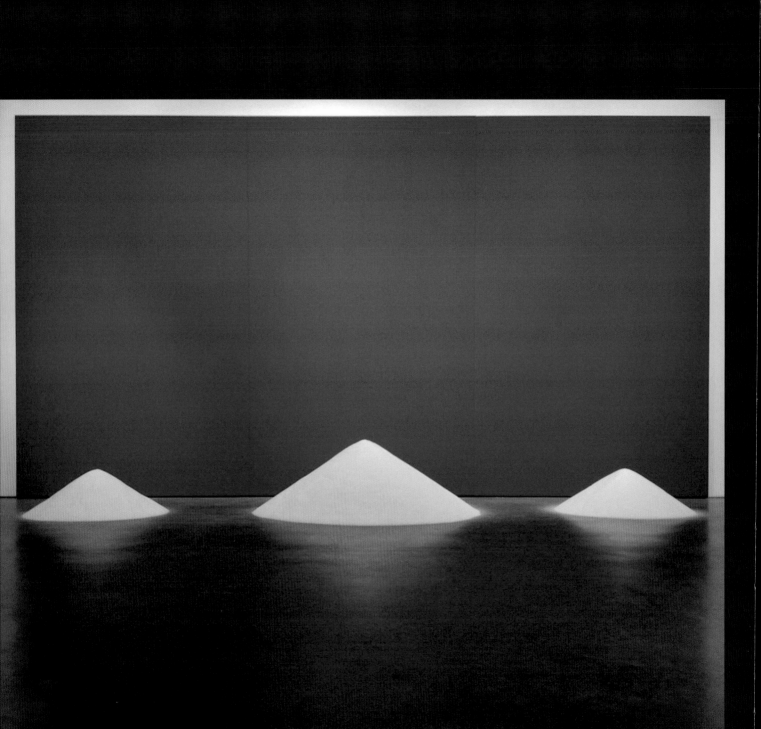

14

The Wholeness of Nature

Science and Art in the Early 21st Century

The most important aim of all physical science is . . . to grasp Nature's essence under the cover of outer appearances.

Alexander von Humboldt, *Cosmos: Draft of a Physical Description of the Universe*, 1845

The nitrogen in our DNA, the calcium in our teeth, the iron in our blood, the carbon in our apple pies were made in the interiors of collapsing stars. We are made of starstuff.

Carl Sagan, *Cosmos: A Personal Voyage*, 1980

We are in the universe and the universe is in us.

Neil deGrasse Tyson, *Cosmos: A Spacetime Odyssey*, 2014

THIS BOOK BEGAN by describing the emergence of abstract art as an expression of the first scientific, secular worldview in human history. By the 1920s the foundations of physics were yielding to the explanatory power of science and inspiring artists, but humankind's fascination turned to horror in 1945 with the detonation of the atomic bomb. Post-war artists were wary of science, but the nuclear dragon has been in hibernation for over seventy-five years; memory of the bomb has faded, and today most artists no longer share the post-1945 generation's reservations about science.

The artists in this chapter, many of whom have had significant training in science, are examples of a distinctive approach that is at the core of the international art world today: the combination of the abstract, minimalist aesthetic with science in research-based studio practices to create powerful artistic metaphors for the natural world and the human condition that incorporate insights from laboratories and telescopes around the world. This artwork demonstrates that science and art combine naturally—like solutes in a solvent—because both aim to capture essences, discover underlying principles, and express truth (plate 14-1).

Two discoveries made after World War II reinforced a central tenet of the scientific worldview: the conviction that the natural world has a wholeness with which humans

14-1. Lita Albuquerque (American, born 1946), *Sometimes the Sea is Silver, Sometimes It Is Red, Other Times It Is Azure Blue*, 2014. Salt and blue paint, installation at Pasadena Museum of California Art. Courtesy of the artist.

The colors of the blue expanse change, as they do at the seashore, as one walks through this installation by Lita Albuquerque, an artist who has combined science and art throughout her long career. In a striking example, the US National Science Foundation funded Stellar Axis, an art expedition led by Albuquerque that included an installation at the South Pole of an array of ninety-nine spheres corresponding to the position of ninety-nine stars in the Antarctic sky (2006) and a performance at the North Pole in which people moved in patterns that emphasized the rotation of Earth (2007).

14-2. Optical light and x-ray composite image of Supernova Remnant 0509-67.5. NASA, ESA, CXC, SAO, the Hubble Heritage Team (STScI/AURA), and J. Hughes of Rutgers University.

This image shows a remnant cloud of gas that is still being shocked by the blast from a supernova that occurred 400 years ago. The cloud, which is 23 light-years in diameter, is expanding by some 3,100 miles (5,000 kilometers) per second. The bright pink shell is optical light recorded by the Hubble Space Telescope; the soft green and blue is gas recorded by the Chandra X-ray Observatory. The telescopes are named for astronomers Edwin Hubble (American, 1889–1953) and Subrahmanyan Chandrasekhar (Indian-born American, 1910–1995).

are one. The first successful test of nuclear fusion on a large scale was a multimegaton detonation of a hydrogen bomb on November 1, 1952, which confirmed the origin of the ninety-two atoms on the Periodic Table of Elements (see Hans Bethe's work in chapters 10 and 12). The presence of all ninety-two elements on Earth is conclusive evidence that our solar system formed from the gaseous remains of a supernova (plate 14-2). This means that—on an atomic level—humans are linked to the cosmos in the sense that atoms in all living things are made in the Big Bang and subsequent stellar fusion. The 1953 discovery of the double-helix structure of DNA gave conclusive proof that—on a molecular level—all *Homo sapiens* are linked to each other and to all earthly organisms on a tree of life. Throughout history every culture has told a creation story about where it came from; today the tree of life is our scientific creation story.

Unification of Forces and the Standard Model

Physicists measure events with two yardsticks: they use gravity (as described in general relativity) to measure large-scale cosmic events, but they switch to electromagnetism (as described in quantum mechanics) to measure small-scale atomic events. (This is akin to an architect measuring the height of a building in feet but switching to metric to measure the windows in centimeters.) After finishing the theory of relativity, Albert Einstein began trying to unify gravity and electromagnetism, so that scientists could measure cosmic and atomic events using one yardstick. He was encouraged because gravity and electromagnetism are similar in certain ways: the strength of the gravitational force between two bodies, such as a planet and its moon, and the strength of the electromagnetic attraction between two charged particles, such as a proton and electron, both decrease in proportion to the square of the distance between them. Every mass generates a gravitational field, and every charged particle generates an electromagnetic field. But the strength of the two force fields is vastly different; the force of gravity measures $1/10^{36}$ of the force of electromagnetism. Einstein defined gravity as an effect of the curvature of space, with disturbances in that curvature propagating at the speed of light. In other words, gravity and electromagnetism are both dynamic forces whose associated waves travel at the same speed—186,282 miles (299,792 kilometers) per second.

By the 1930s physicists had discovered two other forces within the atomic nucleus: the strong nuclear force holds the nucleus together, and the weak nuclear force causes radioactive decay. Thus, the goal of physics became to unify the four forces of nature: gravity, electromagnetism, the strong force, and the weak force. In the 1960s the American physicists Steven Weinberg and Sheldon Glashow and the Pakistani physicist Abdus Salam together were able to unify electromagnetism and the weak force. However, the unification of all four forces remains today an elusive goal of physics.

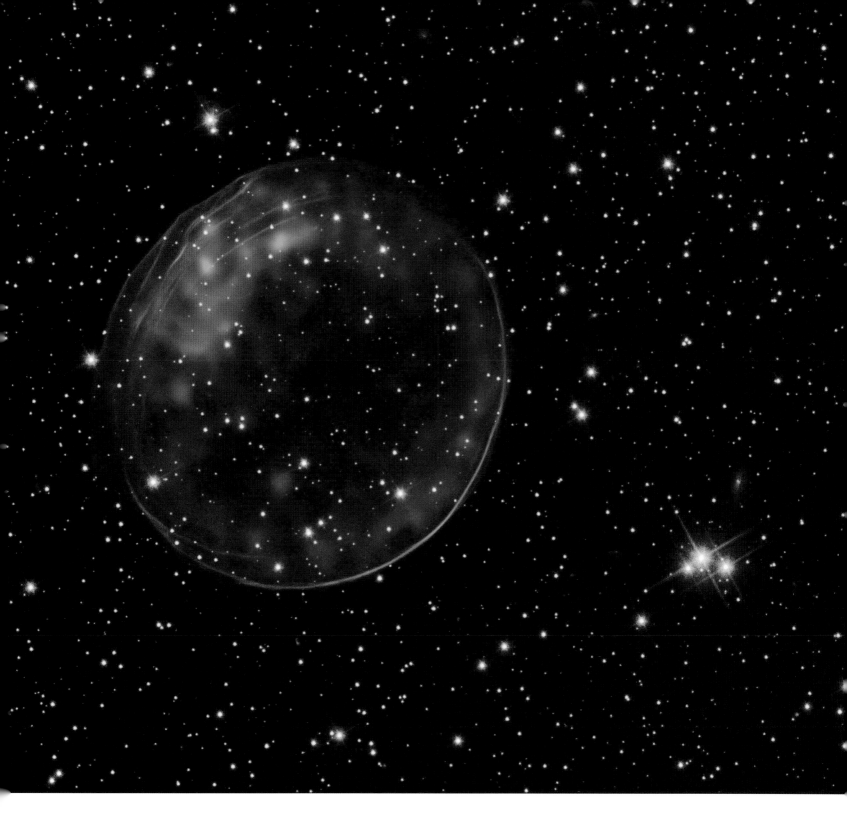

Scientists explore the subatomic realm in particle accelerators by shooting streams of protons and neutrons in opposite directions in a circular path and crashing them into each other head-on. In the 1950s they discovered dozens of subatomic particles not found in ordinary matter. Since the 1860s, scientists have organized atoms on the Periodic Table of Elements; in the 1950s they found that they needed another chart to organize subatomic particles. In 1964 the Japanese physicist Kazuhiko Nishijima and the American physicist Murray Gell-Mann, independently realizing that there is a lower level of matter, composed of quarks and leptons, each proposed that this growing

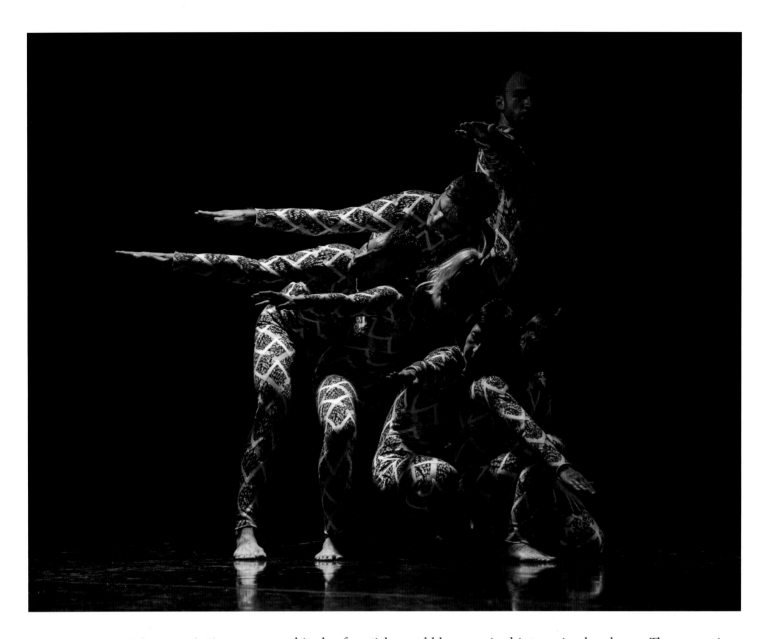

14-3. *Quantum: An Ode to Particle Physics*, 2012. Choreography by Gilles Jobin, performed in an installation by Julius von Bismarck, music by Carla Scaletti, at the Large Hadron Collider, Geneva, Switzerland.

Like many science laboratories, the Large Hadron Collider at CERN has an artist-in-residence program to encourage interdisciplinary dialogue, cleverly titled Collide@CERN. Swiss choreographer Gilles Jobin, German artist Julius von Bismarck, and American composer Carla Scaletti created this performance during their residency, with scientific advice from CERN physicists Michael Doser and Nicolas Chanon. Six dancers vibrate and turn beneath industrial lamps programmed to gyrate in response to movement, in an environment of sound derived from particle-collision patterns.

multitude of particles could be organized into a simple schema. The generations of matter that are known today, together with particles that carry three of the four forces, are displayed on a chart, the Standard Model of Elementary Particles (plates 14-4 and 14-5). Today the most powerful accelerator in the world is the Large Hadron Collider (LHC), located on the French-Swiss border near Geneva. It is operated by CERN (Conseil Européen pour la Recherche Nucléaire/European Organization for Nuclear Research), which was founded in 1954 by twelve European countries to explore peaceful uses of nuclear energy. The LHC is designed for hadrons (such as protons and neutrons), composite particles that are each made up of three quarks. In March 2010 the LHC achieved a collision that surpassed the energy of all previous colliders; it has the power to accelerate streams of protons to 99.999999 percent of the speed of light before colliding them (plate 14-3).

LEFT

14-4. The Standard Model of Elementary Particles

The Standard Model describes how elementary particles are organized and how they interact with one another via the forces. There are three generations of matter, including six quarks and six leptons. The lightest quarks, named "up" and "down," combine in groups of three to make up the protons and neutrons in the nucleus of every atom. Together with electrons, the threesome quarks make up all elements on the Periodic Table of Elements. The other particles were abundant in the early universe but are rare today. Four force-carrying particles (bosons) each transmit an indivisible unit—a quantum—of energy. Quarks are bound together by the strong nuclear force, carried by gluons, to form protons and neutrons. Photons (particles of light) carry the electromagnetic force. The force of gravity is not represented on this chart. There is also one boson (named for the British physicist Peter Higgs) that does not transmit a force but is part of the process that gives mass to particles.

RIGHT

14-5. Barry X. Ball (American, born 1955), 2002–6. Mexican onyx, 41½ × 22 × 14 in. (105.4 × 55.9 × 35.6 cm). Collection of Glenn and Amanda Fuhrman, New York.

The title of this sculpture is:

Plucked from The Standard Model and elevated again,
The Holy Shroud of Nature calls into question The Creator it summons,
as authentic as the original,
yet altogether more remarkable for the image it preserves,
from Rock to rock.

Philosophical Interpretations of Quantum Mechanics

As the monolithic Copenhagen interpretation began to fracture after World War II, several rival interpretations of quantum mechanics emerged:

- *De Broglie–Bohm Interpretation:* In the 1920s Louis de Broglie gave an interpretation of quantum mechanics that preserves causality, and in the 1950s American physicist David Bohm independently came up with the same approach, so the interpretation carries both their names (see chapter 9). In the 1980s, a new generation of physicists renewed efforts to describe the natural world in a seamless picture including both quantum and classical physics, and they developed the de Broglie–Bohm interpretation into today's Bohmian mechanics.[1]

- *Many-Worlds Interpretation:* In the 1950s, the American physicist Hugh Everett hypothesized that in addition to the familiar world there are other worlds that exist in parallel in the same space and time. When an experiment is performed, such as shooting an electron with a fifty-fifty chance of being absorbed by an atom, both outcomes occur—the electron is absorbed in one universe and passes by an alternative universe. In other words, observers detect the absorption of the electron in their world, while in a parallel universe their doubles detect nothing. Everett's motivation was that this so-called multiverse restores determinism to the microworld ("Relative State Formulation of Quantum Mechanics," 1957). No experiment has been designed to test the many-worlds interpretation (since parallel universes, by definition, are not observable by Earthlings), so today it remains philosophy, not science.

- *String Theory:* In the 1980s some physicists hypothesized that the smallest known subatomic particles (quarks and leptons) are themselves made of one-dimensional lines ("strings") of mass-energy. So far, there is only a mathematical description of the hypothetical strings, which have not been observed. In the history of science there are many examples of theories that were first written as a mathematical description of an event; the mathematics predicted an observation, which was made later, confirming the theory (examples: Halley's description of the elliptical path of a comet, which was confirmed when the comet returned in 1758; Einstein's general theory of relativity of 1915, which was confirmed by observation of stars during a solar eclipse in 1919). The mathematical description of string theory supposes supersymmetry: for every known subatomic particle (everything on the Standard Model), there exists a partner particle. The goals of string theory are to unify the forces of nature, confirm supersymmetry, and account for the values of about twenty numbers—including the speed of light, the mass of an electron, and

the force of gravity—that make the universe the way it is. One difficulty in designing an experiment to confirm (or rule out) the existence of strings is that the size of one string is to a hydrogen atom, as one hydrogen atom is to the solar system. String theorists, such as the Greek physicist Maria Spiropulu and the American physicist Joseph Lykken, have expressed high confidence in the theory: "Supersymmetry is an amazingly beautiful solution to the deep troubles that have been nagging at physicists for more than four decades. . . . It is not an exaggeration to say that most of the world's particle physicists believe that supersymmetry *must* be true—the theory is that compelling."[2] Is this overconfidence in mathematics? A main motivation for a 2010 upgrading (increasing the power) of the Large Hadron Collider was to confirm the existence of partner particles by creating them, thereby confirming supersymmetry; physicists have been trying (unsuccessfully) to do this since 2010. Until there is experimental data, string theory remains philosophy, not science.

Black Holes

When a star collapses and becomes a supernova, its future depends on its mass. If it has between 10 and 29 solar masses, its atomic nuclei fuse into one huge atomic nucleus—a neutron star—from which light can escape only at its magnetic poles (see plate 10-29 in chapter 10). If the star has 30 or more solar masses, presumably its nuclei fuse and form an even larger rotating sphere of neutrons with even more gravity, such that no light at all can escape—a black hole. This is "presumably" true because once electromagnetic waves or matter cross the boundary—the event horizon—into a black hole, they are no longer observable and hence not knowable.

In addition to a supernova, the other place a black hole forms is in the center of a galaxy, a rotating disk of stars held together by the force of gravity, which pulls most stars toward the center, where the mass becomes extremely dense (plate 14-6). Astronomers believe there is a black hole in the center of every galaxy; the one at the Milky Way's center exerts the gravitational force of an object several million times the mass of the sun. The black hole at the center of the Milky Way is inactive, but occasionally and unpredictably a galactic black hole springs into action, spewing forth jets of particles from its top and bottom axis, an event known as a "blazar" (plate 14-7).

Today there is an international collaboration of telescopes dedicated to observing black holes. Synchronized by the Large Millimeter Telescope in Mexico, the eight ground-based radio telescopes together form an instrument—the Event Horizon Telescope—as big as Earth. In April 2019, scientists announced that they had obtained the first image of a black hole (plate 14-8).

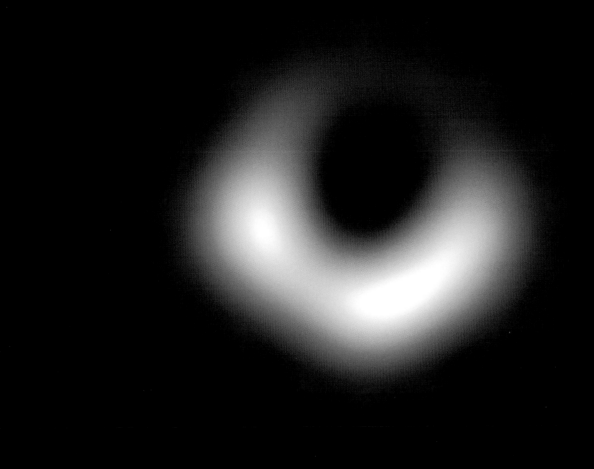

OPPOSITE, TOP

14-6. Messier 104 (M104). NASA and the Hubble Heritage Team (STScI/AURA).

Messier 104 is a spiral galaxy, seen from Earth nearly edge-on, with a brilliant globular cluster of stars at its center. This photograph is a composite of three taken with red, green, and blue filters and then combined to produce this natural color image. Located 28 million light-years from Earth, M104 is nicknamed the Sombrero Galaxy because it has the shape of a broad-brimmed Mexican hat.

OPPOSITE, BOTTOM

14-7. Blazar

This diagram shows a galactic black hole that has become a blazar, shooting out streams of particles from its axis.

ABOVE

14-8. Black hole at the center of the galaxy M87. Event Horizon Telescope Collaboration.

This image shows a bright ring of light that bends in the intense gravity around a black hole, several billion times more massive than the sun, at the center of Messier 87, a galaxy located 55 million light-years from Earth in the constellation Virgo. The image was made by computer analysis of two years of observations made by eight ground-based radio telescopes in the Americas, Europe, and Antarctica working in unison.

Gravitational-Wave Astronomy

As a consequence of the general theory of relativity (1915), Einstein predicted that a cataclysmic event would cause a detectable ripple—a gravitational wave—in space. In the 1960s scientists began discussing the possibility of building an instrument— an interferometer—capable of testing Einstein's prediction. In the 1880s, American physicists Albert Michelson and Edward Morley invented the interferometer to split a beam of visible light and send half straight ahead and half at a right angle. The light is reflected back from mirrors positioned at precisely the same distance from the beam splitter, then rejoined so that any displacement in the light-waves can be observed (see plate 9-2 in chapter 9). Michelson and Morley's interferometer sat on a stone slab mounted on a tabletop in their laboratory.

When a pebble is dropped into a pond, waves of water spread out from the source. The same is true of gravitational waves, which compress space in one direction and stretch it in another, travelling outward from their cataclysmic source. Scientists built an interferometer to detect gravitation waves, reasoning that if gravitational waves rolled over the perpendicular arms, the waves would cause one arm to be longer, which would be detectable. Gravitational waves travel at the speed of light, but like waves of water moving across a pond, they diminish with distance. Depending on their point of origin, the gravitational waves could be very small by the time they reached Earth. In 2002 the US National Aeronautics and Space Administration (NASA) completed two Laser Interferometer Gravitational-Wave Observatories (LIGO), in the state of Washington and in Louisiana. LIGO splits a beam of light in the form of a laser (a narrow beam of monochromatic light in which all the light-waves are parallel). LIGO's perpendicular arms are 2.5 miles (4 kilometers) long, and the instrument can detect a change in the length of one of its arms as small as 1/10,000th the diameter of a proton. The precisely positioned mirrors are suspended in a vacuum, which runs the entire length of the arms, to keep them isolated from any disturbance from the environment. Six European countries subsequently collaborated to build the Virgo interferometer in Italy. In 2016, LIGO and Virgo announced that they had detected a gravitational wave that was emitted when two massive black holes collided 1 billion years ago, releasing stupendous energy in a fraction of a second. In August 2017, LIGO and Virgo observed a second gravitational wave that was emitted when two other massive objects—neutron stars—slammed together.

Meanwhile, the European Space Agency (ESA) began plans to build an interferometer in outer space, the Laser Interferometer Space Antenna (LISA), consisting of three spacecraft, one for the beam splitter and two carrying the mirrors, flying 621,371 miles (1,000,000 kilometers) apart. For an idea of the size of the space interferometer, the length of each of its arms will be more than twice the distance between Earth and the moon, which is an average of 238,855 miles (384,400 kilometers). If the mirrors are

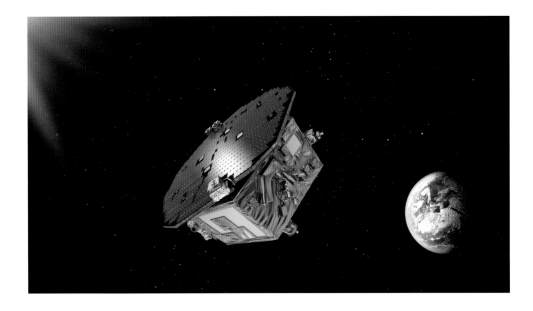

flying in separate spacecraft, can they be kept in precise position relative to each other? To answer this question, in January 2016 ESA launched a scout for LISA, the spacecraft LISA Pathfinder, which arrived at a place where the gravity of Earth and sun cancel each other. There it carried out an experiment: cubes of solid gold were suspended (allowed to go into free fall) in zero gravity in the hollow interior of the spacecraft to determine whether or not they would remain perfectly still. LISA Pathfinder showed that they do; therefore, the project moved to its next phase, in which the gold cubes will function as the motionless mirrors off which laser beams will be bounced (plates 14-9 and 14-10). In the 2030s, ESA plans to launch LISA, three spacecraft in an equilateral triangle linked by laser beams—an immense interferometer dedicated to the detection of gravity waves.

ABOVE

14-11. Stanley Greenberg (American, born 1956), *DOM Hole, IceCube Neutrino Observatory, South Pole, Antarctica*, 2009. Photograph, 18⅛ × 22¾ in. (46 × 57.8 cm). Courtesy of the artist.

RIGHT

14-12. IceCube Neutrino Observatory, South Pole, Antarctica. Courtesy of the IceCube Collaboration.

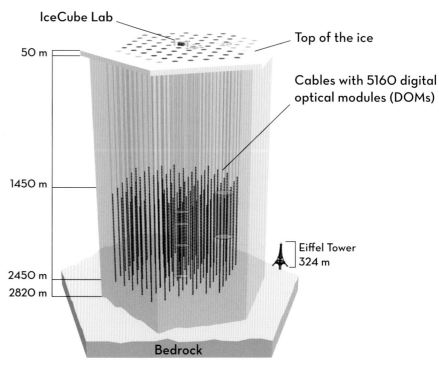

IceCube Lab

Top of the ice

Cables with 5160 digital optical modules (DOMs)

50 m

1450 m

2450 m

2820 m

Eiffel Tower 324 m

Bedrock

Astronomy began in antiquity by looking at sunlight, moonlight, and starlight. Then in the early twentieth century scientists expanded astronomy to include observations in the whole electromagnetic spectrum, from radio waves to gamma radiation. Today gravitational waves give astronomers a new tool, uniquely suited to observe events that warp space-time. Neutrinos open another window on the cosmos.

Neutrino Astronomy

Neutrinos are elementary particles equal to electrons in mass but with no electric charge; Enrico Fermi gave them the name *neutrino* (Italian for "little neutral one"). Neutrinos are produced in nuclear fusion, such as the fusion of hydrogen to form helium in the sun. Neutrinos interact via the weak nuclear force, which has a very short range; neutrinos rarely interact with ordinary matter, typically passing through undetected. Each second, 65 billion neutrinos from the sun pass through every cubic centimeter of Earth.

In 1930 Wolfgang Pauli postulated the existence of neutrinos, which were first recorded in 1987, from a supernova named SN-1987A. When SN-1987A collapsed, it sent out a blast of electromagnetic radiation (light), which was scattered in the dense gaseous aftermath of the collapse. After bouncing around in the cloud of gas molecules, the light eventually made its way to the stellar surface and then shone forth in the heavens. The collapse also sent a blast of neutrinos, which, unimpeded by the gaseous aftermath, left the supernova ahead of the light. On Earth, astronomers first recorded neutrinos from SN-1987A, and then three hours later they recorded its light.

Special detectors are built to record neutrinos and distinguish them from other cosmic rays—high-energy particles (such as protons and electrons) that arrive on Earth from outer space. The Super-Kamiokande neutrino detector in Japan is essentially a huge container of water, located deep underground in an abandoned mine shaft, lined with photon detectors to record when a neutrino interacts with a water molecule. A neutrino detector points not up at the sky but down, because it uses Earth to filter out protons, electrons, and other cosmic rays. IceCube Neutrino Observatory at the South Pole records interactions of neutrinos in the clear Antarctic ice by using 5,160 digital optical modules (DOMs), tiny computers that are strung along 100 cables lowered to depths between 4,757 and 8,038 feet (1,450 and 2,450 meters; plates 14-11, 14-12, and 14-13).

Earth is constantly bombarded by low-energy neutrinos from the sun, but astronomers are more interested in high-energy neutrinos, because they offer a window into an event, such as SN-1987A, happening outside the solar system. On September 22, 2017, IceCube Neutrino Observatory detected a high-energy neutrino and sent out the co-ordinates of its source in an alert to astronomers around the world. The astronomers at the controls of Fermilab's Gamma-ray Space Telescope turned its sensors to the co-ordinates and discovered gamma rays coming from the same source as the high-energy neutrino: blazar TXS 0506+056, located 3.7 billion light-years away.

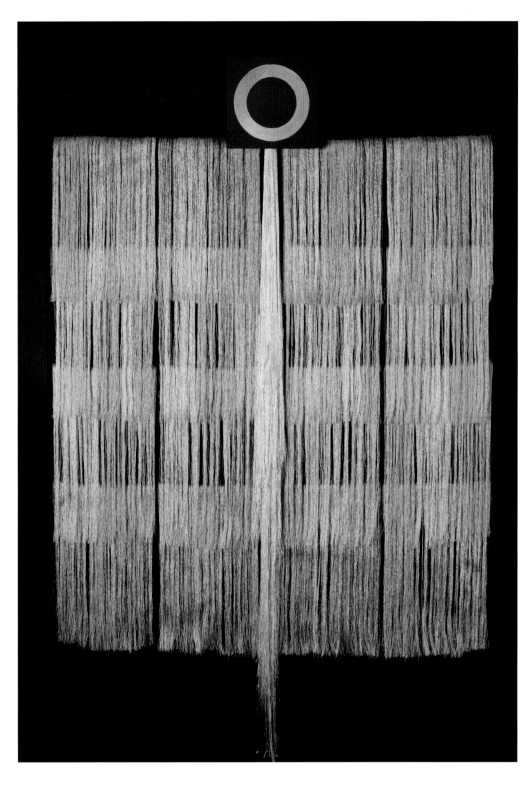

14-13. Lindsay Olson (American, born 1956), *Dark Glamour: Neutrinos*, 2015. Silk, cotton embroidery thread, acrylic, and wood, 52 × 42 in. (132 × 106 cm). Courtesy of the artist.

In 2014–15, Lindsay Olson was artist-in-residence at Fermilab Particle Accelerator near Chicago, where she created this textile, making an analogy between a woven fabric and Fermilab's neutrino-detection equipment, which tries to "net" the elusive neutrinos.

14-14. Cornelia Parker (English, born 1956), *Cold Dark Matter: An Exploded View*, 1991. Tate, London. © Cornelia Parker. Courtesy of the artist and Frith Street Gallery, London.

The artist has stated: "Cold dark matter is the material within the universe that we cannot see. … It's immeasurable, unfathomable" ("The Story of Cold Dark Matter," Tate website, accessed Apr. 15, 2019, https://www.tate.org.uk/art/artworks/parker-cold-dark-matter-an-exploded-view-t06949/story-cold-dark-matter). Parker made this symbol of dark matter by blowing up a garden shed and suspending its fragments.

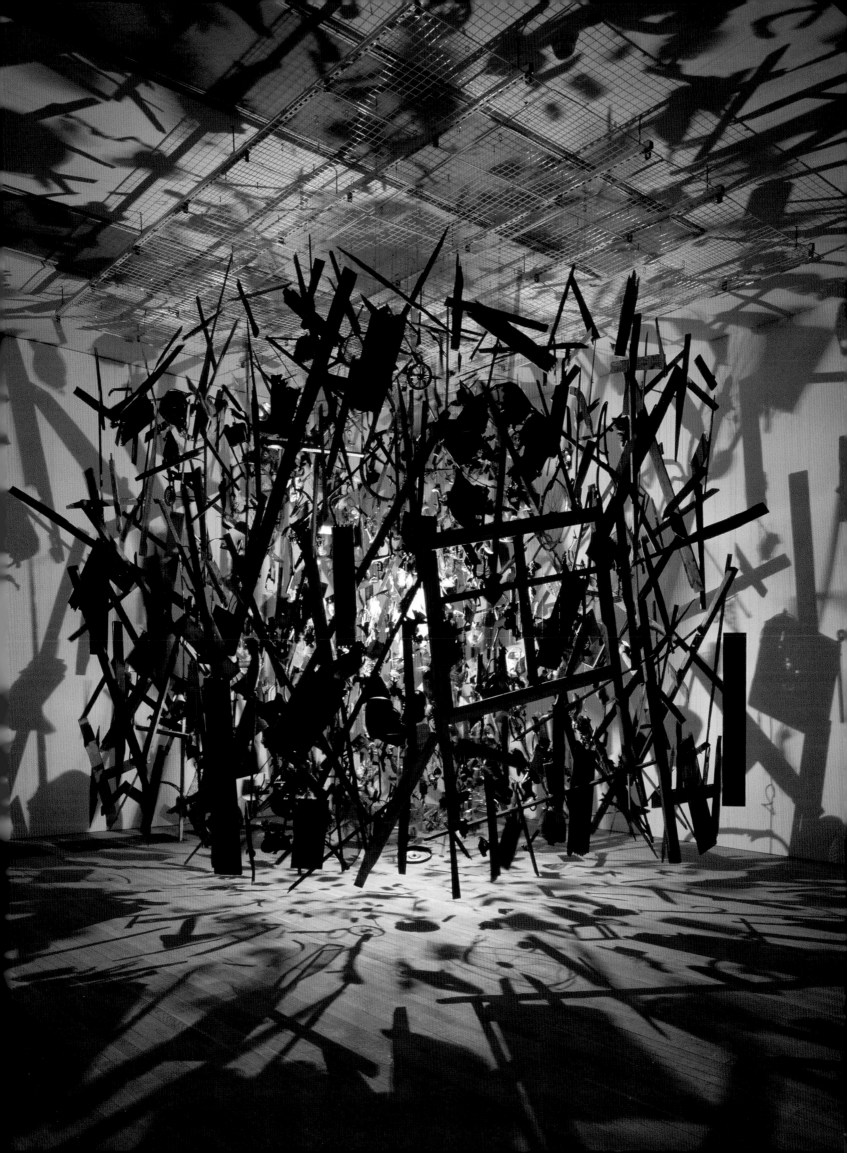

Astronomers have an ideal viewpoint for this blazar, because they are looking directly into the stream coming from the black hole at its core, which is like looking straight into a lighthouse beam (see plate 14-7).

Since cosmic rays were discovered in 1912, scientists have wondered where in the universe particles are being accelerated to such high speeds with so much energy. The most powerful particle accelerator on Earth is the Large Hadron Collider, which accelerates protons to close to the speed of light. What are the most powerful particle accelerators in the universe? Blazar TXS 0506+056 is one of them. Millions of times more powerful than the LHC, blazar TXS 0506+056 has been studied with gamma ray, x-ray, and radio telescopes, and since 2017 with neutrino astronomy.

The universe began in the Big Bang when, from a point of infinite density, there formed a primordial plasma, which included the ingredients of atoms: quarks, electrons, and electromagnetism. In the early years of the new universe, particles and radiation could not move freely in the dense plasma but were scattered; after about 380,000 years, the primordial plasma had expanded and thinned enough to allow atoms to form and light to shine forth (see plate 10-22 in chapter 10). The first 380,000 years of the cosmos are inaccessible using light telescopes. However, the Big Bang also created neutrinos, which could move through the primordial plasma unobstructed, and neutrino astronomy may provide a way for scientists to see back in time, before the cosmos was 380,000 years old.

Dark Matter and Dark Energy

One of the most confounding realizations in recent astronomy is that stars and galaxies are but a small fraction of the total mass of the universe. To explain the motion of galaxies, in 1933 the Swiss astronomer Fritz Zwicky declared that there must exist unseen matter, which he called *dunkle Materie* (German for "dark matter"), that gives off no light. His hypothesis was confirmed in the 1960s by the American astronomer Vera Rubin, who declared that the movement of stars at the edges of galaxies can be explained only if one assumes the existence of dark matter exerting gravitational force on them. Today astronomers estimate that about 90 percent of the matter in the universe is dark (plates 14-14 and 14-15).

Cosmologists agree that the universe began expanding 13.8 billion years ago in the Big Bang, but there is less agreement about the fate of the universe, which depends on the total amount of mass, dark matter, and the law of gravity. Depending on which assumptions are correct, the cosmos may expand forever, its expansion may slow to a point at which gravity causes the universe to contract, or it may remain in equilibrium, balanced between expansion and collapse. Cosmologists used to describe gravity as a force that only pulls toward mass, but in 1998 they announced that a force opposed to gravity, some unknown antigravity effect—dark energy—is accelerating the expansion of the cosmos (plate 14-16).

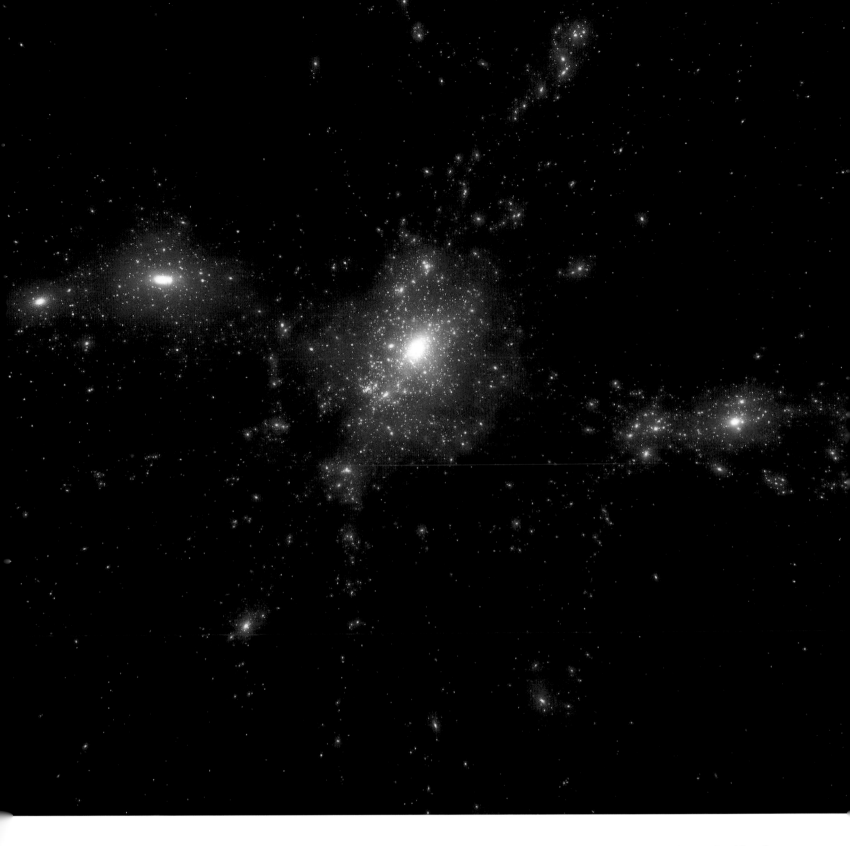

14-15. Bolshoi Cosmological Simulation by Anatoly Klypin and Joel Primack, visualized by Chris Henze on the Pleiades supercomputer at NASA Ames Research Center, Mountain View, California, 2010.

The Bolshoi (Russian for "big") Cosmological Simulation models the evolution of invisible (dark) matter. The scientists began with recordings of the cosmic microwave background, which show the distribution of visible matter in the early universe (380,000 years after the Big Bang; see plate 10-21 in chapter 10). Using their assumptions about where dark matter was in the early universe, they then calculated the evolution of dark matter in a typical region of the universe 1 billion light-years across. This image, which is a small part of the whole simulation, shows dark matter "halos" (as dark matter regions are called)—the bright or white areas—within which the Bolshoi team predicted that a large cluster of galaxies would form. Their dark matter simulation, a theoretical prediction, matched perfectly with astronomical observations of the distributions of galaxies in the visible universe—like hand and glove.

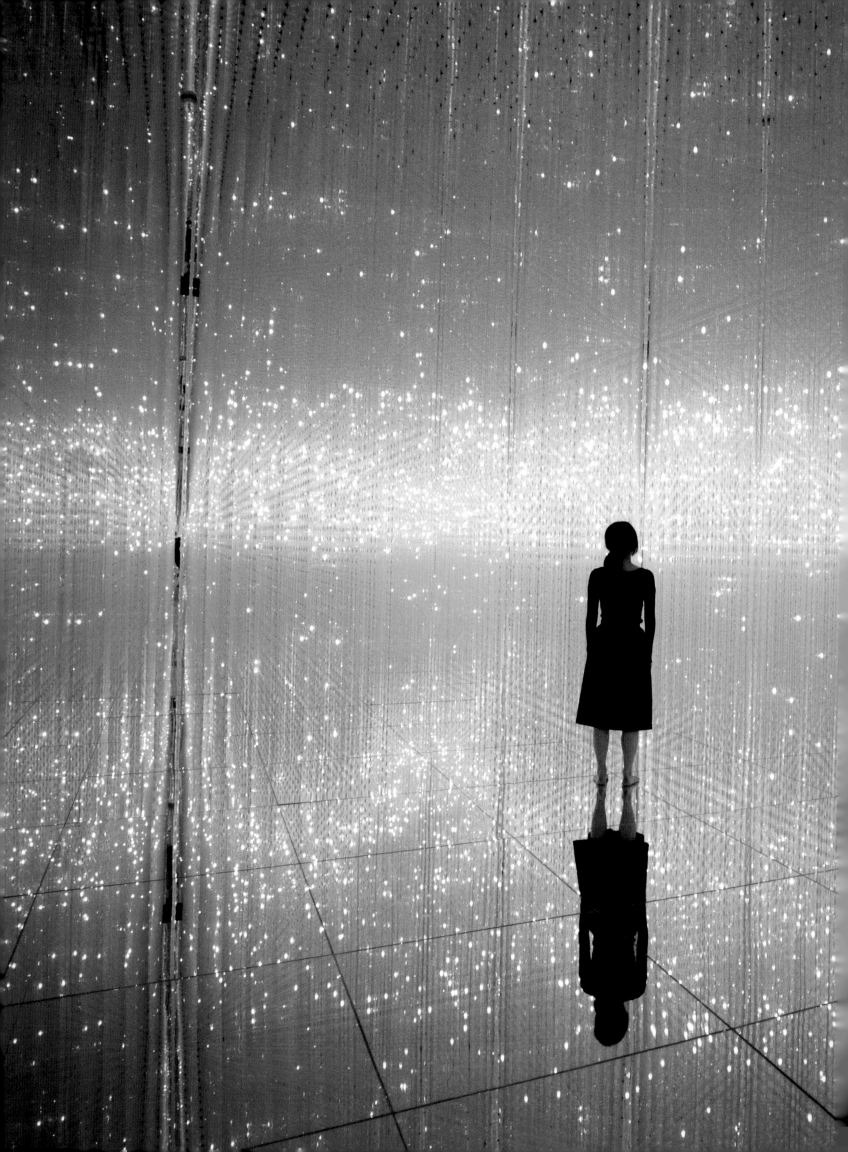

14-16. teamLab, *The Infinite Crystal Universe*, 2015–18. Interactive installation of light sculpture, LED, endless sound. Pace Gallery, New York. © teamLab.

This woman walks around in a suspended grid of light-emitting diodes (LEDs), which suddenly emits a burst of light like a supernova in response to commands from her phone. Surrounded by mirrors that reflect the myriad twinkling lights from here to infinity, she is in *The Infinite Crystal Universe*, created by teamLab of Tokyo.

Nature as a Computer

In the early 1950s Alan Turing began studying morphogenesis (the development of mathematical patterns in nature) such as stripes on a tiger and spots on a leopard. Turing hypothesized (correctly) that two chemicals (for black and white) interact on a blank surface, such as the skin of an animal. If the chemicals mix equally, the animal will be gray. But if one chemical diffuses faster than the other, the result will be a pattern of stripes or spots (Alan Turing, "The Chemical Basis of Morphogenesis," 1952).[3] Turing used formulas that are applied *recursively*, which means that the formula is applied to some number to achieve a result and then applied again to the result, then again to the new result, and so on. For example, take the equation: $x^2 + 1 = y$. If we begin by letting $x = 1$, then $(1 \times 1) + 1 = 2$, so $y = 2$. We feed this result back into the formula; $x = 2$, then $(2 \times 2) + 1 = 5$, so $y = 5$, and so on. Using recursive formulas, Turing gave a precise description of the pattern of chemical diffusion or concentration. His insight was that nature makes a leopard by simple processes (such as cell division, chemical diffusion), repeated over and over again (recursively).

In the 1960s the German computer scientist Konrad Zuse suggested that if space is a three-dimensional lattice of points, and time ticks off in seconds, then the whole universe could be considered one big recursive system (*Calculating Space*, 1969).[4] Then British mathematician Stephen Wolfram concurred and argued that nature can be modelled on a computer, because natural objects (snowflakes, plants) arise when simple rules (crystallization, cell division) are repeatedly applied to basic units. Natural objects are, according to Wolfram, best described by writing the computer code that generates them (*A New Kind of Science*, 2002) (plates 14-17, 14-18, and 14-19).

14-17. Illustration from Stephen Wolfram, *A New Kind of Science* (Champaign, IL: Wolfram Media, 2002), 32 and 33. © Stephen Wolfram.

Rule 110: The top row shows the eight possible patterns of black or white for three cells (left-center-right), which determines the color of the cell below center in the next row.

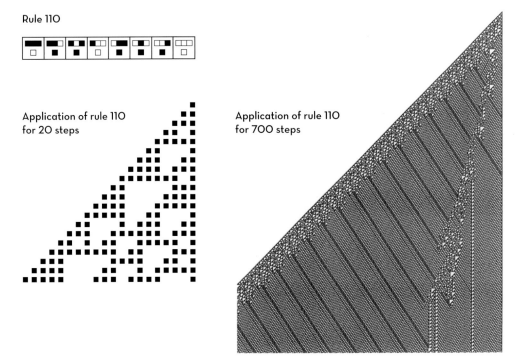

Rule 110

Application of rule 110 for 20 steps

Application of rule 110 for 700 steps

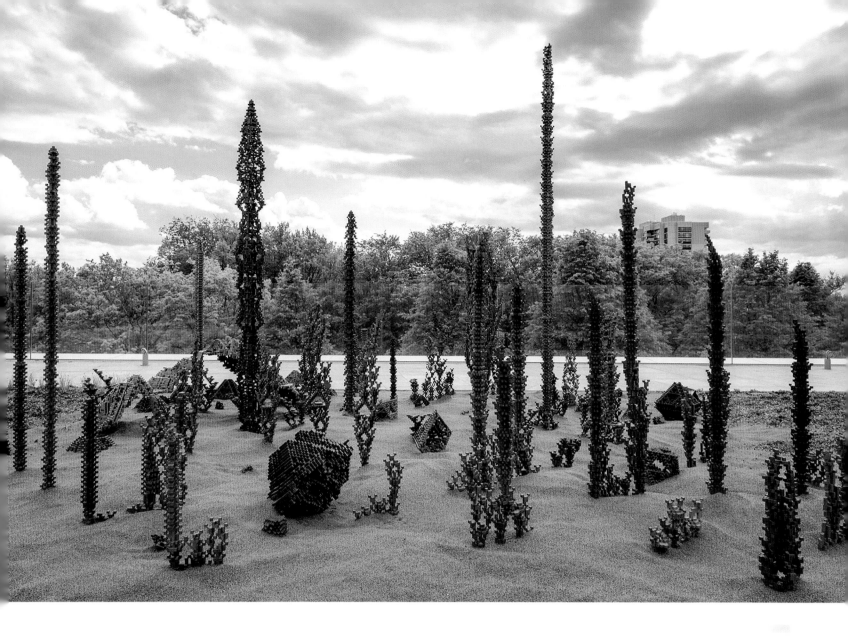

14-18. Patrick Coutu (Canadian, born 1975), *Le Jardin du Sculpteur* (Sculptor's garden), 2014–16. Welded bronze, 8 ft. × 16 ft. 3⅝ in. × 14 ft. 4¾ in. (2.43 × 4.97 × 4.39 m). Musée National des Beaux-Arts du Québec, gift of the Monique and Robert Parizeau Foundation to commemorate the opening of the Pierre Lassonde Pavilion. © Patrick Coutu.

Inspired by the work of Stephen Wolfram (plate 14-17), Patrick Coutu uses mathematics to gain insight into natural patterns. Using simple rules analogous to those with which the diversity of life evolves in nature, Coutu created this garden for the Musée National des Beaux-Arts du Québec in Montreal. Rather than make an artwork for the museum's sculpture garden, Coutu created a whole sculptor's garden— *Le Jardin du Sculpteur*.

14-19. Patrick Coutu, *Le Jardin du Sculpteur*, detail of plate 14-18. © Patrick Coutu.

14-20. Vibha Galhotra (Indian, born 1978), *Breath by Breath*, 2016–17. Performance, Delhi, India, photographed by Rajesh Kumar Singh, digital print on archival paper, 18 × 36 in. (45.7 × 91.4 cm). Courtesy of the artist.

During 2016–17, performance artist Vibha Galhotra collected air in a net at the sources of Delhi's smog—vehicles, industry, crop burning in nearby farmland, and heaps of burning garbage (shown here). Galhotra's absurd way of catching air "breath by breath" symbolizes the desperate, ineffective efforts to breathe clean air commonly seen on the streets of Delhi, such as breathing through a handkerchief.

Global Warming, Environmental Pollution, and Biodiversity

Air pollution from factories and automobiles increased dramatically after World War II. During four days in December 1952, London residents were subjected to the Great Smog, during which 4,000 infants and elderly people died from respiratory ailments; this prompted the British government to pass the first major environmental protection legislation, the Clean Air Act of 1956. The World Health Organization, a branch of the United Nations founded in 1948, surveys health issues in 1,600 cities every year. In 2014 it ranked Delhi, the capital of India, as having the worst air pollution in the world and the highest death rate from chronic respiratory diseases such as asthma (plates 14-20, 14-21, and 14-22).[5]

The burning of oil, coal, and gas releases heat-trapping carbon dioxide (CO_2) into the atmosphere—the greenhouse effect—causing glaciers to melt and sea levels

to rise (plate 14-23). If the current rate of CO_2 emission continues, by 2050 the Greenland ice sheet will melt, and the sea level will rise 16–23 feet (5–6 meters), submerging coastal cities such as Shanghai and New York. The alternative is to abandon carbon-based fuels and derive energy from the sun, which provides massive amounts of electromagnetic energy. Solar-powered machines were developed in the nineteenth century by the French inventor Augustin Mouchot and the early twentieth century by the American engineer Frank Shuman, but they were passed over in favor of coal and oil because exploiting those fuels was cheaper and the danger to the atmosphere was unforeseen.

It's not too late to stop pouring CO_2 into the atmosphere, but one day it will be. The planet Venus used to have oceans and an atmosphere, but volcanoes poured CO_2 into its atmosphere until it reached a tipping

14-21. Jama Masjid of Delhi, India, completed 1656.

With three massive domes and two towering minarets, Jama Masjid is one of the largest mosques in India, constructed from intricately inlaid strips of red sandstone and white marble. It was built by the Mughal emperor Shah Jahan, who also built the Taj Mahal.

14-22. Jama Masjid of Delhi, India, on a smoggy day in 2017.

This photograph of Jama Masjid was taken midday on November 8, 2017, when pollution reached levels almost thirty times what the World Health Organization considers safe, prompting the mayor of Delhi to close elementary schools and order children to stay indoors for almost a week.

temperature C° -40 -30 -20 -10 0 10 20 30 40

temperature C° -40 -30 -20 -10 0 10 20 30 40

OPPOSITE

14-23. Helen Mayer Harrison (American, 1927–2018) and Newton Harrison (American, born 1932), *The Mountain in the Greenhouse*, from the series Peninsula Europe I, 2000–2004. Video, based on research of Austrian conservation biologist Georg Grabherr and his graduate students at the University of Vienna. Courtesy of the Harrison Studio.

The video opens on a snow-capped mountain with flowers and foliage covering the slopes. Slowly a greenhouse forms over the mountain, causing the temperature to rise; the snow melts, and the plants die.

ABOVE

14-24. Volcano on Venus. NASA/JPL-Caltech/ESA.

This image of a volcano, the summit of which rises about 1.5 miles (2.5 kilometers) above the plains, was composed using data collected by NASA's Magellan spacecraft in 1990–94 and ESA's Venus Express in 2006–7.

BELOW

14-25. Laurel Roth Hope (American, born 1973), *Carolina Parakeet*, 2009, from the series Biodiversity Reclamation Suit. Crocheted yarn, hand-carved pigeon mannequin, and walnut stand, 9 × 8 × 13 in. (22.9 × 20.3 × 33 cm). Smithsonian American Art Museum, gift of Joyce Schwartz in honor of Judith S. Weisman, and museum purchase from friends of the Renwick Gallery. © 2009 Laurel Roth Hope.

Laurel Roth Hope crochets outfits for pigeons to disguise them as extinct birds, a bittersweet comment on the futility of reclaiming lost biodiversity.

OPPOSITE

14-26. John James Audubon (Haitian-born American, 1785–1851), Carolina Parakeet, *The Birds of America* (London: published by the author, 1827–38), plate 26. Hand-colored etching and engraving by Robert Havell after a watercolor by Audubon, paper 39 × 26 in. (99 × 66 cm). University of Pittsburgh.

point—a runaway greenhouse effect—which caused its surface temperature to spike and its oceans to boil away. Today Venus is covered with a thick layer of CO_2 mixed with sulphuric acid (plate 14-24).[6] What will happen to Earth?

Human hunters killed off the passenger pigeon (see plate 2-14 in chapter 2), but it was loggers that drove the Carolina parakeet to extinction. These colorful native North American birds thrived in old-growth (ancient) forests from New York to Tennessee and as far west as Colorado, until the species lost its habitat; it was declared extinct in 1939 (plates 14-25 and 14-26). The loss of these birds and other species drove the call for biodiversity in the United States, leading to a law that protects species threatened with extinction as a "consequence of economic growth and development untempered by adequate concern and conservation" (Endangered Species Act, 1973).

The oceans have gotten warmer and also noisier, mainly from ships but also from offshore oil drilling. Man-made sound travels a great distance in water, interfering with the ability of marine life to navigate with sound and to communicate. Another ocean pollutant is oil spilled from tankers during transport. In 1978 the *Amoco Cadiz* oil tanker broke in half in bad weather off the coast of France, spilling 1.6 million barrels of oil that eventually formed a slick covering 200 miles (320 kilometers) of

14-27. Brandon Ballengée (American, born 1974), *RIP African Pompano*, 2014. Giclée print on handmade Japanese paper, 18 × 24 in. (45.7 × 61 cm), edition of 13. Courtesy of the artist and Ronald Feldman Fine Arts, New York.

From an ecological and economic perspective, the *Deepwater Horizon* oil spill couldn't have happened in a worse place. The warm water of the Gulf of Mexico is one of the most biologically diverse environments in the world, and Gulf seafood feeds millions of people in North America and (following the Gulf Stream) Europe. A 2014 US congressional report estimated that about half of the oil (over 2 million barrels) released by the explosion of the rig remains in the Gulf. Brandon Ballengée made this image by collecting a fish killed by the spill, then chemically cleaning and staining the bones and cartilage to reveal the anatomy of this threatened species. Ballengée earned an interdisciplinary doctorate in biology and fine art from the University of Plymouth in England and the Hochschule für Gestaltung in Zurich.

the coastline. In the following weeks, millions of dead snails, oysters, mussels, and sea urchins were washed ashore, and 20,000 dead birds were recovered. In 2010 the *Deepwater Horizon*, a floating oil-drilling rig, exploded, killing eleven workers and sending 4.9 million barrels of oil into the Gulf of Mexico, making it the largest environmental disaster in the history of the United States (plate 14-27).

Human Genome and Epigenome

All life on Earth is interconnected on a tree of life by deoxyribonucleic acid (DNA), which encodes genetic instructions for organisms to metabolize and reproduce (plate 14-28). Every DNA molecule contains many genes, which are regions that encode a function, such as for a protein or for eye color. Mapping a chromosome means giving the order of the nucleic acids in the DNA and specifying the genes the chromosome contains.

In 1990 an international team of scientists launched the Human Genome Project to sequence the complete set of genes (the *genome*) of *Homo sapiens*. One goal of the project was to understand the genetic roots of disease, such as the sequence of nucleic acids linked to a form of cancer. When completed in 2003, the Human Genome Project explained less than researchers had hoped. For example, consider identical twins who have the same genes, but one gets cancer and the other does not. How can that be? In answering that question, geneticists discovered molecules that determine whether

the gene is expressed (in the twin who gets cancer) or silenced (in the healthy twin). Scientists call these molecules the *epigenome* (Greek for "upon the genome").

DNA is protected within the cell's nucleus, which it never leaves. If the body needs a protein (such as a digestive enzyme), the DNA unravels, and the gene responsible for encoding that protein copies itself and sends a messenger molecule out of the nucleus into the cell body, where the protein is made. Ideally, people are born and die with the same DNA; it never changes. But their epigenome changes constantly in response to environmental factors, such as diet, exercise, stress level, and exposure to air pollution. Today an international team of cancer research scientists is working on the Human Epigenome Project, which aims to identify and catalogue the epigenetic switches that turn genes on and off in all major tissues.

14-28. DNA

A cell with a nucleus (upper left) contains chromosomes composed of DNA, two chains of molecules that form a double helix. The chains are made of four nucleic acids—abbreviated as T, C, A, and G—which bond only in a particular way, as shown. When atoms join to form a molecule, they typically have a very strong bond (shown as a single or double line) that requires extreme temperature or pressure to break. The DNA chains join to form a double helix with a different kind of bond—a hydrogen bond (shown as a dotted line)—that easily "unzips."

Discovery of *Australopithecus afarensis*

Most nineteenth-century biologists in the West assumed that *Homo sapiens* evolved in Europe. The French argued that a fossil found in France (Cro-Magnon) represented the first human being, and the Germans declared the honor belonged to a German (Neanderthal) fossil. Lacking a fossil, a British paleontologist forged one (Piltdown man).[7] In the twentieth century, Chinese scientists countered that the first human (Peking man) lived in the Yellow River valley.[8] With the issue of origins unsettled, in 1974 anthropologists excavated in Ethiopia a "missing link," the skeleton of a female, who lived 3.2 million years ago, from a species intermediary between apes and humans, *Australopithecus afarensis* (Latin for "southern ape from Afar" [a region in Ethiopia]). In Africa the skeleton is known as Dinknesh (Amharic for "you are marvelous"), and in the West as Lucy (after the Beatles' song "Lucy in the Sky with Diamonds"). Dinknesh lived in trees and had a small braincase (like that of a chimpanzee), but she had the pelvis and leg bones of a hominid, so she walked upright and stood erect like a *Homo sapiens*. The discovery suggested that *Homo sapiens* evolved from apes in Africa; since 1974 other *Australopithecus afarensis* fossils have been discovered, only in East Africa (plates 14-29 and 14-30).

14-29. Dinknesh, skeleton of a female *Australopithecus afarensis*. National Museum of Ethiopia, Addis Ababa.

The fossil, from a hominid species intermediary between apes and humans, was discovered in 1974 by an international team led by American paleoanthropologist Donald Johanson, who was a curator at the Cleveland Museum of Natural History. In 2013 the fossil was returned to Ethiopia, where it is in the collection of the National Museum of Ethiopia in Addis Ababa.

OPPOSITE AND FOLLOWING SPREAD

14-30. Aïda Muluneh (Ethiopian, born 1974), *Dinknesh: Parts One, Two, and Three*, 2016. Photographs. © Aïda Muluneh. Used with permission.

Aïda Muluneh created the Dinknesh photographs after the bones of *Australopithecus afarensis* (plate 14-29) were returned to Ethiopia, where the fossil was welcomed as a national treasure. In *Part One* a woman lies in stones as did the fossil; in *Parts Two* and *Three* she rises up and stand erect, in her flaming red dress and big Afro.

Muluneh was born in Ethiopia, but she and her parents left when she was an infant, and she spent an itinerant childhood in Yemen, England, and Cyprus, settling with her family in Canada at age eleven. In 2000 she earned a degree in film from Howard University, a traditionally African American school in Washington, DC, and then worked as a photojournalist at the *Washington Post*. In 2007 she moved to Addis Ababa, Ethiopia, where in 2010 she founded Addis Foto Fest, a biennial international photography festival.

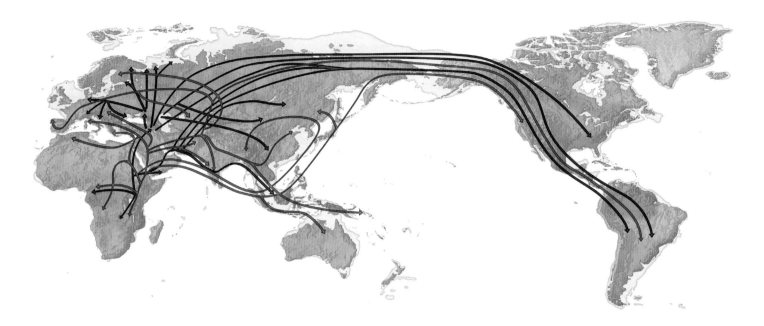

Genetic Adam and Eve

When DNA sequencing tools became available in the 1970s, anthropologists realized they could use DNA to answer the question of human origins, because when scientists compare the DNA of two animals alive today, they can tell when their most recent common ancestor lived. Researchers first traced human lineage through the female line by sequencing DNA from mitochondria (cell bodies outside the nucleus), because mitochondrial DNA is passed only from mother to daughter. After compiling data from 145 women living around the world, scientists announced in 1987 that the most recent common (female) ancestor of all living *Homo sapiens* is a woman who lived in East Africa (modern Ethiopia) between 140,000 and 200,000 years ago; she became known as Mitochondrial Eve.[9] A companion study was conducted to trace the male lineage by sequencing the Y chromosome, which is passed from father to son, and scientists came to a similar conclusion: every human alive today has a most recent common (male) ancestor—Y-chromosomal Adam—who lived in Ethiopia around 200,000 years ago. From Ethiopia, the descendants of Adam and Eve spread across Africa and around the world (plates 14-31 and 14-32).

Plate Tectonics and a Third Branch on the Tree of Life

Early map-makers noticed that the continents fit together like pieces of a puzzle. Soon after Magellan circumnavigated the globe (see plate 2-19 in chapter 2), Abraham Ortelius published the first atlas of the world, *Theatrum orbis terrarum* (Theater of the world; 1570), in which he hypothesized that the land masses may have once been connected. This idea was revived in Darwin's day, because it helped explain why close cousins on the family tree, such as species of monkeys, are found on distant continents (see plate 3-8, in chapter 3).

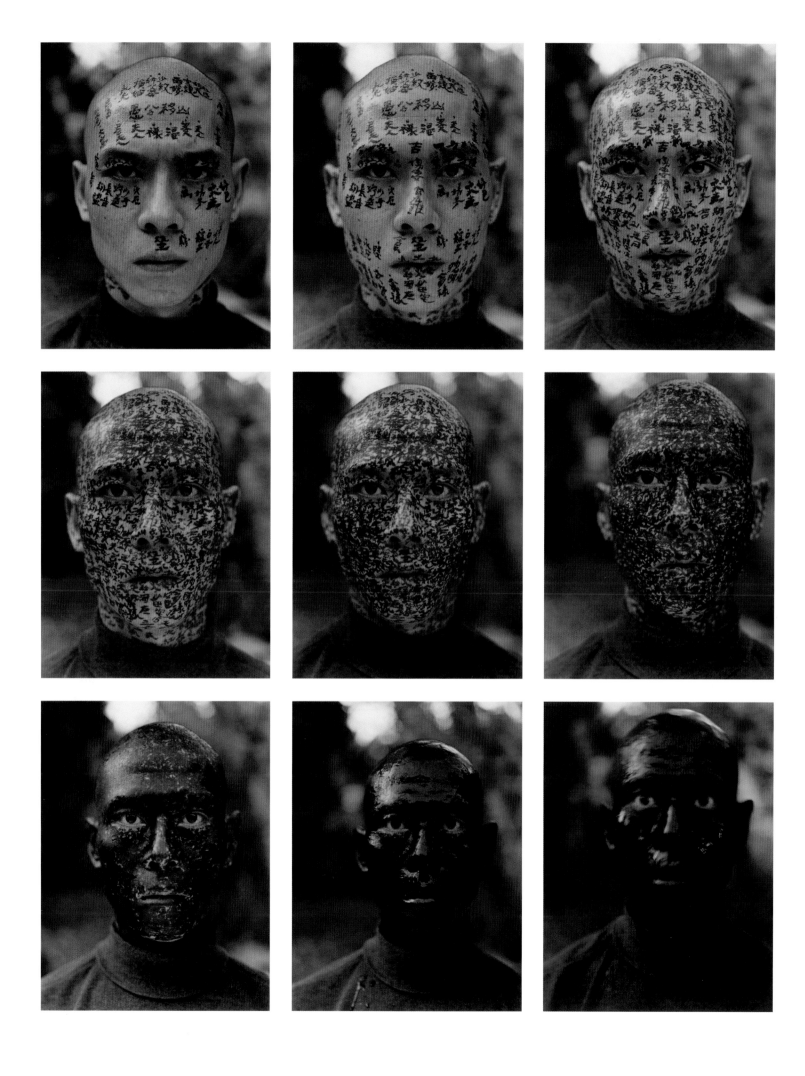

14-33. Continental drift, in Alfred Wegener, "Reconstructions of the map of the world for three periods according to the Displacement Theory," *The Origin of Continents and Oceans*, trans. J. G. A. Skerl (London: Methuen, 1924), 6.

Today geologists have confirmed that Wegener's 1924 diagram is essentially correct: during the Carboniferous (Latin for "I carry coal"), the continents collided to form the supercontinent Pangaea; during the Eocene (Greek for "new dawn"), "new" animals evolved; and the "older" Quaternary (Latin for "consisting of four") begins the geologic period of the present.

In 1912 the German polar researcher Alfred Wegener hypothesized that the continents were once joined together in a supercontinent—Pangaea—which had slowly separated, undergoing *Kontinentalverschiebung* (German for "continental drift"; plate 14-33). Wegener's suggestion was mocked because he couldn't explain how South America could "drift" across the Atlantic Ocean. In the 1950s, the American geologist Marie Tharp gave an explanation: South America and Africa are attached to pieces of Earth's crust, which move due to heat from Earth's inner core. Tharp worked at Columbia University in New York, making maps of the Atlantic Ocean based on photographs and sonar data collected in the 1950s to locate downed aircraft from World War II. In 1850 Matthew Maury had discovered an underwater mountain range when he was making a map of the floor of the Atlantic Ocean (see plate 8-26 in chapter 8). Tharp confirmed the existence of the crest of this chain of mountains, stretching from the Arctic region northeast of Greenland to the southern Atlantic between Chile and South Africa (plate 14-34). She also noticed—crucially—that the crest of this mid-Atlantic range is the site of volcanoes and an epicenter of earthquakes. This suggested to Tharp that the sea floor is shifting and spreading (causing earthquakes), allowing molten lava to spew forth from Earth's core (causing volcanos). Like Wegener's hypothesis, Tharp's idea was initially mocked, but mounting evidence convinced her colleague geologist Bruce Heezen, who joined her in mapping the ocean floors. Eventually they mapped the entire globe (75 percent of the surface of which is ocean), thereby revealing that Earth's mantle (the layer just beneath the crust) is made up of seven large plates that carry the continents and are in continual motion—a phenomenon known as *plate tectonics*. Today the movement of the continents—typically three-eighths inch (one centimeter) per year—is measured from space by the Global Positioning System (GPS).

In 1977 geologists from Woods Hole Oceanographic Institution in Massachusetts went on an expedition to explore underwater volcanoes near the Galápagos Islands. At that time scientists thought that plants were the bottom of Earth's one and only food chain; since plants need sunlight to photosynthesize, there is not much life in the eternal darkness of the ocean floor. When the geologists arrived at the underwater volcanoes, they were astonished to discover life thriving at the juncture of two tectonic plates—hydrothermal vents—from which scalding hot water flows. The vents are

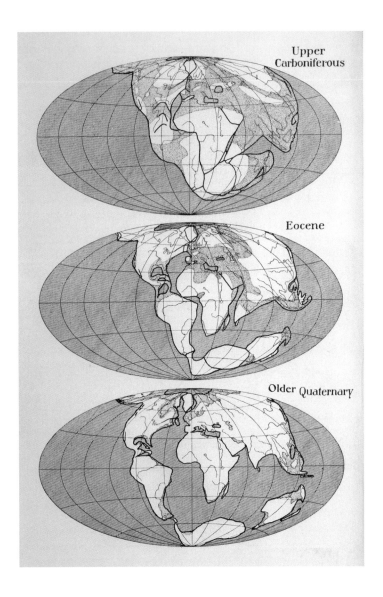

Upper Carboniferous

Eocene

Older Quaternary

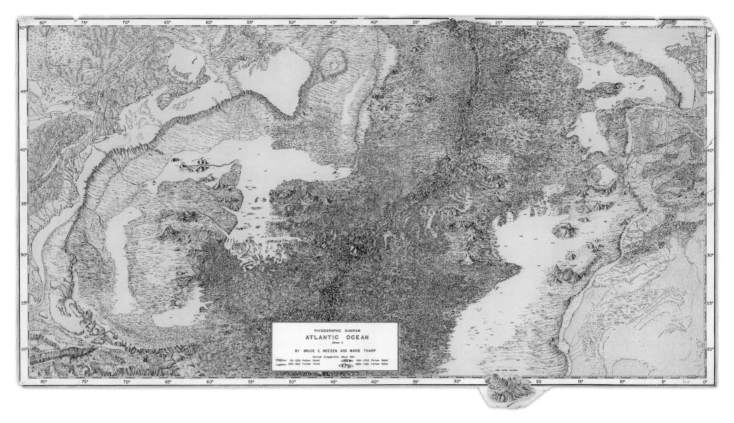

home to microbes that eat the hot minerals and produce food by *chemo*synthesis (as opposed to *photo*synthesis), forming the bottom of Earth's second food chain—an ecosystem of underwater organisms, including giant tube worms and ghostly white, eyeless crabs (plate 14-35). Biologists had long assumed that life began near the surface of water, such as shallow tide pools, because plants and photosynthetic algae need sunlight. But chemosynthesis is strong evidence that life began in hydrothermal vents, where organisms would have been protected from bombardments by meteors and lethal radiation during the formation of the solar system.

Since Darwin's day, biologists thought the tree of life had two branches: *bacteria*, single cells with no nucleus, and *eukaryotes*, organisms (including multicelled plants, animals, fungi) composed of cells with a nucleus. Then in 1977, the American biologist Carl Woese announced that there is a third branch, *archaea*, single-celled organisms, many of which live in the extreme conditions found in hydrothermal vents. Archaea have unusual features, such as an ability to metabolize without oxygen and they produce methane. All previous biologists had mistaken archaea for bacteria, but Woese showed, based on the genetic information encoded in their DNA, that archaea are more distantly related to bacteria than to eukaryotes. He argued that the three branches had diverged early and represent separate lines of descent (plate 14-36). In 2016, biologists produced an updated tree of life that supports Woese's association of archaea and eukaryotes, as well as the vast diversity of bacteria (plate 14-37).

14-34. Bruce C. Heezen and Marie Tharp, *Physiographic Diagram, Atlantic Ocean*, 1957. Engraving, 30¼ × 56 in. (77 × 142 cm). David Rumsey Historical Map Collection. © 2000 by Cartography Associates.

The mid-Atlantic ridge, an underwater mountain range, is seen stretching from the top (at about 30 degrees west of the prime meridian) to the bottom (45 degrees west).

14-35. Giant tube worms and white crabs, film stills from *Volcanoes of the Deep Sea*, 2003. A Stephen Low Film. © The Stephen Low Company.

These film stills capture life at the ocean bottom along a hydrothermal vent. The giant tube worms (*Riftia pachyptila*), which reach lengths of about 7 feet (2.1 meters), are anchored to rock at one end. The worm exchanges chemicals with the environment at its free end, which is bright red because it contains hemoglobin (a protein that transports oxygen). Living in total darkness far from the reach of the sun's rays, the crabs have evolved with neither pigment nor eyes.

14-36. RNA Tree of Life, 1977. Researchers: Carl Woese and Norman R. Pace, University of Illinois.

This tree shows the relationships among Earth's creatures based on the similarity in their RNA, genetic material possessed by all organisms. Ribonucleic acid (RNA) is a component of the molecular machinery that translates genetic information from DNA into the organism's working parts. (The researchers used RNA to make the tree rather than DNA because they believed it to be of earlier evolutionary origin.) The length of a branch indicates how long the organism has been evolving; most forms of life are microscopic and have a very long evolutionary past. Those visible to the human eye—plants, animals, and fungi, which appear in the upper right-hand branches— are some of the most recently evolved. Today biologists work to determine what is at the trunk of the tree. Is there one, single-celled, universal ancestor? Or did the three kingdoms emerge independently from a common pool of genes?

14-37. Microbial Tree of Life, 2016. Researchers: Laura A. Hug, Brett J. Baker, Karthik Anantharaman, Christopher T. Brown, Alexander J. Probst, Cindy J. Castelle, Cristina N. Butterfield, Alex W. Hernsdorf, Yuki Amano, Kotaro Ise, Yohey Suzuki, Natasha Dudek, David A. Relman, Kari M. Finstad, Ronald Amundson, Brian C. Thomas, and Jillian F. Banfield.

This tree includes ninety-two bacterial phyla (groupings), twenty-six archaeal phyla, and five eukaryotic supergroups. The colors are arbitrary (*Nature Microbiology* 1, Apr. 11, 2016.)

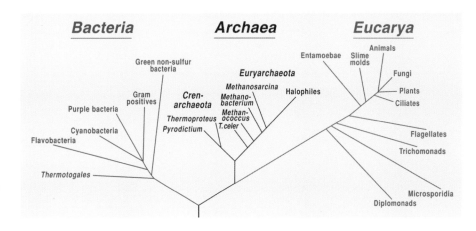

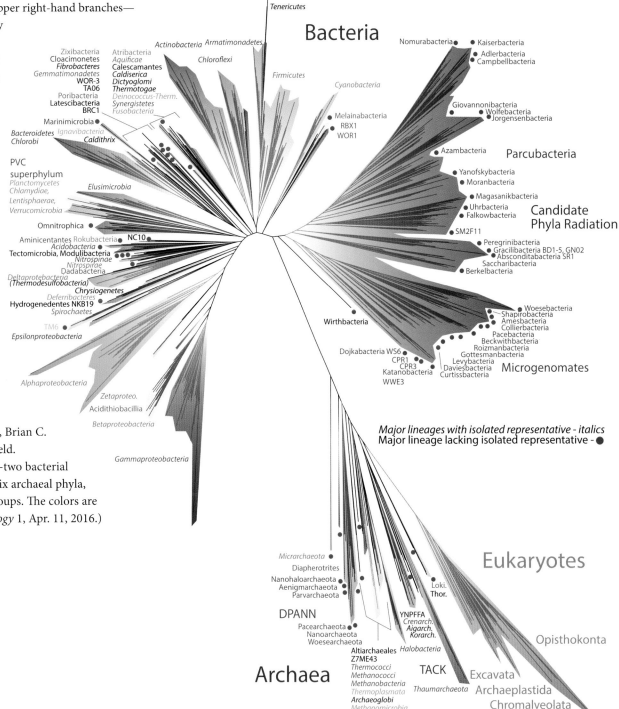

Bioluminescence and Quorum Sensing

Some organisms, such as fireflies and the algae that make ocean waves glow, give off light. Bioluminescence is rare on Earth's surface, which is sunlit half the time, but in the eternal darkness of the deep sea, three-quarters of all creatures—from bacteria to vertebrates—communicate with light the way organisms living on Earth's surface communicate with sound: frightening a predator, luring prey, seducing a mate (plates 14-38, 14-39, and 14-40).[10]

Bioluminescence is produced by essentially the same chemical mechanism in all organisms. A protein (*luciferin*, Latin for "light-bearing") stores energy in the form of electrons that are "excited" (they've absorbed energy, so they're in orbitals farther from the nucleus). To give off light, the organism sends an enzyme (a *luciferase*), which acts as a catalyst, causing the electrons to lose energy and move closer to the nucleus, releasing energy in the form of photons (light).

In the 1970s the American biologist J. Woodland "Woody" Hastings was studying bioluminescence in marine organisms, when he noticed that a single bacterium of the species *Vibrio fischeri* doesn't give off light, but a group will suddenly glow in unison; he had discovered that bacteria communicate with each other and act as a group, much as multicellular organisms do. *Vibrio*

ABOVE

14-38. *Atolla wyvillei*, in Ernst Haeckel, *Kunstformen der Natur* [Art forms in nature] (Leipzig: Bibliographisches Institut, 1899–1904), plate 18, fig. 9.

Ernst Haeckel drew this deep-sea jellyfish, *Atolla wyvillei*, from below, with its twenty-two tentacles floating like a halo. He named *Atolla wyvillei* in honor of C. Wyville Thomson, the British zoologist who was chief scientist on the HMS *Challenger* expedition (see chapter 6). Some in the government wanted only British scientists to catalogue the species collected on the British expedition, but Thomson insisted that zoologists be picked not by nationality but by expertise, so Haeckel, who was German, joined the team.

LEFT

14-39. *Atolla wyvillei.* Photograph. Courtesy of Steven H. D. Haddock, Monterey Bay Aquarium Research Institute, Moss Landing, California.

The jellyfish *Atolla wyvillei* uses bioluminescence as a defense. When attacked, it gives off bright blue flashes of light that radiate in circular waves.

ABOVE

14-40. Iyvone Khoo (Singaporean, born 1975), in collaboration with biologist Michael Latz, *Infinity Cube*, 2017. Video projection on Plexiglas, installation at the Birch Aquarium at Scripps Institution of Oceanography, University of California, San Diego.

Two young children explore *Infinity Cube*, a video projection of moving pictures of bioluminescent algae onto a reflecting cube, accompanied by a soundscape. Iyvone Khoo filmed the marine microorganisms in collaboration with Michael Latz, who is an expert on bioluminescence at Scripps Institution of Oceanography.

RIGHT

14-41. Nurit Bar-Shai (Israeli, born 1974), *Objectivity [tentative]: Sound to Shape*, 2013. Microbial culture on agar in a Petri dish. Courtesy of the artist.

Nurit Bar-Shai was inspired by Eshel Ben-Jacob's work on communication among bacteria when she was invited to do scientific research in his laboratory at Tel Aviv University in Israel. Moving from the controlled environment of a laboratory to the public space of an art gallery, Bar-Shai introduced variables, such as sound, three-dimensional forms made from the gelatinous culture agar, and custom-made Petri dishes, which all affect the complex group microbial behavior and result in distinct patterns of organisms, as shown in this example.

fischeri secretes a molecule into the water, where it is sensed by other *Vibrio fischeri*, which respond by also secreting the molecule. When the bacteria sense that the density of the molecule in the water has reached a critical level, this indicates to them that there are a certain number of their species in the immediate vicinity—they have reached a quorum—and together they shine forth.

Researchers have since discovered that populations of bacteria use quorum sensing not only for bioluminescence but to regulate the expression of many genes by the whole community (plate 14-41). This has important implications for control of bacterial infections, because one bacterium in a person's body may not be harmful, but when the population reaches a critical size, the group can release a toxic substance. A bacterium is one cell, and acting alone it can't kill a mammal, which has trillions of cells, but a quorum can take down large prey. One goal of biologists is to develop antimicrobial drugs that can interrupt the transfer of information in quorum sensing, thereby preventing chemical messages from "going viral" and causing a lethal infection.[11] Another goal is to encourage quorum sensing that is beneficial to the host, because the key role of bacteria in human health has begun to emerge in studies of the microbiome.

Microbiome

The human microbiome is the aggregate of microorganisms (bacteria, viruses, and fungi) living on and within tissues of the body, including the skin, mouth, nose, lungs, and digestive tract. Each person has at least as many microbial cells as human cells. The human genome, the epigenome, and the microbiome all evolved together to produce *Homo sapiens*.

The human infant is in a sterile environment within the womb before birth and acquires its initial microbiome from its mother as it passes through her birth canal and then from breast milk. As the child develops, so does its microbiome, in response to diet and the environment. The microbes that reside in the gut (the stomach and the gastrointestinal tract) are especially crucial to the health of the host; the lack of key gut microbes may cause a poor immune response and has been implicated in colon cancer, inflammatory bowel disease, and the progression of HIV.

Antibiotics (drugs that kill bacteria) were developed in the 1930s, and penicillin saved many lives during World War II, but the overuse of antibiotics has led to the evolution of drug-resistant bacteria. People are not only prescribed antibiotics, they also consume them in meat from livestock that has been fed antibiotics to promote growth. The depletion of the human microbiome due to overuse of antibiotics has been linked to the dramatic rise since the 1950s in allergies and asthma. In 2007 in the United States, the National Institutes of Health launched the Human Microbiome Project, a research initiative to gain understanding of the role of the microbiome in health and disease, the first phase of which was completed in 2012 (plates 14-42 and 14-43).

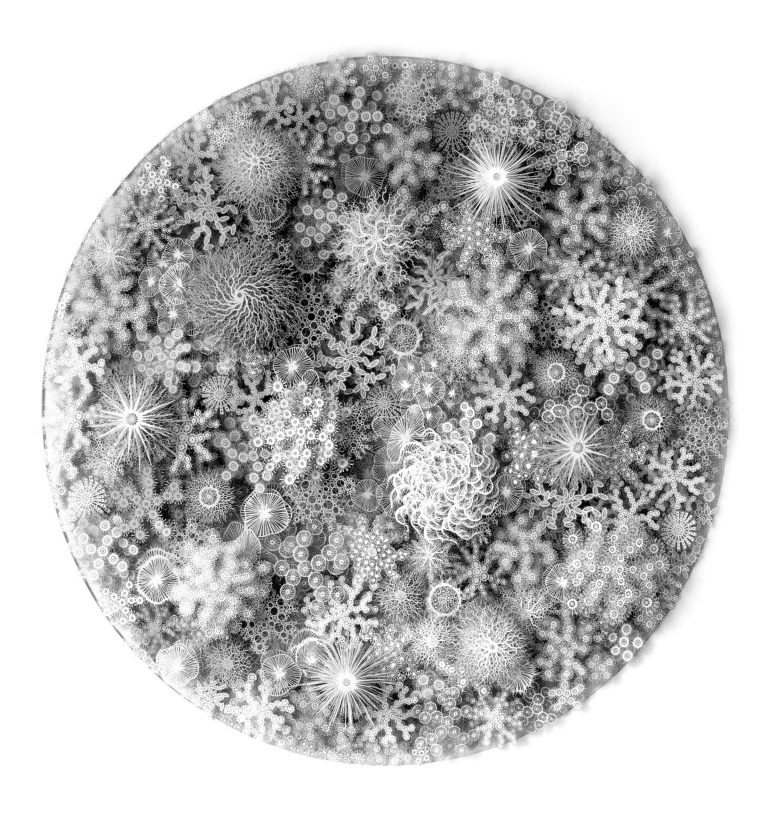

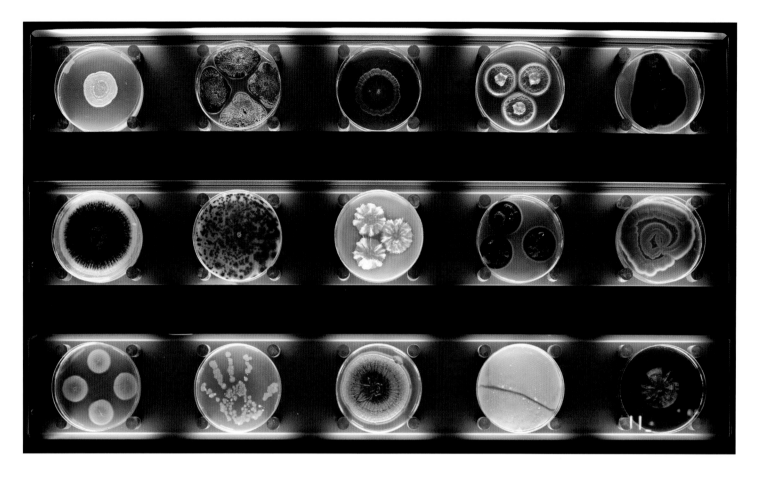

14-44. Display of microbes growing in Petri dishes in Micropia, Amsterdam.

Viewed from left to right:

Top row: unknown, *Penicillium verrucosum, Penicillium roqueforti, Aspergillus oryzae,* unknown

Middle row: Alternaria arborescens, Biergist, Penicillium isariiforme, Ulocladium alternariae, Fusarium equiseti

Bottom row: Aspergillus campestris (most likely), washed hand, *Penicillium italicum, Blakeslea trispora, Penicillium polonicum*

14-45. Film still from *Human Immunodeficiency Virus (HIV),* 2013. Animation and narration by Janet Iwasa, music composed and performed by Joshua Roman.

This three-dimensional model of an HIV particle shows the protein shell—or capsid (yellow)—open on top to reveal the genes of the virus.

In the city of Amsterdam is the Netherlands's oldest zoo, home to exotic birds, elephants, lions, and tigers. Right next door, there is a new zoo, Micropia, which is home to bacteria, viruses, and fungi. Open since 2014, Micropia gives the public information about the role of microorganisms in maintaining health (plate 14-44). In the past decade there is also a new field of film-making, molecular animation, which aims to help researchers, medical students, and the public visualize how molecules look, move, and act (plate 14-45).

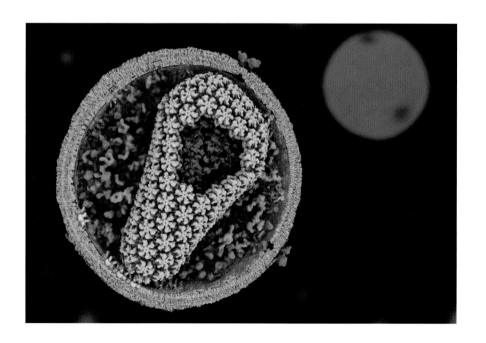

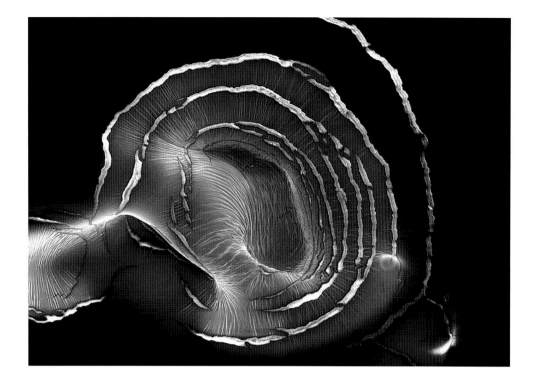

14-46. Anastasia Tyurina (Russian, born 1982), *Brown Lake*, 2015. Photomicrograph, 16½ × 23⅝ in. (42 × 60 cm). Courtesy of the artist. © 2015, Anastasia Tyurina

This is a photograph of an image produced by a scanning electron microscope of a drop of water from Brown Lake (also known as Lake Bummeira), North Stradbroke Island, Queensland, Australia.

Electron Microscopy

After electrons were discovered in the 1890s, scientists began to imagine using them to build a microscope with which they could see microbes, such as a virus, which Louis Pasteur hypothesized but couldn't see with his light microscope. Just as visible light can be considered either a light-wave or a particle (a photon), an electron can be considered either a subatomic particle or an electron wave. An electron microscope uses a beam of electrons, which can be accelerated so that their wavelengths are 100,000 times shorter than visible light-waves. A light microscope focuses light by passing it through a glass lens. An electron microscope focuses electrons by passing them through a solenoid—a glass tube around which a coil of wire is wrapped. When electric current passes through the wire it induces a magnetic field within the glass tube, and thus the path of the negatively-charged electrons travelling through the solenoid can be controlled by altering the current.

Early versions were built in the 1920s and '30s, but high-resolution electron microscopes were possible only after the development of the computer. An electron microscope records the surface of an object by scanning back and forth, building up an image by detecting electrons that are emitted because the surface is being excited (energized) by the beam, resulting in an image of the surface in extremely high definition (plate 14-46). An image recorded by an electron microscope is black and white (because it records details smaller than the wavelength of visible light); color can be added at the discretion of the person at the keyboard (plates 14-47 and 14-48).

14-47. AIDS virus (HIV) infecting a human T-cell. Scanning electron micrograph, 2014. Courtesy of Seth Pincus, Elizabeth Fischer, and Austin Athman, National Institute of Allergy and Infectious Diseases, National Institutes of Health, Bethesda, Maryland.

A T-cell is a type of white blood cell that plays a key role in the immune system. This image shows a human T-cell (blue and green) under attack by HIV (yellow). If HIV kills T-cells, the body can't fight off bacteria and viruses.

14-48. Ross Bleckner (American, born 1949), *In Sickness and in Health*, 1996. Oil on linen, 84 × 72 in. (213.4 × 182.9 cm). The Broad Art Foundation, Santa Monica, California, courtesy Mary Boone Gallery, New York.

Early twentieth-century artists using transmission (light) microscopes developed a vocabulary of flat biomorphic shapes because they were looking through specimens sandwiched between pieces of glass (see plate 3-60 in chapter 3). In Ross Bleckner's painting, blood cells infected with HIV look three-dimensional, because the artist relied on imagery from an electron microscope, which makes a topological map of the hills and valleys of the surfaces of the blood cells.

Neuroscience

In the 1890s, Sigmund Freud abandoned hope of finding physical causes of mental illness and developed psychoanalysis to identify its psychological causes. By 1900 brain scientists had divided into two groups: those who worked in mental hospitals and looked for physical causes of severe psychotic illness, and those, such as Freud, who worked in an outpatient setting and sought psychological causes of mild neurotic conditions such as anxiety. Throughout the 1920s and '30s neurologists, who studied physical features of the brain, repeatedly charged that psychoanalysis is not a science because the data (dreams, memories) is unobservable and its method (free association) does not yield repeatable results. Freud responded that his methods were as scientifically rigorous as possible, given the inherently elusive nature of the data. After Freud's death, in 1939, researchers made three crucial discoveries about physical—chemical, neurological, and genetic—features of the brain, which gave brain scientists the physical tools that Freud lacked. The chemical breakthrough came in 1952, when chlorpromazine (trade name Thorazine), the first drug effective against a psychotic illness (schizophrenia), was released in France. In 1953, neurologists discovered that at regular intervals throughout the night, a person who is sleeping enters a phase in which the body has signs of wakefulness (increased heart rate and breathing) and, although the eyelids are closed, the eyes are darting around as if looking at something, which gave the phenomenon its name—rapid-eye-movement (REM) sleep. If people are awakened during REM sleep, they report having a dream, which suggested a *physical* basis for the *psychology* of dreaming. After the discovery of the double-helix structure of DNA in 1953, geneticists began isolating the components of mental illness that are inherited. The computer also became available in the 1950s, although it was not until the 1970s that it had enough processing power to produce images of the living, conscious human brain, which is composed of 100 billion neurons. The invention by computer scientists of non-invasive imaging tools, such as magnetic resonance imaging (MRI) and computed tomography (CT), are as important for neuroscience as the invention of the telescope was for astronomy (plate 14-52).

In the 1940s, Jorge Luis Borges wrote a short story about the scientific quest for absolute accuracy. Once upon a time there was a kingdom where map-makers wanted to create an accurate drawing of their land, and so "the Cartographers Guild drew a map of the Empire that was the size of the Empire, and coincided with it point for point" ("Del rigor en la ciencia" [On precision in science], 1946).[12] Borges's parable is realized today in the Neurosurgery Simulation Core at Mount Sinai Hospital in New York, where physicians view the real brain of a living patient augmented by a one-to-one model of that patient's brain in virtual reality (see sidebar on page 456).

AUGMENTED REALITY IN NEUROSURGERY

Advances in medical imaging give physicians the tools to make surgery safer and more accurate. For example, before a patient undergoes surgery for removal of a tumor from the pituitary gland, which may cause hormone problems and vision loss, images are made of the brain (such as an MRI and CT) and then integrated to form a three-dimensional simulation of the patient's anatomy in virtual reality. In the operating room, this simulation and the patient's real-life anatomy are linked by a system such as Surgical Theater, which has a "heads-up display," meaning that transparent overlays present data without requiring the surgeon to look away from the real-life patient, as shown in the accompanying images. In plate 14-49, on the control panel in the lower right, is an overview of the three-dimensional simulation; the white tube with black stripes shows the planned point of entry into the brain through the nose and a small incision at the back of the nasal cavity. The

14-50. Two-dimensional outline of tumor and critical structures

14-51. Zoomed-out view; tumor shown as a three-dimensional purple mass

process begins by the insertion of an endoscope, a flexible tube at the tip of which is a light and a camera. The image in the upper right shows the view of the three-dimensional simulation from the tip of the endoscope in the real-life patient as it threads its way to the pituitary; the warning sign "Aneurysm" (a bulge in an artery) alerts the navigator that the endoscope is moving in the vicinity of this danger zone. Having safely avoided rupturing the aneurysm, the endoscope arrives at the pituitary. The image in the upper left is the viewpoint of the surgeon looking through the eyepieces of a microscope (as well as others in the operating room looking at monitors) without augmented reality. The surgeon can bring up two-dimensional outlines of the tumor and critical structures, as shown in plate 14-50. A magenta line is drawn around the tumor; the small magenta circle indicates the tumor's upper tip. The blue line indicates the carotid arteries (which carry blood to the brain), and the green line indicates the basilar artery in the brainstem. Solid lines are in the surgeon's focal plane and dotted lines are lower. A key feature of the Surgical Theater system is that the microscope knows where the surgeon is looking and automatically keeps the live tissue and overlays in focus. Plate 14-51 shows the same view but zoomed out, so that the surgeon can get in position to insert instruments and remove the tumor, which is now shown as a three-dimensional volume in magenta, attached to which are carotid arteries, shown in blue. The surgeon then removes the tough, fibrous tumor without damaging the soft, delicate carotid arteries or disturbing the basilar artery (shown in a green dotted line).

The three images in this sidebar were made using a Zeiss Microscope, a Karl Storz Endoscope, Brainlab Navigation software, and the Surgical Theater integration system. Courtesy of the Neurosurgery Simulation Core, Mount Sinai Hospital, New York.

14-52. An MRI and CT of the median plane of the human head.

This composite image shows an MRI of the soft tissue of the brain and spinal cord within a CT of the rock-hard bony framework of the skull and backbone. The CT machine records bone by taking a series of two-dimensional x-rays around an axis of rotation, and then combines (computes) them into a cross section (tomography) of the three-dimensional volume. The MRI machine creates a picture of soft tissue by recording the positions of hydrogen atoms, which have one (positive) proton in the nucleus, around which hovers one (negative) electron. The hydrogen atom is polarized, which means it has more negative charge concentrated on one side. To get an MRI of the brain, the patient lies down on a platform, which is slid inside a large metal coil. When the radiologist flips a switch, electric current flows through the coil and transforms it into a powerful electromagnet, causing every hydrogen atom in the patient's brain to (harmlessly) snap into orientation with the magnetic field. If a radio wave is then passed through the brain tissue, it momentarily knocks all the hydrogen atoms off alignment. As they reorient themselves, they *resonate* with the magnetic field and emit a radio wave. In other words, each hydrogen atom acts as a tiny transmitter, sending out a radio signal that indicates its location. Using this data, the radiologist produces an image of the density of hydrogen in the brain, which creates a picture of the soft tissue.

14-53. Chiharu Shiota (Japanese, born 1972), *Labyrinth of Memory*, 2012. White dresses and black wool, installation in La Sucrière, Lyon. Courtesy Blain|Southern, Berlin.

Central to Chiharu Shiota's work are themes of nostalgia and personal identity; as she has written: "When I create, I do not think about Japan or my background. Once I have completed a work, however, and I look at it from the position of an observer, I see that there is a Japanese element in everything I do. It is like a passport, a visit card, an inseparable sign. I have been living in Europe for many years. This is where I live my life, but I still miss Japan. However, when I go back there, I do not find what I seek" (*Unconscious Anxiety* [Paris: Galerie Christophe Gaillard, 2009], 24).

Today, Freud's dream of a unified physical and psychological theory of the human mind—neuroscience—has come true. Contemporary artists Chiharu Shiota and Aïda Muluneh also close the gap between body and mind by creating powerful symbols of the observable body combined with the hidden realm of dreams and memories (plates 14-53 and 14-54).

· · ·

14-54. Aïda Muluneh (Ethiopian, born 1974), *Canto 20*, from The 99 Series, 2013. Photograph. © Aïda Muluneh. Used with permission.

This photograph by Aïda Muluneh was inspired by the medieval Italian poet Dante's journey to paradise, purgatory, and hell (*The Divine Comedy*, 1308–20). Canto 20 takes place in the inferno of hell, where Dante sees people with backward-looking heads whose necks are twisted 180 degrees. Unable to look forward, they are damned for eternity to see only the past. Muluneh has written:

> Inferno is made of history, not only of a country but of self, of exile, of bloodshed, of loss, of mourning, of bitterness, of broken hearts and broken wings. The inferno is not down below; it is here, ever-present, next to us, in our memories and in our minds. It is made of delusions, of prostration, of hiding behind masks to validate our existence and our hidden agendas; it's a mask we wear to fool ourselves and others in an attempt to get ahead, yet we are void in our survival. We live in the gray existence, uncomfortable like the dirty snow of Western winters or like the polluted skyline of what we call "Ethiopian Modernity." Pulled between the past, the present and the future, we wrap ourselves with forgotten heritage and dream of looking towards the future, but we are stuck looking into the past. For eternity we are toiling with rituals and ceremony, yet our past deeds are marked by un-healing wounds, the blood of false victory stitched by the threads of nostalgia. A story we each carry, of loss, of oppressors, of victims, of disconnection, of belonging, of longing; you see paradise in the dark abyss of eternity ("The 99 Series," Aïda Muluneh's website, accessed Feb. 15, 2019, https://www.aidamuluneh.com/the-99-series-1).

14-55. The sun in x-rays. Yohkoh Legacy data archive, Montana State University.

This image was made by an x-ray telescope that was launched into space in 1991 by the Institute of Space and Astronautical Science in Japan. The Yohkoh (Japanese for "sunbeam") telescope was the first spacecraft to observe the sun during an entire solar cycle (a periodic, nearly eleven-year change in activities, such as sunspots and flares, which has been observed from Earth for centuries). Then, during a total solar eclipse, the spacecraft lost pointing (its orientation pointing toward the sun). After Yohkoh lost its lock on the sun, its solar panels were unable to charge its batteries and the spacecraft began an irreversible loss of power, eventually burning up during reentry into Earth's atmosphere.

14-56. Carina Nebula. NASA, ESA, and M. Livio, and the Hubble 20th Anniversary Team (STScI).

The Carina Nebula is a tower of gas and dust, 3 light-years tall, located in the constellation Carina, which is visible in Earth's southern sky, best seen south of the equator. This composite image was recorded by the Hubble Space Telescope in February 2010. The colors correspond to oxygen (blue), hydrogen and nitrogen (green), and sulphur (red). Inside the top of the nebula, rotating clouds of gas are forming stars, which fire off jets of gas that appear as gray wisps streaming out from the top of the tower.

Stars are formed from clouds of gas (plate 14-56). The sun formed 4.5 billion years ago when a rotating cloud fused hydrogen to helium, converting mass to energy and lighting up the sky with a burst of electromagnetic radiation (plate 14-55). Earth formed from an eddy in the rotating cloud, and after 1 billion years there was life on Earth. The sun doesn't have enough mass to go out with a bang in a supernova; instead, in 5 billion years it will slowly expand and engulf the inner planets, extinguishing life on Earth. Until then, Earth will remain inhabitable—filled with fascinating art and science—unless there's a runaway greenhouse effect or somebody steps on the nuclear dragon's tail.

Notes

Chapter 1

1 Pythagoras and his followers constitute one body of ancient thought—the Pythagoreans. See Charles Kahn, *Pythagoras and the Pythagoreans: A Brief History* (Indianapolis, IN: Hackett, 2001); and Christoph Riedweg, *Pythagoras: His Life, Teaching and Influence*, trans. Steven Redall (Ithaca, NY: Cornell University Press, 2007).

2 On Platonic themes in German Romanticism, see Douglas Hedley, "Platonism, Aesthetics, and the Sublime at the Origins of Modernity," in *Platonism at the Origins of Modernity: Studies on Platonism and Early Modern Philosophy*, ed. Douglas Hedley and Sarah Hutton (Dordrecht, Netherlands: Springer, 2008), 269–82.

3 Albert Einstein, "Religion and Science," *New York Times Magazine*, Nov. 9, 1930; reprinted in Albert Einstein, *The World as I See It*, trans. Alan Harris (New York: Covici, Friede, 1934), 261–67; the quote is on 264.

4 "But it is desirable that they in turn teach us those things which are especially in our interest: the greatest use of practical philosophy and a more perfect manner of living, to say nothing now of their arts. Certainly, the condition of our affairs, slipping as we are into ever greater corruption, seems to be such that we need missionaries from the Chinese who might teach us the use and practice of natural religion." Gottfried Leibniz, preface to *Novissima Sinica* (1697), in *Writings on China*, trans. and ed. Daniel Cook and Henry Rosemont (Chicago: Open Court, 1994), 51. Leibniz described his attitude toward Chinese theology at length in this preface to *Novissima Sinica*, 45–59.

5 Friedrich Majer, *Brahma: Oder, Die Religion der Indier als Brahmanismus* [Brahma: or, The Indian religion of Brahmanism] (Leipzig: E. H. Reclam, 1818), 214.

6 Friedrich Schlegel, "Reise nach Frankreich," *Europa* 1 (1803), 5–40; the quote is on 35.

7 Friedrich Schlegel, "Gespräch über die Poesie," *Athenäum* 3 (1800), 58–128; the quote is on 103.

8 Schlegel was in Paris during the Napoleonic occupation of northern German territories. For the influence of Schlegel's nationalism on his view of India, see Michael Dusche, "Friedrich Schlegel's Writing on India: Reimagining Germany as Europe's True Oriental Self," in *Deploying Orientalism in Culture and History: From Germany to Central Europe and Eastern Europe*, ed. James Hodkinson and John Walker (Rochester, NY: Camden House, 2013), 31–54.

9 For a critique of Hegel's negative attitude toward China, see Robert Bernasconi, "China on Parade: Hegel's Manipulation of His Sources and His Change of Mind," in *China in the German Enlightenment*, ed. and trans. Bettina Brandt and Daniel Leonard Purdy (Toronto: University of Toronto Press, 2016), 165–180. This volume also includes an English translation of Walter Demel's classic essay about European scholars' invention of five races which they distinguished by skin color, "How the Chinese Became Yellow," 20–59.

10 "Joga in jener Eigentümlichkeit ist weder Vertiefung in einen Gegenstand überhaupt . . . das Schweigen jeder inneren Empfindung, der Regung eines Wunsches oder der Hoffnung oder Furcht, die Stille aller Neigungen und Leidenschaften wie die Abwesenheit aller Bilder, Vorstellungen und aller bestimmten Gedanken." G. W. F. Hegel, "Über die unter dem Namen Bhagavad-Gita bekannte Episode des Mahabharata von Wilhelm Humboldt, Berlin 1826," *Werke in zwanzig Bänden* (Frankfurt am Main: Suhrkamp, 1971), 11:131–205; the quote is on 150–51. On Hegel's view of yoga, see Ignatius Viyagappa, *G. W. F. Hegel's Concept of Indian Philosophy* (Rome: Università Gregoriana Editrice, 1980), 123.

11 G. W. F. Hegel, "Oriental Philosophy" (1816), in *Hegel's Lectures on the History of Philosophy*, trans. E. S. Haldane and Frances H. Simson (London: Routledge and Kegan Paul, 1974), 1:125.

12 Friedrich Schleiermacher, *On Religion: Speeches to Its Cultured Despisers* (1799), trans. Richard Crouter, 2nd ed. (Cambridge: Cambridge University Press, 1996), 53–54.

13 Ibid., 54.

14 Ibid., 22.

15 On their calculations, see H. Floris Cohen, "The Natural Sciences and the Humanities in the Seventeenth Century: Not Separate Yet Unequal?", *The Making of the Humanities: The Modern Humanities*, ed. Rens Bod, Jaap Maat, and Thijs Weststeijn (Amsterdam: Amsterdam University Press, 2014), 43–52.

16 The line is from Ludwig Gotthard Kosegarten's *Jucunde* [Latin for "delightful"]: *Eine ländliche Dichtung* [German for "country poem"], the third of five eclogues (1838):

Als nun jeder die Nummer gesehn und gesucht
 und gefunden,
Scholl der Gemeinde Gesang hinauf zum
 wölbenden Himmel
Voll, stark, prächtig, harmonisch; es scholl in den
 heiligen Chorpsalm
Laut die Posaune des Meers und des Sturms
 vielkehlige Orgel.

17 On Kosegarten's relation to Runge and Friedrich, see Lewis M. Holmes, *Kosegarten's Cultural Legacy: Aesthetics, Religion, Literature, Art, and Music* (New York: Lang, 2005), 121–49.

18 Philipp Otto Runge, *Hinterlassene Schriften*, ed. Daniel Runge (Hamburg: F. Perthes, 1840–41), 1:348.

19 Ibid., 2:202. Runge's friend the poet Johann Ludwig Tieck (1773–1853) offered to compose a text, but nothing came of it.

20 Ibid. (Runge), 2:220.

21 On the similarity in outlook between the theologian and the artist, see Karl Ludwig Hoch, "Friedrich Schleiermacher und Caspar David Friedrich," *Deutsches Pfarrerblatt: Die Zeitschrift evangelischer Pfarrerinnen und Pfarrer* 84 (1984), 167–71. Hoch (1929–2015) was a Protestant theologian and art historian who worked as a pastor in the Dresden-Plauen region for thirty-five years.

22 "Denen Herren Kunstrichtern genügen unsere teutsche Sonne, Mond and Sterne, unsere Felsen, Bäume und Kräuter, unsere Ebene, Seen and Flüsse nicht mehr. Italienisch muß alles sein, um Anspruch auf Größe und Schönheit machen zu können." *Caspar David Friedrich in Briefen und Bekenntnissen*, ed. Sigrid Hinz (Munich: Rogner and Bernhard, 1974), 89. For the impact of local geography on German Romanticism, see Timothy F. Mitchell, *Art and Science in German Landscape Painting, 1770–1840* (Oxford: Clarendon Press, 1993).

23 Vasily Zhukovskii, "Pis'ma k velikoi kniagine" [Letters to the grand duchess] (ca. 1821), trans. Andreas Schönle in his *Authenticity and Fiction in the Russian Literary Journey, 1790–1840* (Cambridge, MA: Harvard University Press, 2000), 108.

24 Johanna Schopenhauer, "Über Gerhard von Kügelgen und Friedrich in Dresden: Zwei Briefe mitgetheilt von einer Kunstfreundin," *Journal des Luxus und der Moden* (1810), 690–93; reprinted in Helmut Börsch-Supan and Karl Wilhelm Jähnig, *Caspar David Friedrich: Gemälde, Druckgraphik und bildmässige Zeichnungen* (Munich: Prestel, 1973), 78.

25 "Oft giebt es aber auch so einen gemachten strengen Styl, und der Künstler setzt darin zuweilen eine Affectation, z.B. bei den Werken Friedrich's aus Dresden." G. W. F. Hegel, *Vorlesung über Ästhetik: Berlin 1820–21*, ed. Helmut Schneider (Frankfurt am Main: Peter Lang, 1995), 192.

26 For a summary of Arthur Schopenhauer's knowledge of Hindu and Buddhist texts in German translation between 1810–18, based on records of books he checked out from libraries in Weimar and Dresden, see Stephen Cross, *Schopenhauer's Encounter with Indian Thought* (Honolulu: University of Hawaii Press, 2013), 37–40.

27 Meister Eckhart, *The Complete Mystical Works of Meister Eckhart*, trans. Maurice O'Connell Walshe (New York: Crossroad, 2009), sermon 7, 73.

28 Arthur Schopenhauer, *Welt als Wille und Vorstellung* (1818); trans. E. F. J. Payne as *The World as Will and Representation* (New York: Dover, 1966), 1:xv.

29 Schopenhauer singled out Buddha, Meister Eckhart, and Saint Francis of Assisi in ibid., vol. 1, section 68, and Jesus in section 70.

30 The association of atheism with wickedness led Thomas Huxley to invent *agnosticism*; see chapter 3.

31 Arthur Schopenhauer, *Über die Freiheit des menschlichen Willens* (1839), trans. Konstantin Kolenda, *Essay on the Freedom of the Will* (New York: Dover, 2005), 19, 24, and 45.

32 They are called *metaphysics* (Greek for "after physics") because in the first century AD an anonymous editor placed these topics after physics in Aristotle's treatise on transcendental philosophy.

33 Aristotle, *De Anima* (4th century BC), 411 a7–8, in *The Works of Aristotle*, trans. J. A. Smith (Oxford: Clarendon Press, 1931; repr., 1968).

34 See Joseph Needham, *Science and Civilization in China* (Cambridge: Cambridge University Press, 1962), 4:231–37 and 249–93. For a history of the compass, from its first documented use by Chinese navigators to the invention of global positioning systems (GPS), see Alan Gurney, *Compass: A Story of Exploration and Innovation* (New York: Norton, 2004).

35 Benjamin Franklin to Peter Collinson, July 29, 1750, in *Writings of Benjamin Franklin*, ed. A. H. Smyth (New York: Macmillan, 1905–7), 2:426–54; the quote is on 437.

36 *Benjamin Franklin's Autobiography*, ed. J. A. Leo Lemay and P. M. Zall (New York: Norton, 1986), 98. Franklin worked on his autobiography intermittently from 1771

to 1789 (the year before his death, in 1790); various incomplete editions of his autobiography were published from 1791 onward.

37 See J. L. Heilbron, *Electricity in the 17th and 18th Centuries: A Study of Early Modern Physics* (Berkeley: University of California Press, 1979).

38 According to Henri F. Ellenberger, author of the classic book *The Discovery of the Unconscious Mind: The History and Evolution of Dynamic Psychiatry* (New York: Basic Books, 1970), 57–69.

39 The woman was a patient of Jean Jallabert, who described her treatment in Jallabert, *Expériences sur l'électricité* (Paris: Durand, 1748), 143–55.

40 "By the term 'neuro-hypnotism,' then, is to be understood 'nervous sleep'; and, for the sake of brevity, suppressing the prefix 'neuro,' by the terms—hypnotic, will be understood 'the state or condition of nervous sleep' . . . hypnotism, 'nervous sleep.'" James Braid, *Neurypnology; or, The Rationale of Nervous Sleep Considered in Relation with Animal Magnetism* (London: J. Churchill, 1843), 13.

41 Zhuangzi, "The Great and Venerable Teacher," in *The Complete Works of Chuang Tzu* [Zhuangzi], trans. Burton Watson (New York: Columbia University Press, 1968), 77–91. For an overview of Taoist texts about dreaming, see Esmaeil Radpour, "Daoist Views of the Dream State," *Journal of Daoist Studies* 10 (2017), 137–48.

42 Zhuangzi, "Fit for Emperors and Kings," in *Complete Works*, 92–97.

43 Trans. Chad Hansen, "Zhuangzi," *The Stanford Encyclopedia of Philosophy* (Spring 2017 ed.), ed. Edward N. Zalta, https://plato.stanford.edu/archives/spr2017/entries/zhuangzi/.

44 Ibid.

45 For example, in a discussion of the distinction between mental and physical phenomena—"idea and substance"—which, although they can be distinguished in the abstract, are (according to the Naturphilosophen) "eternally united and indivisible," Carus noted that this distinction was recognized by Indian philosophers. He refers his reader to a contemporary publication on Hinduism and Buddhism, Peter von Bohlen's *Das alte Indien* (Königsberg: Gebrüder Bornträger, 1830); Carl Gustav Carus, *Psyche: On the Development of the Soul* (1846), trans. Renata Welch, ed. Murray Stein et al. (Dallas: Spring, 1970), 33–34, 73n5.

46 Carus, *Psyche*, 66.

47 Ibid.

48 Carus's discussion of dreams is in "The Unconscious Process of Reproduction," in *Psyche*, 43–51. This translation includes only part one of Carus's three-part text; for a fuller discussion see the German original, *Psyche: Zur Entwicklungsgeschichte der Seele* [Psyche: On the history of the development of the soul] (Leipzig: Alfred Kröner, 1846), pt. 1, 83–86; and pt. 2, sec. 2d, 215–17. Carus gave his most detailed discussion of dreams and the unconscious in *Vorlesungen über Psychologie* (Leipzig: Fleischer, 1831); for further information see Matthew Bell, "Carl Gustav Carus and the Science of the Unconscious," in *Thinking the Unconscious: Nineteenth-Century German Thought*, ed. Angus Nicholls and Martin Liebscher (New York: Cambridge University Press, 2010), 156–72.

49 Carus, *Psyche*, 1.

50 Johann Wolfgang von Goethe to Carl Gustav Carus, Apr. 20, 1822, in introduction to Carus, *Neun Briefe über Landschaftsmalerei, geschrieben in den Jahren 1815–24* (Dresden: Wolfgang Jess, 1955), 10.

51 Johann Wolfgang von Goethe, *Faust: A Tragedy* (1808/1832), trans. Bayard Taylor (London: Ward and Lock, 1890), 38 and 43. For a discussion of Faust's dream see Harold Jantz, "The Function of the 'Walpurgis Night's Dream' in the Faust Drama," *Monatshefte* 44, no. 8 (Dec. 1952), 397–408.

52 Goethe in *Faust* and Carus in his psychological writing describe the distinction between sleeping and waking in a way that also reflects Zhuangzi's insights; Carus writes: "z. B. eine Rede die wir hielten, oder einen Plan den wir träumend entwarfen, uns im Traume ganz außerordentlich erscheinen kann, während wir dagegen, so bald wir uns an alles dieses im Wachen erinnern, wir beides nur für unbedeutend zu erklären" (For example, a speech we held, or a plan that we dreamt, may seem quite extraordinary in the dream, while, on the other hand, as soon as we remember all this in waking, we declare both insignificant); *Psyche: Zur Entwicklungsgeschichte der Seele*, pt. 1, 83–86; and pt. 2, sec. 2d, 217.

Chapter 2

1 See Richard Hamblyn, *The Invention of Clouds: How an Amateur Meteorologist Forged the Language of the Skies* (New York: Farrar, Straus and Giroux, 2001).

2 "Foster's [*sic*] is the best book: he is far from right, still he has the merit of breaking such ground." John Constable to George Constable, Dec. 12, 1836, in *Memoirs of the Life of John Constable: Composed Chiefly of His Letters*, ed. Charles Robert Leslie (London: Longman, Brown, Green and Longmans, 1845), 281.

3 John Constable, letter of Oct. 1821; the entire text is in C. R. Leslie, "Skies," *Crayon*, July 11, 1855, 26.

4 Ralph Waldo Emerson, "The Transcendentalist" (1841), in *The Collected Works of Ralph Waldo Emerson*, ed. Robert E. Spiller and Alfred R. Ferguson (Cambridge, MA: Harvard University Press, 1971), 1:201, 207.

5 See Russell B. Goodman, "East-West Philosophy in Nineteenth Century America: Emerson and Hinduism," *Journal of the History of Ideas* 51, no. 4 (1990), 625–45; and Carl J. Dull, "Zhuangzi and Thoreau: Wandering, Nature, and Freedom," *Journal of Chinese Philosophy* 39, no. 2 (June 2012), 222–39.

6 Henry David Thoreau, journal entry, Apr.–May 1850, in *Journal: 1848–1851*, ed. John C. Broderick (Princeton, NJ: Princeton University Press, 1990), 3:62. Emerson and Thoreau read Friedrich Schleiermacher, *A Critical Essay upon the Gospel of St. Luke* (London: John Taylor, 1825). By "Hare Buddha" Thoreau is referring to a story about a previous life of Buddha as a hare (rabbit) who is willing to sacrifice himself to feed the hungry (Jātaka, tale 316, ca. 4th century BC).

7 Ralph Waldo Emerson, *Nature: Addresses and Lectures* (1849), in *Ralph Waldo Emerson*, ed. Richard Poirier (Oxford: Oxford University Press, 1990), 3.

8 For the impact of the natural sciences on Romantic landscape painting, see Barbara Novak, *Nature and Culture: American Landscape and Painting, 1825–1875* (New York: Oxford University Press, 1995); and Alexis Drahos, *Orages et tempêtes, volcans et glaciers: Les Peintres et les sciences de la terre aux XVIIIe et XIXe siècles* (Paris: Hazan, 2014).

9 Thomas Cole, "Essay on American Scenery" (1836), in *American Art 1700–1960: Sources and Documents*, ed. John W. McCoubrey (Englewood Cliffs, NJ: Prentice-Hall, 1965), 105.

10 Carolus Linnaeus, *Systema Naturae*, 2nd ed. (Stockholm: Gottfried Kiesewetter, 1740), 14–15.

11 "Comme une faible marque d'admiration et de reconnaissance." Alexander von Humboldt and Aimé Bonpland, *Plantes équinoxiales* (Paris: F. Schoell, 1808), frontispiece.

12 Alexander von Humboldt, *Cosmos: A Physical Description of the Universe*, trans. E. C. Otté (London: Henry G. Bohn, 1849), 1:3–4.

13 See Edmunds V. Bunske, "Humboldt and an Aesthetic Tradition in Geography," *Geographical Review* 71, no. 2 (Apr. 1981), 127–46.

14 On the relation of Church's painting to Humboldt, see Stephen Jay Gould, "Church, Humboldt, and Darwin: The Tension and Harmony of Art and Science," in *Frederic Edwin Church*, ed. Franklin Kelly (Washington, DC: National Gallery of Art, 1989), 94–107; and Günter Metken, "*Heart of the Andes*: Humboldt's *Cosmos* and Frederic Edwin Church," in *Cosmos: From Romanticism to the Avant-Garde*, ed. Jean Clair (Montreal: Montreal Museum of Fine Arts, 1999), 60–66.

15 Frederic Church to Bayard Taylor, May 9, 1859, in Bayard Taylor Papers, coll. no. 14/18/1169, Division of Rare Books and Manuscript Collections, Cornell University Library; quoted by Stephen Jay Gould in "Church, Humboldt, and Darwin: The Tension and Harmony of Art and Science," in *Latin American Popular Culture* (Lanham, MD: Rowman and Littlefield, 2000), 41n3.

16 Darwin, diary entry, Feb. 28, 1832, in *Charles Darwin's Diary of the Voyage of HMS* Beagle, ed. Nora Barlow (Cambridge: Cambridge University Press, 1933), 39.

17 *The Polar Sea* is often confused with a painting (now lost) in which Friedrich depicted the wreck of another ship, the *Hoffnung* (German for "hope"). For the impact of Arctic explorations on artists of the era, see Chauncey C. Loomis, "The Arctic Sublime," in *Nature and the Victorian Imagination*, ed. U. C. Knoepflmacher and G. B. Tennyson (Berkeley: University of California Press, 1977), 95–112. For an overview of artistic responses to polar landscapes, see *Arktis Antarktis* (Bonn: Kunst-und Ausstellungshalle der Bundesrepublik Deutschland, 1997).

18 Carl Gustav Carus, *Lebenserinnerungen und Denkwürdigkeiten* (Leipzig: Brockhaus, 1865), 1:206–7.

19 "Der maler soll nicht bloß malen, was er vor sich sieht, sondern auch, was er in sich sieht. Sieht er aber nichts in sich, so unterlasse er auch zu malen, was er vor sich sieht." Hinz, *Caspar David Friedrich in Briefen und Bekenntnissen*, 125 (see chap. 1, n. 22).

20 Paul Tillich, *The Courage to Be* (New Haven, CT: Yale University Press, 1952).

Chapter 3

1 For the history of the discovery of mammoth and mastodon fossils, see Claudine Cohen, *The Fate of the Mammoths: Fossil, Myth, and History* (Chicago: University of Chicago Press, 2002).

2 Thomas Jefferson, "Memoir on the *Megalonyx*," presented to the American Philosophical Society, Feb. 10, 1797, in *The Papers of Thomas Jefferson*, ed. Barbara B. Oberg (Princeton, NJ: Princeton University Press, 2002), 29:291–

304; the quote is on 295. On Jefferson's scientific pursuits, see Silvio A. Bedini, *Thomas Jefferson: Statesman of Science* (New York: Macmillan, 1990); and Keith Stewart Thomas, *Jefferson's Shadow: The Story of His Science* (New Haven, CT: Yale University Press, 2012).

3 Gideon Mantell, journal entry, Sept. 27, 1834, in *The Journal of Gideon Mantell: Surgeon and Geologist*, ed. E. Cecil Curwen (London: Oxford University Press, 1940), 125.

4 For the impact of geology and its popularization on the arts in the Romantic era, see Barbara Maria Stafford, *Voyage into Substance: Art, Science, Nature, and the Illustrated Travel Account, 1760–1840* (Cambridge, MA: MIT Press, 1984); Rebecca Bedell, *The Anatomy of Nature: Geology and American Landscape Painting, 1825–1875* (Princeton, NJ: Princeton University Press, 2001), 3–15; and Hartmut Böhme, "Kräfte und Formen in der Geo-Ästhetik / Forces and Forms in Geo-Aesthetics," in *Die Kräfte hinter den Formen: Erdgeschichte, Materie, Prozess in der zeitgenössischen Kunst / The Forces behind the Forms: Geology, Matter, Process in Contemporary Art*, ed. Beate Ermacora, Helen Hirsch, and Magdalena Holzhey (Cologne: Snoeck, 2016), 23–50.

5 John Ruskin, *Modern Painters* (1843–60), preface to 2nd ed. (New York: Wiley, 1886), 1:xxxiv.

6 On Darwin's metaphor, see Howard E. Grubber, "Darwin's 'Tree of Nature' and Other Images of Wide Scope," in *On Aesthetics in Science*, ed. Judith Wechsler (Cambridge, MA: MIT Press, 1978), 121–39; and Matthew Rowlinson, "Darwin's Ideas," in *Marking Time: Romanticism and Evolution*, ed. Joel Faflak (Toronto: University of Toronto Press, 2017), 68–91.

7 "I am almost convinced (quite contrary to the opinion I started with) that species are not (it is like confessing to a murder) immutable." Darwin to British botanist Joseph Hooker, Jan. 11, 1844, in *The Correspondence of Charles Darwin*, ed. Frederick Burkhardt et al. (Cambridge: Cambridge University Press, 1987), 3:1–3; the quote is on 2.

8 *Punch* 40 (May 25, 1861), 213. On the popularization of Darwinian evolution in Britain, see David Roger Oldroyd, *Darwinian Impacts: An Introduction to the Darwinian Revolution* (Kensington, Australia: New South Wales University, 1980); and Alvar Ellegård, *Darwin and the General Reader: The Reception of Darwin's Theory of Evolution in the British Periodical Press, 1859–1872* (Chicago: University of Chicago Press, 1990). On the cultural impact of Darwin in Europe, see *The Literary and Cultural Reception of Charles Darwin in Europe*, vol. 3: Germany, Northern Europe, Scandinavia, Holland, Eastern Europe, and Russia, vol. 4: France, Italy, Portugal, Spain, and Greece, ed. Thomas F. Glick and Elinor Shaffer (London: Bloomsbury Academic, 2014).

9 Johann Caspar Lavater, *Physiognomische Fragmente* (Leipzig and Winterthur, Switzerland: Weidmannc Erben, Reich, and Heinrich Steiner, 1775), 1:45.

10 Huxley recalled his remarks in a letter to the British naturalist Frederick Dyster, Sept. 9, 1860, T. H. Huxley Manuscripts, Imperial College, Huxley Archives, 15:fol. 115; excerpts from the letter are reprinted in Adrian Desmond, *Huxley: From Devil's Disciple to Evolution's High Priest* (Reading, MA: Addison-Wesley, 1997), 279.

11 Desmond, *Huxley*, 374–75.

12 The term *agnosticism* was quickly popularized by British journalists such as R. W. Hutton: "In theory he [Huxley] is a great and even sincere agnostic,—who goes about exhorting all men to know how little they know, on pain of loss of all intellectual sincerity if they once consciously confound a conjecture with a certainty"; "Pope Huxley," *Spectator*, Jan. 29, 1870, 135–36, the quote is on 135.

13 Charles Darwin, *On the Origin of Species by Means of Natural Selection* (London: John Murray, 1859), 490.

14 Rudolf Clausius, "On the Second Fundamental Theorem of the Mechanical Theory of Heat," *Philosophical Magazine and Journal of Science* 35, no. 239 (1868), 405–19; the quote is on 419.

15 *The Autobiography of Charles Darwin* (1870), ed. Nora Barlow (London: Collins, 1958), 92.

16 Camille Flammarion, *Astronomie populaire* (Paris: C. Marpon and E. Flammarion, 1881), 101.

17 H. G. Wells, *The Time Machine* (1895; repr., New York: Random House, 1931), 80.

18 On the cultural impact of entropy, see Stephen G. Brush, "Degeneration," in *The Temperature of History: Phases of Science and Culture in the Nineteenth Century* (New York: Burt Franklin, 1978), 103–20; Greg Myers, "Nineteenth-Century Popularizations of Thermodynamics and the Rhetoric of Social Progress," *Victorian Studies* 29, no. 1 (Autumn 1985), 35–66; and Tamara Ketabgian, "The Energy of Belief: The Unseen Universe, and the Spirit of Thermodynamics," in *Strange Science: Investigating the Limits of Knowledge in the Victorian Age*, ed. Lara Karpenko and Shalyn Claggett (Ann Arbor: University of Michigan Press, 2017), 254–78.

19 For the impact of Darwin's theory of evolution on the visual arts in the nineteenth century, see *Endless Forms: Charles Darwin, Natural Science and the Visual Arts*, ed. Diana Donald and Jane Munro (New Haven, CT: Yale University Press, 2009).

20 For a complete listing see Bruno Béguet, ed., *La Science pour tous: Sur la vulgarisation scientifique en France de 1850 à 1914* (Paris: Bibliothèque du Conservatoire National des Art et Métiers, 1990), 70, 94–95.

21 The film was released in New York on Jan. 11, 1908; *Motion Picture Herald* 2 (1908), 29.

22 Kandinsky's biological and microscopic sources have been catalogued by Vivian Endicott Barnett, "Kandinsky and Science: The Introduction of Biological Images in the Paris Period," in *Kandinsky in Paris: 1934–44* (New York: Solomon R. Guggenheim Museum, 1985), 61–87.

Chapter 4

1 On French negative attitudes toward evolution by natural selection, see Robert E. Stebbins, "France," in *The Comparative Reception of Darwinism*, ed. Thomas F. Glick (Austin: University of Texas Press, 1974), 117–67; and Patrick Tort, "1909: The Great Silence—Remarks on the Non-Celebration of Darwin's Centenary in France," in *The Literary and Cultural Reception of Charles Darwin in Europe*, ed. Thomas F. Glick and Elinor Shaffer (London: Bloomsbury Academic, 2014), 4:400–415.

2 Louis Pasteur, "Chimie appliquée à la physiologie: Des générations spontanées" [Chemistry applied to physiology: About spontaneous generation], *Revue des cours scientifiques* 1, no. 21 (Apr. 23, 1864), 257.

3 Louis Figuier, *La Terre avant le déluge* (Paris: Hachette, 1863), xv.

4 Louis Daguerre, "Fixation des images qui se forment au foyer d'une chambre obscure," *Comptes rendus hebdomadaires des séances de l'Académie des sciences* 8 (1839), 4–7.

5 William Henry Fox Talbot, "Introductory Remarks," *The Pencil of Nature* (London: Longman, Brown, Green, and Longmans, 1844), n.p.

6 Émile Zola, interview by Louis Trebor, "Chez M. Émile Zola," *Le Figaro*, Mar. 6, 1893, 2. "Musset" is probably the playwright Alfred de Musset. On the influence of Taine's positivism on realist writers and Impressionist artists, see Marianne Marcussen and Hilde Olrik, "Le Réel chez Zola et les peintres impressionnistes: Perception et représentation," *Revue d'histoire littéraire de la France* 80, no. 2 (Nov.–Dec. 1980), 966–77.

7 Émile Zola, preface to *Thérèse Raquin*, 2nd ed. (Paris: A. Lacroix, Verboeckhoven, 1868), ii.

8 Claude Bernard wrote *Introduction à l'étude de la médecine expérimental* (Paris: J. B. Baillière, 1865). Having endured criticism for the alleged cruelty of his novels, Zola may have identified with Bernard because the scientist's experimental method was attacked by antivivisectionists.

9 "La science a voulu avoir des bases solides, et elle en est revenue à l'observation exacte des faits. Et ce mouvement ne s'est pas seulement produit dans l'ordre scientifique; toutes les connaissances, toutes les oeuvres humaines tendent à chercher dans la nature des principes fermes et définitifs. Nos paysagistes moderne l'emportent de beaucoup sur nos peintres d'histoire et de genre, parce qu'ils ont étudié nos campagnes, se contentant de traduire le premier coin de forêt venu. Édouard Manet applique la même méthode à chacune de ses oeuvres." Émile Zola, "Une nouvelle manière en peinture: Édouard Manet," *Revue du XIXe siécle* 4 (Jan. 1, 1867), 43–64; the quote is on 53.

10 For examples of physiognomy in the writings of Zola, Honoré de Balzac, and others, see F. Baldensperger, "Les Théories de Lavater dans la littérature française," in *Études d'histoire littéraire*, 2nd ser. (Paris: Hachette, 1910), 51–91; the author argues that Zola based his description of the characters in *Thérèse Raquin* on Lavater (89). See also Philippe Sorel, "La Phrénologie et l'art," *L'Âme au corps: Arts et sciences, 1793–1993*, ed. Jean Clair (Paris: Gallimard, 1993), 266–79.

11 George Combe, *Notes on the United States of North America during a Phrenological Visit* (Edinburgh: Machlachlan and Stewart, 1841), 339.

12 "Faire de la *tête d'expression* (style d'Académie) une étude du sentiment moderne. Cest du Lavater, mais du Lavater plus relatif, en quelque sorte, avec symboles d'accessoire quelquefois." *The Notebooks of Edgar Degas*, ed. Theodore Reff (Oxford: Clarendon Press, 1976), vol. 1, notebook 23, pt. 44 (1868–72), 117. See Anthea Callen, *The Spectacular Body: Science, Method, and Meaning in the Work of Degas* (New Haven, CT: Yale University Press, 1995), esp. 21–29; and John House, "Towards a 'Modern' Lavater? Degas and Manet," in *Physiognomy in Profile: Lavater's Impact on European Culture*, ed. Melissa Percival and Graeme Tytler (Newark: University of Delaware Press, 2005), 180–97.

13 Henry Trianon, "Sixième Exposition de peinture par un groupe d'artists" (1881), reprinted in *The New Painting: Impressionism 1874–1886: Documentation*, ed. Ruth Berson (San Francisco: Fine Arts Museums of San Francisco, 1996), 1:367–68.

14 Charles Ephrussi, "Exposition des artistes indépendants" (1881), reprinted in Berson, *The New Painting: Impressionism*, 1:336–67.

15 According to Chevreul's son Henri Chevreul, in his introduction to the revised edition of *De la loi du contraste simultané des couleurs* (1889; repr., Paris: Léonce Laget, 1969), iv.

16 The many references to Helmholtz's theory of vision in French publications of the 1870s–1880s include: Amédée Guillemin, *La Lumière et les couleurs* [Light and colors] (Paris: Hachette, 1874), in which the author quoted from Helmholtz's *Optique physiologique* (Paris: Masson, 1867), a French translation of *Handbuch der physiologischen Optik* (1856–67), in his discussion of vision; and Eugène Véron, "La Peinture" [Painting], in his *L'Esthétique* (Paris: C. Reinwald, 1883), in which the critic summarized Helmholtz's work on physiology. The American chemist Ogden N. Rood based his *Modern Chromatics* (New York: Appleton, 1879) on a Helmholtzian view of vision, as did the French critic Georges Guéroult in "Formes, couleurs, et mouvements," *Gazette des beaux-arts* 25, no. 2 (Feb. 1882), 165–79.

17 Ernst Wilhelm von Brücke's other books on the fine arts include, *Die Physiologie der Farben für die Zwecke der Kunstgewerbe* [The physiology of colors for the arts and crafts] (Leipzig: Hirzel, 1866); *Die physiologischen Grundlagen der neuhochdeutschen Verskunst* [The physiological foundations of new high German poetry] (Vienna: Gerold, 1871); and *Schönheit und Fehler der menschlichen Gestalt* [Beauty and defects of the human figure] (Vienna: Braumüller, 1893).

18 Hippolyte Taine, *L'Intelligence* (1870), 9th ed. (Paris: Hachette, 1900), 161–62.

19 Chevreul evidently never understood the difference between colored pigment and light, which we can surmise because he criticized Helmholtz for naming the "wrong" primaries (red, blue, and green). In 1879 Chevreul (now age ninety-three) appealed to artists to defend his "true" primary colors (red, blue, and yellow) by joining his battle against Helmholtz, which the old chemist waged as if the future of French art and science were at stake; see Chevreul, "Complement des études sur la vision des couleurs," *Memoires de l'Académie des sciences*, 2nd ser., 41 (1879), 14, 15, 178ff, 248ff.

20 Erwin Panofsky, "Die Perspektive als 'symbolische Form,'" *Vorträge der Bibliothek Warburg* (1924–25), trans. Christopher S. Wood as *Perspective as Symbolic Form* (New York: Zone Books, 1991). Highlights of the extensive literature Panofsky inspired include Hubert Damisch, *L'Origine de la perspective* (Paris: Flammarion, 1987), and James Elkins, *The Poetics of Perspective* (Ithaca, NY: Cornell University Press, 1994).

21 "Claude Monet a réussi à fixer des impressions fugitives que les peintres, ses devanciers, avaient négligées ou considérées comme impossibles à rendre par le pinceau. Les mille nuances que prend l'eau de la mer et des rivières, les jeux de la lumière dans les nuages, le coloris vibrant des fleurs et les reflets diaprés du feuillage aux rayons d'un soleil ardent, ont été saisis par lui dans toute leur vérité." Théodore Duret, "Claude Monet," *Les Peintres impressionnistes* (Paris: Librarie Parisienne, 1878), 17–19; the quote is on 17–18.

22 Edmond Duranty, *La Nouvelle peinture: À propos du groupe d'artistes qui expose dans les Galeries Durand-Ruel* (Paris: E. Dentu, 1876), 20. On Duranty and Amédée Guillemin, see Marianne Marcussen, "Duranty et les Impressionnistes," *Hafnia*, no. 6 (1979), 29; Duranty's library contained both Guillemin's *La Lumière et les couleurs* (1879) and Brücke's *Principes scientifiques des beaux-arts* (1878).

23 Martelli's copy of Brücke's *Principes scientifiques* is preserved in an archive in the Biblioteca Marcelliana, Florence; see Norma F. Broude, "The Macchiaioli as 'Proto-Impressionists': Realism, Popular Science and the Re-shaping of *Macchia* Romanticism, 1862–86," *Art Bulletin* 52, no. 4 (Dec. 1970), 407n24. In this article (406) Broude translates Diego Martelli's lecture "Gli Impressionisti," first published as a pamphlet in Pisa, Italy, in 1880.

24 For the former view, see Aaron Scharf, *Art and Photography* (London: A. Lane, 1968); and for the latter see Kirk Varnedoe, "The Artifice of Candor: Impressionism and Photography Reconsidered," *Art in America* 68, no. 1 (Jan. 1980), 66–78.

25 Monet, recorded by Lilla Cabot Perry, in "Reminiscences of Claude Monet from 1889–1909," *American Magazine of Art* 18, no. 3 (Mar. 1927), 120. In 1857 John Ruskin had made a similar observation: "The whole technical power of painting depends on our recovery of what may be called the *innocence of the eye*; that is to say, of a sort of childish perception of these flat stains of color, merely as such, without consciousness of what they signify, as a blind man would see them if suddenly gifted with sight";

John Ruskin, *The Elements of Drawing* (London: Smith and Elder, 1857), 5–6. Taine summarized the case histories of five patients who had been born blind (due to cataracts) and whose sight had been restored by removal of all or part of the lens. The risky procedure was performed successfully in Paris in 1743, and European medical literature reports about a dozen more cases by the mid-nineteenth century. In 1884 the Viennese ophthalmologist Carl Koller discovered that cocaine could be used as a local anesthesia for cataract surgery, making the procedure safer and more endurable, and hence suddenly common in the late nineteenth century. Helmholtz's research on the retina had aroused great interest in these cases because they offered a rare opportunity to test whether vision was innate or learned. In other words, does a newly sighted adult first see "a flower" or "a patch of red and green," which the person learns through experience is a flower? According to Taine, in *L'Intelligence*, 163 (see n. 18), in the reports of all the post-operative patients, on first looking at the world, "the eye has only the sensation of different colored patches more or less light or dark." Taine pointed out that this evidence supported Helmholtz, who "has shown by a multitude of experiments" that humans construct the world from sensations of "colors and shades." Taine went on to compare newborns and newly sighted persons with artists: "Painters know this state well, for they return there; their talent consists in seeing their model as a patch of color, dull, lively and mixed."

26 Claude Monet, letter to the art critic Gustave Geffroy, Oct. 7, 1890, reprinted in G. Geffroy, *Claude Monet: Sa vie, son temps, son oeuvre* (Paris: G. Crès, 1922), 189.

27 Jules Laforgue to Charles Ephrussi, Dec. 12, 1883, in Jules Laforgue, *Oeuvres complètes*, ed. Jean-Louis Debauve (Lausanne: L'Age d'Homme, 1986), 3:348.

28 Jules Laforgue, "Impressionisme" (1883), reprinted in Laforgue, *Oeuvres complètes*, 3:330.

29 Ibid., 3:330–32.

Chapter 5

1 As evidence that all animals have a common ancestor, Haeckel published diagrams of embryos of reptiles, birds, mammals, and humans that were strikingly similar; Ernst Haeckel, *Anthropogenie, oder Entwicklungsgeschichte des Menschen* [Anthropogeny, or the history of human development] (1874; repr., Leipzig: W. Engelmann, 1891), plates 6–9, between 352–53. After reproducing them in textbooks for over a century, biologists determined in the 1990s that the drawings are either over-interpretations or outright fakes; see James Hanken, "Beauty beyond Belief:

The Art of Ernst Haeckel Transcends His Controversial Scientific Ideas," *Natural History* 107, no. 10 (Dec. 1998–Jan. 1999), 56–58; and James Glanz, "Variations on an Embryo," *New York Times*, Apr. 8, 2001.

2 For the reception of Darwin's theories in Russia, see Alexander Vucinich, *Science in Russian Culture* (Stanford, CA: Stanford University Press, 1970), 2:273–97; see also Vucinich, "Russia: Biological Sciences," in Glick, *Comparative Reception of Darwinism*, 227–55 (see chap. 4, n. 1).

3 K. A. Timiriazev, *Kratkii ocherk teorii Darvina* [A brief sketch of Darwin's theory] (1865; repr., Moscow: Sel'khozgiz, 1948).

4 Darwin, *The Descent of Man, and Selection in Relation to Sex* (1871), 2nd ed. (New York and London: D. Appleton, 1874), 163.

5 Kovalevsky, quoted in Alexander Vucinich, "Russia: Biological Sciences," in Glick, *Comparative Reception of Darwinism*, 229 (see chap. 4, n. 1).

6 On Fechner's illness, see Michael Heidelberger, *Nature from Within: Gustav Theodor Fechner and His Psychophysical Worldview*, trans. Cynthia Klohr (Pittsburgh, PA: University of Pittsburgh Press, 2004), 47–50.

7 Fechner, quoted in Johannes Emil Kuntze, *Gustav Theodor Fechner* (Leipzig: Breitkopf and Härtel, 1892), 114; and in Heidelberger, *Nature from Within*, 48.

8 Gustav Fechner, *Über das höchste Gut* [On the greatest good] (Leipzig: Breitkopf and Härtel, 1846), 3; quoted in Heidelberger, *Nature from Within*, 51. For Fechner's influence on modern psychology via Sigmund Freud, see Henri Ellenberger, "Fechner and Freud," *Bulletin of the Menninger Clinic* 20 (1956), 201–14.

9 Fechner's law states that the minimal difference in intensity between two stimuli (in the physical world) that can be distinguished by the perceiving subject (in the psychological realm) bears a constant relation to the percentage of the stimulus.

10 Indeed, Fechner's tally determined that the rectangles perceived as most pleasurable had sides with the ratio 34:21; Fechner declared this was empirical proof of the pleasing proportions of what had been known in Germany since the 1830s as the *Goldener Schnitt* (golden section); Gustav Fechner, *Vorschule der Aesthetik* [Introduction to aesthetics] (Leipzig: Breitkopf and Härtel, 1876), 193–96.

11 Fechner, *Vorschule der Aesthetik*, 15–17.

12 Hermann von Helmholtz, "Gustav Magnus: In Memoriam," in *Popular Lectures on Scientific Subjects*, trans. E. Atkinson, 2nd ser. (London: Longmans, Green, 1881), 1–25; the quote is on 19.

13 Isaac Newton, *Opticks: A Treatise of the Reflexions, Refractions, Inflexions and Colours of Light* (London: S. Smith and B. Walford, 1704), bk. 1, pt. 2, 154.

14 *Kant's Critique of Aesthetic Judgment* (1790), trans. J. C. Meredith (Oxford: Clarendon Press, 1911), 210.

15 Johann Friedrich Herbart, *Kurze Encyklopädie der Philosophie aus praktischen Gesichtspunkten entworfen* (Halle: Schwetschke, 1831), sec. 72, 124–25.

16 Eduard Hanslick, *The Beautiful in Music* (1854), trans. Gustav Cohen (London: Novello and Ewer, 1891), 162.

17 G. W. F. Hegel, *Aesthetics: Lectures on Fine Art* (1835), trans. T. M. Knox (London: Oxford University Press, 1975), 2:933.

18 Hermann von Helmholtz, "The Physiological Causes of Harmony in Music" (1857), trans. A. J. Ellis, *Selected Writings of Hermann von Helmholtz*, ed. Russell Kahl (Middletown, CT: Wesleyan University Press, 1971), 107.

19 Theodor Lipps, *Raumaesthetik, und geometrisch-optische Täuschungen* [Aesthetics of space, and geometrical optical illusions] (Leipzig: Johann Ambrosius Barth, 1897).

20 Lipps included a chapter on the subjective experience of musical harmony and discord in *Psychologische Studien* [Psychological studies] (Heidelberg: Weiss, 1885), 92–161.

21 For the origins of abstract painting in Munich, see Peg Weiss, "Emergence to Abstraction," *Kandinsky in Munich: The Formative Years* (Princeton, NJ: Princeton University Press, 1979), 107–35.

22 See Christoph Kockerbeck, "Ernst Haeckels *Kunstformen der Natur* und die bildende Kunst des Art nouveau am Beispiel von Hermann Obrist," in *Ernst Haeckels* Kunstformen der Natur *und ihr Einfluss auf die deutsche bildende Kunst der Jahrhundertwende* (Frankfurt am Main: P. Lang, 1986), 43–211.

23 G. Fuchs, "Hermann Obrist," *Pan* 1 (1895), 324.

24 Ibid., 321, 324.

25 August Endell, "Formenschönheit und Dekorative Kunst" [The Beauty of forms and decorative art], *Dekorative Kunst* 1, no. 6 (Mar. 1898), 75–76. Endell published two other installments of his treatise on the decorative arts: "Die Gerade Linie" [The straight line] and "Geradlinige Gebilde" [Straight-line images], *Dekorative Kunst* 1, no.

9 (June 1898), 119–25. See also Zeynep Çelik Alexander, "Metrics of Experience: August Endell's Phenomenology of Architecture," *Grey Room*, no. 40 (Summer 2010), 50–83.

26 August Endell, *Um die Schönheit* [About beauty] (Munich: Emil Franke, 1896), 9. The related idea of looking at nature in terms of its abstract structure motivated Endell's contemporary the Berlin botanist Karl Blossfeldt to create stunning photographs of stems, buds, and leaves on stark blank backgrounds; see plates 10-42 and 10-43, and Blossfeldt, *Urformen der Kunst: Photographische Pflanzenbilder* [Original forms of art: photographs of plants], ed. Karl Nierendorf (Berlin: E. Wasmuth, 1928). Generations of mid-twentieth-century artists were encouraged to continue looking at nature abstractly by the British biologist D'Arcy Thompson's *On Growth and Form* (Cambridge: Cambridge University Press, 1942).

27 August Endell, *Die Schönheit der grossen Stadt* [Beauty in the big city] (Stuttgart: Strecker and Schröder, 1908), 44–45.

28 Arthur Roessler, "Das abstrakte Ornament mit gleichzeitiger Verwendung simultaner Farbenkontraste" [Abstract ornament used for color contrast], *Wiener Abendpost*, suppl. to no. 228 (Oct. 6, 1903), n.p.

29 Arthur Roessler, *Neu-Dachau: Ludwig Dill, Adolf Hölzel, Arthur Langhammer* (Bielefeld, Germany: Velhagen and Klasing, 1905), 123.

30 Ibid.

31 Bucke cited Whitman and *Leaves of Grass* in Richard Bucke, "From Self to Cosmic Consciousness," in *Cosmic Consciousness: A Study in the Evolution of the Human Mind* (1901; repr., New Hyde Park, NY: University Books, 1961), 51–68.

32 *Leaves of Grass* was translated by Konstantin Bal'mont, as *Pobiegi travy* (Moscow: Skorpion, 1911); Bucke's *Cosmic Consciousness* was translated into Russian in 1915, as *Kosmicheskoe soznani*.

33 Theosophists Annie Besant and Charles Leadbeater describe their séances in chapter 1 of *Occult Chemistry: Clairvoyant Observations on the Chemical Elements* (London: Theosophical Publishing House, 1919). See Sumangala Bhattacharya, "The Victorian Occult Atom: Annie Besant and Clairvoyant Atomic Research," in *Strange Science: Investigating the Limits of Knowledge in the Victorian Age*, ed. Lara Karpenko and Shalyn Claggett (Ann Arbor: University of Michigan Press, 2017), 197–214.

34 After non-Euclidean geometries were published by nineteenth-century Russian and German mathematicians, the public became enchanted with the idea that there might be additional spatial dimensions. See Linda Dalrymple Henderson, "Hyperspace Philosophy in Russia: Peter Demianovich Ouspensky," in *The Fourth Dimension and Non-Euclidean Geometry in Modern Art* (Princeton, NJ: Princeton University Press, 1983), 245–55.

35 Peter Ouspensky, *Tertium Organum: The Third Canon of Thought; A Key to the Enigmas of the World* (1911), trans. Claude Bragdon and Nicholas Bessaraboff (New York: Knopf, 1968), 236.

36 Nikolai Kulbin, *Chuvstvitelnost: Ocherki po psikhometree e klinicheskomu primeneniiu eia dannykh* [Sensitivity: Studies in psychometry and the clinical application of its data] (Saint Petersburg, 1907).

37 Rudolf Virchow, quoted in Wassily Kandinsky, "Kuda idet 'novoe' iskusstvo" (1911), trans. John E. Bowlt as "Whither the 'New Painting,'" in *Kandinsky: Complete Writings on Art*, ed. Kenneth C. Lindsay and Peter Vergo (Boston: G. K. Hall, 1982), 1:98–104; the quote is on 1:98.

38 Ibid., 1:101.

39 Kulbin, *Chuvstvitelnost*, 151.

40 Nikolai Kulbin, "Free Art as the Basis of Life: Harmony and Dissonance" (1908), in *Russian Art of the Avant-Garde: Theory and Criticism, 1902–1934*, trans. John E. Bowlt (London: Thames and Hudson, 1988), 13. Kulbin published a related essay on music in *Der Blaue Reiter* (1912); trans. Henning Falkenstein as "Free Music," *The Blaue Reiter Almanac* (New York: Viking, 1965), 141–46.

41 Wassily Kandinsky, "Soderzhanie i forma" (1910–11), trans. Peter Vergo, as "Form and Content," in Lindsay and Vergo, *Kandinsky: Complete Writings*, 1:87–90; the quote is on 1:87.

42 Wassily Kandinsky's note to his 1911 translation from German to Russian of Schoenberg's "On Parallel Octaves and Fifths," *Salon 2* (Odessa, Russia, 1911), trans. Peter Vergo, in Lindsay and Vergo, *Kandinsky: Complete Writings*, 1:93.

43 On Kandinsky's relationship with Schoenberg, see Peter Vergo, "Music and Abstract Painting: Kandinsky, Goethe, and Schoenberg," in *Towards a New Art: Essays on the Background to Abstract Art, 1910–1920* (London: Tate Gallery, 1980), 41–63.

44 D. G. Konovalov, *Religioznyi ekstaz vrusskom misticheskom sektantstve* [Religious ecstasy in Russian mystical sectarianism] (Sergiev Posad, Russia: Troitse-Sergieva Monastery, 1908). Kruchenykh described the monks as sincere, religious people who speak in unknown tongues when "filled with the Holy Spirit," in "Novye puti slova" [New ways of words] (1913), in *Manifesty i programmy russkikh futuristov* [Manifesto and program of the Russian Futurists], ed. Vladimir Markov (Munich: Fink, 1967), 67. In his book *Utinoe gniezdyshko durnykh slov* [Bird's nest of bad words] (Saint Petersburg: EUY, 1913), Kruchenykh claimed that for the first time he and other writers gave the world poems written in a free language (*zaumnom*) that is beyond reason and universal. Kruchenykh also published *Zaumnaia kniga* [Abstruse book] (Moscow: Knigi Budetlian, 1915).

45 Kazimir Malevich to Mikhail Matiushin, summer 1913, archives of the Tretiakov Gallery, Moscow, f. 25, no. 9, sheets 11–12; quoted in Charlotte Douglas, "Beyond Reason: Malevich, Matiushin, and Their Circle," in Maurice Tuchman et al., *The Spiritual in Art: Abstract Painting 1890–1985* (New York: Abbeville, 1986), 199. On Malevich and theosophy, see Jean Clair, "Malévitch, Ouspensky, et l'espace néo-platonicien," *Malévitch 1878–1978*, ed. Jean-Claude Marcadé (Lausanne: L'Age d'Homme, 1979), 15–30.

46 On the relation of Malevich to Khlebnikov, see Rainer Crone, "Malevich and Khlebnikov: Suprematism Reinterpreted," *Artforum* 17, no. 4 (Dec. 1978), 38–47.

47 Kazimir Malevich, *From Cubism to Suprematism in Art, to the New Realism of Painting, to Absolute Creation* (1915), trans. Charlotte Douglas, as an appendix to *Swans of Other Worlds: Kazimir Malevich and the Origins of Abstraction in Russia* (Ann Arbor, MI: UMI Research Press, 1976), 110.

48 Kazimir Malevich to Mikhail Matiushin, Nov. 10, 1917, trans. Evgenii Kovtun, in "Suprematism as an Eruption of Universal Space," *Suprematisme* (Paris: Galerie Jean Chauvelin, 1977), 27.

49 Kazimir Malevich, *The Non-Objective World* (1926), trans. Howard Dearstyne (Chicago: Paul Theobald, 1959), 68.

50 David Burliuk, "Cubism (Surface—Plane)" (1912), in *Russian Art of the Avant Garde: Theory and Criticism, 1902–1934*, trans. John Bowlt (New York: Viking, 1976), 70.

51 A photograph of this lost piece is in the Russian State Archive of Literature and Art, Moscow, inv. no. 998-1-3623-3.

52 On the music/color analogy in abstract film, see: William Moritz, "Abstract Film and Color Music," in Tuchman, *Spiritual in Art*, 296–311; and Thomas Patteson, "Sonic Handwriting: Media Instruments and Musical

Inscription," in his *Instruments for New Music: Sound, Technology, and Modernism* (Berkeley: University of California Press, 2016), 82–113, esp. 85–92.

53 Bruno Corra, "Abstract Cinema—Chromatic Music" (1912), trans. Caroline Tisdall, in *Futurist Manifestos*, ed. Umbro Apollonio (New York: Viking, 1973), 69.

Chapter 6

1 For Haeckel's influence on Art Nouveau design, see Erika Krausse, "Zum Einfluss Ernst Haeckels auf Architekten des Art Nouveau," *Die Natur der Dinge: Neue Natürlichkeit?*, ed. Olaf Breidbach and Werner Lippert (Vienna: Springer, 2000), 85–93; and J. Malcolm Shick, "Toward an Aesthetic Marine Biology," *Art Journal* 67, no. 4 (Winter 2008), 62–86.

2 Sullivan's slogan "form follows function" is a shortened version of what he first wrote, in "The Tall Office Building Artistically Considered," *Lippincott's Monthly Magazine* (Mar. 1896), 403–9; the quote is on 408. On the art and philosophy of organic architecture, see David Van Zanten, "Louis Sullivan, Herbert Spencer, and the Medium of Architecture," in *Design in the Age of Darwin: From William Morris to Frank Lloyd Wright*, ed. Stephen F. Eisenman (Evanston, IL: Northwestern University Press, 2008), 26–37.

3 "Puisse donc ce cristal refroidi garder le reflet de votre flamme." Émile Gallé, *Écrits pour l'art* (Paris: Renouard, 1908), 154.

4 There is critical writing beginning in the 1880s showing that Seurat, Paul Signac, and Camille Pissarro assembled under a banner of science because of its prestige and because artists found scientific information useful; the key publications are: Charles Henry, "Introduction à une esthétique scientifique," *La Revue contemporaine* 2 (Aug. 1885), 441–69; Félix Fénéon, "Les Impressionnistes" (1886), reprinted in *Les Écrivains devant l'impressionnisme*, ed. Denys Riout (Paris: Macula, 1989), 394–405; William Innes Homer, *Seurat and the Science of Painting* (Cambridge, MA: MIT Press, 1964); Martin Kemp, *The Science of Art: Optical Themes in Western Art from Brunelleschi to Seurat* (New Haven, CT: Yale University Press, 1990), 306–22; John Gage, "Seurat's Silence," *Color and Meaning: Art, Science, and Symbolism* (Berkeley: University of California Press, 1999), 219–27; and Robert L. Herbert, "Seurat and the Making of *La Grande Jatte*," in *Seurat and the Making of* La Grande Jatte (Chicago: Art Institute, 2004), 22–177. There is also a trail of commentary alleging that Seurat misused scientific data: J. Carson Webster, "The Technique of Impressionism:

A Reappraisal," *College Art Journal* 4, no. 1 (Nov. 1944), 3–22; Alan Lee, "Seurat and Science," *Art History* 10, no. 2 (June 1987), 203–26; John Gage, "The Technique of Seurat: A Reappraisal," *Art Bulletin* 59, no. 3 (Sept. 1987), 448–54. Others have stressed the link of science with the anarchist political outlook held by artists in Seurat's circle: Robyn S. Roslak, "The Politics of Aesthetic Harmony: Neo-Impressionism, Science, and Anarchism," *Art Bulletin* 73, no. 3 (Sept. 1991), 381–90; John G. Hutton, *Neo-Impressionism and the Search for Solid Ground: Art, Science, and Anarchism in Fin-de-Siècle France* (Baton Rouge: Louisiana State University Press, 1994).

5 Ogden N. Rood, *Modern Chromatics with Applications to Art and Industry* (1879; facsimile repr., New York: Van Nostrand Reinhold Company, 1973), 14; French trans., *Théorie scientifique des couleurs et leurs applications à l'art et à l'industrie* (Paris: Librarie Germer Baillière, 1881).

6 Rood, *Modern Chromatics*, 140.

7 Early forms of color printing were introduced in France in the 1880s, and color separations began to be used the following decade. On the possible impact on Seurat, see Norma Broude "New Light on Seurat's 'Dot': Its Relation to Photo-Mechanical Color Printing in France in 1880s," *Art Bulletin* 56, no. 4 (Dec. 1974), 581–89.

8 "Georges Seurat, Paul Signac, Camille and Lucien Pissarro, Dubois-Pillet, eux, divisent le ton d'une manière consciente et scientifique. Si, dans *La Grande Jatte* de M. Seurat, l'on considère, par exemple, un cm^2 couvert d'un ton uniforme, on trouvera sur chacun des centimètres de cette superficie, en une tourbillonnante cohue de menues macules, tous les éléments constitutifs du ton. . . . Ces couleurs, isolées sur la toile, se recomposent sur la rétine: on a donc non un mélange de couleurs-matières (pigments), mais un mélange de couleurs-lumières." Félix Fénéon, "Les Impressionnistes" (1886), *Les Écrivains*, ed. Riout, 394–405; the quote is on 402 (see n. 4).

9 Ibid.

10 Following Fénéon, many art historians have repeated the myth that optical mixture appears more luminous, applying the misconception to all Impressionism (not just Seurat and his circle). In a popular mid-twentieth-century textbook, *The Story of Modern Art*, Sheldon Cheney declared: "The Impressionists discovered that they gained vividness if, instead of mixing blue and yellow on the palette, for instance, to form a green, they placed side by side on the canvas little streaks of blue and yellow, leaving it to the observer's eye to merge the two primary hues into the one derived hue, a phenomenon occurring as soon as the observer stepped back the proper

distance"; Cheney, *The Story of Modern Art* (New York: Viking Press, 1941), 191. In fact, Rood specifically warned against trying to optically mix blue and yellow (or any hues located across the color wheel) because they tend to mix optically to mud: "If colors are quite distant from each other in the chromatic circle, a rapid transition from one to the other, by blending, produces always a strange and disagreeable effect"; Rood, *Modern Chromatics*, 275. High-saturation mixed pigments like green, orange, and violet are more efficiently mixed on the palette to produce more predictable results. Indeed, green pigment must be mixed because, as Rood wrote: "cobalt-blue and chrome-yellow give a white or yellowish-white, but no trace of green"; 140. On his palette, Seurat mixed many shades of green paint to create the lawn in *La Grande Jatte*; nowhere did he juxtapose small dots of blue and yellow.

The myth continues in the 2005 edition of the standard textbook *Gardner's Art through the Ages*: "The juxtaposition of colors on a canvas for the eye to fuse at a distance produces a more intense hue than mixing the same colors on the palette. Although it is not strictly true that the Impressionists used only primary hues, juxtaposing them to create secondary hues (blue and yellow, for example, to create green), they did achieve remarkably brilliant effects with their characteristic short, choppy brushstrokes, which so accurately caught the vibrating quality of light"; Fred S. Kleiner and Christin J. Mamiya, *Gardner's Art through the Ages*, 12th ed. (Belmont, CA: Wadsworth/Thomson, 2005), 875. Historians who have pointed out that the myth is founded on an error, include Kemp, *Science of Art*, 312–19; and Herbert, "Making of *La Grande Jatte*," 34 (for both see n. 4).

11 C. Blanc, *Grammaire des arts du dessin* (Paris: Jules Renouard, 1867), 68.

12 Ibid., 568.

13 For example, the Neo-Impressionist painter Louis Hayet criticized Seurat for painting adjoining brushstrokes of complementary colors and thereby dulling the hues, in an 1897 entry in an unpublished notebook, excerpted in G. Dulon and C. Duvivier, *Louis Hayet, 1864–1940: Peintre et théoricien du néo-impressionnisme* (Pontoise, France: Musée de Pontoise, 1991), 185–86; the quote is on 185. For a more recent example of the same misreading of Seurat's dots, see Lee, "Seurat and Science" (see n. 4).

14 Paul Bourget described Fechner's method of measuring sensations in a discussion of Impressionist work in "Paradoxe sur la couleur," *Le Parlement*, Apr. 15, 1881, in Riout, *Les Écrivains*, 317 (see n. 4). Jules Laforgue cited *la lois de Fechner* (Fechner's law) in "L'Impressionnisme"

(1883), in Laforgue, *Oeuvres complètes*, ed. Jean-Louis Debauve (Lausanne: L'Age d'Homme, 1986), 3:333; as did Félix Fénéon in a discussion of Signac's work, "Paul Signac," *La Plume*, Sept. 1, 1891, reprinted in *Félix Fénéon: Oeuvres plus que complètes* (Geneva: Dros, 1970), 1:198. The French science writer Charles Henry was familiar not only with Fechner and Wundt but also other German, British, and French researchers in the physiology of perception; Henry, "Introduction à une esthétique scientifique," 444 (see n. 4). There were also French scientific publications on German psychophysics, such as Théodule Ribot's chapters on Fechner and Wundt in *La Psychologie allemande contemporaine: École expérimentale* (Paris: Félix Alcan, 1885).

15 On Henry's attempt to formulate an aesthetics based in science, see Henri Dorra, "Charles Henry's 'Scientific' Aesthetic," *Gazette des beaux-arts* 74 (Dec. 1969), 343–56; José A. Argüelles, *Charles Henry and the Formation of a Psychophysical Aesthetic* (Chicago: University of Chicago Press, 1972); and Robert Michael Brain, "Algorithms of Pleasure," in *The Pulse of Modernism: Physiological Aesthetics in Fin-de-Siècle Europe* (Seattle: University of Washington Press, 2015), 95–149.

16 In *Grammaire*, Blanc wrote "These observations on the horizontality or oblique angles of lines of the face have been made by the original and profound writer, Humbert de Superville," 36 (see n. 11). Blanc reproduced on the page schematic diagrams of the face from Superville's book, *Essai sur les signes inconditionnels dans l'art* (Leiden: C. C. van der Hoek, 1827), 6.

17 "La gaîté de *ton*, c'est la dominante lumineuse; de *teinte*, la dominante chaude; de *ligne*, les lignes au-dessus de l'horizontale." Georges Seurat letter to Maurice Beaubourg, Aug. 28, 1890, reprinted in Gustave Coquiot, *Georges Seurat* (Paris: Albin Michel, 1924), 231–33; the quote is on 232.

18 The format matches a woodblock print owned by Signac, per Françoise Cachin, "Le Portrait de Fénéon par Signac: Une source inédite," *La Revue de l'art*, no. 6 (1969), 90–91.

19 See Robert L. Herbert, *Seurat's Drawings* (New York: Shorewood Publishers, 1962), and Jodi Hauptman et al., *Georges Seurat: The Drawings* (New York: Museum of Modern Art, 2007).

20 On van Gogh's collection see Janet A. Walker, "Van Gogh, Collector of Japan," *The Comparatist* 32 (May 2008), 82–114; and Louis van Tilborgh et al., *Van Gogh and Japan* (Brussels: Mercatorfonds, 2018). Van Gogh also painted *Flowering Plum Tree (after Hiroshige)* (1887; Van Gogh Museum, Amsterdam).

21 Gaugin noted that van Gogh read Émile Burnhouf, "Le Bouddhisme en Occident," *Revue des deux mondes* 88, (July 15, 1888), 340–72; see *Correspondance de Paul Gauguin: Documents, témoignages*, ed. Victor Merhlès (Paris: Fondation Singer-Polignac, 1984), 504, document no. 283.

22 "J'ai un portrait de moi tout cendré, la couleur cendrée qui résulte du mélange du véronèse avec la mine orange, sur fond véronèse pâle tout uni, à vêtement brun rouge mais exagérant moi aussi ma personalité j'avais cherché plutôt le caractère d'un bonze, simple adorateur du Bouddha éternel." Van Gogh to Gauguin, Oct. 3, 1888, in *Les Lettres: Edition critique complète illustrée*, ed. Leo Jansen, Hans Luijten, and Nienke Bakker (Arles: Actes sud, 2009), 4:304–5; the quote is on 304.

23 Anagarika Dharmapala, "The World's Debt to Buddha," in *The World's Parliament of Religions*, ed. John Henry Barrows (Chicago: Parliament Publishing, 1893), 2:862–80; the quotes are on 868 and 878.

24 Soyen Shaku, "The Law of Cause and Effect, as Taught by Buddha," in Barrows, *The World's Parliament of Religions*, 2:829–31; the quote is on 831.

25 Paul Carus, "Science: A Religious Revelation" (1893), in *The Dawn of a New Religious Era* (Chicago: Open Court, 1916), 22–40; the quote is on 34–35.

26 Mutationism was articulated by Alexis Jordan, a botanist in Lyon, co-author with botanist Jules Fourreau of *Icones ad floram Europae* (1866–68); on this undercurrent in French biology, see Adrien Davy de Virville, "Le Jordanisme," in *Histoire de la botanique en France* (Paris: Société d'Édition d'Enseignement Supérior, 1954), 326–28. In 1883 Armand Clavaud wrote his *Flore de la Gironde* (Paris: G. Masson, 1882–84), in which he supported Jordan's view that species originated by abrupt jumps that produced freaks or odd combinations of characteristics (Gironde is the region that includes the city of Bordeaux). The origin of species by mutation was an unpopular theory that continued to be promoted by French botanists such as Charles Naudin in the late nineteenth century. After Mendel's laws of genetics were rediscovered in 1900, the Dutch botanist Hugo de Vries demonstrated that mutations could be explained by characteristics that vary independently. For a discussion of Darwinian aspects of the art of Redon, see Barbara Larson, "La Génération symbolist et la revolution darwinienne," in *L'Âme au corps: Arts et sciences, 1793–1993*, ed. Jean Clair (Paris: Gallimard, 1993), 322–41.

27 Odilon Redon, letter to A. Bonger, May 1909, reprinted in Redon's book *À soi-même* (Paris: H. Floury, 1922), 19–20.

28 The influence of Clavaud and the microscope on Redon's work has been noted since André Mellerio's classic study, *Odilon Redon: Peintre, dessinateur, et graveur* (Paris: H. Floury, 1923); see: Douglas W. Druick and Peter Kort Zegers, "In the Public Eye," in *Odilon Redon: Prince of Dreams, 1840–1916*, ed. Douglas W. Druick (Chicago: Art Institute of Chicago, 1994), 120–74; Marco Franciolli, "Les Merveilles du monde invisible," in *Odilon Redon: La natura dell'invisible / La Nature de l'invisible*, ed. Manela Kahn-Rossi (Milan: Skira, 1996), 295–97; and Barbara Larson, *The Dark Side of Nature: Science, Society, and the Fantastic in the Work of Odilon Redon* (University Park: Pennsylvania State University Press, 2005), 5–11.

29 Redon, *À soi-même*, 19. The titles of Clavaud's six publications between 1864 and 1884, and his eighty-five oral presentations to the Linnean Society of Bordeaux, indicate that he worked exclusively on classifying plants of the Bordeaux region. Redon's remark about "intermediary life" raises the possibility that Clavaud may have studied insect-eating plants such as the Venus flytrap. But of the approximately eighty plant species named by Clavaud, none is carnivorous (per e-mail from Philippe Richard, conservator of the Bordeaux Botanical Garden, Nov. 14, 2001). So the intermediary creatures that Clavaud studied were evidently microscopic.

30 "Il aurait fallu le crayon d'Odilon Redon pour donner la vie à ces monsters." Pasteur made the remark, according to Redon's wife, after Pasteur looked at Redon's *Origins* with great curiosity for a long time. Redon's wife relayed the anecdote to André Mellerio, who included it in his 1923 book *Odilon Redon*, 155 (see n. 28). Before beginning his career in chemistry, Pasteur had academic training in drawing and was an accomplished draftsman; see René Vallery-Radot, "Pasteur Artiste," in *Pasteur inconnu* (Paris: Flammarion, 1956), 162–74.

31 On bacterial infection and the visual arts in the late nineteenth century, see Barbara Larson, "Microbes and Maladies: Bacteriology and Health at the Fin de Siècle," *Lost Paradise: Symbolist Europe*, ed. Jean Clair (Montreal: Montreal Museum of Fine Arts, 1995), 385–93; and Barbara Larson, "The Microbe," in *Dark Side of Nature*, 85–106 (see n. 28).

32 E. Munch, Notebook N69 (1928–29), fol. 1r, trans. Francesca M. Nichols, Munch Museum, Oslo, Norway.

Chapter 7

1 J.-K. Huysmans, "L'Expositions des indépendants en 1880," *L'Art moderne* (Paris: Plon-Nourrit, 1883), 104.

2 On Helmholtz's transformation of Kant's views on space, see Gary C. Hatfield, "Helmholtz: The Epistemology and Psychology of Spatial Perception," in *The Natural and the Normative: Theories of Spatial Perception from Kant to Helmholtz* (Cambridge, MA: MIT Press, 1990), 165–234.

3 See Maurice Merleau-Ponty, "Cézanne's Doubt" (1948), in *Sense and Non-Sense*, trans. H. Dreyfus and P. Dreyfus (Evanston, IL: Northwestern University Press, 1964), 9–25. Merleau-Ponty described Cézanne as having anticipated Gestalt theories of spatial perception, but I think it is more accurate to describe both Cézanne and Gestalt psychologists as having a common source in Helmholtz. For related discussions, see Laurence Gowing, "The Logic of Organized Sensation," in *Cézanne: The Late Work*, ed. William Rubin (New York: Museum of Modern Art, 1977), 55–71; and the sections on Cézanne in Edwin Jones, *Reading the Book of Nature: A Phenomenological Study of Creative Expression in Science and Painting* (Athens: Ohio University Press, 1989).

4 See Cézanne's epigraph to this chapter, which was one of several "opinions" of the artist recorded by Émile Bernard and approved by the artist for publication in "Paul Cézanne" (1904), reprinted in Bernard, *Conversations avec Cézanne*, ed. P. Michael Doran (Paris: Macula, 1978), 36.

5 Paul Cézanne to Émile Bernard, Apr. 15, 1904, in Paul Cézanne, *Correspondance*, ed. John Rewald (Paris: Grasset, 1978), 296.

6 Hermann von Helmholtz, "On the Relation of Optics to Painting" (1871), trans. E. Atkinson, in *Selected Writings of Hermann von Helmholtz*, ed. R. Kahl (Middletown, CT: Wesleyan University Press, 1971), 329.

7 Braque and Picasso wrote no statements about their work during the Cubist era. However, in 1912 two artists in their circle, Albert Gleizes and Jean Metzinger, described the Cubist approach as trying to capture the artist's experience of space by "moving around an object so as to record successive views of it which, when combined in a single image, reconstitute it in time"; Albert Gleizes and Jean Metzinger, *Du Cubisme* (Paris: Figuière, 1912), 36. In treatises on Cubism written after the war, Maurice Raynal and Daniel-Henry Kahnweiler introduced Kant's terms "analytic" and "synthetic" to describe Cubist techniques. Kant used the terms to describe two types of judgments. An analytic judgment is one in which the predicate is contained within the subject (such as "One and one equals two"); it is verified by simply analyzing the concepts. A synthetic judgment puts together (synthesizes) unrelated ideas (such as "There are two rivers in Königsberg"); the predicate concept is not contained in the subject. Raynal

related Cubist technique to the writings of Helmholtz and Kant: "Helmholtz . . . has shown us that each sense organ only records particular sensations. As Kant said: 'The senses give us only the material of knowledge, while understanding gives us the form.' This Idealist conception, which has been so fertile for art and poetry, is the traditional basis of great art and most modernists concur with it"; Maurice Raynal, *Quelques intentions du cubisme* (Paris: L'Effort Moderne, 1919), n.p. In other words, Braque covered his canvas with planes of green and ochre (plate 7-5), which the viewer's mind organizes into the perception of hills, houses, and trees. Kahnweiler, a German who was well-educated in Idealist philosophy, wrote similarly: "Now Cubism . . . depicts objects in the world as close as possible to their 'primary forms.' . . . The unconscious work that we must do to recognize the structure underlying an object in order to conceive an exact picture of it in our mind is simplified for us by the Cubist painting because it puts the object before our eyes in its basic form"; Daniel-Henry Kahnweiler, *Der Weg zum Kubismus* (Munich: Delphin, 1920), 40–41. Then, invoking Kant's distinction between analytic and synthetic judgments, Kahnweiler summarized the Cubist vocabulary and technique: "In order to give a thorough analysis of an object's 'primary' characteristics, [the Cubist can] show it as a geometric drawing or combine several views of the same object, which the viewer's consciousness then fuses into the perception of an object. . . . Instead of only an analytic description, the artists can also create a synthesis of the object, that is, according to Kant, 'to add the different representations of the ones to the others, and seize their multiplicity in a moment of knowledge'"; ibid., 34.

8 Alfred H. Barr Jr., *Cubism and Abstract Art* (New York: Museum of Modern Art, 1936); Barr dated Analytic Cubism to 1906–13 (29–46) and Synthetic Cubism to 1913–1928 (77–92).

9 Juan Gris to Maurice Raynal, Jan. 3, 1922, in Juan Gris, *Letters: 1913–1927*, trans. Douglas Cooper (London: privately printed, 1956), 135. Gris had just read Charles Nordmann's popularization of relativity theory, *Einstein et l'universe: Une Lueur dans le mystère des choses* (Paris: Hachette, 1921). Gris expressed great admiration for Einstein and requested anything "by him or about him" to read.

10 This change to a *physiological* perspective is seen in the flickering colors and fluctuating planes suggesting movement, referred to as "simultaneity" in the late nineteenth and early twentieth century. The French word *simultanéité* was first published in reference to a Cubist

work in 1912; see Lynn Gamwell, *Cubist Criticism* (Ann Arbor, MI: UMI Research Press, 1980), 50. On a related topic, some have argued that Henri Bergson's concepts of space and/or time, as well as those of Gustave Le Bon, influenced Cubism; see Timothy Mitchell, "Bergson, Le Bon, and Hermetic Cubism," *Journal of Aesthetics and Art Criticism* 36, no. 2 (Winter 1977), 175–83; and Robert Mark Antliff, "Bergson and Cubism: A Reassessment," *Art Journal* 47, no. 4 (Winter 1988), 341–49.

11 Henri Poincaré, *La Science et l'hypothèse* [Science and hypothesis], 1902, and *Science et méthode* [Science and method], 1908.

12 The mistaken association of Cubism with Einstein's cosmic perspective began right after the confirmation of the general theory of relativity with the solar eclipse of 1919. To my knowledge, the earliest example is the Czech art historian Vincenc Kramář, who was familiar with Mercereau's writing on Cubism; Kramář had formed a collection of Cubist paintings during his trips to Paris in the pre-war years, where he was a regular client of Kahnweiler's gallery. After the 1919 eclipse, Kramář, who may have been proud that Einstein had been a lecturer at Prague's German university in 1911–12, linked Cubism and Einstein's new concept of the cosmos in his 1921 book *Kubismus* [Cubism] (Brno, Czechoslovakia: Nákladem Morav.-Slezské Revue, 1921). He referred to the essential relationship of the new art to "the transformation of our idea of the world, as reflected in Einstein's theory and in the studies of the fourth dimension" (31). This biographical information on Kramář was confirmed for me by Lenka Bydozovská of the Czech Academy of Sciences, Prague (e-mail of Nov. 13, 2001).

Historians who have claimed that Einstein's theory of relativity influenced Cubism include the following: In his 1924–25 essay on "symbolic form," Erwin Panofsky noted that artists in the 1920s were beginning to respond to Einstein's space-time, although Panofsky did not mention Cubism; Panofsky referred specifically to the Russian artist El Lissitzky's recent publication describing his kinetic paintings as expressions of space-time ("A. and *Pangeometry*," 1925; see chap. 10, n. 15); Panofsky, *Perspective as Symbolic Form*, 153–54n73 (see chap. 4, n. 20). Sigfried Giedion wrote in his book *Space, Time, and Architecture: The Growth of a New Tradition* (1941; reprint, Cambridge, MA: Harvard University Press, 1967): "Cubism breaks with Renaissance perspective. It views the object relatively: that is, from several points of view, no one of which has exclusive authority" (14). In 1946 Einstein himself stated, in response to the draft of an essay with a similar thesis sent to him by the art historian Paul M. Laporte, that such connections of Cubism and relativity were based on a misunderstanding of the implications of his theory: "For the description of a state of affairs [*Sachverhaltes*] one uses almost always a *single* coordinate system. . . . This is quite different in the case of Picasso's painting. . . . This new artistic 'language' has nothing in common with the theory of relativity"; Albert Einstein to Paul M. Laporte, May 4, 1946, trans. Max Gould, in Laporte's essay, "Cubism and Relativity with a Letter of Albert Einstein," *Art Journal* 25, no. 3 (Spring 1966), 246. Undeterred, Laporte published two more essays on the topic, "The Space-Time Concept in the Work of Picasso," *Magazine of Art* 41, no. 1 (Jan. 1948), 26–32; and "Cubism and Science," *Journal of Aesthetics and Art Criticism* 7, no. 3 (1949), 243–56. Then, in 1953, Panofsky wrote along similar lines in reference to a diagram of quattrocento linear perspective: "This construction . . . formalizes a conception of space which, in spite of all changes, underlies all post-medieval art up to, say, the *Demoiselles d'Avignon* by Picasso (1907), just as it underlies all post-medieval physics up to Einstein's theory of relativity (1905). . . . It was only with Picasso, and with his more or less avowed followers, that an attempt was made to open up the fourth dimension of time so that objects ceased to be determinable by three coordinates alone and can present themselves in any number of aspects and in all states of either 'becoming' or disintegrating"; Erwin Panofsky, *Early Netherlandish Painting* (Cambridge, MA: Harvard University Press, 1953), 1:5, 362. Panofsky may have been especially interested in Einstein's cultural impact, because by 1953 the two men were friendly colleagues at the Institute for Advanced Study in Princeton, New Jersey. Panofsky, for example, organized Einstein's seventieth-birthday celebration in 1949; see Jamie Sayen, *Einstein in America* (New York: Crown Books, 1985), 226. With Panofsky's immense authority behind the connection of Cubism to relativity, it became engraved into the master narrative of modern art. By 1975 the art historian Samuel J. Edgerton could write, "The paradigm of the Renaissance [linear perspective] in turn, ended with Einstein's special theory of relativity. . . . And today? It is widely agreed that Cubism and its derivative forms in modern art are in the same way the proper pictorial means for representing the 'truth' of the post-Einsteinian paradigm"; Edgerton, *The Renaissance Rediscovery of Linear Perspective* (New York: Basic Books, 1975), 162. But another art historian with immense authority, Meyer Schapiro, presented overwhelming evidence against any connection between Cubism and relativity in an essay written in the late 1970s (published posthumously in 2000); Schapiro's many notes and essay drafts on the topic were compiled by Joseph Masheck into the essay "Einstein and Cubism: Science and Art," in *The Unity of Picasso's Art*, ed. Lillian Milgram

Schapiro (New York: George Braziller, 2000), 49–149. I am grateful to the late George Braziller for bringing this material to my attention before it was published, when I was writing the first draft of this book. Alas, even Meyer Schapiro's cautionary words did not deter enthusiasts for a link between Einstein and Cubism. One reads in the historian William R. Everdell's 1997 book *The First Moderns: Profiles in the Origins of Twentieth-Century Thought* (Chicago: University of Chicago Press, 1997), "In the *Demoiselles d'Avignon* . . . Picasso had done for art in 1907 almost exactly what Einstein had done for physics" (249). The science historian Arthur I. Miller writes, similarly, in *Einstein, Picasso: Space, Time, and the Beauty That Causes Havoc* (New York: Basic Books, 2001), "The treatment of time in *Les Demoiselles d'Avignon* is quite complex. . . . Einstein's temporal simultaneity shares with Picasso's the notion that there is no single preferred view of events" (239). For other recent examples, see Philip Courtenay, "Einstein and Art," in *Einstein: The First Hundred Years*, ed. Maurice Goldsmith, Alan Mackay, and James Woudhuysen (Oxford: Pergamon Press, 1980), 145–57; Leonard Shlain, *Art and Physics: Parallel Visions in Space, Time, and Light* (New York: William Morrow, 1991); and Thomas Vargish and Delo E. Mook, *Inside Modernism: Relativity Theory, Cubism, Narrative* (New Haven, CT: Yale University Press, 1999).

13 See Norma Lifton, "Thomas Eakins and S. Weir Mitchell: Images and Cures in the Late Nineteenth Century," in *Psychoanalytic Perspectives on Art*, ed. Mary Mathews Gedo (Hillsdale, NY: Analytic Press, 1987), 247–74.

14 See Edmond de Goncourt and Jules de Goncourt, *Journal des Goncourt: Mémoires de la vie littéraire* (1891; repr., Paris: Fasquelle, 1956), 3:594, 885, 932; see also G. Hahn, "Charcot et son influence sur l'opinion publique," *Revue des questions scientifiques*, 2nd ser., 6 (1894), 230–61, 353–59.

15 Albert Londe, "La Photographie en médecine," *La Nature* 2, pt. 2 (June–Nov. 1883), 215–18.

16 On hysteria in Symbolist art, see: Jacqueline Carroy, "L'Hystérique, l'artiste et le savant," in *L'Âme au corps: Arts et sciences, 1793–1993*, ed. Jean Clair (Paris: Gallimard, 1993), 446–57; Rodolphe Rapetti, "From Anguish to Ecstasy: Symbolism and the Study of Hysteria," in *Lost Paradise: Symbolist Europe*, ed. Jean Clair (Montreal: Montreal Museum of Fine Arts, 1995), 224–34; in the same volume, see Jean Clair, "The Self beyond Recovery," 125–36. On photographs of patients diagnosed with hysteria, see Georges Didi-Huberman, *Invention de l'hystérie: Charcot et l'iconographie photographique de la Salpêtrière* (Paris: Macula, 1982), 32–68, esp. 47–50; the author argues that photography at Salpêtrière was not an objective method of documenting illness because hysteric patients posed for their photographs by re-enacting their symptoms.

17 Joris-Karl Huysmans, *À rebours* (1884; repr., Paris: Fasquelle, 1955), 86.

18 Josef Breuer and Sigmund Freud, "Studies on Hysteria" (1893–95), in *The Standard Edition of the Complete Psychological Works of Sigmund Freud*, trans. James Strachey (London: Hogarth Press, 1962), 2:1–305.

19 On Anna O. see Dianne Hunter, "Hysteria, Psychoanalysis, and Feminism: The Case of Anna O.," *Feminist Studies* 9, no. 3 (Autumn 1983), 464–88.

20 S. Weir Mitchell, *Lectures on Diseases of the Nervous System, Especially Women* (Philadelphia: Lea, 1881), 218. Mitchell's attitude was scorned by one of his patients, Charlotte Perkins Gilman, in *The Yellow Wallpaper* (Boston: Small and Maynard, 1899). See Elaine Showalter, "Hysteria, Feminism, and Gender," in *Hysteria beyond Freud*, ed. Sander L. Gilman et al. (Berkeley: University of California Press, 1993), 286–344; and Sabine Arnaud, *On Hysteria: The Invention of a Medical Category between 1670 and 1820*, no trans. (Chicago: University of Chicago Press, 2015).

21 On Mitchell's view of hysteria see Nancy Cervetti, "Pandora's Box," in her *S. Weir Mitchell, 1829–1914: Philadelphia's Literary Physician* (University Park: Pennsylvania State University Press, 2012), 104–35.

Chapter 8

1 Johannes Kepler, *Harmonices Mundi* [Harmony of the world] (1619), 5:7; trans. E. J. Aiton, A. M. Duncan, and J. V. Field (Philadelphia: American Philosophical Society, 1997), 446.

2 See D. P. Walker, "Kepler's Celestial Music," *Journal of the Warburg and Courtauld Institutes* 30 (1967), 228–50; and Michael Fend, "Probleme mit der Idee der 'Harmonia universalis' in der frühen Neuzeit," *Archiv für Musikwissenschaft* 71, no. 4 (2014), 307–34.

3 On Čiurlionis's interest in combining astronomy, music, and art, see Alfred Erich Senn, John E. Bowlt, and Danute Staskevicius, *Mikalojus Konstantinas Čiurlionis: Music of the Spheres* (Newtonville, MA: Oriental Research Partners, 1986).

4 Michael Faraday, "On Some New Electro-Magnetical Motions, and on the Theory of Magnetism," *Quarterly Journal of Science* 12 (Oct. 1821), 74; reprinted in Michael Faraday, *Experimental Researches in Electricity* (London: Taylor, 1844), 2:127–47.

5 Faraday recounted the incident in "Historical Statement Respecting Electro-Magnetical Rotation," *Quarterly Journal of Science* 15 (July 1823), 288; reprinted in Michael Faraday, *Experimental Researches in Electricity* (London: R. and J. E. Taylor, 1844), 2:159–62.

6 James Clerk Maxwell, *A Treatise on Electricity and Magnetism* (Oxford: Clarendon Press, 1873), 1:ix–x.

7 Michael Faraday, letter to James Clerk Maxwell, Mar. 25, 1857, commenting on Maxwell's paper titled "On Faraday's Lines of Force" (1855); letter published in *The Life of James Clerk Maxwell: With a Selection from His Correspondence*, ed. Lewis Campbell and William Garnett (London: Macmillan, 1882), 519–20. Maxwell read his paper to the Cambridge Philosophical Society on Dec. 10, 1855, and Jan. 11, 1856.

8 James Clerk Maxwell, "Science and Free Will" (1873), reprinted in Campbell and Garnett, *Life of James Clerk Maxwell*, 434–44; the quote is on 438.

9 Alfred Jarry, "Exploits and Opinions of Doctor Faustroll, Pataphysician: A Neo-Scientific Novel," in *Selected Works of Alfred Jarry*, ed. and trans. Roger Shattuck and Simon Watson Taylor (London: Eyre Methuen, 1965), 173–256.

10 Diogenes Laertius, *Lives, Teachings, and Sayings of Famous Philosophers* (3rd century AD), 6:38, trans. Pamela Mensch, ed. James Miller (New York: Oxford University Press, 2018), 278.

11 Duchamp made the remark in an interview with the art critic Pierre Cabanne, who recorded it in *Entretiens avec Marcel Duchamp* (Paris: Belfond, 1967), 81. Craig Adcock has argued that Duchamp was inspired by Poincaré's view of the conventionality of the axioms of geometry, "Conventionalism in Henri Poincaré and Marcel Duchamp," *Art Journal* 44, no. 3 (Summer 1984), 249–58.

12 Duchamp's notes were published as *La Mariée mise a nu par ses célibataires, même* (Paris: Edition Rose Sélavy, 1934). His unbound, loose-leaf notes were sold in a green box, and so "The Green Box" became the nickname for the publication.

13 "… d'une *réalité possible en distendant un peu* les lois physiques et chimiques," from note 22 of "The Green Box," Marcel Duchamp, *Marchand du sel: écrits*, ed. Michel Sanouillet (Paris: Le Terrain vague, 1958), 92–95; the quote is on 95.

14 On the relation of the telegraph to Morse's painting, see Jean-Philippe Antoine, "Inscribing Information, Inscribing Memories: Morse, *Gallery of the Louvre*, and the Electromagnetic Telegraph," in *Samuel F. B. Morse's Gallery of the Louvre and the Art of Invention*, ed. Peter John Brownlee (New Haven, CT: Yale University Press, 2014), 110–29.

15 On Morse's role in the development of the telegraph, see David Hochfelder, *The Telegraph in America, 1832–1920* (Baltimore: Johns Hopkins University Press, 2013), 2, 83–84.

16 *Motion Picture Herald* 2 (New York: Quigley, 1908), 103.

17 *Motion Picture Herald* 5 (1909), 23. On the cultural impact of the discovery of x-rays, see Bettyann Kevles, *Naked to the Bone: Medical Imaging in the Twentieth Century* (New Brunswick, NJ: Rutgers University Press, 1997), esp. "X-Rays in the Imagination: The Avant-Garde through Surrealism," 116–41.

18 "Nous concevons la possibilité de déterminer leur formes, leur distances, leurs grandeurs et leur movements; tandis que nous ne saurions jamais étudier par aucun moyen leur composition chimique." Auguste Comte, *Cours de philosophie positive* (Paris: Bachelier, 1835), 2:8.

19 The art historian Albert Boime has identified the following celestial objects: the moon, Venus, the constellation Aries, and a spiral nebula in *The Starry Night* (plate 0-2); the constellation Aquarius in *Cafe Terrace at Night* (1888; Kröller-Müller Museum, Otterlo, Netherlands); and the Big Dipper in *Starry Night over the Rhône* (plate 8-44); Boime, "Van Gogh's *Starry Night*: A History of Matter and a Matter of History," *Arts Magazine* 59, no. 4 (Dec. 1984), 87–103. Astronomers Donald W. Olsen and Russell L. Doescher have identified the moon, Venus, and Mercury in *Road with Cypress and Star* (1890; Kröller-Müller Museum, Otterlo, Netherlands); Doescher, "Van Gogh, Two Planets, and the Moon," *Sky and Telescope* 76, no. 4 (Oct. 1988), 406–88. See also Charles A. Whitney, "The Skies of van Gogh," *Art History* 9, no. 3 (Sept. 1986), 352.

20 "La science—le raisonnement scientifique me parait être un instrument qui ira bien loin dans la suite." Van Gogh to Bernard, June 26, 1888, in *Les Lettres: Edition critique* 4:155 (see chap. 6, n. 22).

21 "La ville est bleue et violette, le gaz est jaune et ses reflects sont or et roux et descendent jusqu'au bronze vert. Sur le champ bleu-vert de ciel la Grande Ourse a un scintillement vert et rose dont la pâleur discrète contraste avec l'or brutal du gaz." Van Gogh to Theo van Gogh, Sept. 29, 1888, in *Les Lettres: Edition critique*, 4:292 (see chap. 6, n. 22).

22 "Et cela me fait du bien de fair du dur. Cela n'empêche que j'ai un besoin terrible de, dirai je le mot—de religion—alors je vais la nuit dehors pour peindre les étoiles." Ibid.

23 On the impact of time-lapse photography on Kupka, see Margit Rowell, "Kupka, Duchamp and Marey," *Studio International* 189, no. 973–75 (Jan.–Feb. 1975), 48–51. On the impact of x-ray imagery, see Linda Dalrymple Henderson, "X-Rays and the Quest for Invisible Reality in the Art of Kupka, Duchamp, and the Cubists," *Art Journal* 47 (Winter 1988), 323–40. On a related topic, see also Linda Dalrymple Henderson, "Francis Picabia, Radiometers, and X-rays in 1913," *Art Bulletin* 71, no. 1 (Mar. 1989), 114–23.

24 Robert Delaunay, "Über das Licht" (1912), trans. from French to German by Paul Klee and first published in *Der Sturm*, no. 144–45 (Feb. 1913); reprinted, as "On Light," in *The New Art of Color: The Writings of Robert and Sonia Delaunay*, trans. from German to English by David Shapiro and Arthur A. Cohen (New York: Viking, 1978), 81–86; the quote is on 81. On Delaunay's interest in light, see Gordon Hughes, "Envisioning Abstraction: The Simultaneity of Robert Delaunay's *First Disk*," *Art Bulletin* 89, no. 2 (June 2007), 306–32.

25 "La science victorieuse de nos jours a renié son passé pour mieux répondre aux besoins matériels de notre temps; nous voulons que l'art, en reniant son passé, puisse répondre enfin aux besoins intellectuels qui nous agitent." Umberto Boccioni et al., "Manifeste des peintres futuristes" (1910), reprinted in *Futurisme: Manifestes, proclamations, documents*, ed. Giovanni Lista (Lausanne: L'Age d'Homme, 1973), 164. This manifesto was first published in Italian, as a pamphlet, on Apr. 11, 1910, in Milan; the following month the entire manifesto was published in this French version in Paris, in *Comoedia*, May 18, 1910.

26 Giacomo Balla, letter to Alfred H. Barr Jr., Apr. 24, 1954. The entire letter, in Italian with translation, is quoted in Susan Barnes Robinson, *Giacomo Balla: Divisionism and Futurism, 1871–1912* (Ann Arbor, MI: UMI Research Press, 1981), 83–84, 153.

27 "Le geste que nous voulons reproduire sur la toile ne sera plus un *instant fixé* du dynamisme universel. Ce sera simplement la *sensation dynamique* elle-même." Boccioni et al., "Manifeste des peintres futuristes," in Lista, *Futurisme: Manifestes*, 163.

28 On Balla and Lombroso, see Christine Poggi, "Picturing Madness in 1905: Giacomo Balla's *La pazza* and the Cycle *I viventi*," *RES: Anthropology and Aesthetics* 47 (Spring, 2005), 38–68.

29 Umberto Boccioni, "Peinture et sculpture futuristes" (1914), extracts in Lista, *Futurisme: Manifestes*, 194. Boccioni first published this collection of manifestos in Milan in 1914.

30 "Il faut partir du noyau central de l'objet que l'on veut créer pour découvrir les nouvelles formes qui le rattachent invisiblement et mathématiquement à *l'infini plastique apparent* et à *l'infini plastique intérieur*." Boccioni, "Manifeste technique de la sculpture futuriste" (1912), in Lista, *Futurisme: Manifestes*, 173. This manifesto appeared first in Italian in *L'Italia*, Sept. 30, 1912, and in French in *Je dis tout*, Oct. 6, 1912.

31 Boccioni, "Manifeste technique de la sculpture futuriste," in Lista, *Futurisme: Manifestes*, 173. In their manifestos, the Futurists frequently quoted the French philosopher of evolution Henri Bergson; an Italian translation of a selection of Bergson's writings was published in 1909. On Bergson's view of time and Futurism, see Ivor Davies, "Western European Art Forms Influenced by Nietzsche and Bergson before 1914, Particularly Italian Futurism and French Orphism," *Art International* 19 (Mar. 1975), 49–55; Brian Petrie, "Boccioni and Bergson," *Burlington Magazine* 66 (Mar. 1974), 140–47; and Mark Antliff, "The Fourth Dimension and Futurism: A Politicized Space," *Art Bulletin* 82, no. 4 (Dec. 2000), 720–33.

32 Boccioni, "Peinture et sculpture futuristes," in Lista, *Futurisme: Manifestes*, 193.

33 Ezra Pound, *Blast* 1 (June 29, 1914), 153.

34 Ezra Pound, "The Serious Artist" (1913), in *Literary Essays of Ezra Pound*, ed. T. S. Eliot (Westport, CT: Greenwood, 1979), 49.

35 William Crookes, "On Radiant Matter," lecture to the British Association for the Advancement of Science, 1879, printed in *Popular Science Monthly* 16 (1880), 157–67; the quote is from 167.

36 On Crookes's interest in the occult, see Janet Oppenheim, *The Other World: Spiritualism and Psychical Research in England, 1850–1914* (Cambridge: Cambridge University Press, 1985), 338–54.

37 Wassily Kandinsky, "Rückblicke" (1913), trans. Peter Vergo as "Reminiscences," in *Kandinsky 1901–1913* (Berlin: Der Sturm, 1913); reprinted in Lindsay and Vergo, *Kandinsky: Complete Writings*, 1:364 (see chap. 5, n. 37).

38 Franz Marc, aphorism 35, in *Briefe, Aufzeichnungen und Aphorismen* (Berlin: P. Cassirer, 1920), 1:128.

39 Ibid.

40 Paul Klee, *Tagebücher, 1898–1918* [Diary, 1898–1918], ed. F. Klee (Cologne: M. Du Mont Schauberg, 1957), entries 885, 253. On Klee and physics, see Sara Lynn Henry, "Form-Creating Energies: Paul Klee and Physics," *Arts Magazine* 52, no. 1 (Sept. 1977), 118–21.

41 "Ich war von seltsamen Formen umkreist, und ich zeichnete, was ich sah: harte, unselige Formen, schwarze, stahlblaue und grüne, die gegeneinander polterten, daß mein Herz vor Weh schrie; denn ich sah, wie alles uneins war und sich im Schmerz störte. Es war ein schreckliches Bild." Franz Marc, *Unteilbares Sein: Aquarelle und Zeichnungen* (Cologne: M. DuMont Schauberg, 1959), 51.

Chapter 9

1 "Les axiomes géométiques ne sont donc ni des jugements synthétiques a priori ne des faits expérimentaux. Ce sont des conventions. . . . Une géométrie ne peut pas être plus vraie qu'une autre; elle peut seulement être plus *commode*" [The axioms of geometry are neither synthetic a priori judgments nor experimental facts. . . . One geometry cannot be more true than another; each can only be more *convenient*]. Henri Poincaré, *La Science et l'hypothèse* (Paris: Flammarion, 1908), 66.

2 Alfred North Whitehead, "The Origins of Modern Science" (1925), reprinted in *Science and the Modern World* (New York: Free Press, 1967), 10.

3 Einstein, "Religion and Science," *New York Times Magazine*, Nov. 9, 1930, sec. 5, 1–4; reprinted in Einstein, *The World as I See It*, trans. Alan Harris (New York: Covici, Friede, 1934), 261–67; the quote is on 264.

4 Albert Einstein, letter to Max Born, Dec. 4, 1926, in *The Born-Einstein Letters: Correspondence between Albert Einstein and Max and Hedwig Born from 1916 to 1955*, trans. Irene Born (London: Macmillan, 1971), 90–91, the quote is on 91; the original German letter is in *Briefwechsel 1916–1955: Albert Einstein, Hedwig und Max Born* (Munich: Nymphenburger, 1969), 129–30.

5 Albert Einstein, "Science and Religion" (pt. 1, 1939; pt. 2, 1941), *Out of My Later Years* (New York: Philosophical Library, 1950), 21–30; the quote is on 26.

6 Sigmund Freud, "Future of an Illusion" (1927), *Standard Edition*, 21:5–56 (see chap. 7, n. 18).

7 Albert Einstein, letter to Eduard Büsching, Oct. 25, 1929 (Einstein Archive, reel 33–275); trans. and quoted by Max Jammer, in *Einstein and Religion: Physics and Theology* (Princeton, NJ: Princeton University Press, 1999), 51. Büsching had sent a copy of his 1929 book *Es gibt keinen Gott* [There is no God] to Einstein, who replied that Büsching's book only considered the Judeo-Christian-Islamic God of Abraham, and thus he should have titled his book *Es gibt keinen persönlichen Gott* [There is no personal God].

8 Einstein, "Religion and Science," *The World as I See It* (New York, 1934), 264–65 (the reference is in n 3).

9 Albert Einstein, "The World as I See It," *Forum and Century* 84 (1930), 193–94; the original German text is in Albert Einstein, *Mein Weltbild* (Amsterdam: Querido, 1934), 11–17; the text is reprinted in *The World as I See It* (London: Lane, 1935), 1–5.

10 *Vossische Zeitung*, Apr. 15, 1919.

11 See Gerald Holton, "Einstein's Influence on Our Culture," in *Einstein, History, and Other Passions* (Woodbury, NY: American Institute of Physics, 1995), 21n29; Lewis Elton, "Einstein, General Relativity, and the German Press, 1919–1920," *Isis* 77 (Mar. 1986), 95–103; and *The Comparative Reception of Darwinism*, ed. Thomas F. Glick (Austin: University of Texas Press, 1974).

12 For example, the French astronomer Charles Nordmann published "Einstein expose et discute sa thèorie" [Einstein gives an exposition and discusses his theory], *Revue des deux mondes* 9 (1922), 129–66.

13 Gaston Bachelard, *Le nouvel esprit scientifique* [The new scientific spirit] (Paris: Félix Alcan, 1934).

14 For a discussion of Bachelard as a precursor of Kuhn, see Gary Gutting, "Thomas Kuhn and French Philosophy of Science," in *Thomas Kuhn*, ed. Thomas Nickles (Cambridge: Cambridge University Press, 2002), 45–64.

15 See Jeffrey Crelinsten, "Einstein, Relativity, and the Press: The Myth of Incomprehensibility," *Physics Teacher* 18 (Feb. 1980), 115–22.

16 "Dr. Albert Einstein," *Times* (London), Nov. 8, 1919.

17 Einstein, quoted in *Times* (London), Nov. 28, 1919.

18 The first astronomer is unidentified; the second is W. J. S. Lockyer, "Lights All Askew in the Heavens," *New York Times*, Nov. 8, 1919.

19 Lynn Gamwell, *Mathematics and Art: A Cultural History* (Princeton, NJ: Princeton University Press, 2016), 277–319; Max Jammer, *The Conceptual Development of Quantum Mechanics* (New York: McGraw-Hill, 1966), esp. 166–80, and Jammer, *The Philosophy of Quantum Mechanics: The Interpretations of Quantum Mechanics in Historical Perspective* (New York: Wiley, 1974); Paul Forman, "Weimar Culture, Causality, and Quantum Theory, 1918–1927: Adaptation by German Physicists and Mathematicians to a Hostile Intellectual Environment," *Historical Studies in the Physical Sciences* 3 (1971), 1–115, and Forman, "*Kausalität*, *Anschaulichkeit*, and *Individualität*, or How Cultural Values Prescribed the

Character and Lessons Ascribed to Quantum Mechanics," in *Society and Knowledge*, ed. Nico Stehr and Volker Meja (New Brunswick, NJ: Transaction Books, 1984), 333–47.

20 On Kierkegaard's critique of G. W. F. Hegel, see David L. Rozema, "Hegel and Kierkegaard on Conceiving the Absolute," *History of Philosophy Quarterly* 9, no. 2 (1992), 207–24.

21 On Kierkegaard's understanding of science, see Danish philosopher Harald Høffding, "Søren Kierkegaard," in his *A History of Modern Philosophy*, trans. B. E. Meyer (London: Macmillan, 1908), 2:285–89, esp. 287.

22 Bohr knew the work of William James by 1905, according to a 1962 interview, which is quoted at length by Gerald Holton in "The Roots of Complementarity," *Daedalus* 99 (Fall 1970), 1015–55; the quote is on 1034–35.

23 Immanuel Kant, *Critique of Pure Reason* (1781), A 125–26, trans. Norman Kemp Smith (London: Macmillan, 1929), 147.

24 Werner Heisenberg, "The Physical Content of Quantum Kinematics and Mechanics" (1927), trans. Max Jammer, in *Conceptual Development of Quantum Mechanics*, 330.

25 Heisenberg's thought experiment is described in David C. Cassidy, "Heisenberg, Uncertainty, and the Quantum Revolution," *Scientific American* 266, no. 6 (May 1992), 106–12; sidebar "The Gamma-Ray Thought Experiment" is on 111.

26 For a description of Louis de Broglie's presentation at the Solvay conference and Wolfgang Pauli's response, see Guido Bacciagaluppi and Antony Valentini, *Quantum Theory at the Crossroads: Reconsidering the 1927 Solvay Conference* (Cambridge: Cambridge University Press, 2009), 212–20.

27 Werner Heisenberg, "Über den Inhalt der quantentheoretischen Mechanik" (1927); trans. by John A. Wheeler and W. H. Zurek as "The Physical Content of Quantum Kinematics and Mechanics," in *Quantum Theory and Measurement*, ed. John Wheeler and Woyciech Hubert Zurek (Princeton, NJ: Princeton University Press, 1983), 62–86; the quote is on 83.

28 Niels Bohr, "The Quantum Postulate and the Recent Development of Atomic Theory," *Nature* 121, no. 3050 (Apr. 14, 1928), 580–90; the quotation is on 580.

29 For a description of the Bohr-Einstein debates, see David Lindley, *Uncertainty: Einstein, Heisenberg, Bohr, and the Struggle for the Soul of Science* (New York: Doubleday, 2007); and Manjit Kumar, *Quantum: Einstein, Bohr, and the Great Debate about the Nature of Reality* (New York: Norton, 2008).

30 Niels Bohr, "The Quantum of Action and the Description of Nature" (1929), in Bohr, *Atomic Theory and the Description of Nature* (Cambridge: Cambridge University Press, 1954), 92–101; the quotes are on 100–101.

31 For a description of category mistakes, see Bernard Harrison, "Category Mistakes and Rules of Language," *Mind* 74, no. 295 (1965), 309–25.

32 Erwin Schrödinger, "The Present Situation in Quantum Mechanics" (1935), trans. John D. Trimmer, in Wheeler and Zurek, *Quantum Theory and Measurement*, 152–67; the quote is on 157.

33 John Stewart Bell, *Speakable and Unspeakable in Quantum Mechanics* (Cambridge: Cambridge University Press, 1987), 160.

34 Albert Einstein and Leopold Infeld, *The Evolution of Physics: The Growth of Ideas from Early Concepts to Relativity and Quanta* (Cambridge: Cambridge University Press, 1938), 312.

35 Gavin Parkinson, *Surrealism, Art, and Modern Science: Relativity, Quantum Mechanics, Epistemology* (New Haven, CT: Yale University Press, 2008), 35.

36 Gaston Bachelard, *Le Nouvel esprit scientifique* (Paris: Presses Universitaires de France, 1934), 48. Consider also, "De la cause à l'effet, il y a une liaison qui, jusqu'à un certain point, subsiste en dépit des défigurations partielles de la cause et de l'effet" (From cause to effect, there is a connection, which, to a certain extent, exists despite partial deformity in the cause and in the effect) (87).

37 On Einstein's quantum-entanglement paradox, see M. A. B. Whitaker, "The EPR Paper and Bohr's Response: A Reassessment," *Foundations of Physics* 34 (Sept. 2004), 1305–40.

38 Niels Bohr, "Quantum Mechanics and Physical Reality," *Nature* 136 (July 13, 1935), 65.

39 The historian of science Cathryn Carson has described the origin and development of this genre of science journalism, which (in a generous use of the word *philosophical*) she calls "philosophical popularizations" of physics; see Carson, "Who Wants a Postmodern Physics?" *Science in Context* 8, no. 4 (1995) 635–55, esp. 644ff.

40 Max Born, "Gibt es physikalische Kausalität?" *Vossische Zeitung*, Apr. 12, 1928, 9.

41 Niels Bohr, "The Atomic Theory and the Fundamental Principles Underlying the Description of Nature" (1929), in Bohr, *Atomic Theory*, 102–19; the quotes are on 118–19 (see n. 30).

42 On the cultural roots of postmodernism, see Michiko Kakutani, *The Death of Truth: Notes on Falsehood in the Age of Trump* (New York: Tim Duggan, 2018).

43 There have, however, been attempts to revitalize it. For a recent attempt, see S. Tanona, "Idealization and Formalism in Bohr's Approach to Quantum Theory," *Philosophy of Science* 71, no. 5 (2004), 683–95.

Chapter 10

1 Bruno Taut, *Die Stadtkrone* (Jena: Eugen Diederichs, 1919). Wilhelm Worringer, author of *Abstraktion und Einfühlung ein Beitrag zur Stilpsychologie* [The contribution of abstraction and empathy to the psychology of style] (Munich: R. Piper, 1908), had published a book on the eve of World War I that made German architects especially aware of the symbolism of the Gothic cathedral, *Formprobleme der Gotik* [Problem of form in the Gothic] (Munich: R. Piper, 1912).

2 Hans Maria Wingler, *Bauhaus: Weimar, Dessau, Berlin, Chicago*, trans. Wolfgang Jabs and Basil Gilbert (Cambridge, MA: MIT Press, 1969), 78.

3 László Moholy-Nagy, *Vision in Motion* (Chicago: Paul Theobald, 1947), 279.

4 See Georges Vantongerloo's construction drawings for *Construction in a Sphere* (1917), in his book *L'Art et son avenir* (Anvers: De Sikkel, 1924), 11.

5 Theo Van Doesburg et al., "Manifesto I of *De Stijl*, 1918," *De Stijl* 5, no. 4 (1918–19), reprinted in *De Stijl: Extracts from the Magazine*, trans. R. R. Symonds, ed. Hans Ludwig Jaffé (New York: Abrams, 1971), 172–73; the quote is on 172–73.

6 Piet Mondrian, "Neoplasticism in Painting," *De Stijl* 1, no. 1–12 (1917), reprinted in Symonds and Jaffé, *De Stijl: Extracts*, 36–93; the quote is on 36.

7 Van Doesburg et al., "Manifesto I of *De Stijl*, 1918," 172–73.

8 Theo Van Doesburg, "Elementarism (Fragments of a Manifesto)," *De Stijl* 7, no. 7/8 (1926–27), reprinted in Symonds and Jaffé, *De Stijl: Extracts*, 214–17.

9 Theo Van Doesburg, "Towards a Plastic Architecture," *De Stijl* 6, no. 6/7 (1924), reprinted in Symonds and Jaffé, *De Stijl: Extracts*, 185–88; the quote is on 186–87.

10 On the influence of x-ray technology on Gabo, see John E. Bowlt, "The Presence of Absence: The Aesthetic of Transparency in Russian Modernism," *Structurist* 27–28 (1987–88), 15–22.

11 Naum Gabo and Antoine Pevsner, "Realist Manifesto" (1920), reprinted in *Russian Art of the Avant Garde: Theory and Criticism, 1902–1934*, trans. John E. Bowlt (London: Thames and Hudson, 1988), 209.

12 Ibid., 211–12.

13 Ibid., 211.

14 El Lissitzky, "Proun" (1920–21), reprinted in *El Lissitzky: Ausstellung* (Cologne: Galerie Gmurzynska, 1976), 63. On mathematics in Lissitzky's work, see Yve-Alain Bois, "Lissitzky, Malevich, et la question de l'éspace," in *Suprematisme* (Paris: Galerie Jean Chauvelin, 1977), 29–46; Esther Levinger, "El Lissitzky's Art Games," *Neohelieon* 14, no. 1 (Dec. 1987), 177–91; Esther Levinger, "Art and Mathematics in the Thought of El Lissitzky: His Relationship to Suprematism and Constructivism," *Leonardo* 22, no. 2 (1989), 227–36; and Yve-Alain Bois, "From − ∞ to 0 to + ∞: Axonometry, or Lissitzky's Mathematical Paradigm," in *El Lissitzky, 1890–1941: Architect, Painter, Photographer, Typographer*, ed. Caroline de Bie et al. (Eindhoven, Netherlands: Municipal van Abbemuseum, 1990), 27–33.

15 El Lissitzky, "A. and *Pangeometry*" (1925), reprinted in *El Lissitzky: Life, Letters, Texts*, ed. Sophie Lissitzky-Küppers, trans. Helene Aldwinckle and Mary Whittall (Greenwich, CT: New York Graphic Society, 1968), 351.

16 Alexander Calder, "What Abstract Art Means to Me," in *Museum of Modern Art Bulletin* 18, no. 3 (Spring 1951), 8.

17 Herbert Bayer, artist's statement, in *Herbert Bayer: A Total Concept* (Denver: Denver Art Museum, 1973), 22.

18 František Kupka, *La Création dans les arts plastiques* [Creation in the plastic arts] (1912–13; repr., Paris: Diagonales, 1989), 115.

19 Richard Huelsenbeck [Charles R. Hulbeck], "Psychoanalytic Notes on Modern Art," *American Journal of Psychoanalysis* 20, no. 2 (1960), 60. After World War I, in 1922, Huelsenbeck completed a medical degree in neuropsychiatry at the University of Berlin, but because of his association with Dada, he was harassed by the Nazis after they came to power in 1933. In 1936 Huelsenbeck fled to the United States, where he changed his name to Charles R. Hulbeck and practiced psychoanalysis at the Karen Horney Clinic in New York.

20 Arp's essay was the preface to the catalogue of an exhibition that included collages, tapestries, and embroideries by himself and Sophie Taeuber at Galerie Tanner in Zurich (1915); Arp's German text, "Wirklichkeit" [Reality], was published in Jean (Hans) Arp, *On My Way: Poetry and Essays 1912–1947*, ed. Robert Motherwell (New York: Wittenborn, Schultz, 1948), 82.

21 Jean (Hans) Arp, *On My Way*, 82; the quote is from the German Lutheran mystic Jakob Böhme, *Aurora, oder Morgenröte im Aufgang* (1634; repr., Frankfurt am Main, Germany: Insel, 1992), chap. 22, no. 47. Arp's interest in Böhme was noted by Jennifer Mundy in her essay "Form and Creation: The Impact of the Biological Sciences on Modern Art," in *Creation: Modern Art and Nature* (Edinburgh: Scottish National Gallery of Modern Art, 1984), 21.

22 Jean (Hans) Arp, "Forms" (1950), in *Jours effeuillés: Poèmes, essais, souvenirs, 1920–1965* (Paris: Gallimard, 1966), 360.

23 Wassily Kandinsky, "To Retninger" (1935), trans. Peter Vergo as "Two Directions," in Lindsay and Vergo, *Kandinsky: Complete Writings*, 2: 777–79; the quote is on 779 (see chap 5, n. 37).

Chapter 11

1 On the biological basis of psychoanalysis, see Frank J. Sulloway, *Freud, Biologist of the Mind: Beyond the Psychoanalytic Legend* (Cambridge, MA: Harvard University Press, 1979).

2 For a list of early French publications on Freud, see William Ray Ellenwood, "André Breton and Freud" (PhD diss., Rutgers University, 1976), appendix 2, 246–48.

3 Philippe Soupault, "Origines et début du surréalisme," *Europe*, nos. 475–76 (Nov.–Dec. 1968), 4.

4 *Manifeste du surréalisme* (1924), in André Breton, *Manifestes du surréalisme* (Paris: Pauvert, 1962), 40.

5 For a comparison of the layout and typography of the two periodicals, see Dawn Ades, *Dada and Surrealism Reviewed* (London: Arts Council of Great Britain, 1978), 189–90.

6 Psychologists objected at their Nov. 1929 meeting of the Société Médico-Psychologique, a report of which was carried in the Parisian press. Proud to be taken as a serious threat, Breton reprinted the report in his *Second manifeste du surréalisme*, Breton, *Manifestes du surréalisme*, 150–52.

7 Christian Zervos, "Mathématiques et l'art abstrait" [Mathematics and abstract art], *Cahiers d'art* (1936), 4–20; the quote is on 4.

8 Ibid., 8.

9 Ernst's borrowings from *La Nature* are detailed by Charlotte Stokes, in "The Scientific Methods of Max Ernst: His Use of Scientific Subjects from *La Nature*," *Art Bulletin* 62, no. 3 (Sept. 1980), 453–65. For a survey of natural science images in the work of Ernst and others, see Karin Orchard and Jörg Zimmermann, eds., *Die Erfindung der Natur: Max Ernst, Paul Klee, Wols und das surreale Universum* (Freiburg im Breisgau, Germany: Rombach, 1994).

10 Rudolf Laban, *Ein Leben für Tanz* (1935), trans. Lisa Ullman, as *A Life for Dance: Reminiscences* (New York: Theater Arts Books, 1975), 95. On Laban's career, which was unfortunately tainted by his enthusiastic design of Nazi parades and performances, see Evelyn Dörr and Lori Lantz, "Rudolf von Laban: The 'Founding Father' of Expressionist Dance," *Dance Chronicle* 26, no. 1 (2003), 1–29.

11 Jean Goudal, "Surréalisme et le cinema," *La Revue hébdomadaire*, Feb. 21, 1925, 349.

12 Sigmund Freud, *Three Essays on the Theory of Sexuality* (1905), in *Standard Edition*, 7:156 (see chap. 7, n. 18).

13 Luis Buñuel, quoted by Francisco Aranda, in *Luis Buñuel: A Critical Biography* (London: Secher and Warburg, 1969), 56.

14 Sigmund Freud, letter to Breton (1937), reproduced in André Breton, *Trajectoire des rêves* (Paris: GLM, 1938), 127.

15 See Keigo Okonogi, "The Ajase Complex and Its Implications," *Asian Culture and Psychotherapy*, ed. Wen-Shing Tseng, Suk Choo Chang, and Masahisa Nishizono (Honolulu: University of Hawaii Press, 2005), 57–75.

16 See *Dada et surréalisme au Japon*, trans. Věra Linhartová (Paris: Publications Orientalistes de France, 1987).

17 Takiguchi Shuzo, "Jihitsu nenpu" [Chronology in my own hand], in Nakamura Giichi, "Chōgenjtsu-shugi no botsuraku' ronsō" [Debate on the fall of Surrealism], *Zoku Nihon kindai bijutsu ronsō-shi* [History of modern Japanese art debates] (Tokyo: Kinryūdō, 1982), 223–24; trans. John Clark, in *Japanese Art after 1945: Scream against the Sky*, ed. Alexandra Monroe (New York: Abrams, 1994), 48.

18 From an interview with Ohtsuki Kimi, Kenji's widow, by Kazushige Munakata (July 2000), "Dosaka kaiwai no

sakkatachi: Ohtsuki Kimi-san intabyii" [Writers in the neighborhood of Dosaka Town: An interview with Mrs. Kimi Ohtsuki], in *Waseda Daigaku Toshokan Kiyo* 48 (Mar. 2001), 40, trans. Yasuo Kawabata, in "Kenji Ohtsuki and the Tokyo Centenary of the Birth of William Morris," *Journal of the William Morris Society* 16, no. 4 (Summer 2006), 26n26.

19 For a description of Einstein's visit, see Eduardo L. Ortiz, "A Convergence of Interests: Einstein's Visit to Argentina in 1925," *Ibero-amerikanisches Archiv* 21, no. 1–2 (1995), 67–126.

20 On the extreme popularity of psychoanalysis in Argentina beginning in the 1920s, see Nancy Caro Hollander, "Buenos Aires: Latin Mecca of Psychoanalysis," in *Social Research* 57, no. 4 (Winter 1990), 889–919; and Mariano Ben Plotkin, "Freud, Politics, and the Portenos: The Reception of Psychoanalysis in Buenos Aires, 1910–1943," *Hispanic American Historical Review* 77, no. 1 (Feb. 1997), 45–74.

21 On the artist's use of x-ray technology, see Michael Wellen, "Paranoia and Hope: The Art of Juan Batlle Planas and Its Relationship to the Argentine Technological Imagination of the 1930s and 1940s," *Journal of Surrealism and the Americas* 3, no. 1–2 (2009), 84–106.

22 On Pichon-Rivière's interest in Surrealism, see Hugo Vezzetti, "Enrique Pichon-Rivière: Psiquiatría, psicoanálisis, poesía," in *Aventuras de Freud en el país de los argentinos* (Buenos Aires: Paidós, 1996), 245–90, esp. his discussion of Pichon-Rivière's analysis of the Uruguayan-born French poet Comte de Lautrémont, 278–90. Pichon-Rivière's collages are reproduced in Vicente Zito Lema, *Conversaciones con Enrique Pichon-Rivière sobre el arte y la locura* (Buenos Aires: Timerman, 1976), 14 and 57.

23 On Stern's series for *Idilio*, see Mariano Ben Plotkin, "Tell Me Your Dreams: Psychoanalysis and Popular Culture in Buenos Aires, 1930–1950," *Americas* 55, no. 4 (Apr. 1999), 601–29.

24 "En el Perú, donde todo se cierra, donde todo adquiere, más y más, un color de iglesia al crepúsculo, color particularmente horripilante, . . . esperamos desacreditar en tal forma la pintura en América, que ni uno solo de esos bravos e intrépidos pintores pueda ya enfrentarse a la tela sin sentir la urgencia de mandar todo al Diablo y de hacerse reemplazar por un aspirador mecánico." *Exposición de las obras de Jaime Dvor, César Moro, Waldo Parraguez, Gabriela Rivadeneira, Carlos Sotomayor, María Valencia* (Lima: C.I.P., 1935), n.p.; a facsimile of this exhibition catalogue is included at the end of an anthology of poetry by César Moro, *Viaje hacia la noche*, ed. Julio Ortega (Madrid: Huerga y Fierro, 1999).

25 In 1942 Paalen sent out a questionnaire to Western intellectuals, asking, "Is the 'dialectic method' a scientific method of investigation?" to which Albert Einstein responded that the dialectic method "is not of any special interest either from the standpoint of contemporary physics or of the history of physics." W. Paalen, "Inquiry on Dialectical Materialism" (1942), in *Wolfgang Paalen's DYN*, ed. Christian Kloyber (Vienna: Springer, 2000), 50. Others who responded to Paalen included André Breton, Harold Rosenberg, Meyer Schapiro, Clement Greenberg, Robert Motherwell, and Bertrand Russell.

26 Matta wrote an essay about mathematics and architecture, "Mathématique sensible—Architecture du temps" [Perceptible mathematics—architecture of the time], *Minotaure*, no. 11 (Spring 1938), 43. Also, he discussed cosmology in an interview with Max Kozloff, *Artforum* 4, no. 1 (Sept. 1965), 23–26.

27 Matta suggested his diverse sources: "To use a symbolic morphology or symbolic logic, I picture this non-Euclidean space" (Matta interview with Kozloff, 26).

28 Jean-Paul Sartre, *Qu'est-ce que la littérature?* (Paris: Gallimard, 1948), 164.

29 "La littérature comme négation absolue devient l'anti-littérature; jamais elle n'a été *plus littéraire*: la bouche est bouclée" [Literature as absolute negation becomes anti-literature; it is no longer literary: the mouth is closed], Sartre, *Qu'est-ce que la littérature?*, 165.

30 Salvador Dalí, "L'Âne pourri" [Rotten ass], *La Surréalisme au service de la révolution* 1 (July 1930), 10.

31 Jacques Lacan, *De la psychose paranoïaque dans ses rapports avec la personnalité* [Paranoid psychosis in relation to personality] (Paris: Le François, 1932). Lacan's development of structuralist psychoanalysis dates to the 1950s, well after the Surrealist era. In his revision of Freud, Lacan argued that Freud was wrong in claiming that the unconscious mind is fundamentally visual. Employing French structural linguistics, Lacan countered that "the unconscious is structured like a language"; Lacan, "The Insistence of the Letter in the Unconscious" (1957), trans. J. Miel, in *Structuralism*, ed. J. Ehrmann (Garden City, NY: Anchor, 1970), 103. By the time Lacan's theory had widespread influence on the visual arts his work had moved from the psychiatric clinic into academia, where in the 1980s the pendulum had swung back to arguing for the visual nature of the unconscious; see Jean-François Lyotard, "The Dreamwork Does Not Think," trans. Mary

Lydon, in *The Lyotard Reader* (Oxford: Blackwell, 1989), 19–55.

32 Carl Jung, *Modern Man in Search of a Soul* (1933), trans. E. F. C. Hull (New York: Bollingen Foundation, 1966), 82.

33 For example, see Mark Solms, "Dreaming and REM Sleep Are Controlled by Different Brain Mechanisms," *Behavioural and Brain Sciences* 23 (2000), 843–50; Mark Solms and George Ellis, *Beyond Evolutionary Psychology: How and Why Neuropsychological Modules Arise* (Cambridge: Cambridge University Press, 2017).

34 Mark Rothko and Adolph Gottlieb interview, Oct. 13, 1943, WNYC, New York, in *Abstract Expressionism: Creators and Critics*, ed. Clifford Ross (New York: Abrams, 1990), 210.

35 Pollock's analyst, Joseph L. Henderson, unleashed a firestorm of criticism among mental health professionals and legal experts on medical ethics when, for personal gain, he sold a group of drawings that Pollock had made for him as part of the artist's psychotherapy. In 1977 Pollock's widow, the artist Lee Krasner, lost a lawsuit against Henderson for violation of patient confidentiality; see Claude Cernuschi, *Jackson Pollock: "Psycho-analytic" Drawings* (Durham, NC: Duke University Press, 1992). Some art historians complained that these drawings shouldn't be used to "analyze" Pollock; see especially Donald Kuspit, "To Interpret or Not to Interpret Jackson Pollock," *Arts Magazine* 53, no. 7 (Mar. 1979), 125–27; and William Rubin, "Pollock as Jungian Illustrator: The Limits of Psychological Interpretation," pts. 1 and 2, *Art in America* 67, no. 7 (Nov. 1979), 104–23, and no. 8 (Dec. 1979), 72–91. For a recent Jungian reading of Pollock, see Alexander B. Herman and John Paoletti, "Re-Reading Jackson Pollock's 'She-Wolf,'" *Artibus et Historiae* 25, no. 50 (2004), 139–55.

Chapter 12

1 Enrico Fermi, *Introduzione alla fisica atomica* [Introduction to atomic physics] (Bologna: N. Zanichelli, 1928).

2 On cosmic themes in second-generation Futurism, see Giovanni Lista, "The Cosmos as Finitude: From Boccioni's Cosmogony to Fontana's Spatial Art," 93–97; and Claudia Gian Ferrari, "The Idea of the Cosmos during the Second Phase of Futurism," 99–103, in *Cosmos: From Goya to de Chirico, from Friedrich to Kiefer, Art in Pursuit of the Infinite*, ed. Jean Clair (Milan: Bompiani, 2000).

3 *Manifesto dell'aeropittura* (1929), signed by Giacomo Balla, Benedetta Cappa, Fortunato Depero, Gerardo Dottori, Fillìa (Luigi Colombo), Filippo Tommaso Marinetti, Enrico Prampolini, Mino Somenzi, and Tato (Guglielmo Sansoni), trans. Kenneth Syme, in Renato Miracco, *Futurist Skies: Italian Aeropainting* (Milan: Gabriele Mazzota, 2005), 69–70; the quote is on 69.

4 In fact, a proton and neutron each carry the nuclear force, so technically they both hold the nucleus together, but it's when the particle carries no charge (is a neutron) that it does the heavy lifting.

5 Lise Meitner and Otto Robert Frisch, "Disintegration of Uranium by Neutrons: A New Type of Nuclear Reaction," *Nature* 143, no. 3615 (Feb. 11, 1939), 239–40. A month earlier Otto Hahn and Fritz Strassmann had reported their laboratory data, without Meitner's interpretation of it; "Über den Nachweis und das Verhalten der bei der Bestrahlung des Urans mittels Neutronen entstehenden Erdalkalimetalle" [About the radiation of uranium using neutrons which produced alkaline earth metals], *Die Naturwissenschaften* 27 (Jan. 6, 1939), 11–15. (Barium is an alkaline earth metal.)

6 On Heisenberg's attitude after the German defeat, see the annotated transcript of his conversations, secretly recorded during the months that he was detained at Farm Hall in England, in Jeremy Bernstein, ed., *Hitler's Uranium Club: The Secret Recordings at Farm Hall* (Woodbury, NY: American Institute of Physics, 1996). See also John Powers, *Heisenberg's War: The Secret History of the German Bomb* (New York: Knopf, 1993).

7 "Oui, le choc été rude" (Yes, the shock was harsh), André Breton, interviewed by Jean Duché, Oct. 5, 1946, in Breton, *Oeuvres complètes* (Paris: Gallimard, 1988–1999), 3:588–99; the quote is on 588. In this interview, conducted in Paris, Breton repeatedly referred to the bombing of Japan.

8 In 1939, with Nazism on the rise, Breton expelled Dalí from the Surrealist group for expressing erotic fantasies about Adolf Hitler and making art about him (*The Enigma of Hitler*, 1939; Museo Nacional Centro de Arte Reina Sofía, Madrid). Dalí's fantasies included: "La chair dodue d'Hitler que j'imaginais comme la plus divine chair d'une femme à la peau blanchissime" [The plump flesh of Hitler, which I imagined as the most divine flesh of a woman with the whitest skin]; Salvador Dalí, *Journal d'un génie* [Diary of a genius] (Paris: Gallimard, 1964), 30.

9 Salvador Dalí, *Anti-Matter Manifesto* (New York: Carstairs Gallery, 1958), n.p.

10 Salvador Dalí, *Manifeste mystique* (Paris: Godet, 1951), in *The Collected Writings of Salvador Dalí*, ed. and trans. Haim Finkelstein (Cambridge: Cambridge University Press, 1998), 363–66; the quote is on 363.

11 "The force from which the sun draws its power has been loosened against those who brought war to the Far East," press release by the White House, Aug. 6, 1945, Harry S. Truman Presidential Library and Museum, accessed Feb. 15, 2019, https://www.trumanlibrary.org/whistlestop /study_collections/bomb/large/documents/index. php?documentid=59&pagenumber=1.

12 Editorial Board, "The Atomic Bomb: Its First Explosion Opens a New Era," *Life*, Aug. 20, 1945, 87B.

13 Editorial Board, "Hiroshima Before, Hiroshima After," ibid., 30–31.

14 Hanson W. Baldwin, "The Atomic Bomb and Future War," ibid., 18.

15 E. R. Murrow, broadcast of Aug. 12, 1945, *In Search of Light: The Broadcasts of Edward R. Murrow, 1938–1961* (New York: Knopf, 1967), 102.

16 See Barnett Newman, "The Sublime Is Now," in *Barnett Newman: Selected Writings*, ed. John P. O'Neill (New York: Knopf, 1990), 51–53; Robert Rosenblum, "The Abstract Sublime," *Artnews* (Feb. 1961), 38–40, 56–68; and John Golding, *Paths to the Absolute: Mondrian, Malevich, Kandinsky, Pollock, Newman, Rothko, and Still* (Princeton, NJ: Princeton University Press, 2000).

17 Thomas B. Hess described Newman's interest in Spinoza, based on his conversations with the artist, in *Barnett Newman* (New York: Museum of Modern Art, 1971), 13–14.

18 Barnett Newman, "The New Sense of Fate" (1948), reprinted in *Newman: Selected Writings*, 100.

19 Newman, "The Plasmic Image" (1945), reprinted in *Newman: Selected Writings*, 140.

20 Newman, "The Sublime Is Now" (1948), reprinted in *Newman: Selected Writings*, 53.

21 Mark Rothko and Adolph Gottlieb interview, Oct. 13, 1943, WNYC, New York, in Ross, *Abstract Expressionism: Creators and Critics* (see chap. 11, n. 34).

22 Mark Rothko, interview, in Selden Rodman, *Conversations with Artists* (New York: Devin-Adair, 1957), 93.

23 Ibid.

24 Jackson Pollock, interviewed by William Wright, who was Pollock's neighbor in East Hampton, New York, 1951, WERI, Westerly, Rhode Island, in *Pollock: A Catalogue Raisonné*, ed. Francis V. O'Connor and Eugene Victor Thaw (New Haven, CT: Yale University Press, 1978), 4:248–51.

25 Jackson Pollock, speaking as narrator of the film *Jackson Pollock* (1951), in *Theories of Modern Art*, ed. Herschel B. Chipp (Berkeley: University of California Press, 1968), 548.

26 Yoshihara Jiro, *Gutai bijutsu sengen*, 1956, in *Geijutsu Shinchō* 7, no. 12 (Dec. 1956), 202–4; trans. Reiko Tomii, in "Readings in Japanese Art after 1945," Monroe, *Japanese Art after 1945*, 370 (see chap. 11, n. 17).

27 *Bokubi*, no. 1 (June 1951), trans. Alexandra Monroe, in *Japanese Art after 1945*, 137 (see chap. 11, n. 17).

28 For the association of the Copenhagen interpretation with an occult worldview, see Victor J. Stenger, *Physics and Psychics: The Search for a World beyond the Senses* (Amherst, NY: Prometheus Books, 1990); and also Stenger, *The Unconscious Quantum: Metaphysics in Modern Physics and Cosmology* (Amherst, NY: Prometheus Books, 1995).

29 Bohr designed his coat of arms, for which he chose the yin-yang symbol, together with the Latin dictum *contraria sunt complementa* (opposites are complementary), to symbolize the dual wave-particle nature of subatomic particles. The occasion for this was the Danish government's honoring Bohr with a knighthood in 1947. Bohr's biographer Abraham Pais has written that Bohr pursued his interest in philosophy later in life, after his 1920s–1930s work on complementarity, and that his work on atomic theory was not influenced by philosophy; see Pais, *Niels Bohr's Times, in Physics, Philosophy, and Polity* (Oxford: Clarendon Press, 1991), 424.

30 For one example, in 1952 Heisenberg was invited to contribute an essay to *Trans/formation: Arts, Communication, Environment*, a short-lived but widely read journal in the New York art world. Produced by the American artist Harry Holtzman together with consulting editors Marcel Duchamp and Stuart Davis, the journal aimed to bridge art and science. Heisenberg gave his essay the bombastic title "The Quantum Theory: A Formula Which Changed the World" and repeated his pre-war pronouncement that physics is not about the physical world but rather human consciousness: "The new quantum theory . . . had no immediate relation to nature itself but rather to our knowledge of nature"; Werner Heisenberg, "The Quantum Theory: A Formula Which Changed the World" (1950), trans. Christian Vogel, Günther Schoen, and Warren Robbins, *Trans/formation: Arts, Communication, Environment* 1, no. 3 (1952), 129–34; the quote is on 134.

31 New Agers were heirs of the theosophist Helena Petrovna Blavatsky; on the links between theosophy and the New Age movement, see Olav Hammer, *Claiming Knowledge: Strategies of Epistemology from Theosophy to the New Age* (Leiden: Brill, 2001).

32 Fritjof Capra, *The Tao of Physics: An Exploration of the Parallels between Modern Physics and Eastern Mysticism* (1975), rev. ed. (New York: Bantam, 1984); Capra reproduced Bohr's coat of arms on 144 and referred to Heisenberg throughout the book, quoting him directly on 10, 18, 28, 45, 50, 53, 67, 140, and 264.

33 Ibid., 70.

34 For history of the theosophical movement, see Bruce F. Campbell, *Ancient Wisdom Revised: A History of the Theosophical Movement* (Berkeley: University of California Press, 1980); and Isaac Lubelsky, *Celestial India: Madame Blavatsky and the Birth of Indian Nationalism*, trans. Yael Lotan (Sheffield, England: Equinox, 2012).

35 The conflict between Indian scientists and Hindu scholars began in the context of nineteenth-century colonialism and the adoption of a scientific worldview. See Gyan Prakash, "The Modern Nation's Return in the Archaic," *Critical Inquiry* 23, no. 3 (1997), 536–56, in which Prakash writes: "The authority of the Vedas as science and as a sign of the nation was part of a general revaluation and positioning of the Hindu past as an expression of the nation" (543).

36 See *Jamini Roy: From Tradition to Modernity / Jamini Roy: Dalla tradizione alla modernità*, ed. Alessia Borellini, Francesco Paolo Campione, and Caterina Corni (Milan: Silvana, 2015).

37 If a radioactive element has a half-life of 28 years, then after it decays for 28 years about 50 percent of the atoms will remain radioactive, after 112 years 6.25 percent will be radioactive, and after 196 years its radioactivity will be negligible (0.78 percent).

38 Barnett Newman, "Fourteen Stations of the Cross" (1966), in *Newman: Selected Writings*, 190 (see n. 16).

Chapter 13

1 Ludwig Wittgenstein, *Tractatus Logico-Philosophicus* (1921), trans. C. K. Ogden (London: Kegan Paul, Trench, Truber, 1922), 89.

2 In 2013 the British government granted Turing a posthumous pardon. See the biography of Turing by Andrew Hodges, a professor of mathematics at Oxford University, who emerged in the 1970s as a gay rights activist: Hodges, *Alan Turing: The Enigma* (New York: Simon and Schuster, 1983). The book was the basis for the film *The Imitation Game* (2014), directed by Morten Tyldum.

3 See Martin Davis, *The Universal Computer: The Road from Leibniz to Turing* (New York: Norton, 2000), 209.

4 Maxwell imagined an entity (a demon) that allows only fast-moving molecules to pass through a hole in one direction and slow-moving in the other, such that one side of a gas-filled container becomes warm and the other cool, in violation of the second law of thermodynamics. J. Clerk Maxwell, *Theory of Heat* (London: Longmans, Green, 1872).

5 "Electronic Waste Poses Growing Risk to Environment, Human Health, UN Warns," *UN News*, Dec. 13, 2017.

6 "Wer das Auge auf dem Bildschirm genau ansieht, erblickt in der Pupille die Kamera, d.h. im Abbild erblickt er auch das Abbildungsorgan. Die (vorgetäuschte) Unmittelbarkeit und Subjektivität des Blicks wird auf seine technischen und objektiven Bedingungen reflektiert. Die Abbildungskette durchbricht die Subjektivität." "Video Lumina," Peter Weibel's website, accessed Feb. 15, 2019, http://www.peter-weibel.at/index.php?option=com _content&view=article&id=38&catid=13&Itemid=67.

7 On Constructivism in Brazil, see *Arte Constructiva no Brazil / Constructive Art in Brazil*, ed. Aracy Amaral (São Paulo: DBA Melhoramentos, 1998). On Max Bill in Latin America see María Amalia García, "Max Bill and the Map of Argentine: Brazilian Concrete Art," in *Building on a Construct: The Adolpho Leirner Collection of Brazilian Constructive Art*, ed. Héctor Elea and Mari Carmen Ramírez (Houston: Museum of Fine Arts, 2009), 53–68.

8 See Héctor Elea, "Waldemar Cordeiro: From Visible Ideas to the Invisible Work," in Elea and Ramírez, *Building on a Construct*, 128–55.

9 Lucio Fontana, "Manifiesto blanco" [White manifesto] (1946), in *Lucio Fontana: Catalogo generale*, ed. Enrico Crispolti (Milan: Electa, 1986), 1:33–37.

10 Lucio Fontana, interviewed by Carla Lonzi, in *Autoritratto* (Bari: De Donato, 1969), 169–71.

11 Tomás Maldonado, "Lo abstracto y lo concreto en el arte moderno" [The abstract and the concrete in modern art], *Arte Concreto* 1 (1946), 5–7; the quote is on 7.

12 On Maldonado in Ulm, see William S. Huff, "Albers, Bill, e Maldonado: Il corso fondamentale della scuola di design di Ulm (HfG) / Albers, Bill, and Maldonado: The Basic Course of the Ulm School of Design (HfG)," English to Italian trans. by Language Consulting Congressi, Milan, in *Tomás Maldonado* (Milan: Skira, 2009), 104–21.

13 See Francine Birbragher-Rozencwaig, "La pintura abstracta en Venezuela 1945–1965," in *Embracing*

Modernity: Venezuelan Geometric Abstraction, ed. Francine Birbragher-Rozencwaig and Maria Carlota Perez (Miami: Frost Art Museum, 2010), 9–14.

14 Lynn Gamwell, *Mathematics and Art*, 436–47 (see chap. 9, n. 19).

15 James Lawrence has contrasted the void of meaning in Minimal Art with the complex content of the Russian avant-garde in "Back to Square One," in *Rethinking Malevich*, ed. Charlotte Douglas and Christina Lodder (London: Pindar, 2007), 294–313, esp. 307–13.

16 Wolfgang Laib, interview with Klaus Ottmann, 2001, *Journal of Contemporary Art*, accessed Feb. 15, 2019, http://www.jca-online.com/laib.html.

17 Wolfgang Laib, *Light/Seed*, ed. Harald Szeemann (Tokyo: Watari-Um, 1991), 66.

18 David Burliuk, "Cubism (Surface—Plane)" (1912), in *Russian Art of the Avant Garde: Theory and Criticism, 1902–1934*, trans. John Bowlt (New York: Viking, 1976), 70, 73.

19 For a description of Burliuk's visit to Japan, see Toshiharu Omuka, "David Burliuk and the Japanese Avant-Garde," *Canadian-American Slavic Studies: Revue canadienne-américaine d'études slaves* 20, no. 4 (1986), 111–34; and Ihor Holubizky, "David Burliuk in Japan," in Myroslav Shkandrij, *Futurism and After: David Burliuk, 1882–1967* (Winnipeg: Winnipeg Art Gallery, 2008), 27–31.

20 "Trajectory of Wood: Talking with Saito Yoshishige," trans. Reiko Tomii, in "Readings in Japanese Art after 1945," *Japanese Art after 1945*, 379 (see chap. 11, n. 17); originally published as "Ki no ato: Saito Yoshishige to kataru," *Saito Yoshishige-ten* (Tokyo: Tokyo Metropolitan Art Museum, 1984), 8–17. On Saito and his contemporary Yamaguchi Takeo in the context of Japanese modernism, see *Yamaguchi et Saito: Pionniers de l'art abstrait au Japon* (Bruxelles, Musée d'Art Moderne, 1989).

21 Notebook entry by Sekine, quoted in Lee Ufan, "World and Structure—Collapse of the Object" (1969), in "Writings by Lee Ufan," trans. Stanley N. Anderson, in Alexandra Monroe, *Lee Ufan: Marking Infinity* (New York: Guggenheim Museum, 2011), 104–12, the quote is on 111.

22 The quotation is from the closing lines of the preface to Nishida Kitaro, *From That Which Acts to That Which Sees* (1926), trans. Bret W. Davis, in "The Kyoto School", *The Stanford Encyclopedia of Philosophy* (Spring 2017 ed.), ed. Edward N. Zalta, https://plato.stanford.edu/archives/spr2017/entries/kyoto-school/.

23 "Not only are the drops of rain mere appearances, but . . . even their round shape, nay even the space in which they fall, are nothing in themselves, but merely modifications or fundamental forms of our sensible intuition, and . . . the transcendental object remains unknown to us." Immanuel Kant, *Critique of Pure Reason*, 85 (see chap. 9, n. 23).

24 Zhuangzi, "Fit for Emperors and Kings," *Complete Works*, 97 (see chap. 1, n. 41).

25 Lee Ufan, "Beyond Being and Nothingness: On Sekine Nobuo" (1971), trans. Reiko Tomii, in "Readings in Japanese Art after 1945," *Japanese Art after 1945*, 378 (see chap. 11, n. 17).

26 Endo Toshikatsu, "On Fire," trans. Stanley N. Anderson, in *Endo Toshikatsu / Toshikatsu Endo* (Tokyo: Tokyo Museum of Contemporary Art, 1991), 42.

Chapter 14

1 For discussion of Bohmian mechanics, see *Bohmian Mechanics and Quantum Theory*, ed. James Cushing, Arthur Fine, and Sheldon Goldstein (Dordrecht: Kluwer, 1996); and Detlef Dürr, Sheldon Goldstein, and Nino Zanghi, *Quantum Physics without Quantum Philosophy* (New York: Springer, 2013).

2 Maria Spiropulu and Joseph Lykken, "Supersymmetry and the Crisis in Physics," *Scientific American* 310, no. 5 (May 2014), 34–39; the quote is on 36.

3 Alan Turing, "The Chemical Basis of Morphogenesis," *Philosophical Transactions of the Royal Society of London, series B, Biological Sciences* 237, no. 641 (Aug. 14, 1952), 37–72.

4 Konrad Zuse, *Rechnender Raum: Schriften zur Datenverarbeitung* (Braunschweig, Germany: Vieweg, 1969), trans. (MIT Technical Translation AZT-70–164-GEMIT) as *Calculating Space* (Cambridge, MA: MIT, 1970).

5 "Ambient (Outdoor) Air Pollution in Cities Database, 2014," World Health Organization.

6 This data is from the Venera (Russian for "Venus") series of space probes, which were operated by the Soviet Union between 1961 and 1984; NASA's Magellan spacecraft in 1990–94; and spectrometer recordings made by the European Space Agency's Venus Express spacecraft in 2006–7.

7 For a history of racism in human anthropology and a critique of biological determinism, see Steven Jay Gould, *The Mismeasure of Man* (New York: Norton, 1981). On British nationalism and the Piltdown forgery, see Peter

Hancock, "Piltdown Man," in *Hoax Springs Eternal: The Psychology of Cognitive Deception* (New York: Cambridge University Press, 2014), 132–53.

8 See Barry Sautman, "Peking Man and the Politics of Paleoanthropological Nationalism in China," *Journal of Asian Studies* 60, no. 1 (Feb. 2001), 95–124.

9 Rebecca L. Cann, Mark Stoneking, and Allan C. Wilson, "Mitochondrial DNA and Human Evolution," *Nature* 325, no. 6099 (Jan. 1, 1987), 31–36. Subsequent genome sequencing studies have upheld these conclusions.

10 See Séverine Martini and Steven H. D. Haddock, "Quantification of Bioluminescence from the Surface to the Deep Sea Demonstrates Its Predominance as an Ecological Trait," *Scientific Reports* 7 (2017), article no. 45750.

11 See Bonnie L. Bassler and S. T. Rutherford, "Bacterial Quorum Sensing: Its Role in Virulence and Possibilities for Its Control," *Bacterial Pathogenesis*, ed. S. Maloy and P. Cossart (Cold Spring Harbor, NY: Cold Spring Harbor Laboratory Press, 2012), 201–26.

12 "… los Colegios de Cartógrafos levantaron un Mapa del Imperio, que tenía el Tamaño del Imperio y coincidía puntualmente con él." Jorge Luis Borges, "Del rigor en la ciencia" [On precision in science] (1946), in *Historia universal de la infamia* (Buenos Aires: Emecé, 1958), 131–32; the quote is on 131. Borges annotated this one-paragraph story as if it were an excerpt from a historical document written by Suárez Miranda (a fictional character of Borges's invention): "Suárez Miranda, *Viajes de Varones Prudentes* [Travels of prudent men], libro cuatro, cap. XIV (Lérida, 1658)."

15-1. Leafy Seadragon (*Phycodurus eques*), photograph by Hiroya Minakuci. The leafy seadragon is a fish with leafy protrusions all over its body that create the illusion that the animal is floating seaweed. The seadragon propels itself with fins; the leafy protrusions are only for camouflage. The animal is found in waters along the southern coast of Australia; this photograph was taken at an aquarium in Japan.

Acknowledgments

MANY YEARS AGO, Bob Milgrom gave me the chance to pursue my intuition that modern art is an expression of the scientific worldview when he hired me to teach my first science course for art students at the School of Visual Arts in New York. Over the years I've taught many art and science courses at SVA, and with the insights I've gained, I've written the second edition of this book. I thank my students for their enthusiasm about astronomy and biology, as well as Jeff Nesin and Chris Cyphers, the former and current provosts, for their leadership in the interdisciplinary education of artists. In my day-to-day teaching, I receive steadfast encouragement from Tom Huhn, chair of Art History, and Kyoko Miyabe, acting chair of Humanities and Sciences. I am also grateful that the School of Visual Arts, led by president David Rhodes, generously supported this publication.

I wrote the first edition of this book soon after I began teaching at SVA, while also working at Binghamton University of the State University of New York, led by president Lois B. DeFleur, and the New York Academy of Sciences, led by the president of the board of directors, Swedish neuroscientist Torsten N. Wiesel. The first edition received generous support from Novartis Corporation in Basel, Switzerland, and the College Art Association of America.

I received invaluable assistance from the staff of the New York Public Library, Jean and Rolf-Walter Becker, Jan Peter Becker, Stephen Jay Gould, Nancy Grubb, Eric Heller, Suzanne Kotz, Ed Marquand, Elizabeth Meryman, Robert Rosenblum, Neil deGrasse Tyson, and John M. Vickers. The translations from Russian and Polish were done by Silvia Vassileva-Ivanova, from Chinese by Jiajun Liu, and from Japanese by Takumi Segi. Translations from German were done by Silvia Vassileva-Ivanova and myself, and I am responsible for translations from French and Spanish.

The elegant appearance of this book is thanks to graphic artist Jason Snyder. Umbra Studio in New York created twenty-five science diagrams for this volume. The production was guided by Vickie Kearn, executive editor, Susannah Shoemaker, associate editor, and Lauren Bucca, Princeton University Press, under the watchful eye of production editor Karen Carter and Steven Sears. I am also grateful for the meticulous copyediting of Amy K. Hughes, as well as her irrepressible enthusiasm.

For help in keeping my circuits firing, I'm grateful to the staff of the Department of Neurosurgery and the Corinne Goldsmith Dickinson Center for Multiple Sclerosis at Mount Sinai Hospital in New York, as well as my terrific physical therapists: Stefanie DiCarrado, Duane Grell, and John R. Martínez.

In addition to the organizations listed in the credits, certain individuals were exceptionally helpful in securing images for this book: Steven E. Ruzin, Golub Collection, University of California, Berkeley; Alexander Lavrentiev, Moscow; Stephen Addiss, New Orleans; Kurt Gitter, New Orleans; Cathy Ricciardelli, Terra Foundation for American Art, Chicago; Nirmalya Kumar, London; Bart de Sitter, Lukas photography, Ghent, Belgium; Shan Kuang, The Conservation Center of The Institute of Fine Arts, New York University; Tea Temim, Space Telescope Science Institute, Baltimore; Gloria Dubner, Instituto de Astronomía y Física del Espacio, Buenos Aires; Frederick D. Seward, Harvard-Smithsonian Center for Astrophysics, Cambridge, MA; Paola Casini, ESRIN, Frascati, Italy; Cheryl S. Gundy, Space Telescope Science Institute, Baltimore; Takayuki Mashiyama, Taka Ishii Gallery, Tokyo; Jiro Shindo, Kindai Eiga Kyokai, Tokyo; Luciana Senna, Touring Club Italiano Archive, Milan; Toshio Mizohata, Dance Archive Network, Tokyo; Takashi Morishita, Midori Moriyama, and Kae Ishimoto, Hijikata Tatsumi Archive, Tokyo; Yumi Umemura, SCAI The Bathhouse, Tokyo; Jack Hughes, Rutgers University, Piscataway, NJ; Alexander Low, The Stephen Low Company, Quebec; Sílvia Bravo Gallart, IceCube Particle Astrophysics Center, University of Wisconsin-Madison; J. Michael Roney, University of Victoria, BC; Darren Grant, University of Alberta, Edmonton, Canada; David Rumsey, Cartography Associates, San Francisco; Joel Primack, University of California High-Performance Astro-Computing Center, Santa Cruz; Anatoly A. Klypin, New Mexico State University, Las Cruces; Chris E. Henze, NASA Ames Research Center, Mountain View, CA; M. J. Williams, M. J. Williams Law, New York; John Benicewicz, Art Resource; Thomas Haggerty, Bridgeman Images; and Alan Baglia, Artists Rights Society, New York.

15-2. *Orchideae*, in Ernst Haeckel, *Kunstformen der Natur* [Art forms in nature] (Leipzig: Bibliographisches Institut, 1899–1904), plate 74. University of North Carolina at Chapel Hill.

Credits

ArtRes; **11-36** © 2019 The Pollock-Krasner Foundation/ARS; **12-1** Nakatani Tadao; **12-7** Umbra; **12-8** © 2019 Salvador Dalí, Fundació Gala-Salvador Dalí/ARS/BI; **12-11** © 2019 The Barnett Newman Foundation, New York/ARS; **12-12** MoMA/Scala/ArtRes/ARS; **12-13** © 1998 Kate Rothko Prizel & Christopher Rothko/ARS/BI; **12-14** © 2019 The Pollock-Krasner Foundation/ARS/BI; **12-16** Universal History Archive/UIG/BI; **12-17** Granger; **12-22** © The Art Institute of Chicago/ArtRes; **12-23** Naoya Ikegami; **12-27** © Columbia Pictures Corporation (A Stanley Kubrick Production)/Hawk Films/Diltz/BI; **12-28** © 2019 The Barnett Newman Foundation, New York; ARS; **12-30** Sunhi Mang/ARS; **13-1** Adam Reich; **13-2** © Michael Ihle/ Kunsthalle Bremen/ARTOTHEK; **13-3** Franz Warmhof; **13-5** Adam Reich; **13-7** Kristina García; **13-8** ProLitteris, Zurich/ARS; **13-10**, **13-11** ARS/ADAGP; **13-12** © Archivio Penone; **13-14** Robert Divers Herrick; **13-15** MoMA/Scala/ArtRes; **13-16** M. Carrieri/BI; **13-18** ARS/BI; **13-19** © 2019 Judd Foundation/ARS/Christie's/BI; **13-20** © 2019 Stephen Flavin/ARS/Christie's/BI; **13-24** Susumu Koshimizu; **13-25** David Regan; **13-26** Nnobutada Omote; **14-7**, Mark Garlick; **14-13** Reidar Hahn; **14-14** Hugo Glendinning; **14-18**, **14-19** Idra Labris; **14-20** Rajesh Kumar Singh; **14-22** Sajjad Hussain/Agence France-Presse /Getty Images; **14-27** Casey Dorobek; **14-29** Laura Dempsey/Cleveland Museum of Natural History; **14-31** Science Photo Library; **14-32** BI; **14-40** Sandy Huffaker; **14-44** Maarten van der Wal, Micropia; **14-52** Zephyr/Science Photo Library; **14-52** Sunhi Mang; 15-1 Hiroya Minakuci/Minden Pictures.

MUSIC LYRICS CREDIT

Credit for the music lyrics, which appears in the margin of page 57: "Northwest Passage," words and music by Stan Rogers, 1981, Fogarty's Cove Music, Dundas, Ontario, Canada.

15-3. Eric J. Heller (American, born 1946), *Bach Chorale (piano)*. Digital print. Courtesy of the artist.

Index

Page numbers in *italic* refer to a plate or sidebar

artist-scientist collaboration: by Bar-Shai and Ben-Jacob, *449*; by Khoo and Latz, *449*; by Maxwell and Sutton, 124; by McElheny and Weinberg, *298*; by Smirnova and the ESA, *419*; by Viola and USC computer scientists, *259*

Asociación Arte Concreto-Invención, 397, *398*

astrophotography: Common and, 203, *204*

astrophysics, 227

asylum medicine, 188–90

atmosphere (of Earth): carbon dioxide in, 430–31; clouds and, 306; electricity in, 20; electromagnetism and, *300*, 300; magnetic properties of, 220, *222*, 223; Martians and, 98; radio waves in, 219; strontium-90 in, 375; Yohkoh destroyed in, 460

atom: Bohr's quantum model of, 263; fusion of nucleus of, 374–75, 410; electrical properties of, 20, 223; electromagnetism and, 201; indivisibility of, 201; origin of, 297, 300, 410; splitting of nucleus of, 349–50, 352–55, *354*; structure of, *264*, 264; sub-atomic structure of, 238–45, *245*, *246*; transmutation of, 349–50

atomic bomb, 352–55; American art after, 356–61, *357*, *358*, *359*, *360*; Japanese art after, *348*, *362*, 362–72, *368–69*, *370*, *371*

atomism (ancient), 244

Audubon, John James, 45, *48*, 49, 434, *435*

augmented reality (in neurosurgery), 455, *456*, 456

Australopithecus afarensis, *438*, 438

automatism: Arp and, 306–7, *308;* Breton and, 317; Calder and, *304*, 304; Ernst and, 317; Janet and, 198, 315, 317; Kruchenykh and, 149; Miró and, 308, *310;* Paalen and, *340*, 341; in speech, 149; in writing, 317; Yoshihara and, 364, *365;* zaum and, 149

axiomatic method (in mathematics), 382–84

Azari, Fedele, 350

Bachelard, Gaston, 261–62, 276, 337; Surrationalism and, 317–18

bacteria, *88*, *307;* asylum medicine and, 190; drug-resistant, 450; Pasteur and, 87–89, *89;* quorum sensing in, *449*, 449–50

Baldwin, Hanson W., 356–57

Ball, Barry X., *413*

Balla, Giacomo, *233*, 233–35, *234*, 350

Ballengée, Brandon, *436*

balloon. *See* hot-air balloon

Barbizon painters, 124–25, 131

Barr, Alfred H., 185–86, 233

Bar-Shai, Nurit, *449*

basilar membrane, 139–41, *140*

Batlle Planas, Juan, *335*, 335

battery: invention of, 20, *21*

Baudelaire, Charles, 126, 161, 176

Bauhaus, 283, *285*, 285–86; Klee and, *154*, 154

Bayer, Herbert, 304, *305*

Becquerel, Henri, 238–39, 246

Bell, Alexander Graham, 217

Bell, John Stewart, 275–76

Bense, Max, 386

Bernard, Claude, 115

Bernard, Émile, 181, 227

Bernheim, Hippolyte, 194

Besant, Annie, 372–73

Bethe, Hans, 297, 374–75, 377

Big Bang, 296–97, 424; Brown and, *299*; Matreyek and, *xi*; matter and, 410, *425*; McElheny and, *298*; neutrinos and, 424

Bill, Max, *390*, 390; Brazil and, 396; Maldonado and, 397

Binet, René, 157, *160*, 161

Bing, Siegfried, 157

binomial nomenclature (of species), 40

biodiversity, 49, *434*, 434

bioluminescence, *448*, 448–50, *449*

biomorphic abstract art, 306–8, *307*, *308*, *309*, *310*, *311*, 311; Calder and, *304*, 304; Kandinsky and, 100, *101*; origin in microscopy, *99*, 100, 454

Bismarck, Julius von, *412*

Bismarck, Otto von, 135

black hole, *358*, 358, 415, *417*; blazar and, 424; collision of, 418

Black, Adam and Charles, *46*

black body, 262

Blanc, Charles, 167

blazar, 415, *416*, 421, 424

Bleckner, Ross, *454*

blindness: Cubism's (metaphorical) brush with, 184; Hakuin and, *172*; Monet's view of, 130, 468–69n25; mysticism and, 306

Blondeel, Lancelot, 268

Blossfeldt, Karl 311, *312*, *313*, 470n26

blue-shift spectra, *293*, 293

Boccioni, Umberto, 233–34, *235*, 236

Bodhidharma (Daruma), *173*

Böhme, Jakob, 4; Arp and, 306; Runge and, 10, *11*

body imaging, 455; CT (computed tomography), *457*; MRI (magnetic resonance image), *457*; PET (positron emission tomography), *192*

Bohr, Niels: Copenhagen interpretation and, 253–54, 270–78;

Chandrasekhar, Subrahmanyan, 410

Chanon, Nicolas, 412

Charcot, Jean-Martin: Breton and, 317; Freud and, 315–16; hypnotism and, 192–94, *196*, 196–98; model of mind of, 180

Charles V (Holy Roman Emperor), 268

chemosynthesis, 445

Chevreul, Michel-Eugène, *118*, 118–19, 122–23, 468n19; Albers and, 285–86; Delaunay and, 233; Seurat and, 167–69

Chiavacci, Gianfranco, *394*, 394

China: Buddhism in, 25, *173*; calligraphy of, 367; Cold War and, 364, 402; European trade with, 33, 53; Japan and, 330, 333, 355; Leibniz and, 7; nuclear weapons and, 377; sketch-finish debate in, 130–31, *131*, *133*; Taoism in, 6, 24–25

chlorpromazine (trade name Thorazine), 455

cholera, *88*, 88

chromatic distortion, 90, *91*, 202

Church, Frederic Edwin, 45, 47, *50*, *57*

Cicero, 350

Čiurlionis, Mikalojus K., 203, *206*

classical mechanics, 263. *See also* Newton, Isaac

Clausius, Rudolf, 83

Clavaud, Armand, 174, 176, 474n29

Clémentel, Étienne, *129*

climate change. *See* greenhouse effect

Clodion (pseudonym of Claude Michel), *41*

cloud chamber, *246*, 246

cloud: atmospheric, 36, *37*, 306; of energy, 263; nebulas and, 292, *302*; of hydrogen, 374, 460; of hydrogen and helium, 297; supernova and, 410, 421; vaporization and, 362

COBE (COsmic Background Explorer), 296, *297*, *298*

cognitive science, 185. *See also* mind

Cold War, 300, 345, 364, 374–77, 399–400, 402

Cole, Thomas, 38, *39*, 45, *57*, 74

collage: Ei-kyu and, *329*, 330; Ernst and, 319, *321*; montage and, *324*, 324; Pichon-Rivière and, 336

collective unconscious, 346, 360

Colombia, 42, 45

color: primaries of, *119*, 119; printing of, 472n7. *See also* eye

color photography, *124*, 124

color theory: Albers's, 119, 285–86; Chevreul's, *118*, 118–19, 123, 285; Fénéon's, 165, 167–68, 170; Goethe's, 12–13, *13*; Rood's, 164–65, *165*, 167–68, *168*; Runge's, *11*, 11

color and music analogy. *See* music and color analogy

Combe, George, 116–17, *117*

comet: Carus and, 28–31, *30*; Halley and, 30–31, *31*, 414

Common, Andrew Ainslie, 203, *204*

compass: Chinese invention of, 19; magnetism and, *20*, 20; Ørsted's experiment with, *208*, 208; Aristotle's twelve winds and, *52*

computed tomography (CT), 455, *457*

computer: 381, 384–85; Brainlab navigation software, 456; Fortran programming language, *273*; nature as, 428, *429*; neuroscience and, 197, 455; Pleiades supercomputer (of NASA), *425*

computer art: Chiavacci and *394*, 394; Cordeiro and *396*, 396; Feuerstein and, 386, *387*; Franke and, *385*; Iwai and 154, *155*; Kawano and, *386*, 386; Sime and, *380*, *387*, 388

Comte, Auguste, 58, 224, 270, 316; Bachelard and, 261; Latin America and, 333, 336

Concrete Art (Swiss), *390*, 390

Confucius, 7, 25, 326

Conseil Européen pour la Recherche Nucléaire (CERN), 375, 377, 412

conservation laws: entropy and, 83, 87; of mass and energy, 83; of mass-energy, 255–56

Constable, John, *36*, 36, *37*

Constructivism: Japanese, 402–4, *403*, *405*, *406*, 406, *407*; Latin American, *396*, 396–97, *397*, *398*, *399*, 399. *See also* Russian Constructivism

continental drift. *See* plate tectonics

Copenhagen interpretation, 253–54, 270, 272, 274–77; decline of, 414; quantum mysticism and, 372–73

Copernicus, Nicolaus, 201, *202*

Coppola, Horacio, *334*, 334

Corbino, Orso, 350, 353

Cordeiro, Waldemar, *396*, 396

Corra, Bruno, 152

cosmic consciousness, 145–46

cosmic microwave background, 296–97, *297*, 425

cosmos. *See* universe

Coster, Dick, 353–54

Coutu, Patrick, *429*

Crab Nebula, *302*, 302, *303*

Crali, Tullio, *352*, 352

Cro-Magnon man, 106, *175*, 438

Crookes tube, *240*

Crookes, William, *246*, 246

cross-cultural exchange, 172, 333

cross-cultural studies, 8–9, 77

CT (computed tomography), 455, *457*

Cubism, 183–86, *184*, *185*, *186*, *187*, 187, 282; "analytic" and "synthetic", 185–86, 475n7; Einstein and, 186–88, 476–77n12; model of mind of, 179

Figuier, Louis, *62, 104–105*, 106, *218*

film/cinematography: dream and, 323–24; microscopy and, *307, 449*; molecular animation and, *452*; non-objective, *152*, 152–53, 291; photochronography and, *194, 194*; submarine, *446*; x-ray and, *230, 230*

Fischinger, Oskar, *152*, 153

fission of nucleus. *See* atom, splitting of

fission bomb. *See* atomic bomb

FitzRoy, Robert, 76

Fizeau, Hippolyte, 211

Flammarion, Camille, 87, *180, 228*

Flavin, Dan, 399–400, *400*

Flaxman, John, *24, 227*

flood (biblical), 65, *66*, 68, 106

Fluxus, 388

Foer, Anna Fine, *279*

Fontana, Lucio, 396, *397*

Ford, Walton, *49*

Forman, Paul, 269

formalism (in mathematics), 150, 382–84

formalism (in art). *See* non-objective art

fossil, 61–67; of Cro-Magnon, 106, *175*, 438; of Dinknesh (*Australopithecus afarensis*), *438*, 438; of *Iguanodon*, 63–64, *67*; of Irish elk, *97*; Jefferson's interest in, 45, 62–63; of mammoth, *62, 63*; of mastodon, *64, 65, 66*; of *Megalonyx*, 62–63; of Neanderthal, *106*, 438; of Peking man, 438; of protozoa, *96*; of pterodactyl, *67*; stratum of rock and, *68, 69, 70*; of tree resin (amber), 19, 239

four-dimensional geometry, 256: Gabo and, *280*, 290; Einstein and, 256, 281; Eisenstein and, 291; Lissitzky and, 290–91, *291*

Franke, Herbert W., *385*, 386

Franklin, Benjamin: electricity and 20–21, *21*, 239; hot-air balloon and, *33*, 33, 40; Pennsylvania Hospital and, 45; political career of, 21–23

Franklin, John. *See* Northwest Passage

Fraunhofer, Joseph von, *224*, 224

Fraunhofer lines, 224, *225, 264*, 264, 293

free association, 197, 316, 318–19, *321*, 455

free will: Bohr and, 275; Descartes and, 4; Einstein and, 18, 275; Schopenhauer and, 18; Zola and, 115

Freud, Sigmund: Fechner and, 138; Japan and, 325–26; Jung and, 346–47; Lacan and, 345; Latin America and, 334–37; neurology and, 190, 192–94, *193*; neuroscience and, 455, 458; psychoanalysis and, 179, 187, 196–98, *198*, 316; religion and, 258; Schopenhauer and, 15, 18. *See also* dream

Friedrich, Caspar David, *xiv*, 1–2, *10*, 10, 15, *16, 55*; Arctic and, 53–54, *54*, 465n17; Gerhard Richter and, *3*; Johanna Schopenhauer and, 17

Frisch, Otto Robert, 354–55

Fromm, Erich, 338

frottage, 317

Fuchs, Georg, 142

Fukuzawa Ichiro, 326, *328*, 332

Fuseli, Henry, *81*, 81; Moore and, *210*

fusion bomb. *See* hydrogen bomb

fusion of nucleus. *See* atom, fusion of

Futurism, *233*, 233–36, *234, 235*; Bergson and, 479n31; film and, 152; Gabo and, 290; second-generation, 350, *351, 352*, 352

Gabo, Naum, 261, *280*, 281–82, 290

galaxy: Andromeda, 292, *294*; black hole and, 415, *417*; dark matter and, 424, *425*; Hubble Ultra Deep Field, and, *295*; Hubble's law and, *296*, 296; Messier 51a (Whirlpool), 227, *228*; Messier 104 (Sombrero), *416*; Milky Way, *292*, 292, *293*; Wright and, *31*, 31

Galhotra, Vibha, *430–31*

Galileo, 202

Gall, Franz Joseph, 116–17, *117*

Gallé, Émile, *164*, 164

Galle, Johann Gottfried, 205

Gamow, George, *274*, 296–97

Gandhi, Mahatma, 373–74

García-Lopez, Pablo, *192*

García Rossi, Horacio, 392

Gauss, Carl Friedrich, 281–82

Gell-Mann, Murray, 411–12

Genet, Jean, 370

genetic (Y-chromosomal) Adam, 442

genetic (Mitochondrial) Eve, 442

genetics, 197; Mendel's laws of, 77, *80*

geology, *68*, 68–74, *69, 70, 71, 72–73, 74*

geometry. *See* Euclidean geometry; non-Euclidean geometry

Georgiades, Thrasybulos, 388

germ theory of infectious disease, 87–88, *88*, 95; achromatic microscope and, 92, 95, Art Nouveau and, 157; anti-biotics and, 308, 311

German Idealism: Bohr and, 272; Copenhagen interpretation and, 253, 270; end of, 254, 381; Kant and, 1, 19, 52, 59, 272, 404; music and, 140–41; non-objective art and, 154; second-generation of, 2, 19, 52, 137, 404. *See also* Kant, Immanuel; Hegel, G. W. F.; Schelling, Friedrich; Schlegel, Friedrich

Hilbert, David, 150, 382–84

Higgs boson, *413*

Hijikata Tatsumi, *348*, 367, *370*, 370, 372

Hinduism: Gandhi and, 373–74; German Romanticism and, 5, 7–8; pantheism and, 2

Hiroshige, Utagawa, 170, *171*

Hiroshima; 349, 355–56, 358, *362*, 362, 375

Hitchcock, Henry-Russell, 283, 285

Hitler, Adolf, 265, 324, 330, 353, 355, 400

HIV (human immunodeficiency virus*)*, 450, *452*, *454*

HMS *Challenger* expedition, 161, *162*, *163*, *448*

Hölzel, Adolf, *144*, 144

Homo sapiens: African origin of, 436–38, *438*, *439–441*, *442*, *442*, *443*; evolution from apes of, 80–81, *81*; Figuier and, *105*, 106; microbiome and, 450

Hooke, Robert, *90*, 90

Hope, Laurel Roth, *434*

Horacio Coppola, *334*, 334

Horta, Victor, 157, *158*

hot-air balloon, *32*, 40, *41*

Howard, Luke, 36, *37*

Hubble, Edwin, 292–93, 296

Hubble Space Telescope, *295*, *411*, *460*

Hubble's Law, *296*, 296

Hubble Ultra Deep Field, *295*

Hudson, Henry, 53

Hudson River school, 38, 74

Huelsenbeck, Richard, 306, 483n19

human being. See *Homo sapiens*

human epigenome, 437, 450

human genome, 436–37, 450

human immunodeficiency virus (HIV), 450, *452*, *454*

human microbiome, *450*, 450, *451*

Humboldt, Alexander von, 1, 42, 45–47 *47*, 92; Darwin and, 52; *Cosmos* by, 136, 409

Hume, David, 21

Hundred Schools of Thought, 19, 24

Hutton, James, 68, 70, 74

Huxley, Thomas H.: Germany and, 136; human evolution and, 80–81, *81*; Wells and, 100; Wilberforce and, *82*, 82–83

Huysmans, Joris-Karl, 180, 193–94

hydrogen: fusion of, 374–75, 410, 421; MRI and, *457*; origin of, *297*, 297; structure of, 242, *263*, 263, *264*, 264; origin of solar system and, 374, 460; spectra of, *225*, *264*, *293*

hydrogen bomb, (H-bomb), 375, *376*, 377, 410

hydrogen bond, 437

hydrothermal vents, 161, 444–45, *446*

hygiene movement, 88, *89*, 157, 176

hypnotism: Charcot and, 192–94, *196*, 197; discovery of, *23*, 23; Freud and, 197

hysteria: Aragon and Breton on, 317; Charcot and, 193, *194*, *196*; Freud and, 196–97, *198*; Mitchell and, 196, *198*; Moreau and, *195*

ice age, 74

IceCube Neutrino Observatory, *420*, 421

Idaike (known also as Vaidehi; mother of Ajase), 325, *327*

Idealism. *See* German Idealism

Impressionism, *102*, 103, 125–31, *126*, *127*, *128*, *129*; Delaunay and, 230; Neo-Impressionism and, 164

indeterminism. *See* uncertainty

India, 373–74, *374*: air pollution in, *430*, *431*, 430–31; Ajase legend and, 325–26; American Romanticism and, 38–39; German Romanticism and, 5–8; Schopenhauer and, 17–18; theosophy and, 372–73

Indo-European language, 8

Industrial Revolution, 33–59; hot-air balloons and, *32*, *41*; machines and, *112*; railroad and, *34*; sailing and, *35*, *53*, *54*, *56*, *57*; textile factories and, *34*, *112*

ineffability: aesthetic judgment and, 140; music and, 140–41; mysticism and, 260, 383

insanity. *See* mental illness

interference pattern, *223*, 223, 300

interferometer: Laser Interferometer Space Antenna (LISA), 418–19; Michelson and Morley's, *254*, 254

Ioffe, Abram, 290

irrationality: Bohr and, 275–76, 372; Faust and, 28

Iris (Greek goddess), *227*, 227

Ishii Baku, 367

Ishiro Honda, *376*

Iwai, Toshio, 154, *155*

Iwasa, Janet, *452*, 452

Jackson, John Hughlings, 181

Jama Masjid, *431*

James, William, 174, 270

Jammer, Max, 269

Janet, Pierre: Breton and, 317; Charcot and, 197–98, 315; Freud and, 315; in Mexico, 338

Japan: atomic bomb and, 355, *362*, 362; dance in, *348*, 367, *370*, 370, *371*, 372; calligraphy in, 367, *368–69*; Mono-ha and, 402–4, *403*, *405*, 406, *406*, *407*; nuclear arms race and, *376*, *378*, 378, *379*; psychology in, 170–74, 325; Surrealism in, 325–26, *327*, *328*, *329*, 330, *331*, *332*, 332; US occupation of, 363–64, 366, 402; Western trade with,

Mendeleev, Dmitri, 138, *244*, 244

mental illness: asylum medicine and, *188*, 188, *189*, 190; neuroscience and, 455, 458; phrenology and, 116, *117*, 117–18; Rush and, 45. *See also* Charcot, Jean-Martin; Freud, Sigmund

Merleau-Ponty, Maurice, 475n3

Mesmer, Franz, 22–23, *23*

mesmerism, 22–23, *23*, 192

Messier, Charles (numbers of), 302

Mexico: Surrealism in, *337*, 338, *340*, *341*, 341–43, *342*

Michelson, Albert, 254, 418

Michelson and Morley Experiment, *254*, 254–55, 418

microbe. *See* microorganism

microbiome, *450*, 450, *451*

microorganism: asylum medicine and, 190; Binet and, 157, *160*; Ehrenberg and, *321*; germ theory and, 87–88, *88*; Kandinsky and, *101*, *309*; microbiome and, *450*, 450, *451*; photography of, *93*, *94*, 95, *96*, *98*; popularization of, *92*, *98*, *452*, 452, *111*; marine, 445, *446*, *449*; Miró and, *311*, 311. *See also* Haeckel, Ernst

Micropia (in Amsterdam), 452

microscope: electron (scanning), *453*, 453, *454*; filming with, 306, *307*; γ-ray (gamma-ray), *274*; photography and, 92, *93*, *94*, 95; Surgical Theater and, *456*, 456: visible light (transmission), *90*, 90, *91*, *92*, 92

microwave background. *See* cosmic microwave background

mid-Atlantic ridge, *445*

Mies van der Rohe, Ludwig, 283, *285*, 285

Milky Way Galaxy, 31, *292*, 292–93, *293*, 296; black hole in, 415

Mill, John Stuart, 58

Millet, Jean-François, 124

mimesis: Cubism and, 183–88; Plato and, 81; seeing-is-believing and, 59

mind: Descartes and, 4–5, *5*; Kant and, 1–2, 4, 19, 135–36; Naturphilosophen and, 2, 19, 139, 145; neurology and, 190, 192; neuroscience and, 455, *456*, *457*, 458; unconscious, 24–25, 28, 31, 179, 197–98. *See also,* asylum medicine; Charcot, Jean-Martin; Fechner, Gustav; Freud, Sigmund; Helmholtz, Hermann von; hypnotism; Jung, Carl; mental illness; mesmerism; physiognomy; phrenology

mind-matter dualism: Descartes and, 4–5, *5*, 19; Nishida and, 404, 406. *See also* subject-object dualism

mind-body problem, 4

Minimal Art, 399–400, *400*

Miró, Joan, 308, *310*, *311*, 311

Mitchell, John Kearsley, 188, *189*

Mitchell, S. Weir, 190, 196

mitochondrial DNA, *442*, 442

Mitochondrial Eve, 442

modern dance: Ankoku Butoh and, *348*, 367, *370*, 370–72, *371*; Jobin and, 412; Wigman and, *323*, 323

modernism: definition of, 277

Moholy-Nagy, László, *285*, 285, 330

monad. *See* monism

Mondrian, Piet, 282, 287, *288*

Monet, Claude, *102*, 103, 125–26, *126*, *128*, *129*, 129–30, 131, *133*; vision and, 179, 181

monochrome painting: Rodchenko and, 150, *151*

monism, 2, 4–5, 19, 145, 404

Mono-ha, 402–4, *403*, 404, *405*, *406*, 406, *407*

Montgolfier balloon. *See* hot-air balloon

moon, *xii*, *204*; travel to, 203, *205*, *206*, *207*

Moore, Harriet Jane, *210*

Moreau, Gustave, 193, *195*, 197

Morellet, François, *392*, 392

Morita Shiryū, 367, *368–69*

Morley, Edward, 254, 418

Moro, César, 338, *340*, 341

morphogenesis: Turing and, 428

Morse, Samuel F. B., *216*, 216–17, 219

Morse code, 217

Motora, Yūjiro, 170–71, 325

Mouchot, Augustin, 431

Mozart, Wolfgang Amadeus, 7

MRI (magnetic resonance imaging), 455, *457*

Müller-Lyer illusion, *142*

Muluneh, Aïda, 438, *439–41*, 458, *459*

Munari, Bruno, 394

Munch, Edvard, 176, *177*

Murrow, Edward R., 357

music, 140–41, *141*, 142, *152*, 152–54, *153*, *154*, *155*; Endell and, 135, 143–44, *144*; Kandinsky and, 134, 147–48; Kepler and, *202*, 202; Runge and, 11

Mussolini, Benito, 330, 350, 353, 355

mutationism, 174, 474n26

Mutis, José Celestino, 42, 45

Mutis, Sinforoso, 42

mysticism: Arp and, 306; of Böhme, 4, 10, *11*, 306; of Eckhart, 17; of Einstein, 258; James and, 174; Malevich and, 150; Newman and, 358; pantheism and, 2, 132, 139; of Plato, 260; quantum (pseudo-science), 372–73; of Spinoza, 4, 257–60, 358; of Wittgenstein, 260, 383; Viola and, *258*

paradox: physical, 276–77, *278*, *279*; logical, 383–84

paranoia, 345

Parker, Cornelia, *423*

Parkinson, Gavin, 276

particle accelerator, 242, 245, 411; Large Hadron Collider, 377, *412*, 424

Parsons, William, *228*, 292

Pasteur, Louis, 87–88, *89*, 92, 157; evolution and, 103, 106; Gallé and, 164; Redon and, 176; virus and, 453

Patterson, Clair, 374

Pauli, Wolfgang, 270, 274, 276; neutrino and, 421

Pavlov, Ivan, 145–46

Paz, Octavio, 338

Peale, Charles Willson, 62, *64*, *65*

Peale, Rembrandt, *65*, 116

Peano, Giuseppe, 382

Penone, Giuseppe, *394*, 394

Péret, Benjamin, 341

Periodic Table of Elements, *244*, 244–45, *245*, 297, 410

Perrin, Jean-Baptiste, *238*, 238

perspective: cosmic, 187; linear, 125, 187, 326; lived, 125–26, 181; physiological, 125, 132, 187–88, 475–76n10; psychological 188, 315–16, 318–19, 323, 338; relativity of, 24–25. *See also* theory of relativity

Perry, Matthew, *113*, 114

Persephone, *86*, 87

Peterhans, Walter, 334

Pevsner, Antoine, 281, 290

Philolaus, 140

physiology of perception, 119, 180. *See also* Helmholtz, Hermann von

photochronography, *194*, 194

photoelectric effect, *262*, 262

photogenic drawing. *See* Talbot, William Henry Fox

photography, 106–7, *107*, *108*, *109*, *110*, 111; astronomy and, 203, *204*, *294*, *295*; aerial, *110*, 111; camera-less, *200*; color, *124*, 124; microscopy and, 92, *93*, *94*, 95; Monet and, 129–30; photochronography, *194*, 194; subatomic realm and, *246*, 246; time-lapse, 193, *194*, 290

photon, 262–63, *264*, 264; bioluminescence and, 448; electromagnetism and, 413; electron microscopy and, 453; gravity and, 302; Ross and, 271

photon entanglement, 276–78, *279*

photosynthesis, 444–45

phrenology, 116–18, *117*, *118*

physiognomy, 116–18, *117*, *118*

Picasso, Pablo, 183–86, *185*, *187*, 282; Einstein and, 186–88, 476–77n12

Pichon-Rivière, Enrique, 335–36

pigment: primaries of, *119*, 119

Pissarro, Camille, 168, 472n4

Planck, Max, 262, 276

Planck's constant, 262

plate tectonics, 63, *66*, 442, *444*, 444–45, *445*

Plato, 4–5, 404; mimesis and, 81; mysticism and, 260, 306

Pleiades supercomputer (of NASA), *425*

Pluto, 304

Poe, Edgar Allan, 35, 176

Poincaré, Henri, 188, 254–55, 261

Pollock, Jackson, *347*, 347, 357, *360*, *361*, 361, 485n35; Gutai and, 364

pollution (of atmosphere): in England, 33, *34*, *35*; in India, *430*, 430, *431*

pollution (of ocean), 434–36, *436*

popularization of science, ix–xi; Europe and, 95–100; French style of, 106, 114; German style of, 136; psychoanalysis and, 316; quantum mechanics and, 276–77, 372–73; theory of relativity and, 260–62

positivism, 58–59; Latin America and, 333; *logical, 253, 270, 272; World War I and, 316;* Zola and, 114–15

postmodernism: definition of, 277

Pound, Ezra, 236, 238

Poyet, Louis, 112, 328

Prampolini, Enrico, 350

Primack, Joel, *425*

prism, *12*, 12, *13*, *223*, 223; diffraction grating and, 224, *226*; spectrometer and, *224*, 224

probability: determinism and, 214, 269; Einstein and Maxwell's use of, 274; an electron's position and, *263*, 263; Heisenberg's use of, 274. *See also* chance

proton, 242. *See also* atom, origin of; atom, splitting of; atom, structure of; Periodic Table of Elements and

Proust, Marcel, 298

pseudo-science: of Crookes, 246; of quantum mysticism, 372–73

psychoanalysis: Freud and, 179, 196, *198*, 198, 258, 315–16, 319, 455, 458; in Japan, 325–26; Jung and, 346–47; Lacan and, 345; in Latin America, 333–37; Varo and, *342*; Wigman and, *323*

psychosis: Charcot and, 316; Lacan and, 345

psychophysics: Fechner and, 138, 145; Motora and, 170

pterodactyl, 63, *67*

pulsar, 302

Purism, 282

Puységur, Marquis de, 23

Pythagoras, 2, 4–5, 404; music and, 140

scientific Buddhism, 172, 174

scientific method, 77, 80

scintillating grid illusion, *123*

Scipio, 350, 352

Scriabin, Alexander, 152, *153*

Sekine Nobuo, 402–4, *405*, 406

Seung, Sebastian, *361*

Seurat, Georges, 164–70, *166*, *169*, 472n4

Shannon, Tom, *222*

Shen Zhou, 6

Shiota, Chiharu, *27*, 378, *379*, *458*, 458

Shuman, Frank, 431

Signac, Paul, *169*, 169–70

Sime, Elias, *380*, *387*, 388

simultaneous contrast: of hue, *118*, 118–19, 285; of value, *123*

skyscrapers, 283, *285*, 285

sleepwalking, 23

Smirnova, Ekaterina, *419*

Smith, William, *68*, 68, *69*

Soavi, Giorgio, 394

Sobrino, Francisco, 392

solar mass, 302

solar system, 201–2, *202*, *206*; origin of, 374, 410

somnambulism, 23

Soto, Jesús Rafael, 392, 397, *399*, 399

sound-wave, 139, *141*, 141; telephone and, 217, *218*

Soupault, Philippe, 317

Spaatz, Carl, 349

space-time, *256*, 256

Spazialismo, 396

spectrography, 223–24, *224*, *225*, *226*, *227*, 227

spectrograph: emission and absorption, *225*, *264*; red-shifted and blue-shifted, *293*, 293

spectrum (of sunlight): Fraunhofer and, *224*, *225*, *227*, 227, *264*, 264, *293*, 293; Hertzsprung and Russell and, 249–50, *251*; Hubble Ultra Deep Field and, *295*; Newton and, *12*, 12, *13*, 140, 223; vision and,119; Young and, *223*, 223. *See also* electromagnetic spectrum

Spinoza, Baruch, 4, 135; Einstein and, 257–58, 260, 269; Newman and, 357–58

spinthariscope, *246*, 246

Spiropulu, Maria, 415

Standard Model of Elementary Particles, 411–12, *413*

statistics. *See* probability

star: absolute magnitude of, 249; Cepheid variable, 292; chemistry of, 224, 249–50, *251*, 300; color of, *229*, 229, 249–50, *251*; cross section of, *297*, *300*, 300; neutron,

302, 302; nuclear fusion and, 374–75, 460, *461*; spectra of, *293*, 293

constellation: Andromeda, 292; Aries, *viii*, 227, 478n19; Arp and, 306–7, *308*, Big Dipper, *229*, 478n19; Carina, *461*; Cepheus, 292; Miró and, *311*, 311; Sagittarius, 300; Virgo, *417*

steam engine, 33, *34*, *35*

Stein, Jöel, 392

Steiner, Rudolf, 287

Stephenson, George and Robert, 33

Stephenson's Rocket, *34*

Stern, Grete, 334, *336*, 336

Stoney, George Johnstone, 239

Strakhov, N. N., 137

string theory, 277, 414–15

strontium-90, 375, *376*, 487n37

subject-object dualism, 272, 388, 404, 406

sublime: Romanticism and, 1, 38; Abstract Expressionism and, 258

Sugimoto, Hiroshi, *109*, *241*

Sullivan, Louis, 159, *160*

sun. *See* star

Super-Kamiokande neutrino detector, 421

supernova, 300; black hole and, 415; neutrinos and, 421; neutron star and, *302*, 302, *303*; remnant of, *303*, 410

superposition, 278

supersymmetry, 414–15

Suprematism. *See* Russian Suprematism

Surrationalism, 318

Surrealism: in Japan, 325–26, *327*, *328*, *329*, 330, *331*, *332*, 332; in Latin America, 333–38, *334*, *335*, *336*, *337*, *339*, *340*, *341*, 341–43, *342*, *343*, 345; in Paris, *317*, 317–19, *319*, *320*, *321*, *322*, 323–24, *324*, 343, 345, 355–356, *356*

Sutton, Thomas, 124

Suzuki, D. T., 174

syllogism, 282

Symbolism, *174*, 174, *175*, *176*, 176

synapse, 190, *191*

Taine, Hippolyte, 114, 123

Talbot, William Henry Fox, *94*, 95, 107, *108*, 109, 111; Monet and, 129–30

talk therapy, 197, 319

Tamayo, Rufino, *340*, 342–43

Tanaka Atsuko, 364, *366*

Tanizaki Jun'ichiro, 402

Taoism, 2, 5–6, 373; Nishida and, 404, 406. *See also* Laozi, Zhuangzi

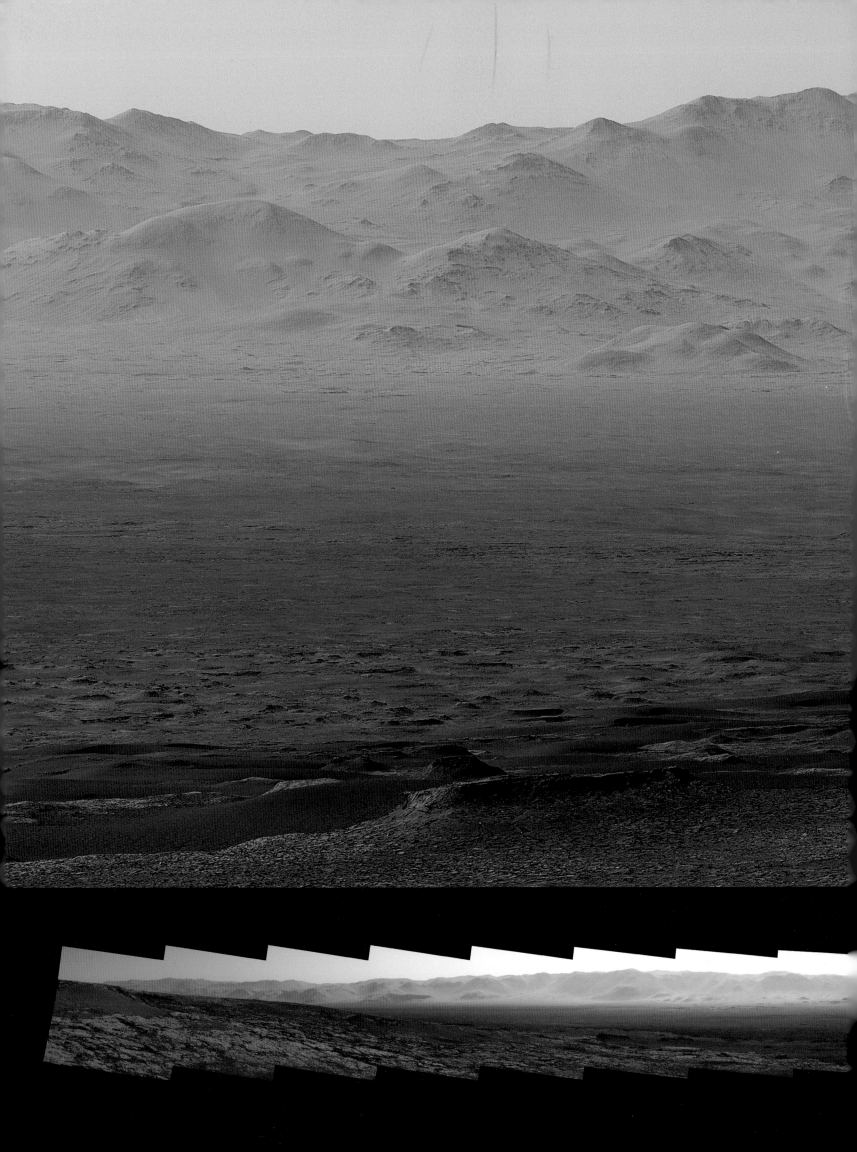

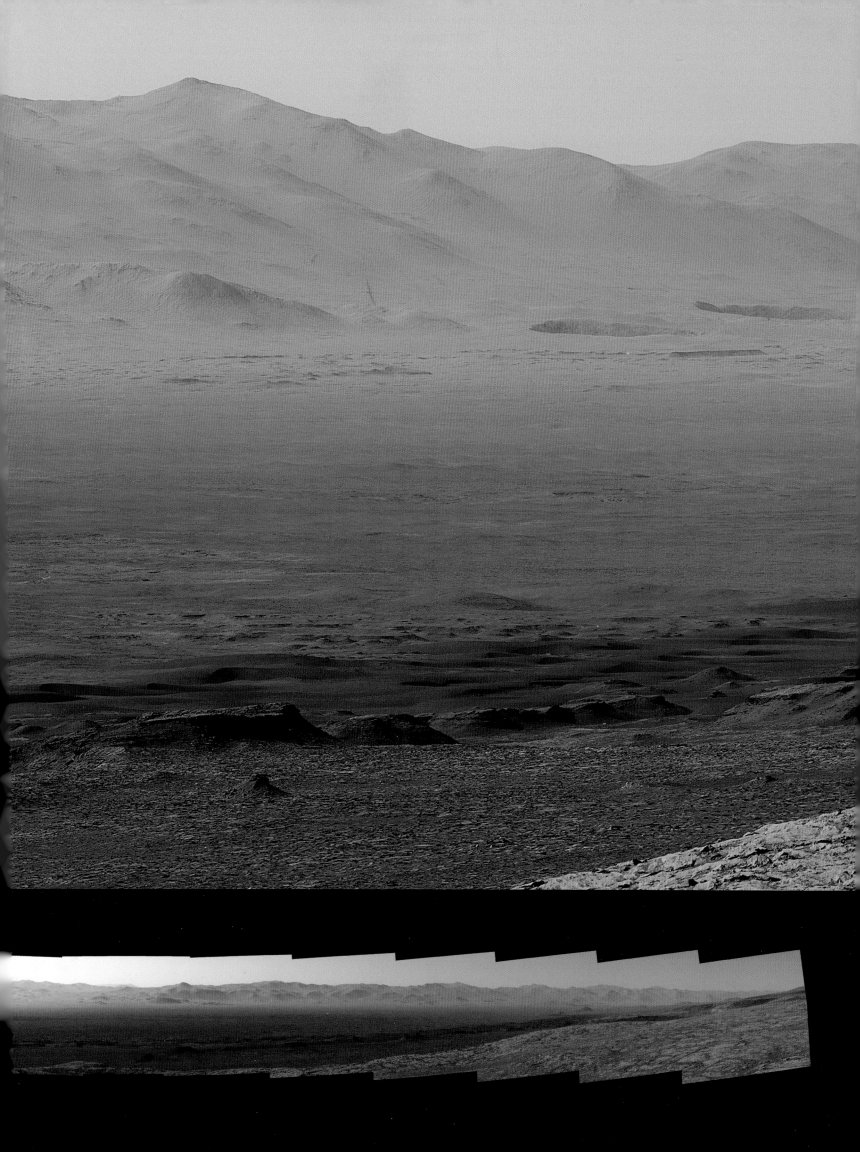

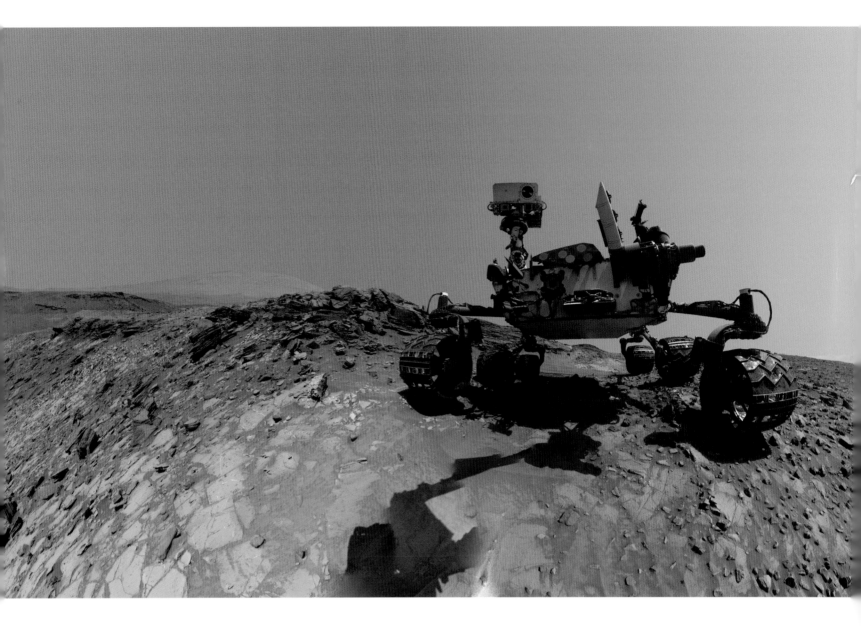

15-4. Curiosity, from the mission Mars Science Laboratory, landed August 6, 2012. Photograph. NASA/JPL-Caltech/MSSS.

15-5. Mars landscape, telephoto vista and wide-angle panorama by Curiosity Mars rover, 2017. Photographs. NASA/JPL-Caltech/MSSS.

In 2012, Curiosity landed on Mars at the foot of a mountain in a flat region in the center of the huge crater shown in the photographs on the previous pages; the crater was formed when a meteor hit Mars. Scientists chose this as Curiosity's landing site because the crater has many signs that water was once present there, and water is a key ingredient to life as Earthlings know it. Curiosity is a vehicle (a "rover") about the size of a small SUV that carries scientific instruments for studying geology; it found evidence that Mars once had a freshwater-lake with all of the basic chemical ingredients for microbial life.

Curiosity has explored over 13 miles (21 kilometers), carrying cameras aloft on a high mast (a "Mastcam"), with which it took the 16 side-by-side images in visible light with its wide-angle lens to form the panorama. The photograph (above) of Curiosity was taken with a camera on its robotic arm (not shown in the composite image). The Martian landscape photographs have been white-balanced so the colors of the rock and sky appear as they would in daylight on Earth; Curiosity's selfie shows the rocks and sky as they appear on Mars.

Besides studying Martian geology and looking for signs of life, a goal of the mission is to prepare for human exploration. Earthlings have long been fascinated with Mars; the planet has inspired hundreds of novels and films expressing a range of human emotions from fear of invasion by Martians (*War of the Worlds*, 1897, British novel by H. G. Wells), to falling in love with the queen of Mars (*Aelita*, 1924, Russian film directed by Yakov Protazanov based on a story by Aleksey Tolstoy), to confidence in the power of science after being stranded on Mars (*The Martian*, 2015, American film directed by Ridley Scott).

Curiosity's Mastcam was built and is operated by Malin Space Science Systems in San Diego. NASA's Jet Propulsion Laboratory at Caltech in Pasadena, California, designed and built Curiosity and manages its mission: the Mars Science Laboratory Project.

Rien d'impossible [Nothing (is) impossible], late nineteenth
century. Hand-colored etching on an embossed card.
Tissandier Collection, Library of Congress, Washington, DC.